Silk
Roads

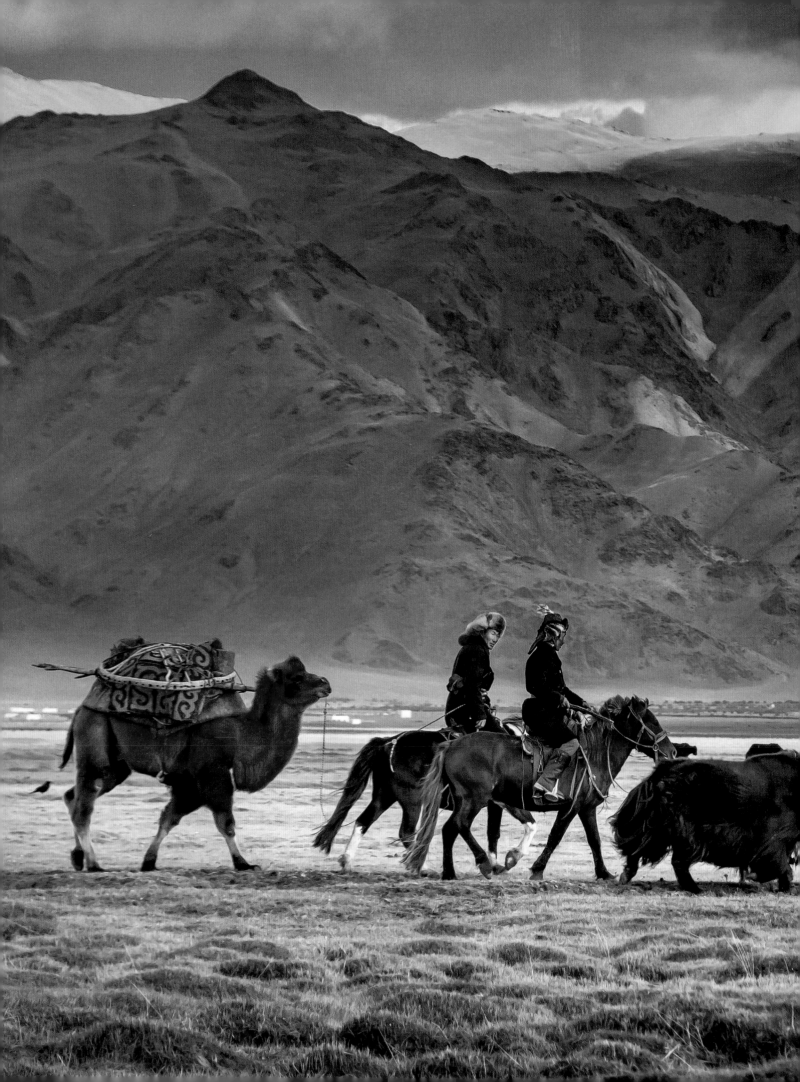

Silk Roads

Peoples, Cultures, Landscapes

Edited by Susan Whitfield

Foreword by Peter Sellars

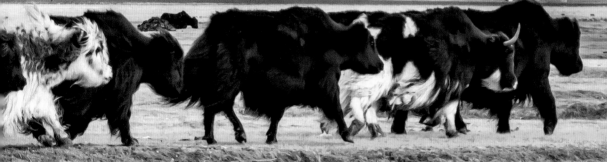

UNIVERSITY OF CALIFORNIA PRESS

20 Mapping the Silk Roads

40 Photography of central Asia

48 Steppe

118 Mountains and highlands

206 Deserts and oases

276 Rivers and plains

368 Seas and skies

Material culture of the Silk Roads

Cross-categories are indicated with letters. Additional to those noted in category headings are: religion (R); military (Mi); clothing and accoutrements (CA); science (Sc).

Contributors

Essay contributors are credited by name and contributors of shorter caption texts by their initials. Contributors' biographies are on pp. 466–67.

General editor Susan Whitfield

Foreword Peter Sellars

Advisory board

Alison Aplin Ohta
Bérénice Bellina
John Falconer
Sergey Miniaev
Luca M. Olivieri

Ursula Sims-Williams
Daniel C. Waugh
Tim Williams
Zhao Feng

Contributors

AB	Arnaud Bertrand	KD	Koray Durak	TW	Tim Williams
AF	Anna Filigenzi	KI	Karel C. Innemée	UB	Ursula Brosseder
AHK	Anne Hedeager Krag	KMR	Kate Masia-Radford	USW	Ursula Sims-Williams
AO	Alison Aplin Ohta	LL	Lew Lancaster	VM	Valentina Mordvintseva
ASc	Angela Schottenhammer	LN	Lukas Nickel	WB	Warwick Ball
ASe	Assaad Seif	LO	Luca M. Olivieri	WKR	Wannaporn Kay Rienjang
ASh	Angela Sheng	LT	Li Tang	WXD	Wang Xudong
BB	Bérénice Bellina	LWY	Li Wenying	ZF	Zhao Feng
BH	Berit Hildebrandt	LXR	Liu Xinru	ZG	Zsuzsanna Gulácsi
CC	Cristina Castillo	MH	Mark Horton		
CD	Claire Dillon	MO	Mehmet Ölmez		
CO	Charles R. Ortloff	MP	Marinus Polak		
DN	Davit Naskidashvili	MT	Marina Tolmacheva		
DV	Dmitriy Voyakin	NM	Noriko Miya		
DW	Daniel C. Waugh	NR	Nicolas Revire		
EHS	Eivind Heldaas Seland	NS	Nikolaus Schindel		
EL	Elizabeth A. Lambourn	NSW	Nicholas Sims-Williams		
ES	Eberhard W. Sauer	PPH	Puay-Peng Ho		
FG	Frantz Grenet	PW	Paul D. Wordsworth		
GH	Georgina Herrmann	PWe	Peter Webb		
GL	George Lane	PWh	Peter Whitfield		
GM	George Manginis	RB	Robert Bracey		
GR	Gethin Rees	RD	Rebecca Darley		
HOR	Hamid Omrani Rekavandi	RS	Robert N. Spengler		
HW	Helen Wang	RT	Richard J. A. Talbert		
IA	Idriss Abduressul	RWH	Rosalind Wade Haddon		
IS	Ingo Strauch	RXJ	Rong Xinjiang		
IT	Ilse Timperman	SB	Sonja Brentjes		
JB	Jonathan M. Bloom	SD	Sophie Desrosiers		
JC	Joe Cribb	SH	Susan Huntington		
JF	John Falconer	SM	Sergey Miniaev		
JH	Julian Henderson	SP	Sara Peterson		
JK	Jun Kimura	SS	Sarah Stewart		
JM	James A. Millward	SW	Susan Whitfield		
JMBB	Jean-Marc Bonnet-Bidaud	TC	Tamara T. Chin		
JN	Jebrael Nokandeh	TD	Touraj Daryaee		

Title pages — Horses were central to the Silk Roads, used in warfare, diplomacy and trade and for travel, driving much of the economy from China to Arabia. Camels and yaks were more specialist and localized Silk Roads transport, here shown on the eastern steppe.

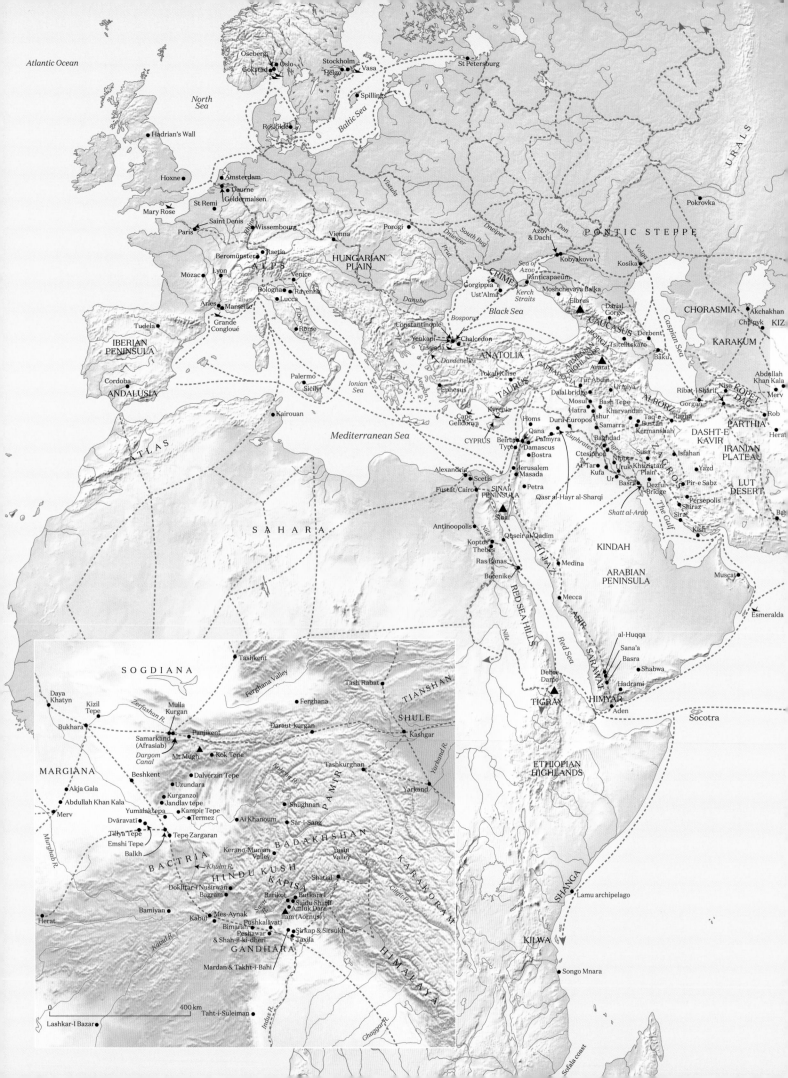

SIBERIA

Yenisei

MINUSINSK BASIN
Abakan

Tomsk

Arzhan Tuva

Pazyryk

BEREL

ALTAI

Takhiltyn Khotgor

DZUNGARIA
PLAIN

Lake
Baikal

TRANSBAIKAL

Orgoiton
Selenga

Tsaram

Orkhon

Gol Mod Noin Ula Duurlig Nars

MONGOLIAN STEPPE

MANCHURIA

Tuzusai
Almaty Ili

Ili

Kucha Tarim R.
TIAN SHAN Aksu
Tumshuk

Kashgar

zm
Mugh

PAMIR

RIA

HINDU KUSH

Ai Khanoum

Butkara Barikot
Bimaran
ul

Turfan Kocho
JUSHI Bulayik

TARIM BASIN

TAKLAMAKAN
Djoumboulak koum
Karadong
Keriya R.
Danjan-Uliq
Khotan Domoko
Sanju Pass Cadota
Sampula

KARAKORAM

KUNLUN

Yingpan
KRORAINA
Miran
Yangguan
Cherchen
Zaghunluq
Cemetery

LOP
DESERT

Dunhuang
Jiuquan

Hami

Yumenguan Karakhoto

HEXI CORRIDOR

QILIAN

Wuwei

Xigoupan

GOBI DESERT

Yellow

ORDOS

Yanqi

Yungang

Paektu

BAEKDUDAEGAN

KOREAN
PENINSULA

Hōryūji
Nara

Kofu

Mount Fuji

Zhangye
Bazhou

Guyuan Chang'an

Gongxian Xuzhou

Dazaifu

Osaka

HIMALAYA

TIBETAN
PLATEAU

QINLING

NORTH
CHINA
PLAIN

Longmen &
Luoyang

Yangzhou

Koreda straits

Laoguanshan Sanxingdui
Chengdu

Yangzi

Hangzhou

PUNJAB
PLAIN

Delhi
Mathura

Birkot

Jodhpur

THAR
DESERT

arikon
mbhore

GUJARAT

Cambay Narmada
Bharukaccha
takavapra

SICHUAN
BASIN

Ganges

Pataliputra

Fuzhou
Quanzhou

Guangzhou

Nanhai No.1

Fengtian

Pacific Ocean

Hooghly Padma

AJANTA

Yunnar

Ajanta caves

Kanheri
ai
le
se

KONKAN COAST

DECCAN
PLATEAU

WESTERN GHATS

SAHYADRI

Amaravati

Sanganakallu

Pagan

Irrawaddy

HAINAN

ANNAM

Chau Tan

PHILIPPINE
ISLANDS

Bay of
Bengal

Phu Khao Thong

Binh Som

Mangalore
Malaba

Arikamedu
Puducherry

Muziris
Kodungallur

Kollam

Mantai

Colombo

SRI LANKA

Godawaya

Indian Ocean

ANDAMAN
ISLANDS

Ban Don ta Phet Ayutthaya
Phanomsurin
Angkor

Óc Eo

Mekong
Delta

Isthmus of Kra

Khao Sam Kaeo

MALAY
PENINSULA

South
China
Sea

Pasai

Malacca

SUMATRA

Geldermalsen

Belitung

Palembang

Ternate
Tidore

Sulawesi

Banda
Islands

Batavia Punjulkarjo

BANTEN JAVA

LESSER SUNDA ISLANDS

TIMOR

Lanzhou Settlement
 Wreck site
Ganges River
 Mountain
 Major trade route

0 1000 km

Foreword

Peter Sellars

"What can I do, Muslims? I do not know myself.
I am neither Christian nor Jew, neither Magian nor Muslim,
I am not from east or west, nor from land or sea,
not from the shafts of nature nor from the spheres of the firmament,
not of the earth, not of water, not of air, not of fire.
I am not from the highest heaven, not from this world,
not from existence, not from being,
I am not from India, not from China, not from Bulgar, not from Saqsin,
not from the realm of the two Iraqs, not from the land of Khurasan."

Rumi (1207–1273), 'Only Breath', translated from Persian by Bernard Lewis.

Welcome to central Asia, or the Silk Roads, or Afro-Eurasia, as it is termed by the writers in this book. 'Silk Roads' is a convenient term for extremely inconvenient geographies, histories, peoples and spiritual expanses that edge uncomfortably and miraculously towards the unknown, the impossible and the impassable. The fastnesses and vastnesses of these landscapes have nurtured cultures of inner light and secret freedoms, metaphysical daring and notable human courage. One cannot conceive of these regions in terms of flags and nation-states; Silk Roads studies take us deep into the heart of composite cultures, interdisciplinary ways of understanding and populations in motion that bring us face to face with the complexities of the contemporary globalism unfolding with shocking speed in our own lifetimes.

Susan Whitfield has assembled a book that suggests a new era in scholarship, multi-vocal, collaborative bodies of knowledge held by communities of insiders and outsiders where each breakthrough leads inevitably to further discussions and revision of previous frameworks. Each of the entries in this book is contributed by a leading scholar as a springboard to further reading and research. The result is a book that is truly as dynamic as its unruly subject.

'There are many ancient places where one finds stones in graves, woods carved with some artistic design. Sometimes there are letters engraved in the rock of a mountain, on a stone; letters today which no one can read. Yet one endowed with the gift of intuition can read them from the vibrations, from the atmosphere, from the feeling that comes from them. Outwardly, they are engravings, inwardly they are a continual record, a talking record....No traveller with intuitive faculties open will deny the fact that in the land of ancient traditions he will have seen numberless places which, so to speak, sing aloud the legend of their past.'

These evocative words, spoken in London in the 1920s by Hazrat Inayat Khan, one of the first Sufi teachers in Europe, evoke the poignance and mystery of central Asian cultures and should be borne in mind as you gaze at the charged and magical objects featured throughout this book. The satisfying surprise is that there are people who can read the ancient inscriptions and are writing the entries accompanying the photographs. The objects and the peoples featured here are speaking in new ways thanks to new generations of scholars, but their songs are something you can only hear in the inner recesses of your own imagination, meditating on the transience of all things and their rebirth in new forms. These gorgeous objects, like the landscapes that have held and preserved them, are living beings. The tombs and stupas are for saints who never died and whose influence will only resonate more deeply after they have left the earth – their holy domes, nestled in the desert like nuclear power plants of a civilization that has yet to arise, radiating strength, compassion and infinite beauty.

Opposite — Banqueter drinking from a rhyton. Detail of 8th-century murals at Panjikent in Sogdiana.

Overleaf — Carpets of wool and silk travelled along the Silk Roads as items of use and of trade. The carpet-makers of Iran continue the tradition today, using wool from sheep bred in the mountains and organic dyes.

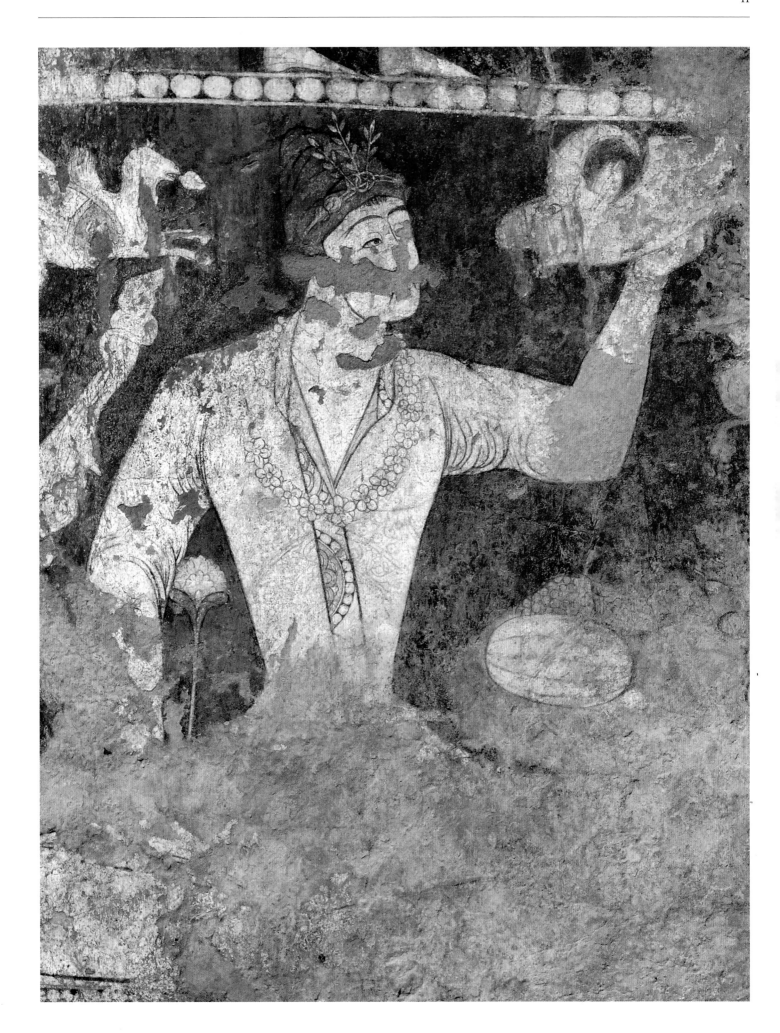

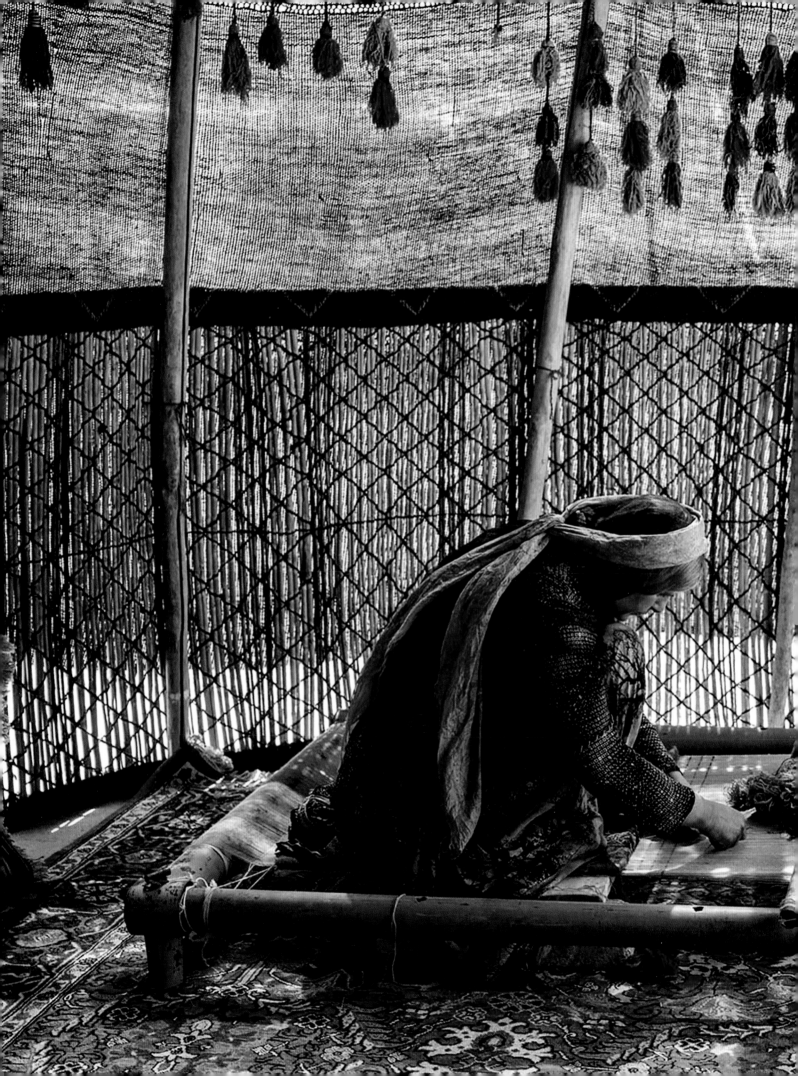

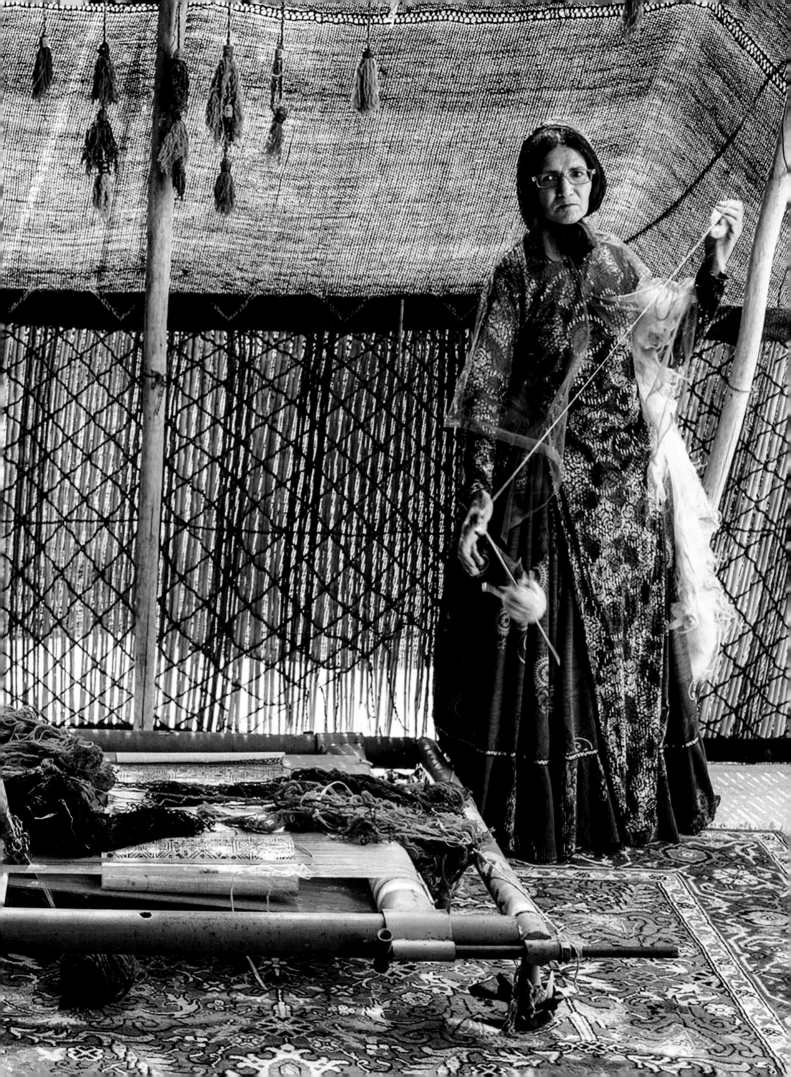

Introduction

Susan Whitfield

"The World is not a Home. It is a Marketplace.
 A market is kind haven for the wandering soul
Or the merely ruminant. Each stall
Is shrine and temple, magic cave of memorabilia.
Its passages are grottoes that transport us,
Bargain hunters all, from pole to antipodes, annulling
Time, evoking places and lost histories."

Wole Soyinka, 'Samarkand and Other Markets I Have Known', 2002.

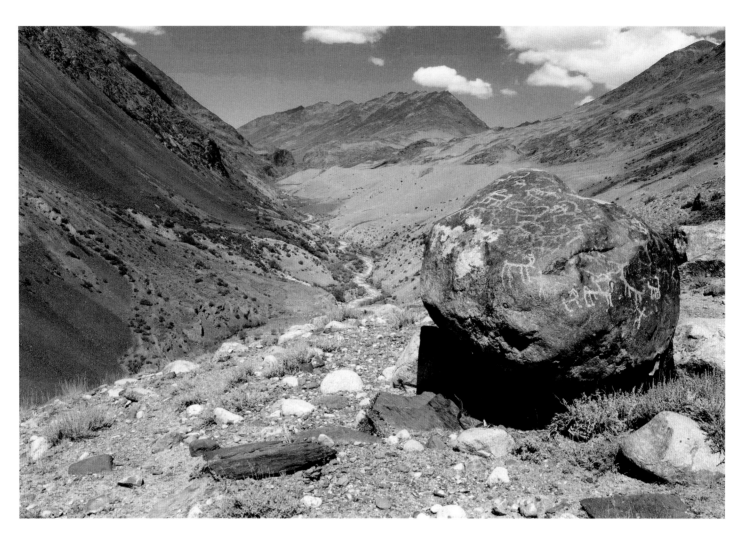

The Silk Roads used ancient routes over mountain passes, often marked with petroglyphs, as in this valley in the Pamir in central Asia.

There was no 'Silk Road'. It is a modern label in widespread use only since the late 20th century and used since then to refer to trade and interaction across Afro-Eurasia from roughly 200 BCE to 1400 CE.[1] In reality, there were many trading networks over this period. Some of these dealt in silk, yarn and woven fabrics. Others did not. Some started in China or Rome, but some in central Asia, northern Europe, India or Africa – and many other places. Journeys were by sea, by rivers and by land – and some by all three. Despite these ambiguities, the term has acquired a familiarity and brought regions and peoples often less well covered by modern historical writings to greater prominence and accessibility. It could also be argued that the growing popularity of the term has encouraged a more global historical viewpoint. For this reason I have referred to the 'Silk Road' – or perhaps slightly less misleadingly, the 'Silk Roads' – unashamedly in my writings and exhibitions. If I were to provide a general definition of what I mean by the term – and how it is used in this book – it would be something like:

A system of substantial and persistent overlapping and evolving interregional trade networks across Afro-Eurasia by land and sea from the end of the 1st millennium BCE through to the middle of the 2nd millennium CE, trading in silk and many other raw materials and manufactured items – including, but not limited to, slaves, horses, semi-precious stones, metals, pots, musk, medicines, glass, furs and fruits – resulting in movements and exchanges of peoples, ideas, technologies, faiths, languages, scripts, iconographies, stories, music, dance and so on.

1. For discussions on the initial adoption (in 1877) and growth of the use of the term in the 20th century, see Chin 2013, Waugh 2010, Whitfield 2007 and 2015 (Introduction). Others have been more sceptical of the term's usefulness: 'nothing but a myth' (Ball 1998: 23) and 'a romantic deception' (Pope 2005).

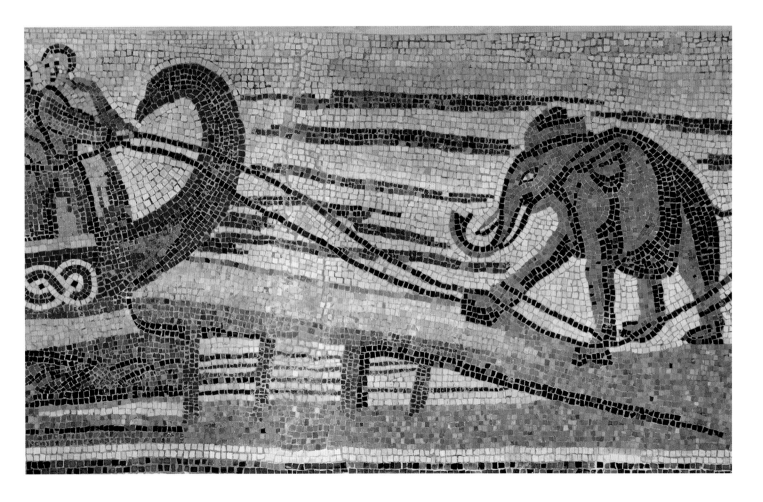

Central to the Silk Roads is the interaction across 'boundaries', be they chronological, geographical, cultural, political or imaginary. This book therefore starts with a section on the maps, geographies and other means by which humans have attempted to record and to bound the known and mythical worlds for various purposes: only sometimes were these intended primarily to aid travellers. In modern times, photography has been used as a tool of record, especially for archaeologists and explorers, but also to give viewers a window into different worlds. It is also considered in a brief essay, while some of the historical archaeological photographs are reproduced in later sections.

The main part of this book is not arranged by any political or cultural divisions, nor chronologically. To give the reader some basic orientation in both time and space, maps are provided throughout showing the places mentioned in the text and dates are given for political entities and their rulers, where mentioned. Inevitably major empires, the dates and rulers of which are well known, take centre stage in Silk Road histories, often crowding out the many peoples and cultures who are less well served by history. This is the case, for example, with many of the steppe cultures, often neglected or presented as passive recipients of the products of neighbouring empires, such as China, Rome or Sasania. But, as discussed by the authors of the essays on the influences between the steppe and these cultures, this was always a two-way interdependent relationship and the steppe is an essential part of the Silk Road story. Similarly, the many small oasis kingdoms of the Taklamakan or Arabian deserts are barely mentioned in most Silk Road histories, despite some having their own languages and art, and thriving for hundreds of years. This book aims to gives a more balanced picture. For readers wishing to learn more, suggestions are given throughout for further reading.

Descriptive names have been used for geographical areas where possible, such as west Asia, the Iranian plateau or the Tarim basin; inevitably many of these bring in historical and political connotations or will cause consternation among some. There is little way round this: it shows the ongoing interaction between humans and the landscape and how the latter is invariably politicized as a result. Naming is often an act of appropriation.[2] But while trying to circumvent being bounded, nevertheless a book demands a structure. Here the material culture – including the landscape – is showcased to give a sense of the richness and diversity of the interactions of the

Sea transport was more efficient and cheaper for large, heavy and fragile cargo, including metals, glass, ceramics, slaves and, as shown in this 3rd- to 4th-century Roman mosaic from Veii, animals such as elephants.

2. For an exploration of the issues with naming as appropriation see Brian Friel's play *Translations*, which dramatizes the early 19th-century period when English surveyors sought to map Ireland as part of the Ordnance Survey.

Silk Roads. As well as the finished products, this book also considers how some of the artifacts were made – the technology of the Silk Roads – as well as why they were made where they were. Much depended on factors such as the availability of raw materials: some of these were very rare, such as lapis lazuli, only found in a few sites across Afro-Eurasia. Others, such as the clay used to make ceramics in Mesopotamia, was common throughout the region. Raw materials – or partially worked goods, such as glass slag or silk yarn – were not always worked locally, but were traded, to be worked into finished products in lands distant to where they were found.

As well as providing raw materials, the landscape sustained agriculture and pastoralism, so enabling human life and leisure. It both supported and impeded long-distance travel and, above all, it continues to hold traces that can reveal something of the transmissions across the Silk Roads.

Each section of this book starts with brief introductions to the landscapes of Afro-Eurasia, to some of the many peoples and cultures inhabiting these landscapes over the Silk Road period, and to the uncovering of their archaeological legacy. The book is structured by the types of landscape through which the Silk Road networks passed – steppe, mountains and highlands, rivers and plains, deserts and oases, and seas. The skies are common to all, but included with seas because of their role in maritime navigation.[3] These are no more than broad and permeable divisions: rivers rise in mountains, emerge into plains and disperse into seas or desert sands. Nor are they intended to be comprehensive: this is not a book on the complex ecosystems of Afro-Eurasia. But the landscape is an essential character in any Silk Road story, and too often given only a minor role.

The landscape, however, can also bias or limit our viewpoint. It preserves and destroys without discrimination. For example, the desert sites of eastern central Asia and north Africa have yielded numerous silks, local and imported. But the monsoons have long destroyed south Asia's textile legacy and we can only reconstruct it from clues in historical texts, from paintings and other artifacts and, very importantly, from textiles exported to distant lands, such as the desert settlements of Cadota and Antinoopolis. In recent times, the legacy of the sea has started to be uncovered with the

3. Of course, the stars were also used in land navigation, especially in the large sandy deserts where landmarks were few, paths were easily covered by sand and heat often led to night travel.

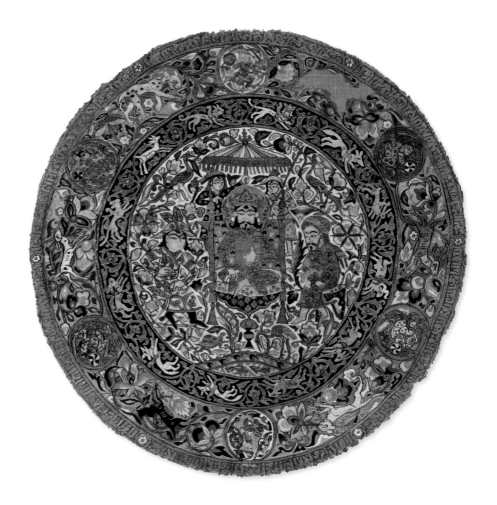

This 14th-century medallion exemplifies the interactions of the Silk Roads. Made in Ilkhanid west Asia, it is a tapestry, a weave common to China, with gold thread of animal origin wrapped around cotton, a west Asian technique. The prince in the centre is flanked by a Mongol prince and an Arab or Persian minister. The iconography resembles that on Islamic metalwork.

growth of maritime archaeology. The hulls of long-sunk ships have preserved their cargoes of ceramics and glass, but direct evidence of the human cargoes of slaves – very much part of Silk Road trade – has long disappeared. Wherever it is possible, or known, such absence is noted.

The landscape's role in the logistics and risks of long-distance trade is also discussed – navigation across seas of sand and water by the stars, fording rivers in spate, negotiating high mountain passes – along with the specialist modes of transport: ships for the sea, yaks for the passes, mules for the perilous mountains and camels for the desert. The cost and efficiency of the various forms of transport were also a factor: a ship could carry both heavy and fragile goods across great distances far more cheaply than a camel, but the risks were much greater.

The economics of the Silk Roads remains a large gap in our knowledge, mainly because of the lack of evidence to reconstruct it, even for trade in specific goods across discrete sections of time and space. Some of the coinages are discussed and illustrated in this book but, as the essay on mints and monetary systems notes [see pp. 302–9], these are only a small part of the story. Many cultures did not produce or use coins or use other forms of money. Texts help in some places at some times, but probably many if not most transactions were not recorded and, even if they were, these were probably among the millions of ephemeral documents long since discarded. Serendipitous finds such as the Cairo *geniza* [see box on p. 285] or the Dunhuang Library Cave [see box on p. 138] provide some clues, but they provide small and discrete pieces of data, usually not sufficient to reconstruct the larger picture. In other cases, we can estimate extent of trade through the material legacy, easier with products such as lapis lazuli, which not only has a known provenance but also survives well in the archaeological record. Its rarity also means that it has often retained its original purpose – unlike many metal objects, for example, which have been melted down over the past two millennia. The development of more sophisticated testing, such as isotopic analysis, is providing much useful data and will, inevitably, add to the story.

The essays on the acquisition of raw materials and their manufacture into finished products are assigned across the landscape sections. So the lapis mines of northeastern Afghanistan are discussed under mountains [see pp. 182–87]. But many materials and production sites are found in different landscapes. The clay needed for ceramics is the most obvious example, but ceramic production is placed under rivers [see pp. 338–45]. The same can be said for the other essays as, for example, on the major religions of the Silk Roads. Early Christianity is often associated with desert sites, but Christians also sought out mountain retreats. And once the religion grew and became more institutionalized, it became powerful in the cities on the rivers and plains and was transported by sea to distant ports. Therefore themes, such as religion, although of necessity placed in a specific landscape section, are not intended to be bounded by that section.

Apart from religions, an essay on music on the Silk Roads is included, as a reminder of the intangible cultural heritage that also travelled alongside material goods. Manuscripts in various written languages and scripts are illustrated too, but they represent a tiny part of the richness of spoken languages used across the Silk Roads, many now forgotten or lost.

As well as the objects considered in the thematic essays, each section showcases around twenty artifacts, from complex architectural or archaeological structures, such as cities or shipwrecks, down to small objects, such as glass beads. As well as illustrating the various topics discussed, the showcased items also exemplify interaction, having been influenced from elsewhere in their materials, form or motifs,

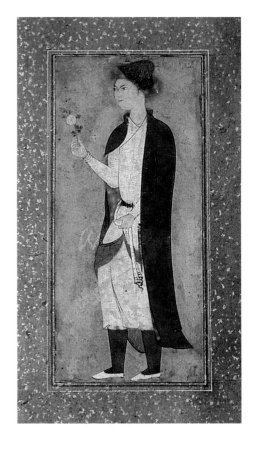

Fur was a major import from northern Europe to adorn the clothes of the west and central Asian elite, such as the fur-trimmed hat of this 16th-century Persian youth.

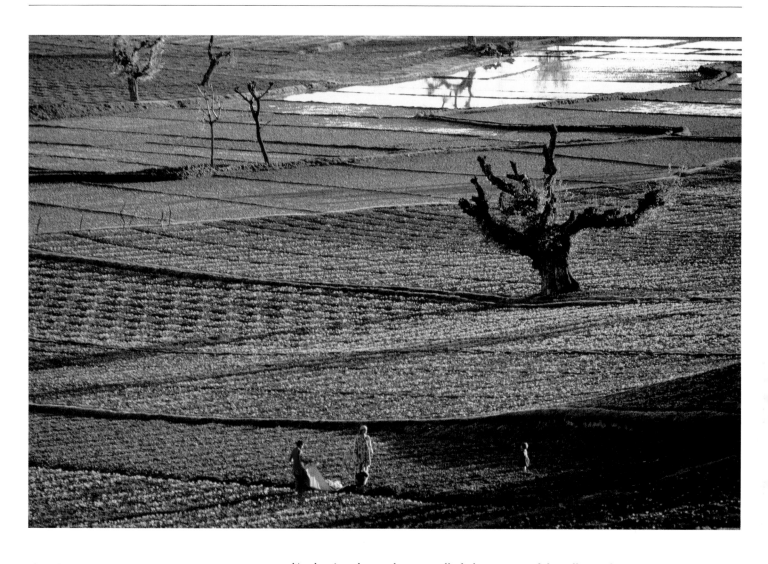

Plants for food, medicine and dyes were once transported along the Silk Roads but most have long disappeared. This field of saffron in Kashmir today is a reminder of this once thriving trade.

and/or having themselves travelled along some of the Silk Road networks. Some of the artifacts are oft-reproduced, but I have also tried to include some lesser-known and newly excavated objects. These are not always the most spectacular or best preserved, but have an important part in the story. The story of the Silk Roads is not only one of luxury goods.

In part because of its long timescale but, more crucially, because it covers areas of the world that are not part of the cultural and historical landscape of most readers – whether from Africa, Asia, Europe or America – the study of the Silk Roads can be daunting. A plethora of unfamiliar names and places can confuse and befuddle. I beg the reader's patience to try not to be distracted by these. This work is intended, like one of the complex weaves discussed in the looms and textile essays [see pp. 316–29], to reveal a design through an interweaving of layers of numerous coloured threads. Reading one essay or caption may show little, but looking at more will, I hope, start to reveal something of the complex pattern of the Silk Roads.

I am delighted that so many of the leading scholars from institutions worldwide have contributed to this book, some with thematic essays and others describing objects they have excavated or studied. Understanding anything about the Silk Roads demands collaboration across cultures and languages. The diversity of styles and the different opinions expressed by the contributors is also key to this volume: it, too, is part of the weave.

Mapping the Silk Roads

Peter Whitfield

"We cannot navigate and place ourselves only with maps that make the landscape dream-proof, impervious to the imagination. Such maps – and the road-map is first among them – encourage the elimination of wonder from our relationship with the world. And once wonder has been chased from our thinking about the land, then we are lost."

Robert Macfarlane, *The Wild Places*, 2007.

There are many reasons why people produce guides to their physical worlds, and the information appears in different forms, with maps, geographies and travel itineraries among them. Some of these would be considered myth or fiction today, but they still often contain geographical information. People travelled across Eurasia by land and sea from the earliest times, but their knowledge, even if passed down orally, was rarely recorded. Nor were there guides to the premodern 'Silk Road', at least until it was conceived in 1877. But there are early geographical descriptions of the known and mythical worlds, and maps made of them.

In ancient Greece, the world according to the 5th-century BCE historian Herodotus, for example, included India but not lands to the north beyond the Caspian Sea. For the Chinese, the 4th-century BCE *Shanhaijing* (Classic of Mountains and Seas) gave geographical information, possibly extending to the Kunlun mountains of central Asia. The expeditions eastwards of Alexander the Great (r. 336–323 BCE) and of Zhang Qian (164–113 BCE) westwards extended the knowledge base considerably. The territories conquered by Alexander were settled by Greeks and their subjects, and became kingdoms within the Greco-Roman world. China similarly expanded and included information, geographical and otherwise, about these 'western regions' in its official histories: for empires controlling foreign lands, such data were vital.

In the 2nd century CE, Ptolemy of Alexandria (c. 100–168) mapped the world known to the Roman empire with greater precision than ever before, showing Asia as far east as China but not the ocean beyond [*see* pp. 24–25]. His *Geography* contained a gazetteer giving some 8,000 place names with coordinates of latitude and longitude. He included instructions on how to construct a map allowing for the curvature of the earth, identifying features such as the Himalaya, the Ganges, the southeast Asian peninsula and *Serica Regio*, the name by which China was known in the Greco-Roman world, meaning the 'Kingdom of Silk'. Ptolemy claimed that he consulted all available geographical descriptions and travellers' accounts, but does not give a list. He names the peoples inhabiting each region, but scarcely mentions their activities or material cultures.

Very close in time to Ptolemy is a great monument of Roman mapping, which is utterly different from the scientific approach of the Greek scholar. The Peutinger map [*see* pp. 26–27] is a medieval copy of a map of the entire Roman empire. The structure of this detailed and fascinating map is geographically non-representational and difficult to grasp, and was probably produced for political display rather than for navigation.

The map in a book by a 6th-century Alexandrian monk and merchant, Cosmas Indicopleustes ('the Indian navigator'), also has little use as a guide, despite its author being well travelled. Instead it is an argument against his contemporaries for their belief in a round earth, taking instead a literal view of the Bible and presenting a map of a flat earth [*see* pp. 30–31].

Many centuries later, as Islamic rule spread to central Asia, their cultures developed their own schools of sophisticated mapmaking, in advance of those of their Byzantine neighbours. Al-Kashgari (1008–1105 CE) is one of the few cartographers known from central Asia, his map prepared as part of his great Turkic dictionary [*see* pp. 36–37]. Cartography skills reached their culmination with al-Idrisi (493–560 AH or 1100–1165 CE), who was active in Norman Sicily [*see* pp. 28–29]. He was a disciple of Ptolemy, and constructed a series of regional maps that dovetailed together within a rational framework to form one unified map of the known world. The al-Idrisi maps and accompanying book offer a wealth of topographical and settlement detail, the maps focusing on three features: place names, mountains and water. The book also gives itineraries with distances and includes a rich array of place names in central Asia, especially around Sogdiana, suggesting a strong interest in this area – and good sources of information.

Chinese pilgrim-monks, famously Xuanzang (c. 602–664), also produced itineraries with distances. The accuracy of these is seen in their largely successful use in modern times to identify significant sites of the historical Buddha by Alexander Cunningham (1814–1893) and places in the Taklamakan desert by Aurel Stein (1862–1943). Chinese learning, like Chinese society as a whole, was very much under centralized, imperial control, and the maps produced were predominantly made to show political, administrative divisions. Although very accurately plotted, they were at a small scale. The rise of the Mongols and their spread across Eurasia changed this, with the Mongol emperor, Kublai Khan (r. 1260–1294), commissioning a world map in 1286. This must have brought greater knowledge to many more people, not just the merchants and diplomats who visited distant lands, and it formed the basis for a map of the succeeding Ming empire (1368–1644) in China [*see* pp. 34–35].

In medieval Europe, Marco Polo's (1254–1324) account of his overland trading journey to China became one of the most popular books of the time, and its descriptions of the wonders of China, called Cathay, was hugely influential in preparing the way for the subsequent so-called European Age of Discovery. Yet one of the surprising things about his book is that it was not accompanied by a map, and scholars have argued continuously about the route followed. It was left to others to plot his narrative in map form, and the Catalan Atlas is the earliest and the best known [*see* pp. 32–33]. Produced around 1375 in Majorca, its mapping of Asia represents a real advance in European knowledge. Its most famous feature is the vivid picture of a group of merchants crossing the desert on horseback with their goods carried by Bactrian camels (only dromedaries were ridden, as shown in another image of the trans-Saharan routes). The caption reads: 'This caravan has set out from the Kingdom of Sarra [the Caspian region] to travel to China.'

Further reading: Black 2000; Edson et al. 2004; Forêt & Kaplony 2008.

Östl. L. v. Greenwich

50 55 60 65 70 75 80

ARALO-KASPISCHE

Tiau-tshi

TURANISCHE

ODER

NIEDERUNG

Yuë-tshi

ERANISCHES HOCHLAND

Ta hia

Ki-pin

PANDJAB

INDISCHE WÜSTE

Kaspisches M.

Urgendsch
Khiwa
Bokhara
Samarkand
Karschi
Antiochia Margiana
Merw
Hissar
Balkh
Baktra
Khulm
Kunduz
Astarabad
Hekatompylos
Meshed
Tebbes
Herat
Bamyan
Kabul
Peshawur
Kandahar
Hilmend
Kirman
Yezd
Hormuz
Kuhin
Busen von Oman
Kurashi

Karatau
Turkestan
Aulie-ata
Tschemkent
Taschkend
Nurata
Ta-wan
FERGHANA
Khodschent
Khokan
Uratübe
Namangan
Khose
Dsch
Karategin
Komedon
Wachan
Shignan
Shitral
Gilgit
Skardo
Kashgar
Sedon-skythica
Yarkand
So-kiu
Tashkurgan
Pu-li
Pi-shan
Khotan
Yu-tien
Kiu-mi
Yung-lu

Kopal
Sergiopol
Djungistan
Kuldja
Naryn
Tokmak
Alexander Kette
Issyk-Kul
Tschu
Aksu
Ku-me
Ku-tsha
Uschi
Wensu
Taryn
Tsing-tsu
Yu-lei
Kiu-lei
Kija

Himalaya
Central Gebirgskette
Dehli
Lahor
Simla
Ganges
Indus
Setledj
Bishan P.
Bolan P.

S. 300.

Gebirgsland	Gebirge über 3000 Meter	Steppe Niederste Stufe	Steppe Mittlere Stufe

Kwen-lun System

Himalaya System

Tien-shan System

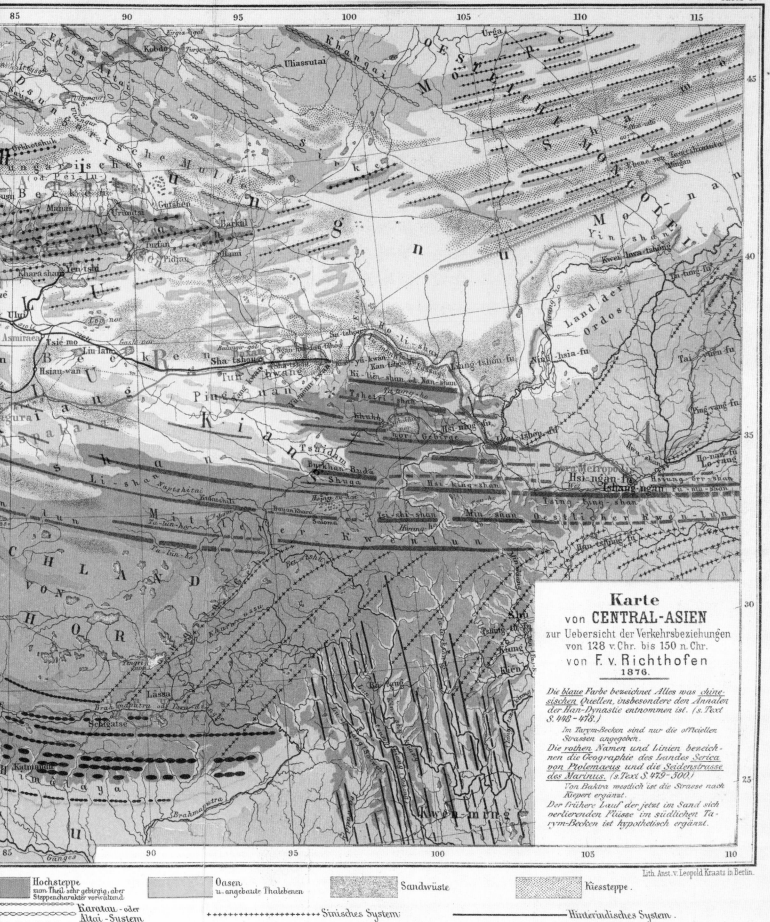

Tafel 8.

Karte
von **CENTRAL-ASIEN**
zur Uebersicht der Verkehrsbeziehungen
von 128 v. Chr. bis 150 n. Chr.
von **F. v. Richthofen**
1876.

Die *blaue* Farbe bezeichnet Alles was *chinesischen* Quellen, insbesondere den Annalen der Han-Dynastie entnommen ist. (s. Text S. 448 - 478.)
Im Tarym-Becken sind nur die officiellen Strassen angegeben.
Die *rothen* Namen und Linien bezeichnen die Geographie des Landes *Serica* von Ptolemaeus und die *Seidenstrasse des Marinus*. (s. Text S. 479 - 500.)
Von Baktra westlich ist die Strasse nach Kiepert ergänzt.
Der frühere Lauf der jetzt im Sand sich verlierenden Flüsse im südlichen Tarym-Becken ist hypothetisch ergänzt.

Lith. Anst. v. Leopold Kraatz in Berlin.

Hochsteppe
zum Theil sehr gebirgig, aber Steppencharakter vorwaltend

Oasen
u. angebaute Thalebenen

Sandwüste

Kiessteppe.

Karatau - oder
Altai - System

Sinisches System.

Hinterindisches System.

Ptolemy and Richthofen

Ptolemy's (*c.* 100–168) world map lies at the origins of the modern idea of the Silk Road. When the German geographer Ferdinand von Richthofen (1833–1905) coined the term *Seidenstrassen* or 'Silk Roads' in 1877, he often invoked the 'Silk Road of Ptolemy'. Ptolemy's 2nd-century CE *Geography* was a touchstone for modern European cartography when it became available in a Latin translation in 1407 (the copy of the map here, British Library Maps C.3.d.7, was made in 1482). It introduced the use of coordinates of latitude and longitude, and encapsulated Greco-Roman geographical knowledge. However, for Richthofen, Ptolemy's Silk Road revealed the limitations of classical European knowledge. Ptolemy's calculation of the easternmost reaches of the world – the route to *Sera*, capital of Serica and home to the *Seres* ('silk-bringers') – was inaccurate, still too reliant on the exaggerations of ancient traders. To remap this 'Silk Road' to *Sera* (which he identified with China's Chang'an), Richthofen advocated looking outside the European tradition, and Chinese historical annals

provided the information required to correct and expand Ptolemy's world map. Richthofen's 1877 'Map of Central Asia' (shown on the previous spread) – the first map to bear the term 'Silk Road' – represented this innovative reinterpretation of Greco-Roman data using Chinese sources. At a time when central Asia had yet to be fully mapped, Richthofen's work also had a more practical purpose. On behalf of the German government, he used his knowledge to help plot a proposed transcontinental railroad linking China and Europe. TC

Further reading: Berggren & Jones 2000; Chin 2013.

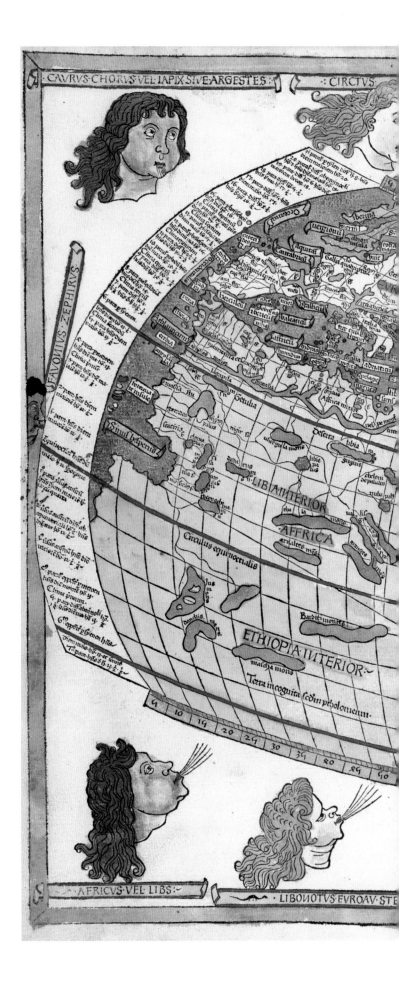

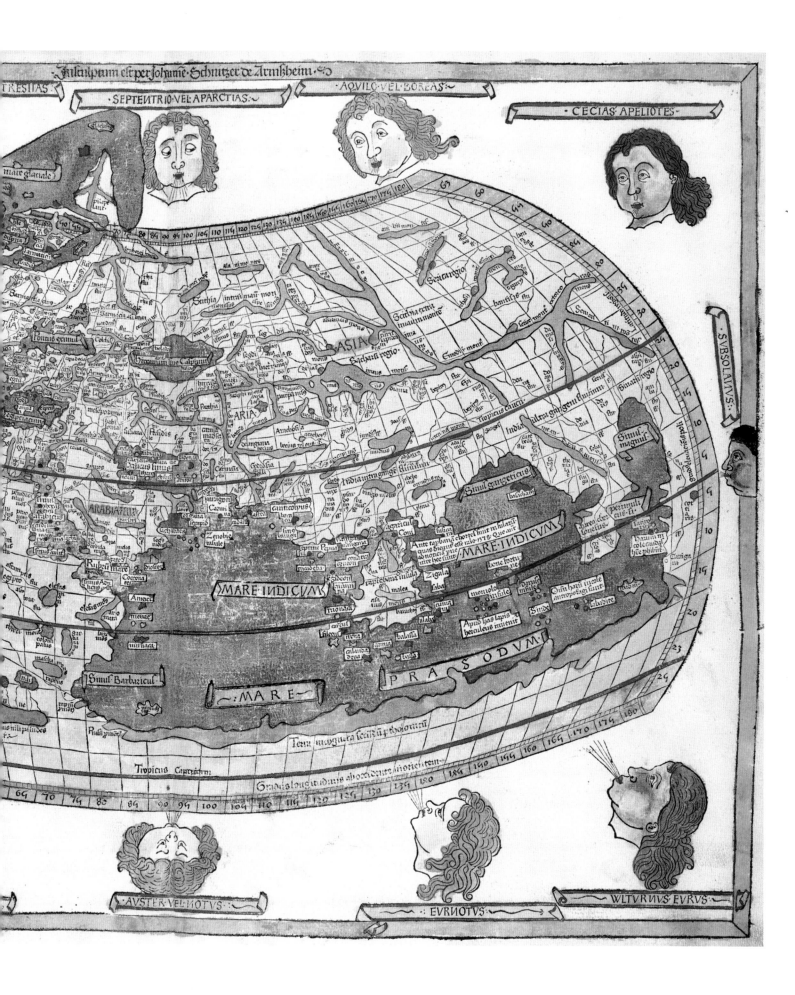

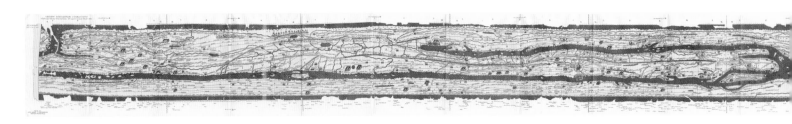

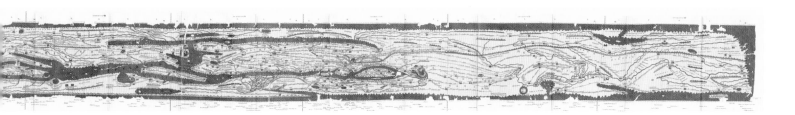

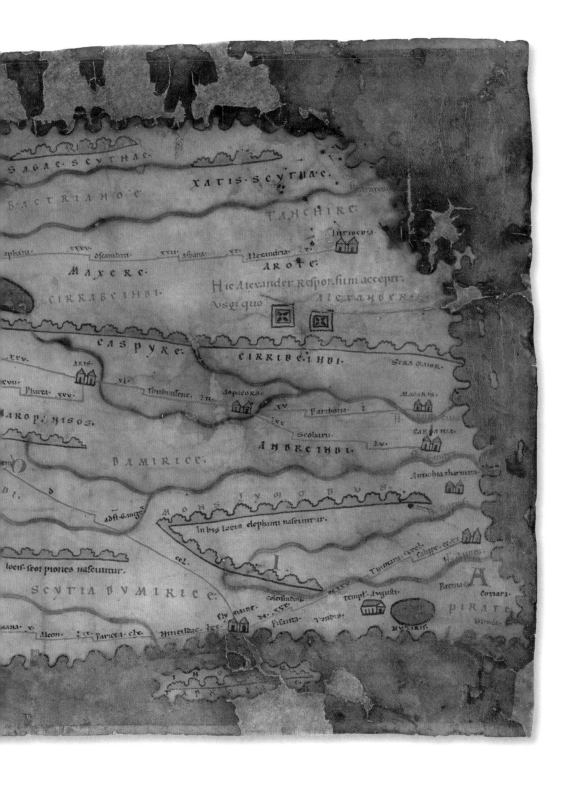

The Peutinger map

The intriguing 'Peutinger' map –
a medieval copy on parchment of
an ancient original – offers the sole
surviving physical and cultural
representation of the known world
produced by Romans, and thus
attracts attention from multiple
perspectives. Although the left-
hand end is lost, the full map
(oriented north) no doubt spanned
from the Atlantic to India (shown
left, from the only known copy, now
in the Austrian National Library),
and Rome itself probably occupied
the centre-point. Because the frame
could accommodate a length of
around 8 m (25 ft), yet a height
of only 33 cm (13 in.), much sea is
contracted into narrow channels
(the Mediterranean especially),
and landmasses are shifted to fit
the restricted vertical dimension
(as shown in the copy above, made
by Konrad Miller in 1872).

The map is not a practical tool,
therefore, but rather cartographic
artwork celebrating Rome's
seamless world-rule with its
civilized benefits of peace,
urbanism and connectivity
overland. As such, the map is likely
to have been commissioned for
display at an imperial court. Persia
and India are encompassed because
Roman emperors from Augustus
(r. 27 BCE–14 CE) onwards, in their
emulation of Alexander the Great
(r. 336–323 BCE), claimed sway
here – mere rhetorical fantasy,
but a boost to Roman pride.
Predictably enough, both realms
appear cavalierly compressed, and
the grasp shown of their geography
and land routes is very defective.
RT

Further reading: Talbert 2010.

Wiederhergestellt und herausgegeben von KONRAD MILLER, Stuttgart 1928.

Charta Rogeriana **WELTKARTE** DES

The *Tabula Rogeriana* of al-Idrisi

The *Tabula Rogeriana*, the most complete medieval map of the world, was produced in 1154 by the Moroccan-born geographer al-Idrisi (493–560 AH or 1100–1165 CE). Named for the Norman king of Sicily Roger II (r. 1130–1154) who commissioned it [see p. 266], the map represents the world-vision of al-Idrisi based on Arabic and European sources, maps and travellers' reports. It was originally composed on a board and subsequently engraved on

a silver disc (neither is extant). The accompanying book, *Nuzhat al-mushtāq fi'khtirāq al-āfāq* ('Entertainment for he who longs to travel the world'), is the most detailed descriptive geography of the known world at that time, unsurpassed until the 16th century.

Al-Idrisi's cartographic method follows Ptolemy and his system of dividing the 'Inhabited Quarter' into seven latitudinal bands, or 'climes', arranged from the equator northwards towards the

Arctic Circle. To this scheme, al-Idrisi added ten longitudinal sections numbered from the Prime Meridian: that of 180 degrees east is drawn at the 'island' of Silla (the Korean peninsula). Africa extends far east, where the Indian Ocean, landlocked on three sides, meets the Pacific. To the resulting seventy rectangular sectional maps is added a round world map that follows the Balkhi tradition of early Islamic cartography, with south at the top. The composite image

shown here was compiled by the German historian Konrad Miller (1844–1933) based on the Paris and Bodleian manuscript maps.

The book follows itineraries, citing distances in various measures but giving no latitudes or longitudes. Al-Idrisi's work was among the earliest secular Arabic works printed in Europe. MT

Further reading: Harley & Woodward 1992; Miller 1926–31, 1981; Tolmacheva 1996, 2005.

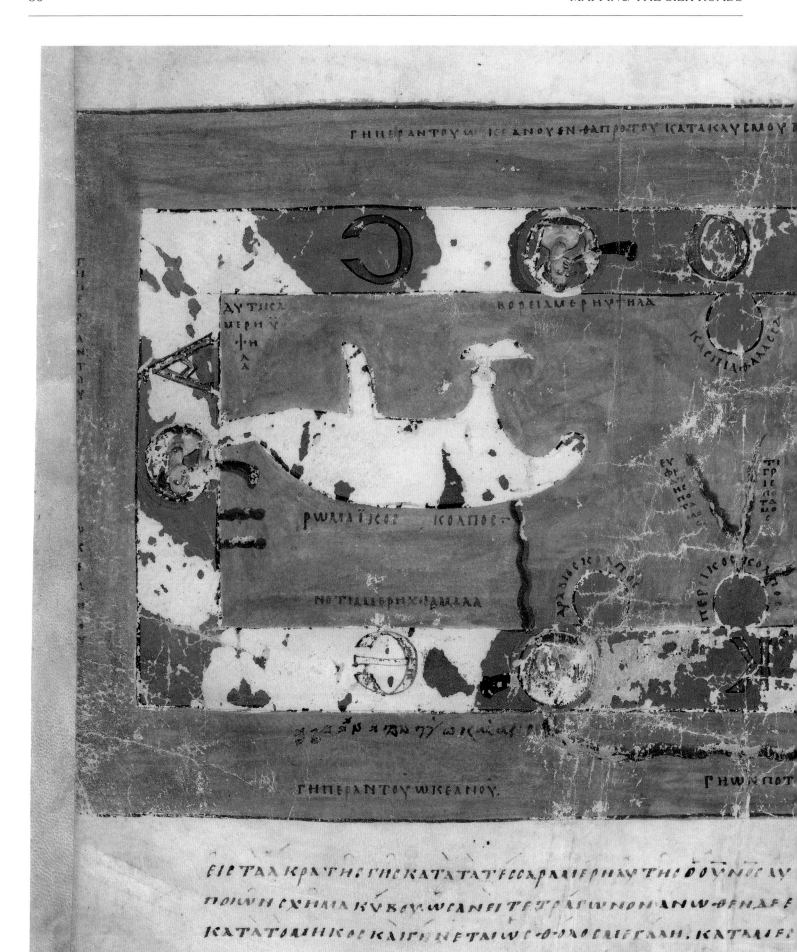

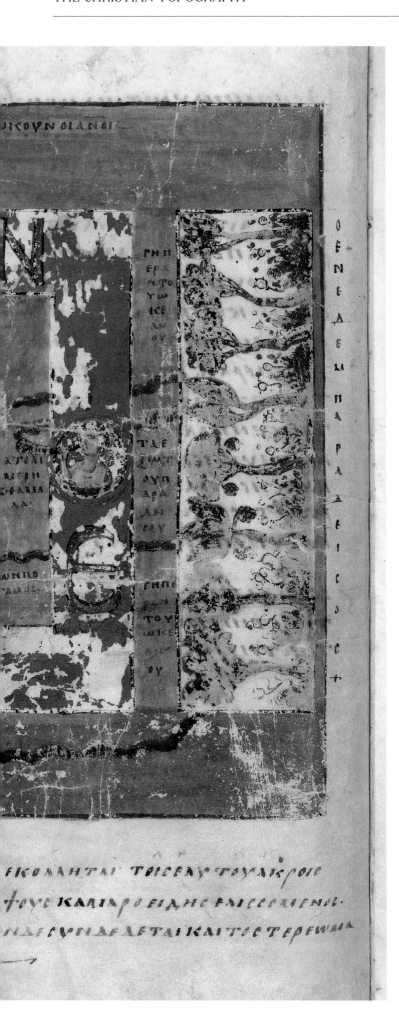

The *Christian Topography*

The *Christian Topography* was written in the middle of the 6th century CE by an Alexandrian merchant and monk known as Cosmas Indicopleustes ('the Indian navigator'). Through a literal interpretation of the Bible, Cosmas argued for a flat, rectangular model of the earth surrounded by an ocean with paradise in the east, situated inside a box that resembled the Israelite tabernacle. Night falls when the sun is moved by angels behind a mountain. This went against prevailing belief among his contemporaries of the roundness of the earth.

As a merchant, the author claims to have travelled through the Red Sea and across the Indian Ocean as far as Sri Lanka. The book gives valuable information about this island and India as well as the Axumites in east Africa and the land and sea routes to China.

The earliest surviving manuscript of this work, shown here, dates to the 9th century (Vatican Library, Vat.gr.699, f.40v), with two more dating to the 11th century. BH

Further reading: Faller 2011; Kominko 2013; Wolska-Conus 1968; McCrindle 1897; Zhang 2004.

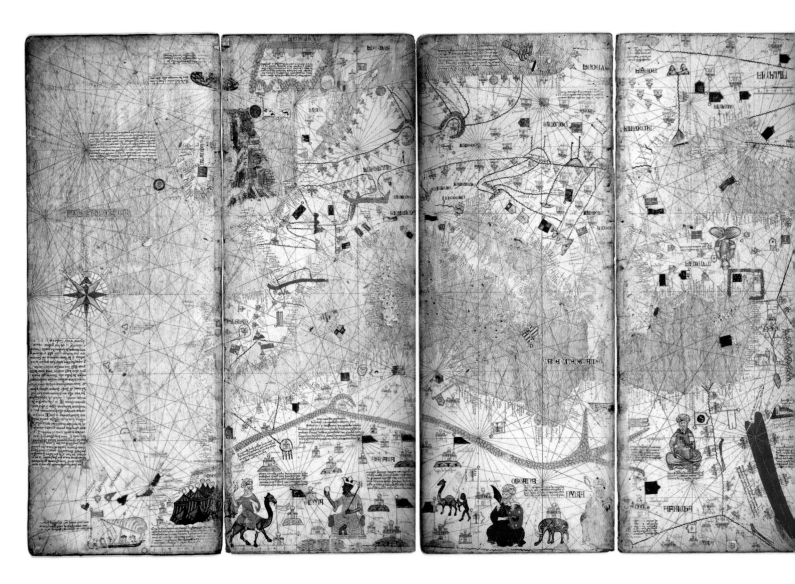

The Catalan Atlas

The nautical chart known as the Catalan Atlas is an unsigned and untitled map now in the Bibliothèque nationale de France (Esp. 30). It is usually attributed to the workshop of the Jewish instrument-maker and book illustrator Elisha ben Abraham Cresques (c. 1325–1387). Cresques worked at Majorca and produced a number of charts, among them some for Peter IV (r. 1336–1387), king of Aragon. The years 1375 and 1376 are noted on the first part of the Catalan Atlas, but some of the iconography seems to contradict such a date.

The illustrators populated Afro-Eurasia with a rich spectrum of written and pictorial stories, beliefs and information drawing on an amazingly broad range of sources – maps, texts, orally provided information, images and symbols. Many of the geographical, political, historical and ethnographic depictions rely on material from Asia and Africa as well as Byzantium. This is seen in the dress, the bodily postures and gestures, the hair- and beard-styles of the rulers of Asia, the king of Gog and Magog, the three Magi, and the merchant caravan in central Asia, as well as geographical units in Africa, around the Black and Caspian seas, in western Iran, and perhaps also in east Asia. In addition, some features of the animals, in particular the horses, are similar to depictions known from Khotan and Iran. SB

Further reading: Ceva n.d.; Grosjean 1978.

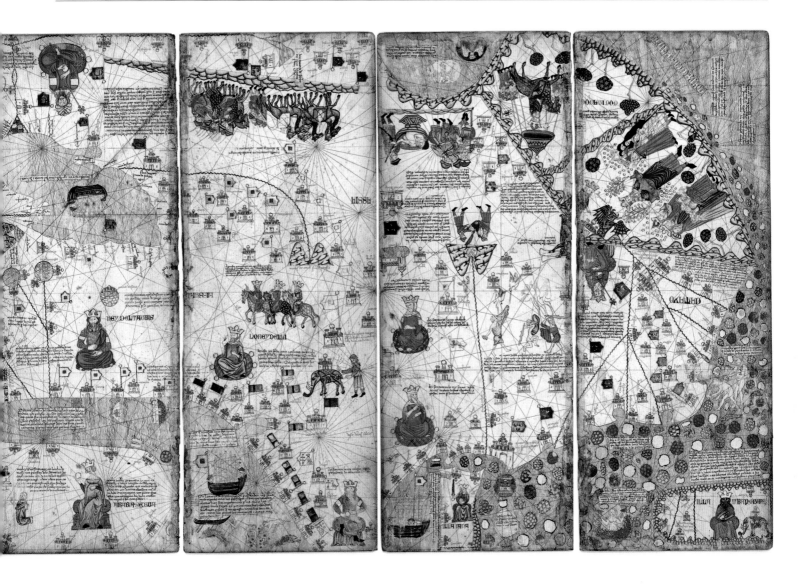

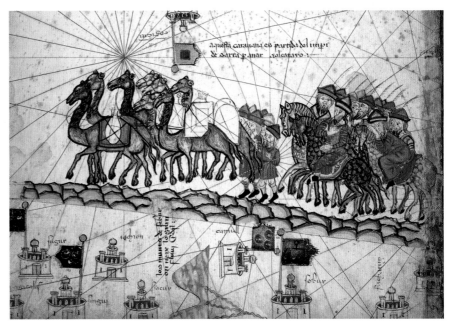

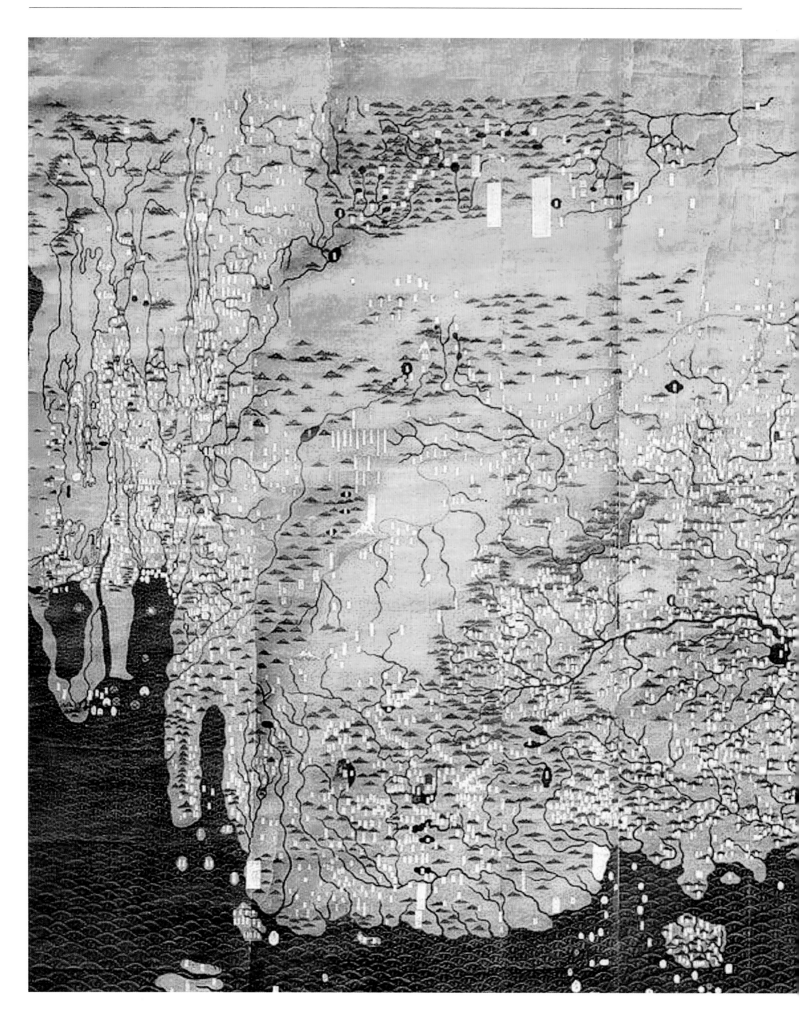

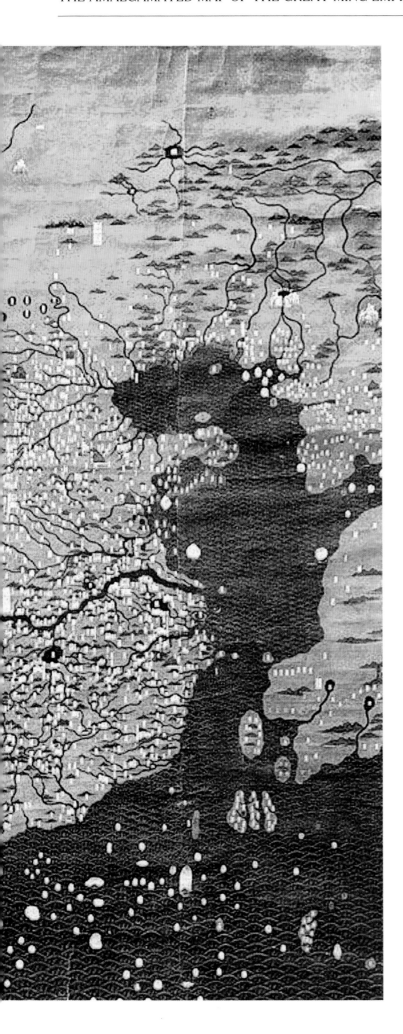

The Amalgamated Map of the Great Ming Empire

The origins of the *Da Ming hun yi tu* (大明混一圖, 'Amalgamated Map of the Great Ming Empire') go back to a world map that the Mongol emperor Kublai Khan (r. 1260–1294) commissioned in 1286. This brought together geographical knowledge from different places, transmitted in various languages and recorded in Arabic and Chinese scripts. Not only did the map identify the names of mountains, rivers, towns, cities, islands and oceans in the whole of Eurasia, from the Iberian peninsula in the west to Japan in the east, it also depicted the shape of the African continent surrounded by sea.

The map was revised at least once, around 1320. The version produced by Li Zemin in the 1360s became the most widely disseminated. Local officials and wealthy merchants hung it on their living-room walls or inlaid it into partition screens to refer to while reading. It was transmitted to the Korean peninsula prior to 1402.

The *Da Ming hun yi tu* (now held in the China No. 1 History Archive in the Gugong) was based on the Li Zemin map, but place names in territory ruled by the Ming were updated and it was enlarged, disregarding the grid, in order to fit the emperor's office. The blank areas were filled with multiple repeats of the same place name. It was changed again when reproduced on silk in the early 17th century. As a result, Europe, west Asia and Africa were compressed and distorted – perhaps an acceptance that the best source for information about these regions was the 1602 world map of Matteo Ricci (1552–1610), which also included the Americas. Under the Qing dynasty (1644–1911), in order to be used as a teaching aid for emperors, Manchu transliterations of the Chinese characters were added above each place name and translations attached to the explanatory notes. NM

Further reading: Cao 1995; Miya 2007.

The dictionary and world map of al-Kashgari

Al-Kashgari (1008–1105 CE) is the first known lexicographer of Turkic languages. Born in Barsgan, in present-day Kyrgyzstan, he was buried near Kashgar, the town from which he gets his name. He held a high position in the Karakhanid empire (840–1212). In order to prepare his dictionary (*Dīwān luγāt at-Turk*), he travelled the lands where various Turkic languages were spoken, noting the lexical, phonological and sometimes morphological differences between them.

The dictionary included a map, focused on the Turkic-speaking lands. At its centre is Balasagun, the Karakhanid capital. Oriented with east at the top, the map extends to Japan (Cabarka) to the east, the Iberian peninsula to the west (Andulus/Endulus) and Sri Lanka (Serendib) to the south. It uses green for seas, yellow for deserts and cities, blue for rivers and red for mountains. The 6,700 or so entries in the dictionary included names of Turkic tribes, titles, military ranks and toponyms, and proverbs, idioms, verses and poems were used in the explanatory notes. It also gives a list of the names and seals of twenty-four Oghuz tribes and some details about their lifestyles and beliefs.

The original manuscript is lost, and the only extant copy of the dictionary is a later example held in the Millet Yazma Eser Kütüphanesi library in Istanbul (AE Arapça 4189). MO

Further reading: Dankoff & Kelly 1982–85; Kalpony 2008; al-Kashgari 2017.

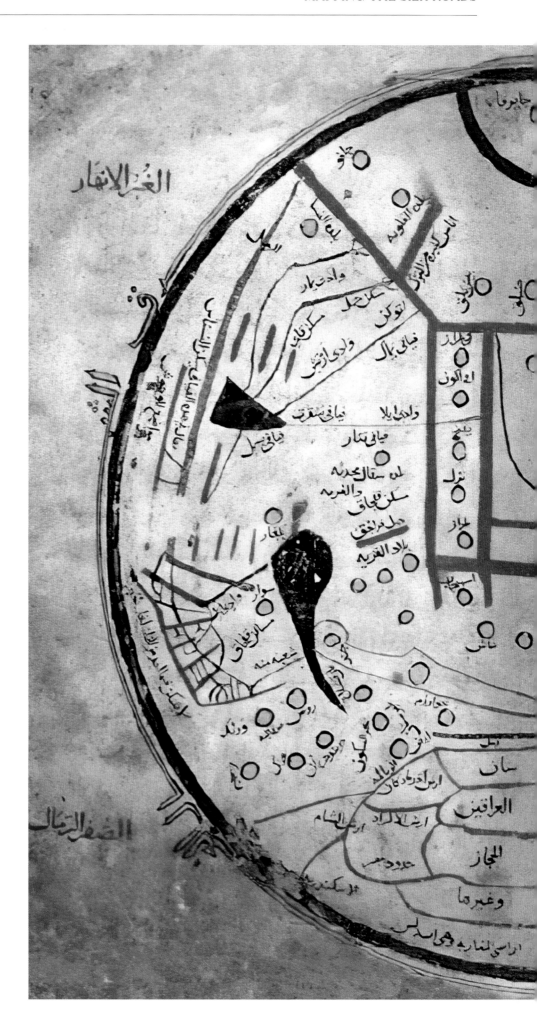

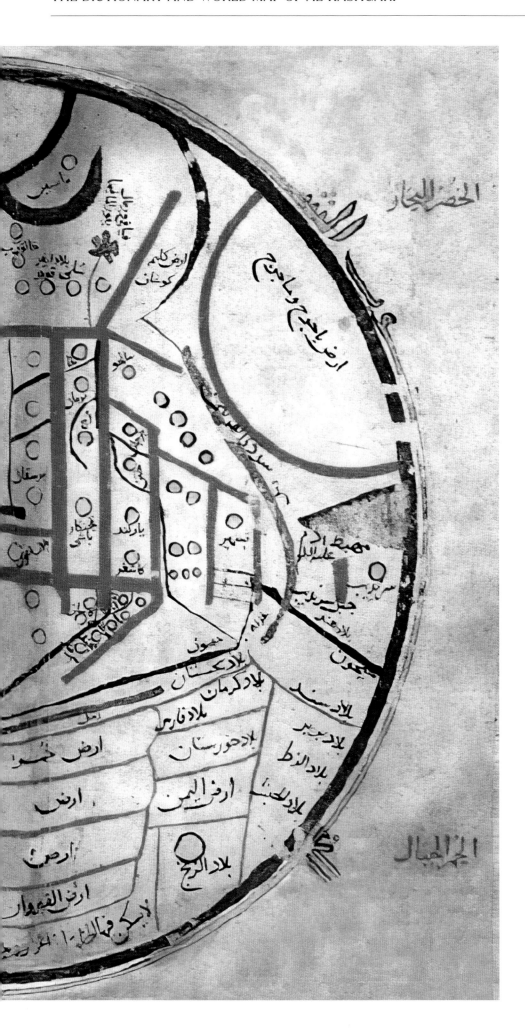

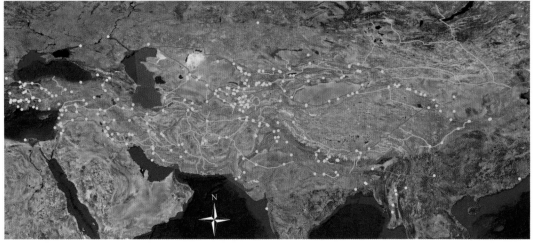

The UNESCO Silk Road

In 1988 UNESCO launched the 'Integral Study of the Silk Roads: Roads of Dialogue' project, to highlight the complex cultural interactions that arose from encounters along the Silk Roads. This led to the development of the 'Silk Roads World Heritage Serial and Transnational Nomination Project', and in 2011 ICOMOS undertook a thematic study that explored the distribution and character of Silk Road archaeology, reflecting the shifting systems of power and patronage over time. This used a computer-based mapping system, enabling information at different scales to be combined into a Geographic Information System (GIS). The study identified larger cities (*nodes*) and the routes between these; and then broadened the routes out to represent the corridors of 'movement and impact' between the nodes (rather than suggesting specific 'roads'). This was a synthesis of existing information: necessarily a broad sweep and so undoubtedly there were many inaccuracies, but it was sufficient to establish some patterns.

More than 60,000 km (37,000 miles) of corridors have been plotted, along with over 5,000 archaeological sites. Nevertheless, in many cases there was insufficient information to argue convincingly the detailed chronology of specific routes. This is a work in progress, aiming to provide a framework for debate, discussion and local research, as well as to aid in the nomination process for UNESCO sites. TW

Further reading: Williams 2014; 2015.

- ▪ *Forts and outposts*
- ○ *Cities*
- ◔ *Towns and settlements*
- ● *Caravanserai*
- ● *All other sites*

— *Major routes*
— *Other routes*

СЫРЪ-ДАРЬИНСКАЯ ОБЛАСТЬ.

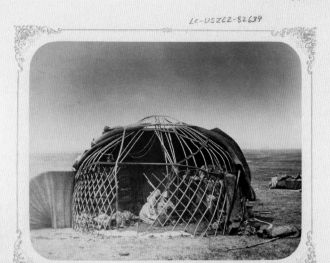

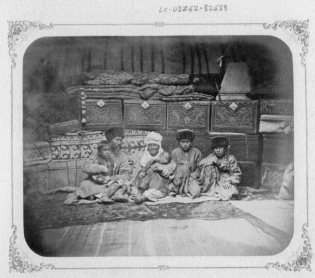

В Н У Т Р Е Н О С Т Ь К И Р Г И З С К О Й К И Б И Т К И

САМАРКАНДСКІЯ ДРЕВНОСТИ

ГРОБНИЦА СВЯТАГО КУССАМА ИБНИ АБАССА (ШАХЪ-ЗИНДЭ) И МАВЗОЛЕИ ПРИ НЕЙ

МАВЗОЛЕЙ УЛЬДЖА ИНАГА И БИБИ ЗИНЕТЪ

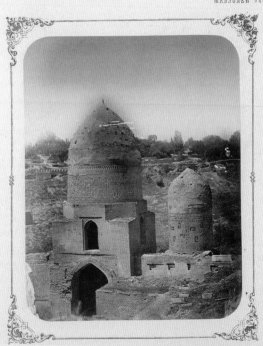

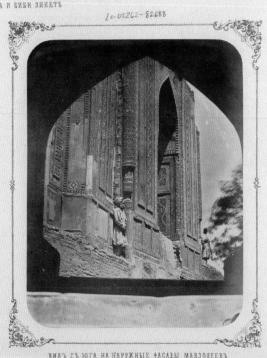

ВИДЪ МАВЗОЛЕЕВЪ КОРМИЛИЦЫ ТАМЕРЛАНА И ДОЧЕРИ ЕЯ
(УЛЬДЖА ИНАГА И БИБИ ЗИНЕТЪ)

ВИДЪ СЪ ЮГА НА НАРУЖНЫЕ ФАСАДЫ МАВЗОЛЕЕВЪ
ЧУГУНЪ БИКА И КУТЛУКЪ ТУРДИ БЕКЪ АКА

Photography of central Asia

John Falconer

The photographic penetration of central Asia, the heart of the Silk Roads, followed in the wake of colonial expansion and the camera found its place both as a tool of record for exploring hitherto little-known lands and, in the form of the resulting prints, as a reflection of imperial celebration in the possession of new territory. The first known photographs in the region were taken only some two decades after the invention of photography in 1839, with the work of the military officer Anton Stepanovich Murenko (1837–1875), who accompanied the 1858 Russian mission to conclude a commercial treaty with the Khiva khanate.

Murenko's work was rewarded with a gold medal from the Imperial Russian Geographic Society in 1860, but the alliance of colonial expansion and visual documentation was made explicit in the immensely ambitious *Turkestanskii Al'bom*, a photographic project commissioned in 1871 by the first governor-general of Russian Turkestan, Konstantin von

Kaufman (1818–1882). Compiled by a number of mainly unidentified photographers under the organization of the oriental scholar Alexander Kuhn (1840–1888), the six large albums that constitute the work cover the archaeology, architecture, ethnology, industry, commerce and history of the newly acquired territories. As part of a wider information-gathering project, the work reflects a prescient awareness of photography's uses in disseminating knowledge of the scholarly and commercial potential of colonial acquisitions. Of the probable seven sets that were produced, the most accessible existing copy can be found in the Library of Congress and is available online (*Turkestan Album*).

A further attempt to create an encyclopaedic visual account of the Russian empire was to be made in the early years of the 20th century in the stunning colour photographs of Sergei Prokudin-Gorskii (1863–1914). Made with the official support of Tsar Nicholas II (r. 1894–1917), the project included an important documentation of Russian possessions in central Asia, photographed using a newly developed colour process.

The southwards expansion of Russian control over central Asia was watched nervously by British officialdom, as the boundaries of Russian influence crept closer to their possessions in India. One response to this perceived threat was the mission sent in 1873 under Thomas Douglas Forsyth (1827–1886) to conclude a commercial treaty with Yakub Beg (1820–1877), Amir of Yarkand and Kashgar. Like the earlier Russian project, photography was one of the means used to gather information on these little-known territories, and the mission's final published report contained over 100 photographic prints, alongside chapters on the history, topography and commerce of western China. The photographs were the work of the mission's secretary Edward Francis Chapman (1840–1926) and a Royal

Opposite — Two pages from the *Turkestanskii Al'bom* commissioned by General Kaufman in 1871.

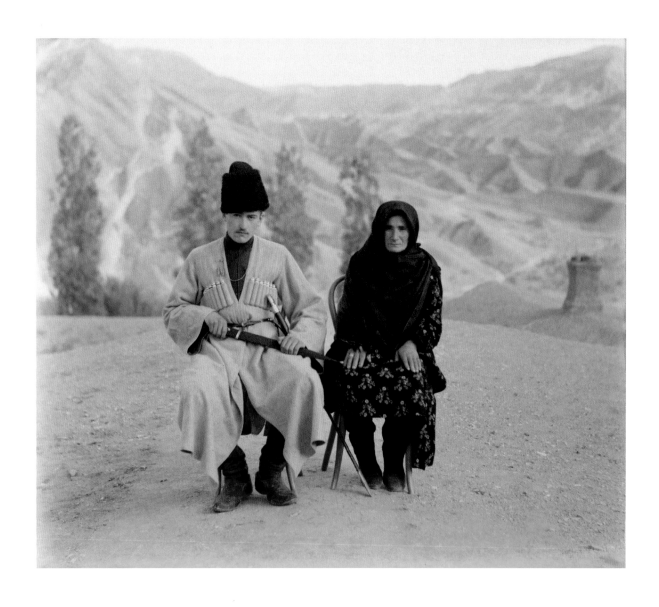

Above — Sergei Prokudin-Gorskii was supported in his work by the Russian Tsar, travelling in the early 20th century to record Russia's new possessions in central Asia. Labelled 'Dagestani types', this print used his own newly developed colour process.

Engineers officer, Henry Trotter (1841–1919). Their account of the technical difficulties of photographic work in winter conditions, allied to the gradually overcome unwillingness of their subjects to be photographed, was a commonly heard complaint in a period when photography was a technically complex and daunting procedure.

Travel along the western portions of the Silk Roads became easier with the construction of railways across Russian territory in central Asia and brought a growing number of European visitors attracted to exotic 'oriental' cultures. As photographic technology became more straightforward, many of these early travellers also carried cameras and published illustrated accounts. The professional photographer Paul Nadar (1856–1939), son of one of Paris's most celebrated portrait photographers, Gaspard-Félix Tournachon (1820–1910) (known as Nadar), made a photographic journey through Russian Turkestan in 1890, using a handheld camera and newly

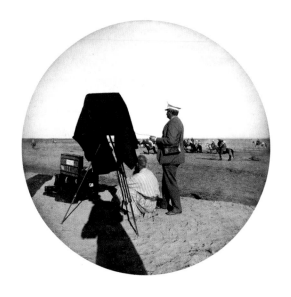

Above — The Frenchman Paul Nadar photographing Bozkachi in 1890.

Hugues Krafft was a private traveller
to Russian Turkestan in 1898, and
used newly introduced roll film and
a handheld camera for his photography,
as in this portrait.

introduced roll film. The wealthy French traveller Hugues Krafft (1853–1935) represents a pre-eminent example of the work of private travellers in the region: his *À travers le Turkestan russe* (1902) records his travels in 1898 and contains a selection of elegantly composed images, finely reproduced in photogravure.

The increasing simplicity and portability of photographic technology was also of huge benefit to the influx of explorers, archaeologists and other travellers from many of the empires that excavated the desert sites of the Taklamakan from the last decade of the 19th century onwards. All of these, including those led by the Swede, Sven Hedin (1865–1952), the naturalized Britain, Marc Aurel Stein (1862–1943), and the German, Albert Grünwedel (1856–1935), used photography extensively, not only for archaeological finds but also to record the cultures and landscapes through which they travelled. One unique figure who straddled the steppes and deserts of both Russian and Chinese Turkestan was Samuel Martinovich Dudin (1863–1929), an extraordinarily talented Russian archaeologist, ethnographer, artist and collector. Photography was merely one among his many skills, but in the course of his career he created a unique archive of images, both from Russian central Asia in the early 1900s and as artist and photographer with the expeditions of Sergei Oldenburg (1863–1934) to Dunhuang and the Tarim basin.

The landscapes and peoples of the Silk Roads have lost none of their fascination to photographers. Lois Conner (b. 1951), best known for her use of a large-format panoramic camera to produce delicately toned platinum prints, has worked in China over several decades, and has extensively documented the Dunhuang Buddhist caves and surrounding landscapes. A radically different approach to the turbulent history and present state of central Asia is seen in the work of the Swiss photographer Daniel Schwartz. In *Travelling Through the Eye of History* (2009), compelling photographs taken in the course of travels in central Asia in the 1990s and early 2000s are interspersed with texts that locate these images in a historical context of geography, war, travel, trade and religious turmoil spanning three millennia; the photographer was 'confronted directly by history, ever-present in the social, geo-economic and political power processes of today' (288).

———

Further reading: Dikovitskaya 2007; Klanten 2012; Menshikov 1999; Schwartz 2009.

Photograph taken of a Buddhist temple
by Edward Francis Chapman on the
British Mission to Yarkand in 1873.

Daniel Schwartz, the photographer,
writes of this piece: 'Ghaligai,
Swat valley, 21 December 2009:
A kid driving home flock of sheep
has stopped to throw stones at
colossal dhyani Buddha'.

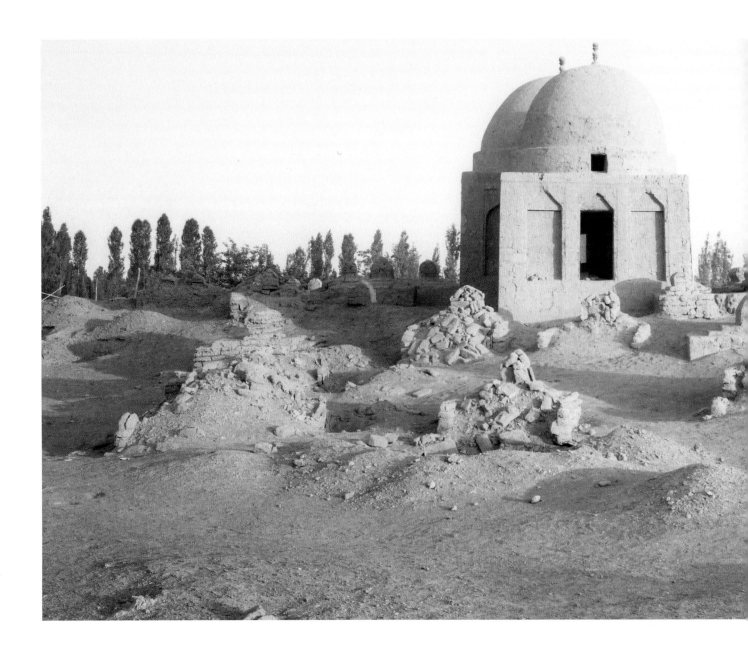

Platinum print by Lois Conner
of Islamic tombs near Turfan in
the Tarim basin, 1991.

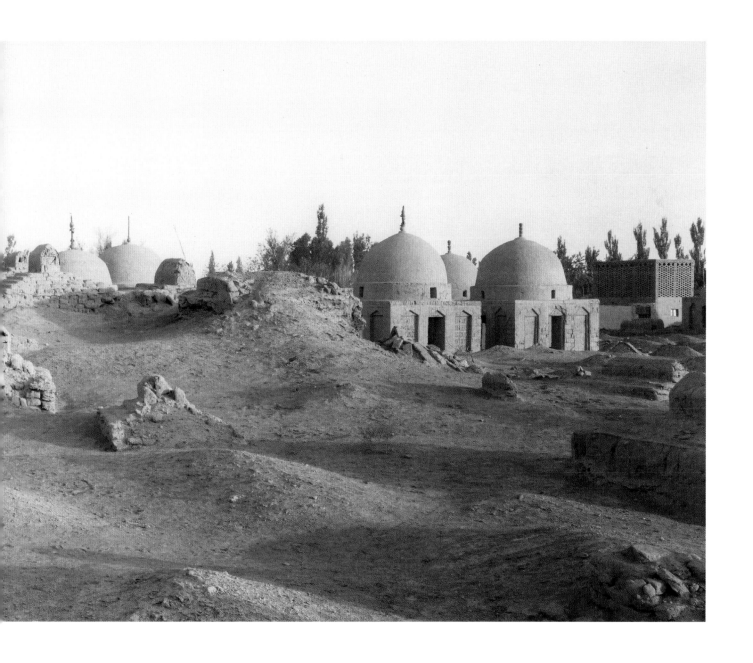

Steppe

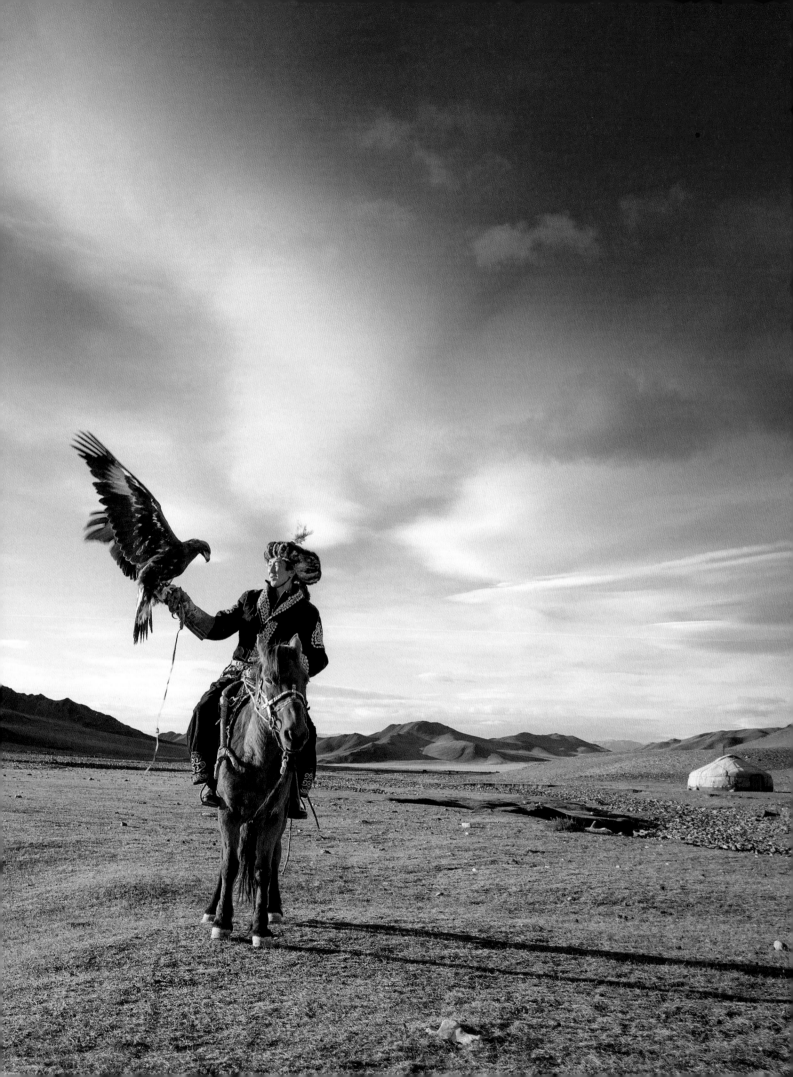

Steppe

Previous pages — Kerch peninsula, western steppe.

Opposite — Hunter with eagle, Bayan-Ölgii, eastern steppe.

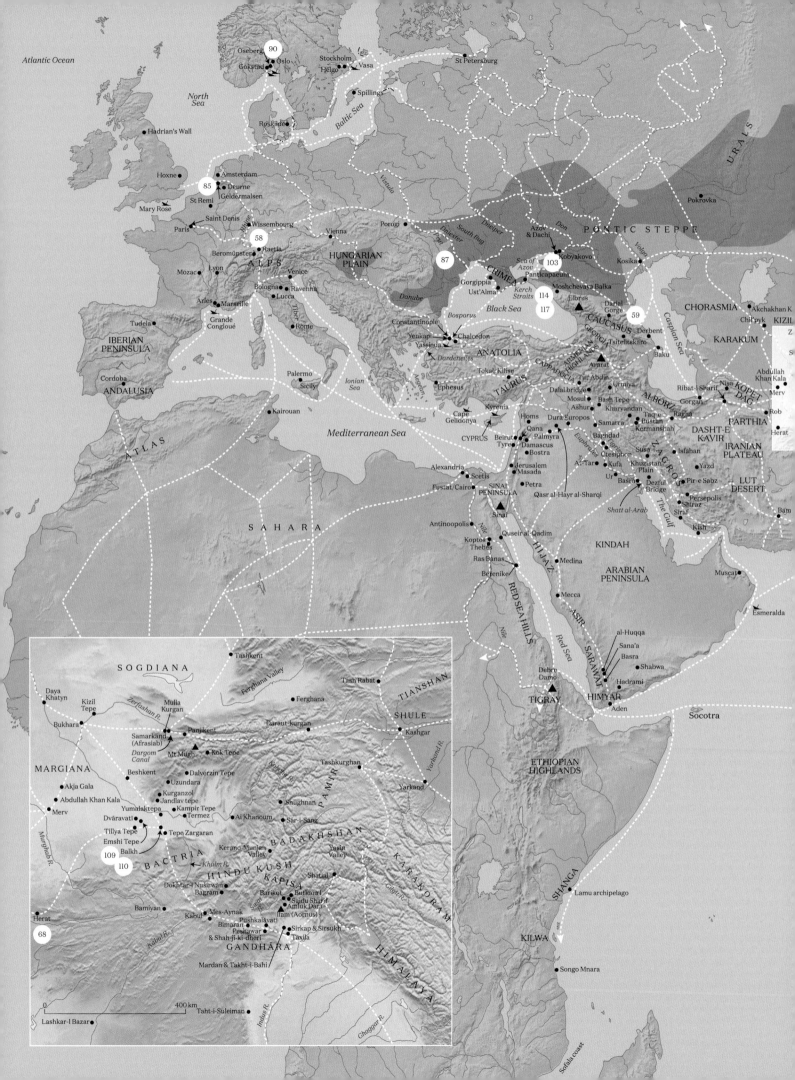

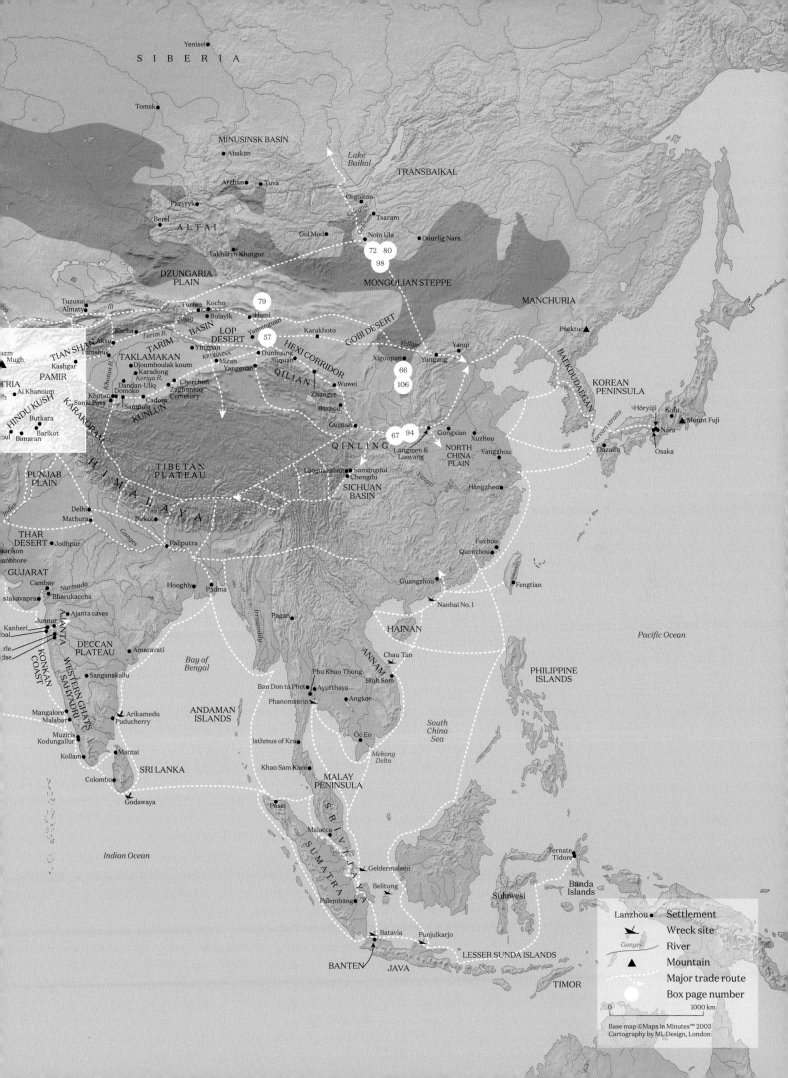

Where the grass meets the sky

Tim Williams

"A barbarian of the northwest tribes
 took me to wife by force.
He led me on a journey to the lands
 at the horizon.
Ten thousand strata of cloudy peaks,
 so stretched the returning road.
A thousand miles of piercing winds,
 driving dust and sand..."

Liu Shang (8th century), Cai Yan in 'Eighteen Songs of a Nomad Flute'.
Translated from Classical Chinese by Dore J. Levy.

Opposite — The horse, domesticated
at multiple places across Eurasia,
became an essential part of pastoralist
life, as on the central steppe shown here
(see pp. 88–95).

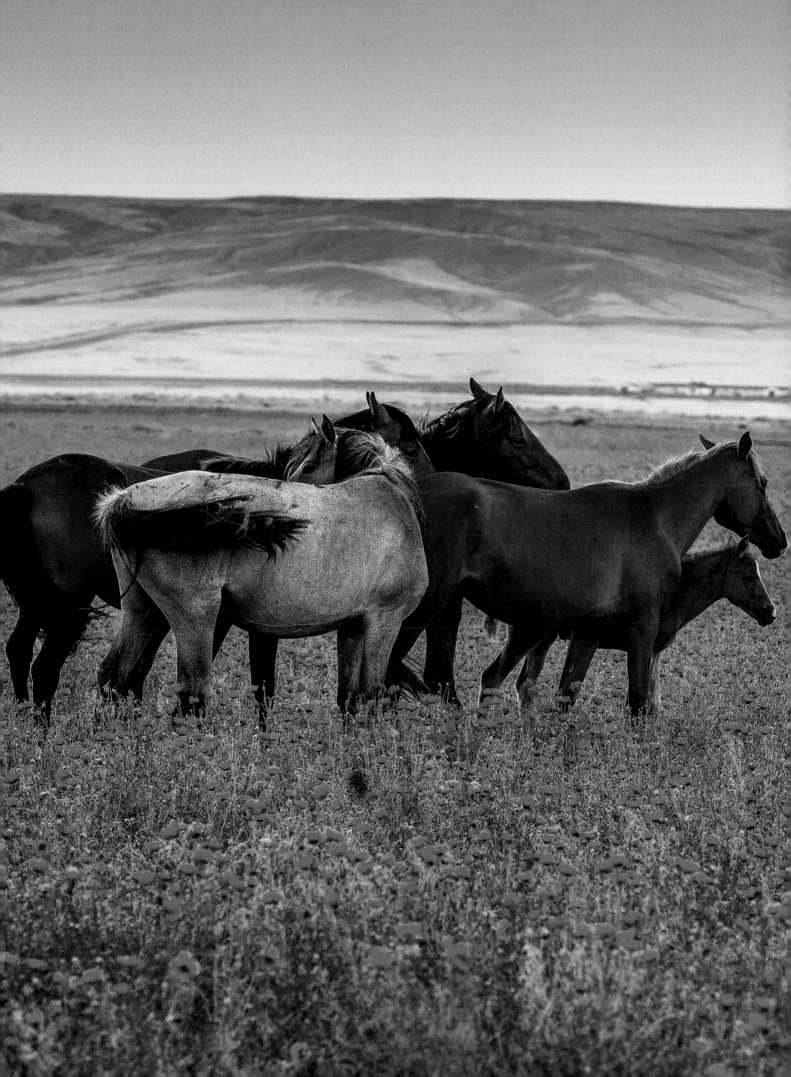

The Eurasian steppe spans a vast area from the Pontic steppe, north of the Black Sea, in the west to Mongolia and Manchuria in the east, and from the forests of southern Russia and Siberia in the north to the deserts of present-day Kazakhstan, Uzbekistan and Turkmenistan in the south.

It forms a giant contiguous ecological zone of temperate grasslands, savannas and shrublands. Commonly imagined as rolling, windy, semi-arid grassland, the steppe is actually not uniform: many areas are interspersed with hundreds of small rivers and streams, most fed by meltwater from the surrounding mountain ranges. Much of the steppe is too dry to support trees, but along the rivers that intersect it they flourish.

The steppe depends on rain driven in on westerly winds, with storm tracks along the mid-latitudes that span the continent from the Atlantic to the Pacific. As a result, the eastern steppe, east of the Altai mountains and encompassing much of Mongolia and Manchuria, is not only higher and colder but also drier than the western steppe. With greater seasonal changes in temperature, it is a harsher land. However, the lower temperatures reduce evaporation, so sparse grass continues to grow, even in areas where as little as 25–50 cm (10–20 in.) of rain falls annually.

Across the whole steppe, these differing landscapes have diverse water sources, raw materials (such as stone), pastures and microclimates, all of which have contributed to the way in which human societies have exploited the region. Farming could be productive near rivers and streams, but mainly (at least until recent times) the people of the steppe were pastoralists, surviving by raising livestock on the grasslands, moving their herds periodically to avoid overgrazing and to exploit seasonal changes. The steppe has an extreme continental climate, characterized by significant seasonal changes in temperature and rainfall. This seasonality means that during the summer months the semi-arid steppe has relatively poor pasture compared with the northern steppe zones and high-altitude meadows, where the pasture is lusher. This has forced communities to be mobile. Unsurprisingly, recent research has suggested that the pastoralist societies had a varied diet, with far higher diversity than the sedentary farming and urban communities to their south.

Mobility was a major feature of steppe life, traversing vast open landscapes, with far-reaching connectivity. The relatively hard surface of the steppe enabled carts to move without roads and animals to have access to ample fodder on the move. With few major geographical barriers to restrict travel, numerous societies and tribal groups spread across Eurasia, including the Scythians, Xiongnu, Yuezhi, Hephthalites, Huns, Avars, Alans, Khazars, Uygurs, Turks and Mongols. These peoples were to have a profound impact far beyond the steppe region. Their importance rested not simply on vast territorial extents, but on a capacity to connect vital economic and ecological nodes: trade corridors, steppe pastures, river valleys, tribute-paying cities and fertile deltas.

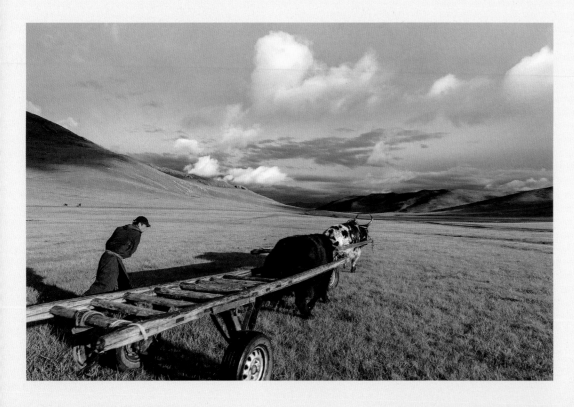

Yak cart, eastern steppe.

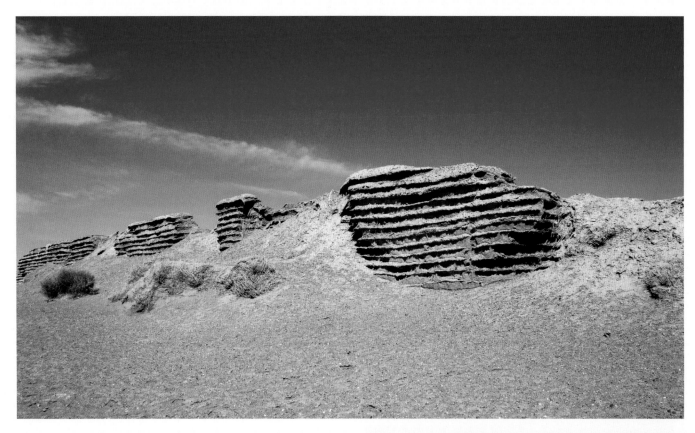

Chinese walls

From 133 BCE onwards, Han expeditions against the Xiongnu led the Han to occupy, temporarily or permanently, a major part of the lands to their northwest and to construct defensive walls. Two different forms of walls can be distinguished from this period: a closed frontier along the Hexi corridor, which connected the Han capital near Xian to the Tarim basin, running between the Qilian mountains to the south and the Gobi desert to the north; and an open frontier further west in the Tarim, the area called the 'Western Regions' in Chinese histories.

The Han established four main military commanderies (Wuwei, Zhangye, Jiuquan and Dunhuang) in the Hexi corridor, each defended by a series of fortified lines (now often referred to as part of the 'Great Wall' of China) that faced the northern steppe. Built primarily of tamped earth reinforced with layers of tamarisk and reeds, as illustrated here, they extended west to Lop Nor in the Gobi desert and were punctuated with watchtowers, such as the one pictured right. The border just west of Dunhuang was controlled by the

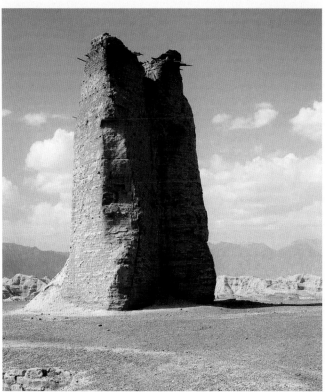

Jade and Sun Gates (Yumenguan and Yangguan). Chinese military control of the Hexi corridor was also strengthened by the presence of thousands of Chinese civilians, forcibly relocated from central China to establish agricultural communities to supply the army.

Chinese commanderies were not established further west. The Han had temporary control of the major kingdoms of the Tarim basin, Kroraina and Khotan [see box on p. 221], but neither the capacity nor the will to establish full and permanent military and administrative control. An administrative and military centre was moved between Jiuzi (Kucha), Jushi (Turfan) and Dunhuang, and diplomatic solutions such as gift exchange and intermarriage were used to provide protection to these kingdoms and to secure the Han's commercial access to central Asia. AB

Further reading: Bertrand 2015; Chang 2006; Hulsewé & Loewe 1979; Trombert 2011.

With the need to move regularly, few large permanent settlements developed. Craft and industrial production tended to be restricted as the output had to be portable and the processes semi-mobile. However, the differences between lands inhabited by sedentary farmers and pastoralists also created opportunities. Animal caravans and river transport made the steppe accessible to trade. To the north of the steppe the dense coniferous forests across the plains were a rich source of furs, from the Baltic Sea came amber, from the Ural mountains came iron and copper, and from Siberia came gold and semi-precious stones. These, as well as steppe horses, became objects to trade with the people in the settled lands to the south, in return for staples, such as grain, and luxuries, such as silk. The complex borders between the western steppe and most of central Asia, a mix of deserts, mountains, grasslands and cultivated areas, made interpenetration between pastoralists and settled agriculturalists inevitable.

The prevailing lack of permanent settlements and sedentary agriculture has often led to steppe peoples being characterized as barbarian by the 'civilizations' to their south; as the antagonists to ancient civilization. Often this was about a fear

Roman walls

During the Republican period (509–27 BCE), Rome protected its economic and territorial interests primarily through diplomacy, which could be followed or supported by military intervention. When the first emperor of Imperial Rome, Augustus (r. 27 BCE –14 CE), failed to control the Germanic peoples across the Rhine and Danube using these means, perimeter defences – *limes* – along these rivers were developed. From the late 1st century CE, the defence line was extended across the upper courses of both rivers, blocking a dangerous inward bend and including some fertile areas. Traces remain in the landscape today, as seen here.

Shortly after the mid-2nd century, the frontier came to be demarcated by the so-called Upper German-Raetian *limes*, a 550-km (340-mile) long linear barrier consisting of a timber palisade with the exception of a 40-km (25-mile) stretch along the Main river. The palisade was later replaced by a stone wall in Raetia and by a ditch and earthen bank in Upper Germany. There were watchtowers every 300 to 800 m (1,000 to 2,500 ft), supported by nearly sixty forts at 10- to 30-km (6- to 18-mile) intervals in the hinterland.

The barrier did not make full use of the landscape, and was not always in a strategically favourable position. Rather than a military bulwark, which would have required a more sturdy design and a stronger garrison, some argue that it was more of a demarcation line regulating access to the Roman Empire. The frequency of toll stations in areas with a dense population outside the frontier suggests that economic control was also a factor, though the channelling of trade is unlikely to have justified by itself the enormous effort of creating the defences. There is ample evidence that Rome also maintained a watch over the immediate foreland to prevent raiding, underlining the primary aim of security. MP

Further reading: Breeze 2011; Klee 2006; Reddé 2014.

Sasanian walls

The Sasanian trans-Caspian defensive chain ran from the Alborz to the Caucasus mountains. From the southeast of the Caspian sea, the Great Wall of Gorgan, at about 200 km (125 miles) in length and protected by almost forty forts, is the late antique world's most substantial barrier west of China. Built in the 5th century CE with the aid of thousands of brick kilns supplied with water through canals, it is an awesome feat of engineering. The four long mounds on the platform of Fort 4, shown here, are ruined double-barracks of over 200 m (650 ft) in length, once housing perhaps 500 soldiers each. On the Gorgan plain to the south, Gabri Qal'eh, measuring over 600 m (1,950 ft) across and enforced by over ninety towers, was just one of several giant fortresses built in the 4th to 5th centuries in this area.

To the west, the Caspian walls blocked the Dariali Gorge, shown right, and further east, the Derbent Wall blocked the coastal corridor between the Caucasus and the Caspian Sea. DN, ES, HOR & JN

Further reading: Gadjiev 2008; Sauer 2017; Sauer et al. 2013, 2016.

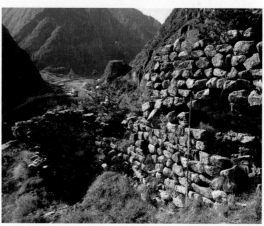

of the different, the 'other'. The Roman historian Ammianus Marcellinus (*c.* 330–*c.* 400), for example, wrote of them that 'they have no huts and care nothing for using the plough, but live upon flesh and an abundance of milk, and dwell in carts, which they cover with rounded canopies of bark and drive over the boundless wastes....As soon as the fodder is used up, they place their cities, as we might call them, on the carts and so convey them' (*History*, Book 31: 391). The perceived differences were not one-sided. Chinese histories record that Tonyukuk (*c.* 646–*c.* 726), military leader and advisor of the Second Turkic khaganate (682–744), advised against the adoption of Chinese culture, especially cities and conversion to Buddhism.

Climatic changes across the steppe, however, created significant pressures on what was a relatively fragile ecological system. Tensions between the settled and the pastoralist existed not simply because of different cultural norms, but also through basic competition for resources. At the end of the 4th century CE, for example, at the time Marcellinus was writing, a major drought across the steppe pushed the Huns westwards in search of the resources to survive. Kyle Harper rather eloquently describes the Huns as 'armed climate change refugees on horseback' (2017: 192). Tree-rings show that

a drought lasting nearly seven decades – from 783 to 850 – beset the eastern steppe. Here the Uygurs, rather than being pushed into neighbouring territories, took advantage of their location to reinvent their economy, trading horses with the Chinese to their south in exchange for silk, and then trading that with Sogdian merchants to their west.

The landscape of the steppe, as well as its ecology and climate, were a major factor in the ebb and flow of the Silk Roads, in shaping and sustaining numerous complex societies and impacting upon their interactions with the sedentary communities to the south.

———

Further reading: Christian 1994; Cunliffe 2015: Harper 2017; Shahgedanova 2003; Taaffe 1990.

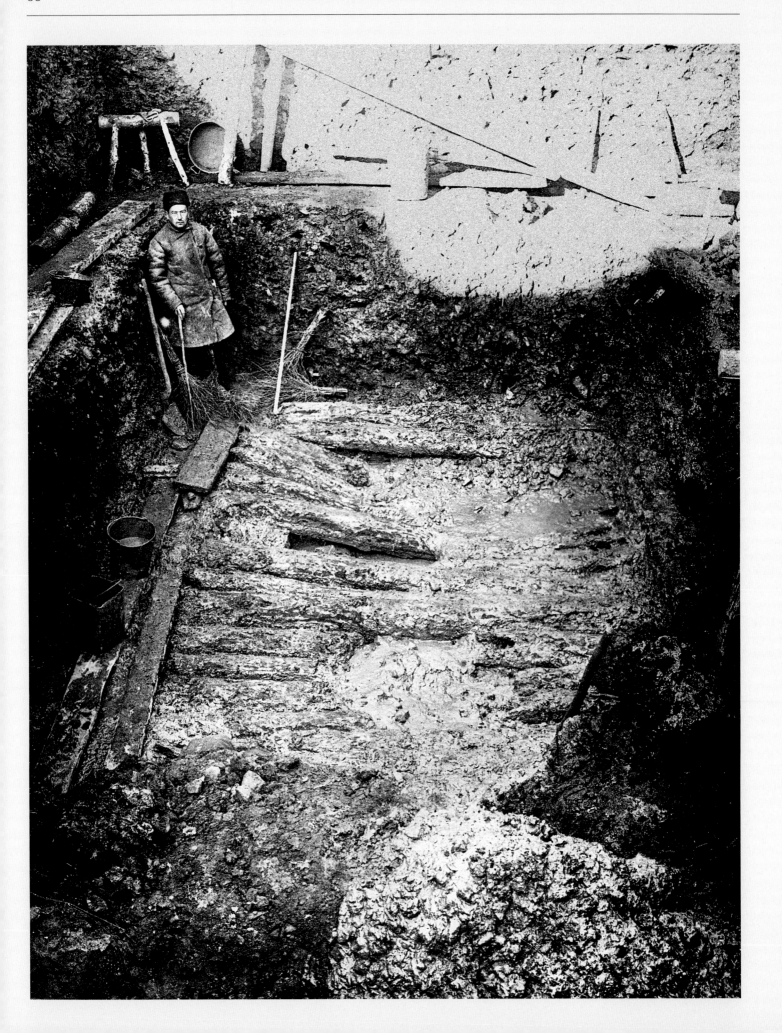

Gold from the earth

Sergey Miniaev

"Gold is only ore beneath russet earth,
Unearthed becomes the ornament of a crown,
If a scholar doesn't impart his knowledge
His wisdom, hidden for years, sheds no light."

Yūsuf Balasağuni (1020–1070), 'On Knowledge'.
Translated from Old Uygur by Dolkun Kamberi and Jeffrey Yang.

Opposite — Excavation of Noin-Ula
burials by Pyotr Kozlov in 1924.

Knowledge of the ancient history and culture of the peoples who occupied the vast expanses of the Eurasian steppe was for a long time limited to sparse geographical and ethnographic information reported by the Greek historian Herodotus (*c*. 485–*c*. 425 BCE), Islamic geographers and the embassies that visited the Mongol khagans from the 13th century CE.

It was only in the middle of the 16th century CE that the situation began to change. After the conquest of the Kazan khaganate on the Volga, the way eastwards, beyond the Urals and into Siberia, was opened for the advance of the Russians. Their main goal in moving to this vast region was the search for gold and silver mines. But they often mistook ancient burial mounds – kurgans or barrows – for mines and, on digging into them, found large quantities of gold and silver artifacts. Most were melted down and, as a result, during this period a huge number of ancient treasures were certainly lost.

Some pieces, however, were bought by Siberian officials who appreciated their artistic value, and these found their way to St Petersburg. They attracted the attention of European diplomats, notably the Dutch scholar Nicolaas Witsen (1641–1717), who spent a year in Russia from 1664 studying its history and amassing a collection. His book, *Noord en Oost Tartarye* ('North and East Tartary'), published in Amsterdam in 1696, contained drawings of some of the gold artifacts from the steppe as well as the first scientific map of Siberia. Artifacts were also purchased by the Governor of Siberia, Matvey

Gagarin (1659–1721), and sent to Peter the Great (r. 1682–1725) in St Petersburg. In 1718, Peter ordered the first scientific expedition to Siberia, under the leadership of the German scientist Daniil Messerschmidt (1685–1735). From 1719 to 1727 the expedition surveyed Siberia from Tomsk to Baikal, collecting important historical and ethnographical data, as well as information on the flora and fauna of this vast region. In 1722, Messerschmidt undertook the first archaeological excavations in Russia, exploring a Scythian-period (9th- to 3rd-century BCE) barrow near present-day Abakan.

The success of this expedition allowed the Russian Academy of Sciences, formed in 1725 by decree of Peter the Great, to continue the exploration of Siberia and central and east Asia. In the decades that followed, several large academic expeditions were organized, led by famous scientists of their time, both Russian and European. The gold finds also stimulated interest in the antiquities and ancient sites of the southern Russian steppes, primarily the Scythian barrows. The beginnings of research in this area can be traced back to 1763 and the excavation of the Lotoy barrow on the right bank of the Dnieper river on the initiative of Novorossiya's governor, A. P. Melgunov (1722–1788). Many gold and silver artifacts were uncovered. Interest in such finds gradually led to the systematic study of the Scythian antiquities of eastern Europe and further excavations followed.

In 1859, the establishment of the Imperial Archaeological Commission led to a more organized approach to archaeological studies of sites in Russia. More Scythian elite burials were excavated in the late 19th and early 20th centuries in the Dnieper basin and the northern Caucasus, where trade routes passed. More recently, tombs here dating from the 6th to 8th centuries have yielded well-preserved textiles [*see* boxes on pp. 114 and 117].

In the first half of the 20th century, outstanding archaeological discoveries were made in the Asian part of the steppe belt.

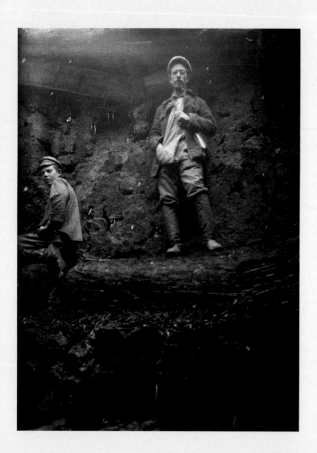

M. P. Gryaznov in 1929 leading excavation of the Pazyryk burials, at Barrow no. 1.

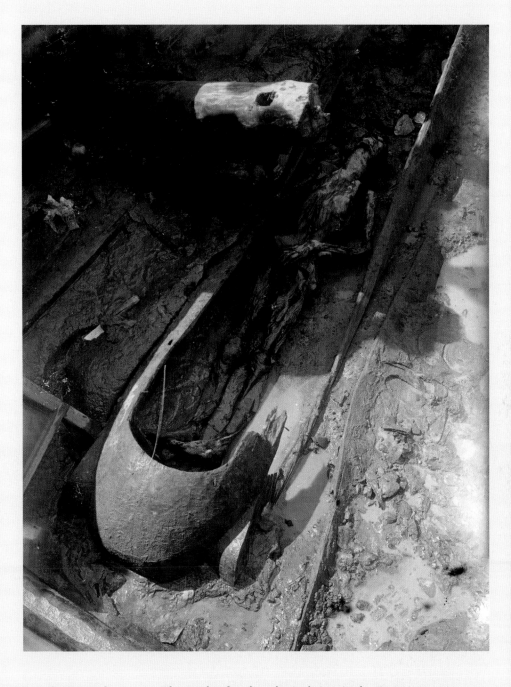

Excavation of Pazyryk.
Barrow no. 5, in 1929.

The first archaeological sites of the Xiongnu were discovered by Y. Tal'ko-Grintsevich (1850–1936) in the Transbaikal area from 1896 to 1903. Several elite Xiongnu barrows were discovered at Noin-Ula in Mongolia in 1924–25 by Pyotr Kozlov (1862–1935), and these yielded 2,000-year-old Chinese silks and embroideries, in addition to other textiles as well as gold, silver and jade items [*see* boxes on pp. 72, 80 and 98]. In the Altai, barrows from the 6th to 3rd centuries BCE in the Pazyryk valley were discovered in 1924 and subsequently excavated in 1929 by M. P. Gryaznov (1902–1984), with work continuing between 1947 and 1949 led by S. I. Rudenko (1885–1969). During the same period, systematic excavations of southern Siberian barrows were conducted by S. A. Teploukhov (1888–1934), who created a classification of the archaeological cultures of this region based on the excavated material. This retains its relevance today. Further west, Boris Grakov (1899–1970) excavated late barrows that he defined as belonging to the Sarmatian culture, which extended from the Black Sea to the Volga up to the 4th century CE. And remains of the Mongol empire of the 13th and 14th centuries were discovered in the Orkhon valley during the 1940s.

The study of archaeological sites in the Eurasian steppe continues today, with tombs and settlements belonging to the Xiongnu, the Huns, the Turkic empires and through to the Mongols regularly uncovered by archaeologists from Europe, the central Asian republics, Mongolia, China and other countries of the steppe.

———

Further reading: Frumkin 1970; Gryaznov 1929; Kiselev 1965; Rudenko 1953, 1970; Teploukhov 1929.

The 'wandering Scythians' and other steppe pastoralists

Daniel C. Waugh

Painting depicting Mongol cavalry in battle, from Rashid al-Din, *Jāmi' al-tawārīkh*. *c.* 1305 CE.

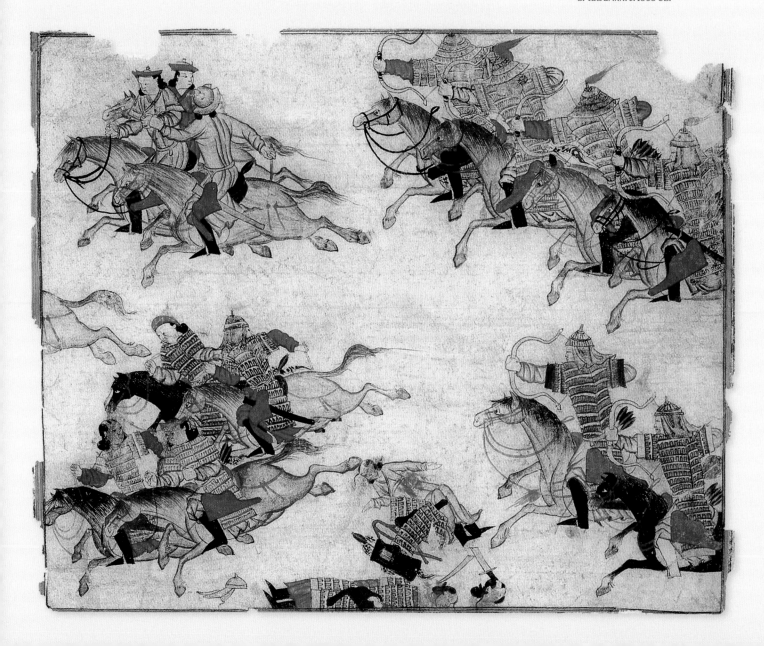

"...we come upon the wandering Scythians, who neither plough nor sow. Their country, and the whole of this region, except Hylaea, is quite bare of trees. They extend towards the east a distance of fourteen days' journey."

Herodotus (5th century), *The History*.
Translated from Ancient Greek by George Rawlinson.

Traditional histories of the Silk Roads often emphasize the sedentary civilizations at the ends of Eurasia: Han China (206 BCE–220 CE) and Imperial Rome (27 BCE–395 CE). In fact the key actors in Eurasian exchange were those in between, including the steppe pastoralists.

The peoples of the steppe and mountain regions provided transport and, once they created large political entities, controlled the overland routes. Some of the most compelling examples of cross-cultural exchange occurred in the zones of interaction between the steppe and sedentary communities. Moreover, given their expertise in animal management and military talent, steppe peoples often were employed in sedentary states, where they could rise to positions of power.

The steppe pastoralists occupied not only the broad band of grasslands stretching all across north-central Eurasia from north of the Black Sea to the Pacific but also the foothills and valleys of the adjacent mountain ranges. While migration over long distances was part of their history, the most common patterns of movement were the quite localized seasonal migrations between winter and summer camps, between the lowland valleys and mountain pastures. The connections among the pastoralist communities were responsible for the spread of technologies relating to transportation and bronze metallurgy [*see* pp. 188–93]. Even the migration of important food crops such as wheat can be connected with the pastoralist communities in the heart of Asia.

For the pastoralists, mobility and access to fodder and water for their herds were the key to survival. Domestication of the most important transport animals – camels and horses – was an essential prerequisite for the formation of larger political entities, as was also the ability of leaders to obtain and distribute the products of sedentary societies such as costly adornments and textiles. Relations between the pastoralists and sedentary societies were sometimes hostile, leading sedentary authors of the early written sources to call the peoples of the steppe uncivilized marauders. However, the relationship was in fact symbiotic, since the pastoralists were the providers of horses, essential for the armies and elites of their sedentary neighbours [*see* pp. 88–95].

Long-distance overland exchange in Eurasia, involving the services of pastoralists, can be traced well back into the Bronze Age, if not earlier. In the first millennium BCE, the Scythians (of Iranian origin) occupied a broad swathe of the steppe from north of the Black Sea to the western borders of today's Mongolia in the Altai mountains in the 1st millennium BCE. They produced some of the most stunning gold craftsmanship found anywhere, in part a result of their interaction with the Greeks in the Pontic steppe. It was also probably in the time of the Scythians that the employment of horses for military cavalry among their settled neighbours became common.

Critically important for the history of the Silk Roads was the rise of an alliance of steppe peoples, now called the Xiongnu, on the northern borders of China from the 3rd century BCE. At its peak, the Xiongnu empire (*c.* 209 BCE–91 CE) extended far to the west. The Han dynasty (206 BCE–220 CE) army was dependant on the Xiongnu for horses [*see* pp. 70–75], and the Xiongnu power and perceived threat led to the Han searching for allies among other pastoralists further to the west and prompted the

A headdress of gold and jade

Xigoupan, on the borders of the Xiongnu and Chinese empires, lies at the northeastern edge of the Ordos plateau in present-day China, where the Yellow river starts to turn south. Tombs were discovered and excavated there in 1979. An elaborate headdress was found in Tomb 4, the grave of an elite woman. Although this tomb and others were originally dated to the 2nd century BCE, when Xigoupan was part of the Xiongnu empire, more recent scholarship suggests that some date from the late 1st century BCE to 1st century CE, when this area was under the control of the Southern Xiongnu alliance.

The headdress displays a cosmopolitan style of elite expression in that components typical of Chinese elites are combined and integrated into ornaments characteristic of the Xiongnu elites of the steppe. This is reflected by the array of different materials used: glass and amber beads with jade pendants, and gold foil strips and ornaments with mother-of-pearl inlays. In its structure, with a diadem and dangling golden elements, complex necklace and earrings (the latter illustrated here, now in the Inner Mongolia Museum, China), it is similar to the crown of Burial 6 at Tillya

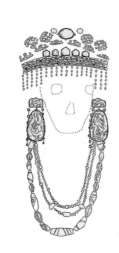

Tepe in central Asia [see box on p. 110] and thus bears witness to a network of elites between northern China, the steppe and central Asia. This elite network is seen among both men and women, who shared an understanding of how to express their status. UB

Further reading: Miller 2015; Pan 2011; Whitfield 2018.

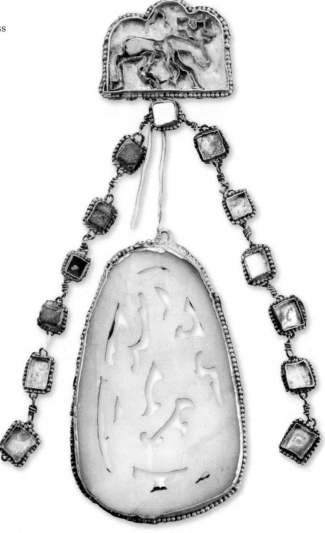

development of trade relations with central and west Asia by the 1st century BCE. Xiongnu tombs on the Mongolian steppe attest to the importance of cultural exchange for the pastoralists, since they have yielded Chinese silks, bronze mirrors and lacquerware [see boxes on pp. 72 and 103].

The rise of the Xiongnu was also the catalyst for the movement of peoples into other regions of central Asia. A notable example is the Yuezhi, who migrated from the Hexi corridor, in what is now northwestern China, through the Ili valley and into the region we know as Bactria, centred in northern Afghanistan. Their descendants founded the Kushan empire (1st to 3rd centuries CE), which extended its boundaries and flourished in the mountains, astride an area that is sometimes called the 'crossroads of Asia' [see pp. 136–43].

The Kushans absorbed the Hellenistic legacy of the descendants of Alexander the Great (r. 336–323 BCE) and facilitated the spread of Buddhism from south Asia into the Tarim basin, the northwestern regions of today's China [see pp. 153–59]. Overlapping with the early period of Kushan history was the rule in greater Iran of the Parthians (247 BCE–224 CE), another group of central Asian pastoralists [see pp. 76–81].

Patterns of confrontation and accommodation can also be found in other regions and later periods. The Sarmatians (c. 300 BCE–375 CE) originally moved from the Syr Darya as far as the Hungarian plains and some settled in western Europe and Africa. They were followed by the Huns (c. 350–c. 545) – whose identification as descendants of the Xiongnu is often suggested but still open to debate – who also moved westwards,

threatening the borders of the Roman Empire [*see* pp. 82–87]. Along the northern borders of China, the semi-nomadic Xianbei founded the Northern Wei dynasty (386–534), under whom Buddhism flourished.

Between the 6th and early 8th centuries, various alliances of Turkic peoples, whose original centre was on the eastern steppe, formed successive empires on the borders of China, including that of the Uygurs (744–840). Other Turkic groups moved westwards to the borders of Iran and Europe. Under the Uygurs, we find not only the development of major Buddhist centres but also the spread of Manichaeism [*see* pp. 356–63]. The Khazars (*c.* 650–969), north of the Caspian, adopted

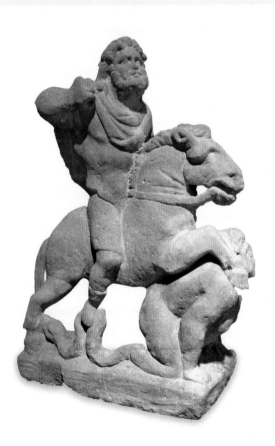

Horse trampling a barbarian

Huo Qubing (140–117 BCE), a young general serving the Han emperor Wu (r. 141–87 BCE), was famous for his victories against the Xiongnu alliance, China's pastoralist steppe neighbours. He was buried in 117 BCE in a monumental tomb located close to the emperor's mausoleum. Large granite boulders covered the mound of the tomb, in style reminiscent of steppe burials. Some sixteen boulders are extant, roughly fashioned into

human and animal shapes, including horses, elephants and tigers.

In the 2nd century BCE, stone was still a new material to craftsmen in China. Previously, they had carved jade and occasionally marble, but stone masonry was introduced only at the end of the 3rd century BCE [*see* pp. 200–5]. The granite sculptures from Huo Qubing's tomb, as well as three more erected by emperor Wu in

Shanglin park, reveal the masons' lack of experience. The example shown above right, 1.68 m (5.5 ft) in height, comes closest to a fully developed three-dimensional sculpture. A man lying on his back is depicted between the horse's legs; he has non-Chinese features, including a beard, and holds a bow. This is usually interpreted as a celebration of Huo's defeat of the Xiongnu. The motif of a horse trampling an enemy is also found in Sasanian

and Roman contexts, an example being the 2nd-century Roman sculpture shown above left of a god on horseback trampling an anguipede, a mythical creature probably of Persian origin with serpents for legs (Musée historique de Haguenau, R192a). LN

Further reading: Howard et al. 2003; Segalen 1923–24; Zhu 2014.

The defeat of the Hephthalites

The Iranian national epic, the *Shāhnāmah*, which narrates the history of Iran from its beginnings to the Arab conquest, was completed by Abu'l Qasim Firdausi (Ferdowsi) of Tus in 651 CE. The poem records the reigns of fifty mythical and historical monarchs and the triumphs and defeats of Iran's national heroes. Included in the narrative is the story of Sukhra's defeat of the Hephthalites, illustrated here in a 16th-century manuscript (Metropolitan Museum, 1970.30.67, f595b).

Sukhra served as minister to the Sasanian rulers between 484 and 493. He inflicted a serious defeat on the Hephthalites in retaliation for the death of Shah Peroz (r. 459–484), who had been killed in an earlier campaign when the Hephthalites had succeeded in taking Herat and Merv [*see* box on p. 219].

The Hephthalites emerged in central Asia in around 450. As one of the waves of migrants from the steppe, they are recorded in Armenian, Arabic, Persian, Byzantine, Chinese, Indian and other sources. They were famed for their mounted archers and they made successive incursions into the eastern part of the Sasanian empire from 458, seizing substantial territory. They became involved in Sasanian dynastic struggles, helping Shah Kavad (r. 488–496) to seize power from Balash (r. 484–488), who himself had succeeded Peroz. Although they made peace with the Sasanians after their defeat by Sukhra, their empire was ended by the Sasanians and Turks in around 565, although they continued to hold smaller territories until the Islamic expansion into central Asia. AO

Further reading: Canby 2014; Ferdowsi 2016; Kurbanov 2010; Whitfield 2018.

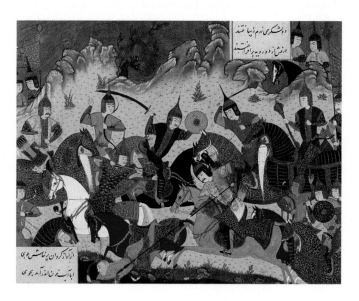

Judaism, whereas the Turkic Bulgars who controlled the trade routes from the north along the Volga adopted Islam.

The culmination of this history of the peoples of the steppe came in the rise of the Mongol empire, which for a relatively brief period in the 13th and 14th centuries embraced more of Eurasia than any polity before or since. From their original home in today's Mongolia, the Mongols first conquered northern China, then moved into central Asia, eastern Europe and west Asia before, finally, conquering southern China. The fate of the territories they controlled varied: some were devastated by the initial invasion, others came to flourish under their new overlords. The Mongols encouraged international trade and facilitated travel across Eurasia (including for the Polo family from Venice). Some of the most evocative examples of cross-cultural exchange are embodied in the work of the Grand Vizier of Iran under the Ilkhanid Mongol dynasty (1256–1353), Rashid al-Din (1247–1318).

———

Further reading: Allsen 2008; Barfield 1992, Di Cosmo & Maas 2018; Fitzhugh et al. 2013; Golden 2010; Spengler et al. 2014.

Turkic guards in Sogdiana. Detail of a watercolour copy of a 7th-century mural on the west wall of the Ambassadors' Hall at Afrasiab [*see* box on p. 284].

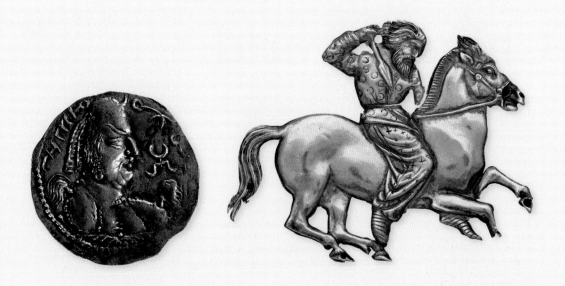

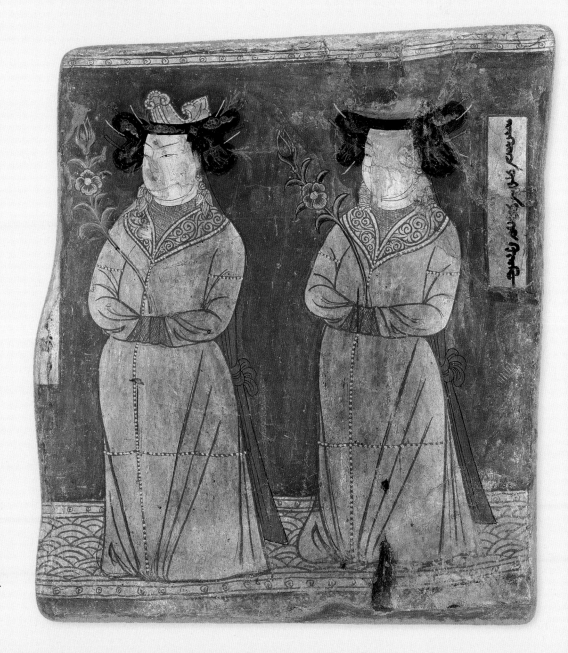

Above left — Silver dinar with Bactrian inscription showing an Alchon Hun ruler, possibly Khingla (r. 455–484).

Above right — Gold plaque of a Scythian horseman, Pontic steppe, 400–350 BCE.

Bottom — Uygur princess donors in a 9th-century Buddhist mural, Bezeklik Cave 9.

The steppe and the Chinese world

Ursula Brosseder

Traditionally interactions and influences between China and the steppe are framed as a collision between settled agricultural and nomadic pastoralist worlds in a single frontier zone.

Often steppe societies have also been assumed to be inferior in comparison to the more advanced civilizations of the Chinese states, with the pastoralists thus dependent on the political institutions and agricultural economy of their neighbours. These misconceptions are driven by the dominance of Chinese written records for reconstructing their history, while much of the steppe world has few written records of its own. But archaeological remains in the steppe provide strong material testimonies of sophisticated pastoralist societies. Recent research is now moving beyond the confines of the texts to demonstrate mutual interactions between the peer powers of China

and the steppe. Well before the rise of empires, prestigious objects from China had made their way into the elite graves of steppe leaders, as seen in the tombs of Pazyryk in southern Siberia from the late 4th to early 3rd centuries BCE, while at the same time cavalry equipment and riding trousers were adopted by several kingdoms in China.

Even during the first century of the Han dynasty (206 BCE–220 CE), prestigious golden belt plaques with steppe motifs, equivalent to those worn by the Xiongnu elite of the same period, were buried in elite Han graves in the Chinese heartland. Interactions between the Han and Xiongnu empires were manifold and encompassed multiple levels of

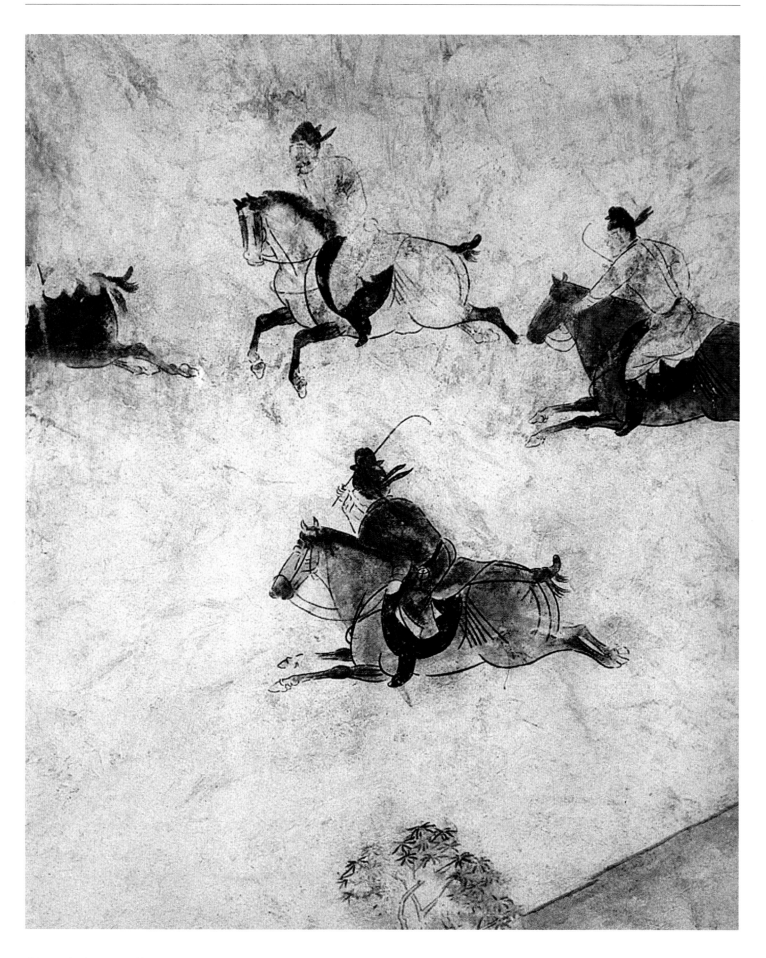

Chinese polo players. Detail from
a mural in a prince's tomb, near Xian,
China, dating to 706.

Chinese silk on the steppe

Many silks originating from China have been discovered in the Xiongnu burial cluster at Noin-Ula in the Selenga river basin, dated between the 1st century BCE and the 1st century CE. These include examples showing four types of weaves as well as embroideries. The site was excavated by the Russian Mongolian-Tibetan Expedition in 1924–25, led by Pyotr Kozlov (1862–1935). Numerous fragments of similar silk pieces to the one shown here, a warp-faced compound tabby or *jin* [*see* pp. 316–23], were found in Kurgan 6; the largest, 176 cm (69 in.) long and 46 cm (18 in.)

wide, is now in the Hermitage Museum (MR 1330).

The silk has a repeated design that includes 'magic' or psychedelic mushrooms, used for religious rituals, as well as trees and mountains that probably represent the links between human earth and the spirit world above. From a technical viewpoint, it has two unusual elements. The first is the proportion of the warp threads, that is the total number of colours used for the patterning. This ranges from four to six, making in places a density of up to 240 warp threads per cm (or around 620 per inch). Second,

the pattern is repeated in the warp direction after about 53 cm (21 in.) and there are 26.5 wefts per cm (about 67.5 per inch). This means that an extremely sophisticated loom with 350 pattern rods lifted by heddles was required to weave this fabric [*see* pp. 316–23]. Based on our current knowledge, it is thought that it was a low pattern draft type, like a bamboo-cage loom. ZF

Further reading: Lubo-Lesnichenko 1961, 1994; Whitfield 2009.

society. Many of the northern regions that Chinese kingdoms had previously taken were conquered by the Xiongnu and later vied for by the Han dynasty, and treaties between Han and Xiongnu rulers were made through marriage alliances and luxury tribute payments to the steppe empire. While Chinese brides were sent to Xiongnu rulers, princes of the steppe were sent as hostages to the Han court. But aside from war and diplomacy, there were many Chinese who became generals and advisors of the Xiongnu rulers, and Chinese people were frequently captured in raids to become slaves or voluntarily fled Han garrisons to live in the Xiongnu steppe lands. Xiongnu leaders that surrendered to the Han

Depictions of two-wheeled carts from the 2nd millennium BC can be found throughout the Afro-Eurasian world. This petroglyph is from the wall of a royal burial at Kivik, Scandinavia, and dates from *c.* 1400 BCE.

at times retained their households; at other times steppe cavalry units served under Han generals. In addition to tribute missions, border markets served as important locales for the flow of various goods to both realms. During the 1st century CE, a faction of Xiongnu nobles established the Southern Xiongnu entity within the northern bend of the Yellow river as a nominal subsidiary of the Han court between China and the steppe, propagating a hybrid mixture of cultures and often acting in its own economic and political interests [*see* box on p. 66].

These patterns of interactions and intermixtures between the Han and the Xiongnu repeated with even greater complexity through subsequent eras.

After the Southern Xiongnu, steppe rulers came to establish dynasties across northern China, including the Northern Wei (386–535 CE). Xiaowen, a Northern Wei hybrid steppe-Chinese emperor, utilized northern steppe soldiers for his Chinese-styled imperial guards. The blending of Chinese and steppe traditions became even greater during the Turkic (552–744) and Tang (618–907) eras, with, for instance, the Tang emperor Taizong – who had Turkic ancestry – adopting the steppe-derived title of Heavenly Khagan. Pacts between the powers were forged again through marital agreements as well as rituals when the two parties met. Cooperation was in the economic and political interests of both, and the

Two-horse chariot burials from Anyang, China, *c.* 1300 BCE.

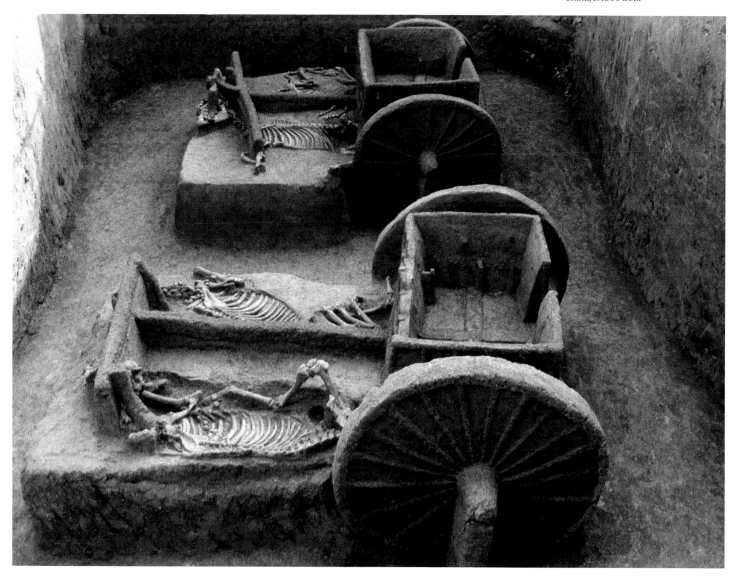

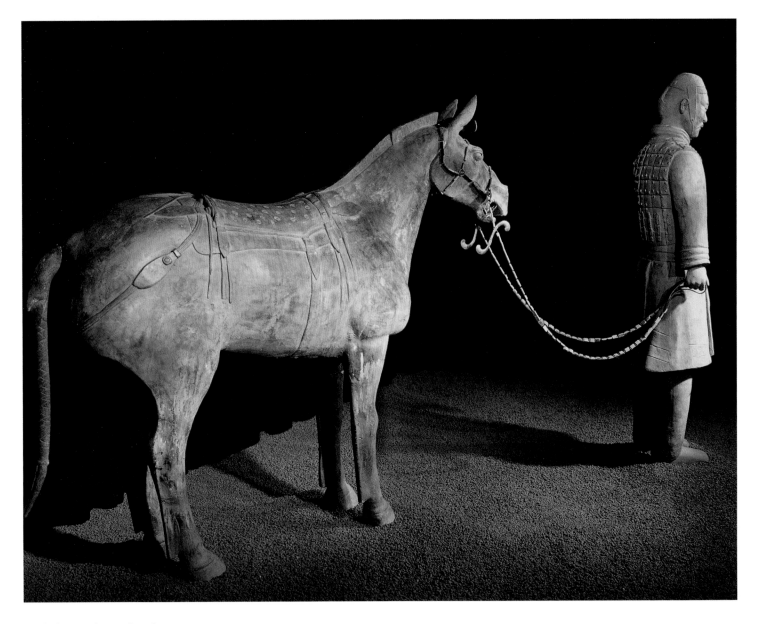

Cavalry horse and groom from the
tomb of Qin Shihuangdi, Xian, China,
210–209 BCE.

close relationship is highlighted by two Tang-style tombs in the heart of present-day Mongolia. Steppe cavalry again were a critical component of Chinese armies, and Chinese captives were put to work for the Turkic economy.

During the Liao (907–1125) and Jin (1115–1234) dynasties, the Khitans and Jurchens, groups from modern-day northeast China, dominated large realms that spanned northern China, the Mongolian steppe and far eastern Russia, well before the Mongol empire, when all of China came under the foreign rule of the Yuan dynasty (1271–1368).

All this demonstrates a plethora of contexts in which people, ideas, technologies and objects were exchanged in both directions. The Silk Roads model, which is often applied throughout these periods, is cited as the main spark that ignited the transfer of luxury goods, commodities, religious ideas and peoples in lines east–west between empires. But this inadequately explains the interactions between Chinese and steppe powers and the broad flow of goods and ideas north–south and into rather than between empires. Instead of viewing the Silk Road merely as an east–west 'highway' dominated by commercial caravans, we may more accurately depict the web of relations encompassing the vast regions of Afro-Eurasia as numerous north–south as well as east–west directed veins. In the beginning

these were used for diplomatic interactions and only later did agents of political powers become coupled with mercantile and economic interests. The Eurasian networks were thus forged not by Chinese merchants bearing silk but by a host of groups. Nodes of the so-called Silk Roads were at times dominated by the Chinese, sometimes by steppe groups, and at other times by central Asian groups like the Sogdians. Thus the steppe powers must be regarded on a par with the Chinese as crucial agents for maintaining and fostering exchanges along this famous web of cross-continental routes.

―――

Further reading: Bemmann & Schmauder 2015; Di Cosmo 2002; la Vaissière 2005; Skaff 2012; Stark 2009.

Female polo player wearing 'foreigners' dress', China, 8th century.

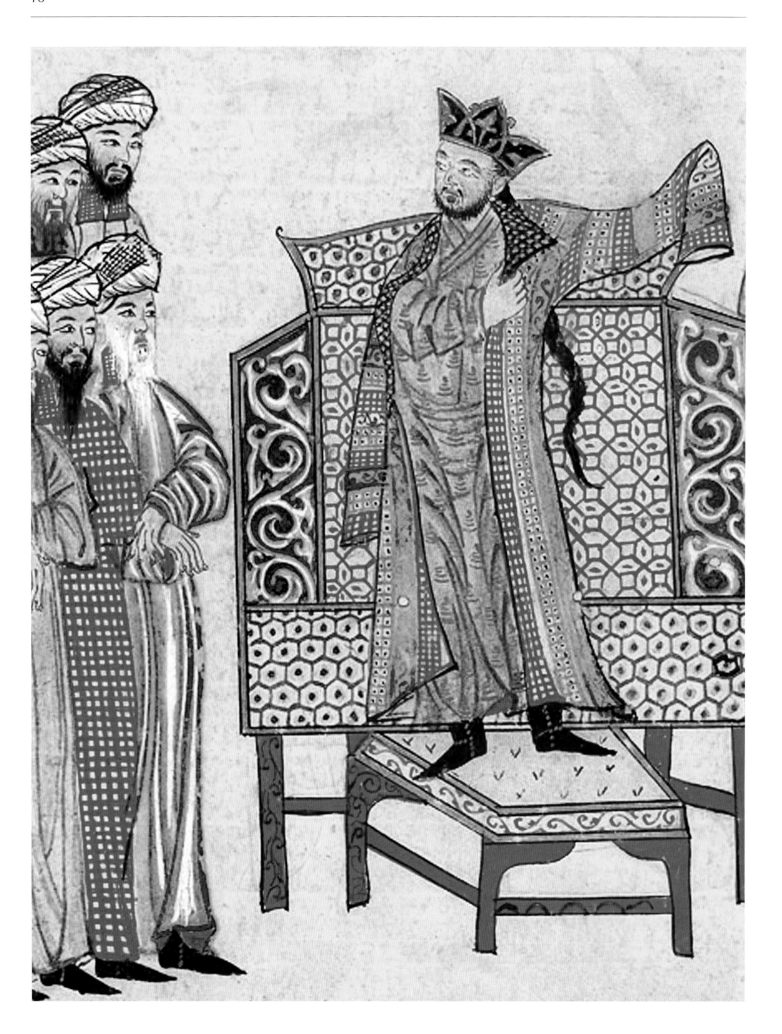

The steppe and the Iranian world

Touraj Daryaee

A constant feature of the Eurasian world has been the movement of people from Ural Asia and the steppes to south and west Asia. Since Indo-Iranian-speaking people moved to south Asia and the Iranian plateau in the 2nd millennium BCE, there has been a steady wave of migration.

While some of these migrant peoples established imperial systems – the Achaemenids (550–330 BCE), Parthians (247 BCE–224 CE) and Sasanians (224–651) – others, such as the Scythians, continued their lifestyle as mounted pastoralists, moving into central Asia and also westwards into the Caucasus, and all the way into eastern Europe. Those who established the successive empires on the Iranian plateau had to deal with other pastoralist steppe people who came to settle at their northern borders. From the 5th to 13th centuries these included the Huns, Hephthalites, Turks and Mongols, all of whom established their own empires. But with the creation of the Silk Roads it was the Parthians and the

Chinese who began to connect the world of the steppe to their empires in a larger world-system that had not been seen before.

The steady migration of pastoralists into the lands of settled people and their empires had significant consequences. The Scythians were early proponents of trade and exchange along the route, gold objects being their best-known commodity, traded for goods from China to eastern Europe [see boxes on pp. 103 and 106]. Huns, Hephthalites [see box on p. 68] and Turks from the steppe prompted the Sasanians to build walls between the Caspian sea and the mountains, including the longest continuous wall in antiquity, the Great Wall

of Gorgan [*see* box on p. 59], to protect both Rome and Persia from the Huns and other pastoralists. These walls were not intended to stop steppe people from entering Sasanian territory, but rather to manage their movement, their presence being beneficial for both trade and political manoeuvring. While in early Iranian literature those who dwelt outside the walls were viewed negatively, nevertheless the settled populace of *Ērānšahr* (The Empire of the Iranians), which was thought to extend from the Amu Darya to the Euphrates river, interacted constantly with the steppe people. Interaction continued with the coming of Islam, with the Muslims pushing eastwards all the way to the borders of China by the 8th century CE [*see* pp. 256–67]. The consequence of the Islamic conquest was the expansion of trade and contact with the east, through both land and sea routes.

During the Abbasid caliphate (750–1258), Muslim, Jewish, Christian, Manichaean and Zoroastrian

Previous spread — Mahmud (r. 998–1030), son of the Turkic slave Sabuktigin and ruler of the Ghaznavid empire. From Rashid al-Din, *Jāmiʿ al-tawārīkh*, *c.* 1305 CE.

Right — The Parthian king of Hatra, Sanatruq I (r. *c.* 140–180 CE). This statue was destroyed during recent warfare.

merchants developed trade networks across Afro-Eurasia, taking much sought-after commodities to Baghdad [*see* box on p. 336] and beyond by land and sea. Many goods, including slaves and furs, were brought to the steppe by river from northern Europe and then traded on through the Samanid empire (819–999) in eastern Iran to Baghdad. The extent of the trade is shown by the discovery in Europe of numerous hoards of Samanid coins acquired by such trade [*see* box on p. 308]. Routes crossing the steppe eastwards took Persian goods as far the kingdoms of the Korean peninsula, as evidenced by Sasanian glass found in the royal Silla tombs, and onwards to Japan [*see* box on p. 426].

Samanid bowl from Nishapur, possibly made in Samarkand. The Arabic inscription reads 'Blessing, Prosperity, Well-Being, Happiness'. Late 10th–11th century.

Gog and Magog: mythical walls

The names Gog and Magog appear in the Old and New Testaments in the books of Genesis, Ezekiel and Revelation. In Genesis, Magog alone is mentioned as the son of Japheth, son of Noah; in Ezekiel, Gog of the land of Magog is described as an enemy of God's people; and in Revelation both are named as the allies of Satan. They also appear in the Qur'an as Yajuj and Majuj. The eighteenth surah of the Qur'an narrates the travels of Dhul Qarnayn, 'the horned one', who is identified with Alexander the Great (r. 336–323 BCE). According to this account, Dhul Qarnayn was approached for help by a people who were being oppressed by Yajuj and Majuj. He ordered them to build a wall of smelted iron covered in molten copper between two cliffs to keep them at bay until their release during the final days of the world, a scene often represented in manuscripts, such as in the 16th-century copy of the *Shāhnāmah* by Ferdowsi [*see* box on p. 68] illustrated here (British Library, IO Islamic 3540, f.390r).

In 842 CE the Abbasid ruler al-Wathiq (r. 842–847) dreamed that the wall had been breached by Gog and Magog. He sent Sallam, one of his Turkic interpreters, on a journey to investigate. Sallam travelled to the Caucasus but, failing to find the gates, went further east through the Turkic Khazar empire and thence to the northern Tarim, also then under Turkic rule. On his return, he reported to al-Wathiq that he had found Alexander's wall intact about 500 km (300 miles) from Igu (sometimes identified with present-day Hami in present-day northwest China). AO

Further reading: Stoneman et al. 2012; Van Donzel & Schmidt 2010.

Parthian textiles on the steppe

This embroidered sheep-wool fragment with couching, about 60 by 44 cm (24 by 17 in.) in size and now in the Hermitage Museum (MR 1953), was found in Kurgan 6 at the Noin-Ula Xiongnu burial site [*see* box on p. 72]. It was hanging on the external southern wall of the burial chamber above a thin silk, functioning as a pictorial mural. It shows a rider on a white horse, equipped with a saddle, bridles, head ornaments and a disc-shaped phalera featuring a five-dot rosette. The rider and the one behind him each wear a close-fitting cap over hair tucked underneath and descending in curls at the back of the neck, as well as tunic, trousers and boots. Their postures and the equestrian and sartorial details point to their Parthian origin, albeit with Hellenistic influence, as seen in the decorative band below. Analyses of the dyes used on similarly embroidered wool fragments excavated from Kurgan 20 in 2006 reveal that the dyes came from the Mediterranean and India, and are comparable to those of woollens from Palmyra [*see* box on p. 217] and Dura-Europos, leading to the hypothesis that such embroideries were made in western Parthia (present-day Syria). Conceivably the Xiongnu had repurposed this fragment as a homage befitting the deceased, probably their ruler, Wuzhuliu Ruodi (r. 7 BCE–14 CE). ASh

Further reading: Lubo-Lesnichenko 1994; Rudenko 1962; Trever 1932; Whitfield 2009.

Mausoleum of the Ilkanid ruler, Öljaitü
(r. 1304–1316), at Soltaniyeh in Iran.

The steppe people were also important in the spread of technologies – such as the stirrup, which revolutionized warfare in Eurasia – and in providing a steady supply of horses [*see* pp. 88–95]. Persian and Muslim armies increasingly relied for their troops on Turkic slaves taken during raids or as prisoners-of-war, some of whom rose to high positions. The result was that the Turkic warriors – Mamluk – became the dominant power throughout west Asia and came to control large tracts of land, from the Mediterranean to Kashgar, between the 10th and 13th centuries [*see* pp. 36–37]. The Mongols and their descendants in the 13th and 14th centuries brought their own vocabulary and worldview,

which in time was fused with the Persianate Islamic and Chinese systems. The Mongols promoted the spread of the Persian language, while Turkish and Mongolian vocabulary entered into the Persian lexicon.

———

Further reading: Bivar 1972; Di Cosmo & Maas 2018; Green 2017; Laing 1991.

The steppe and the Roman world

Valentina Mordvintseva

The meeting of peoples of the Mediterranean civilizations with steppe pastoralists, known in the Greco-Roman tradition under the name of the Scythians and, later, the Sarmatians, took place long before the rise of Imperial Rome (27 BCE–395 CE).

In the late 7th century BCE, the Greeks had founded colonies on the northern shores of the Black Sea, where the sea routes of Europe ended and the steppe began. These became centres of commercial and cultural interaction with the steppe world and beyond. The most powerful united Greek cities on either side of the Kerch strait founded the Bosporan kingdom in around 438 BCE. With its capital in Panticapaeum (present-day Kerch), the kingdom spread its influence far into steppe territories.

Many of the Greek colonies surrounding the Black Sea, including the Bosporan kingdom, were later incorporated into the Pontic empire (281–62 BCE) under the reign of Mithridates VI (r. 120–63 BCE).

This was the first and last unification of the entire Black Sea region under one ruler. Mithridates planned further expansion westwards, making him an immediate threat to Republican Rome (509–27 BCE). His troops included military contingents provided by steppe peoples, Iranians in language and culture. Mithridates paid the Scythians for their help with daughters in marriage and rich gifts, and archaeological evidence of the relationship is provided by the astonishing high-quality grave goods from the burial mounds of the steppe elite [see pp. 96–103]. Defeated by Rome and wanting to avoid being taken prisoner, Mithridates ordered his bodyguard to kill him in his palace in Panticapaeum;

Pontus and the Bosporan kingdom became client Roman states.

By the 1st century BCE, two new empires came to dominate the former Greek world: Rome in the west and Parthia in the east, both surrounded by allied satellite states. The Iranian-speaking Parthians had themselves moved southwards from the steppe [*see* pp. 76–81]. Both Imperial Rome and Parthia (247 BCE–224 CE) pursued an active foreign policy, expanding their respective domains and areas of influence towards each other and forming new networks of interaction, both trade and diplomatic. After a series of conflicts the boundary between their empires was set along the Euphrates river.

The Bosporan kingdom and other Black Sea Greek colonies acted as intermediaries in Rome's communications with the steppe aristocracy, and were rewarded for their loyalty with rich gifts. From the mid-1st century CE, the flow of Roman imports into the steppe increased greatly. Contemporary burials of steppe elite contain Roman bronze vessels, silver tableware, weapons and exotic items [*see* pp. 96–103]. Roman relations with the steppe were aimed at not only ensuring loyalty during

Previous spread — Prytaneion (seat of government) in the Greek city of Panticapaeum on the Kerch peninsula, Pontic steppe, dating from the 2nd century BCE.

Above — Gravestone of Staphilos of the Bosporan kingdom, at Panticapaeum on the Kerch peninsula, Pontic steppe, 2nd century BCE.

The helmet of Deurne

Found in 1910 in a bog in Deurne in the Netherlands and probably left there around 320 CE – whether intentionally or by accident is not known – this helmet belonged to an officer in an elite cavalry unit of the Roman army. This gilded silver outer helmet, 20 cm (7.9 in.) in diameter and 28.5 cm (11.2 in.) high, originally had an inner iron cap lined with leather. An inscription gives the cavalry unit – the sixth division – the name of the maker and the amount of silver used (500 g or 17.5 oz).

Such helmets were made by the *Barbaricarii*, craftsmen in gold thread and leaf, in factories dedicated to producing armour for military officers. The design on this example is considered to be influenced by Sasanian styles, which became popular in the Roman Empire under Emperor Constantine (r. 306–337). It was found together with Byzantine coins – the usual payment for soldiers – dated between 315 and 319, shoes and various other small items, but there were no human or horse remains. The helmet is now at the Rijkmuseum van Oudheden in Leiden (K 1911/4.1–5). SW

Further reading: Aillagon 2008; Granscay 1963; Van Driel-Murray 2000.

Coin showing King Mithridates VI (r. 120–63 BCE), king in the Pontic steppe.

military conflicts but also supporting the long-distance trade that ran along the steppe belt to central Asia, thus avoiding territories controlled by Parthia and hostile to Rome.

Using these trade routes, goods – including luxuries such as silk – from central Asia and beyond, including China, entered Europe. The existence of this northern trade route across Eurasia is shown by the finds of Chinese lacquerware, mirrors [*see* box on p. 103], jade objects and silk clothing [*see* boxes on pp. 114 and 117] in graves of the elite of the north Pontic region.

In the 2nd century CE, Imperial Rome reached its peak, its prosperity in large part based on stable

Wounded Parthian. Detail from
monument originally at Ephesus
celebrating the Roman victory over
the Parthians in 162–165 CE.

political and economic networks across Eurasia. Its elite became enriched and started competing for access to resources and control over the trade. Inhabitants of Rome's provinces were granted Roman citizenship, giving them access to the highest positions in the empire and leading to yet more competition for territory, power and wealth.

After the collapse of Imperial Rome in 395, relations between the steppe and its neighbours continued, as steppe peoples such as the Alans, Avars, Bulgars and Kipchaks formed important kingdoms that interacted with the Byzantine empire (330–1453) in the Black Sea region, while Slavs and others pushed at the borders of eastern Europe. By the end of the 1st millennium CE, Turkic-speaking peoples dominated the steppe across Eurasia but they, too, were conquered and absorbed by another group moving westwards in the early 13th century, the Mongols. Out of the fragmented remains of the short-lived Mongol empire, the khaganate of the Golden Hoard (1240–1502) came to control the western steppe, bringing new influences into Europe.

——

Further reading: Aillagon 2008; Braund 2018; Kozlovskaya 2017; Mordvintseva 2013; Mordvintseva & Treister 2007.

A bird of gold and garnets

Garnet, a red stone often used for gold jewelry made using the cloisonné technique, became very popular in the 4th-century steppe Hun empire and among its neighbours. It is found in graves from the steppe and across Europe, as both jewelry and to adorn clothing. The garnet was probably imported from mines in India, although it is also found in Sri Lanka and, later, in central Europe.

The bird illustrated here, 6.5 cm (2.5 in.) high, was found in a 4th-century tomb discovered in 1812 on the Prut river, in what is now northeastern Romania, and is now in the Hermitage Museum (2160/39). The tomb was that of a military commander who probably died fighting on the steppe. He was buried, with his horse, silver helmet and weapons, among a large quantity of gold items, in a tomb with a vaulted stone ceiling. SW

Further reading: Adams 2003; Aillagon 2008; Granscay 1963; Van Driel-Murray 2000.

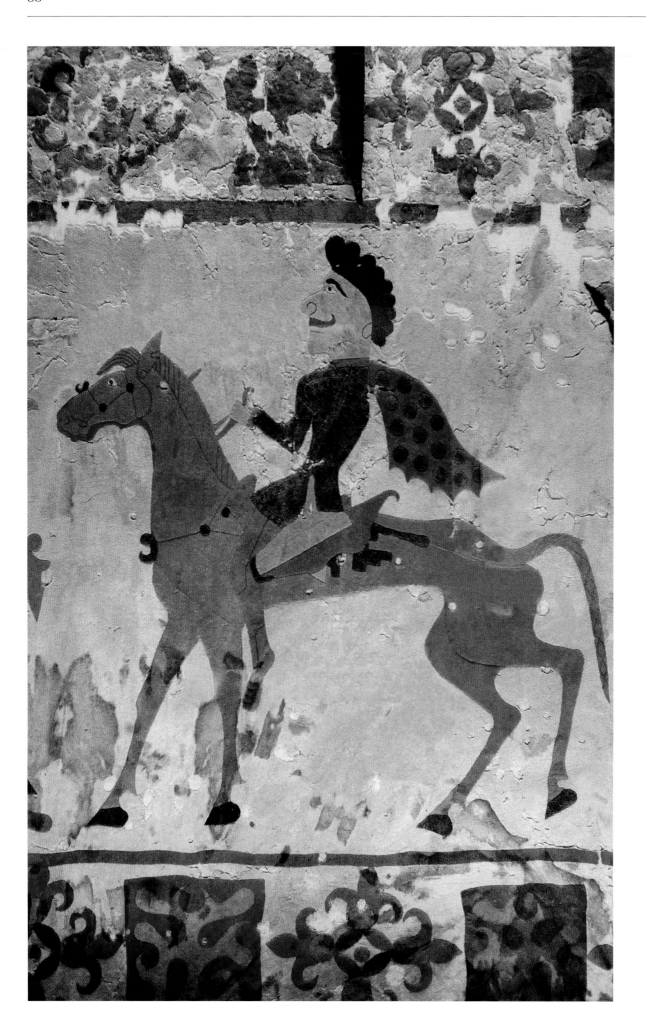

The wings of the Turks: the horse

Susan Whitfield

While the camel is often thought of as the animal most representative of the Silk Road, the horse played an equally if not more important role in trade, diplomacy, warfare, art, myth and culture. The horse was integral to the settlement of the steppe and its domestication probably goes back to at least the 4th millennium BCE in the western steppe.

The horse enabled the great Bronze Age migrations that took peoples from the borders of Europe to Mongolia, the Tarim and India. It was also used to pull a portable two-wheeled chariot that transformed warfare and gave steppe peoples control of ores mined from Mesopotamia to the Altai. These ores were used to make and decorate the horses' tack, and the horse, often buried with its master, became part of myth and art in cultures across Eurasia, from ancient Greece to India [see pp. 96–103].

Alongside the domestication of the horse came the domestication of an important fodder, alfalfa or lucerne (a co-domestication similar to that seen in the case of silkworms and mulberry [see pp. 310–15]). Domesticated alfalfa spread, first to the Iranian plateau and, by the 8th century BCE, to Mesopotamia and Greece. It then filtered eastwards to India and reached China in the 2nd century BCE. Despite this, while horse-breeding programmes were successful across central and west Asia and in ancient Greece, they were far less so in China or India and both cultures relied on trade to supply many of their mounts. Part of the reason for this must have been the lack of suitable pasture, since the plains of northern China and India were devoted to agriculture. Many horses continued to be brought from the steppe and the

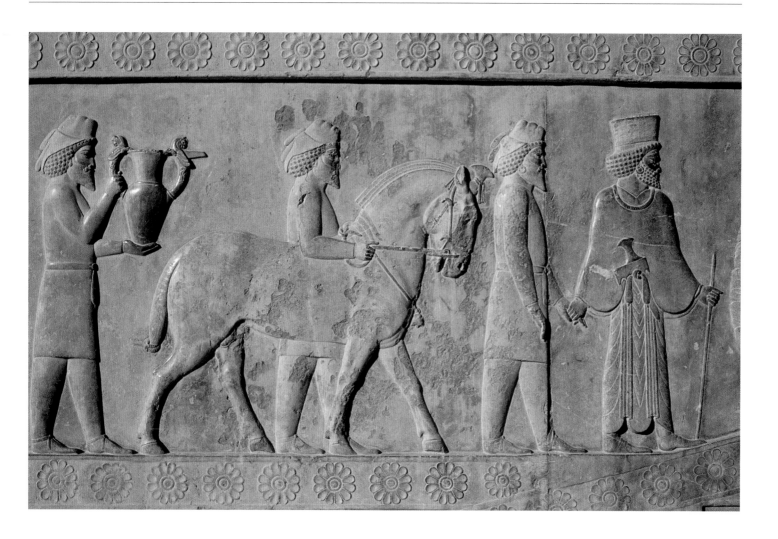

 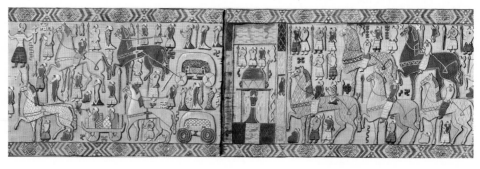

A Viking tapestry

This sheep-wool tapestry fragment (17–23 by 30 cm or 7–9 by 12 in.), showing a procession of figures with horses and carts, was one of two pieces found in 1904 by Gabriel Gustafson in a Viking ship burial at Oseberg in Norway, dated to 834 CE. Both are now in the University Museum, Oslo (Cf25057_I_B). They were tablet woven with a soumak weave of wool warp and two wefts (possibly wool and flax), 1.8 cm (0.7 in.) wide, and then sewn; they were also woven in the horizontal, probably on a vertical loom like the one unearthed from the Hedeby settlement in Denmark, built around 870. As shown in the reconstruction of the two pieces, illustrated above right, figures are depicted with economy, for example with red dots for eyes, and with gendered clothing: women are shown wearing a long dress under a mantle pinned with a brooch on the chest, men with a vest over a tunic and trousers. The mens' spears, shields or swords indicate that they were warriors. The Buddhist 'endless knot' suggests that the Vikings had contact with central Asia and Buddhism through their trade for silver and silk. This is further supported by the discovery of numerous Samanid coin hoards in Scandinavia [see box on p. 308] and a small bronze seated Buddha of the 6th–7th centuries from central Asia found in Helgo, Sweden. Providing rare imagery, these fragments predate the Bayeux tapestry by several centuries. ASh

Further reading: Davidson 1976; Helle 2003; Merrony 2004.

mountains of central Asia. They also arrived by sea; for example, from the 12th century, southern Arabia was a major supplier of horses to India. Horses ranged from the hardy steppe pony to the elegant steeds of the elite, bred for their looks as well as endurance. The former are commemorated by a Chinese official of the 2nd century BCE, who noted that Chinese-bred horses could not rival those of the Xiongnu 'in climbing up and down mountains, and crossing ravines and mountains torrents' (*Hanshu*, 49.10b).

The horses of the elite have an enduring part in the Silk Road story, which is often started with the mission of the Chinese imperial envoy, Zhang Qian (164–113 BCE), to the lands of the Yuezhi, and his travels through the Fergana valley, an oasis of plenty in the midst of central Asian mountains and steppe. Here he encountered a breed of horse that bore little resemblance to those in China and his report gave rise to the 'Heavenly Horses' of Chinese legend. These have been tentatively identified as Nisean or Akhal-Teke horses, bred since the Achaemenids (550–330 BCE) from Armenia to Fergana. They were praised by the Greek historian Herodotus (*c.* 485–*c.* 425 BCE) and found widely across Eurasia. From the rise of the Islamic caliphate in the 7th century, the Arabian horse also became prized across Islamic lands as well as in Europe.

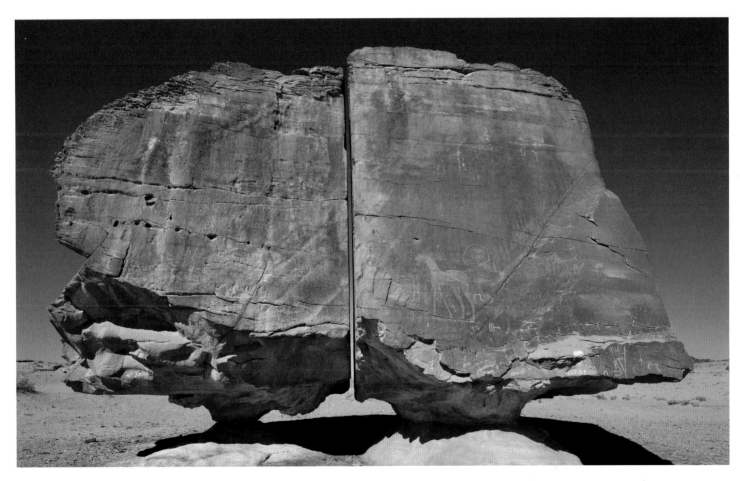

Previous spread — Steppe horseman. Detail of appliqué felt tomb-hanging from a 5th- to 3rd-century BCE Pazyryk barrow.

Opposite above — This 6th- to 5th-century BCE relief from the Apadana east stairs at Persepolis shows Armenians, known for their horse-breeding skills, bringing a horse for the Achaemenid king.

Above — Rock drawing dating to the 1st millennium BCE of a man and horse, at Al-Naasla, Tayma oasis, Saudi Arabia.

Right — Tray showing the Greek goddess of victory, Nike, in her two-horsed chariot. Italy, 4th century BCE.

Following pages — Horses and riders, possibly Hephthalite, at a site in the Himalayan Pir Panjal range, dating to around the 5th–6th centuries.

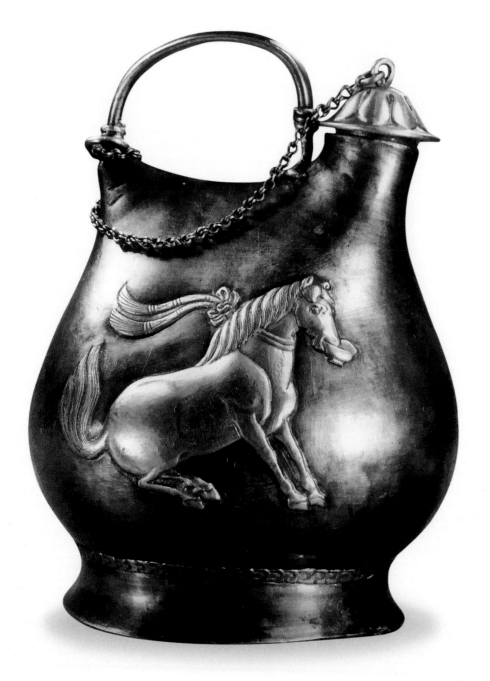

The emperor's dancing horse

Probably made in China, this 8th-century parcel-gilt silver vessel, 14.8 cm (5.8 in.) high, was found in 1970 in Hejiacun, a suburb of the Silk Road Chinese capital, Chang'an [*see* box on p. 286], among a hoard of over 1,000 gold and silver wares and coins. It is now in the Shaanxi History Museum in Xian (七一48). The items probably belonged to the imperial treasury and were buried for safekeeping during a period of unrest.

The vessel exemplifies the interactions of the Silk Roads in its form, materials and design. The form emulates a leather water flask that would have been common among China's horse-riding steppe neighbours [*see* pp. 70–75]. Gilt-silver was a material widely used by Chinese craftsmen by this period, but the skills to use it were first developed by the peoples of the steppe, central Asia and Iran [*see* pp. 104–11]. The design shows one of the dancing horses of the emperor Xuanzong (r. 712–756), immortalized in a contemporary poem by one of his ministers, Zhang Yue (663–730): 'Bending their knees, they clench wine cups in mouth'; both the horse and wine were imports into China. The horse also wears a ribbon around its neck in a style commonly found in Sasanian art. SW

Further reading: Hansen 2012; Kroll 1981.

By the time of the Silk Road, the horse was being used for military cavalry by the lands adjacent to the steppe, requiring these cultures to either breed their own animals or buy them from their steppe neighbours. In addition, the hunt on horseback became a mainstay of royal life across the empires and kingdoms of Eurasia, frequently depicted on textiles and silverware [*see* box on p. 320]. Polo played a similar role, with strings of polo ponies kept in the imperial stables of rulers from the Abbasid caliphs to the Tang emperors. In west Asia, north Africa and Europe, horses were bred for the chariot races, exemplified by the four-horse chariot, the quadriga, possibly created in the 2nd or 3rd centuries CE and long displayed at the Hippodrome at Constantinople.

Horse-riding and polo-playing were not restricted to men. Queen Mavia (r. 375–425) of the Tanukh was famous for helping to save Constantinople from the Goths in the 4th century by leading a charge against them with her soldiers on Arabian mounts in a wedge formation. And three centuries later, Chinese court women discarded their restrictive long gowns for 'foreigners' dress', enabling them to participate in horse-riding and polo-playing.

The horse continued to play a major part in the relationship between settled and steppe peoples. In the 10th century another Chinese official wrote:

'The reason why our enemies in the north and west are able to withstand China is precisely because they have many horses and their men are adept at riding; this is their strength. China has few horses and its men are not accustomed to riding; this is China's weakness' (Creel 1965). During the time of the Turkic Uygur empire (744–840), China purchased tens of thousands of horses with prodigious quantities of silk: the price for peace. And the logistics of finding sufficient pasture for their horses was a significant factor in the spread of the Mongol armies across west Asia and into Europe in the 13th century, with camels being used to transport their fodder.

The horse also became part of literature, myth, art and religion. Motifs of flying horses, including those taking the Sogdian dead to paradise, are found across Eurasia. Among the famous horses of this period was the mount of Xuanzang, the 7th-century Chinese pilgrim to India. He was a grey, echoing

Kanthaka, the horse that carried the historical Buddha from his father's palace in India a millennium before. The 'white' horse also features in legends that grew up around Genghis Khan (r. 1206–1227) being awarded the right to rule. Then there was Rakhsh, the stallion mount of Rostam in the 10th-century Persian epic the *Shāhnāmah*, whose colour is described as 'rose leaves that have been scattered upon saffron'.

———

Further reading: Allsen 2006; Creel 1965; Fragner et al. 2009; Schiettecatte & Zouache 2017; Sinor 1972.

Four horses, originally drawing a chariot, made around the 2nd–3rd centuries CE for the Hippodrome of Constantinople. They were taken to Venice after the fall of Constantinople in 1204 and, although looted by Napoleon in 1797, were sent back to Venice in 1815.

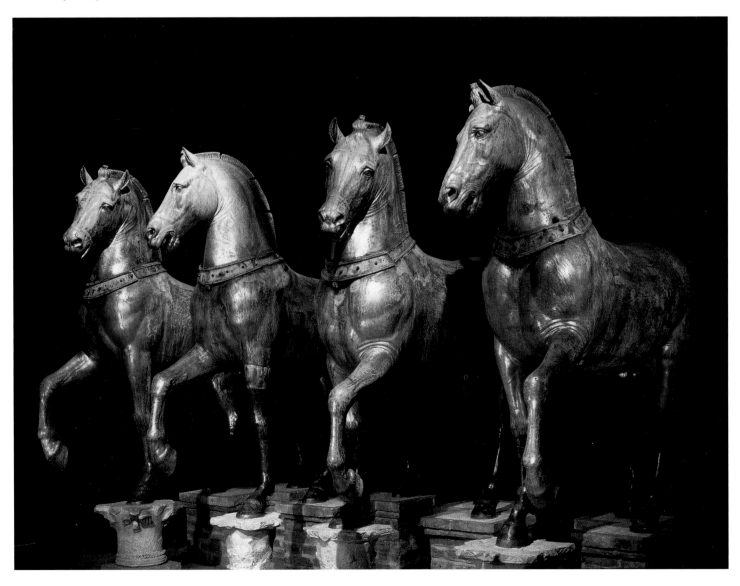

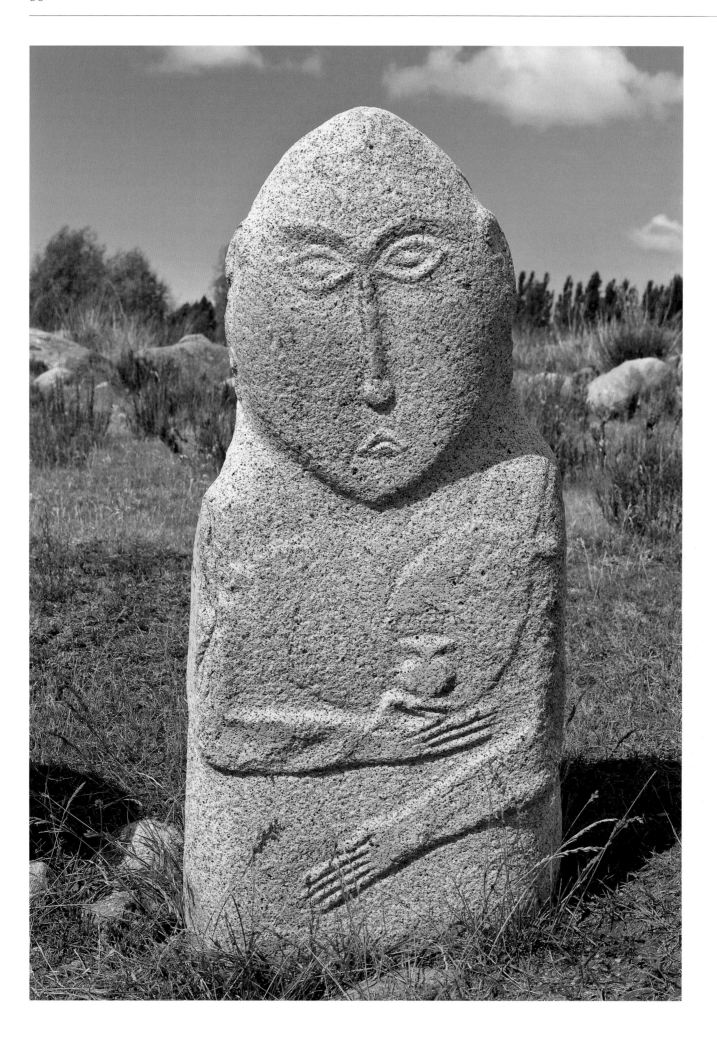

Stones on the steppe: a mortuary landscape

Ilse Timperman

Burial mounds or barrows – kurgans – in the Eurasian steppe are tenaciously associated with the presence of mobile pastoralists. Covering a vast area from the Pontic-Caspian to the Mongolian-Manchurian steppe, they first emerged around the 5th millennium BCE and became prominent in the 1st millennium BCE, when strong socio-cultural and economic changes, along with increased mobility and interaction, altered the mortuary landscape.

Monumental barrows marked the rise of Scythian elites controlling strategic points and the flow of precious goods across much of the steppe. The grave goods are rich in gold and show Greek and Achaemenid influences alongside Scytho-Siberian animal motifs [see pp. 60–63]. The prominence of horse sacrifice, figurative art, bits, cheekpieces, bridles and saddles, alongside daggers, swords, shooting equipment, trousers and belt plaques in steppe burials, was interpreted by early archaeologists as signifying a warrior ideal. The ritual and sacral status of horses was evoked by their sacrifice or adornment with reindeer horns, as seen at Arzhan, Pazyryk and Berel. Burial accompanied

by horses has also continued throughout historic times. But recent scholarly debate is revising both the warrior ideal and gender roles in agro-pastoralist societies. Sarmatian women from Pokrovka in the southern Urals, for example, who practised horse-riding, archery, hunting and warfare, and handled iron swords and daggers, do not seem to be exceptional in steppe society. Conversely, grave goods might be included in a burial not because they were used by the occupant in their life but instead because they signify the power or rank of the interred individual [see boxes on pp. 66 and 106].

The camel, although an animal associated with deserts, was also of socio-economic importance for

pastoralist elites, as shown by the depiction on a royal scabbard from Dachi on the Sea of Azov [*see* box on p. 249] as well as by camel sacrifice in the Turfan basin and in the Tianshan. Camels facilitated the exploitation of deserts connecting the steppe, leading to new networks of exchange.

From around 200 BCE, growing influence from the Sarmatians in the southern Urals and the Xiongnu alliance in the east altered steppe culture. Both forces promoted exchange as intermediaries between pastoralist communities, the Parthians, Romans and Chinese [*see* pp. 70–87]. The distribution of burial mounds and prestige goods from this time exposes a complex communication

network, linking multiple regional trade networks across the steppe.

In a quickly changing landscape where mobile pastoralists competed for pastureland and control of important crossroads, burial architecture became an important medium both to express group identity and to mark territory. Thus the establishment of pastoralist cemeteries on the border between the steppe and settled areas in the Bukhara and Samarkand oases, the Fergana valley, and the Crimea, shows the symbiotic but often tense relationship between pastoralist and urbanized communities.

Increased connections between the communities is indicated by the juxtaposition of lacquer boxes

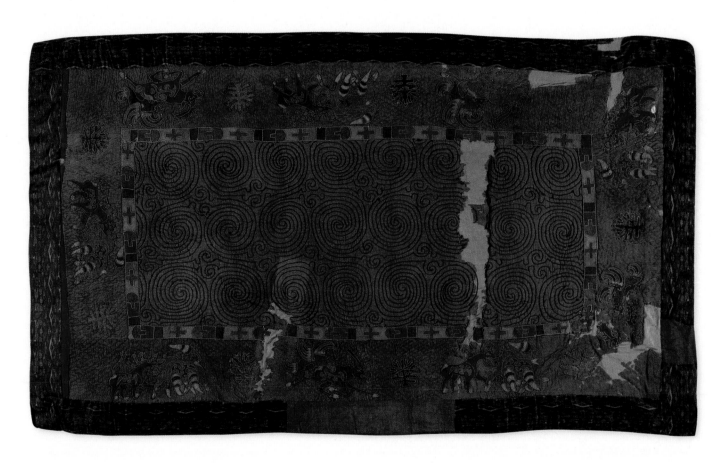

Felt: a steppe textile

The 1st-century CE felt carpets found in Xiongnu burials at Noin-Ula reveal the extensive connections between different regions of Eurasia at this time. The finest carpet was found on the floor of the funeral chamber of Kurgan 6, and is now in the Hermitage Museum (108). Made of camel felt, the whole carpet, pictured here, measures 260 by 195 cm (102 by 77 in.). The central

part is ornamented with spiral patterns of violet-coloured wool cord and geometric figures, and the edge of the carpet is lined with a strip of silk. Felt appliqués depicting struggles between fantastic animals and griffin attacks on elks are found along the perimeter of the carpet, separated by symbolic trees. The combination of stylistically different elements (a sacred tree,

typical of Asiatic art, and an elk, a typical animal of Siberia) indicates that the carpets were made by masters of west Asia taking into account the aesthetics of Xiongnu art. Several other finds of carpets with the same compositions in the barrows of the Xiongnu elite show that these combined motifs probably had a sacred character for the Xiongnu, symbolizing the

mythological struggle between various natural forces. SM

Further reading: Eregzen 2011; Kulikov et al. 2009; Lubo-Lesnichenko 1994; Whitfield 2009.

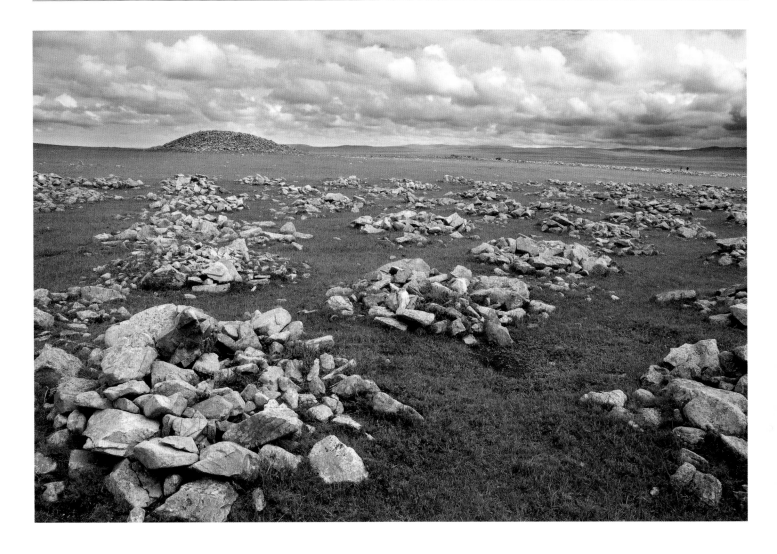

Previous spread — Turkic kurgan stone or balbal at Issyk-Kul in the central steppe.

Top — Over half a million stones were used at the steppe burial site of Urt Bulagyn on the eastern steppe, dating to 1200–700 BCE, with the central mound surrounded by 1,700 satellite mounds.

Above — Chinese 1st-century lacquer box found in a tomb at Ust'Alma in the Pontic steppe.

of Han manufacture with Roman glass and bronze ware, Sarmatian weapons and ornaments at Ust'Alma in the Crimea and by the grave inventories at Kok Tepe north of Samarkand, Kobyakova on the lower Don, Tillya Tepe in the Shebergan oasis, Tulkhar in the Beshkent valley, and in the Fergana basin. The extensive gold finds at Tillya Tepe, dating to the mid-1st century CE and showing Hellenistic, Roman, Indian, Kushan, Bactrian, Han, Parthian, Sarmatian, Scythian and Xiongnu influences, epitomise pastoralist power in the steppe [*see* boxes on pp. 109 and 110].

Interaction and migration generated a complex process of distribution, adoption and adaptation of

innovative burial architecture. The evidence suggests that between around 200 BCE and 100 CE, powerful elites identified by their lateral niche graves secured strategic positions in the eastern Tianshan area, Turfan basin and Fergana and Beshkent valleys, after dispersion from the southern Urals, Yili basin and eastern Hexi corridor. Distribution of such graves, side by side with other grave types, suggests alliances between pastoralist groups.

Burial practice varied considerably under the Xiongnu, the alliance of horse-riding tribes who controlled an area from the Yenisei to Manchuria, Lake Baikal and the Ordos [see box on p. 66]. Assimilation of new groups led to the integration of new burial types, including lateral niche graves. From the late 1st century BCE onwards, monumental terrace tombs with stone superstructures and satellite graves announced the rise of Xiongnu elites, who engaged in long-distance exchange across the steppe, in Transbaikalia, Mongolia and Tuva; sites include Noin-Ula, Gol Mod, Duurlig Nars, Takhiltyn Khotgor, Tsaram and Orgoiton. Similarities with Han elite graves, including stepped shafts with sloping entry pits, nested wooden chambers covered with charcoal, and lacquer coffins with quatrefoil

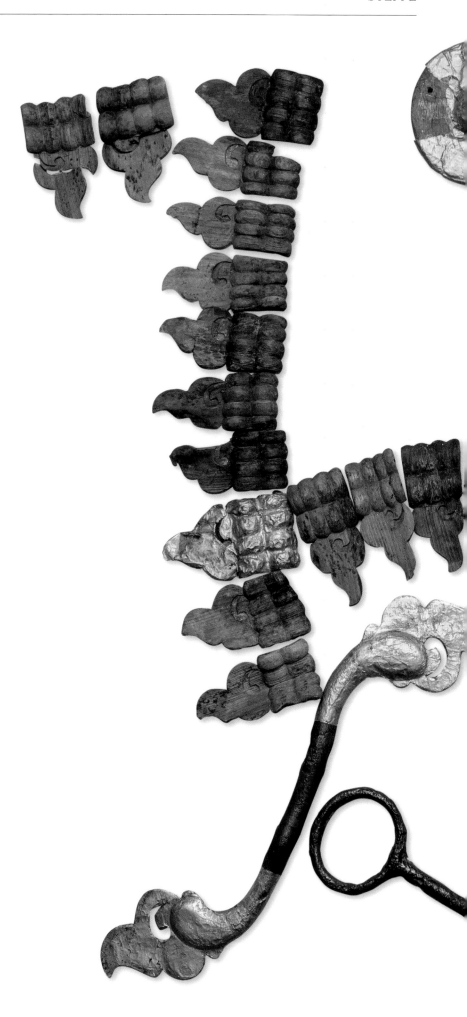

Leather bridle with bronze and gold of the Pazyryk culture, from the 6th-century BCE Bashadar Tomb 2 in the eastern steppe.

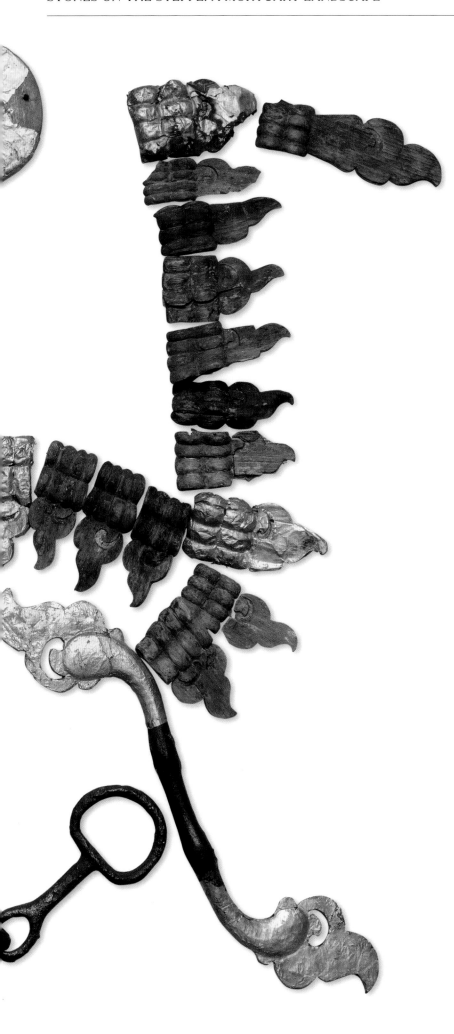

fittings, alongside lacquerware, chariots, silk, mirrors, Chinese inscriptions and *wuzhu* coins, confirm Xiongnu interaction with their Chinese neighbours [*see* pp. 70–75]; Noin-Ula also showed Greco-Bactrian influence. In the other direction, innovative archery equipment and belt plaques travelled from Xiongnu territory across Eurasia.

Medieval burials often occupied older burial grounds and recalled earlier practices. From the mid–6th to 8th centuries, Turks were cremated or inhumated. Ritual structures featured quadrangular slabstone enclosures (*ogradka*) with stone mounds and lines of standing stones, some of them anthropomorphic. Shaft and lateral niche graves with accompanying horse burials prevailed and contained iron horse gear, stirrups, armour, knives, archery equipment, belt decorations and musical instruments. Textiles, silver vessels, pearls, gold-framed gemstones, coins and mirrors suggest exchange with the Sogdians, Sasanians, the peoples of the Black Sea area, and China [*see* box on p. 103].

———

Further reading: Brosseder 2015; Brosseder & Miller 2011; Kubarev 2005; Linduff & Rubinson 2008; Parzinger 2017; Timperman 2016.

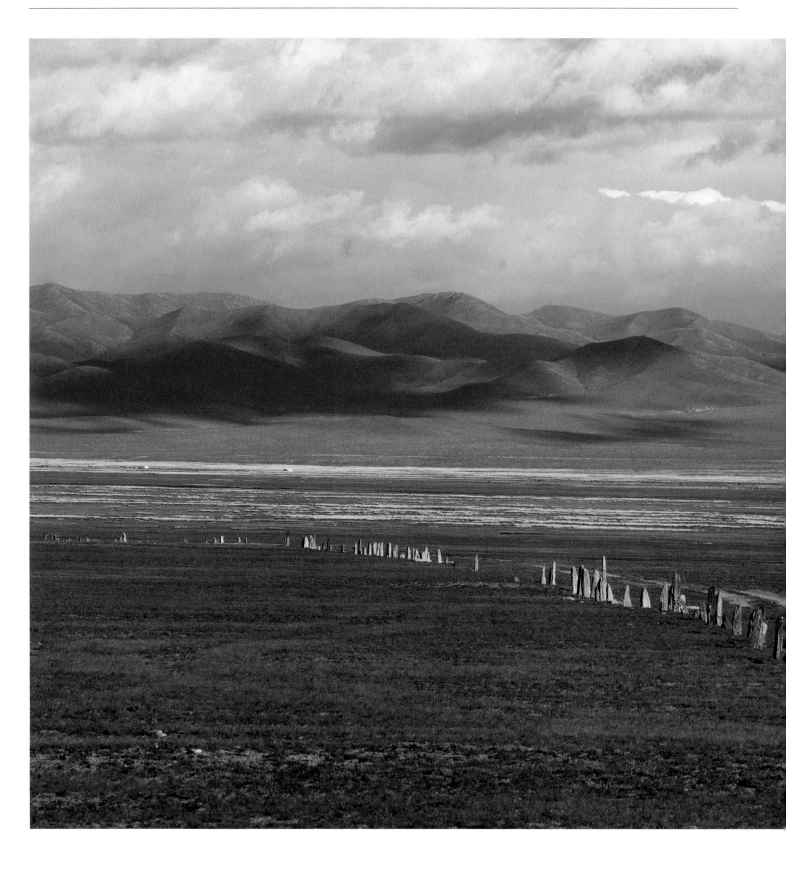

Turkic tomb complex marked by
stones, dating to the 6th–8th centuries,
at Ungut in the eastern steppe.

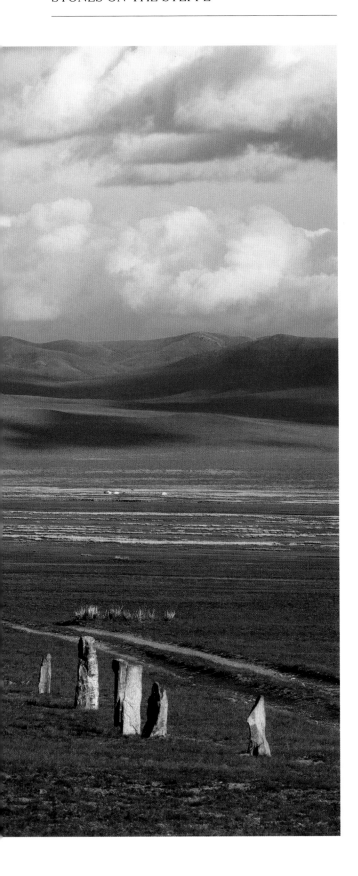

A Chinese mirror

This mirror, 19 cm (7.5 in.) in diameter, was interred with a woman buried in a mounded grave, Kurgan 10, at Kobyakova on the Pontic steppe near the Sea of Azov, dating between the 1st century BCE and 1st century CE. It was found alongside a gold torque with turquoise inlay, a gold diadem, bracelets, a perfume bottle, clothes decorated with gold plaques, beaded shoes, a horse harness with gold foil phalerae, and gold foil ornaments with deer, bird and tree motifs.

Mirrors of this design, with four knobs on the back and four S-shaped scrolls decorating the main register, originate in China from this period, but are usually smaller, about 10 cm (4 in.) in diameter. The quatrefoil surrounding the central knob is a common motif in both Han and Xiongnu funerary art and it is possible that this one is a local copy of a Chinese prototype. Whether from China or a local copy, the presence of this mirror on the western steppe shows the existence and influences of long-distance networks.

Similar mirrors have been found in royal pastoralist graves at Kok Tepe near Samarkand and in Transbaikalia. Mirrors from Xiongnu graves in the eastern steppe often show evidence of being deliberately broken either by mechanical force or through a process of heating and cooling. No such traces have been found on the Kobyakova mirror, suggesting that the ritual breaking of mirrors did not form part of burial practices within this steppe community. IT

Further reading: Brosseder 2015; Miniaev & Sakharovskaia 2007.

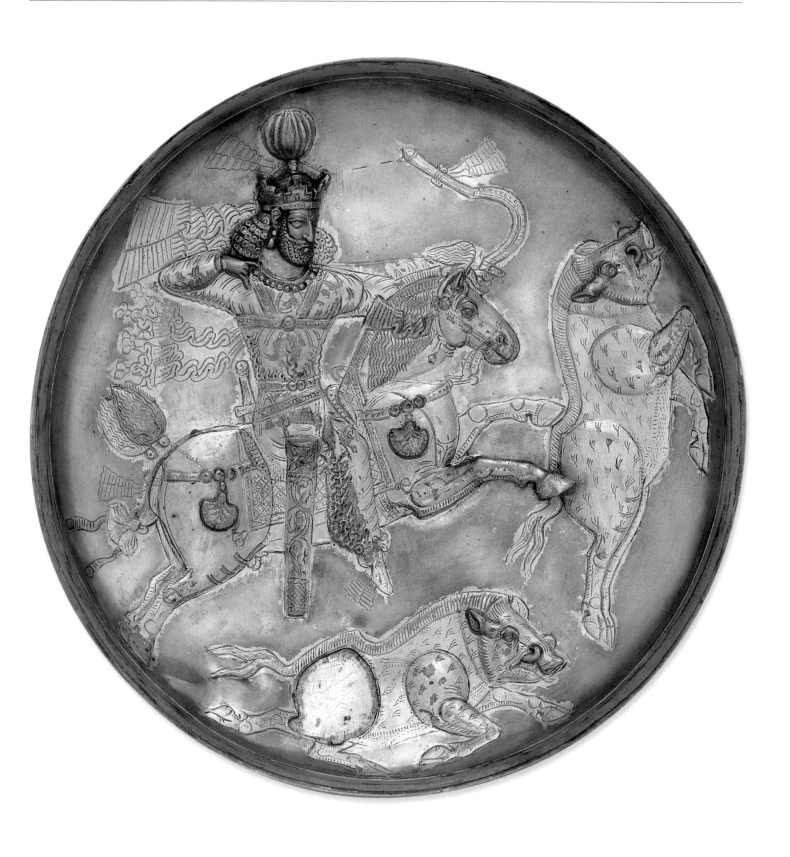

Gilt silver plate showing the
Sasanian emperor Shapur II
(r. 309–379) hunting boar.

Belts, daggers and earrings of gold: steppe luxuries

Ursula Brosseder

Ever since the collections of Peter the Great in the early 18th century brought attention to animal-style metal artifacts from the Eurasian steppe, these objects have generated interest and heated debate among scholars regarding their origins and production.

Gold luxury goods from the 4th century BCE onwards demonstrate that motifs from the steppes as well as technological innovations from central Asia contributed to the luxury metals industries of early China. Especially during the Western Han dynasty (206 BCE–9 CE), gold items reveal the appropriation of such foreign manufacturing techniques as mould-pressing, repoussé, granulation and filigree.

During the late 1st millennium BCE, belt plaques served as symbols of status and prestige throughout the steppe, from China to the Black Sea. Not only was the general fashion of large belt ornaments shared across central Eurasia, but many specific

motifs also spread widely among the highly interconnected steppe regions. Animal combat scenes and certain wild or fantastical beasts, with elements of wolves, tigers or birds of prey, appealed to a common taste and worldview among Eurasian pastoralists. Particularly prolific among the Xiongnu of the eastern steppe during the 2nd and 1st centuries BCE, a variety of animal-themed bronze plaques with identical depictions have been found from the Minusinsk basin to the central Mongolian steppe and across northern China. But while belt plaques among the Xiongnu were found mostly in graves of elderly women, these items belonged more to the male sphere in other areas of Eurasia.

A gold belt plaque

This gold belt plaque belonged to an elite male warrior who was buried during the late Warring States period (475–221 BCE) at Xigoupan in the northeast bend of the Yellow river in the Ordos on the eastern steppe. Made of solid gold, it is a unique piece but depicts a motif widely seen, namely an animal combat – in this case between a tiger and a wild boar. Unlike other belt plaques from the eastern steppe, the rendering of the animals is very fine and realistic. The piece is now in the Inner Mongolia Museum (M2).

The plaque was cast using the lost-textile lost-wax method, as indicated by the woven textile pattern on its back, illustrated right. The back also bears a Chinese inscription that records the weight and the subject matter. While these factors suggest that the item was manufactured by a Chinese artisan, the exact context and location of its production and how it was transferred to the warrior remains uncertain. The most plausible scenario is that it was manufactured in a workshop in China attached to the royal house, possibly in the state of Qin (9th century– 221 BCE), and was then gifted to the steppe warrior for political reasons. UB

Further reading: Bunker 1997; Whitfield 2018.

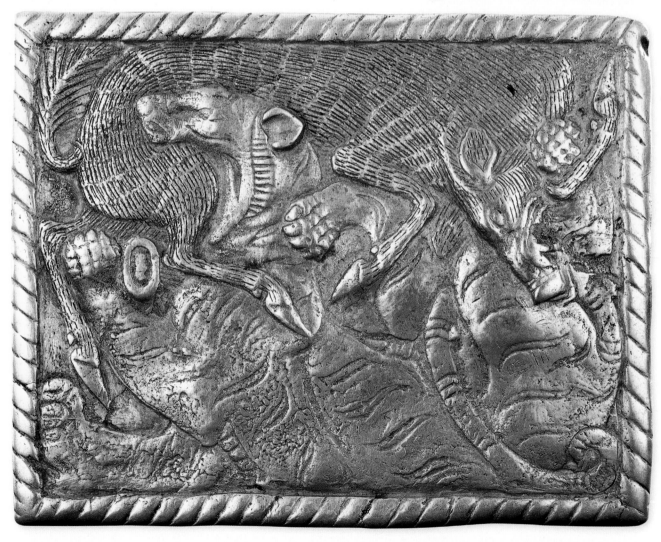

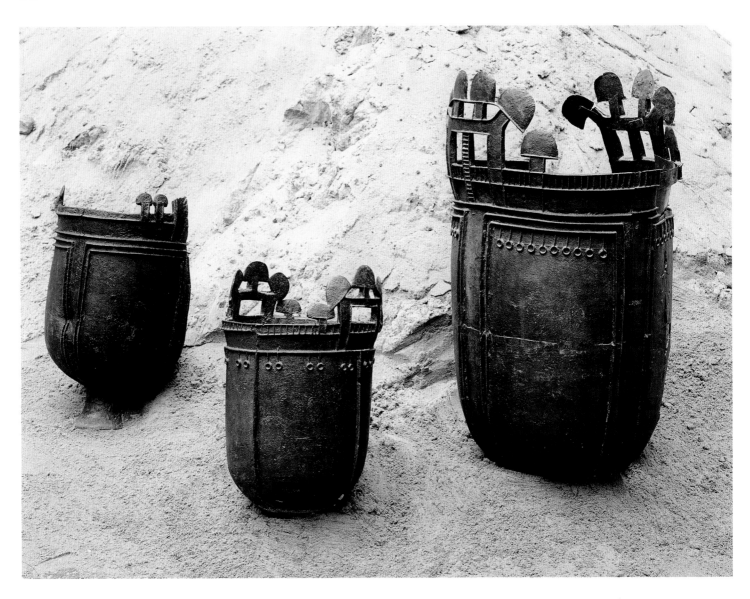

Examples of cauldrons which are a characteristic feature of a variety of steppe peoples, from Scythian times up to the European Huns. These are from Törtel, Hungary and date from the 4th–5th centuries CE.

Some motifs were less widely adopted than others, such as that of two confronting bulls, found mostly in the Minusinsk basin. Others, however, spread across the continent, though often undergoing significant alterations in their stylistic or material executions. Thus, dragon-like creatures are seen among pieces in the Black Sea area, possibly originating in China, as well as other motifs adopted from central Asia, such as the camel. The themes and styles of central Eurasian art – visible in these metal objects – during this period demonstrate a strong network across the steppe, developed independently from the peripheral Eurasian settled cultures, with north–south as

well as east–west directed avenues of exchange [*see* pp. 70–87].

Most of the bronze objects from the steppe were produced locally. Compositional analyses of metal belt plaques, even ones with identical motifs, reveal that they are formed of different alloys, indicating that they were not centrally produced and then distributed. For example, the sometimes crudely cast plaques found in southern Siberia and Mongolia were produced both in the Minusinsk basin, containing more arsenic in the alloy, and in Mongolia, with the alloy containing both lead-tin and arsenic. Belt plaques in steppe areas north of China, however, were made with a lead-tin alloy

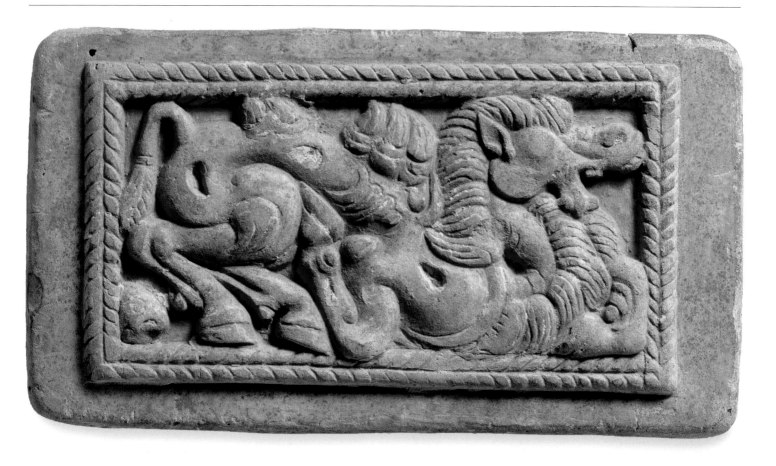

Top — Casting model for a belt plaque, from north China and dating to the 2nd–1st centuries BCE.

Above — Gold belt plaques from a 2nd-century BCE–2nd-century CE tomb at Mount Tianqi, Xuzhou, China.

characteristic of other metal objects produced in that region.

In the frontier zone between Mongolia and China, motifs were intermixed according to the tastes of local steppe peoples, combining fantastical steppe creatures and Chinese icons, such as the turtle. Moreover, as the grave of a craftsman equipped with twenty-five ceramic models near Xi'an shows, Chinese craftsmen could produce animal-style items for both steppe pastoralists and the Chinese. Steppe-style horse-riding clothing was adopted in some Chinese kingdoms, and steppe-style belts, often with traditional Chinese garment hooks, have been found in the tombs of Chinese kings

from the late 3rd to early 2nd centuries BCE onwards [*see* pp. 88–95]. One outstanding example is the gold belt plaque from the tomb of the King of Chu at Xuzhou, with its Chinese inscription and lost-textile lost-wax technique of production evidencing a truly hybrid luxury item. A similar piece was found in a steppe burial at Xigoupan [*see* box on p. 106].

By the 1st century CE, prestige goods across the steppe exhibited a categorically different production pattern than the earlier bronze items. In the tombs of the Xiongnu ruling elites, prestigious horse gear reveals a mix of steppe techniques (gold or silver foil over iron backing) and Chinese techniques (such as mercury fire-gilding).

A medallion belt

This gold belt, consisting of nine medallions linked by braided chains, was excavated from an elite warrior's grave at Tillya Tepe, dated to the late 1st century CE, and is now part of the collection of the National Museum of Afghanistan (04.40.384). The interlocking cordiform cells framing these medallions probably once housed turquoise inlays, characteristic of the Tillya Tepe style. Each medallion was individually cast and encloses a female figure seated on a roaring lion. The fluidity of execution recalls

Scytho-Siberian art, reflecting the steppe pastoralist heritage of the Tillya Tepe people. The side-saddle pose derives from Greco-Roman images of the wine and fertility god Dionysus riding a panther. The figure wears a tunic and buskins – laced open-toed boots – resembling the costume of the hunting and moon goddess Artemis; and her hair is drawn up in a chignon in Greco-Roman fashion, a hairstyle also found in the Hellenized art found in the Parthian city of Nisa. She likely represents the Iranian and central Asian moon goddess

Nana, who was also closely associated with kingship, and who features in a Bactrian inscription found at Rabatak dating from the Kushan period (1st to 3rd century CE) and on Kushan coins.

Similar inlaid gold roundels from the 1st century CE have been found in Parthia and at Dalverzin Tepe in Bactria. In addition, entire medallion belts resembling this Tillya Tepe example appear on 2nd-century statues at Hatra, mostly of Parthian kings. It is clear that belts were prestigious

possessions among elites in the Iranian empires and across steppe cultures from the Black Sea to the Mongolian steppe. SP

Further reading: Peterson 2011–12; Sarianidi 1985.

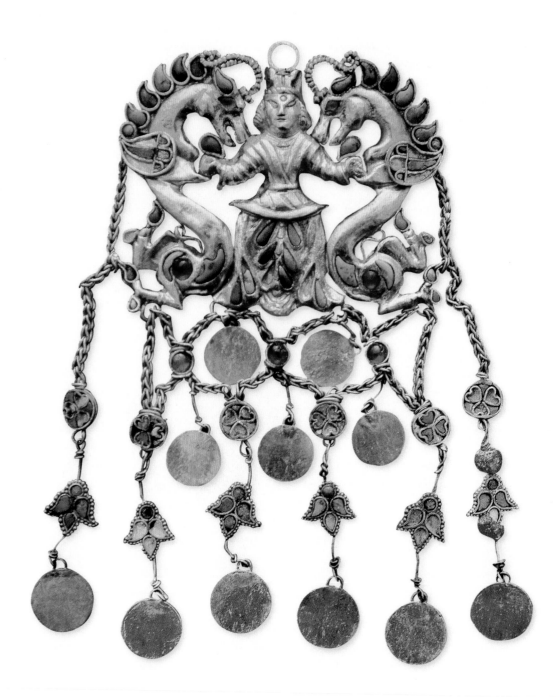

'Dragon Master' temple pendants

Double-sided pendants, of which this is one example, were attached to the crown worn by a richly attired elite woman buried at Tillya Tepe in the second half of the 1st century CE. The pendants depict a male deity with slanting eyes and 'caste mark', standing in a frontal pose and holding a winged, draconic creature in each hand. He is the 'Animal Master', with divine control over beasts, a theme long popular in ancient west Asian and Iranian art. He wears a stepped merlon crown probably derived from Achaemenid (550–330 BCE) sources, although the design also appears on Greek female personifications of cities. He wears a belted cross-jacket, commonly seen in steppe and Iranian imagery of horsemen, and instead of the customary trousers, his lower half is covered by an 'acanthus skirt', connected with divinity in the eastern Greek world. Each dragon sports a prominent curling horn redolent of those found on Achaemenid lions at the palace of Darius (r. 522–486) at Susa and in the Oxus Treasure, but their twisted and contorted hindquarters are characteristic of steppe art, as seen on a winged and horned horse from Issyk (Altai) and among other beasts depicted in Peter the Great's Siberian collection [see pp. 132–35].

The use of imagery from diverse artistic sources is typical of Tillya Tepe. Also characteristic is the prolific use of turquoise inlaid into gold, as well as the ubiquitous gold discs. The piece is now in the National Museum of Afghanistan (04.40.109). SP

Further Reading: Francfort 2011; Sarianidi 1985.

The same is true for the decoration, as clearly some elements were adopted from China (including dragons, phoenixes and cloud motifs), while other themes drew from the animals and mythic beasts of steppe traditions.

Centuries later, in the era of the Turkic empires, belts with multiple strap ornaments were still used as common emblems of status across Eurasia, from eastern Europe to China. The headgear of high-ranking Turkic officials indicates various models inspired by Chinese and central Asian templates, and was probably manufactured by Chinese or central Asian (possibly Sogdian) masters at Turkic residences. Horse gear and belt ornaments also figured as central prestige items during the contemporaneous Tang (618–907) and later Liao (916–1125) dynasties, when they were manufactured in Chinese imperial workshops.

Overall, however, we still know very little about the production of metal and other prestigious objects in the eastern steppes, and almost nothing is known about mining and the exploitation of ores within the steppe [*see* pp. 188–93]. There is ample evidence, however, for the importation of craft workers as well as crafts into the camps or urban centres of the steppe empires, producing steppe-style goods as well as ones imitating foreign objects. Some preliminary gold analyses have shown that local gold ores were utilized to manufacture the prestige items of the Xiongnu. Given the abundance of gold and other precious minerals in present-day Mongolia, and the Eurasian steppes in general, further studies in this direction will surely elucidate the presence of workshops and high-skilled luxury craft production within the steppes.

——

Further reading: Bemmann & Schmauder 2015; Brosseder & Miller 2018; Liu 2013; Liu 2017; Miller & Brosseder 2013; Stark 2009.

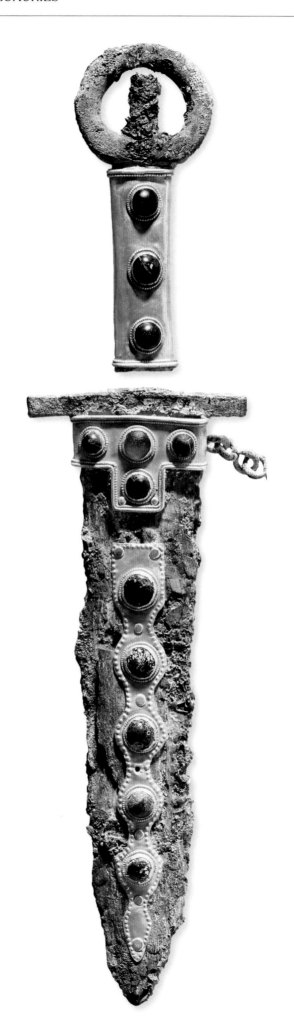

A Sarmatian 1st–3rd-century CE ring pommel dagger from the western steppe.

The caftan: fashion across the Silk Roads

Anne Hedeager Krag

Fashion was very much part of the interaction between the steppe and other cultures, and one of the most obvious examples is that of the caftan. Originally a garment characteristic to central Asia, worn by both men and women, it became a widespread form of clothing across Eurasia in the 1st millennium CE.

Possibly starting in west Asia, it was adopted as 'foreigners' dress' in Persia and Byzantium, and from the northern Caucasus to the Russian steppe, central Europe and Scandinavia. In some cultures, the caftan represented an international dress for the elite. In China the 'foreigners' dress' (*hufu*) became fashionable for both men and women in the Tang dynasty (618–907), emulating the dress of the steppe and being well suited for horse-riding [*see* pp. 88–95].

A caftan-like over-garment is shown in murals in the synagogue of Dura-Europos, near the Euphrates river, dating to the 3rd century CE. This Persian cavalry caftan, also called *scaragmanion*, worn with

trousers, was made of varying colours, including purple and gold. The account of the coronation of Emperor Constantine VII (r. 912–959) mentions the production of silk *scaragmanions* as taking place in the so-called *gynaikeia* (women's quarters) in Constantinople [*see* box on p. 442].

A caftan was also used to clothe the corpse in an elite grave in the Tarim basin dating from the 3rd to 4th centuries CE [*see* box on p. 229]. The burial is probably that of a central Asian, possibly a Sogdian (an Iranian people ruling the cities around the Amu Darya in central Asia). His woollen caftan – deep red, knee-length and opening to the right – was probably made in central Asia. It was held together by a silk

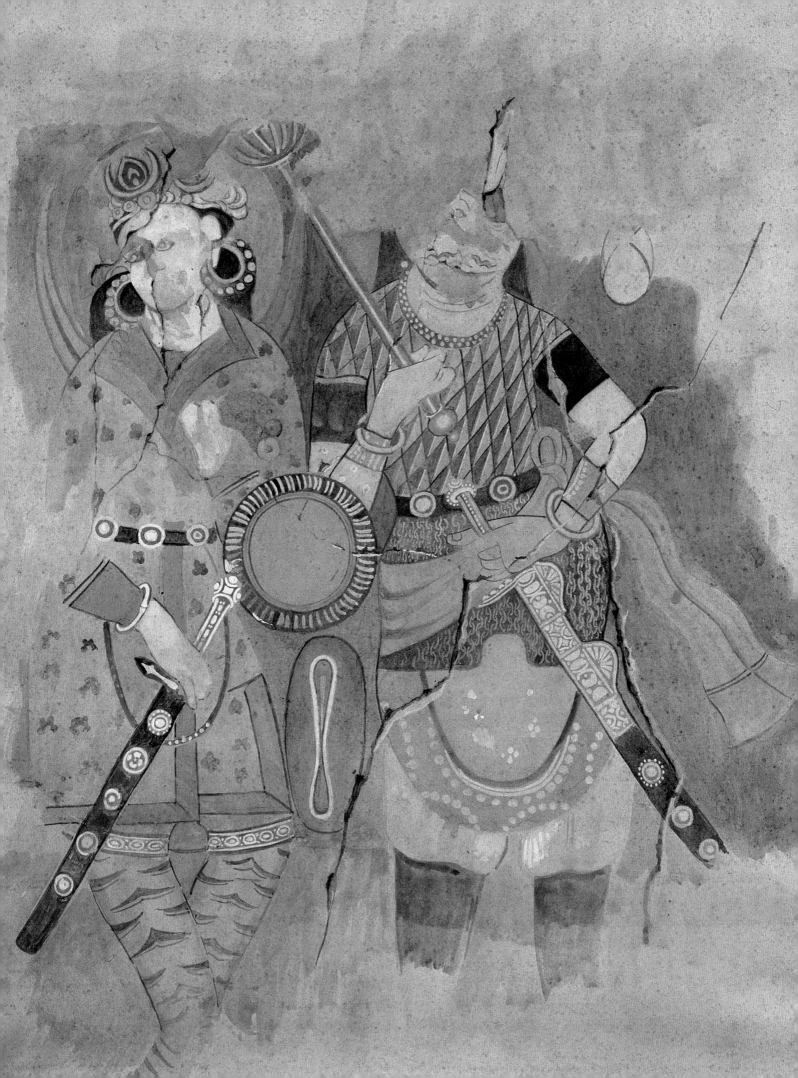

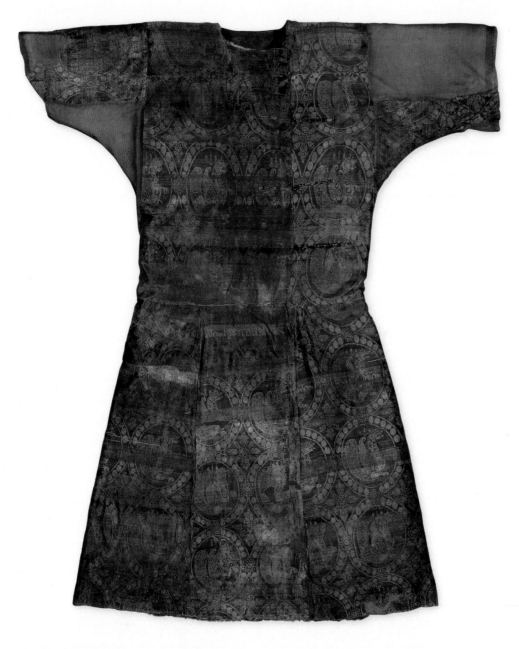

A silk caftan

Russian archaeologists began to excavate the Alan burial site known as Moshchevaya Balka in the northwest Caucasus in present-day Abkhazia, a province in Russia, in 1900/01 and 1905, with the most recent excavations from 1968 to 1976 uncovering about 300 silks, now mostly held in the Hermitage Museum. The burials have been variously dated to between 600 and 800 CE and, thanks to the dry conditions, they have yielded sixteen complete silk caftans. These were analysed by Anna Ierusalimskaja in the 1970s: about 60 per cent of the silk is Sogdian, 20 per cent Chinese and 20 per cent Byzantine, showing the close contacts between these regions and the northern Caucasus. The silks are hypothesized to have been payment for local customs duties.

The caftan shown here (K3-6584), cut from one piece of splendid silk and lined with squirrel fur, was almost certainly made for an Alan chief. The silk, 140 cm (55 in.) long, is a samite weave [see pp. 316–23] with a design of a mythological animal of Sasanian origin, a *simurgh*, with the head of a dog and claws of a lion, shown inside a medallion on a green background [see box on pp. 192–93]. Fragments of Byzantine, Chinese and Sogdian silk were used for the trimmings and hem reinforcement. The motif and weave of the main silk are also seen on the relic shroud of St Rémi in Reims, France, which is variously dated from the 9th to 11th centuries and was probably a diplomatic gift, like many other silks subsequently used to wrap relics in Europe [see box on p. 142]. AHK

Further reading: Ierusalimskaja 1978; Muthesius 1997.

Previous spread — The sun and moon gods, the former in a caftan. Watercolour copy of a 7th-century mural at the Buddhist rock-cut monastery at Fundukistan, central Asia.

Below — Mural of the mid-3rd century at the synagogue at Dura-Europos, depicting the story of the triumph of the Persian king Mordecai from the 'Book of Esther'. Mordecai wears a caftan; the four onlookers are in Hellenistic-style dress.

belt to which a silk bag holding aromatic herbs has been attached.

Trousers were often worn together with a caftan. One of the most spectacular examples of such trousers comes from a grave at Sampula, also in the Tarim basin and probably dating to the 1st century BCE. The woollen tapestry trousers are decorated with a spear-armed man with blue eyes and a patterned frieze with the representation of a centaur. The large and decorative design suggests that the trousers were fashioned from what was originally a wall-hanging created as early as the 3rd or 2nd century BCE, such as those that were produced in Coptic Egypt. This tapestry was

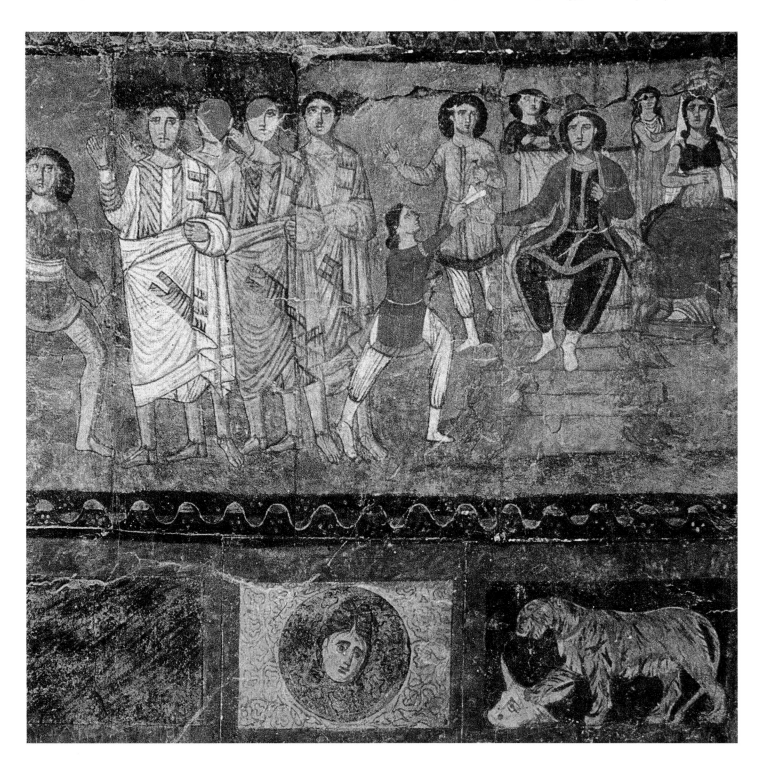

possibly produced in Bactria, the design showing
Hellenistic influences, and was then recycled into
a pair of trousers.

Silk caftans have also been found at Moshchevaya
Balka in the northwest Caucasus [*see* box on p. 114].
The graves there are dated from the 7th to 9th
centuries, when silk production had spread across
Afro-Eurasia [*see* pp. 310–15]. The belt was another
important part of the ensemble, functioning as a
symbol of rank, and golden belt plaques and buckles
are common from Scythian times on the steppe
[*see* boxes on pp. 106 and 109]. Silk belts were also
used and two small fragments of such a belt from
Moshchevaya Balka may therefore be evidence
of a person with a high military rank in the region
[*see* box opposite]. Within cultural groups along the
Silk Road where these types of belts originally were

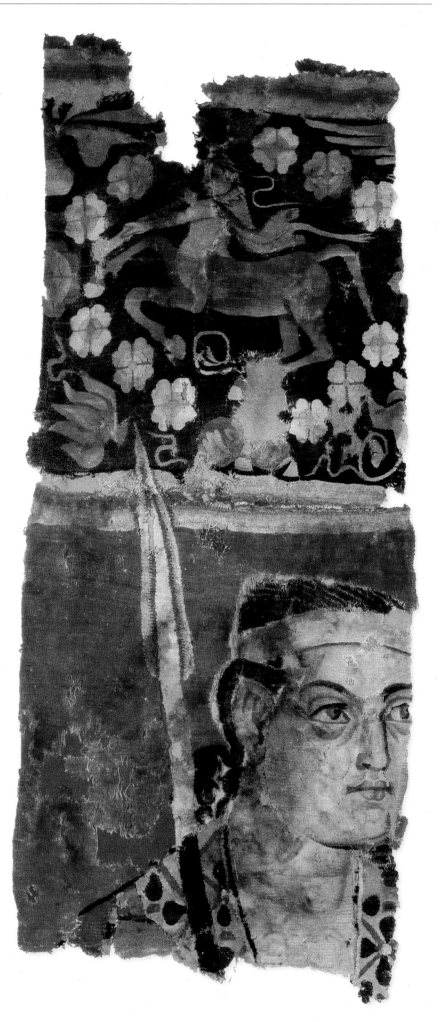

Trousers showing a centaur, made
from a woollen tapestry wall-hanging.
From the tomb at Sampula in central
Asia, and dating to the 3rd–2nd
centuries BCE.

A woven belt

Several pieces of tablet-woven silk belt have been found at the Moshchevaya Balka burial complex. At the time of the burials (between 600 and 800), Turkic Bulgars constituted the largest population group in the northwestern Caucasus, and the belt fragments reveal the close relationship between this steppe region and the Byzantine empire (330–1453). The fragment of the belt shown here was made in the 8th to 9th century in Constantinople and was woven using thirty-seven tablets with four threads in each. The woven design seen across the fragments includes an inscription in Greek that translates as: 'All hail glory Protospatharios Sir Ivanes! May you be well in your young days. May you have courage...'.

The title of *protospatharios* was a high military rank introduced in the Byzantine empire in 718. Ivanes was presumably sent by the Byzantine emperor to the borders of the empire at Moshchevaya Balka, possibly during the time of the invasion of the northern Caucasus by the Arabs in the 720s, which made a strengthening of the Alan-Adygian-Bulgar forces necessary. As pieces of the tablet-woven belt were found at various locations, they could have been distributed to different people. The largest piece, 42 cm by 1.1 cm (16.5 by 0.4 in.) in size, is now preserved in the Stavropol regional museum (O.φ 29164) and a smaller piece, 4.5 cm (1.8 in.) long and illustrated here, in the Hermitage Museum, St Petersburg (Kz 7777). Tablet weaving and similar belts are also found in Viking burials, another example of the spread of clothing and fashion along the Silk Road. AHK

Further reading: Bibikov 1996; Hedeager Krag 2010; Ierusalimskaja 1996.

worn, there are clear indications that they were a sign of the wearer's rank, in Byzantium and China being part of the official dress. Caftans and belts are depicted in numerous paintings and carvings, such as on a wall painting from a 7th-century Buddhist monastery at Fundukistan, central Asia.

―――

Further reading: Hedeager Krag 2004; Ierusalimskaja 1978; Jäger 2007; Schlumberger 1952; Peck 1969; Wagner et al. 2009.

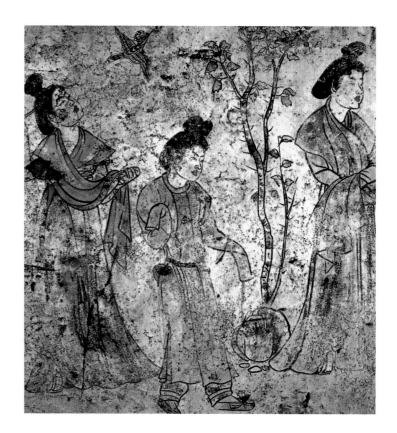

Chinese court women, two in traditional dress and one in the then-fashionable 'foreigners' dress'. From Prince Li Xian's tomb near Chang'an, China, dating to 706.

Mountains and highlands

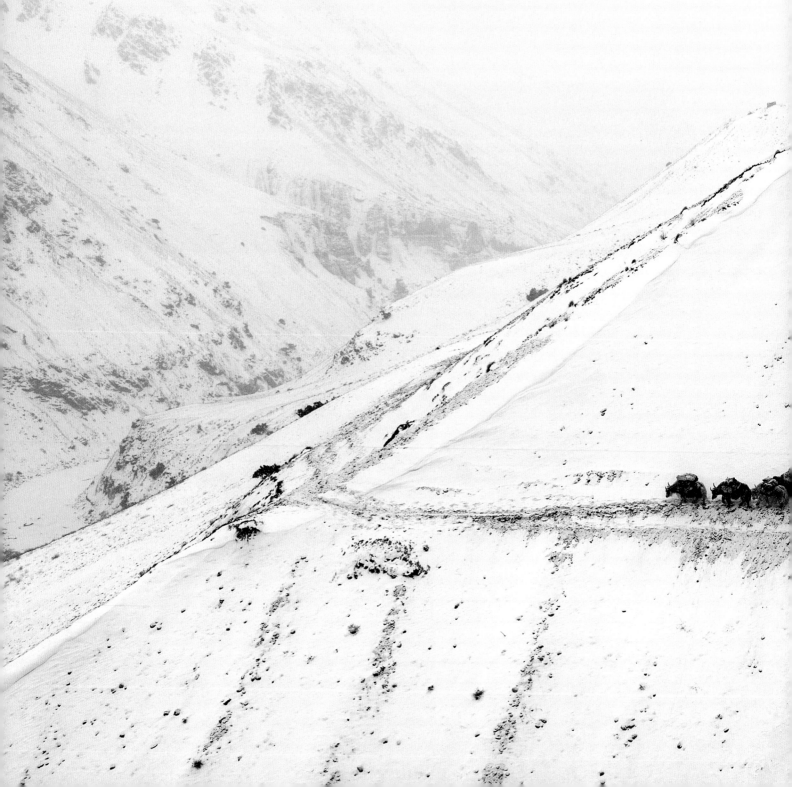

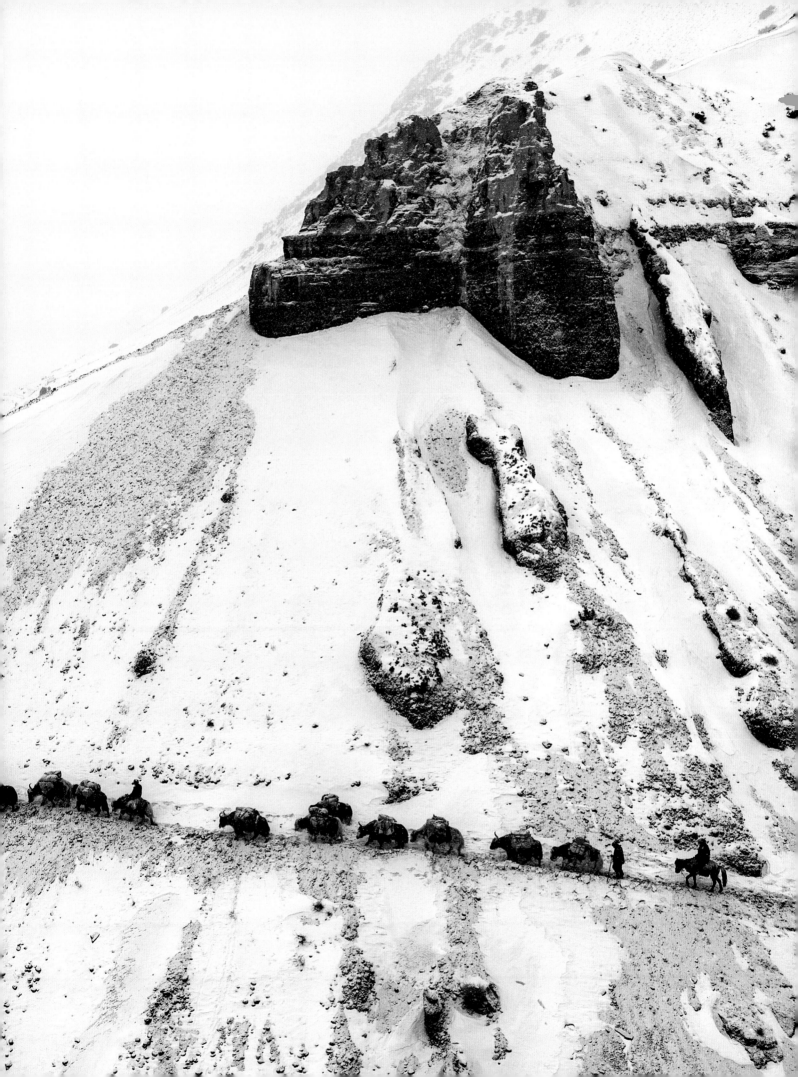

Mountains and highlands

Previous pages — Crossing a pass with yaks in Wakhan Pamirs, central Asia.

Opposite — The 7th- to 8th-century Kansir fort in the Pamir, possibly Tibetan.

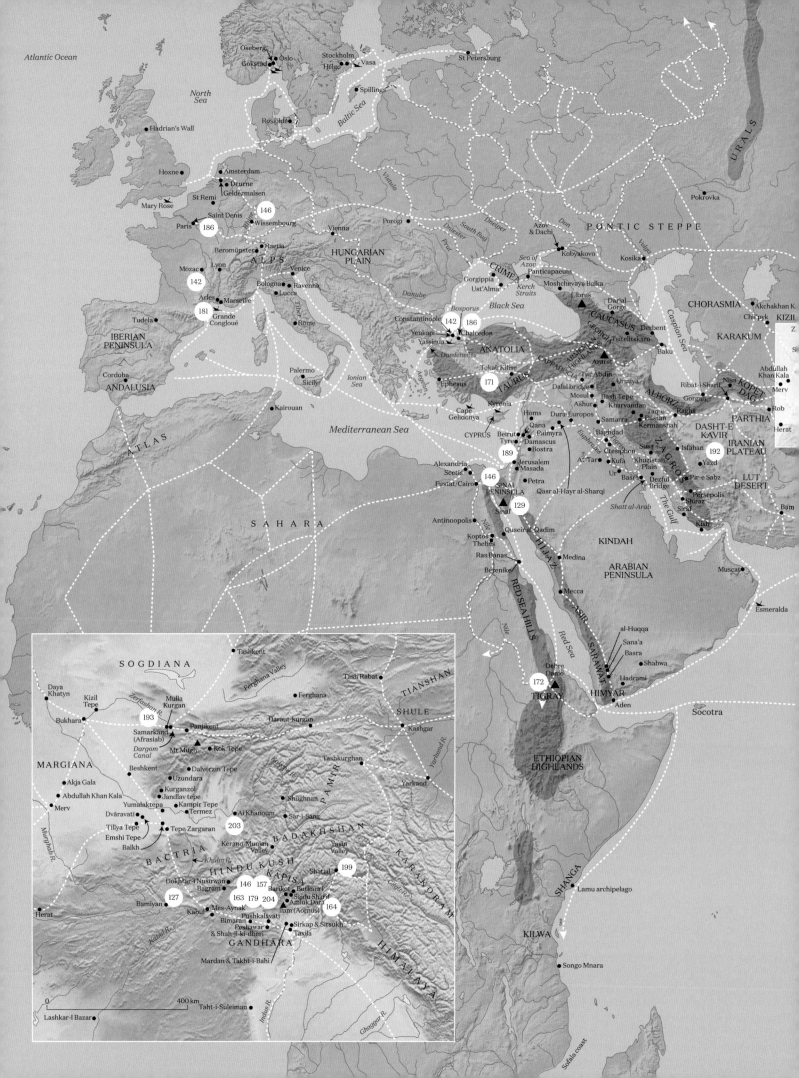

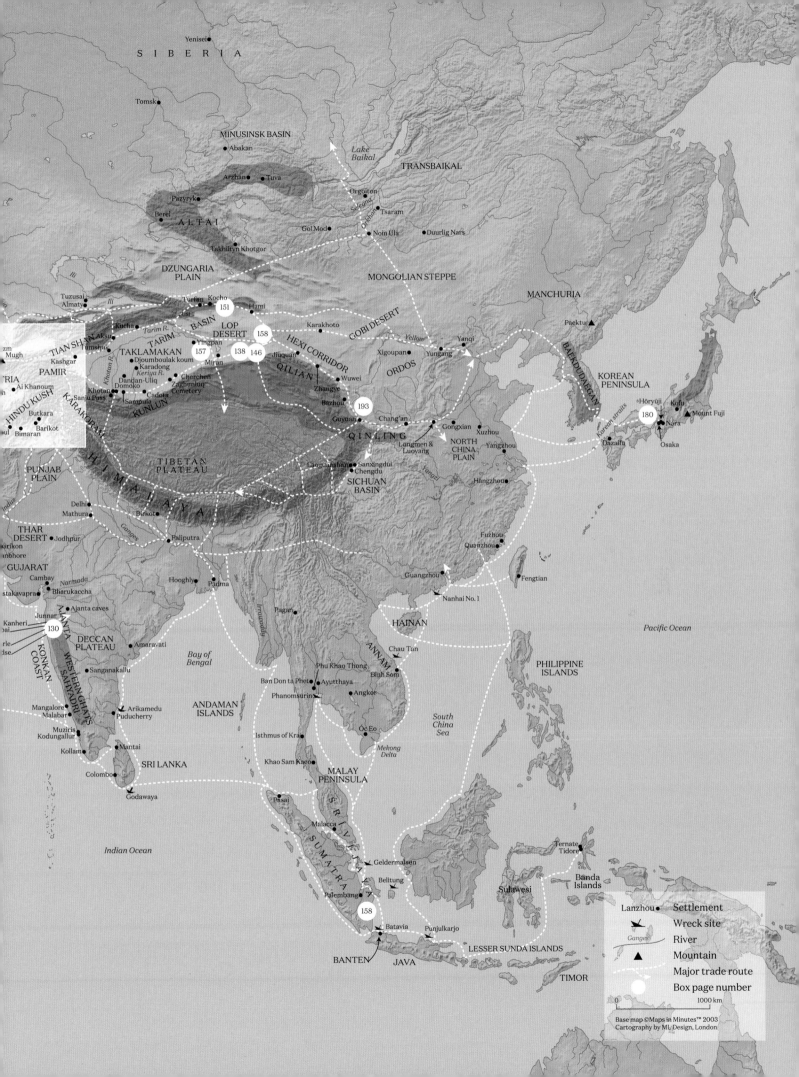

SIBERIA

Yenisei

Tomsk

MINUSINSK BASIN

Abakan

Lake Baikal

TRANSBAIKAL

Arzhan Tuva

Pazyryk

Berel ALTAI

MONGOLIAN STEPPE

Takhiltyn Khotgor

Orgoiton Selenga

Tsaram

Orkhon

Gol Mod Noin Ula Duurlig Nars

MANCHURIA

Paektu ▲

DZUNGARIA PLAIN

Ili Tuzusai Almaty

Ili

Turfan Kocho

151

Hami

GOBI DESERT

Karakhoto

Yellow

Yanqi

BAEKDUDAEGAN

KOREAN PENINSULA

zm Mugh

Kashgar

PAMIR

TIAN SHAN Aksu Kumush

Kucha

Tarim R. TARIM BASIN

158

LOP DESERT

HEXI CORRIDOR

Xigoupan

Yungang

Hōryūji Kofu

Kara straits

Mount Fuji

180

▲ Ai Khanoum

HINDU KUSH

TAKLAMAKAN

157 Yingpan

138 146

QILIAN

Jiuquan

Wuwei

Zhangye

ORDOS

Yungang

Nara

Osaka

Butkara Barikot

Bimaran

KARAKORAM

Djoumboulak koum

Karadong

Keriya R.

Dandan-Uliq Domoko

Khotan Sampula

Sanju Pass Cadota

Cherchen Zaghunluq Cemetery

Miran

Bazhou

193

Guyuan Chang'an

Gongxian Xuzhou

Dazaifu

KUNLUN

Laoguanshan Sanxingdui

Longmen & Luoyang

NORTH CHINA PLAIN

Yangzhou

PUNJAB PLAIN

HIMALAYA

TIBETAN PLATEAU

Chengdu

Yangzi

QINLING

Hangzhou

Delhi

Mathura

Birkot

SICHUAN BASIN

THAR DESERT Jodhpur

Ganges

Paliputra

Fuzhou

Quanzhou

nbhore

GUJARAT

Cambay Narmada

Hooghly Padma

Guangzhou

Fengtian

stakavapra Bharukaccha

Ajanta caves

Junnar

130

Pagan

Irrawaddy

Nanhai No. 1

Pacific Ocean

HAINAN

DECCAN PLATEAU

Amaravati

Bay of Bengal

Chau Tan

PHILIPPINE ISLANDS

Kanheri

ai

rle

ise

KONKAN COAST

WESTERN GHATS SAHYADRI

Sanganakallu

Mangalore

Malabar

Muziris

Kodungallur

Kollam

Arikamedu

Puducherry

Mantai

ANDAMAN ISLANDS

Phu Khao Thong

Ban Don ta Phet Ayutthaya

Phanomsurin

ANNAM

Binh Som

Angkor

South China Sea

SRI LANKA

Colombo

Godawaya

Isthmus of Kra

Khao Sam Kaeo

Óc Eo

Mekong Delta

MALAY PENINSULA

Indian Ocean

Pasai

Malacca

SRIVIJAYA

SUMATRA

Ternate

Tidore

Banda Islands

Geldermalsen

Belitung

Palembang

Sulawesi

158

Batavia

Punjulkarjo

LESSER SUNDA ISLANDS

BANTEN JAVA

TIMOR

Lanzhou ● Settlement

⚓ Wreck site

Ganges ～ River

▲ Mountain

⦙ Major trade route

○ Box page number

0 1000 km

Base map ©Maps in Minutes™ 2003
Cartography by ML Design, London

The roof of the world

Tim Williams

"Rugged roads cross colossal snowy ridges
Dangerous ravines where bandits wander
Even birds in flight fear the soaring cliffs.
Travellers struggle over tilting bridges.
I have never cried once in my life.
Today I shed a torrent of tears."

Hyecho (8th century).
Translated from the Classical Chinese by Matty Wegehaupt.

Opposite — Darial gorge, a strategic
mountain crossing in the Caucasus.

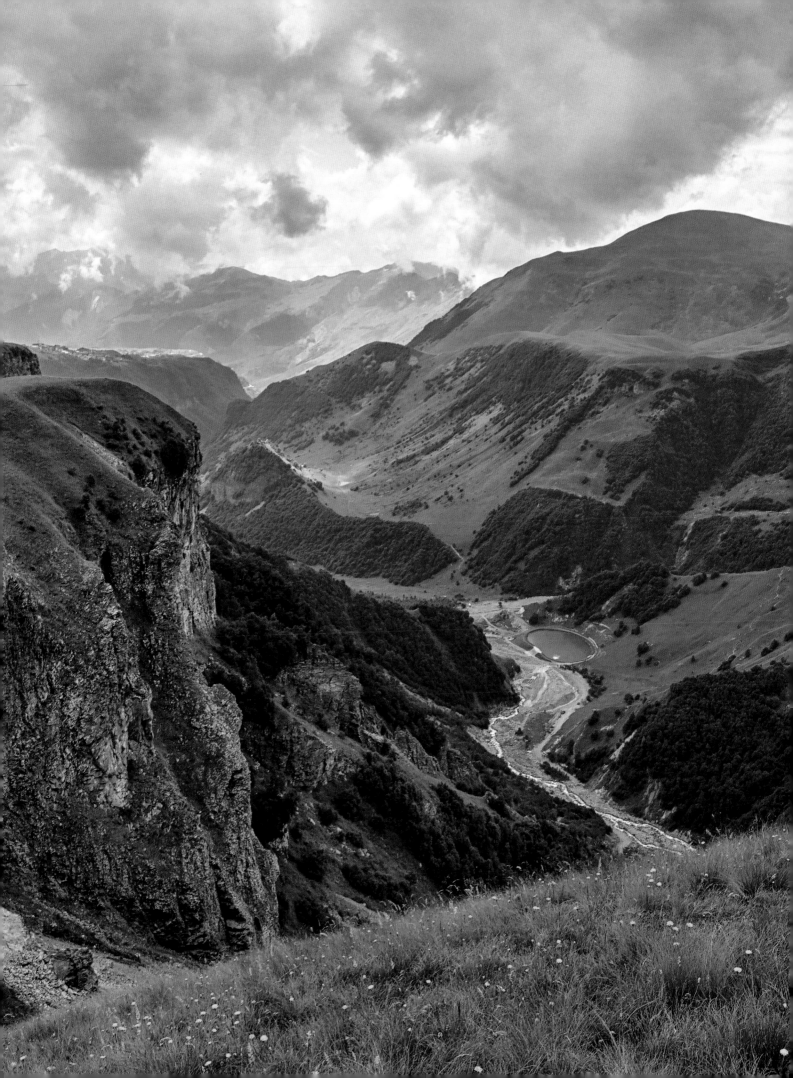

The mountains of Afro-Eurasia played a crucial role in shaping the communities, societies and empires that flourished along their length. As physical barriers, they bounded, demarcated and protected. Crucially, they were also the most important source of water; snow melt, rain catchment and drainage formed the essence of the rivers and streams that flowed into the lowlands, creating lush river valleys, wide fertile deltas and desert oases. Without these, the people of the Silk Roads would not have survived; indeed, the very existence of a network of long-distance routes would have been impossible.

The ranges that rise in central and south Asia are the highest of the Silk Roads, containing all the world's peaks above 7,000 m (23,000 ft). Most notably the ranges are (from west to east) the Kopet Dag, Hindu Kush, Pamirs, Karakoram, Kunlun, Himalayas, Qilian and Qinling, and further north, the Tianshan and Altai. Together they dominate the centre of the continent: they shape its climate, its ecology and its human habitation. The mountains also shield central Asia from the southern ocean monsoons, which, combined with high pressure created over the highlands, means that most of central Asia gets little rainfall, creating high plateau deserts. Radiating river systems – including the Amu Darya, Indus and Yellow rivers – shaped the agriculture and settlement of the entire region.

The Kunlun on the southern edge of the Taklamakan desert form the northern edge of the Tibetan plateau, a vast elevated highland stretching approximately 1,000 km (620 miles) north to south and 2,500 km (1,550 miles) east to west. With an average elevation in excess of 4,500 m (14,800 ft), it has been called 'the roof of the world'. The routes across this high-altitude plateau, and through the Himalayas into south and southeast Asia, cross mountain passes that were the conduits for the exchange of goods, people, cultures, ideas and technologies.

Below —Kunar river valley in the northeastern Hindu Kush.

Overleaf — Khorv Vrap monastery, Armenia, founded in the 5th century, with Mount Ararat in the background.

Bamiyan: Buddhist rock-cut temples in central Asia

The Buddhist rock-cut carvings and caves along an expansive cliff in the Bamiyan valley of the Hindu Kush may have been among the religion's most impressive artistic achievements at the time they were created. At one end of the cliff, a niche contained a standing Buddha figure measuring approximately 55 m (180 ft) in height; at the other end, approximately a mile away, stood another colossal figure, this one approximately 35 m (115 ft) tall. In between, the cliff wall was honeycombed with rock-cut carvings and rock-cut temples painted with Buddhist scenes, such as the ceiling cupola of Buddhas shown here (now in the National Museum of Afghanistan). The temples would have been used by members of the resident monastic community. Most of the temples probably date from the 5th or 6th century, although recent archaeological work at the site suggests that artists may have been active there until the 9th century. The features at Bamiyan suggest a stylistic and cultural source in India, the homeland of Buddhism. Its location on the central Asia trade routes to the north and east makes it likely that the Buddha figures and paintings in the temples in particular were influential in the transmission of Buddhism and Buddhist art to the Tarim basin and east Asia.

In March 2001, the Taliban dynamited and completely destroyed both Buddha statues at Bamiyan. Although the original works have been lost, new archaeological work at the site since the destruction has revealed fifty additional rock-cut temples, some with extant paintings, as well as the remains of a 19-m (62-ft) long reclining Buddha statue. SH

Further reading: Ball 2008; Japan Center 2005; Klimburg-Salter 1989; Morgan 2012.

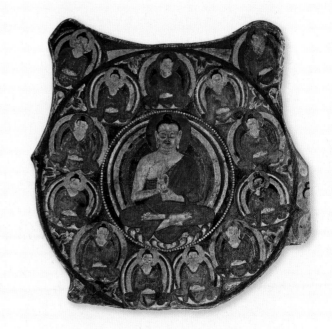

Saint Catherine: a Christian monastery on Mount Sinai

New models for the lives of individuals emerged around the eastern Mediterranean during the 3rd and 4th centuries CE. Urban and peasant populations disengaged from the secular societies of antiquity and aspired to a life of Christian piety and destitution, enabling personal salvation in the afterlife. Such exercises were better suited to arid deserts than fertile plains and busy cities.

The mountains of south Sinai emerged as a place of hallowed hardship and were invested with associations from the Old Testament about the life of Moses, making them sacred to Christian, Muslim and, later, Jewish communities. When the Christian pilgrim Egeria visited in 383 CE, she was shown by local anchorites the place where, according to tradition, Moses saw the burning bush.

In later centuries the anchorite community grew and the stream of pilgrims swelled. By the 550s imperial providence intervened to protect and control both. On the orders of Justinian I (r. 527–565), a fortress (pictured here) was erected in the valley of the burning bush and, within it, a basilica church pointed at the divine bramble. On the summit of Mount Sinai, another church sheltered further sites with biblical significance. Thousands of rock-hewn steps bridged the two ends of the visitor track in what was a veritable Old Testament 'theme park'. The fortress soon became a monastery, and survives to this day protected by its patron saint, Catherine of Alexandria (*c.* 287–*c.* 305). GM

Further reading: Egeria 2006; Kalopissi-Verti & Panayotidi 2010; Manginis 2016.

Rock-cut monasteries in the Western Ghats

The isolated group at Lenyadri, pictured above, is one of more than ten Buddhist monasteries cut from the rocky scarps of the Western Ghats mountains around Junnar in the early centuries CE. Monks and nuns living in these monasteries spent their day-to-day lives in rock-cut chambers replete with exquisite paintings and sculptures, such as the *chaitya* arches at Bedsa, pictured right. Majestic pillared *chaitya* halls were used for worship while courtyard rock-cut *vihara* provided personal and communal living spaces.

These temples were hewn from cliff faces to form cool and shady retreats from life in the valleys below. Although similar rock-cut temples can be found across south Asia, it is within the Western Ghats, which run parallel to the western coast of India, that the greatest concentration of Buddhist, Jain and Hindu rock-cut

architecture exists. The Buddhist monasteries in this region as a whole, including those at Junnar, Lenyadri and Bedsa, as well as at Kanheri, Karle and elsewhere, date from between the 2nd century BCE and the 9th century CE.

The monasteries were positioned close to ancient cities, ports and mountain trade routes, suggesting that monks and nuns did not lead an isolated existence. Indeed, monumental inscriptions attest to connections with wider society and record donations of cisterns, caves and land from metalworkers, merchants and members of royal courts as well as the monks and nuns themselves. GR

Further reading: Dehejia 1972; Michell & Rees 2017; Nagaraju 1981.

In the east, several spectacular mountain chains in the Japanese archipelago and the Korean peninsula, although not as high as the central Asian massif, are hugely significant. Those extending along the eastern coast of the Korean peninsula form the Baekdudaegan range, with several lower, secondary ranges running almost perpendicular across the peninsula; these mountains were significant in enabling important kingdoms, such as the Silla, Baekje and Goguryeo, to develop in relatively protected, geographically distinct regions.

Moving west from central Asia, the mountains of the Zagros, Caucasus and Taurus form vital barriers, demarcating empires and shaping the lives of the peoples living in their shadows. Routes through them dictated trade and travel, as well as the ways in which neighbours connected with each other and the wider world. The Caucasus, for example, stretches for nearly 1,200 km (750 miles) from the Black to the Caspian seas, and is often considered to be the boundary between eastern Europe and western Asia. Dominated by a number of high peaks, including Mount Elbrus (5,642 m or 18,510 ft), the range is pierced by strategic passes. The Darial gorge at its centre was called *Porta Caucasica*, the Caucasian Gates, by the Roman geographer Strabo (*c*. 64 BCE–*c*. 24 CE). Successive empires built forts here to control their frontiers and protect or restrict the movement of people and goods: the Alans, Romans, Sasanians, Western Turks and Umayyads [*see* box on p. 59].

The Zagros mountains stretch south from the Caucasus to the opening of the Gulf, forming a natural barrier between the Iranian plateau to its east and Mesopotamia to its west. The range has been traversed since ancient times by the Great Khorasan Road through the so-called Zagros Gates – also known as the Patagh pass or Taq-e Gara. The Hijaz, Asir and Saraw mountains form the western edge of the Arabian peninsula. Crossing the Red Sea, the Great African Rift valley has pushed up the land to create the Ethiopian highlands in east Africa, with the Red Sea hills extending into north Africa and the Sinai peninsula.

These great mountain ranges of the Silk Roads present formidable obstacles to both travellers and trade. Nearly all the mountain passes were seasonal, and navigating the routes required appropriate pack animals – such as yaks – and an understanding of those seasons and the opportunities they afforded. Ingenuity and engineering skills were required to build and maintain paths, sometimes on sheer rock faces, and to construct bridges across ravines or rivers made treacherous by the summer spates [*see* pp. 194–99].

As a result, it is not surprising that many mountains attained a symbolic, mystic and often deeply spiritual meaning for local communities. For example, Mount Fuji in Japan has a special significance for the Japanese people today, as an icon of nationhood, a spiritual place and an inspiration for art. Both the Koreans and the Manchu people consider Mount Paektu to be the place of their ancestral origin; Mount Ilam in the Swat valley has been a place of pilgrimage for Buddhists, Hindus and Muslims; Hindu, Jain and Buddhist cosmology all have the sacred Mount Meru as the centre of the world, identified by some as lying in the Pamirs; the dormant volcano Mount Ararat, today in eastern Turkey, is held by many as the resting place of Noah's ark and is considered a sacred mountain among Armenians; and Mount Sinai, traditionally where Moses received the Ten Commandments, is sacred to Jewish, Christian and Muslim communities [*see* box on p. 129].

Religious communities also utilized mountain landscapes to construct shrines and excavate temples, from the Christian rock-cut churches and monasteries in Cappadocia and east Africa to the Buddhist monasteries and rock-cut temples of south, central and east Asia [*see* boxes on pp. 127, 130, 138, 157 and 171]. Sometimes the remoteness of a dramatic setting contributed to the choice of site, but many such shrines and temples were placed near trade routes, where they flourished by offering solace to passing pilgrims and merchants in return for donations [*see* pp. 144–51 and 160–75.

Mountains were also the source of raw materials, among them metals, gemstones, lapis lazuli and jade, traded the length of the Silk Roads in both worked and unworked states [*see* pp. 182–93]. They provided wood and stone for building, while nuts and fruits could be cultivated on their slopes [*see* pp. 364–67]. Thus the mountains of the Silk Roads not only shaped the routes along which people could pass and goods could be traded, but also were often the source of those very goods.

———

Further reading: Bernbaum 1997; Merzlyakova 2002; Price et al. 2013.

The Bactrian hoard and other unearthed treasures

Luca M. Olivieri

"Digging in an unassuming mound known as Tillya Tepe, the 'Hill of Gold', we chanced upon the graves of six ancients...And with their bones we found the wealth they were to carry to the afterlife – more than 20,000 artifacts, mostly crafted of gold and semi-precious stones – a treasure of such artistic and descriptive richness that to speak of it was already to begin to understand that distant time."

Viktor Sarianidi, *The Golden Hoard of Bactria*, 1985.

Russian and Afghan archaeologists at Shibargan (Tillya Tepe), on an excavation led by Viktor Sarianidi, 1978–79.

Culturally, mountains can unite rather than divide, although politics may sometimes challenge such unity. The existence of cultural networks that bridged mountain ranges is demonstrated far back into prehistory, for example, by the Northern Neolithic cultural complex that Swat (and possibly some of the eastern Pamirs) shared with Kashmir and the more easterly trans-Himalayan territories, as far as the north China plains.

Unfortunately studies on the Northern Neolithic have declined in recent decades, alongside the cooling of political relationships in this region. The latter has also affected research on the historical phases of these eastern bounds of the ancient trade routes. For instance, the great quantity of data produced by the Pakistani-German missions since 1980 in the Karakoram remains for the time being the major world archive of information available on the Upper Indus region, although a Franco-Indian project was launched in 2013 on the Indian side of the border.

At the western end of the Himalayas, archaeology is suggesting new ideas concerning the relationship between the regions north and south of the Hindu Kush. In recent times these regions have been divided by political boundaries, as a result of which, up to the 1990s, different archaeological teams were forced to carry out local and regional studies instead of large-scale analysis. But thanks to the opening of the borders, and the diversification of archaeological approaches, cultural questions and historical perspectives have widened radically since then. Recent research is now providing solid data to show the strong and persistent interaction between different regions. There are no apparent chronological limits to this trend, which is confirmed by Late Bronze and Early Iron Age archaeology. It is now certain that groups broadly sharing the same cultural backgrounds (and gene frequency) were gradually occupying and sharing territories as far south of Bactria and Margiana as Gandhāra, along the foothills of the Hindu Kush-Karakoram. If it is still too early to conclude with certainty that urbanization in these regions began mainly during the time of the Achaemenid empire (c. 550–330 BCE), it is a fact that the role of cities was enhanced during the last centuries BCE, and remained as such until the collapse of the Kushan empire (c. 250 CE) [see box on p. 163].

The first research into urbanization was initiated by two great archaeological schools, those of the Soviets and the French, with teams working on both sides of the 20th-century political boundaries. Soviet archaeologists including Boris Marshak (1933–2006) and Viktor Sarianidi (1929–2013) remain famous for their excavations at sites such as Panjikent and Tillya Tepe (the Bactrian hoard) [see boxes on pp. 109 and 110], their work continuing beyond the end of the Soviet era. Their new ideas and data, recently enhanced by an increase in surface and regional surveys, support the establishment of new urban centres during the Achaemenid period. Further excavations at Kok Tepe and Afrasiab (Samarkand) [see box on p. 284] carried out by Uzbek-French teams, and at Tillya Tepe and Emshi Tepe by the Russians, have yielded significant evidence to support this.

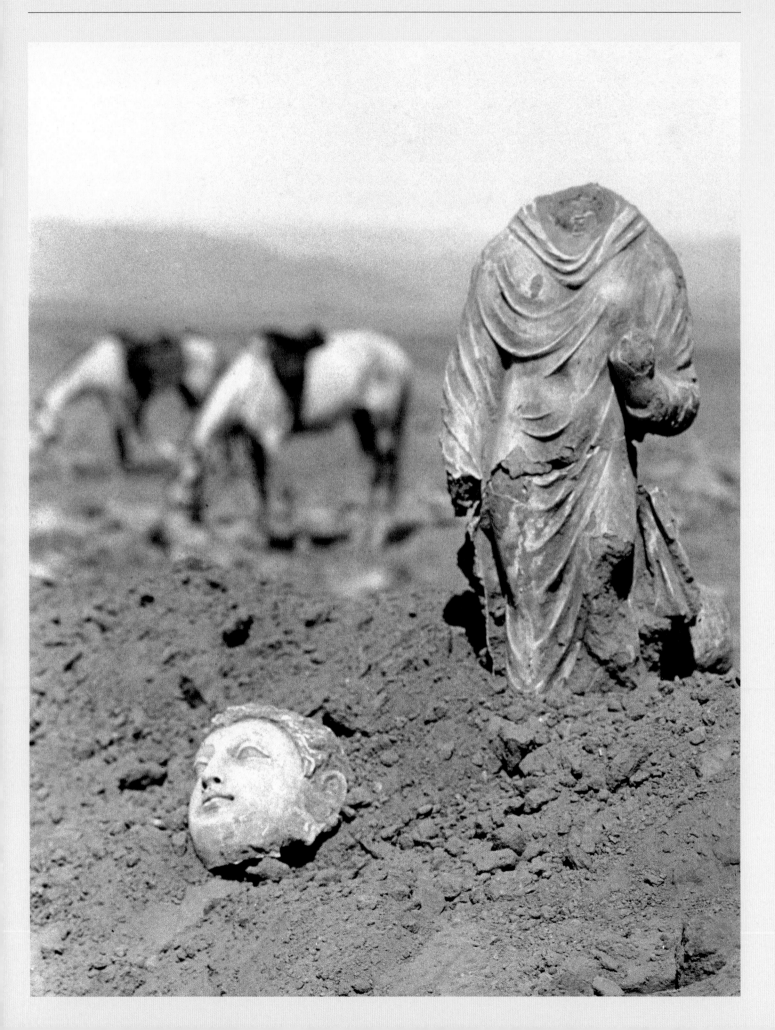

French research on Hellenistic settlements was initiated as early as 1920 at Bactra (Balkh) by Alfred Foucher (1865–1952), but French expectations of a lost Hellenism of central Asia remained unfulfilled until the discovery of a 'true' Greek city at Ai Khanoum in the 1960s [see box on p. 203]. French archaeological efforts have recently been supported by a number of different international projects, in the form of discoveries at Tepe Zargaran of Hellenistic elements, as well as fieldwork results obtained in Northern Bactria at Termez/Kampir Tepe, Kurganzol, Uzundara, Jandlav Tepe, and very recently at Kizil Tepe and Bash Tepe. Practically no part of central Asia remained untouched by Hellenism. Besides the regional metropolis of Maracanda at Samarkand/Afrasiab, excavated by Uzbek-French teams, there has recently been a discovery by a Karapalpak-Australian mission of Hellenistic layers and materials at Akchakhan Kala. Hellenistic remains at Gyaur Kala (Erk Kala), probably Antiochia in Margiana, have also been under study since 1992 by a Turkmen-Anglo-Russian team.

The Hellenistic network all across these territories, besides the obvious political subdivisions and ground realities, which still elude full understanding, was firmly established at least as an elite phenomenon. Residential areas of Hellenistic cities have yielded luxury tablewares, which were standardized from Bactria to Gandhāra, as demonstrated by the independent production of fish plates and east Hellenistic bowls at Barikot, in the Swat valley, as early as 300 to 250 BCE. Contemporary local styles were destined to last far longer than the status symbols of the elites, but their specifics still remain unclear.

The global role played by the Kushans (1st to 3rd centuries) across central Asia does not need to be explained here. What should be emphasized, though, is the side-effect of their role in patronizing and supporting Buddhism [see pp. 152–59]. Virtually opening an entire empire for its religious diffusion and artistic interchanges had a strong impact on the growth of urban life and trade. This is the moment when a cross-cultural centre like Barikot really went global. Pottery shapes and techniques were deeply influenced by the Gangetic world, while ornaments and bangles made of shell were imported from Gujarat and as far as south India. New devices for milling arrived from the southern harbours of India, such as the more effective Mediterranean rotary querns, which belatedly broke the resistance of traditional Indian systems. Lastly, apart from the typical Gandhāran Buddhist shrines and stupas, Barikot hosted cultural buildings with columned verandas, echoing central Asian antecedents.

The importance for trade and urban life of the Kushans' system of power can be inferred by the changes after their collapse. Results of recent extensive surveys have shown that, as seen in Gandhāra, cities had already started declining during the first stages of Kushano-Sasanian rule (3rd to 4th centuries), and were then rapidly abandoned. During the same period, Buddhist monasteries, although not everywhere and to different degrees, managed to endure the crisis [see pp. 160–67].

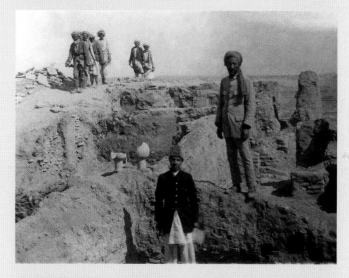

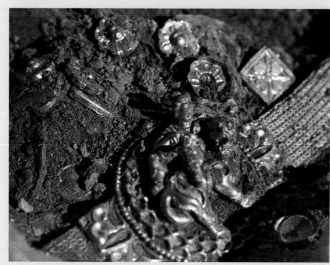

Further reading: Bendezu-Sarmiento 2013; Lindström et al. 2013; Lindström & Mairs 2017; Lo Muzio 2017; Mairs 2011, 2013–2018; Narasimhan et al. 2018.

Opposite — Buddha statue from Tapa Kalan (Hadda), photographed during excavations led by J. Barthoux, 1927–28.

Top — B. Marshak, V. I. Raspopova, A. M. Belenitsky and colleagues during excavations in the Ambassadors' Hall, Afrasiab, 1965.

Centre — Excavations at Balkh, led by A. Foucher, 1924–25.

Bottom — Gold belt at Tillya Tepe (see p. 109), found during Russian-Afghan excavations, 1978–79.

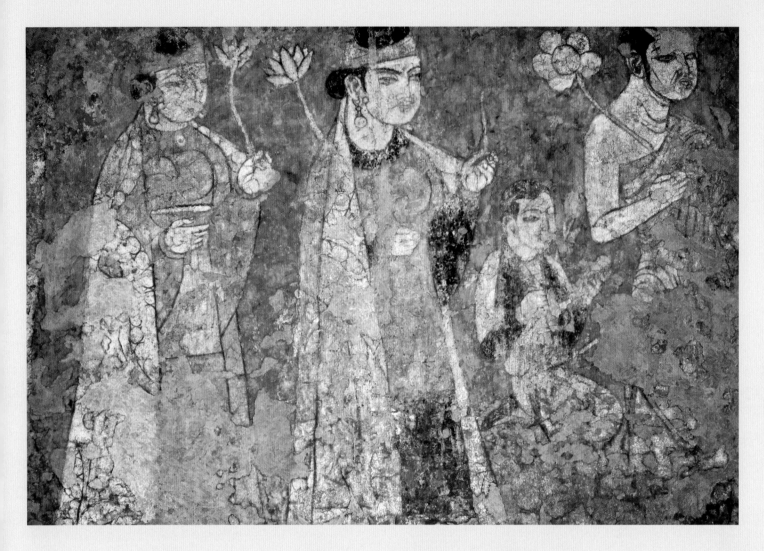

Settlers from the steppe: the Kushan, Hephthalites and other empires

Frantz Grenet

Mural showing worshippers with
offerings. Kala-i Kafirnigan Buddhist
temple, central Asia, 5th–8th centuries.

"The Hephthalites are of the stock of the Huns in fact as well as in name; however... they are not nomads like the other Hunnic peoples, but for a long time have been established in a goodly land....they are ruled by one king, and since they possess a lawful constitution, they observe right and justice in their dealings both with one another and with their neighbours, in no degree less than the Romans and the Persians."

Procopius (6th century CE), 1.3:2–8.
Translated from the Ancient Greek by H. B. Dewing.

It has been said that each of the three geographical milieus that frame the life-concentrating valleys and oases of central Asia – steppes, deserts, mountains – represents the ultimate of its type. This is certainly true for the mountains, which are the highest on earth.

During Alexander the Great's (r. 336–323 BCE) expedition and after, the Greeks considered the Hindu Kush, which branches off to the west of the Himalayas, as part of a continuous mountain chain, the main dividing line of Asia, stretching from the Taurus mountains via the Caucasus and the Kopet Dagh. Its reputation of being almost impassable gave rise to its Persian name *para-upari-saēna*, 'above the eagles', and thence to its Greek name *Paropamisos*. North of the Himalayas one meets first the lower Kunlun range that separates the Tibetan plateau from the Taklamakan desert. To the north of the desert, the Tianshan and Altai ranges enclose the Dzungaria plain. The Tianshan have long western offshoots (the Alatau, Turkestan range and the Hissar) forming a continuous mountain zone that frames the upper valleys of the Amu Darya, Zarafshan and Syr Darya while enclosing the Fergana plain.

Geography played a major role in the history of central Asia. The only passable east–west corridor for an army of horsemen was the Dzungaria plain and the Ili valley, leaving the region vulnerable to recurring invasions of peoples from the steppe. The cluster of mountains around the Pamirs has always created

a barrier between the western and eastern parts. Control of the mountain passes was vital both to conquerors and to those empires (the majority) that had a foot on both northern and southern sides of the western ranges. When Alexander arrived in the eastern satrapies of the Achaemenid empire (c. 550–330 BCE), he exerted considerable effort securing the passage though the central Hindu Kush. It then took him two years to subdue the 'rocks' in the Hissar range to the northwest; he did not cross the ranges further to the east.

After Alexander, the kingdoms in the north of the mountains on either side of the Amu Darya, the Sogdians and Bactrians to the north and south respectively, took a different approach to the Hissar. For them the range was important as the border with steppe pastoralist confederations not integrated into their kingdoms. Consequently they erected a formidable fortification line. A few centuries later, it was reinforced by the Kushan empire (1st to 3rd centuries CE), and later by the Sasanians (224–651) [*see* box on p. 59].

The mountains were the initial power base of several central Asian empires. The Kushan empire was formed from five clans of the Yuezhi people from the Hexi corridor who, after being pushed westward by Xiongnu incursions from the steppe, had settled in the late 2nd century BCE in the valleys between the Hissar range and the Amu Darya. It was here that the Chinese envoy Zhang Qian (164–113 BCE) encountered them, estimating that they had a force of 90,000 mounted archers. Two centuries later, as the Kushans, they had unified much of the central Asia mountain region and started their expansion towards India. In the 5th century the Hephthalites (c. 450–c. 560), also from the steppe, first emerged as an independent state in the foothills of southeast Bactria, where their rulers retained a pastoralist

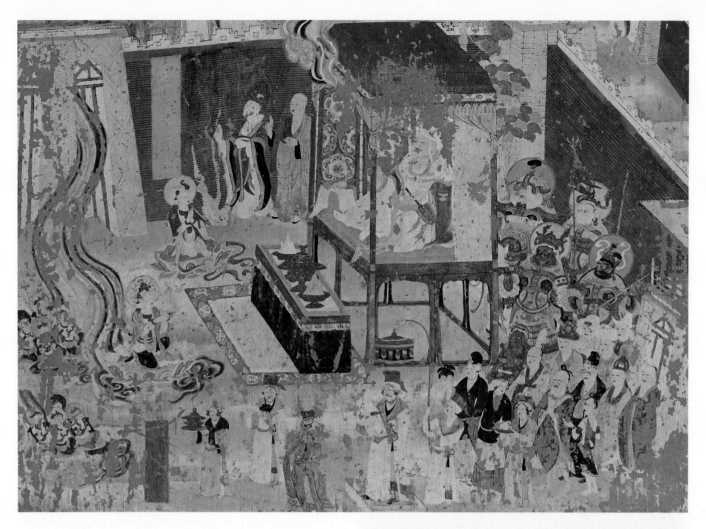

Dunhuang: Buddhist rock-cut temples in the Hexi corridor

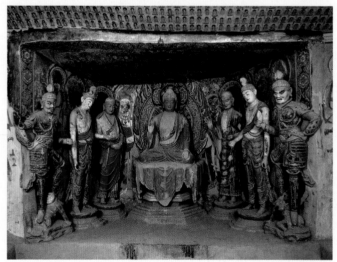

The Mogao Caves near the oasis town of Dunhuang, dating to between the 4th and 14th centuries, are one of a series of Buddhist rock-cut temple sites in the Tarim basin and the Hexi corridor that punctuate the trade and pilgrimage routes between central Asia and China.

The 735 extant caves contain 45,000 sq. m (485,000 sq. ft) of murals, such as the 8th-century scene from the *Vimalakīrti Sūtra* shown above, from Cave 159. Below the seated Vimalakīrti, the Tibetan emperor leads a retinue of his entourage and dignitaries from neighbouring lands.

The temples also contain over 2,000 painted clay sculptures, such as the 7th-century grouping around the Buddha in Cave 45, pictured right. These are testament to the many generations of patrons and artists who worked on the caves.

The layout and art are the product of the interaction and assimilation that took place between the many cultures that used the trade routes, with Indian, Gandhāran, Iranian, Chinese, Tibetan, Uygur and Tangut influences [*see* boxes on pp. 146 and 158]. The same diversity is shown by a cache of manuscripts and early printed documents discovered in 1900 in a hidden cave at the site, dating from the 4th to early 11th centuries [*see* boxes on pp. 333, 350 and 404], and in more recent finds of later manuscripts, including a Syriac copy of the Psalms. The manuscripts from the hidden cave were dispersed to collections worldwide by visiting archaeologists, including the French Sinologist Paul Pelliot (1878–1945). WXD

Further reading: Fan 2013; Thurman 1976; Whitfield et al. 2015.

lifestyle. In the late 10th century the Ghaznavids (977–1186) started as a mixed military force, partly Turkic, established in the south of the Hindu Kush. And the Ghorids (c. 879–1215) were initially petty mountain rulers in the western Hindu Kush.

After periods of crisis the oases were repopulated by new settlers from the foothills who introduced their own pottery styles, as happened in Sogdiana after invasions in the 4th century. Vanquished peoples or religious minorities were sometimes driven upwards: the last political and cultural shelters of Sogdian civilization after their conquest by the Arab caliphate were the valleys of the Upper Zarafshan and its tributaries, with the main settlement downstream at Panjikent. By the 8th to 9th centuries the last independent power in this zone was Usrūshana. The large Jewish population documented in the 11th to 12th centuries in the western valleys of the Hindu Kush may have come, at least in part, from the populous Jewish community in Sasanian Merv [see box on p. 219], pushed into the mountains by the Arab conquest centuries before.

The Arab caliphate was just one of several powers from both east and west Asia who made conquests in the central Asian mountains. Before them, the Achaemenids and Sasanians had established satrapies here. From the east the Tang (618–907) extended their empire as far as the kingdom of the Yasin valley, which provided a north–south route between the Pamirs and the Hindu Kush. Their control was challenged and overthrown for periods by the Tibetan empire (618–842). Mountain forts from this period are reminders of the military activity that took place. But military networks were not necessarily a barrier to merchants, since they often secured routes, helping to ensure safe passage. The Greco-Roman geographer Ptolemy (c. 100–c. 170) wrote of a 'Stone Tower' in the central Asian mountains where merchants from both east and west traded goods. Among its various identifications are Daraut kurgan, Taht-i-Suleiman or Tashkurgan. An archive of Bactrian manuscripts discovered in ancient Rob, west of Herat, provides evidence that Bactria at times exploited its control of communication between the Sasanians and Hephthalites [see box on p. 241]. In the 6th century, the kingdom of Bamiyan to their south prospered as a consequence of a shift in the main Hindu Kush crossings.

Mountains and highlands contributed their resources to the oasis economies. The value of irrigated land in the valleys often obliged farmers to graze their flocks on mountain pastures. And skins and leather were a major element in the economy of Panjikent, as shown by Sogdian manuscripts found at Mount Mugh. As early as the 4th century, Sogdian merchants went to the Tibetan plateau in search of musk deer, the scent from their glands being more valuable than gold. All the region's mining resources, except gold and jade washed down in rivers, were

Bactrians bringing a camel for the Achaemenid king. From the Apadana east stairs at Persepolis, dating to the 6th–5th centuries BCE.

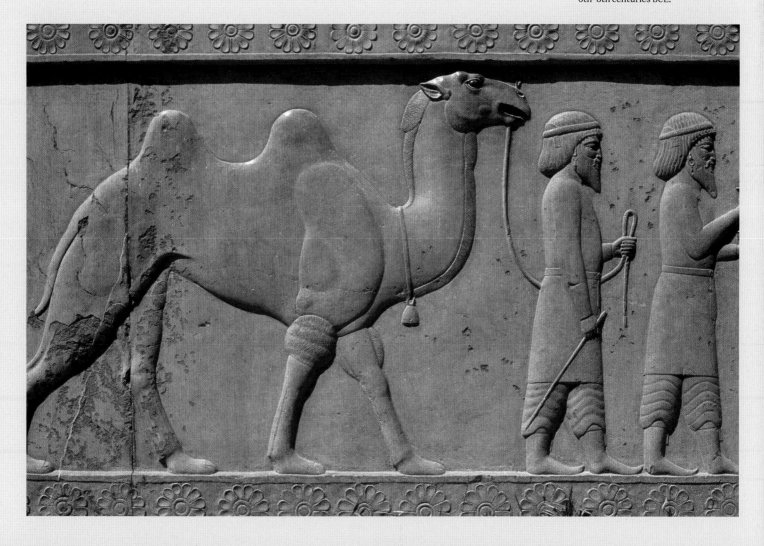

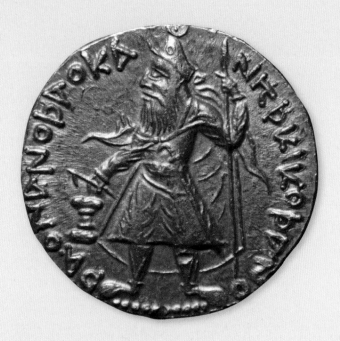

in the mountains, sometimes at a very high altitude, such as the lapis lazuli and spinel ruby mines in the Hindu Kush and the silver mines in Shughnan to the west of the Pamirs [*see* pp. 182–93]. An important settlement, Mes Aynak, developed around a copper mine south of Kabul between the 2nd and 8th centuries. High mountain trees, especially juniper, were used in architecture and decoration. A recently discovered 7th-century wall painting in a house in the Sogdian city of Afrasiab illustrates a pastoral festival, with girls sacrificing young sheep on their return from the summer pastures in the high mountains; this festival was still being observed among mountain Tajiks in the 1930s.

Further reading: Burjakov 2006; Foucher 1942, 1947; Fray et al. 2015; Klimburg-Salter 1989; Rapin 2013; Sims-Williams 2007, 2012.

Previous pages — Zoroastrian priests leading animals for sacrifice. Copy of murals in the Ambassadors' Hall, Afrasiab, Sogdiana, *c*. 650.

Above — Gold coin with Bactrian inscription of the Kushan king, Kaniska I, shown sacrificing at a fire altar.

Byzantine hunter silk

This fragment of silk was probably woven in the Byzantine imperial workshops of Constantinople [*see* box on p. 442] in the 8th or 9th century. The weave is a weft-faced compound twill – a samite – with Z-twisted warps, one binding and one main [*see* pp. 316–33]. The wefts are untwisted and dyed blue, a reddish brown, yellow and light blue. At this time silk production in Europe was limited to Islamic Spain but silk was nevertheless highly valued in the north, especially among the courts and Christian clergy. It was therefore a perfect diplomatic gift, being light and portable. And it was even more so if the design reflected the power of the giver: this piece shows the royal hunt.

Our first record of this fragment is a source referring to the translation of the relics of Saint Austremoine from the church at Volvic, in the modern Puy de Domes in France, to the Abbey of Mozac, some 6 km (4 miles) to its east. The translation happened under the patronage of Pepin – probably Pepin II of Aquitaine (r. 838–864) – who provided a piece of silk to wrap the relics, had the bundle marked with his royal seal, and travelled with them to their new home. It is probable that Pepin received the silk from which this fragment derives as a gift from an envoy from Constantinople.

In the 16th century, a wooden reliquary was made to house the relics, decorated by an Italian artist with paintings of the twelve apostles. Early in the 20th century the silk was divided and sold, and this piece was purchased by the Musée des Tissus in Lyon (MT 27386), where it remains today. SW

Further reading: Allsen 2016; Desrosiers 2004; Durand 2014; Muthesius 1997; Whitfield 2018.

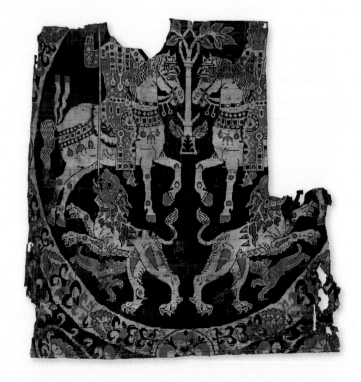

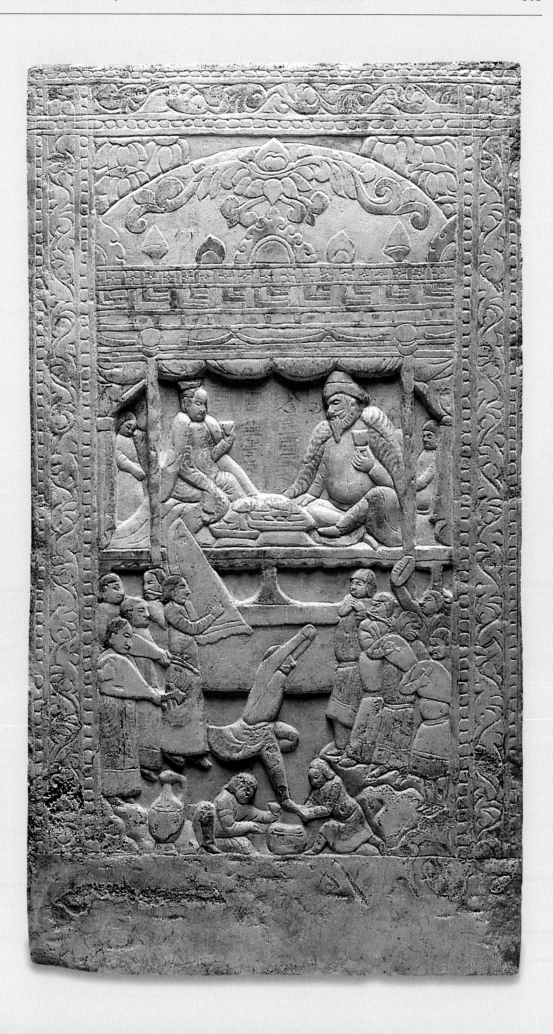

Panel from the 6th-century marble funerary couch of a Sogdian merchant living in China, showing him and his wife with an orchestra and Sogdian dancer below.

Buddhism and Christianity on the Silk Roads

Lewis Lancaster

The Buddhist and Christian monastic tradition was a significant economic, social and religious factor in Eurasian history and international cultural exchange. During the lifetime of the historical Buddha, Śākyamuni (5th century BCE), his disciples in north India were wandering ascetics. However, the monsoon rains forced them to stay in one place, and as early as the 2nd century BCE there is archaeological evidence in India for Buddhist monastic structures.

Before monasticism, the first permanent Buddhist structures were the earthen burial mounds that covered the relics found after the cremation of Śākyamuni. The mounds, called *stūpa*, were encased in bricks and over time had features added such as fencing, gateways and reliefs depicting events in the life of the Buddha. For some years, relic veneration was the major focus of Buddhist followers, both the wandering ascetics and householders [*see* pp. 176–81]. In time, structures were built adjacent to some of the mounds, and were used by the ascetics for times of meditation. Since the bodily relics of the Buddha were thought to have great power that could emanate outwards and change the nature of any site

where they were present, it is not surprising to find that ascetics gathered at such places. Cells constructed for meditation in the presence of relics are the first signs in archaeology of the emergence of permanent dwellings that were to develop into monasteries [*see* box on p. 130]. Textual evidence provides us with the storyline for how communities of both men and women set themselves apart from normal society and over time formulated the rules of conduct required for those who chose to lead their lives in this way. Known as *Vinaya*, and first transmitted through oral recitation, these rules were then transcribed into Sanskrit and Pali, and later translated into Chinese and Tibetan.

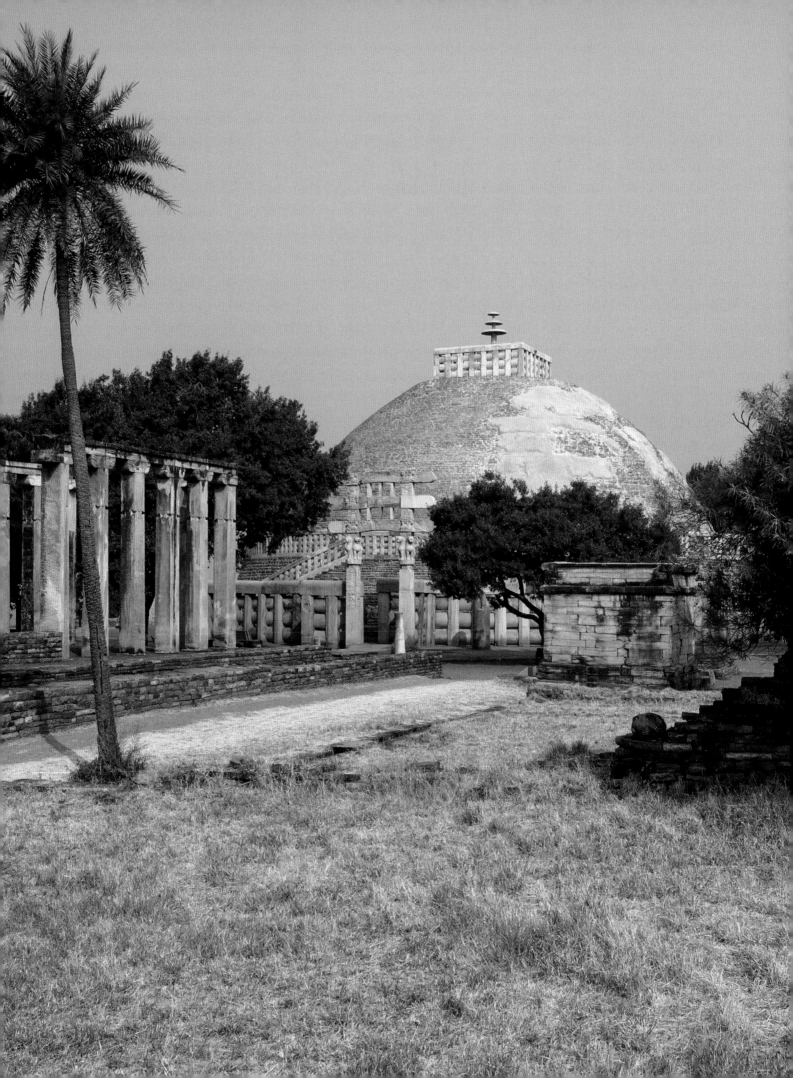

The three hares

The motif of three hares or rabbits in a rotating composition, each sharing an ear that together form a triangle at their centre, is a cross-cultural symbol, widely attested in west and central Asia as well as Europe. The earliest appearance known to date is the Buddhist version appearing from the late 6th century in the centre of lotus flowers painted on the ceiling apex in several caves at Dunhuang in the Hexi corridor. The hares from Cave 407 are shown above left. As well as in Buddhist contexts, the three hares occur as a decoration on objects of ceremonial or domestic use, particularly in Islamic art, as with the fragment shown above middle of glazed pottery from Egypt or Syria, dating from the late 12th or early 13th centuries and now in the Museum of Islamic Art in Cairo (6939/1). The motif also appears on an Ilkhanid (1256–1353) coin, minted in Urmiya in 1281/82. Later, it is found in European Christian and Jewish architecture, where, starting from the 14th century, the three hares are seen in churches, on roof bosses, tiles and stained glass, such as the roof boss from the Wissembourg church in France, dated *c.* 1300, shown above right. From the 17th and 18th centuries, it also appears in wooden synagogues in Germany.

While the motif has a number of meanings, including immortality, prosperity and spiritual renewal, it is the symbolic association with the astral sphere that represents its essential and enduring feature. In pre-Buddhist Upanishadic literature, the moon is called *śaśin*, 'the hare-like'. And in the Buddhist tale of the selfless hare,

Śāśa jātaka, the generous readiness of the hare for self-sacrifice is remunerated by the god Sakka, who traces out the sign of the hare on the moon as a perennial remembrance of its meritorious deed. The association of this animal with the moon travelled with Buddhism to China.

Against this background, of special interest is a circular terracotta plaque from Barikot in the Swat valley, pictured below. Dated to the Shahi period

(7th to 9th centuries), this small and apparently modest object, 7.9 cm (3.1 in.) in diameter, shows the three rotating hares within a beaded frame. It adds a further level of complexity to the story, since it comes from a cultic space of unknown nature. AF

Further reading: Filigenzi 2003; Greeves at al. 2017; Schlingloff 1971; Whitfield & Sims Williams 2004.

These communities of what could now be called monks and nuns – shaven-headed, celibate, wearing special garments, giving up wealth and begging each day for food – had begun as a means to achieve special states of awareness through days and months of concentration. However, the monasteries developed not only as a place for individual effort and spiritual growth, but also as social institutions, physical campuses of buildings, and they were central to the spread of the Buddhist tradition from its birthplace in the Gangetic plain of northeast India. Growing monasteries of full-time residents required sizeable funding for food, clothing and the construction of buildings. Thus institutional organization became necessary to handle these needs. The main supporters were rulers and merchants, and as Buddhism spread across boundaries of kingdoms, merchant involvement grew and the monasteries played an increasingly important role in international trade. Monastic campuses were used for housing travellers, providing education for children, banking and medical facilities, safe keeping of valuables, and spiritual protection from illness and bandits. Along the trade routes of central Asia, they became much like caravanserais, serving the needs of passing traders [see pp. 152–59 and 244–55].

Previous spread — The 2nd-century BCE Great Stupa at Sanchi, India, showing the early hemispherical style [see p. 179].

Below — Women being tonsured prior to entering a Buddhist nunnery. From Mogao Cave 445 at Dunhuang, 8th century.

Christian monastic practices are similar to Buddhist ones, and can also be traced back to ascetics [*see* pp. 168–75]. In the case of Christianity, asceticism is seen in the deserts along the Nile in Egypt in the 3rd and 4th centuries CE. Individuals lived in caves and constructed cells mainly as solitary practitioners. At the height of such activity, thousands of these sites dotted the deserts. In the eastern Mediterranean and around the Dead Sea, there were 1st-century precursors such as the Essenes, who lived a life of poverty, celibacy and obedience and sought spiritual perfection. As a group they are thought to have splintered from the Jewish Zadok priestly class. However, the founding of the first communal setting for Christian monastics is often attributed to Pachomius (292–348), a Copt, in 4th-century Thebes in Egypt. This was an important trade centre where goods being shipped on the Red Sea were brought across the desert to be floated down the Nile. The communal monastery pattern spread to the eastern Mediterranean and Mesopotamia. In these regions the church was split into Jacobite (West Syria) and Nestorian (East Syria), and it was the Nestorians who carried Christian monastic culture across the Silk Roads to central Asia and into China [*see* box opposite]. This group has often been depicted as a Christian heresy because its teachings about the nature of Christ were unacceptable to the Council of Ephesus in 431. As a result, the Nestorian church has been seen as a minor splinter group. In reality, it was for centuries the dominant tradition in the eastern regions and occupied a position of great power.

Another 3rd-century tradition was that of Mani (216–274/277 CE), whose movement, partly influenced by Christianity, filtered along the trade routes through the Tarim basin to China [*see* pp. 356–63]. Many of the Manichaean communal practices of living took their cue from Buddhist monasteries in India.

——

Further reading: Dunn 2003; Gernet 1998; Rousseau 1999; Schopen 1997.

Previous pages — The Holy Lavra of Saint Sabbas (Mar Saba), a Christian monastery founded in the desert between Jerusalem and the Dead Sea in 483.

Opposite above — A church at Jubail in the Arabian desert, founded in the 4th century.

Below — Takht-i-Bahi Buddhist monastery, central Asia, founded in the 1st century.

Christian monastics in central Asia

Almost all known Christian texts in the Sogdian script come from a single site, a ruined monastery at Bulayïq, a short distance north of Turfan in the Tarim basin. The Bulayïq manuscripts, written in an adapted Syriac script or in the native Sogdian script on paper, the usual medium in this region, chiefly consist of translations from Syriac, with a special emphasis on texts concerning asceticism and the religious life.

A particularly significant group of fragments is that known as E28, a collection in the handwriting of a single scribe, whose choice of material to translate or to copy clearly demonstrates his interest in the practice and traditions of Christian monasticism, beginning with the 'Desert Fathers', the solitaries and monks of the Egyptian desert, and, according to tradition, transplanted to Mesopotamia and the Iranian plateau by Mar Awgin (Saint Eugenios; d. 363).

The collection includes the biography of Awgin along with excerpts from and commentaries on some of the basic texts of Syrian monastic spirituality, such as the stories and sayings of the Desert Fathers and the writings of Isaac of Nineveh (c. 613–c. 700) and Abba Isaiah (late 4th century). The page shown here, now in the Berlin Turfan collection (E28/1, n148R), features the 'selected sayings' of Šemʿon d-Ṭaibuteh, a Syriac monastic writer of the 7th century. NSW

Further reading: Sims-Williams 2009, 2017.

Buddhism and trade: moving eastwards from Gandhāra to China

Liu Xinru

Royal patronage of Buddhism has a long tradition. King Aśoka (r. *c.* 268– *c.* 232 BCE) of the Maurya empire (322–185 BCE) is recorded as having ordered the construction of 84,000 stupas in India to hold relics of the Buddha, where Buddhists could gather and worship. But it was during the time of the central Asian Kushan empire (1st to 3rd centuries CE) that monastic institutions for both monks and nuns developed fully.

During the same period, trading networks from south and into central and east Asia also grew, along with maritime trade from ports in India. The monasteries facilitated trade, providing refuges where merchants could stay and pray for safe passage. For example, rock-cut monasteries lining the foothills of mountains south of the Narmada river facilitated commercial activities that transported cotton, the most famous and highly demanded product of the Deccan plateau in central and south India, to the ports on Konkan coast in west India. The cotton was then transported across the Indian ocean to the Roman empire.

Merchants helped support the building of rock-cut temples and their decoration with murals and sculptures. Among the most famous sites from this period are the Ajanta temples, those at Aurangabad with their stone sculptures, as well of those of the Western Ghat mountains. The patronage of temples and monasteries by merchants continued along the routes into central Asia, where there was considerable risk from travelling across the high mountain passes [*see* pp. 194–99]. The main stupas that dominated most monasteries also became major places of pilgrimage, such as at Mathura and Taxila. But the influence of Buddhism extended much further, with remains of a stupa from this period at Merv [*see* box on p. 219], some 1,000 km (650 miles) to the northwest of Taxila. Monasteries

in the mountains of central Asia survived the decline of the Kushan empire and continued to serve as landmarks for travellers and traders on the Silk Roads, as witnessed by the gigantic Buddha statues at Bamiyan [*see* box on p. 127].

The relationship between merchants and monasteries continued as Buddhism spread along the trade routes into the kingdoms of the Tarim basin, such as Khotan [*see* box on p. 221]. The remains of stupas are found from as early as the 2nd or 3rd centuries in the south, often decorated with murals showing influences from Gandhāra. Rock-cut temples dot the north of the Tarim from at least the

Previous spread — The 5th-century interior of Cave 26, one of the rock-cut Buddhist temples at Ajanta, northern India.

Right — Buddha preaching, in a 9th- to 10th-century mural in Cave 43 at the rock-cut Buddhist temples at Kumtura in the Tarim basin.

Below — An 8th-century rock-carved Buddha at Chilburam Rock, Mount Namsan, Gyeongju, South Korea.

4th century, with numerous sites in the mountains around Kucha, Turfan and Dunhuang.

Buddhist monasteries and rock-cut temples spread into the north China plains during the rule of the Northern Wei (386–534). Buddhism was made the state religion and rock-cut temples were excavated under imperial order at Yungang, outside the capital. Five gigantic Buddha statues, carved during the 460s, are believed to represent five ancestors of the Northern Wei emperor. In 476, a royal monastery, Yongning Temple, was built and records show that there were around a hundred monasteries in the capital by the 490s. The capital was moved south to Luoyang in the Yellow river

basin in 494 and Longmen, another rock-cut temple site, was established under imperial patronage. Central Asian merchants were already residents here and Buddhism proliferated. By the end of the Northern Wei, there were over a thousand monasteries in Luoyang.

It was also during this period that Chinese Buddhist missionaries reached Goguryeo (37 BCE–668 CE) and Baekje (18 BCE–660 CE) on the Korean peninsula. After the Silla kingdom (57 BCE–935 CE) unified the peninsula in the late 6th century, with the support of the Chinese, Buddhist monasticism was established as a state institution. Buddhism probably spread into the Japan archipelago with

Rock-cut 5th- to 6th-century Buddhist temples at Yungang, northern China.

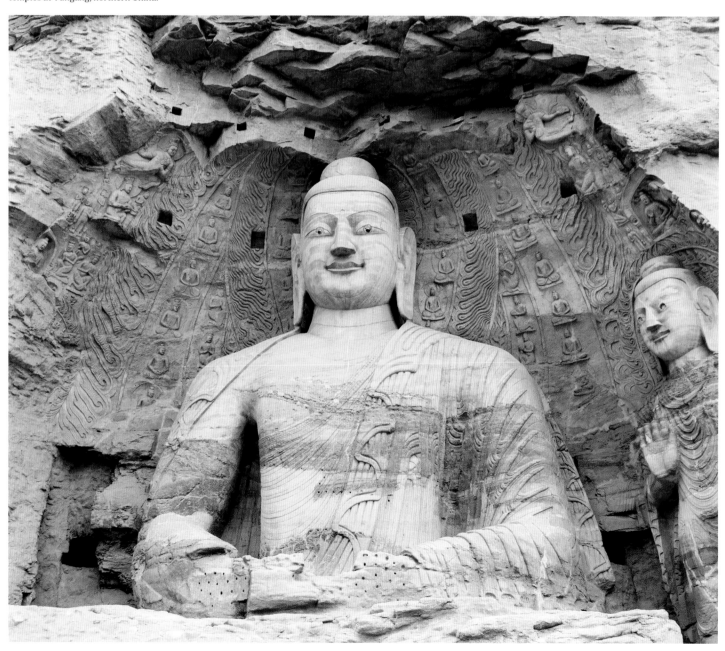

settlers from the Korean peninsula before this but
also started receiving royal patronage during the
6th century; stupas were also built to house relics,
such as at the 7th-century Hōryūji in Nara [*see* box
on p. 180]. Buddhism also travelled by sea to
southeast Asia.

———

Further reading: Brancaccio 2011; Gordon et al. 2009; Hansen 2012;
Hawkes & Shimada 2009; Liu 1988.

Right — Novices copying sutras onto
Indian-format pages. From the 7th- to
9th-century rock-cut Buddhist temples
at Shorchuk, near Karashar, in the
Tarim basin.

Below — 3rd- to 4th-century murals
showing Hellenistic influence, Stupa
M.III, Miran, in the Tarim basin.

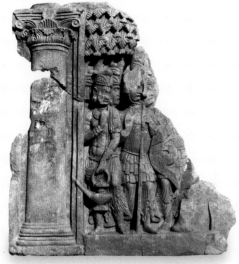

Buddhist art:
from the Swat to the Taklamakan

The Buddhist art of Gandhāra emerged in the Swat valley to its north in the early 1st century CE with the so-called 'drawing' style, clearly distinguishable by a predominance of lines over volume and echoing the contemporary Indic visual tradition. First attested at Butkara I, this style finds its most mature expression in the monumental narrative frieze of the main stupa of Saidu Sharif I, details of which are shown right and above right (dating to the second quarter of the 1st century CE). At the same time, this frieze heralds the transition towards the 'naturalistic' style, characterized by more pronounced Hellenistic features and fully developed in the second half of the 1st century. Besides representing the earliest Gandhāran narrative cycle so far brought to light, the frieze is also, to the best of our present knowledge, the only one of such a large size (42 m or 138 ft in circumference, originally

composed of about sixty-five panels of 41 by 51 cm or 16 by 20 in.). It must have been long regarded with admiration and astonishment not only for its originality but also for being representative of one of the most celebrated Buddhist holy lands.

The fame of this frieze (or, at least, of similar works) had an unmistakable bearing upon the later paintings at Miran dating to the 2nd to 4th centuries CE, a thousand miles' journey east across the mountains to the oasis kingdom of Kroraina in the southern Tarim basin. The murals decorating the circumambulatories of the Miran stupas, such as the piece illustrated above left and far right, show similarities to the visual aesthetics of the Saidu frieze in terms of physiognomic features, clothing, attitudes and attributes, compositional schemes and settings.

Undoubtedly, the artists of Miran worked with specific

precedents in mind. The Saidu frieze may well have afforded an authoritative and sacred model for artists to copy in the Buddhist world beyond the frontiers of India, with Swat forming a cultural link between ancient Gandhāra and the Tarim basin.
AF

Further reading: Bussagli 1979; Faccenna 2001; Filigenzi 2006, 2012; Stein 1921.

Bhadrāsana Buddha in southeast Asia

Representations of the Buddha seated with his legs pendant (*bhadrāsana*) rather than crossed and dating to the 1st millennium CE are found throughout Buddhist Asia, seen in the painting and bronze statues illustrated here. Bhadrāsana Buddha images usually display one of two *mudrā* or hand gestures, either the teaching gesture with one hand (*vitarkamudrā*) or some variant of 'Turning the Wheel of the Law' with both hands (*dharmacakramudrā*). But the different forms seem to have spread separately.

The seated Buddha with the one-handed teaching gesture is commonly seen in mainland and maritime southeast Asia, particularly in Dvāravatī (Thailand) and Śrīvijaya (Sumatra) in around the 7th and 8th centuries, as well as in east Asia. But it is rarely seen in south Asia. Conversely, the seated Buddha with the two-handed gesture occurs mostly in south Asia as well as in maritime southeast Asia, but is rare in mainland southeast Asia and east Asia. One hypothesis for their separate distribution is that east Asian models played an important role in the transmission of the imagery of the Bhadrāsana Buddha with the one-handed gesture to southeast Asia.

This hypothesis raises intriguing questions about the impact of Chinese Buddhist pilgrims such as Yijing (635–713) and the many others who travelled by sea during this formative period of Buddhist iconography in southeast Asia. The almost simultaneous iconographic appearance of the Buddha in different places reveals how artistic styles and motifs might travel relatively rapidly from one region of the Silk Road to another, both by land and sea.

The painted Bhadrāsana Buddha shown below left is from Mogao Cave 405 at Dunhuang, dating from the late 6th or early 7th centuries. The high-backed throne with a scalloped edge is a type commonly seen in Buddha images in China, which usually show the Buddha seated with legs pendant, but is unknown in India. A similar throne-back can also be seen in some southeast Asian imagery, such as the small bronze Buddha also pictured, and now in the Tropenmuseum (TM 2960–157). It is said to be from Palembang – the capital of Śrīvijaya – and probably dates from the end of the 7th or the first half of the 8th centuries. NR

Further reading: Revire 2012; Rhie 1988; Woodward 1988.

Buddhist monk reading a Chinese
paper scroll. From Mogao Cave 201
at Dunhuang, late 8th to 9th century.

Linked economies: Buddhist monasteries and cities

Luca M. Olivieri

The study of the interdependence between Buddhist monasteries and towns in Gandhāra has been largely neglected. Despite the ample evidence documented around the metropolises of Pushkalavati (Shaikhan-dheri) and Taxila (Sirkap and Sirsukh), the relationship of these ancient cities with the rich monasteries in their surroundings has not been addressed. Moreover, in the Taxila valley the ruins of the city of Sirsukh have not even been excavated.

In Swat, however, there is evidence of close economic connections between cities and monasteries from the 1st century CE. The city of Bazira (Barikot) was home to elites who owned large mansions and maintained the urban infrastructure and defences; it was also the seat of craftsmen's guilds and communities (including potters, copperworkers, ironsmiths and stonecarvers). Initially, the presence of Buddhism in the city was limited to a few public sacred areas embedded in the city layout, as well as private shrines in elite mansions and large pilgrimage centres in the outskirts (such as at Butkara I). The monastic communities were crucial for the control of the irrigation network and

agriculture. In the hinterland of Barikot, there was roughly one Buddhist complex per sq. km (or about two-and-a-half per sq. mile). Tribal groups might also have played a crucial economic role.

Agriculture was an important factor in the ancient Swat economy, as the local microclimate allows double cropping. A variety of wild products from the lower savannas and the forests was also available. At Barikot, botanical evidence shows that all terrain was exploited, with paddy fields for rice and terraces on the mountainsides for cereals and mustard. It is possible that there was overproduction of rice allowing some to be exported. Mustard seeds were probably used for the

production of lamp oil. The city's refuse areas give evidence for widespread cattle and sheep farming, both at the lower grazing lands and the higher pastures. Hunting was not only for edible game but also non-edible precious animals such as large cats and rhinoceroses. Wild grapes and wine in ancient Swat were also a factor in the economy, as proven by several wine-presses and fermentation vats found in the more remote fringes of countryside controlled by the monasteries.

Recent analysis has shown that protein-based resources were also used to produce collagen, probably in late autumn. The importance of collagen in architecture is shown by samples from Amluk-dara [*see* box on p. 164]. There, in late spring, after the end of the rainy season, it was mixed into stucco to make it more stable and weather-resistant. It was used also as a binder for colours.

In general, the economy of the Buddhist monasteries – where wealthy donations were collected – doubtless favoured the growth of the city. Decadence of both the city and the monasteries proceeded initially at the same rate, as can be seen at Amluk-dara. However, over time we see an increase in the Buddhist presence in the city as a reaction to the progressive decline of the urban

Previous page — A 3rd-century stela showing the goddess Hārītī, from Temple B at Barikot in the Swat valley.

Below — View from the Malakand Pass, leading into the Swat valley and routes north.

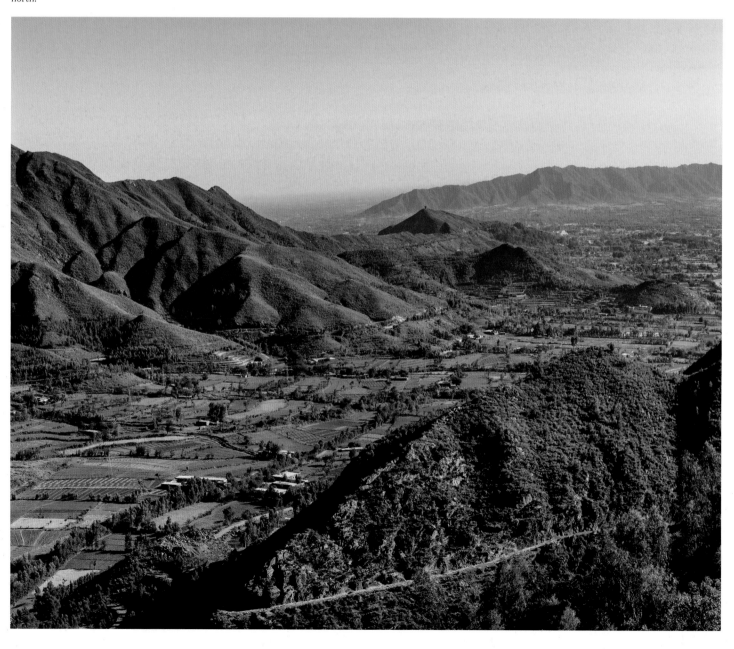

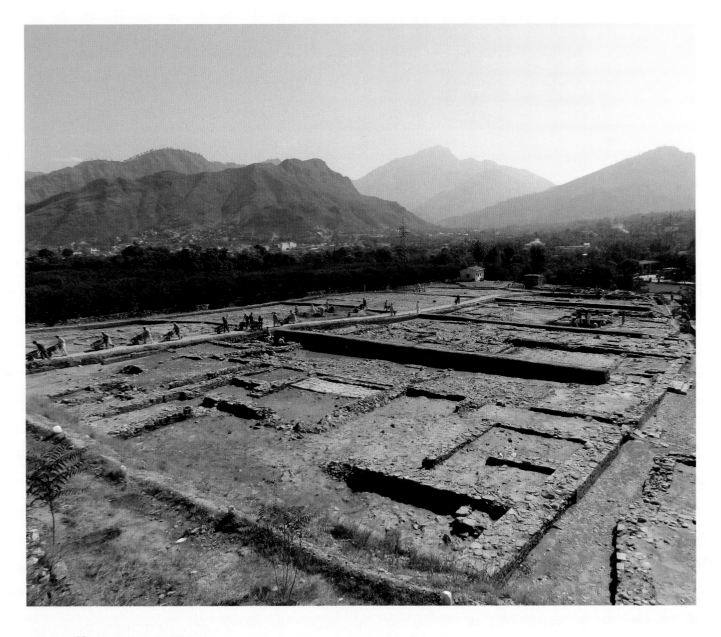

Gandhāran cities: a heartland of Buddhism

New chronologies and evidence dating to the mid-1st millennium BCE at Barikot may have an important impact on the reconstruction of ancient Gandhāra. The spread of a second urbanization phase in Gandhāra began in the 6th century BCE as it became a satrapy under Achaemenid rule (550–330 BCE) and lasted until the end of the Kushan empire in the mid-3rd century CE. It was in this period that urban centres were established anew. Apart from at the important southern regional centres (Kandahar and Akra), archaeology has revealed the existence of two major regional metropolises in Gandhāra, to the east and west of the Indus river respectively: Puskhalavati and Bhir Mound (Taxila). An important sub-regional trade centre in the Swat highlands was Bazira (Barikot), pictured above.

A major effect of the establishment of the Gandhāra satrapy was the development of inter-regional exchanges. The early presence of specialized craftsmanship areas linked to the production of faience, glass, copper-smelting and iron-smithing is attested at Bazira. Interestingly, it was only in this period that Indo-Gangetic pottery forms, which were already present at Bhir Mound, started to be used at Puskhalavati and Bazira, overcoming local traditions. On the other hand, a ceramic marker of the Achaemenid world, so-called tulip-bowls, became common in the territories immediately west of the Indus and at Taxila. LO

Further reading: Olivieri & Iori 2019; Petrie & Magee 2014.

Amluk-dara: a Buddhist stupa in the Swat valley

Amluk-dara is a Buddhist sacred area at the foot of Mount Ilam (ancient Aornos), a short distance southeast of Barikot in the Swat valley. The main stupa of Amluk-dara is square in plan with a double stairway on its north side, and was originally approximately 32 m (105 ft) high. It was built around the 2nd century CE and remained in use until the 7th to 8th centuries. Archaeological work on the site includes that carried out by Aurel Stein (1862–1943) in 1926 as well as by an Italian team in 2012.

The podium (with moulded base) is decorated with Gandhāran-Corinthian pilasters surmounted by capitals with modillions, topped by brackets supporting projecting slabs, as shown in the plan. The presence of cornices of coping slabs supported by cyma reversa brackets on each storey of the stupa suggests that all the areas below the cornices were originally painted. The entire surface was plastered.

The stupa was modified throughout its life. It originally had a grey-bluish schist decoration, which was replaced with *kanjur* (limestone) after the mid-3rd century. The staircase was rebuilt, perhaps after an earthquake: the new flight of steps was built on top of the damaged ones and so the staircase became longer, and its inclination changed. In around the 7th century, a pent-roofed shrine was built in the middle of the steps. The main stupa continued to be used, even when more than half the height of its first storey had become buried. LMO

Further reading: Faccenna & Spagnesi 2014; Olivieri 2018; Stein 1930; Whitfield 2018.

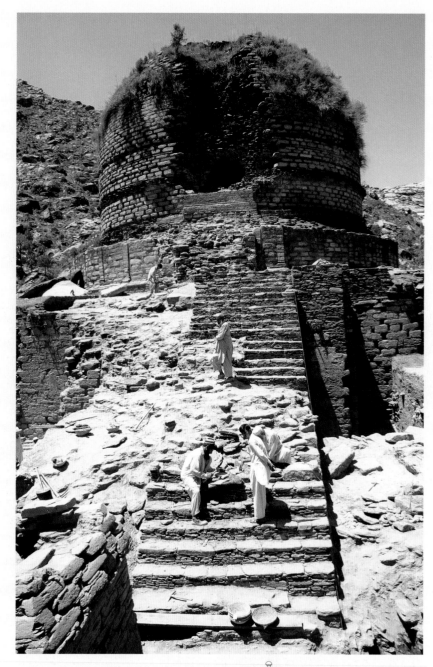

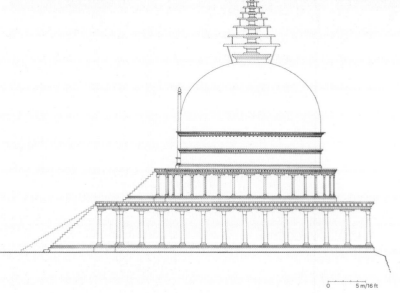

0 5 m/16 ft

elites. Entire residential units were transformed into cultic units. This might also suggest a progressive shift of ownership alongside the growth of the monastic properties both in the city and in its environs.

Cities began to fall as part of a major crisis of urbanism over northern India in the mid-3rd century, and as a by-product of the decline of the elites following the collapse of the Kushan with the incursions of the Sasanians (224–651). A general economic crisis may be inferred from the closure of the major schist quarry areas, which had a severe impact on sculptural stone production [*see* box on p. 204], as well as from both the decline of the

metallic value of Late Kushan coinage and the diffusion of locally minted copper issues (so-called sub-Kushan coins). The latter may be related to the relative scarcity of copper due to the decline of mining activity in the upper Swat. It is likely that during this period monasteries were far wealthier than the urbanite elites. When cities collapsed the land property probably changed hands and monasteries became the major landlords and the true pivot of the agrarian economy. The Buddhist communities therefore not only managed to cope with the general crisis of the 3rd century, but also expanded their presence in the upper mountain territories, thereby acquiring control of regional

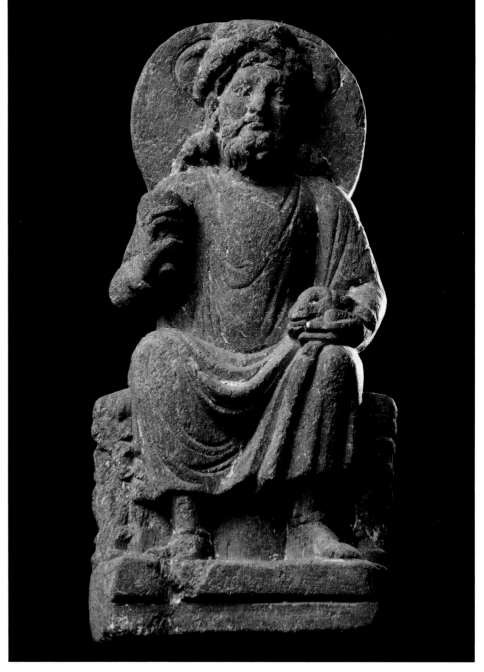

Above — Copper didrachm coin of the Kushan king, Wima Takto (*c.* 90–113), found at Barikot. The reverse shows the king on horseback with the Greek inscription 'The King of Kings, Great Saviour'. Begram mint.

Right — Deity with chalice and severed goat's head, from Dwelling D, Barikot, and dating to the 3rd century.

routes, mountain passes, springs, summer pastures and forests. It was at this time that the Buddhist communities progressively intruded into the ecological space of the rural tribes who, as shown by their rock art, had not converted to Buddhism.

From the 4th to 5th centuries, Buddhist monasteries also saw a progressive decline. The rural non-Buddhist communities probably started regaining control of the pastures and the passes, thereby bringing about a new transformation of the economy (from agriculture to pastoralism), as well as of the landscape.

Further reading: Olivieri 2018a; Olivieri & Filigenzi 2018.

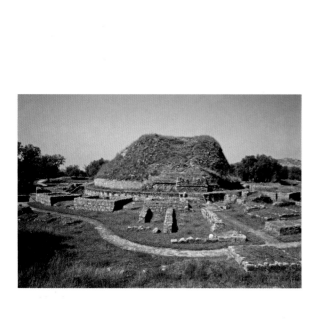

Dharmarajika Stupa at Taxila, dating from the 2nd century.

The city ruins of Bhir mound (Taxila).

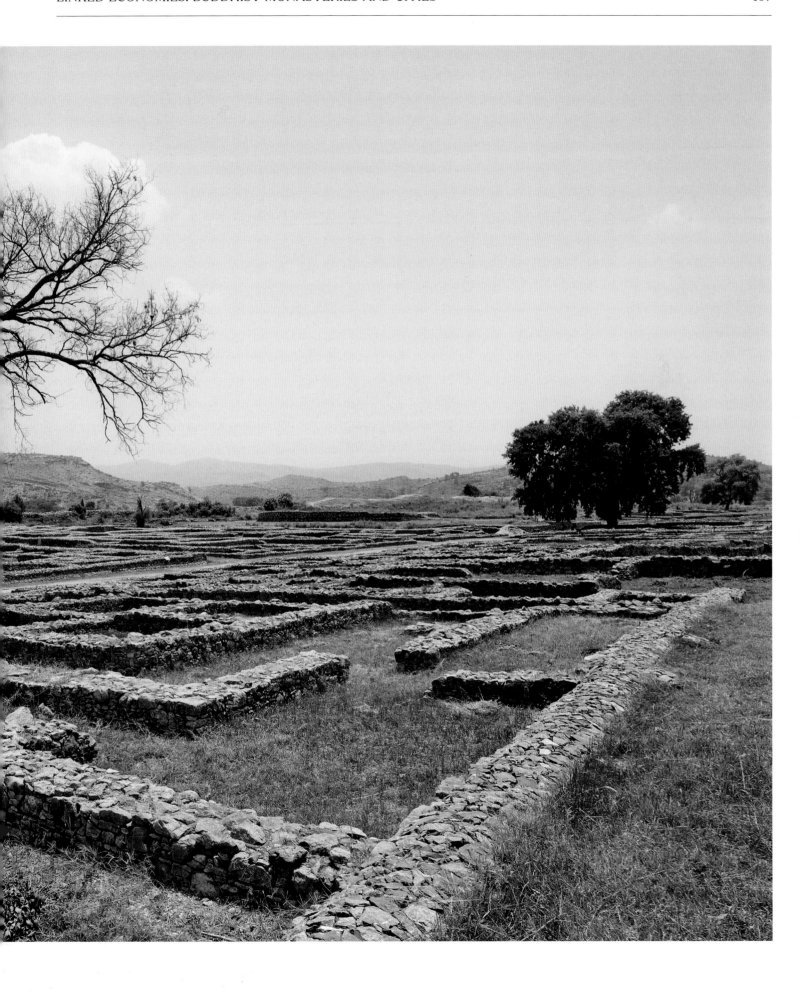

Christian monasticism in Africa and Asia

Karel C. Innemée

It is almost impossible to pinpoint the origins of Christian monasticism in time and place. Recently it was common opinion that it started in 4th-century Egypt, where Antony (251–356) was considered to be the founder of anchoretic monasticism, while Pachomius (292–348) was credited with the foundation of the first monasteries stressing community life. But this theory turned out to be too simplified.

Since Christian monasticism has been extremely pluriform from the beginning and must have gained popularity in various regions simultaneously (especially in Egypt and the eastern Mediterranean), it is more correct to speak of 'the monastic movement' than a single point of origin.

Early monasticism has a number of aspects that could be represented as partially overlapping spheres, but a clear definition of what it actually comprised is difficult to give. Withdrawal from society and asceticism are two of these spheres, but neither are exclusive to monasticism. Asceticism, abstinence and celibacy have been advocated by various authors, Christian and non-Christian,

and for many, such as Origen (c. 184–c. 253) and Athanasius (c. 297–373), they were considered a virtue. *Anachoresis* (Greek for 'withdrawal') is the root of the word anchorite, meaning a religious recluse, but not all those who turned their back on society in late antiquity did so for spiritual reasons. Some tried to escape from taxes or criminal prosecution, and Christians sometimes tried to avoid persecution in this way, while indeed many others saw a life of solitude as the only route to salvation of the soul, especially after the persecutions of Christians ended under Constantine (r. 306–337) and martyrdom as a guarantee for salvation thus ceased to exist.

Some anchorites preferred complete isolation, while others lived in loosely knit communities, spending most of their time in caves or makeshift cells and meeting once a week for a common liturgy. The degree of isolation and asceticism was a personal choice. Some would simply give away their possessions and live at the edge of society (so-called village hermits), trying to serve the community in one way or another, while others would go to extremes, such as living naked in the desert or chaining themselves to the top of a column, exposed to cold, heat and rain. Syrian anchorites were renowned for such extreme behaviour. Apart from the village hermits, who maintained some ties with society, a general ideal behind monasticism was 'being dead to the world', which meant not only severing ties with family and loved ones but also limiting one's biological functions to a minimum and avoiding emotions such as joy, pride and anger in order to reach a state of *apatheia* ('passionlessness'). Some anchorites, as is illustrated by certain sayings in the *Apophthegmata Patrum* (a collection of maxims by desert fathers dating to around the 5th century), would avoid judging the sins of others, even the most severe ones, in order not to disturb one's inner peace. This stands in contrast to some of the monasteries, where sanctions existed for even minor violations of the rules.

Previous spread — Jvari Monastery in Georgia, dating from the 6th century.

Bottom — The 6th-century Scetis monastery at Wadi El Natrun, Egypt.

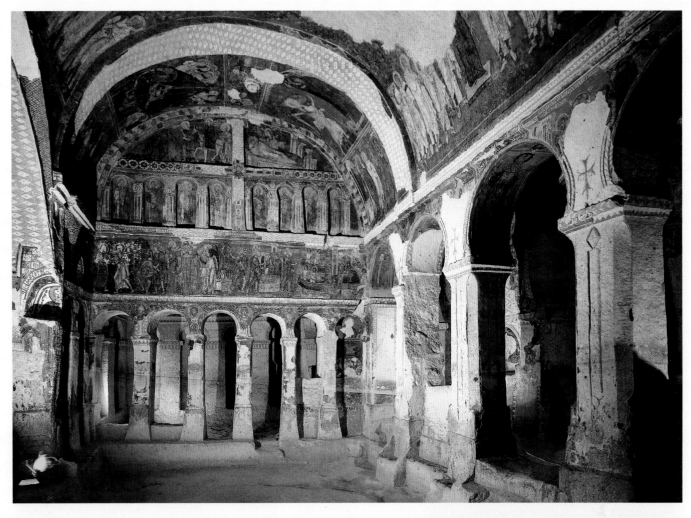

Tokalı Kilise: a Christian rock-cut church in Cappadocia

Carved into the volcanic stone of central Turkey between the 9th and 11th centuries, Tokalı Kilise was the principal church of a large monastic complex in Byzantine Cappadocia. This region had been home to Christian communities since the 4th century, the original anchorite followers of Basil of Caesarea (*c.* 330–379) cutting cells into the soft rock. Small churches were carved in the following centuries but the area was on the borders of the empire and subject to raids, especially from the Abbasid caliphate (750–1258) during their expansion in the 8th century.

The Byzantine empire (330–1453) secured the region during the 9th to 10th centuries and there was a subsequent growth in the Christian community. The original small 9th-century barrel-vaulted church was replaced by a much larger church in the 10th or 11th centuries. Murals in fresco technique covered the walls of both churches and showed the influence of the metropolitan style from Constantinople. Those in the newer church, pictured above, used expensive materials such as gold leaf and lapis lazuli pigments from central Asia [*see* pp. 182–87]. An inscription records the name of the master artist, Nikephorus, and his sponsors, Constantine and his son Leo. SW

Further reading: Epstein 1986; Ousterhout 2017; Rodley 2010.

Debre Damo: a Christian monastery in the Ethiopian highlands

The Axumite kingdom (*c.* 100–940) in east Africa became Christian under King Ezana (r. *c.* 333–*c.* 356). In the late 5th century, nine Christians travelled there from various parts of the Roman empire to avoid possible persecution after the Council of Chalcedon in 451. Among them was 'Aragawi Zä-Mika'el, the Elder Zä-Mika'el. According to his later – and often contradictory – biography, Zä-Mika'el was the son of a Roman prince. It states that at fourteen he became a monk with Pachomius (292–348) in Egypt.

The nine lived at the court for twelve years before separating to evangelize in the countryside.

Zä-Mika'el went with his mother and a disciple called Mattéwos to Eggala in the north. Here he decided to found a monastery on top of a steep-sided plateau. He was unable to climb the cliffs until a serpent, living on top, lowered his tail to pull him up.

The monastery was erected with the support of King Gabra Masqal (mid-6th century), a large ramp being constructed to transport the building materials. The ramp was removed upon completion, making the perilous cliff climb the only route up. Zä-Mika'el's biography also reports that his mother became part of the community, which suggests

there might also have been a nunnery, although women are now forbidden to climb the cliff.

Around 1940, a hoard of coins from the central Asian Kushan empire (1st to 3rd centuries CE) was discovered in the cliff [*see* box on p. 306]. SW

Further reading: Munro-Hay 2002; Phillipson 1998; Whitfield 2018.

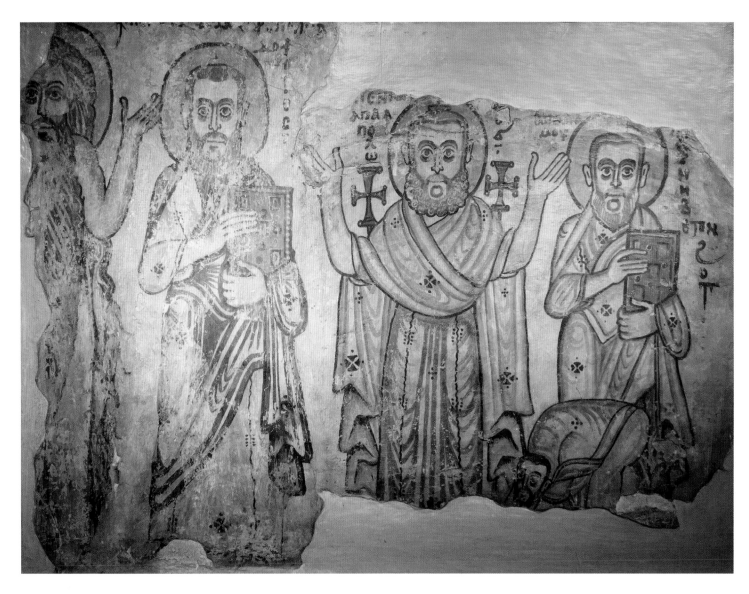

Mural showing the hermit
Saint Onuphrius (left) and others,
at the 6th- to 7th-century Christian
monastery of Apa Jeremiah at
Saqqara, Egypt.

Apart from the solitary anchorites and the monastic communities that lived by the rules of a founder – such as Pachomius (292–348) or Basil of Caesarea (c. 330–379) – in a sedentary way, there was also a class of wandering anchorites, who interpreted the duty of *imitatio Christi* (following the example of Jesus) by leading an itinerant life of preaching and praying, while depending on the generosity of the people they met for their sustenance. These mendicants, whose lifestyle was especially popular in the Syrian region in the 3rd and 4th centuries, came under increased criticism by the end of this period, when they were suspected of the heresy of Messalianism, the supposed belief that prayer only can bring salvation to the soul. Until the Council of Chalcedon (451), when all monastic communities and individual anchorites were placed under the supervision of bishops, the monastic movement was in fact an extra-ecclesiastical lay-movement, in which many were opposed to becoming consecrated priests, out of an attitude of utmost humility and egalitarianism. The Council of Chalcedon also restricted the freedom of movement of monks, thereby putting an end to the mendicant variety of monasticism in the eastern churches. The integration of the monastic movement into ecclesiastical structures also had consequences for the composition of monastic communities.

Where at first certain regions such as Sinai and Scetis attracted anchorites from various backgrounds (and for this reason could be suspected of being potential hotbeds of heresy), after Chalcedon monasteries and monastic communities became more and more dominated and controlled by the ecclesiastical authorities under whose supervision they fell. As a result, most were inhabited by monks adhering to one specific denomination.

With the eastern spread of Christianity across the Silk Roads by land and sea, monasticism followed, at first in its anchoretic form, and shortly afterwards in its communal, institutionalized form. East Africa, Cappadocia, Tur Abdin, Armenia, Georgia and finally regions beyond the former Roman–Persian border and into central Asia became centres of monasticism.

The sources of inspiration for Christian monasticism are as difficult to define as its place and time of birth. The Therapeutae, a Jewish community living close to Alexandria and mentioned in *De Vita Contemplativa*, a text ascribed to Philo of Alexandria (25 BCE–50 CE), has been proposed as such. Eusebius of Caesarea (263–339), in his *Historia Ecclesiastica* (2.16–17), mistakenly mentions them as Christian monks but no proof for a connection with real Christian monasticism has been found.

In the 3rd and 4th centuries the figure of the Buddha and rumours of his teachings were known in the Mediterranean region, judging from passages in the writings of Jerome (*c.* 347–420) in *Against Jovinianus* (I, 42) and Clement of Alexandria (150–215) in *Stromata* (I, 15). It is tempting to consider similarities between monastic traditions in both religions as indications for eastern influence on the west. Techniques of meditation, using repeated prayers or mantras and the control of breath and heartbeat, have been used in a comparable way by monks on the eastern and western sides of Eurasia. But Buddhism and Christianity have many more differences and a direct link seems unlikely. Seclusion, detachment from society and asceticism are attitudes that have taken root in various religions, with similar goals and using similar means.

———

Further reading: Caner 2002; Dunn 2003; Finn 2009; Laboa 2003; Rousseau 1999.

Christian church of Saint Simeon Stylites in Syria, named after the hermit and consecrated in 475.

176

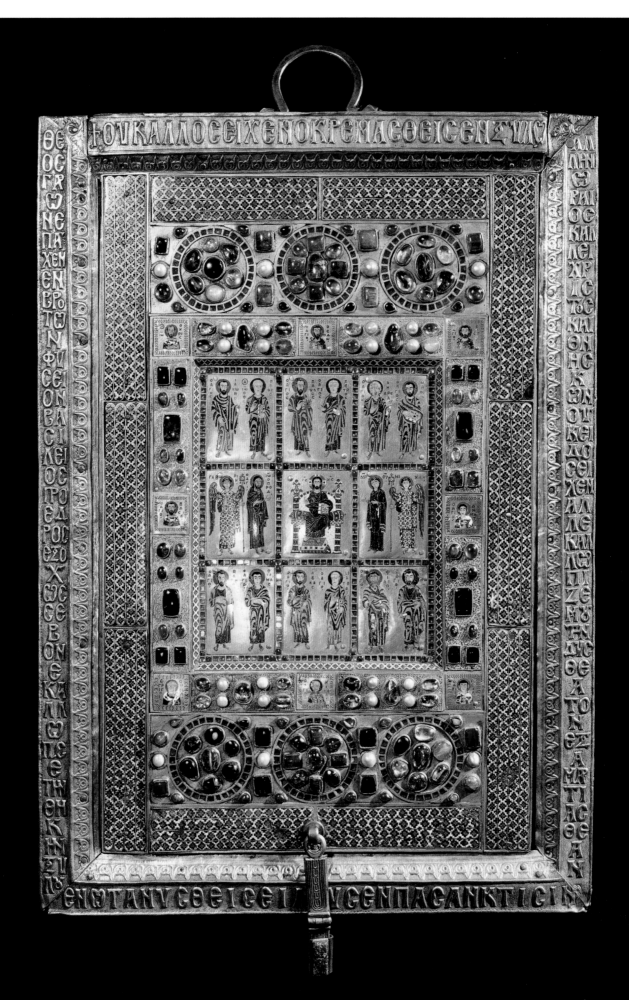

Revering the bones of the dead: relic worship in Buddhism and Christianity

Liu Xinru

As Buddhism and Christianity spread across Afro-Eurasia during the early 1st millennium CE, missionaries and pilgrims took religious messages, manuscripts and sacred relics to newly proselytized regions. While Buddhist pilgrims from central and east Asia travelled to India to seek the relics of the Buddha, Christians transferred relics throughout Europe of events concerned with the life of Jesus, such as parts of the True Cross, as well as remains of saints ranging from apostles such as Saint Peter to lesser-known martyrs.

There were striking similarities in the formality of the rituals of relic worship between the two religious traditions.

Śākyamuni (5th century BCE), the historical Buddha, did not name a successor of authority to his disciples. The community, called *sangha*, gathered periodically around stupas, earthen burial mounds covering the relics found after the cremation of Śākyamuni, to meditate and discuss doctrinal and disciplinary matters. While the *sangha* had no permanent residences, stupas remain as landmarks showing the extent of the spread of Buddhist teachings. King Aśoka (r. *c.* 268– *c.* 232 BCE) of the Maurya empire (*c.* 322–180 BCE), the first royal patron of Buddhism, had stupas built to promote the faith to the peripheral regions of his empire. By the beginning of the 1st millennium CE, Buddhism had spread northwest and stupas were built along the trade routes of the Hindu Kush and Pamirs [*see* box on p. 164]. From here the religion moved into the oasis kingdoms of the Tarim basin and into China. Chinese monks made pilgrimages to India and by the 7th century there was an itinerary with accommodation, and a guidebook was available. Meanwhile, Buddhism also spread south and across to Sri Lanka and southeast Asia by sea [*see* box on p. 158]. A monastery in the mountains of Sri Lanka held Buddha's tooth relics.

Buddhist pilgrims paid money to see and touch the relics. Monasteries decorated reliquaries with jewelry and draped stupas with silk banners inscribed with the names and images of the donors. Buddhist texts listed a standard set of seven precious materials, *saptaratna*, to donate to the Buddha and these were used to make and ornament the reliquaries: they were gold, silver, lapis lazuli, crystal, and various gemstones, such as lapis, agate and carnelian. Golden reliquaries decorated with gemstones have been found in stupa relic chambers from south, central and into east Asia. Many of the gemstones were mined in the mountains of central Asia and traded along the land and sea routes

Previous spread — Lid of the Limburg Staurotheke, a Christian reliquary of the True Cross made in Constantinople in the 10th century. Gilded silver with semi-precious stones.

Below — Christian reliquaries containing bones of Saints Stephen, James and Nicholas, from Halberstadt Cathedral Treasury in Germany. Gilded silver with semi-precious stones, made *c.* 1125.

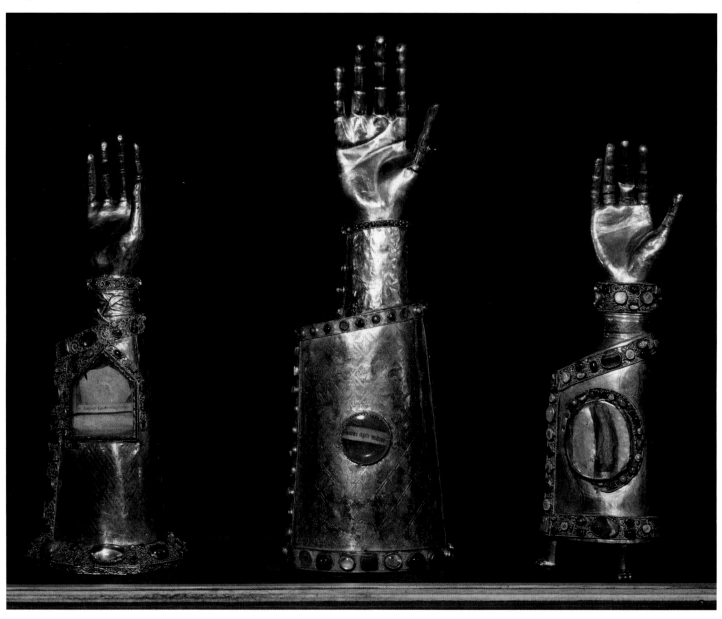

The Bimaran reliquary

This gold relic casket inlaid with garnets was discovered between 1833 and 1834 by the British explorer Charles Masson (1800–1853), in Stupa 2 in the village of Bimaran, northwest of Taxila. It is now in the British Museum (1900,0209.1). It was found inside an inscribed stone container, placed in a small relic chamber, an inscription upon which records the donation of relics by an individual called Śivarakṣida. Inside the casket and its container were several loose beads of semi-precious stones and organic materials, gold buttons, and a signet ring. The casket, 6.5 cm (2.6 in.) high, was lidless. The Buddha is depicted on it, flanked by two important south Asian deities, Brahma and Indra. Next to Indra is an unidentified figure with his hands raised in the gesture of worship. Each of the four figures, standing under an arched niche supported by pilasters, is depicted twice.

The date of the casket is generally interpreted on the basis of the four coins that were discovered next to the stone container. These coins have recently been attributed to Mujatria, the satrap who ruled the region in the last decades of the 1st century CE during the early Kushan period. Whether the casket and the coins were contemporary is still the subject of debate. If contemporary, this casket might provide one of the earliest known images of the Buddha [*see* box on p. 204]. WKR

Further reading: Baums 2012; Cribb 2019; Errington 2017.

Carved 2nd-century BCE relief showing the worship of a stupa. From the Great Stupa at Sanchi, India (*see* p. 145).

[*see* pp. 182–87]. Relic cults also travelled along with merchants on their camels and ships, and relics themselves could be bought and sold.

Many early Christians martyred under the Roman empire were canonized. Soon after Constantine (r. 306–337) stopped the persecution of Christians, patrons started the building of *martyria*, churches built to shelter the graves of martyrs or to commemorate an event in Christ's life. A few decades later, the practice started of relics being taken – or translated – to a church. As Christianity spread through Europe, successive popes dispatched bishops equipped with bibles, ritual robes and relics from one of the martyr saints

to establish new churches. Some Christian communities created their own saints from local martyrs or translated relics from sites in the eastern Mediterranean. Relics were traded, but also often smuggled or stolen, justified as an act having the consent of the saint. A church in Ethiopia, Maryam Seyon, claims to hold the most famous relic of Christianity, the Ark of the Covenant.

Christian reliquaries were also made of precious materials, often gold or silver decorated with gemstones. Inside the reliquaries, bone fragments were wrapped first in linen and then in pieces of fine silk from the Byzantine empire (330–1453)

or further east (*see* box on p. 142). Byzantine silk was also sought in Europe for vestments, regalia and banners for decorating church altars.

———

Further reading: Benard 1988; Brown 1982; Geary 1991; Liu 1996; Stargardt & Willis 2018.

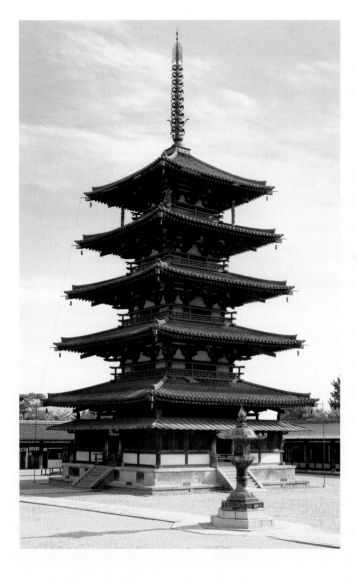

Hōryūji: a Buddhist temple in Japan

Hōryūji, established near the then imperial capital, Nara, is one of the earliest Buddhist monasteries in Japan. Shown here is the late 7th-century stupa – the building holding relics – located in the central cloister and lined up side-by-side along an east–west axis with the main Buddha hall of the multiple-cloistered monastery. This layout is rare but indicates the importance of relic worship. Buddhism had been brought from China through the Korean peninsula into Japan.

The stupa is in the form of a wooden pagoda, measuring 31.5 m (103 ft) from its base to the tip of the finial. Five storeys are marked by layers of eaves, but in fact the structure lacks intermediate floors on the inside. Instead, the entire stupa is supported by a central pillar. A small chamber is hollowed out of the foundation to hold relics. The form and decorative schema of the stupa followed the same transmission route, and similar construction details can be seen in 6th-century rock-cut architecture in north China. Inside the stupa at ground level is a sculpted Mount Meru, the Buddhist cosmic mountain, with scenes in each of the four cardinal directions, two from the life of the Buddha and two illustrating Buddhist sutras. PPH

Further reading: Mizuno 1965; Wong 2008.

Relics of Saint Caesarius of Arles

Belts with plaques and buckles made of precious materials, usually gold and silver, are found across the steppe [*see* box on p. 106] and became valued in many empires across Eurasia. This leather belt and ivory buckle, the latter 10 by 5 cm (4 by 2 in.), was among the relics of Caesarius (470–542), Bishop of Arles in France from 502. It might well have been a royal gift given by Theodoric (r. 475–526) when Caesarius visited him in Ravenna.

These were unsettled times in western Europe. Theodoric was born shortly after his people, the Ostrogoths, had finally defeated the Huns. He became king in 475, and defeated the Visigoths in 511. But, after his death, Arles was taken by the Merovingian Franks.

It is not known where this belt plaque was made. The buckle design of a fruiting grapevine is a Christian symbol, but is used in numerous contexts across Afro-Eurasia. The plaque depicts the Holy Sepulchre in the centre, with the gates of Jerusalem on either side. The sleeping soldiers evoke the scene of women visiting the tomb of Jesus to find it empty. Both African and south Asian ivory was in use by craftsmen along the Silk Roads, but rarely is the origin of ivory identified.

The proximity of this item to Caesarius's body conferred its status: it was found together with his sandals, a tunic and his *pallia*. It is now in the Musée Départemental de l'Arles Antique (FAN 92 00 2604). SW

Further reading: Aillagon 2008; Hahn 2012.

More precious than gold: lapis lazuli

Georgina Herrmann

Lapis lazuli is easily recognized by its characteristic solid blue colour, sometimes speckled with 'gold' flecks, which are actually iron pyrites or 'fool's gold'. Lapis lazuli is not a mineral but a rock, the principal component of which is lazurite, responsible for its blue colour. The shade of blue can vary from pale to dark, depending on the amounts of sodium and sulphur present.

The highest grade of lapis lazuli is a bright blue and consists of pure lazurite. The stone has a hardness of six on the Mohs scale and occurs in veins in bands of metamorphosed limestones or marbles.

Lapis lazuli is a comparatively rare stone, only occurring at about a dozen sites in the world, three of which are located in central Asia, one at Lake Baikal, one in the Pamirs and the best known and principal one in the Hindu Kush. Marco Polo (1254–1324), who visited the last in 1273, described its lapis as 'the finest in the world, and is got in a vein like silver' (1993: Bk.1, ch. 29]. The environment here is harsh, consisting of steep bare mountains with deep river valleys: vegetation is limited to small flat areas. The few, widely separated settlements are linked by rocky trails, open for less than half the year because of snow and ice. The mined stone has to be carried out by man or donkey.

There are four known mines in the Kerano-Munjan valley in the Hindu Kush, located at altitudes between 2,000 and 5,500 m (6,500 and 18,000 ft), although surveys by Russian and Afghan geologists have suggested that most of the mountain range may contain the stone. The source exploited in antiquity was at Sar-i-Sang ('Place of Stones'), a steep valley beside the Kokcha river. The ancient workings, located 330 m (1,100 ft) above the valley floor, consist of a series of lofty caverns, up to 50 m (165 ft) high, connected by narrow passages. The walls and roofs of these impressive caverns are covered by a thick deposit of black soot, proof of the ancient method of working: camelthorn and tamarisk twigs were piled against the rock face and lit. When the rock became hot, cold water was thrown on it, causing cracks that could then be worked to extract the stone.

Above — Detail of the Standard of Ur, a wooden box inlaid with shell, red limestone and lapis lazuli in Mesopotamia in 2600 BCE.

Overleaf — A lapis miner in the Hindu Kush in 2008.

A Byzantine lapis cameo

This Byzantine cameo (Musée du Louvre, OA MR 95), dating from the first half of the 12th century, is made from lapis lazuli with a gold filigree inlay. The mount, 10 cm by 6 cm (4 by 2.5 in.), is silver-gilt inlaid with pearls and turquoise held with wax. Rings around the edge of the frame originally held a string of pearls and the object also has a ring at the top, suggesting that it was worn on a chain around the neck.

The piece is unusual in Byzantine art both because of the materials used – stone inlaid with gold – and because of the juxtaposition of Jesus on one side and the Virgin Mary on the other. The source of the lapis was almost certainly the Hindu Kush in central Asia and the combination of gold with this rare stone makes it probable that this was a product of Constantinople [see box on p. 442]. However, at some point the cameo travelled to France, possibly as a gift taken by an emissary from the Byzantine court, in the same way as the Byzantine hunter silk [see box on p. 142], or looted during the Crusades. It is listed in the inventory of the Trésor de l'Abbaye de Saint-Denis in 1501.

The object's aesthetic – deep blue with gold and silver – is seen in other Christian as well as Buddhist and Islamic contexts, an example being the Blue Qur'an [see box on p. 264]. SW

Further reading: Evans & Wixon 1997.

Although there is no conclusive scientific proof because of the stone's variability, it is probable that the mine at Sar-i-Sang was that known and exploited in antiquity, providing this highly valued stone both to Mesopotamia and Egypt. Massive quantities of lapis were found in the tombs of the Royal Cemetery at Ur, where it was used for jewelry in a beautiful combination of lapis lazuli, carnelian and red gold, as well as for seals, amulets, statuettes, inlays, vessels and dagger handles. Since the stone probably came from a single source, its presence or absence from as early as the 5th millennium BCE reflects changing conditions in this extraordinarily long-distance trade. Blue glass is seen used as a substitute, presumably cheaper and an option for when supplies of lapis were unavailable.

Lapis lazuli is perhaps best known today for its use as a pigment in Renaissance Italy, where it was ground up to form a deep true blue, known as ultramarine, which was commonly used for the gown of Mary. This was one of the costliest of painting materials, only replaced by an artificial substitute in 1832. But lapis is also found in other Christian contexts, used for votive objects and to decorate shrines [*see* box on p. 171]. It was also listed as one of the Seven Treasures of Buddhism and is commonly found in Buddhist reliquaries.

——

Further reading: Finlay 2007; Herrmann 1968.

Left — Filippo Lippi's painting of c. 1483–84, *Madonna and Child*, typical of its time for using ultramarine, a blue pigment made from lapis lazuli, for Mary's robe.

Above — Lump of the treasured lapis lazuli stone, mined from the Hindu Kush.

Ores from the mountains: mining and metallurgy

Dmitriy Voyakin

Metallurgical technologies have always had an influence on a wide range of human activities. Their development ensured progress in agriculture, weaving, woodworking, the leather and wool industries, jewelry-making and mining. Military development also depended on high-quality weaponry and, therefore, a high level of skill in metallurgy.

Metalwork is a well-organized craft dependant on a complex structure for metal production as well as links with various groups of artisans and others, such as miners, metallurgists, blacksmiths and customers.

Unfortunately, most extant metal artifacts, which form the basis for the study of ancient metallurgy and blacksmithery, are in such a corroded state that sometimes it is hard even to establish their form. Nevertheless, it is possible to estimate the level of metallurgy and blacksmithery across central Asia during the Silk Road period.

The mountains of central Asia are rich in gold, silver, tin, mercury and other non-ferrous metals,

as well as turquoise and other minerals, a point noted by the 10th-century geographer, al-Iṣṭakhrī. As for iron, he wrote that there were 'so many iron mines in the country that the supply [of iron] is higher than the demand' (2014: 312–13). Geologists and archaeologists continue to discover small ancient exploratory excavations, as well as more major shafts and pits used in large-scale production.

The remoteness of the sources of raw material from the main production sites and markets led to the formation of a basic iron production process consisting of the following elements: a source of the raw material (mines); preliminary processing sites; transportation routes for the semi-manufactured

articles; and blacksmiths' workshops. There were three main end products, iron, cast iron and steel.

Cast iron – which involved the production of a finished item through the pouring of liquid metal into a mould – occupied a special place in the metalworking tradition of central Asia. The discovery of numerous cast iron artifacts, including oil lamps, cauldrons and plough blades, testifies that central Asian craftsmen had mastered the complex methods of controlling cast iron's physical and chemical properties. Recent dating work indicates that cast iron production centres have existed in central Asia since the early 1st millennium CE. This is supported by the *Hanshu*, the Chinese history of the Western Han (206 BCE–25 CE), which mentions that the mining industry was quite developed in central Asia. It further notes that gold and silver were taken from China to Fergana, where these metals were used to produce artifacts, but not coins. At this time, the history records, the people of Fergana were not familiar with all iron ore processing methods, such as those used to make cast iron, and officials from the Chinese embassy of Zhang Qian (164–113 BCE) had to teach them.

It is significant to note that the vast area covering central Asia and the eastern steppe had a long-established and unique iron tradition based primarily on technology using a furnace for smelting that produces a product of iron and slag called a bloom. This tradition is in strong contrast to

The Hippolytus Ewer, a gilt silver Roman vessel of the late 4th or early 5th century from the Sevso Treasure (*see* box on pp. 192–93).

the Chinese style of cast iron-based technology. An important recent development is the confirmation that cast iron was used in pastoralist communities in the eastern steppe from early periods, although on a smaller scale and as a supplement. This observation raises questions regarding the origin of such cast iron objects – were they domestically produced or imported from China? Regardless of the answer, there is no doubt that communities in central Asia and the eastern steppe were fully aware of the presence of cast iron along with the various methods required to control its properties. It could be suggested that their preference for bloomery-based technology did not result from lack of technological skill but was a deliberate selection based on their social, political, ecological, demographic, geological and technological environment as well as a long-established infrastructure. Central Asian cast iron production continued without interruption for almost 2,000 years until the 19th century.

Cast iron artifacts from central Asia also shed light upon the study of fuel used in metal production. Until recently, charcoal was regarded as the basic fuel. However, analysis of the structure of cast iron items has shown that there the main melting element was actually coal. Certainly, coal was known since very ancient times, a fact supported by written sources which state that 'black stones which burn as well as charcoal' were found in Bukhara and Fergana (Mez 1973). So it is clear now that coal was not regarded as a rare natural marvel, but was used by medieval craftsmen to produce metal.

Among the types of steel found is a ledeburite (crucible) hyper-carbon steel with a striated structure. Such steel is known in southern India from the 6th century BCE and was shipped to Syria, hence it is also called Damascus steel. It is probable that the technology travelled from south to central Asia. It is yet more interesting to find out that such steel was used for the production of ordinary household items. The analysis of a pair of scissors and a chisel from a collection of metal items found at Talgar, a medieval town near Almaty, shows that these simple tools were made from this valuable and expensive alloy.

A 10th-century sword found in the Rosenlund grave in Scandinavia, with Ulfberht engraved in the blade. This was a name used by several blacksmiths in northern Europe, some using steel imported from central Asia.

The general picture of the development of metal production and blacksmithery in central Asia indicates that it was at a high level and shows how rapidly and widely technologies and innovations could spread, primarily along the trade routes. At the same time, the techniques also show characteristic features specific to individual historico-cultural areas within this vast region.

Central Asia is known to have been crossed by major continental trade routes, with iron articles, weaponry and semi-manufactured goods carried along them. According to sources, from the 4th to 6th centuries CE the entire regional economy and army depended on Turkic metallurgists living near mines in the Altai mountains. They presented both raw iron and iron artifacts to the Avars (567–822) in the Caucasus. In the 6th century, a Byzantine embassy to the Turkic court, reported back that the khagan had suggested that Byzantium buy iron from the Turkic peoples as they had mines and furnaces, smelting iron and trading in both semi-manufactured and finished articles.

When they invaded central Asia, the Arabs were impressed by the quality of the weapons and armour of the Sogdians, Ferganans, the people of Chach and the Turks. And iron weaponry manufactured in Fergana was so popular that it was exported as far as Mesopotamia.

———

Further reading: Gavrilov 1928; al-Iṣṭakhrī 2014; Jettmar 1970; Linduff & Mei 2008; Masson 1953; Mez 1973; Papahrist 1985.

A 5th–4th-century BCE iron foundry mould for casting socketed axes. Excavated in 1953 from Xinglong, north China plains.

Ewers across the Silk Roads

The silver pear-shaped ewer is documented in regions as diverse as the eastern Mediterranean world, Sasanian Iran, Bactrian and Sogdian central Asia and western China. Its presence in these geographically and culturally diverse regions demonstrates both the movement of luxury items along trade routes as well as the exchange and adaptation of forms and iconography between cultures. While it is difficult to establish a chronology and place of manufacture for these vessels due to the lack of meaningful archaeological context, their changing form demonstrates how artistic styles were assimilated and given meaning in new cultural contexts.

Some of the distinctive features of these ewers, such as the pear-shaped body, mouldings at the neck and above the high foot, and the curving handle with decorative terminals including a thumb rest, have prototypes occurring in Roman examples from the 4th century CE. The Hippolytus Ewer, illustrated on p. 189, a partially gilded and lavishly decorated Roman vessel of the late 4th or early 5th centuries and now in the Hungarian National Museum (Sevso Treasure), perfectly exhibits the features that came to influence examples along the Silk Road. One of the largest of its kind at 57.3 cm (22.6 in.) tall, distinctive components include the convex neck moulding in the form of an oak wreath, beading around the mouth and foot, the lion-shaped thumb-piece and the handle terminating in the heads of a male and female goat at the rim and a muse emerging from an acanthus leaf at its base. The body of the vessel, decorated in repoussé relief and divided into three registers, depicts a mythological hunting scene with centaurs, a traditional hunt with boars and lions and images from the story of Hippolytus and Phaedra. Scenes of the hunt, stories of love and mythological heroes were favoured design elements on late Roman silver. Such images not only alluded to popular stories and themes but also displayed a knowledge of literary traditions and forged a connection to a Greco-Roman past.

It is clear that a number of distinctive localized centres in Sasanian Iran, Bactria and Sogdiana were producing versions of the Roman ewer by the 6th century. While such vessels have their antecedents in Roman styles, it is uncertain whether the distinctive ewer shape was first adopted in Sasanian Iran or in neighbouring areas to the east such as Bactria. Regardless, shared features and variations in form and imagery attest to the increasing cultural contact throughout these regions.

The silver-gilt vessel shown right, 34.2 cm (13.5 in.) high and now in the Metropolitan Museum of Art (67.10), is one of a small number of Sasanian ewers attributed to the 6th and 7th centuries. Specific features differentiate Sasanian examples and suggest their profile and design became standardized. In contrast to the Hippolytus Ewer, the decoration surrounds the vessel rather than dividing the body into a number of horizontal registers. The thumb-piece, in the form of a decorative ball, does not exceed the height of the vessel and the handles terminate in the heads of onagers. This ewer belongs to a group of silver-gilt vessels decorated with female figures incorporating symbols relevant to the social and religious aspects of banqueting and festivities in the Sasanian world. The design, once again, draws inspiration from the Mediterranean world, particularly Dionysiac motifs associated with celebration and drinking ceremonies, such as the feline drinking from a ewer. The maenads of Dionysus and representations of the Roman seasons influenced the female form, as did the curvaceous *yakśi* of India. They have, however, been transformed into an image that is identifiably Sasanian.

Such imagery stands in contrast to the Greco-Roman motifs of heroic tales and divinities that persisted in the Bactrian region. This influence may be seen on a ewer, 37.5 cm (14.8 in.) high, found in northwest China in the tomb of Li Xian (d. 569) and now in the Guyuan Museum, pictured opposite left. It is likely this ewer was manufactured in Bactria, possibly during the time of Hephthalite rule (*c.* 450–*c.* 560), and it belongs to a group of vessels that emulated Sasanian as well as Roman and Greco-Bactrian silverware. While the

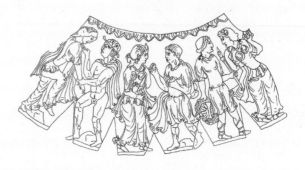

form of this vessel is comparable to the Sasanian ewers, late Roman influences include the fluted neck and foot, beaded decoration on the base of the foot and the mouldings and the decorative thumb-piece in the form of a human head. The frieze, as seen in the line drawing opposite, shows scenes from the Trojan war.

The vessel reflects the strong Hellenistic influence in this area from the Seleucid empire (312 BCE–32 CE) and the Greco-Bactrian kingdom (256–125 BCE). The popularity of Greek mythology and literature is reflected in the imagery from the Trojan war, although iconographic and stylistic differences indicate that this was misunderstood and far removed

from its original source by the 5th or 6th century. The terminals of the handle are decorated with the heads of Bactrian camels, a feature reflective of a central Asian influence, further adding to this stylistic combination.

A winged camel with a freely curving plumed tail and a billowing scarf draped over its leg appears on a Sogdian silver-gilt ewer, 39.7 cm (15.6 in.) high, from the late 7th or early 8th century and now in the Hermitage Museum (S-11), shown above right. The winged camel has been connected to Verethragna, god of victory, and may have been symbolic of the bestowal of Royal Glory or good fortune. It belongs to a tradition of winged animals, sometimes in the form of composite creatures, identifiable

and meaningful in varied cultural contexts. The composition of the winged creature placed within a decorative roundel is reflective of Sasanian designs, particularly a late-Sasanian silver ewer depicting a *simurgh*, a winged bird from Iranian mythology.

The more bulbous body of the Sogdian ewer is indicative of eastern Mediterranean examples from the 4th and 5th centuries, and the way in which the handle attaches to the rim is similar to the Hippolytus Ewer. This is in contrast to Sasanian and Bactrian ewers, where the upper handle attaches to the body. The neck is decorated with an outlined floral motif within a ring-punched background, a feature later adopted by Tang (618–907) craftsmen in China.

While this vessel demonstrates motifs derived from Sasanian Iran, with antecedents in western styles, it is clear that Sogdian artists developed their own style and narrative content unique to their worldview. KMR

Further reading: Carter 1978; Compareti 2006, 2016; Harper 1971, 2001, 2006; Juliano & Lerner 2001; Leader-Newby 2004; Lukonin & Ivanov 2003; Mango & Bennett 1994; Marshak 1971, 2004; Masia-Radford 2013.

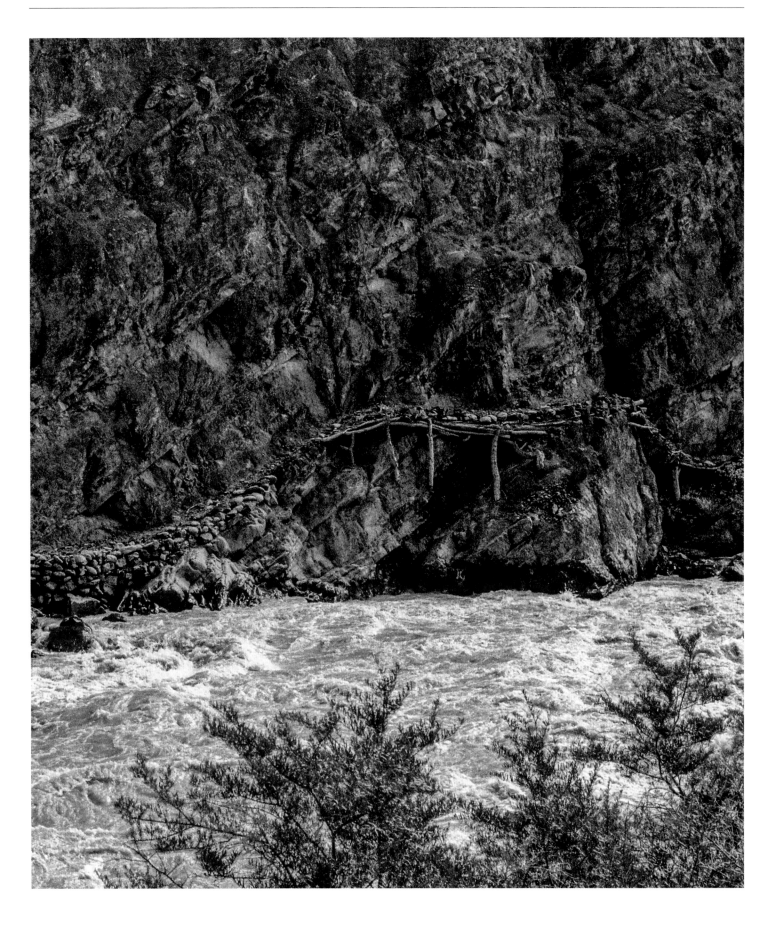

Above — A rafik, or overhanging
path, above the Karatash river in the
Kunlun mountains.

Overleaf — A scene from the
Avalokiteśvara sutra showing
merchants calling on the bodhisattva
for help when being robbed by bandits.
From Mogao Cave 45 at Dunhuang,
south wall, 650–780.

Precarious paths and snow-covered summits: traversing the mountains

Daniel C. Waugh

Travellers through the central Asian mountains can expect, even today, to encounter difficult terrain and often harsh climatic conditions, which can be successfully navigated only with careful planning, expertise in various modes of transport and the assistance in some cases of engineering to pass otherwise insurmountable obstacles.

While in some parts of the Silk Roads, complex infrastructure, such as paved roads and masonry bridges, was in place, in the mountainous areas roads as such were non-existent. Overcoming obstacles to movement relied very much on traditional wisdom and experience.

Travel had to be flexible, finding alternatives when preferred routes were blocked by nature, banditry or political events. Even though from the standpoint of many sedentary observers travel in the mountains was viewed with trepidation, those who frequented the routes would know of paths followed by wild animals fording rivers and leading over high passes, which could be followed in

favourable conditions. It is clear, for example, that there were several routes through the mountains from south into central Asia, evidenced by petroglyphs and other archaeological evidence attesting to their use by merchants and pilgrims.

Transport of loads on the most difficult paths might have been on the backs of porters, but animals were also used, especially those that were adapted to uneven footing, high altitudes and adverse weather. Camels were of limited value over the most demanding passes – their skills were in the desert – but ponies bred at altitude were often adapted well to such conditions; the practice of slitting their nostrils to aid breathing is still used

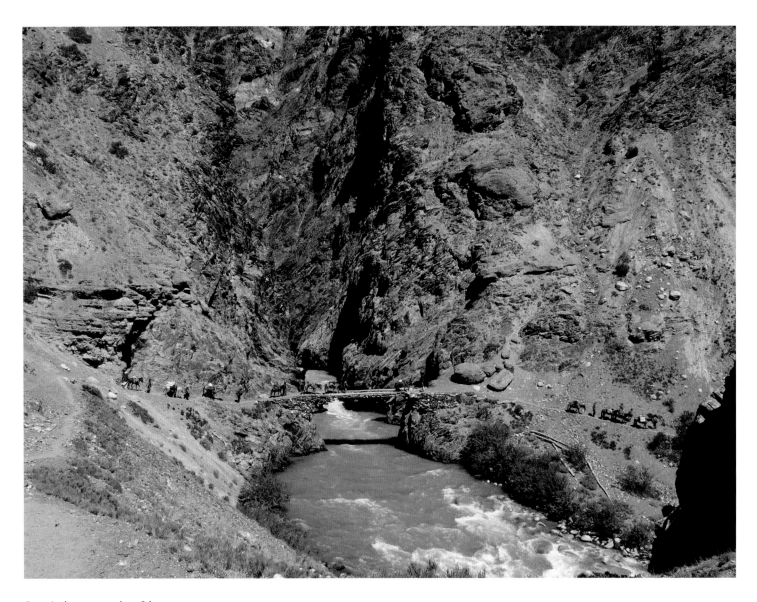

Gorge in the upper reaches of the
Amu Darya, in the Wakhan Pamir.

in the region today. Donkeys or mules were commonly used, the mule caravans even into modern times important for the tea trade between southwestern China and the Tibetan plateau. Salt sent from the plateau into India might cross the mountains in bags tied to the backs of sheep or goats. In the highest regions, given their strength and adaptation to altitude, yaks were common, and, as with camels, their wool and milk were important products.

Traversing the steepest slopes above gorges, impassable at river level due to the narrowness of the channel and the possibility of rapidly rising water caused by melting mountain ice and snow, often required the building and maintenance of overhanging paths. Called rafiks, these were made by driving stakes or stones into crevices and constructing a bridgework of sticks and stones on top. No complicated technical knowledge was needed for such construction, but they were fragile and precarious. River crossings were among the most fraught, and it was necessary to locate fords or in certain instances build cantilever bridges at narrow points using logs and stones. As with the mountain passes, travel through many river gorges was possible only during certain seasons. Even in benign weather, when passage through the mountains might be relatively easy, travellers would be aware of the dangers encountered by others before them, some of whom had drowned in flash floods, frozen to death in an unexpected blizzard or succumbed to altitude sickness.

———

Further reading: Ciolek 2012; Price et al. 2013.

Shatial:
travellers' graffiti

Among the numerous rock-carvings and inscriptions on boulders at Shatial near the banks of the Indus river in central Asia are more than 600 inscriptions in Sogdian, together with a few in other Middle Iranian languages (Bactrian, Middle Persian and Parthian). These inscriptions are very short, typically consisting of a personal name, with or without a patronymic or other personal details such as a family name. Nevertheless, they are important since they document the presence of Sogdians and others who came to this area during the 3rd to 5th centuries CE, almost certainly as traders rather than as pilgrims or missionaries.

The Sogdian inscription (36:38) illustrated right is by far the longest and most informative:

'(I), Nanai-vandak the (son of) Narisaf, came (here) in/on (the day/year) ten and asked a boon from the spirit of the sacred place Kart (that) I may arrive at Kharvandan very quickly and see (my) brother in good (health) with joy.'

Since Kharvandan is an old name of Tashkurgan on the route east from the Pamirs into the Tarim basin, this inscription shows that the Sogdian merchants traded not only between south Asia and their homeland to the northwest but also on the route northeast across the Karakoram mountains from south Asia to the Tarim basin and thence to China. NSW

Further reading: Sims-Williams 1989, 1992, 1996 and 1997–98.

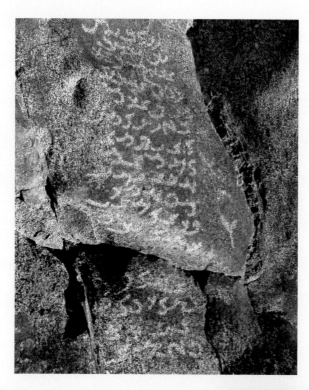

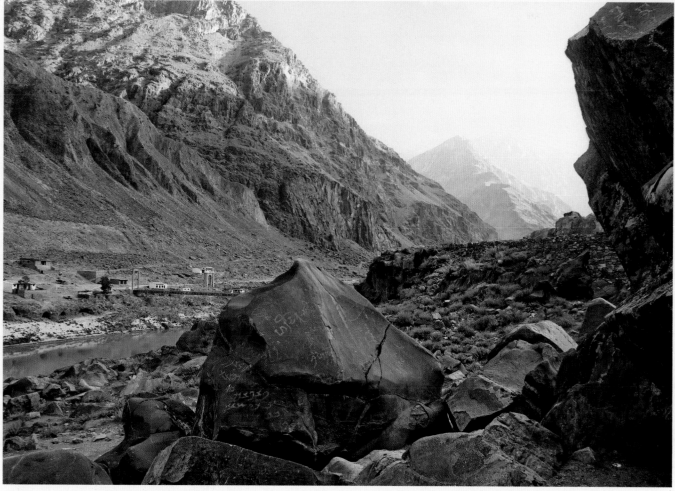

Sculpting men and gods: influences across Eurasia

Lukas Nickel

By the 1st millennium BCE, sculpture was a central element of the visual environment of north Africa, Europe and west Asia. Egyptian temples and tombs were adorned and filled with depictions of gods in human or animal form. Greek cities competed with each other, displaying holy figures in their public spaces and graveyards, and Achaemenid rulers employed sculpture to promote their claim to power. During the same period throughout Asia, however, the situation was different.

While all the cultures of the region developed various elaborate arts, the anthropomorphic image was largely absent. In China, for example, sculpture was hardly used before the late 3rd century BCE. Among all the highly developed Bronze Age cultures that flourished in China, there were only brief engagements with sculpture-making – including the Yin culture in the Yellow river valley and at Sanxingdui in the Sichuan basin, both dating from the end of the 2nd millennium BCE. In central Asia, sculpture is barely seen until the first contacts with Hellenistic art. And, for all we know, Indian artisans avoided the medium until the spread of Buddhism. Some peoples of the northern steppes occasionally erected so-called deer stones in front of high-ranking tombs, but beyond these instances did not develop sculptural art of any scale.

This situation seemed to change only with the conquests of Alexander (r. 336–323 BCE). Reaching Bactria and Sogdiana, he founded cities that were to flourish for centuries. Greek and Hellenic artisans, among them sculptors, followed in the wake of the armies and established workshops. Excavations in one of the cities founded in the 4th century BCE, Ai Khanoum, have revealed that sculpture in Hellenistic fashion was widely displayed in the public and private spheres. Non-Greek elites soon developed an interest in the new art medium.

Previous spread — Statues of soldiers
guarding the tomb of Qin Shi Huangdi
(r. 221–210 BCE), the earliest examples
of life-size statues in China.

Left — Deer stones at a ritual complex
in Uushigiin Uvur, eastern steppe,
dating from the 1st millennium BCE.

From the early 3rd century BCE onwards we find
sculpture adorning the citadel of Takhti Sangin
north of the Amu Darya, crowning the columns that
King Aśoka (r. *c.* 268– *c.* 232 BCE) erected across
northern India, and soon after, embellishing the
residence of Qin Shi Huangdi in China (r. 221–
210 BCE) and – in their thousands – populating his
mausoleum. The rise of the early Silk Roads was
marked most visibly by a dramatic spread of
sculpture eastwards.

In Greece sculptors worked mainly in bronze and
stone, while fired clay became the material of choice
along the coastline of the eastern Mediterranean.
In central Asia, many artisans turned to unfired clay
and stucco, materials well suited for the arid climate
of the region, such as seen at Takhti Sangin. Stucco
is a mixture of lime, sand and water, often mixed
with animal hair or plant fibres. It was applied over
a wooden scaffold or a clay core. Smaller figures
were often moulded, while features of large
sculptures were carved out of the semi-dry material.
Some monumental figures, such as the 5-m (16.5-ft)
tall Zeus statue from a temple in Ai Khanoum, was
made from clay on a wooden core with his head, feet
and hands carved from marble. When the Chinese
began making sculptures, they employed bronze
and terracotta, both materials they had successfully
been working with for millennia. The first

Ai Khanoum:
a Greek colony in central Asia

The only archaeological site in central Asia that corresponds entirely to what we might think of as a Greek colony is that known today as Ai Khanoum, situated in northeast Afghanistan on the border with Tajikistan. It was excavated from 1964 to 1978 by the Délégation Archéologique Française en Afghanistan under the direction of Paul Bernard.

According to archaeological evidence, it is almost certainly the city of Eucratidia mentioned by the Greek geographer Strabo (63 BCE–23 CE) as the capital of the last Greco-Bactrian king Eucratides (r. 171/5–145/8 BCE). It had been founded as a Seleucid colony in *c.* 290, under a name that remains unknown.

The site was selected because of several favourable factors: a large plain already irrigated in the Achaemenid period (550–330 BCE), a strategic position facing valleys that could serve as invasion corridors from the north, and access through the Kokcha river (then the Dargoidos) to the wood and mineral resources of the

Hindu Kush (a large quantity of unworked lapis lazuli [*see* pp. 182–87] was found in the palace). The defensive potential of the site (a plateau sheltered by a high acropolis on one side and rivers on the others) was exploited from the beginning, with a total fortified area of 135 hectares (330 acres), and a northern suburb also comprising monumental structures (see plan below).

Almost all the monuments were built of mud brick, the Greek element being mainly confined to the spectacular stone decoration (columns, pilasters, statues). One fifth of the lower town was occupied by the palace. The main temple was built according to Mesopotamian models; there is evidence of the cults of Zeus (the foot from his massive statue is shown below right) and Artemis, probably both syncretized with local deities. Other public monuments were the gymnasium and the theatre, also built of mud brick, and the arsenal.

Few inscriptions have been discovered, the most famous

being a copy of the Delphic maxims with a dedicatory poem. Contact with Hellenistic intellectual centres is also testified by fragments of a Greek philosophical papyrus that contained a hitherto unknown text by Aristotle or his school. FG

Further reading: Bernard 2008; Francfort et al. 2014; Martinez-Sève 2015.

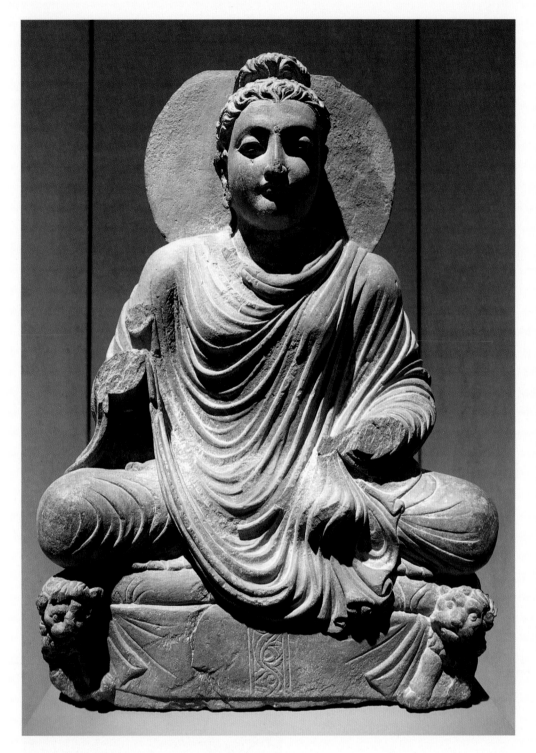

A Gandhāran Buddha

Gandhāran sculptors introduced the depiction of the Buddha in human form to Asian art [*see* box on p. 179]. Large numbers of seated or standing images were carved out of the local grey schist. In this piece, 52 cm (20.5 in.) high, dating from the 2nd to 3rd centuries and now at the Museum of Asian Art in Berlin (MAK.I.74), the Buddha is sitting cross-legged on a throne covered with cushions and framed by two lions, a reference to early Persian royal imagery. The lost right hand likely showed the gesture of fearlessness – *abhayamudrā* – while the similarly absent left hand probably held the hem of the figure's robe. Drapery folds in high relief cover both shoulders of the well-articulated body in a manner reminiscent of Hellenistic and Roman artistic practice. This type of seated Buddha image was popular among Gandhāran patrons and was carved in various versions. This example was found at Takht-i-Bahi, a large monastic complex spreading over several hilltops near Mardan. The site was active from the 1st century CE until it lost its influence during the 7th century [*see* pp. 160–68]. The Chinese pilgrim monk Xuanzang (602–664) described its stupa as the most impressive structure he had seen on his travels. LN

Further reading: Behrendt 2007; Ghose 2000; Härtel et al. 1982; Kunst 1985.

anthropomorphic stone sculptures emerged in the 2nd century BCE [see box on p. 67].

A second, perhaps more powerful wave of sculptural activity swept across central Asia from the middle of the 1st century CE, following the rise of the Kushans. In Gandhāra, craftsmen working for an affluent group of Buddhist patrons merged Roman sculptural concepts with Indian artistic practices and developed a tradition that remained active for several centuries. Gandhāran sculptors used widely available schist, a grey, fine-grained stone that proved easy to carve and polish. Some bronze images are also known, but from the 3rd century onwards figures were increasingly fashioned in stucco. As was the case in the Hellenistic and Roman worlds, sculpture in central and east Asia was generally painted in vivid colours.

Gandhāran workshops under Kushan rule adopted the practice of depicting the Buddha, as well as items and events associated with his life. The Gandhāran Buddha had a visible impact on figurative art in north India and the oasis towns of the Tarim basin [see boxes on pp. 138 and 157], as well as some of the earliest known depictions of the Buddha in China, those in the 2nd-century tombs of the Sichuan basin.

As lime, a crucial ingredient of stucco, was not always available in the oasis towns of the Tarim basin and the Hexi corridor, the majority of figures were made of clay mixed with fibres. The clay was built up around a wooden or reed frame, covered with a thin layer of stucco, and then painted.

In China, although Buddhism had been known since at least the 2nd century CE, few figures that may have been venerated as Buddhist icons seem to have been made before the mid-5th century. The ones we know of were usually cast in bronze using both traditional Chinese mould casting and lost-wax technology. Once the emperors of the Northern Wei (386–534) began publicly supporting Buddhism from about 460, the religion spread rapidly throughout their empire. They excavated monumental rock-cut temples such as Yungang and Longmen, and their subjects donated thousands of images to temples and monasteries that had sprung up in towns and cities.

Chinese craftsmen occasionally followed the example from the Tarim basin and used clay for their sculptures, as is known at the Yongning temple erected in 519 and from other sites in the Northern Wei capitals. For monumental statues the material of choice became stone, usually sandstone, limestone or marble. In later centuries, figures carved in wood, fashioned in lacquer or cast in iron also became widespread.

——

Further reading: Abe 2002; Bernard 2008; Huntingdon 2015; Nickel 2013; Rowland 1960; Xu 2001.

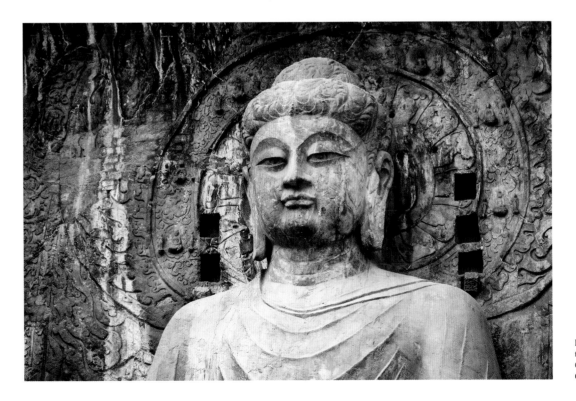

Large Buddha at the Buddhist rock-cut temple complex at Longmen, central China, carved in 676 on the order of the Chinese empress, Wu Zetian.

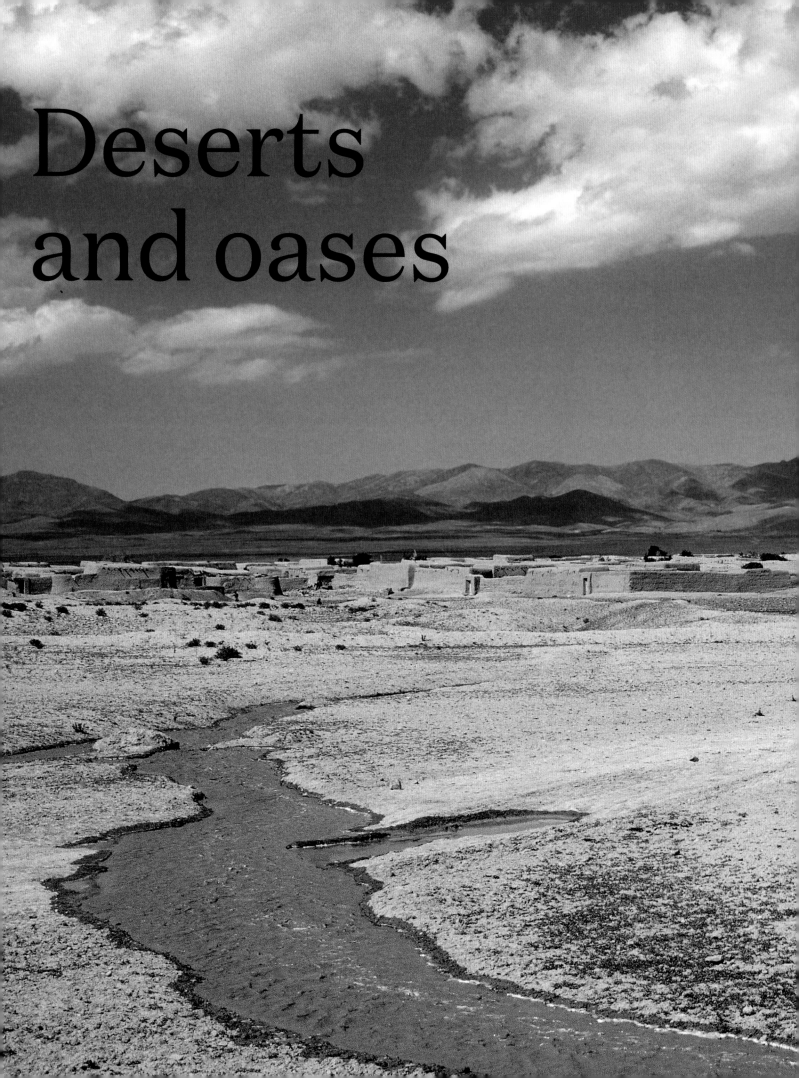

Deserts
and oases

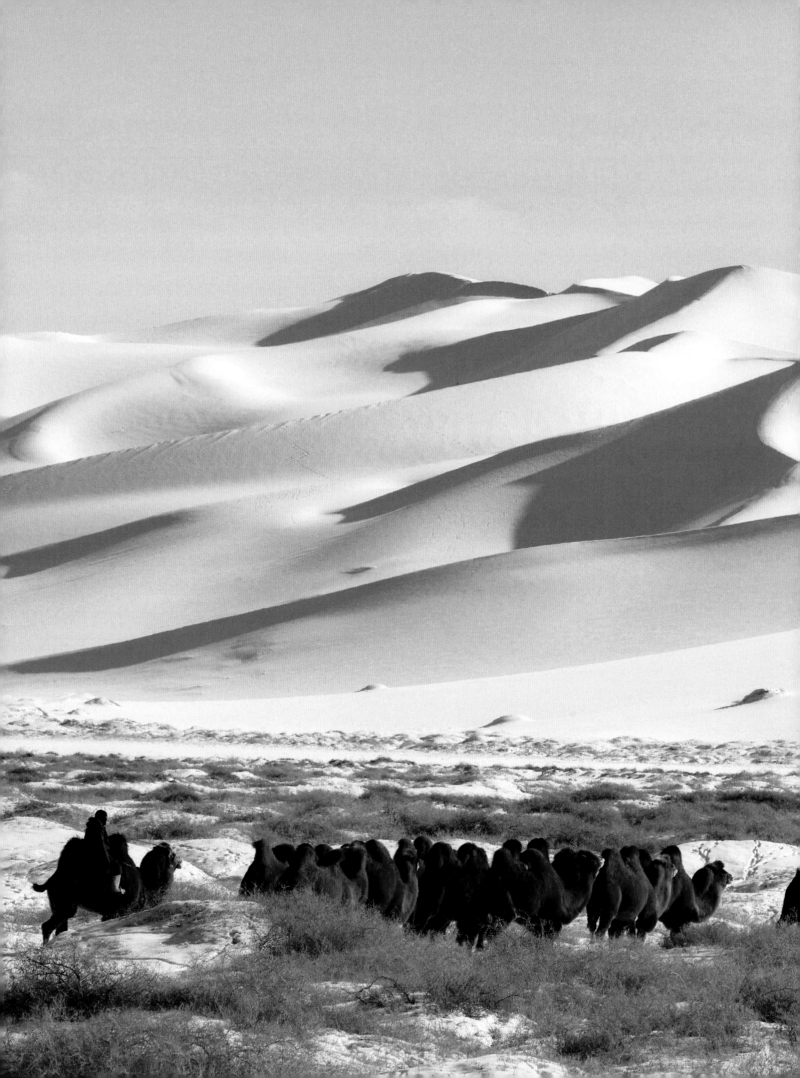

Deserts and oases

Previous pages — The mausoleum of Öljaitü (r. 1304–1316), ruler of the Ilkhanids, at their oasis capital Soltaniyeh, now a desert village.

Opposite — Bactrian camels in the snow-covered 'Singing Sands' in the Gobi desert, in the foothills of the Altai, Mongolia. The dunes resonate in the wind, hence their name.

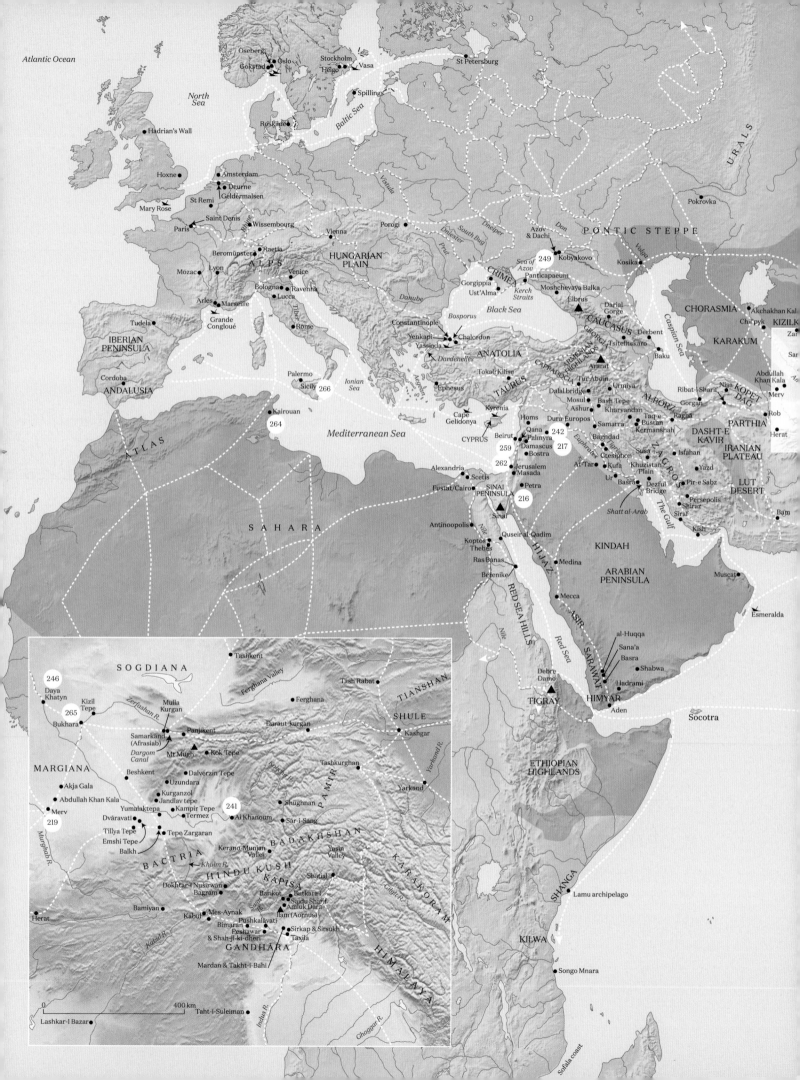

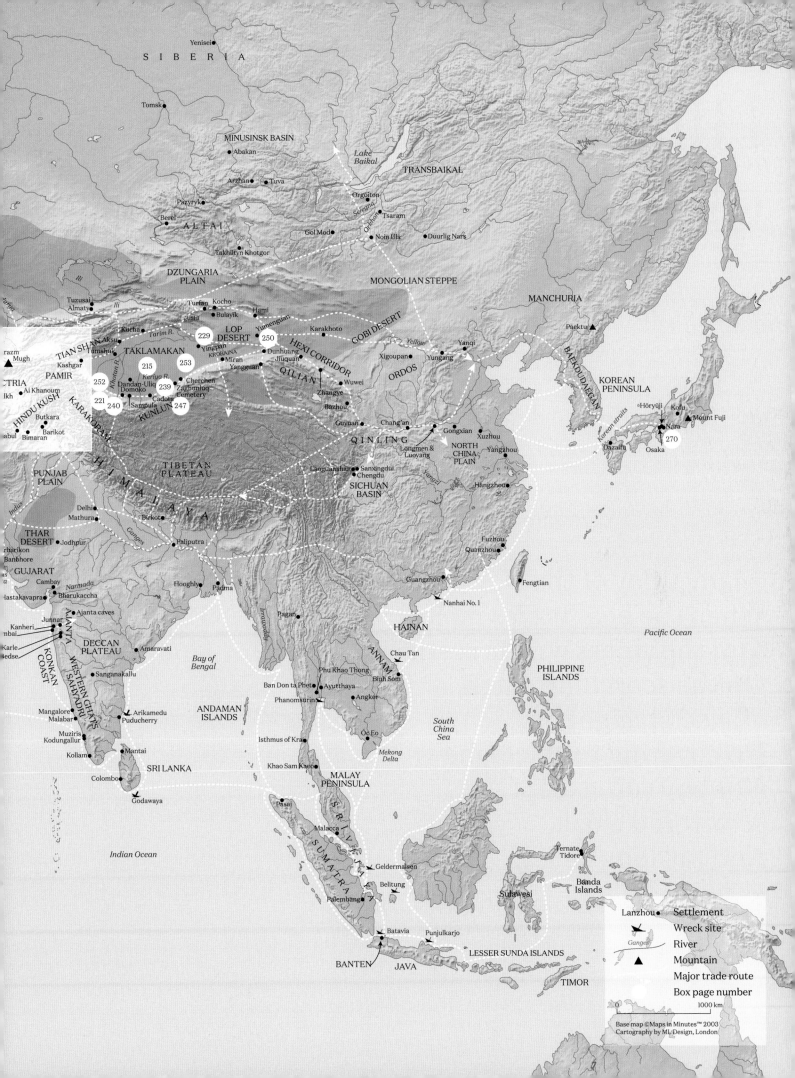

Hills and valleys of sand

Tim Williams

"Many a day of the Dog Star,
When the heat waves melt,
And the vipers writhe restlessly
On the scorching earth,
I faced straight on,
No covering to shield me
Nor any veil, except
A tattered cloak,
And full long hair...."

Al-Shanfarā (6th century), 'Lāmiyyat 'Al-Arab'.
Translated from the Arabic by Suzanne Pinckney Stetkevych.

Opposite — Black poplars with
their autumnal leaves in the
Taklamakan desert.

The deserts of Afro-Eurasia furnish the iconic image of so many Silk Road journeys: camel trains traversing the sands. However, there is a great complexity to desert forms, from the high plateau deserts surrounded by chains of mountains, such as the Gobi and the Taklamakan, to the lowland dunal deserts, such as the Karakum, and the great expanse of the Sahara. All have very different ecosystems and present different challenges to the people living in or around them, and of course to Silk Road travellers.

Dromedaries on the fringe of an oasis in the Sahara desert.

Few deserts are completely uninhabitable: while salt-encrusted lowlands are perhaps the most extreme, elsewhere even the most barren deserts often have seasonal vegetation, and many are home to complex flora and fauna.

Nevertheless, deserts provide some of the most hostile and challenging environments on earth, forcing travellers to make lengthy detours, or to carry enough water and fodder for the crossing. Navigational skills have always been vital. But for well-provisioned and well-led caravans, deserts provided routes of communication and travel, and many such routes could be relatively fast and efficient, especially those with hard, pebbly surfaces.

It is impossible to think about deserts without also considering the fertile oases that interspersed them. These range from small watering pools to vast river deltas, capable of supporting large populations. Human societies have also continually adapted to and challenged the desert, creatively using wells and underground water sources, channelled through tunnels (known as *qanāts* or *karez*), developing complex irrigation systems to take advantage of the meltwaters from

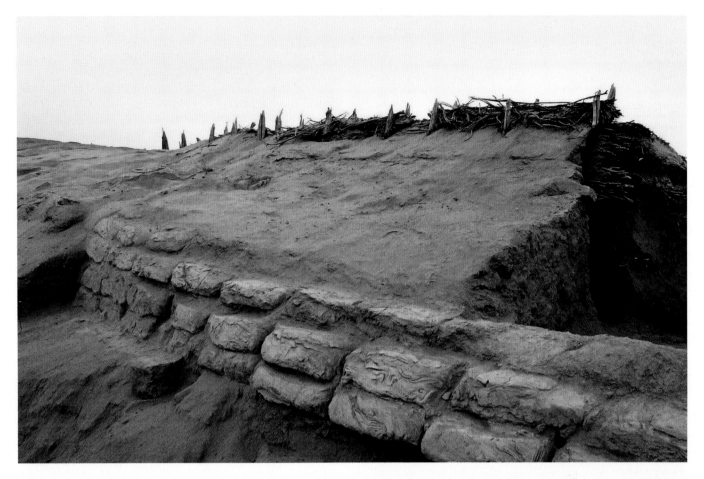

Keriya: river routes across the Taklamakan

The Keriya river, pictured above right, drains northwards from the Kunlun to the east of Khotan [*see* box on p. 221]. Once probably extending across the Taklamakan desert, it now soon disappears into the desert sands. An oasis settlement called Karadong was discovered in the early 20th century [*see* pp. 222–25] not far beyond where the river disappears. More recently, during a decade of archaeology, more sites have been discovered by the Sino-French Keriya Joint Archaeological Team deeper into the desert to the northwest.

At Karadong, the team discovered Buddhist shrines and houses, the former dating back to the first half of the 3rd century CE, as well as remains of an irrigation system surrounding the town. The Buddhist wall paintings and other artifacts show the region's links with the Kushan empire (1st to 3rd centuries) beyond the Pamirs to the west. Textile finds include woven and felted wool made from sheep, cashmere, mohair, goat and calf, as well as silk and cotton [*see* pp. 324–29].

Bronze Age remains, including a walled settlement, pictured top, and a cemetery, have since been discovered further to the northwest at Djoumboulak Koum, along the course of the ancient riverbed. IA

Further reading: Abduressul 2013; Debaine-Francfort & Abduressul 2001; Desrosiers & Debaine-Francfort 2016.

Petra's pools

Petra's ability to provide a constant potable water supply for its population of 20,000 with sufficient reserves for arrivals of large caravans and periods of drought in one of the driest and most desolate areas of southern Jordan was key to its centuries of prominence as the nexus city of a trade network across Afro-Eurasia for luxury goods.

Archaeological investigation of the city centre has revealed elaborate monumental architecture, including hundreds of tombs, royal burial structures, major temples, a treasury (below left), marketplace stalls, fountains, baths and a theatre, as well as a central garden pool area. All major structures were individually supplied with water through an elaborate distribution network. This relied on the capture of the sparse rainfall in over 350 basins and reservoirs, with elaborate dams to secure rainfall runoff, as well as four major springs that conducted water through long pipelines, a section of which is pictured below right, to the city centre. Of note is the early use of sophisticated hydraulic engineering principles; for example, the use of partial critical flow in the Ain Mousa pipeline provided both a maximum flow rate from the Zurraba reservoir source while eliminating pressurized leakage at the thousands of connecting joints. The use of multiple pipelines to serve key areas (the marketplace, royal housing and ceremonial areas) guaranteed a continuous water supply even if one of the pipelines failed. CO

Further reading: Morris & Wiggert 1972; Ortloff 2003; 2009; 2014, 2014a.

surrounding mountains, and canalizing rivers – all techniques to diversify and extend access to water so making larger areas of settlement sustainable [*see* pp. 236–43]. The location of oases was critical in determining routes. Better infrastructure – way-stations, caravanserais, watering holes, oases – allowed camels to carry goods instead of water, food and fodder for the caravan. As a result, political powers invested considerable resources in controlling desert routes and oases, maintaining water sources and constructing caravanserais to assist, control and profit from travellers [*see* pp. 244–55].

Some of the most significant deserts lie in central Asia, where the mountain chains to the south effectively block the Southern Ocean monsoon rains, while those to the north and west block the westerly rains that feed the steppe grasslands. These mountains create a rain shadow that forms large desert areas in the heart of the continent: from east to west, these include the Gobi, Lop, Taklamakan, Kizilkum and Karakum.

In the east, the vast Gobi straddles the boundary between the Mongolian steppe and the north China plain, and forms a considerable barrier, the limit of many empires. It mostly consists of exposed rock, rather than sand, and its northerly location and upland plateau setting (*c.* 900–1,500 m or 3,000–5,000 ft), give it an extreme climate: a cold desert in the winter, with frost and occasional snow, and reaching as low as -40 °C (-40 °F), but with temperatures of up to 45 °C (113 °F) in the summer. While the monsoons reach the southeast parts of the Gobi, the north is very dry. Nevertheless, the Gobi has been inhabited since prehistory, mostly by pastoralist groups.

Southwest of the Gobi is the Tarim basin, formed of the Lop and Taklamakan deserts, the latter one of the largest sandy deserts in the world, covering an area of *c.* 320,000 sq. km (125,000 sq. miles). The wind-borne sand is up to 300 m (1,000 ft) thick, with massive dune chains ranging from 30 to 150 m (100 to 500 ft) in height, and with some pyramidal dunes rising 200 to 300 m (650 to 1,000 ft).

The Taklamakan is flanked by high mountain ranges: the Tianshan to the north, the Kunlun to the south and the Pamirs to the west. To its northeast, the oasis of Turfan lies in a vast depression, covering some 50,000 sq. km (19,000 sq. miles), and one of the lowest points on earth. It receives very little rainfall and from antiquity its rich agriculture has depended on water from the Tianshan. Turfan became a major centre of long-distance trade, a vital stopping point for caravans heading west from China, east from central Asia and north from the steppe.

South of Turfan is the Lop desert, the end point of the Tarim river, which rises in the Karakoram mountains to the west and runs along the northern edge of the Taklamakan, before turning southeast. Its waters sustain a line of jungle that, up to the early

Palmyra: a desert-city

The Syrian desert-city of Palmyra grew from insignificant origins to become a major hub for the commerce between the Mediterranean and the Indian Ocean in the first three centuries CE. At the height of its power the queen of the city, Zenobia (*c.* 240–*c.* 274), was able to challenge the might of Rome with an attempt to install her son on the imperial throne. But Palmyra was sacked by the Romans in 273 CE. It remained a regional centre, but gradually declined until only a village was left inside the compound of the ancient Temple of Bel (pictured overleaf).

Due to its isolated situation, Palmyra was for a long time left relatively undisturbed. From the 17th century, however, an increasing number of European travellers found their way to the site, and Palmyra became justly famous for its spectacular ruins, shown here, and its artistic and architectural records, which combined Greco-Roman, Mesopotamian, Iranian, Syrian and Arabian traditions into a distinct and unique Palmyrene style. Excavations started in the early 20th century and continued until the start of the Syrian Civil War in 2011 [*see* pp. 222–25]. Palmyra was twice occupied by the forces of the Islamic State, who systematically destroyed the monuments, including the famous temples of Bel and Baal Shamin and the iconic funerary towers. EHS

Further reading: Kaizer 2002; Schmidt-Colinet 1995; Seland 2016; Sommer 2017.

20th century, was home to tigers. This and water from the Tianshan rivers, such as the Aksu, feeds the oasis settlements. The Taklamakan desert plain slopes down from south to north, and important rivers, such as the Khotan and Keriya rivers, draining off the Kunlun to the north, have created a number of oases and fertile valleys in the southern landscape, such as Khotan [see box on p. 221].

Moving further west, the Kizilkum ('Red Sand') desert, in modern-day Uzbekistan and Kazakhstan, lies between the Amu Darya and Syr Darya; while across the Amu Darya lies the Karakum ('Black Sand') desert, in modern-day Turkmenistan, extending as far as the Caspian Sea. Both form extensive plains, with numerous depressions and highlands, and mostly consisting of sand dunes, but also with large areas of *takirs* (shallow depressions, filled with a heavy clay soil, inundated during seasonal rains). Together, these deserts could have formed a major obstacle for the Silk Roads, but with major rivers intersecting them, and a series of fertile deltas and oases, such as Merv [see box opposite] and Bukhara, important routes developed. The careful management of water was vital to ensure control of the routes.

To the south, the Thar desert covers around 200,000 sq. km (75,000 sq. miles), lying south of the Indus river valley and forming a natural boundary between modern-day India and Pakistan. It mainly consists of large sand dunes, which are highly mobile due to strong pre-monsoon winds, with some large seasonal saltwater lakes. It is a well-populated region, despite the water scarcity, with settlements in the oases and along intermittent rivers, such as the Ghaggar, which bisect the area, as well as intermittent ponds used by pastoralist

communities. Irrigation enabled the development of strategically important oasis cities – such as Jodhpur, linking Delhi to Gujarat – which became important in the trade in copper, silk, sandalwood and opium.

Two important deserts in modern-day Iran were crucial in shaping the routes people used to connect central and south Asia with west Asia. The Lut desert, or Dasht-e Lut ('Emptiness Plain'), has extensive stony deserts and dune fields, but it is swept by strong winds, causing erosion on a huge scale that creates spectacular *yardangs* (corrugated ridges). The more northern Dasht-e Kavir ('Low Plain'), a sand and pebble desert, has seasonal lakes and riverbeds, with very hot temperatures causing extreme evaporation, leaving marshes and large salt crusts.

Further west, the Syrian desert is actually a combination of steppe and gravel desert, cut with occasional wadis (seasonal channels), covering nearly 500,000 sq. km (195,000 sq. miles). Numerous important oasis cities, such as Palmyra [see box on p. 217], and the crucial Euphrates river crossing at Dura-Europos, developed on the cross-desert routes. The Syrian desert merges to the south into the deserts of the Arabian peninsula, today spanning Yemen, Oman, Qatar, Bahrain, Kuwait, Saudi Arabia and the United Arab Emirates, along with parts of Jordan and Iraq. These deserts have been inhabited for centuries by Bedouin tribes, whose traditional way of life has adapted to, and been shaped by, the challenging environment.

In north Africa, the Sahara forms the largest and most arid hot desert on earth, covering almost 9 million sq. km (3.5 million sq. miles). It is a mixture of stone plateaus and sand seas, with the iconic sand dunes – many over 180 m (600 ft) tall – forming

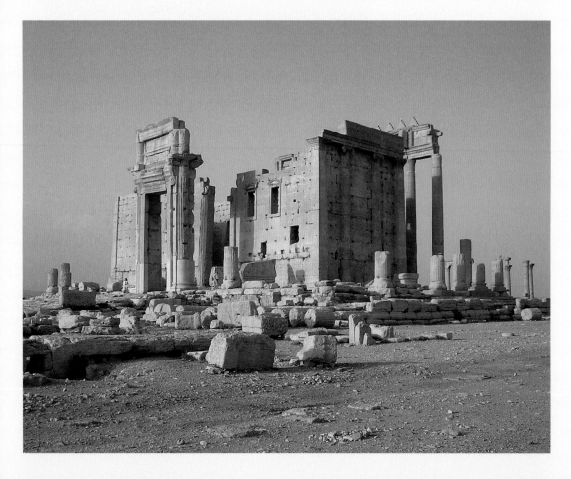

The Temple of Bel at Palmyra, dating from the 1st century CE, showing a fusion of Hellenistic and local architectural styles. This photograph was taken before the building's destruction in 2015.

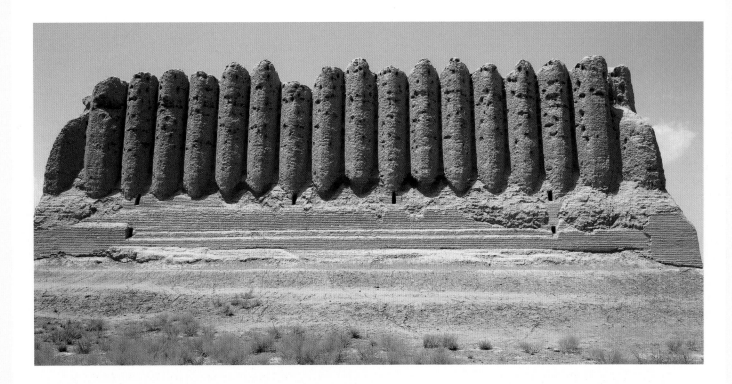

Merv: cities in the red desert

The cities of Merv lay in the rich alluvial delta of the Murghāb river at the southern edge of the Karakum. The earliest, around the 5th century BCE, was an Achaemenid (c. 550–30 BCE) administrative and trading city (today called Erk Kala), enclosing 12 ha (30 acres). In the 3rd century BCE, the Seleucids (312–63 BCE) undertook a massive expansion programme. Erk Kala was converted into a citadel and a vast new city was laid out, Antiochia Margiana (today known as Gyaur Kala), nearly 2 km (1.2 miles) across and covering some 340 ha (840 acres). The city continued to develop over the next 1,000 years, as the Parthians (247 BCE–224 CE), Greco-Bactrians (256–126 BCE) and then Sasanians (224–651 CE) made it a major administrative, military and trading centre.

With the coming of Islam in the 7th century CE [*see* pp. 256–67], a self-contained walled town, Shaim Kala, was built outside the eastern gates of the old city to house colonists. By the mid-8th century, a new city, Marv al-Shahijan (today Sultan Kala), developed alongside a canal to the west of the old city. With a central core of magnificent administrative and religious buildings, and a carefully managed water supply (with reservoirs in each district)

[*see* pp. 236–43], it became the capital of Khurasan ('eastern lands'). During the time of the Seljuks (1037–1194), substantial walls were built (a 13-km or 8-mile circuit, enclosing some 550 ha or 1,360 acres), and a walled citadel, Shahriyar Ark, was constructed to hold a palace complex, administrative buildings and elite residences. At this time, Merv was one of the largest cities in the world, where markets, mosques and madrasa proliferated, and substantial caravanserais were built within the city and along the main roads nearby [*see* pp. 244–55]. There was also a large suburban industrial quarter, producing metalwork, glass and pottery.

Merv was sacked by the Mongols in 1221. Many were massacred, but there is evidence for some continuity, possibly as an industrial settlement in and around the old citadel. By the 15th century, the old town was finally abandoned, and a smaller planned Timurid (1370–1507) town, Abdullah Khan Kala, was built 2 km (1.2 miles) to the south. TW

Further reading: Herrmann 1999; Williams & Van der Linde 2008.

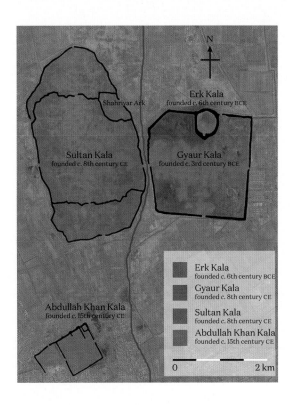

Shahriyar Ark

Erk Kala
founded c. 6th century BCE

Sultan Kala
founded c. 8th century CE

Gyaur Kala
founded c. 3rd century BCE

Abdullah Khan Kala
founded c. 15th century CE

Erk Kala
founded c. 6th century BCE

Gyaur Kala
founded c. 8th century CE

Sultan Kala
founded c. 8th century CE

Abdullah Khan Kala
founded c. 15th century CE

0 2 km

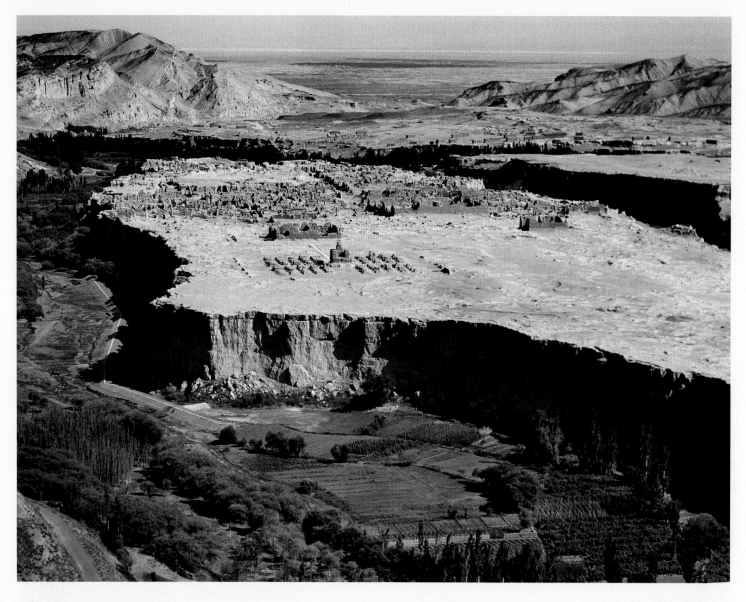

Jiaohe ('Between the Rivers'), capital
of the Jushi kingdom (108 BCE–450 CE)
in the Tarim basin near Turfan.

only a small part of the whole. The Sahara comprises several
distinct eco-regions, with the central Sahara hyper-arid, with
very sparse vegetation, and the fringes having sparse grassland
and scrub, with trees and shrubs in wadis where moisture
collects. A pastoralist way of life was a necessary adaptation,
with mobility a key factor in survival. In antiquity this
encouraged trans-Saharan traffic, which significantly opened
the door to sub-Saharan Africa. Oases again played a vital part
in establishing and controlling routes.

Camels are the ultimate desert travellers. In central and east
Asia, the larger two-humped Bactrian camel was dominant;
to the west, the smaller dromedary. The Bactrian has a greater
tolerance for cold, drought and high altitudes. They were
seldom ridden, and their primary role was to carry goods and
supplies. Dromedaries, in contrast, were used both as riding
and pack animals.

Many deserts are also a source of raw materials. For example,
the Eastern desert, between the Nile and the Red Sea, was an
important region in antiquity for sourcing building stone, ore
and precious stones, while in the northern Kizilkum extensive

deposits of gold, copper and silver have been exploited since
antiquity. However, because of the many challenges deserts
present, they have often attained a symbolic significance for
the communities who lived in or encountered them. There are
many stories of desert demons and the desert mirage, luring
travellers off course, which only reinforce the fear of becoming
lost in these vast regions, and the importance of navigational
knowledge for the Silk Road traveller.

———

Further reading: Bulliet 1990; Middleton 2009.

Khotan: a Taklamakan kingdom

Khotan was the most enduring of several oasis kingdoms along the southern edge of the Taklamakan, thriving for the whole of the 1st millennium CE. It was supported by meltwater flowing north from rivers rising in the Kunlun mountains, carrying the jade that ensured Khotan's prosperity. The rivers joined beyond the capital to cross the Taklamakan, providing a route to the northern kingdoms and the steppe beyond.

The early history of Khotan is uncertain but stories tell that the kingdom was founded by exiles banished from Gandhāra by King Aśoka (r. c. 268–c. 232 BCE). They also assign a role to Vaiśravaṇa, one of the Buddhist Heavenly Kings, and Khotan indeed became a thriving Buddhist kingdom with numerous monasteries and shrines, such as Rawak stupa pictured below. Sino-Kharoṣṭhī coins from the first few centuries CE show the influence of the Kushan and Chinese [see box on p. 304], but the Khotanese kings have Iranian names. The local language,

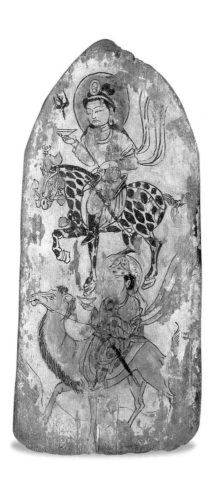

Khotanese, is of the Middle Iranian group and was transcribed in Brahmi, an Indian script [see box on p. 240]. The art is also distinctive, as shown on this votive wooden plaque [see also pp. 310–11].

Turkic influences came in from the west and north and Tibetan influences from the south, while Khotan developed strong relationships with the kings of Dunhuang to the east in the 10th century. Their ruling families intermarried, and Khotanese patrons are depicted on the walls of the Mogao Buddhist rock-cut temples [see pp. 227 and 230]. The kingdom came to an end with the invasion of the Karakhanids (840–1212) in around 1006. SW

Further reading: Hansen 2012; Whitfield 2018; Whitfield & Sims-Williams 2004; Zhang 1996.

Sand-buried ruins

John Falconer

"There was an abundance of grazing on dry reeds and thorny scrubs of all sorts for our hard tried animals, and big Toghraks to feed the camp fire and shelter us from the cold... what cheered my own heart...was the prospect which I now felt sure was opening before me of novel and fascinating work in this desert."

Marc Aurel Stein, *Ruins of Desert Cathay*, 1912.

Opposite above — Gertrude Caton Thompson (driving) at the temple at Qasr el-Sagha in Egypt, 1934.

Opposite below — Marc Aurel Stein with his team and dog Dash II at Ulugh-mazar in the southern Taklamakan, 1908.

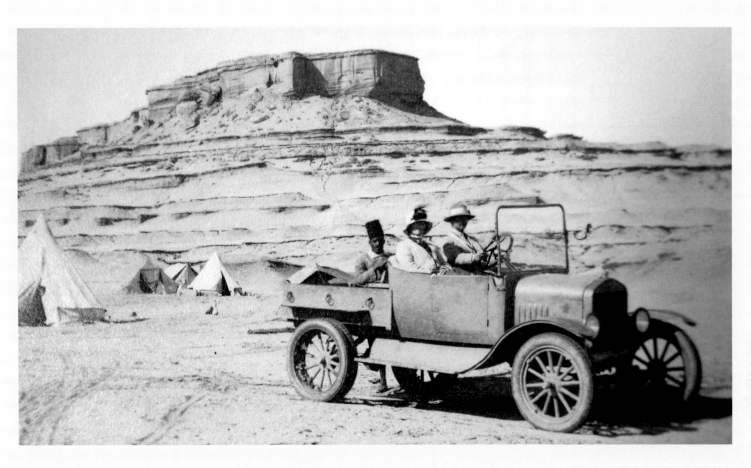

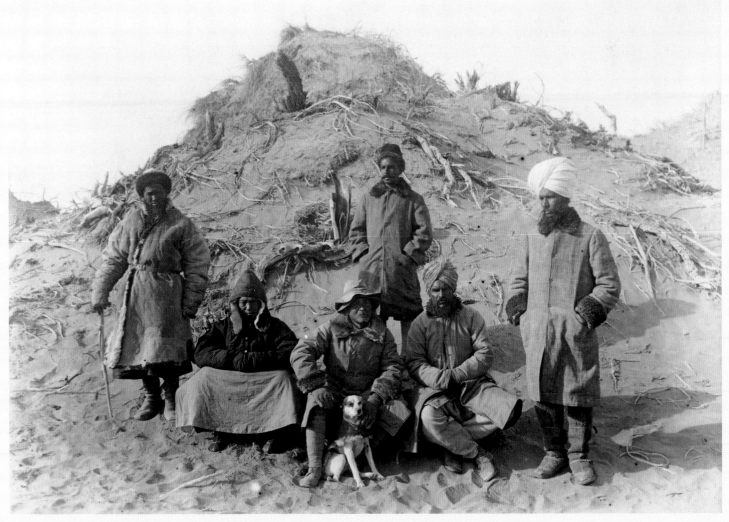

Imperial rivalry between Russia and Great Britain to control the power vacuum left by weakened Chinese authority in its northwestern territories led to an influx of European explorers and surveyors to these regions from the 1860s onwards. As the Russian presence expanded south and eastwards into the khanates of Turkestan, the British sought to extend commercial and political influence in northwestern China from their base in India. While the thrust of these explorations and missions was directly primarily towards imperial consolidation and commercial advantage, they also revealed growing evidence of the network of abandoned and buried oasis settlements along the trade routes that skirted the edges of the Taklamakan and Lop deserts. The Survey of India officer William Johnson (d. 1883), for instance, surreptitiously visited Khotan [see box on p. 221] in 1865 and was told of hundreds of cities buried beneath the sands of the Taklamakan, although he made no further investigation. In the following decade, the Russian geographer and explorer Nikolai Przhevalsky (1839–1888) came across the Lop Nor site (Kroraina) during his 1876–78 expedition, but his interests were primarily scientific and political and he made no extensive excavations.

The prolific Swedish explorer Sven Hedin (1865–1952) represents a transitional figure in the shift of focus from mapping and physical exploration towards a greater concentration on the archaeology of the desert regions of the Taklamakan. During his first two expeditions, between 1893 and 1902, Hedin became increasingly interested in the abandoned oasis settlements of the southern Taklamakan and his reports and maps were vital to later explorers.

Of all those for whom the deserts of western China held an almost mystical attraction, Marc Aurel Stein (1862–1943) made perhaps the greatest contribution to the unravelling of their secrets. The support of the Viceroy of India was critical in his receiving approval for his first Central Asian Expedition in 1900; it was also an implicit acknowledgment of archaeology's increasing prominence as an imperial tool. In the course of three

major expeditions to central Asia between 1900 and 1916, Stein excavated at a huge range of sites along the edges of the Taklamakan, including in the desert kingdoms of Khotan, Caḍota and Kroraina [see pp. 226–31], and he surveyed and mapped throughout his journeys. In early 1907 he reached Dunhuang, where he secured the sensational cache of manuscripts and paintings that was to ensure his reputation [see boxes on pp. 333 and 338].

The intimate connection between archaeology and imperial pride, and the popular acclaim of explorer-archaeologists like Hedin and Stein, inevitably attracted other nations to the desert sites of western China. Among the expeditions that streamed into central Asia in an attempt to secure treasures for their national museums in the early 20th century, the Russians Pyotr Kozlov (1863–1935) and Sergey Oldenburg (1863–1934) investigated the Tangut city of Karakhoto as well as Dunhuang and the northern Taklamakan, while four German expeditions under Albert Grünwedel (1856–1935) and Albert von Le Coq (1860–1930) acquired a huge hoard of artifacts from the ancient cities and rock-cut Buddhist temples of the northern Taklamakan kingdoms [see pp. 226–31]. The activities of Japanese, Finnish and French expeditions further expanded the range of material available to scholars.

The Sino-Swedish Expedition of 1927–35 was to mark the culmination of Hedin's career, but also the end of foreign activity in this region following a political clampdown. Huang Wenbi (1893–1966), a Chinese archaeologist on this mission, was to carry on work in the region. In more recent times, local archaeology along with joint Sino-Japanese and Sino-French excavations have led to many new discoveries, such as at Karadong [see box on p. 215].

If few other areas have attracted such an intense concentration of international activity and rivalry as the Taklamakan, the desert regions of the western continuation of the Silk Road have also received their share of archaeological attention, and some specific sites have been the subject of

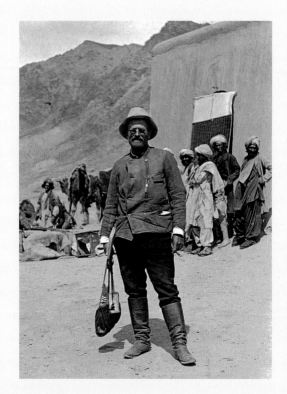

Far left —Sven Hedin in Kikki Rabat on the border of Iran and central Asia, 1906.

Left —Paul Pelliot in the Library Cave at Dunhuang, 1908.

intense research. In the Merv oasis in present-day Turkmenistan [*see* box on p. 219], exploratory excavations were undertaken in 1885, immediately after the area came under Russian control, and again by Valentin Zhukovsky (1858–1918) in 1890. In the modern era, the city has been the subject of the detailed and ongoing Ancient Merv Project since the early 1990s. And after the Taklamakan was closed to foreign archaeologists, Stein carried out four expeditions between 1932 and 1936 in the deserts of Iran and Iraq. He was also a pioneer in the use of aerial photography to identify archaeological remains.

Further westwards, the great Syrian city of Palmyra [*see* box on p. 217] grew wealthy from trade caravans from the east and Palmyrene merchants established colonies along the Silk Road. Although destroyed by the Timurids in 1400, Palmyra's ancient fame made its classical ruins a magnet for antiquarians from the 17th century onwards. The first professional excavations of the modern age were undertaken by Otto Puchstein (1856–1911) in 1902. By 1932, when the area was under a French mandate, villagers inhabiting the site had been removed to new homes so that Henri Seyrig (1895–1973) could continue excavations unimpeded. The variety of international teams who dominated excavations at Palmyra until the Syrian Civil War stopped work there in 2011 emphasizes the continuing ascendancy of the former colonial powers in determining the course of archaeological research. By way of contrast, in Yemen the archaeological history of the succeeding kingdoms that controlled the spice trade from their strategic position at the southern tip of the Arabian peninsula did not receive sustained attention until well into the 20th century. While inscriptions from the area had been collected by a number of travellers from the mid-19th century onwards, the first archaeological excavations were only made at al-Huqqa (to the north of Sana'a) by Carl Rathjens (1887–1966) and Hermann von Wissmann (1895–1979) in 1928: news of their finds was published in the *Illustrated London News* under the title 'In the Realm of the Queen of Sheba'. Further expeditions by Gertrude Caton Thompson (1888–1985) from 1937 to 1938 and Wendell Phillips (1925–1975) in 1951 added to our knowledge of the early history of the area.

The widely varying desert sites of the Silk Roads – from the great urban centres of Palmyra to small oases, rock-cut temples, shrines and stupas – have fascinated travellers and archaeologists for over 150 years. Many are located in areas at present riven by conflict or political instability, which has interrupted further excavation and discovery. Until circumstances permit the renewal of archaeological activity, the huge volume of excavated manuscripts and other artifacts, together with an extensive corpus of published accounts, provide a rich resource for understanding life and travels in the deserts of the Silk Roads.

Further reading: Diaz-Andreu 2007; Hopkirk 2011; Mirsky 1998; Trümpler 2008; Wood 2004.

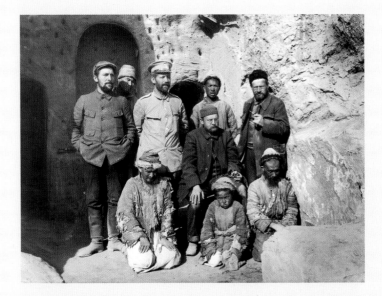

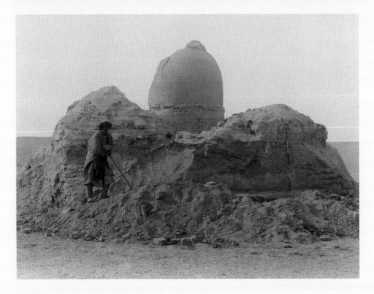

Top — Albert Grünwedel, Albert von Le Coq and their team at Kizil in the Tarim basin, 1906.

Centre — Otto Puchstein, the first excavator at Palmyra in 1902.

Bottom — Marc Aurel Stein's excavation of a Buddhist stupa M.III. at Miran in the oasis kingdom of Kroraina in the Tarim basin, 1907.

Oasis kingdoms of the Taklamakan

Rong Xinjiang

"Khotan is a pleasant and prosperous kingdom, with a numerous and flourishing population....Throughout the country the houses of the people stand apart like stars, and each family has a small stupa in front of its door. The smallest of these may be twenty cubits high, or rather more. The monasteries have rooms for...travelling monks who may arrive, and who are provided with whatever else they require."

Faxian (5th century).
After translation from Classical Chinese by James Legge.

Opposite — Viśa' Sambhava (r. 912–966), ruler of the Taklamakan oasis kingdom of Khotan, depicted as a donor in the Buddhist temples of Mogao, Cave 98, in the neighbouring kingdom of Dunhuang.

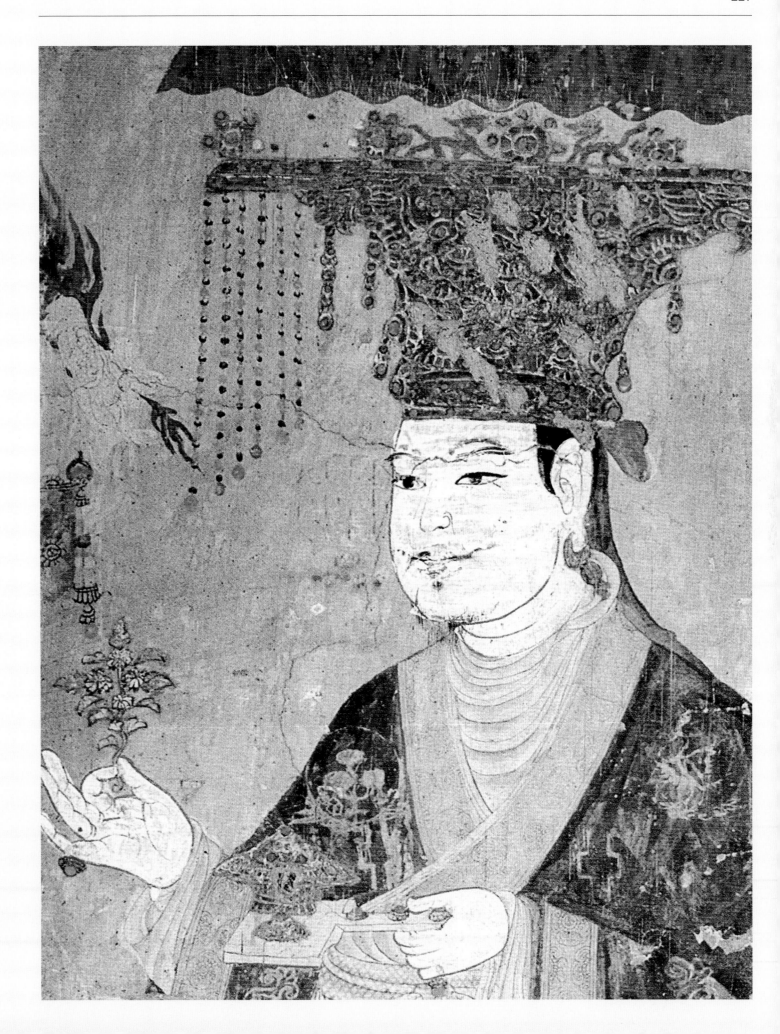

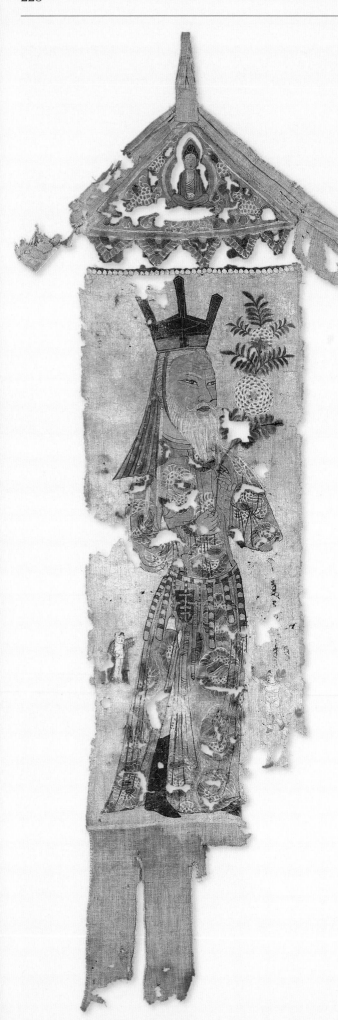

Deep in Asia, at the fringes of the Taklamakan desert, meltwater from the Tianshan mountains to the north and the Kunlun to the south formed oases and nurtured many regional kingdoms. Settlements and tombs have been excavated from the Bronze Age, but around the start of the 1st millennium CE Chinese historical sources variously list thirty-six or fifty-five kingdoms. Following annexations and migrations, larger states took shape along the edges of the Tarim basin: Shule, Qiuci and Yanqi, to the north; Yarkand, Khotan [*see* box on p. 221], Caḍota [*see* box on p. 239] and Kroraina to the south; and, to the northeast in the Turfan basin, Jushi and then Kocho.

Among the local population were eastern Iranian-speaking Sakas as well as the so-called 'Tocharians', who spoke a western branch of Indo-European. Generally speaking, the early inhabitants of the above-mentioned larger and more powerful kingdoms also spoke different branches of Indo-European. After the 4th century CE, when Turfan was mainly ruled by immigrants from the central Chinese plains, Chinese became the administrative language here, whereas a Gandhāran form of Prakrit, originating in the Kushan empire (1st to 3rd centuries) to the west, became the administrative language of Kroraina in the south, whose control extended westwards to Caḍota. After a period of control of much of the southern

Turkic Uygur prince, dating to the 10th century and possibly a memorial portrait, painted on a ramie banner discovered near Kocho in the Tarim basin.

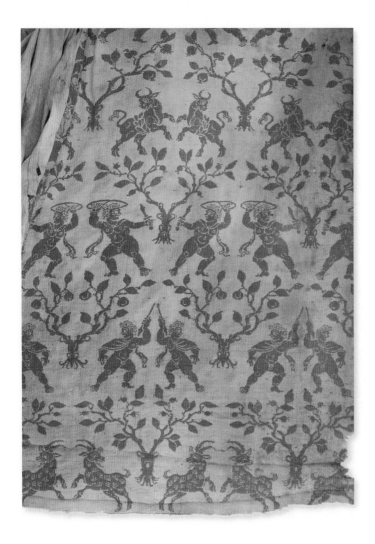

A woollen caftan

This fine woollen fabric was used for the outer caftan [see pp. 112–17] of the male grave occupant of a tomb (M15) excavated in 1995 at Yingpan in the southern Taklamakan, dating from the 4th to 5th centuries. It is a compound tabby, with interwoven red and yellow warp and weft threads, constituting a double-faced fabric with the same design but contrasting colours. The characteristics of colour and pattern lifting are identical to those of fabrics with multiple weft colours excavated elsewhere in central Asia [see pp. 316–29].

The pattern, with repeats in the weft direction, consists of rows of six groups of confronted naked human figures, representing the ancient Greek god, Eros, and confronted rearing horned ovicaprids, the rows separated by pomegranate trees. Confronted animals below

trees are a common Sasanian decorative theme, whereas Eros is found in Gandhāran art. Judging from its technical and artistic features, this fabric may originate in central Asia, possibly Gandhāra or Khotan [see box on p. 221]. The clothes of the tomb occupant comprise many rich wool and silk textiles, some probably made locally and others acquired from both west and east. LWY

Further reading: Lin 2003; Whitfield 2009; Zhao 2005.

The Khotanese wife of Cao Yuanlu, king of Dunhuang, with other family members. Dunhuang Mogao, Cave 61.

Taklamakan in the mid-8th to mid-9th centuries by the Tibetan empire, Tibetan persisted as a lingua franca in some regions.

The smaller and weaker kingdoms were often subject to invasions and control from the surrounding larger states: to the north, on the Mongolian plateau, the Xiongnu, Rouran, Turkic and Uygur khanates; the Tibetan empire to the south; the Kushan, Hephthalites and Karakhanids to the west; and the Han and Tang dynasties to the east. These empires used various methods to exert influence over the oasis kingdoms of the Tarim and Turfan basins, often consisting of loose control such as the conferment of rank and privileges, marriage alliances, and the establishment of military and agricultural garrisons. The smaller states paid tribute and taxes in return for peace. After the 10th century, the area was gradually occupied by Turkic Uygurs driven south after the fall of their empire to the north.

From the 2nd century BCE to the 10th century CE, the oasis kingdoms of the Taklamakan developed their own cultures with influences – and goods – from the trade routes leading in all directions. The region was home to communities of Sogdian traders [see box on p. 250] and there is also evidence of Jewish merchants [see box on p. 252]. The early religion of the Taklamakan is unclear, but Buddhism came in with Silk Road trade and soon became established and patronized by all the kingdoms. Evidence has also been found of Zoroastrian communities [see pp. 346–55] and of Manicheanism [see pp. 356–63] and Nestorian Christianity [see pp. 168–75]. Later the whole region became Islamicized [see pp. 256–67], starting with the invasions of the Turkic Karakhanids, who reached Khotan in 1006, but then accelerating after the Mongol invasions of the Chagatai khanate in the 14th century.

———

Further reading: Hansen 2012; Whitfield 2015; Zhang 1996; Zhang & Rong 1998.

Painted clay statue of a Tocharian from a Buddhist rock-cut temple at Kizil, Tarim basin, 6th century.

وَكَادَ يَنْزِعُ الجِمَالَ الشَّمَّرَ وَأَشَّدَ
مَا الحُجَّ شَيْءٌ بَرَكَتْ أَوْ بَيْنَا وَادْلَاجًا وَلَا أُغَنِّيكُمُ أَجْمَالًا وَأَجْمَالًا

الحُجَّ أَنْ تَقْصِدَ البَيْتَ الحَرَامَ عَلَى تَحْرِيرِ بِكَ الحَجُّ لَا تَبْغِي بِهِ حَاجَا
وَتُعْطِيَ كَأَهْلِ الإِنْصَافِ مُنْتَجِزًا رَدْعَ الهَوَى هَادِيًا وَالحَقَّ مِنْهَاجَا

Arabia: the land of frankincense and myrrh

Peter Webb

"Tayma is...a great city, and the extent of their land is sixteen days' journey. It is surrounded by mountains – the mountains of the north. The Jews own many large fortified cities. The yoke of the Gentiles is not upon them. They go forth to pillage and to capture booty from distant lands in conjunction with the Arabs, their neighbours and allies. These Arabs dwell in tents, and they make the desert their home. They own no houses, and they go forth to pillage and to capture booty in the land of Shinar and El-Yemen."

Benjamin of Tudela (12th century).
Translated from the Hebrew by Marcus Nathan Adler.

Opposite — Painting of camel caravan of pilgrims on their way to Mecca by al-Wasiti, in al-Hariri's *Maqamat*, Baghdad, 1237.

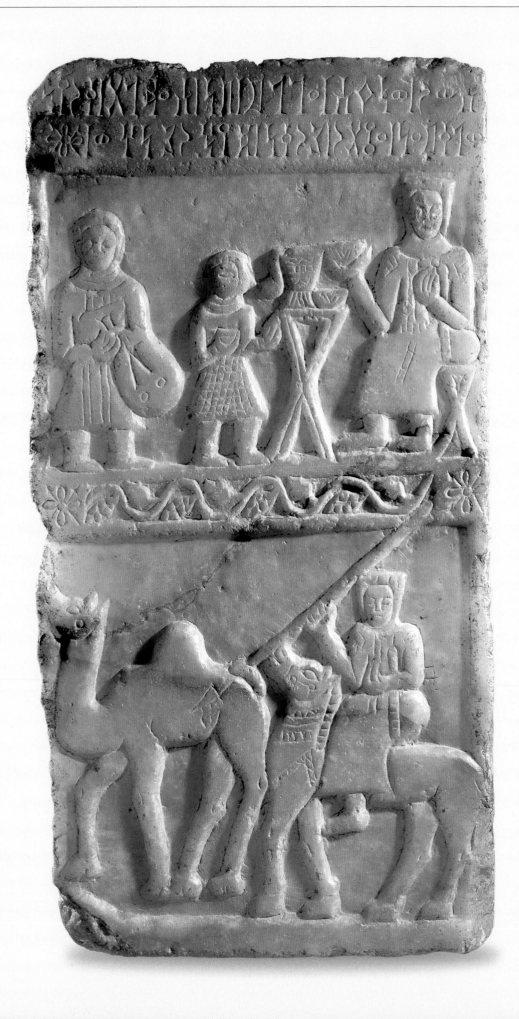

Alabaster funerary stela of the 1st–3rd
centuries CE for ʿIglum, son of Saʿadillat
of Qaryot, kingdom of Ḥimyar, with
the inscription in the Sabean dialect,
written in south Arabic script, 'Athtar
smite whoever would destroy it'.

In 200 CE, Arabia was a region fragmented along manifold lines: political, cultural, linguistic and social. In the northwest, the Nabataean kingdom, which controlled caravan trade from Syria to southern Arabia, was defeated by the Romans in 106 CE, and the lands of what is now Jordan and northern Saudi Arabia became a Roman province ruled from Bostra/Buṣrā on the modern Syrian–Jordanian border. The Sasanian empire (224–651) was beginning to spread its influence from the Iranian plateau into northeast Arabia, constructing outposts along the Gulf coast from the 3rd to 6th centuries. And southern Arabia was a patchwork of independent states that would become unified for the first time by 300 CE under the Ḥimyar kingdom (110 BCE–525 CE).

Ancient Arabia's most celebrated assets were frankincense and myrrh: harvested in south Arabia and transported through Nabataean lands to lucrative profits in Mediterranean markets, their trade fostered the growth of wealthy cities on caravan routes between south Arabia and the eastern Mediterranean. By 200 CE, however, trade had turned increasingly to the Red Sea, and the four centuries prior to Islam's rise in the early 600s witnessed pivotal changes. Roman power declined in the 3rd century, and its direct control receded to the eastern Mediterranean, leaving the northern Arabian frontier in the hands of various groups of client kings, notably the Salīḥids, and, by the 6th century, the Ghassānids (220–638). South Arabian Ḥimyar expanded northwards and had its own client kings at Kindah in central Arabia, as well as close links with its Axumite neighbours in east Africa across the Red Sea, while the Sasanians sought influence in Arabia through their proxies, the Lakhmids (300–602). Between these three routes of power, Arabia's history during this period was one of shifting spheres of influence and allegiance: the semi-nomadic client kingdoms competed with and pressured nomadic and semi-nomadic pastoralist groups as well as the smaller agriculture-based oasis towns in the Arabian interior.

Arabian populations resist straightforward classification at this time. They spoke (and wrote) varied languages, expressed themselves via diverse material cultures, and worshipped different faiths: Christianity may have been ascendant, but Judaism (especially in Ḥimyar) [see pp. 434–39], other monotheisms and paganism are also attested. By applying the generalized label 'Arabia' to the region, we imply a misleading sense of unity, and it seems inaccurate even to label its populations as 'Arab'. The word 'Arab' is scarcely, if at all, visible in any records, whereas the region's pre-Islamic inhabitants used an array of different names to describe their communities and identities, reflective of their chequered socio-political organization. Outsiders had their own names for Arabian pastoralists: the Romans called them 'Saracens', they were ṭayyāyē according to the Sasanians, and a'rāb in Ḥimyar, but these were generalized labels and did not connote cohesive ethnic groups either. Agricultural communities interacted uneasily with the pastoralists who in turn competed with each other, and the diversity yielded localized and fragmentary social groups across the region.

The founding of Muhammad's community in Medina in 622 marked the beginning of unprecedented change [see pp. 256–67]. For the first time, a vigorous state from central Arabia exerted power outwards towards Mesopotamia and southern Arabia, and the Muslim conquests created the first ever transregional empire based in Arabia. At this point, Arabic language and script also began spreading across the region – before Islam, earlier forms of Arabic were much more restricted and more varied in script and grammar – and within fifty years of Muhammad's death, records show individuals beginning to regularly refer to themselves as 'Arabs'. The rise of Islam provided opportunities for novel forms of unity, and was a watershed for Arab ethnogenesis.

Throughout the 7th century, further changes occurred. The city of Medina was too far removed from the caliphate's prized territories in the eastern Mediterranean and Mesopotamia, and by the 650s the political capitals moved to Damascus [see box on p. 259] and then Baghdad [see box on p. 336]. Arabia still retained Mecca, Islam's sacred shrine, and between 650 and 800, caliphs sponsored massive road-building and construction projects to facilitate Hajj pilgrim traffic and to enhance the Meccan shrine and also Medina, which became sacralized as the city of Muhammad's grave.

By the 9th century, caliphal patronage of the Hajj dwindled with wars, impecunious treasuries and changing Muslim political elites eroding the power of the caliph. The last caliphal pilgrimage was in 803; afterwards attention to the Hajj roads declined, central control weakened and pastoralist resistance flared. Pastoralists attacked private Hajj caravans, and in 930 Mecca was sacked and its sacred Black Stone removed by the Qarāmiṭa, a breakaway movement based in eastern Arabia. For much of the 10th to 13th centuries, northern Arabia is absent from the historical record: the Iraqi Hajj routes virtually disappeared and pilgrims diverted to shorter routes, or came by sea from Egypt. In south Arabia, terraced farming communities survived: they broke away from the collapsing caliphate and flourished as independent states. Trade routes, however, shunned the unstable Arabian land routes, and intensive sea trade through the Gulf benefited the Omani coast, where sultanates – with their Kharijite religious creed, distinct from mainstream Islam – rose and prospered.

Further reading: Fisher 2015; al-Ghabban & Ali Ibrahim 2010; Landau-Tasseron 2010; al-Rashid 1980; Webb 2016.

Wall painting of the 1st–2nd centuries CE from Qaryat al-Faw, capital of the kingdom of Kindah.

Canals, *qanāts* and cisterns: water management in desert oases

Arnaud Bertrand

The main oases along the Silk Road are not just isolated points in the desert landscape, but sometimes include vast irrigated lands that have been home to kingdoms with important fortified towns. It is estimated that tens of thousands lived in the 8th-century oasis kingdoms of the Tarim and Turfan basins, whereas 300,000 to 600,000 lived in the Zerfashan and Bactrian valleys.

The capacity to develop efficient water systems to cope with low rainfall explains the longevity of oases as commercial, religious and political centres.

A desert is a living organism. This is particularly the case in the Taklamakan, where the landscape has greatly changed since the earliest human settlements. Archaeologists have traditionally assumed that the desertification of the Tarim was accelerated by human action. But the main cause was the sliding of the Tarim tectonic plate into the Indian one, which created movement in the hydraulic network. This in turn led to the shifting of deltas and rivers in the Taklamakan. One particular example can be found in the Keriya valley, where three deltas have succeeded one after another through time, east to west. A Sino-French archaeological team has discovered the city of Djoumboulak Koum (*c.* 500 BCE), west of Karadong: protected by a wall made of rammed earth, the fields were irrigated by canals that took the water from the nearby proto-historic delta [*see* box on p. 215].

Irrigation was also used in the Gobi desert, where 150 ancient sites have been discovered. Bazhou, for example, was surrounded by a rammed-earth rampart. When in flood the excess waters from the southwestern and eastern rivers could be diverted through a main canal, which enabled the irrigation of the fields. This is a common feature in most of the

Gobi ancient settlements, as well as in many of the oases in fertile lands where rivers were numerous.

When an entire oasis depends on flooding for its crops but the water in its rivers was variable, a more sophisticated system is necessary to ensure the efficient solution control and diversion of water. Such was the case for Shabwa, the ancient capital of the Hadhramaut (13th century BCE–3rd century CE) in the south of the Arabian peninsula. Violent storms during the spring and summer monsoon created a succession of flash floods flowing over approximately 7 sq. km (2.7 sq. miles) of land. Over time, multiple irrigation systems were developed. From the south, the water was tapped by a series of multiple deflector canals, which in turn led to the fields. In the 2nd century BCE, a great water gate made of stone helped to control the flow. Aqueduct canals were also built to irrigate specific areas.

The water systems at Shabwa were planned before the city was built, since its survival depended on the solidity of the canals. This explains the absence of water tanks, or reservoirs, which are often seen in other parts of the Eurasian world where water had to be stocked for a certain time, not only for irrigation but also for consumption, religious or recreational matters. One striking example lies in Petra [see box on p. 216]. This great city on the caravan route from Gaza to the Gulf

Previous spread — Channel distributing water from a spring at the oasis of Wadi Bani Khalid in the Arabian desert.

Left — Line of a *qanāt*, an underground water channel, between Kashan and Isfahan.

Above — Tree-lined water tanks such as this one in Samarkand, photographed in 1902 by Hugues Krafft, have long been part of oasis life. The desiccated poplar trees lined a similar tank in the 2nd–4th century Taklamakan kingdom of Caḍota [see box opposite].

Caḍota: poplar-lined canals

Caḍota is located deep in the Taklamakan desert, nearly 100 km (60 miles) north of present-day Minfeng. The remains of this city-state, dating from the 2nd to the late 4th centuries CE, are spread along the course of the Niya river on a strip of land 25 km (15 miles) long by 7 km (4.5 miles) wide. The river, rising in the Kunlun mountains and entering the city from the south before bending to the west and then to the northwest, fed a complex irrigation network. Water tanks were designed to store water and distribute it across the fields next to the houses. The tanks are the same shape, lined with a thin layer of clay and enclosed by poplar trees, some still surviving in desiccated form today, as shown here. The trees protected water from hot temperatures and resulting evaporation. The size of the tanks varies between 9 and 30 sq. m (30 and 100 sq. ft), with a depth of 1 to 3 m (3 to 10 ft). A poplar-lined canal fed the tanks.

Caḍota developed when a large influx of people migrated from the Kushan and Kidarite territories across the Pamirs to the west. It is possible that these immigrants introduced the system of water tanks as it was a technology frequently used – up to the present day – in western central Asia and all across India. AB

Further reading: Bertrand 2012; Grenet 2002; Hansen 2004.

Part of a *qanāt*, an underground water channel, in the Lut desert near Bam.

A Khotanese legal case

Several examples of box-shaped legal wooden contracts in Khotanese [*see* box on p. 221] have been discovered, dating from the first half of the 8th century and deriving from the area around Domoko in Khotan in the Taklamakan desert. The shape, whereby the lid/envelope, featuring a summary of the case, slides off to reveal further texts underneath, is perhaps a development of the simpler wooden wedge-shaped documents used in the 3rd-century kingdom of Caḍota [*see* pp. 226–31].

This double wooden tablet, 23.4 by 14 by 7 cm (9.2 by 5.5 by 2.8 in.), includes two versions of the same document, written in Prakrit using the Kharoṣṭhī script (British Library, Or.9268A). The second, written on the inside of the cover and the top of the under-tablet, is the more extensive text. The document is dated to either 728 or 731 (depending on reading), during the reign of the Khotan King Viśa' Dharma (r. 728–738), and records a case heard at a legal assembly in Birgaṃdara, a township in the

Domoko area. It concerns the sale of irrigation rights from the pool of Phema by the judge (*pharṣa*) Bara and Braṃgala to Yagura for 2,500 *mūrās* and the consequent division of the harvest produced. It was signed by Bara and Braṃgala, and presumably it was their seals that were impressed in clay in the empty seal socket on the top of the manuscript. USW

Further reading: Hansen 2017; Skjærvø 2002; Zhang 2018.

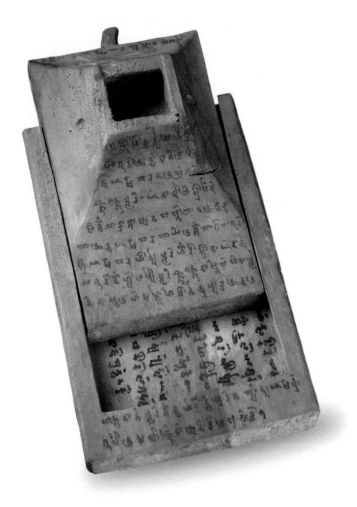

Bactrian water disputes

This parchment document (Khalili collection, Doc. 127, also referred to by the signature 'bg') of the mid-4th century demonstrates the most characteristic form of Bactrian letters. The scribe originally allowed a wide left-hand margin, but filled this with text written vertically when space ran out. After writing, the folded letter was secured with a clay sealing attached to a thin strip of parchment cut along its bottom edge and wound around it. The letter, addressed to a certain Ohrmuzd Faragan by his subordinate Burzmihr Khahran, acknowledges receipt of a letter from the former and assures him that his orders have been carried out. The text is not entirely clear but concerns a dispute over the ownership of a meadow named Yukhsh-wirl and the blocking or diversion of the stream that irrigates it; ultimately, it seems, both the meadow and the stream are given to Khwadew-wanind Kharagan, who may be a relative of Burzmihr, since the 'surname' Kharagan is a variant of Khahran. Another Bactrian letter ('ci'), probably dating from a few years later, is concerned with the same meadow, now assigned by a different ruler to Nawaz Kharagan, perhaps yet another member of the same family. NSW

Further reading: Sims-Williams 2007, 2012; Sims-Williams & de Blois 2018.

existed because of the ingenuity of its builders, able to control the water from the upper cliffs through the use of dams, cisterns and water conduits. Water for recreational purposes was a mark of stability, especially in remote lands. Palmyra, for example, had aqueducts to nourish gardens and feed pools [*see* box on p. 217].

In Iran, the Achaemenids (550–330 BCE) developed the *qanāt* water system: aquifer water was brought to the city from the mountains by the use of shafts and tunnels, as seen at Persepolis, and stored in a cistern made from stone blocks. This system has influenced many cultures, from the Tarim basin to Egypt and Spain, to the present day.

The foundation of a city in an oasis owed nothing to chance. Its siting was the result of a careful study of the local environment. This was particularly so for the central Asian city of Afrasiab [*see* box on p. 284] where, from the 6th to 2nd centuries BCE, the 40-km (25-mile) long Dargom canal rerouted the Zerfashan river so that the plateau and its surrounding fields could be provided with water. It is only under a solid and strong local power that such a system could arise, be controlled and be protected through time.

———

Further reading: Briant 2001; Debaine-Francfort & Abduressul 2001; Gentelle 2003; Jing 2001; la Vaissière 2017.

Page 243 — Aqueduct bringing water from the mountains to the desert village of Kharanaq near Yazd.

Qasr al-Hayr al-Sharqi: a desert castle

Qasr al-Hayr al-Sharqi is a large complex forming part of a wider site extending over 10 sq. km (4 sq. miles), located 95 km (58 miles) northeast of Palmyra [*see* box on p. 217]. It lies at the centre of the semi-arid zone between the fertile Euphrates valley and Damascus [*see* box on p. 259], commanding an important commercial and strategic position on ancient caravan routes. An inscription, now lost, attributed its construction as a *madina* (town) to the Umayyad caliph Hisham ibn 'Abd al-Malik (r. 724–743), the work carried out by the people of Homs between 728 and 729.

It comprises two fortified enclosures – one large with walls 167 m (548 ft) in length and one small with walls of 70 m (230 ft) in length, described as a palace – as well as an outer enclosure with an area of 7 sq. km (2.7 sq. miles), a congregational mosque, olive presses and large baths. Recent excavations have uncovered further structures to the north and south.

It has been interpreted as an urban settlement with supporting agriculture: botanical data has revealed rich and diverse cultivation. The site relied on a complex water system with the major element being an aqueduct bringing water from underground springs located some 25 km (15 miles) to the northwest of the palace. A water mill has also been excavated to the north of the site. AO

Further reading: Ettinghausen et al. 2001; Graber et al. 1978.

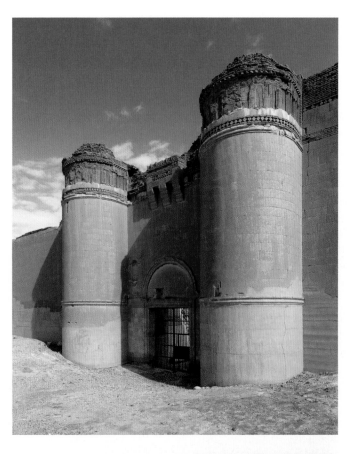

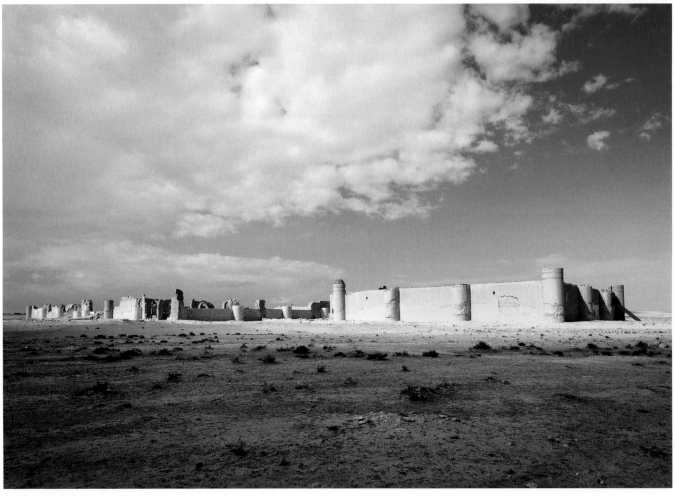

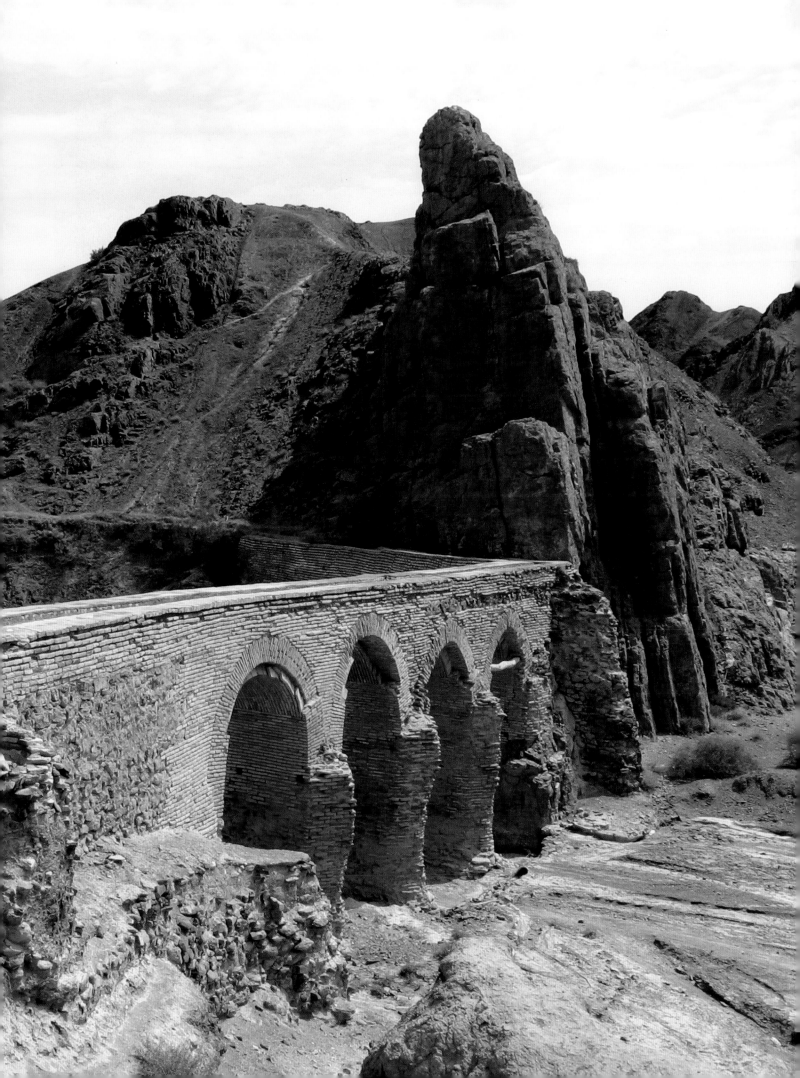

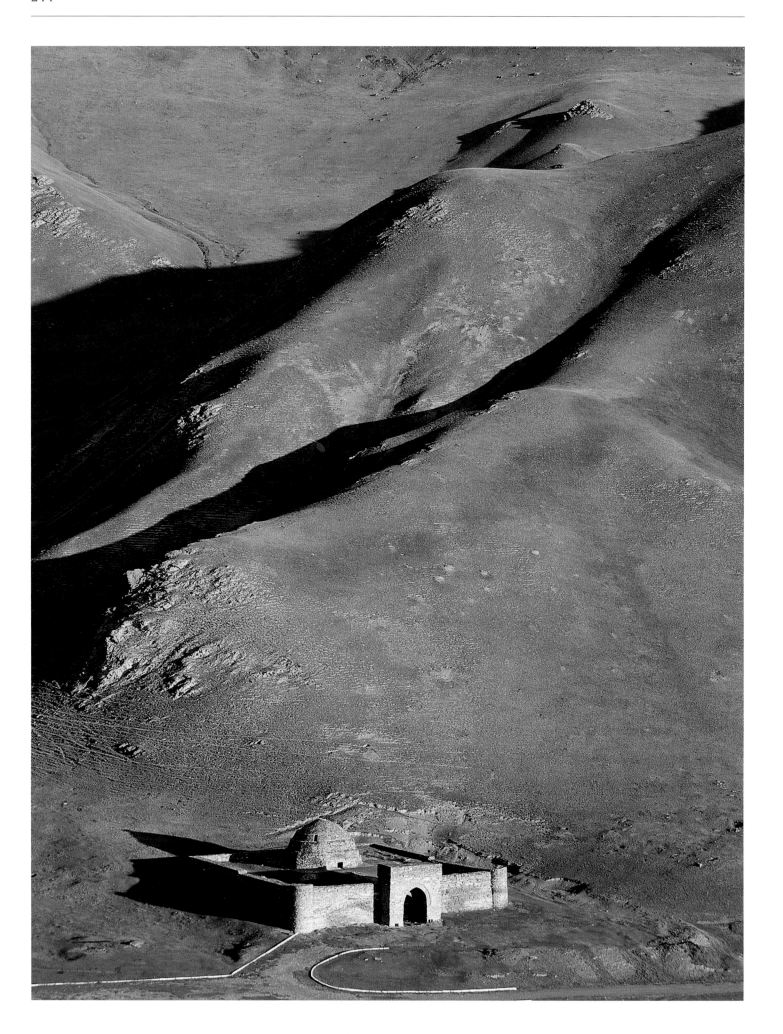

Camels and caravanserai: traversing the desert

Paul Wordsworth

The establishment of regular long-distance trade connections provided an impetus to build infrastructure to facilitate travel along key corridors of the Silk Roads, particularly in areas where there were few towns and villages to serve as halting points. Lodging places in desert regions had to offer shelter, a reliably maintained water source, and in places a change of mount along sometimes perilous highways.

These hostels, now known as caravanserais (from middle Persian *karwan*, 'band of travellers', and *saray*, 'house/palace'), were manifest in diverse styles across the various regions of Eurasia. Discrete groups of such buildings were constructed in different periods along specific sections of routes, when the desire and the economic means to create infrastructure encouraged investment. Although caravanserais became common in many different geographical zones along the Silk Roads from the medieval period onwards, here the focus is on those established in deserts.

Some of the earliest examples of desert way-stations appear not as individual buildings, but small settlements, harnessing limited river resources to establish fertile bases at the edges of the Taklamakan desert, and flourishing from the final centuries BCE onwards [*see* pp. 226–31 and boxes on pp. 221 and 239]. Likewise, remote early Islamic 'desert palaces' in west Asia appear to have been developed for private palatial life, but also incorporated aspects such as large stables and guest accommodation [*see* box on p. 242]. The building typically associated with desert travel and the Silk Road, however, was the caravanserai, mainly referred to in contemporary texts as a *khan* or *ribat*. These institutions flourished towards the last quarter of the 1st millennium CE across the Iranian plateau and western central Asia. It is also clear that from the outset they encompassed a wide range of

Daya Khatyn:
a desert caravanserai

The caravanserai of Daya Khatyn lies on the eastern edge of the Karakum as it meets the Amu Darya. Its remarkable preservation means that it is one of the best examples in central Asia of a Seljuk (1037–1194) caravanserai. Travellers would have entered through a single monumental arched portal or *pishtaq* to find an extensive courtyard (29 m or 95 ft across), brick-paved in a herringbone pattern and surrounded by a decorative arcade. Off this covered walkway, cellular rooms provided accommodation, with long galleries for mounts either side of the main entrance, and a mosque in the right-hand corner room.

The building's form – a square courtyard structure with four corner towers and open vaulted verandas (*eywans*) on the cardinal axes – is typical of Seljuk architecture in the 11th and 12th centuries. At first glance, it appears to be entirely constructed from pinkish-yellow fired bricks, but the core of the outer walls is in fact filled with earth and rubble. Nevertheless, one unusual feature of this grand caravanserai is that the main facade is decorated in brickwork relief, with panels giving the names of the first 'rightly guided' caliphs (the *rashidun*) in tessellated patterns. PW

Further reading: Pribytkova 1955.

uses, from supporting a regular and swift postal system to lodging pilgrims – as well as espionage. The existence of towers or *mil* connected to caravanserais or standing alone suggests that in some instances these buildings played a role in navigation across the desert, possibly providing a guiding light for nocturnal travel.

While there are various antecedents ascribed to the desert caravanserai, the majority of surviving early examples of a recognizable type date to between the 10th and the 12th centuries CE, a formative period for this type of architecture in the Persianate world. Under the Seljuks (1037–1194) and their contemporaries, for example, the

Ghaznavids (977–1186) and the Karakhanids (840–1212), desert way-stations were established in a distinct vernacular architecture. They mostly comprise a square or rectangular structure, set around one or sometimes two courtyards with ranges of small rooms on each side of the open space. Examples from deserts sometimes include covered porticos around the courtyard to provide shade from the fierce summer heat, and on each cardinal axis was a vaulted open space known as an *eywan*. This archetypal form is expressed well in the architecture of the Daya Khatyn caravanserai, on the edge of the Karakum desert in modern-day Turkmenistan [*see* box opposite].

Previous spread — The stone caravanserai at Tash Rabat, Tianshan, 15th century.

Woven camels

Excavated in 1985 from Zaghunluq Cemetery One near Cherchen to the south of the Taklamakan desert, this wool fragment, measuring about 29 by 7.5 cm (11.5 by 3 in.), depicts a Bactrian camel – the vital pack animal of the deserts of the eastern Silk Road. It dates from around the middle of the 1st millennium BCE, showing the peoples of these desert kingdoms before the start of the Silk Roads.

The pattern was manually picked through the brown tabby ground with dyed supplementary weft-threads (1/3 twill) of Z-spun sheep's wool [*see* pp. 316–23]. Similarly hand-picked camels and antelopes with exaggerated antlers appear amid bow-shaped double triangles on a larger piece (86 by 53 cm or 34 by 21 in.). The original item was possibly used as a bed cover,

body wrap or tent furnishing. Archaeological finds of tools and pottery from the site confirm that the occupants were agro-pastoralists, engaging in both farming and hunting. Sericulture was not known in this region at the time and only a few silk fragments were found at the site, suggesting limited contact with China to the east.

The finds are now in the Xinjiang Uygur Autonomous Region Museum (85QZM3:10). ASh

Further reading: Wang et al. 2016.

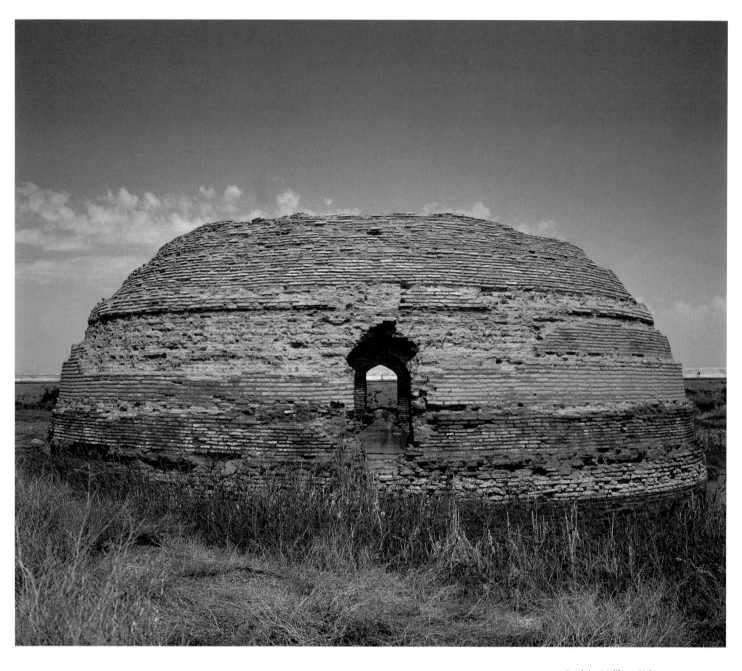

Sardoba Malik, an 11th-century water cistern to supply the Ribat-i Malik caravanserai, fed through an underground channel from the Zerfashan river, on the route between Samarkand and Bukhara.

The building materials naturally reflect both local practice and available resources. Many of the early examples are built in unfired mud brick or rammed earth, a technique that uses locally available clay to construct quickly thick walls from large blocks made *in situ*. Elsewhere fired bricks were used, and there is evidence that these too were made on site as needed, shown for example at Akja Gala where evidence of the kilns used to make them can still be seen. The extraordinary cost of manufacturing bricks in areas of scarce water and fuel underlines the significant investment required for developments of this type. In other regions, particularly northwest Iran, Anatolia and areas close to the Tianshan and Pamirs, stone was more plentiful and a preferable construction material (for example at Tash Rabat). These latter examples tend to be located in more temperate zones, however, and differ considerably in their form, providing a greater covered area for shelter in winter.

Some of the desert caravanserais retain traces of how the buildings were used, for example being divided between an outer courtyard for camels and cargo, and an inner courtyard for lodging. Likewise facilities such as *mihrabs* (prayer niches) and small mosques are evident at some of the larger caravanserais (for example Ribat-i Sharif).

Various solutions were devised to overcome the arid conditions and provide water for drinking and hygiene. Perhaps the most notable is the

A camel dagger

This short weapon, a type worn by horse-riders, was excavated from a robbed Sarmatian-Alan tomb at Dachi, near Azov on the edge of the Pontic steppe. It comprises an iron-bladed dagger with a gold hilt and scabbard. The high relief decoration shows scenes of a raptor attacking a Bactrian camel along the length of the scabbard and whirling compositions on the four lobes and scabbard tip. It both reflects the influence of steppe art as seen in Peter the Great's Siberian collection [*see* pp. 60–63] and, with the portrayal of a camel, reveals links with the desert routes to the east. The extensive use of turquoise and carnelian inlaid into gold is typical of Sarmatian and Alanic workmanship, and the gemstones would have been acquired from further east. The grave is dated to the third quarter of the 1st century CE.

The distinctive quadrilobe shape of the scabbard also originated to the east, in the Kazakh steppe. From the 3rd century BCE, wooden quadrilobe scabbards have been found in the Altai. Typologically similar gold scabbards were excavated from other Sarmatian-Alan sites at Porogi, Kosika and Gorgippia in the north Pontic region, and images of kings bearing comparable daggers appear on Parthian coins, on sculpture at Commagene and on a textile from a Xiongnu tomb at Noin-Ula [*see* boxes on pp. 72, 80 and 98]. The closest example, in both form and ornamental conception, is a turquoise-inlaid dagger scabbard from Tillya Tepe, although it is decorated with undulating animals in a more strongly Scytho-Siberian style. SP

Further reading: Schiltz 2001, 2002.

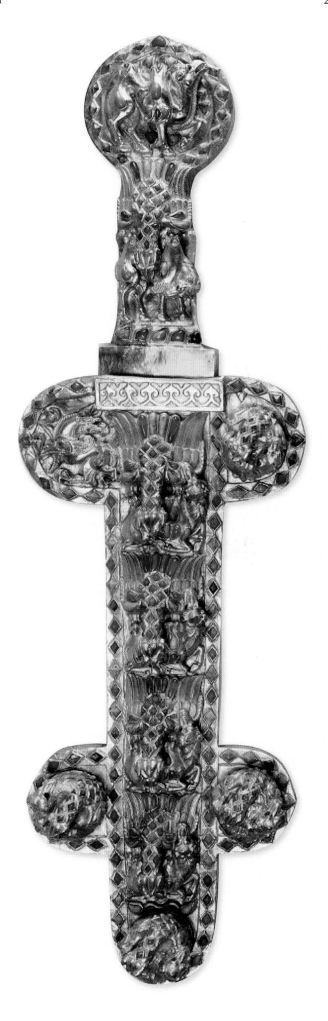

The abandoned wife

The contents of a postbag lost or confiscated in transit from China across central Asia, the 'Ancient Letters' are the earliest surviving Sogdian paper documents, dating from about 313 CE. They were found at a watchtower near Dunhuang, shown right, and are now held in the British Library. Written by Sogdian merchants in what is now northwestern China, the letters are largely concerned with commercial matters, referring to many commodities, including silk, and to Sogdian agents and colonies in various Chinese cities; one letter also reports in detail on the deteriorating political situation in China, the writer's interest in these events being centred on their commercial implications and their disastrous personal consequences for himself and the other foreign merchants. Two of the letters were written by a woman, Miwnay. In the manuscript illustrated here,

Letter 3 (Or.8212/98), addressed to her husband Nanai-dhat, she chides him for leaving her destitute in Dunhuang, exclaiming angrily: 'I would rather be a dog's or a pig's wife than yours!'. In a more mildly worded postscript, their daughter Shayn explains that she and Miwnay have been obliged to become servants of the Chinese. In Letter 1 (Or.8212/92), addressed to her mother Chatis, Miwnay recounts her efforts to find someone willing to escort her home to her mother's house. NSW

Further reading: Sims-Williams 2005; la Vaissière 2005.

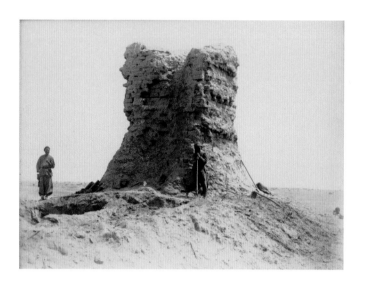

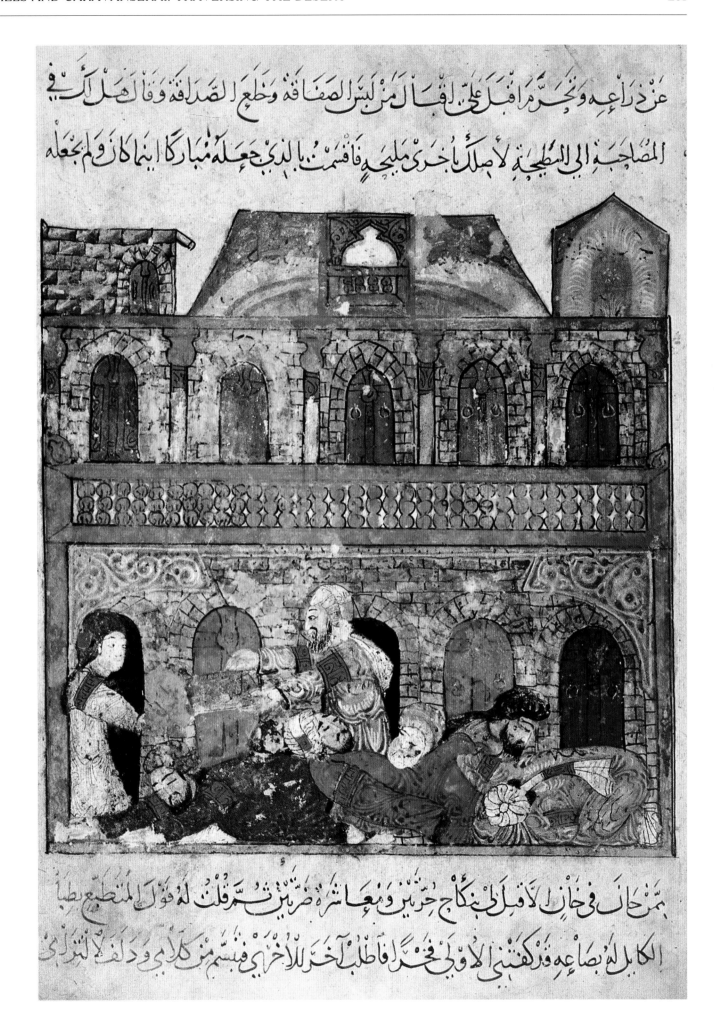

development of the *sardoba/ab-anbar*, or underground reservoir, designed to store fresh water gathered in periods of seasonal rain or snow, and prevent its evaporation. A handful of these reservoirs excavated on the Iranian plateau and central Asia attest to their use at least as early as the 11th century. Well-preserved examples of a standardized type, built to function alongside caravanserais, can be found in northern central Asia dating from the 14th to 15th centuries.

In terms of location, it is often assumed that caravanserais were regularly placed at one day's journey apart. Estimates of this distance tend to cluster around 30 to 40 km (20 to 30 miles), although the actual figure depends heavily on the type of transport and the terrain. From an archaeological perspective, the spacing of caravanserais is in fact much more irregular, given that what we see in the traces that remain is a palimpsest of several different periods of building

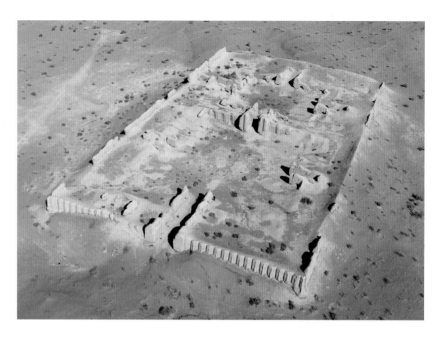

Previous page — Painting of travellers in a caravanserai by al-Wasiti, in al-Hariri's *Maqamat*, Baghdad, 1237.

Above — Akja Gala caravanserai in the Turkmen desert, 11th–12th century.

Jewish merchants in the desert

This document, now in the British Library (Or.8212/166), is a commercial letter written in Judeo-Persian (i.e. New Persian written in Hebrew script). It was presented to the archaeologist Marc Aurel Stein (1862–1943) as a closely crumpled 'lump of thin brownish paper' discovered among debris in a ruin of Dandan-Uiliq in Khotan [*see* box on p. 221], where there had been a Buddhist monastery and a garrison, deserted around the end of the 8th century. Additional confirmation for this date has been provided by the acquisition by the National Library of China of what appears to be the initial page of this same letter (BH1-19). It gives a more detailed historical context by referring to a defeat of the Tibetans at Kashgar, which probably happened around 790. The letter includes references to trading in sheep and textiles and raises the possibility of a Jewish trading community along the Silk Road.

The Dandan-Uiliq letter is probably the oldest document to be written in early New Persian, marking the first phase (8th to 12th centuries CE) of the Persian language after the Islamic conquest. As such it provides important evidence for the development of Persian, in addition to documenting the history of 8th-century Khotan [*see* box on p. 221]. USW

Further reading: Hansen 2017; Margoliouth 1907; Yoshida 2016; Zhang & Shi 2008.

An Indian rug

Deserts provide excellent conditions for the preservation of organic materials, such as wood and textiles, which quickly decay elsewhere. The Taklamakan is no exception, and rich textiles have been uncovered from tombs and temples, such as those of Yingpan [*see* box on p. 229] and Keriya [*see* pp. 324–29]. Elsewhere, desiccated orchards and poplar-wood skeletons of houses from the 2nd- to 4th-century kingdom of Caḍota (Niya) are now half buried by the encroaching sand. Excavation of these has revealed many items of everyday life as well as archives of manuscripts that tell us more about this desert kingdom and its irrigation [*see* box on p. 239].

Fragments of this rug, made from plain woven sheep's wool with tapestry-woven decoration, were found in a house at Caḍota, abandoned at the end of the 3rd century (British Museum, 1997.1111.105). The rug was almost certainly made in India or by Indian weavers in Caḍota – migrants from Gandhāra settled here, bringing with them their language and culture. No textiles from this period have survived in India itself, and so this is a rare example of what we assume must have been a thriving Indian textile tradition. Fragments of other Indian textiles, including tie-dyed cotton, have been found in Karadong to the east of Caḍota [*see* pp. 324–29 and box on p. 215]. SW

Further reading: Crill 2015.

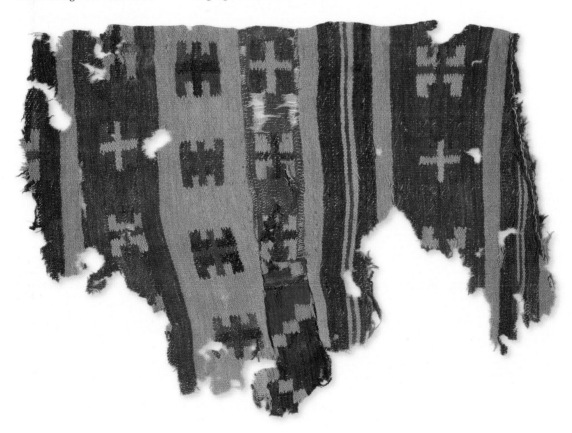

and concurrent use, and many structures are long since destroyed by erosion and land transformations. Undoubtedly, however, these buildings were intended to function together as a network and this is aptly demonstrated by examples from the period of significant investment in caravanserais under the Safavids (1502–1736), many of which are still preserved across the arid Iranian plateau.

Caravanserais, often patronized either by the ruling elite or by wealthy individuals, in many instances provided elaborate lodging. However, not all desert travellers used caravanserai – nor were they available for much of the period and many of the places in which the Silk Roads flourished. Archaeological and historical evidence also confirms a persistent presence of campsites at wells, which, although not furnished with grand facilities, formed way-stations in their own right.

———

Further reading: Hillenbrand 1994; Kiani 1981; Kleiss 1996–2001; Wordsworth 2019.

Following pages — Ribat-i Sharif caravanserai on the route between Nishapur and Merv, 11th century.

Islam: a new faith on the Silk Roads

Peter Webb

Historians date Islam's rise to Muhammad's (*c.* 570–632) mission in the first decades of the 7th century, but in the faith's own self-image, Muhammad's prophecy marks the beginning of Islam's final chapter. The Qur'an presents Islam as the true faith since Creation, the main Judeo-Christian biblical figures from Adam to Jesus are portrayed as a chain of Muslim prophets, and Muhammad's mission is to confirm their messages as the impending Judgment Day draws near.

In terms of the origin of Muhammad's prophecy, Muslim sources state that he began receiving the Divine revelation of the Qur'an in 610 CE when he was about forty years old, and incremental revelations gradually imparted the whole Qur'an by the time of his death in 632. Because the Qur'an incorporates Judeo-Christian figures, some historians propose that Islam was a breakaway sect from Christianity or Judaism, whereas others see it as an Arabian movement influenced by Judeo-Christianity, or as a creed emanating from south Arabian monotheisms that identified God as *Raḥmānān* (one of the Qur'an's names for God is *al-Raḥmān*). The language of the Qur'an has some similarities to earlier south Arabian liturgy, but it also refers to north Arabian geography, and other stylistic elements are unique to the text itself, so the search for external formative influences remains an open question.

The Qur'an articulates a coherent message of essential monotheism, mostly devoid of intercessors, patriarchs and priests – even Muhammad's role is limited (the Qur'an only mentions him by name four times). He is depicted more humbly as a messenger, not a saviour, and perhaps some early Muslims did not believe that he would be the last prophet; but in the century following Muhammad's death, doctrines were

refined and by the 8th century most Muslims conceptualized Muhammad as God's final messenger, though debate continues to the present over the appropriate level of veneration for Muhammad. Some elevate his stature towards saintly reverence, while others cherish his memory yet stress his mortality and subordination before the mighty Face of God.

Details of Muhammad's prophecy face a shortage of material evidence from early 7th-century Arabia, but Muslim literary traditions seem accurate in portraying him as the leader of a faith community that established itself in the city of Medina in 622, and then militarized, capturing the ritual site of Mecca in 630. Muhammad's precedent established the principle of *hijra* whereby Muslims, upon conversion, leave their old communities and move to new towns in which Islam is the dominant or only creed. Early Muslims also believed that Judgment Day was near, and such expectations of the End of Days, and aspirations to establish Muslim-run communities, determined Islam's growth after Muhammad. Believers spread outwards, possibly in the hope of capturing Jerusalem to trigger the Apocalypse [*see* box on p. 262], but they also entered north Africa and the eastern Mediterranean, perhaps to ready the whole world for the End. The exact motivations are uncertain,

Previous page — Pilgrims at Kaa'ba, from *Fiqh Abī Ḥanīfah* by Abū Ḥanīfah, included in a later miscellany prepared for Iskandar Sultan in 1140–41 (813–14 AH).

Below — Minaret of the Great Mosque at Samarra, 847–61. The origins of this spiral form are still unclear.

The Great Mosque of Damascus

The Great Mosque of Damascus (also illustrated overleaf) was built between 706 and 715 by the Umayyad Caliph al-Walid I (r. 705–715). Like many religious buildings across Afro-Eurasia, its history reflects the changing faiths of the region. It stands on the site of a pagan temple that was later converted to a church dedicated to St John the Baptist under the Roman emperor Theodosius (r. 379–395). After the Umayyad conquest in 634, the church was shared by Christians and Muslims, but in 706 al-Walid purchased and demolished it.

The large rectangular courtyard, occupying the northern part of the complex, has arcades on three sides. The prayer hall, with its monumental gabled entrance, comprises three arcades running parallel to the south (*qibla*) wall with a domed transept cutting the arcades into two equal halves. The plan became the prototype for the 'hypostyle mosque' and

was influential throughout the eastern Mediterranean and beyond.

Glass mosaics, which can be compared to those found in the Dome of the Rock [*see* box on p. 262], once decorated the upper walls of the courtyard and the prayer hall, but only fragments of the originals survive (shown right). Palaces and houses are depicted in a tranquil river landscape without any figural representation. The iconography is clearly derived from Byzantine and late classical models but differs from that of Byzantine churches [*see* box on p. 171]. AO

Further reading: Burns 2005; Flood 2001.

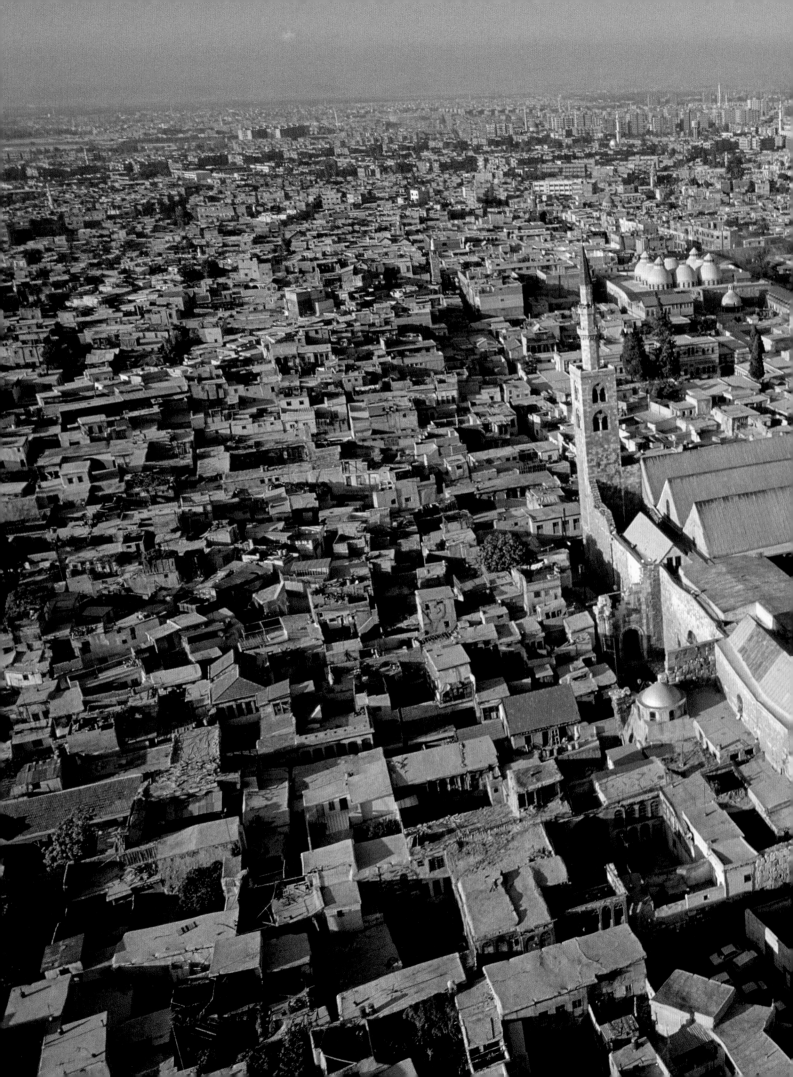

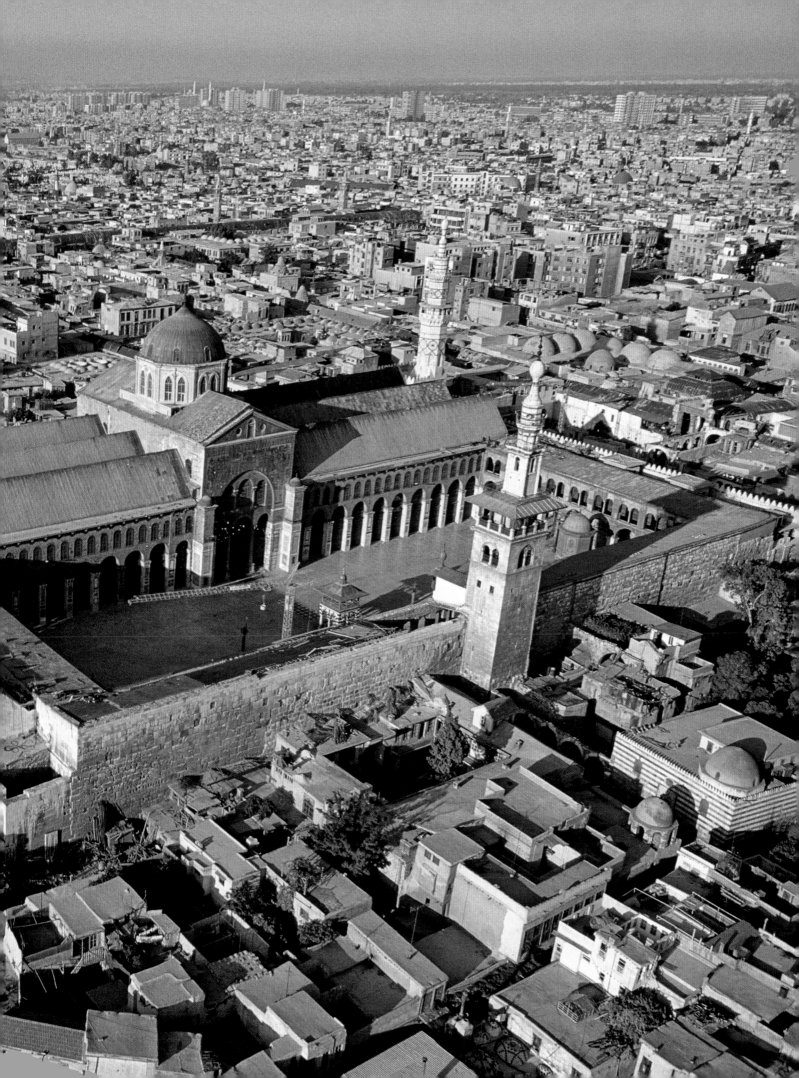

Jerusalem: the Dome of the Rock

The Dome of the Rock in Jerusalem, built in the late 7th century CE, is the first great work of Islamic architecture. It lies in the midst of a large open platform where Solomon's Temple once stood, directly north of where the first Muslims in Jerusalem chose to pray. The octagonal building is placed on a natural rock outcrop that contains a cave. It consists of a central domed space over the rock, surrounded by an octagonal ambulatory divided in half by an arcade of columns and piers. The interior walls are lavishly decorated with quartered marble panelling and mosaics depicting fantastic vegetal ornament. A lengthy inscription in kufic script at the top of the arcade, shown here, contains long quotations from the Qur'an and ends with a date equivalent to 692 CE. The exterior was once decorated with mosaics too, but they were replaced in the 16th century (and again in the 20th) with glazed tiles. Although commonly believed to commemorate the place where the prophet Muhammad ascended to heaven on his mystical night-journey (*mi'raj*), the inscriptions do not mention this but rather emphasize the relationship of Islam and Christianity. JB

Further reading: Graber 2006; Milwright 2016.

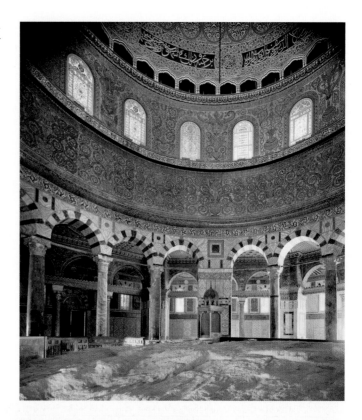

but the results were seminal. Within twenty years of Muhammad's death, his followers defeated the Byzantine empire (330–1453) in these regions and obliterated the Sasanians (224–651) in west Asia. Their rapid spread reached central Asia in the late 7th century, and expansion peaked in the early 8th century when a mostly stable line of control was established. Islam's expansion into south Asia occurred following separate conquests in the 11th century.

In the wake of their 7th-century conquests, Muhammad's followers established new *hijra*-style communities that redrew the lines of existing urban settlement and formed the basis for its major cities:

Cairo [*see* box on p. 285], Basra, Mosul, Merv [*see* box on p. 219], and later Baghdad [*see* box on p. 336]. They organized their territories from north Africa to central Asia into the caliphate, run by Muslim military elites in their new *hijra*-towns. While the caliphate was Muslim-ruled, Muslims initially constituted a tiny minority of the region's population, and most people retained their old faiths.

Conversion was most rapid in urban environments. Conquered peoples resettled in the new towns and converted, and while their reasons are seldom articulated, we can conjecture that conversion was driven by a combination of the

Previous spread — Aerial view of Damascus showing the Great Mosque, built in 706 on the site of a Roman *temenos*, land dedicated to a god.

Above — Possibly the earliest extant Qur'an. The parchment for the two folios at the University of Birmingham has been carbon dated to the late 6th to 7th centuries, but it is uncertain when the text was written.

The Blue Qur'an

The Blue Qur'an is a dispersed manuscript written in gold on indigo-dyed parchment. Several leaves were acquired in Istanbul in the early 20th century and initially attributed to northeastern Iran in the early 9th century, but the subsequent discovery of many more leaves in Tunisia led scholars to suggest other attributions, ranging from 9th-century Baghdad [*see* box on p. 336] to 10th-century north Africa or the Iberian peninsula. According to the late 13th-century catalogue of the Kairouan mosque library in north Africa, the manuscript was already there at that time.

The original manuscript was in seven volumes of about ninety leaves each, with each page measuring 30 x 40 cm (12 x 16 in.) and with fifteen lines of text written in gold leaf outlined in black ink. The verses were marked with silver-leaf ornaments, which subsequently tarnished to black. The unusual gold and blue colour scheme has provoked much speculation about its origin and meaning.

Although other manuscripts of the Qur'an were written in gold, the deep blue ground is unusual and visually stunning, and sometimes compared to Byzantine imperial manuscripts written in gold or silver on purple parchment but more closely resembling Buddhist Chinese texts written in gold on indigo-dyed paper, a fragment of which from the Dunhuang Library Cave [*see* box on p. 138] is shown right. Although blue is mentioned only once in the Qur'an (and in a negative way), the combination of gold writing on a blue ground is attested in Islamic mosaics from the Dome of the Rock [*see* box on p. 262] and the Great Mosque of Cordoba, and gold and lapis lazuli had been combined in jewelry and other arts since ancient times across all of Eurasia. JB

Further reading: Bloom 2015; George 2009; Whitfield 2018.

appeal of Islam's monotheism, preferential tax rates for Muslims, work opportunities in the caliphal administration, and the simple desire to assimilate. Conversion required knowledge of the faith, and while some teachings were translated into Persian, Islam remained predominantly Arabic, and thus the Arabization and Islamization of west Asia occurred in tandem. By the 10th century, most cities had majority Muslim populations, but in many regions, the less Arabized countryside still retained previous beliefs. Thus, while Islam appears to emerge from the Arabian desert, its growth and articulation into the form we know today was an urban phenomenon.

Gold dinar of the Umayyad caliph 'Abd al-Malik, minted in 695 (76 AH).

The Samanid mausoleum

The Samanid dynasty (819–1005) came to govern much of the region between Baghdad [see box on p. 336] and India for the Abbasid caliphs. Their dynastic tomb in the capital city of Bukhara, erected in the early 10th century, is a relatively small (around 10 m or 33 ft) cube of baked brick covered by a hemispherical dome on squinches (corner arches), with smaller domes at the corners.

There is a large arch opening to the interior in the middle of each face, and a miniature gallery with ten arched openings runs around the exterior. Inside are the graves of several members of the Samanid family. The slightly sloping walls are decorated on both the exterior and interior in a variety of patterns created by varying the setting and spacing of the bricks, a technique known in Persian as *hazar-baf*,

or 'a thousand weaves', because of its similarity to textile patterns.

This is one of the earliest surviving examples of the domed-cube type of commemorative structure that would become common throughout much of the Muslim world from China to the Atlantic coast of north Africa, despite the Prophet Muhammad's disapproval of monumentalizing the graves

of the deceased. Although we know of no earlier examples, the evident mastery of structure and decorative techniques indicate that they must once have existed. JB

Further reading: Ettinghausen et al. 2001; Grabar 1966.

The coronation mantle of Roger II

The coronation mantle of Norman king of Sicily Roger II (r. 1130–1154), created in Palermo in 1133 or 1134 CE (528 AH), as recorded in its Arabic inscription, is noted for its design and ornament combining visual languages from across Eurasia. It is now in the Kunsthistorisches Museum in Vienna (WS XIII 14). This hybrid aesthetic is central to the Norman kingdom's self-representation as a diverse realm encompassing a wide range of faiths and languages. Scholars continue to grapple with the specific meaning of the iconography – a palm tree flanked by symmetrical lions tackling dromedaries, or single-humped camels – but the predominant view is that the lions represent the Normans and the dromedaries the Arab world.

The mantle (345 by 146 cm or 136 by 57 in.) is made from a figured samite silk dyed crimson with kermes, an insect-based pigment, with embroidery in red, blue and white silk, couched gold, with vermiculated filigree, cloisonné enamels, pearls, rubies, sapphires, spinels, garnets, glass and a woven border. Material expression was of great importance to Roger II, who in 1147 captured silk workers from Thebes in order to increase the production of Byzantine-quality textiles in his own Fatimid-style royal workshop. The diverse media and skills required to create the mantle could be interpreted as a map of the political powers that the garment sought to subsume. While Roger II and his descendants appropriated and transformed image, text and governance from kingdoms around the Mediterranean, these elements were combined in Palermo into a specifically Norman context.

Fragments of three different silks are attached to the mantle's red linen lining, acquired throughout its journey across time and space. The original tapestry-woven lining is formed of five pieces, created with seven wefts of coloured silks and gilded thread made with leather substrate. These pieces have been labelled according to their main motifs: the tree of life cloth, dragon cloth and bird cloth. A 13th-century green lampas lining with vegetal decoration and a 15th-century rose-coloured double lampas with a floral pattern are also attached, which testify to the mantle's reuse throughout the centuries.
CD

Further reading: Andaloro 2006; Dolezalek 2017; D'Onofrio 1994.

Mamluk ruler of Mosul, possibly Badr al-Din Lulu (d. 1259 CE), from the *Kitāb al-Aghānī* of al-Isfahani.

In central Asia, Islam was likewise practised in cities run by Muslim rulers. Conversion via trade is virtually unattested, and the decisive shift towards majority Muslim demographics in the region occurred with the 11th-century arrival of Turks, who converted and spread across the Iranian plateau, reorganizing land tenure and political territories, and embedding Islam across most levels of society.

Further reading: Donner 2010; Kennedy 1986; Robinson 2010; Simonsohn et al. forthcoming; Sinai 2017.

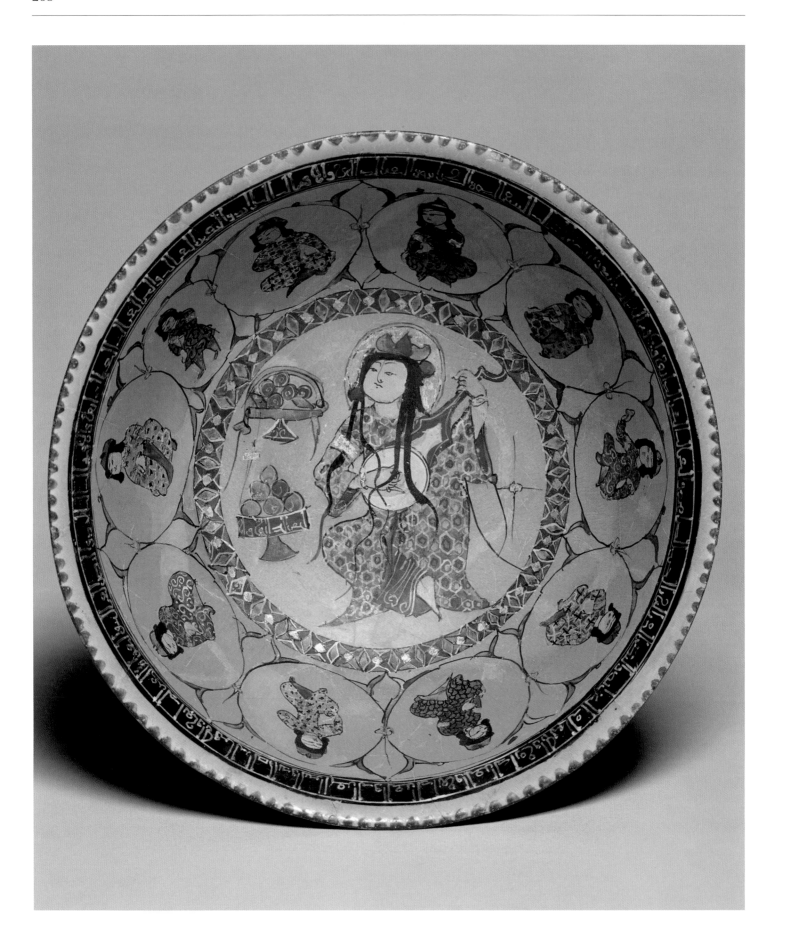

Iranian glazed bowl, gilded and painted
with an oud-player and audience.
Late 12th to early 13th century.

Lutes, *pipa* and ouds: the Silk Road spread of the stringed instrument

James Millward

Chordophones – stringed instruments – are both technologies for making organized sound and vectors of musical and other culture. Three main lute types appear across Afro-Eurasia from ancient times, and evidence of their exchange and hybridization remains apparent in the forms and playing techniques of modern stringed instruments.

Harps and lyres were the first chordophones, perhaps derived originally from the hunting bow. Their strings are played 'open', vibrating over their full length. The lyre enjoyed the highest cultural status in ancient Mesopotamia and the classical Mediterranean, and the 'lyrical' or Orphic tradition (from the mythological poet-musician Orpheus) formed a much-travelled complex of ideas involving art, love, the spirit, the intellect and human interaction with nature.

Zithers are instruments consisting of strings crossing boxes of various shapes. The strings are played open or, on some zithers, 'stopped' at different places along their length. Zithers provide examples of independent invention across Eurasia, from tube zithers made of bamboo in southeast Asia, to the *santur* and psaltery box zithers further west, to the elongated wooden Chinese zithers, one of which was deployed in a (failed) attempt to assassinate the notorious first emperor of China. The *guqin*, pre-eminent instrument of Chinese literati, is a stopped zither that evolved somewhat later from central Asian harps.

The strings of a lute run over a drum-like resonating box and then along a neck. Critically, each string can be stopped at different places along the neck to produce pitches of different frequencies. This makes the physics of sound visually apparent

in a way no other instrument can match: for example, a vibrating string stopped at half its length produces a frequency twice that of the open string (an octave); at two thirds its length, the pitch is one and a half times the open string (a fifth). As a result, music theory was developed on lutes across Eurasia from the 3rd millennium BCE (stopped zithers likely served this purpose in early China). Building on Mesopotamian tradition, Pythagoras (*c.* 570–*c.* 495 BCE) codified musical mathematics with a single-stringed lute. He also linked music to other concepts: the elements, organs, humours, seasons, emotions and the celestial spheres. Islamic scholars elaborated Pythagorean science and philosophy upon the lute-like oud: thus for al-Kindī (*c.* 801–*c.* 873), the oud's highest string equated to fire, the full moon, the heart and yellow bile. Both Orphic and Pythagorean traditions, incubated in the lute culture of the Islamic lands, were later exported to Europe, where they inspired Renaissance musical allegory and raised the lute to the status of 'Prince of Instruments'.

The lute epitomizes Silk Road exchange, since it had its origins in one place and disseminated across Afro-Eurasia and the world. Each transmission was also a transculturation: the technological features of the instrument travelled and evolved incrementally, and its cultural associations travelled, sometimes

A five-stringed lute

Lutes spread across Eurasia from the 3rd millennium BCE, the ovoid type moving into India and China from western and central Asia and thence to the Korean peninsula, Japan and southeast Asia.

The quality and condition of this 8th-century ovoid lute, or *pipa* as it was called in China, where it was probably made, suggest that it was presented to the Japanese court by an envoy and placed immediately into the Japanese Imperial Treasury, the Shōsōin in Nara, where it remains today. The instrument, 108.1 cm (42.6 in.) long, is made from red sandalwood. The pick guard, inlaid with mother of pearl, depicts birds around a palm tree and, below them, a musician on a camel. The figure is probably central Asian or Persian, indicative of the associations between this instrument and its central Asian antecedents: many of the musicians and dancers at the Chinese Tang court (618–907) came from central Asia. SW

Further reading: Shōsōin 1967; Smith 2002; Sotomura 2013; Zhuang 2001.

Celestial musician playing the lute, from the tomb lintel of the 6th-century Sogdian community-leader, An Jia, buried in the Chinese capital, Chang'an.

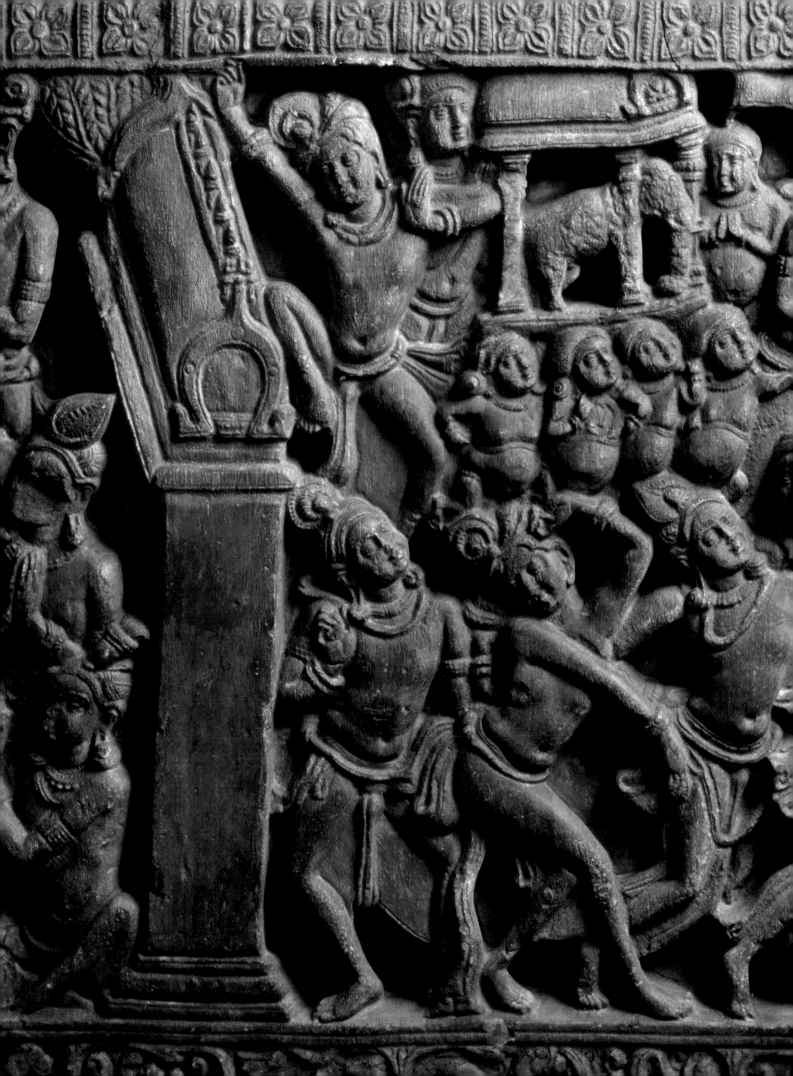

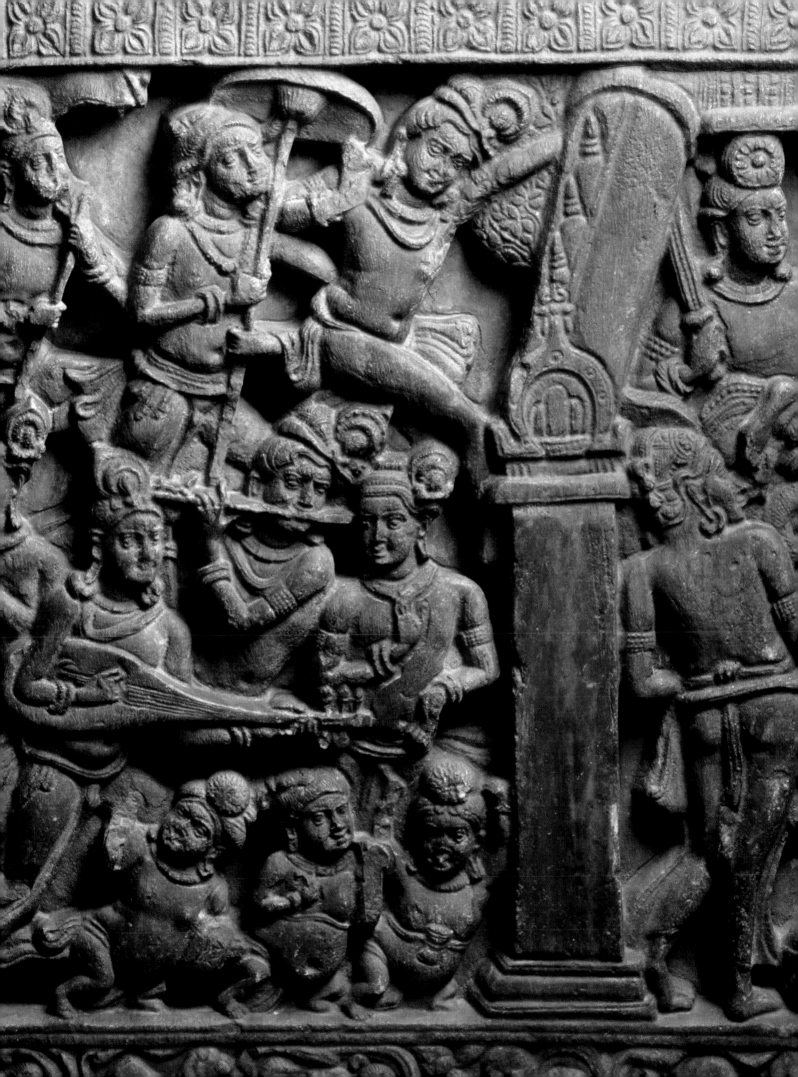

Previous pages — Limestone relief showing scenes from the Buddha's birth, with celestial musicians and dancers, including player of an ovoid lute. Amaravati, 2nd century.

Left — Wall painting of lute-player at the Buddhist caves of Kizil in the Tarim basin, 7th–9th century.

Below left — Statue of a zither-player from the Yungang Buddhist temples, 6th century.

transformed, and were sometimes replaced with entirely new meanings.

For example, the first extant representations of lutes, on Mesopotamian terracottas, are long-necked instruments with small drum-like bodies, played by bizarre men with wild eyes, strange hair, bowed legs and, often, provocatively bare genitals. However, around 1500 BCE, when the chariot-warrior Hyksos brought lutes southeast, in Egypt it was mainly elite female entertainers who played the instrument.

The lute is also feminized in later Mesopotamia, in Persian figurines and in central Asia in the last centuries BCE and early centuries CE. Plastic arts

from Sogdiana, Bactria and Gandhāra in the time of the Kushan depict female lutenists, often in religious contexts, associated with the Kushan tutelary goddess Nana. Nana's horizontal crescent attribute (seen on Kushan coins dedicated to the goddess) is echoed in the shape of sound-holes of the short-necked, ovoid or oval central Asian lutes. The same crescent moons are suggested in carvings of somewhat longer ovoid lutes depicted in Ajanta, Amaravati and other Indian Buddhist rock-cut temples in the late 1st millennium. (Lutes later disappear from Indian iconography, until re-imported by Islamic groups from the 12th century.)

The ovoid lute moved from central Asia to China as the *pipa*, and ultimately to Vietnam, the Korean peninsula and Japan. In Tang China, it carried strong associations with central Asians, but was still generally played by women – perhaps a continuation of the central Asian tradition. As the *barbat*, the

ovoid lute moved to Iran, then to Islamic lands including Andalusia as the *'ud* or oud, and thence by the 14th century throughout Europe, where *al-'ūd* became 'lute'. Modern descendants of Silk Road lutes include the guitar, mandolin, banjo and the violin family.

——

Further reading: Lawergren 1995/96, 2003; Millward 2012; Picken 1955; Sotomura 2013; Turnbull 1972; Zeeuw 2019.

Five celestial musicians, carved from schist in the Swat valley in the 4th–5th centuries CE.

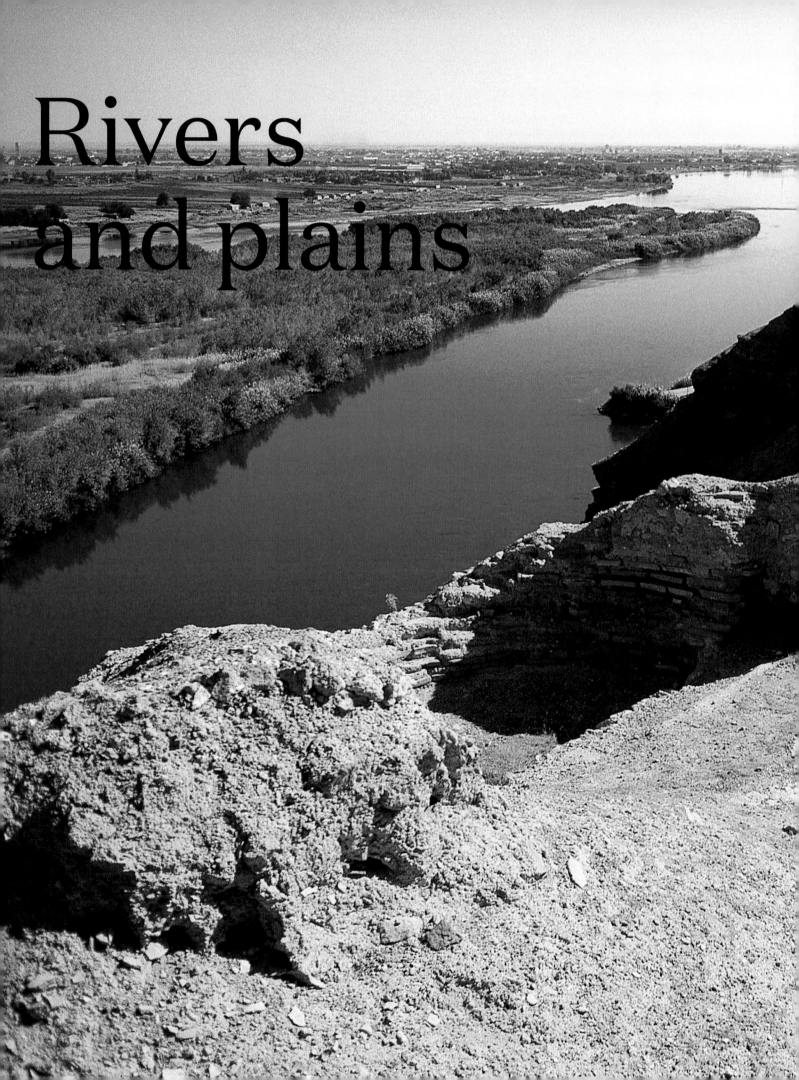

Rivers
and plains

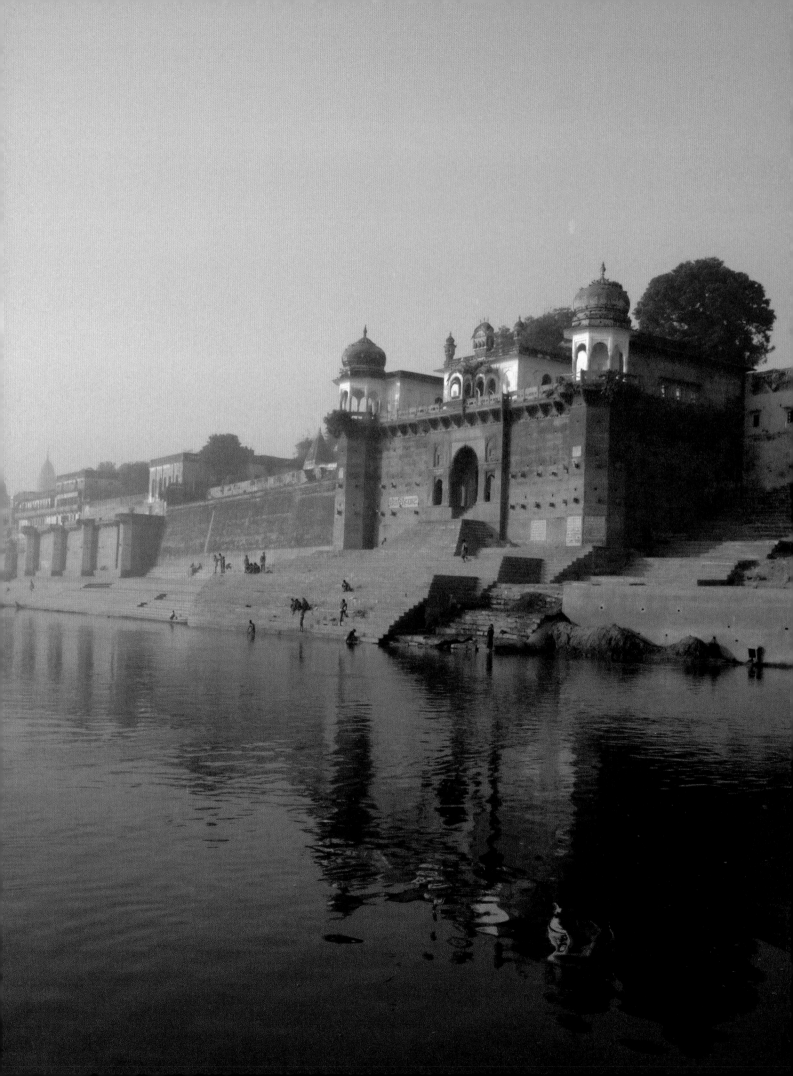

Rivers and plains

Previous spread — The ruins of Dura-Europos on the banks of the Euphrates.

Opposite — The Ganges river at Varanasi.

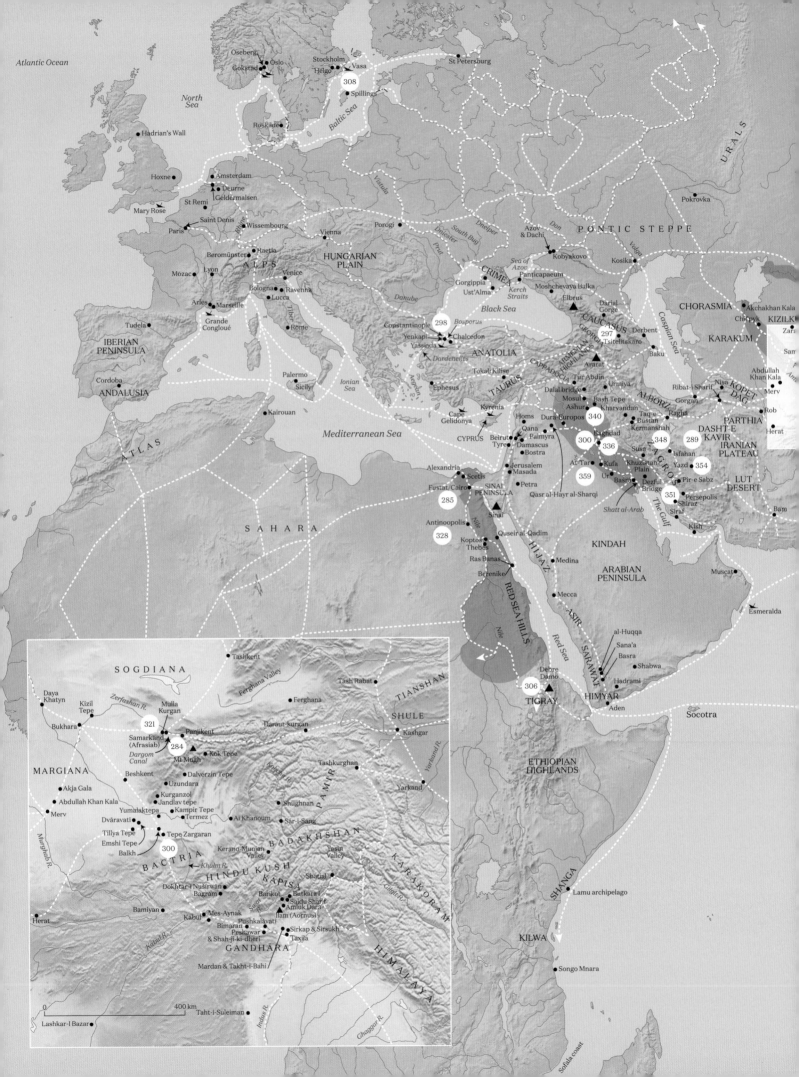

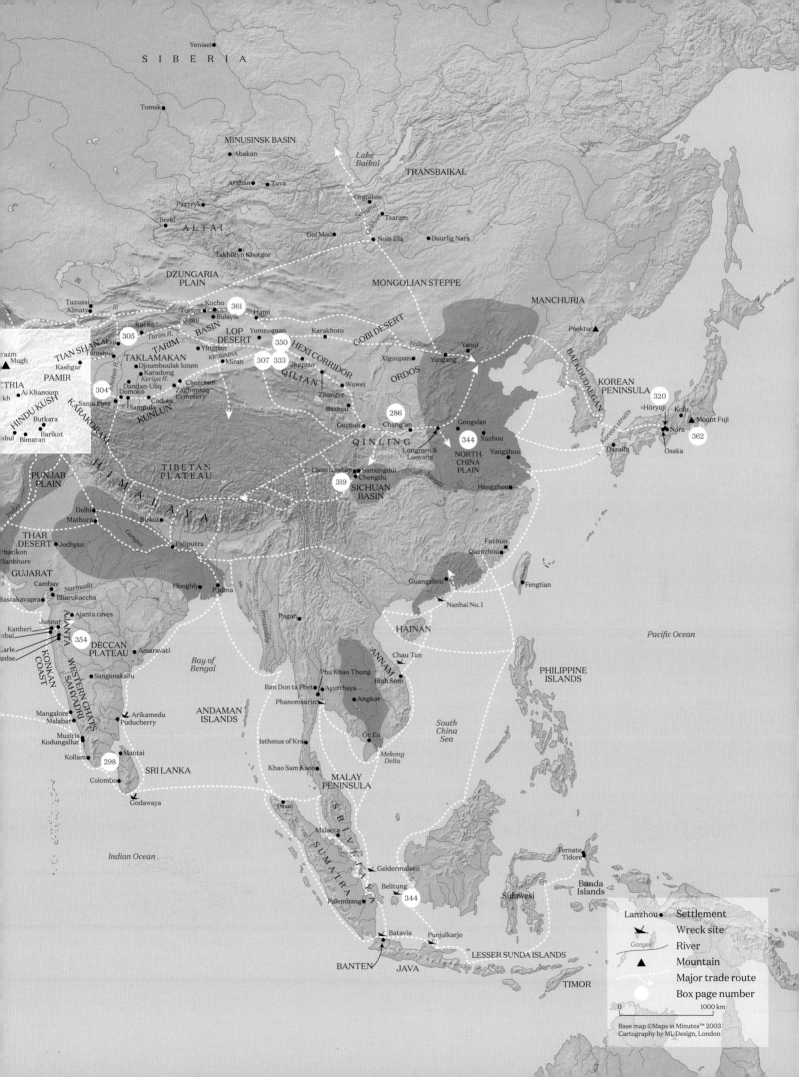

SIBERIA

Yenisei

Tomsk

MINUSINSK BASIN

Abakan

TRANSBAIKAL

Lake Baikal

Arzhan Tuva

Pazyryk

Berel

ALTAI

Orgoiton

Selenga

Tsaram

Orkhon

Takhiltyn Khotgor

Gol Mod Noin Ula Duurlig Nars

MONGOLIAN STEPPE

MANCHURIA

DZUNGARIA PLAIN

Ili

Tuzusai
Almaty

Ili

Kocho Hami

361

Turfan Bulayik

JUSHI

Kucha Yumenguan Karakhoto

GOBI DESERT

Paektu

TIAN SHAN Aksu 305 TARIM Tarim R. BASIN LOP DESERT

350 HEXI CORRIDOR

Yellow

Yanqi

Kashgar Tumshuk Yingpan Xigoupan Yungang

BAEKDUDAEGAN

Kharazm
Mugh

TAKLAMAKAN Djoumboulak koum KRORAINA 307 333 QILIAN Jiuquan

Ordos

KOREAN PENINSULA

320

TRIA

PAMIR Karadong Miran Zhangye Wuwei

Hōryūji Kōfu

kh Ai Khanoum Khotan R. Dandan-Uliq Zaghunluq Cemetery

Bazhou Guyuan 286 Chang'an Gongxian 344 Xuzhou

Mount Fuji

HINDU KUSH Sanju Pass 304 Domoko Cherchen

Nara

abul Butkara Sampula Cadota KUNLUN

QINLING Longmen & Luoyang NORTH CHINA PLAIN Yangzhou

Dazaifu Osaka 362

Bimaran Barikot KARAKORAM

Laoguanshan Sanxingdui Chengdu 319 SICHUAN BASIN

Yangzi Hangzhou

PUNJAB PLAIN HIMALAYA TIBETAN PLATEAU

Delhi

THAR DESERT Mathura Birkot Ganges

Jodhpur

barikon Pataliputra

Banbhore

GUJARAT Indus

Cambay Narmada

astakavapra Bharukaccha

Fuzhou
Quanzhou

Guangzhou Nanhai No.1 Fengtian

Pacific Ocean

Hooghly Padma

Pagan

Irrawaddy

HAINAN

Chau Tan

PHILIPPINE ISLANDS

Ajanta caves

Kanheri AJANTA 354 DECCAN PLATEAU Amaravati

bai Junnar

WESTERN GHATS

Karle KONKAN COAST SAHYADRI

edse

Bay of Bengal

ANNAM

Phu Khao Thong

Bình Sơn

Mangalore Sanganakallu

Malabar Arikamedu

Muziris Puducherry

Kodungallur

Kollam Mantai 298

Colombo

Godawaya

SRI LANKA

ANDAMAN ISLANDS

Ban Don ta Phet Ayutthaya Angkor

Phanomsurin

Isthmus of Kra

Khao Sam Kaeo

MALAY PENINSULA

Óc Eo

Mekong Delta

South China Sea

Pasai

SRIVIJAYA

Malacca

SUMATRA

Indian Ocean

Geldermalsen

Belitung 344

Palembang

Batavia Punjulkarjo

BANTEN JAVA

Ternate
Tidore

Banda Islands

Sulawesi

LESSER SUNDA ISLANDS

TIMOR

Lanzhou ● Settlement

⏄ Wreck site

Ganges River

▲ Mountain

Major trade route

○ Box page number

0 1000 km

Base map ©Maps in Minutes™ 2003
Cartography by ML Design, London

Arteries of the Silk Roads

Tim Williams

"From the peaks of the mountains water courses down and nourishes the plains which need no irrigation...the fertile earth-smelling fields which adorn the mountain flanks and level ground struck the refreshed gaze of the viewer more like clothing than the colour of vegetation."

Łazar P'arpec'i (5th century), *History of the Armenians*.
Translated from the Armenian by Robert Bedrosian.

Opposite — The ruins of Mari on the Euphrates.

Agriculture has long flourished in the river valleys and plains of Afro-Eurasia, supporting large populations and leading to the growth of cities and the rise of empires. These fertile plains were a vital part of the Silk Roads, enabling the development of markets, producing the goods transported along them and helping to shape the selection of routes for many travellers. The control of these zones was a strategic priority, and the rivers themselves have acted both as boundaries and connections between empires.

The perennial and seasonal rivers of east, central and west Asia, starting in the high mountains, and peaking with the spring and early summer meltwater, made the irrigation of vast areas for agriculture possible [see pp. 236–43]. But the Amu Darya and the Syr Darya, for example, were so deeply incised that very little irrigation was possible until systems of dams and canals could be developed to harness their huge potential. People grasped this challenge at an early date. In Iran, for instance, the qanāt system may have been used as early as the 7th century BCE, while on the China plain the practice of canal irrigation appears to have started during the Warring States period (481–221 BCE), demonstrating a complex knowledge of hydraulic engineering at this early time.

Boris Andrianov's groundbreaking reconstruction of the water systems in the Amu Darya and Syr Darya deltas identified a period of development between the 4th century BCE and the

Afrasiab and the Ambassadors' Painting

Afrasiab is the archaeological site corresponding to the walled inner city of Samarkand, from its foundation in the aftermath of the Achaemenid conquest (at the end of the 6th century BCE) until its abandonment after the Mongol conquest (1220 CE). The focus of the city then moved down the plain, where later Timur and his successors rebuilt it as their capital.

Archaeological excavations started shortly after the Russian conquest in 1868 and, with some interruptions, have continued to the present. Since 1989 they have been carried out by the French-Uzbek Archaeological Mission in Sogdiana (MAFOUZ-Sogdiane). As the chief town of the middle Zarafshan valley, Samarkand had

been preceded by Kok Tepe, an early Iron Age and Achaemenid ceremonial site 26 km (16 miles) to the north, but the Afrasiab plateau had better defensive potential. In order to exploit this, the first builders erected a massive mud-brick rampart around its edge (replaced by a hollow rampart after the Greek conquest), encircling an area of 220 ha (545 acres). The construction of the Dargom canal, ensuring a permanent supply of water to the plateau, possibly also dates from this period. In 329, Alexander (r. 336–323 BCE) took Samarkand, named Maracanda by his historians. Coin finds seem to indicate that Greek occupation was continued until the reign of Diodotus I (c. 250–240 BCE).

Except for the rampart, the only building from this period excavated at Afrasiab is a monumental granary, which is consistent with Samarkand's function as a military stronghold facing invasions from the steppe.

After a period of decline – during which urban life continued – the plateau was re-fortified on a smaller scale under the Kidarites and Hephthalites (5th–6th centuries). The following 'golden age' of Sogdian rule has left us a masterpiece in the form of the 'Ambassadors' Painting' [see details illustrated on pp. 68, 135, 140–41, 314 and 328] of c. 660, a monumental painted cycle focusing on the Zoroastrian New Year celebration.

Two successive palaces testify to the later establishment of Arab power, the second erected in the 750s by Abu Muslim (d. 755), the instigator of the Abbasid revolution. On its ruins a cluster of pleasure pavilions was built in the 12th century by Turkic rulers of the Karakhanid empire (840–1212), with remarkable painted decoration showing hunting scenes, birds in gardens with Persian verses, guards, and the enthroned ruler.
FG

Further reading: Compareti 2016b; Grenet 2004; Karev 2005.

Citadel

Residential areas

2nd rampart

'Hall of the Ambassadors'
3rd rampart

0 100 200 400

Old and new Cairo

Fustat, or old Cairo, was established on the Nile at the time of the Arab conquest in 641. It was a base for soldiers of the caliphate, but also a production centre for fine artifacts, including ceramics. It thrived until the 12th century when much of the city was burned. The Ben Ezra synagogue and its *geniza* – a repository for discarded documents [illustrated, for example, on pp. 436, 438 and 439] – survived the fire and continued to grow. Its discovery in the 19th century, like that of the Dunhuang Library Cave in central Asia [*see* box on p. 138], transformed Silk Road scholarship. In the 12th century, however, Fustat's administrative functions moved to Cairo, the palace city to its northeast that had been founded by the Fatimid caliphate (909–1171) in 969. Cairo flourished under the Fatimids, with the construction of buildings, such as the 10th-century Al-Hakim Mosque, shown above right. The walled city, containing palaces and administrative offices, was reserved for the caliph and his attendants. It remained the nucleus of the medieval and modern city until the 19th century.

In 1171 the Ayyubids under Saladin took control, reasserting Sunni orthodoxy, and in 1250 the Mamluks (1250–1517) seized power and Cairo became the cultural, religious and intellectual centre of the Islamic world. The Qalawun complex, shown below right, was built over the remains of the Fatimid palace in the 13th century. The defeat of the Mongols in 1260 and the re-establishment of the Abbasid caliphate brought the Mamluks recognition as the 'defenders of Islam'. They created a society in which patronage flourished and numerous religious and educational institutions were constructed. But in 1516, Cairo fell to the Ottomans and despite its history became something of a provincial backwater. AO

Further reading: Behrens-Abouseif 1989; Behrens Abouseif et al. 2012; Raymond 2002.

Chang'an: Chinese imperial capital

The cosmopolitan city of Chang'an was at the heart of Chinese territory and a major trading centre of the Silk Road. For two millennia, most Chinese dynasties had their capital built at this strategic location, which controlled the passes leading west and was near the great agricultural plains of northern China. The first emperor of the Sui dynasty (581–618) ordered a new capital to be built in 582. The resulting rectangular walled city was oriented to the cardinal directions, measured around 10 km (6 miles) east–west by 8 km (5 miles) north–south, and was divided into 110 residential areas or wards by twelve avenues in the east–west direction and nine running north–south. The 155-m (510-ft) wide Scarlet Sparrow Boulevard joined the great south gate to the imperial palace to the north and served as the central axis of the great city. The wards each had a perimeter wall with two or four gates. Large mansions as well as Buddhist, Manichaean and other temples could also be found in the wards. Of the two major markets in the city, the western one, about 1 sq. km (0.6 sq. miles), was where traders from the Silk Road sold their wares. At the height of Silk Road trading, foreign merchants might have numbered more than several thousand in a city with a population close to 2 million. Chang'an was thus a cosmological, political, religious and international centre unequalled in the world at the time. PPH

Further reading: Heng 1999; Huang 2014.

KEY
- wards of city
- watercourses
- lake
- 卐 Buddhist monastery or nunnery
- D Daoist monastery or nunnery
- x Manichaean or Zoroastrian
- 1. Guest house for foreign envoys
- 2. Court for foreign envoys

Labels on map: Guest house of Diplomatic Reception; Court of Diplomatic Reception; Daming Palace; Western market; Palace City; Tonghua Gate; Zhangjiang Temple (outside the gate); Eastern market

2nd century CE when an estimated 2 million ha (5 million acres) were being irrigated in the two deltas (four times the area currently under permanent irrigation). This represents an example of the outstanding adaptation of local conditions to support the cities of Afro-Eurasia. There is little doubt that such intensification of agriculture, and concomitant population growth, would have had a significant impact upon craft specialization, the development of elite classes and the scale of exchange.

The great rivers of east, central and south Asia are formed by the continental watersheds, along the crests of the mountain chains, which divide the main river basins. The Tibetan plateau and Kunlun drain to the north, and the Karakoram range northeasterly, into the Taklamakan desert. Civilization on the China plain formed along the Yellow and Yangzi rivers.

The former rises in the Kunlun and its waters brought down rich loess soil enabling intensive agriculture but also silting its lower reaches and thus causing frequent life-destroying floods. To the west, other rivers flowing from the Kunlun, such as the Yarkand, Khotan and Keriya, created the vital oases of the southern Taklamakan. To the north, a number of rivers, such as the Aksu, flow south from the Tianshan, to join the remnants of the Yarkand to create the Tarim, a shifting river within the Taklamakan. It flows eastwards and historically fed Lop Nor, a major and evocative lake in antiquity, which has now disappeared.

The Indus river, crucial to so many civilizations and travellers, rises on the Tibetan plateau and drains southwards, a vast basin that includes both the flanks of the Himalayas and the southern slopes of the Karakoram and Hindu Kush. The Amu Darya, which

drains the Pamirs northwards, and the Syr Darya, which rises in the central Tianshan, flow into the Aral Sea. From these mountain ranges emanate numerous smaller, but hugely significant, rivers, such as the Murghāb, which rises in the Hindu Kush and flows northwards to create the large fertile delta that sustained the ancient city of Merv [*see* box on p. 219], before petering out in the Karakum desert.

Undoubtedly the most significant river of south Asia is the Ganges. Rising in the western Himalayas, it flows eastwards, dividing into the Hooghly and the Padma before emptying into the Bay of Bengal. It is a sacred river, especially for Hindus, but it is also vital for the irrigation and daily needs of the people living along its course. The Gangetic plain, a massive fertile expanse, has been used for large-scale irrigation since at least the 4th century BCE, and it has been hugely significant for the

development of many empires, from the Mauryan (322–185 BCE) to the Mughal (1526–1857).

Further west, the Tigris and Euphrates have also been instrumental in shaping major civilizations in the region known as Mesopotamia. Originating in the Armenian highlands, they flow through Syria and Iraq before discharging into the Gulf. Traversing deserts, the rivers form the extensive alluvial plain that dominates central Iraq, which was so crucial to the development of Mesopotamian civilizations as well as to overland trade, enabling travel from the Iranian plateau to the Syrian desert.

To the north, the iconic Volga, Don and Dnieper rivers were major routes connecting northern Europe to central and west Asia. The Volga is the longest river in Europe, and its watershed offers a huge area of fertile land that, throughout antiquity, was

The Yellow river and the North China plains.

a platform for major urban development and dominated the movement of people and goods in the region. Also significant was the so-called Amber Road, named after the prehistoric movement of amber from the North Sea and Baltic Sea coastal areas, by way of the Vistula and Dnieper, to the Mediterranean.

In north Africa, the Nile almost defines Egypt. Pliny the Elder (23–89 CE) described its delta as a triangular island of habitation in a desert. The Nile is arguably the longest river in the world and it played a crucial role in the development of civilizations, as the silt deposits from the annual overflow of its banks created a massive fertile plain. This enabled enormous agricultural production, not only sustaining major urban centres such as Cairo [*see* box on p. 285] but also providing significant export products, such as grain.

Transport along rivers was critical to the development of trade networks, in places providing a significantly easier mechanism for moving goods than by land. The Roman emperor Diocletian's (r. 284–305) price edict of 301 CE, for example, showed it was considerably cheaper to transport goods by river than by road. However, in practice, seasonal fluctuations in river levels and the rapid changes in height of many rivers meant that they were not all easily utilized without engineering works. In winter, the northern rivers froze, making seasonal travel possible on these ice roads.

River crossings were important in restricting and enabling travel. Sometimes rivers were fordable, or covered with ice, but many of the large rivers required ferry boats and bridges. One of the oldest surviving examples of the latter is the Sasanian Dezful bridge, in southern Iran, which was commissioned in 260 CE by King Shapur I (r. 240–270) to bridge the Karun river, enabling routes across southern Iraq and Iran to be developed. Similarly, the Abbasid Dalal bridge over the Khabur river facilitated the

Bridge over the Karun river in Dezful, built by Roman prisoners of war under Shapur I (r. 240–270) of Sasania.

Isfahan: city of many religions

Isfahan is one of the most important urban centres on the Iranian plateau. Its strategic location, surrounded by exceptionally fertile soils, made it an ideal site for the development of a trading city, vital to both the east–west routes across the plateau and the north–south connections east of the Zagros mountains. Perhaps as early as the Median empire (7th–6th centuries BCE), an urban centre (Gabae, later called Jayy) developed alongside the Zāyandah-Rūd river, which has the most abundant flow of any river in the Iranian interior.

Later Arab geographers described this land as a paradise.

The province was the homeland of the founders of the Achaemenid empire (c. 550–330 BCE), but there remains little trace of the early city and its Zoroastrian temples. Peroz I (r. 459–484) of the Sasanians built a village and a Zoroastrian fire temple outside one of the gates, commonly known as Jews' Gate. This perhaps referred to the Jewish colony at Yahūdiyya, some 3 km (2 miles) northwest of Jayy, reportedly founded by Queen Shushandukht, the Jewish wife of Sasanian king Yazdegerd I

(r. 399–420). Gradually, the two cities merged, with Yahūdiyya becoming the dominant part.

After the Islamic conquest in 642, Isfahan became the provincial capital and flourished for many centuries. But it was sacked by the Mongols in 1226, besieged in 1228, and occupied in 1240/1241. Ibn Battuta, visiting in 1327, noted that the city was largely in ruins. However, Isfahan regained its importance during the Safavid period (1501–1736), becoming a cosmopolitan capital under Shah Abbas I (r. 1588–1629), home to Armenians, Turks, Chinese potters and

European missionaries and merchants. There was also a considerable Zoroastrian community. Isfahan developed into one of the most beautiful cities of the 17th-century world, with many of its monuments, including the Jameh Mosque shown here, designated as UNESCO World Heritage Sites today. TW

Further reading: Lambton & Sourdel-Thomine 2007; Matthee 2012.

northern trade routes through the region. Rivers could also act as barriers, forming the limit of empires and impeding travel. The Amu Darya, for example, divided the Sasanians (224–651) and the Hephthalites (c. 450–c. 560), and later the khanates of Merv and Bukhara.

As special places, imbued with power and significance, rivers have a major place in the cosmology of many societies. Rivers were gods, or intimately linked to gods. The ancient Egyptians are thought to have equated the Nile floods with the emergence of life from the primeval chaos, and the spirit of the Nile was a prevalent concept. In the Roman world, representations of river deities, mostly of the Tiber and Nile, were prominent. Many rivers are regarded as sacred and treated with deep reverence because of their purifying effect. For Hindus, for instance, there are seven holy rivers in India, all associated with Śiva. The Ganges is the

most significant, while the Manas, in the Himalayan foothills between Bhutan and India, is named after the serpent god in Hindu mythology. Zoroastrian worship often took place at sources of water [*see* box on p. 351] while, to the east, Buddhist shrines were located at springs. In general, the crossing points of rivers were often associated with rituals and symbolism, and archaeological discoveries of votive offerings at such points are common.

———

Further reading: Andrianov 2016; Cunliffe 2015; Penn & Allen 2001; Pietz 2015; Sen 2019; Verkinderen 2015.

Uncovering great cities and temples

Warwick Ball

The discovery of a 2nd-century BCE Corinthian column at the Bactrian city of Ai Khanoum [*see* box on p. 203] during French excavations led by Paul Bernard between 1964 and 1979.

"They started digging and have now excavated a large room...with frescoed walls, unfortunately all fallen...I have been going over the plaster fragments, and we have found at least four faces, mostly of women, and a lovely hand, plus quantities of unidentified pieces, probably garments...one, I think, was a yellow robe with an elaborate swastika design in lavender. It's heaps of fun."

Susan Hopkins on Dura-Europos, 21 December 1928.

In 1920, soldiers from British-occupied Iraq crossed over into French-occupied Syria in pursuit of a band of rebels. The rebels took refuge in some ruins on the edge of the desert on a cliff overlooking the Euphrates river. In the ensuing shoot-out, the sands fell away uncovering a startling ancient wall painting. The spectacular site of Dura-Europos was revealed.

The discovery encapsulates many of the themes that this book explores: a dramatic discovery; an international expedition; spectacular finds; Jewish, Christian and pagan religions; ancient chemical warfare; Greeks, Romans and Iranians; and a trade network that spread through west Asia and beyond.

Joint excavations by the French Academy and the University of Yale were undertaken at Dura-Europos in the 1920s and 1930s, headed by the émigré Russian scholar Mikhail Rostovtzeff (1870–1952). They uncovered a city founded in about 300 BCE as a Macedonian military colony and extended by the Parthians (247 BCE–224 CE) and Romans (27 BCE–395 CE), and the preservation of its buildings led to it being dubbed 'the Pompeii of the desert'. Among the most dramatic structures were an extraordinarily eclectic range of religious monuments: the Temple of the Palmyrene Gods, the startling paintings of which were discovered by the British soldiers; a Mithraeum with paintings depicting Zoroaster and other Iranian deities [see pp. 346–55]; a synagogue with paintings depicting scenes from the Old Testament [see pp. 434–39], the oldest such cycle surviving; and the world's oldest Christian church, accurately dated by an inscription to 231/2 CE and containing paintings depicting the miracles of Christ. In addition, there were temples to the Greek gods Artemis, Apollo and Zeus, as well as to Roman Jupiter, to the Syrian deities Atargatis and Azzanathkona, to the Palmyrene gods Bel, Yarhibol and Aglibol and to Arab gods such as Arsu, Ashera and Sa'ad.

The story of the rediscovery of another Hellenistic city overlooking another famous river at the far eastern end of the Hellenistic world is, if anything, even more curious. In the late 1880s a young journalist, Rudyard Kipling (1865–1936), working for the *Civil and Military Gazette* in Lahore, heard rumours of a lost Greek city built by Alexander (r. 336–323 BCE) deep in the unknown territory of eastern Afghanistan. The rumours probably originated from the American adventurer and soldier of fortune Colonel Alexander Gardner (d. 1877), but the lost Greek city remained nothing more than a myth until a king made an astonishing discovery.

King Zahir Shah (r. 1933–1973) of Afghanistan was hunting along the banks of the Amu Darya in the far northeast of his country in 1961 when he stumbled across a perfectly preserved Corinthian capital. He at once notified the French Archaeological Mission in Afghanistan, who began excavations in 1964 under the direction of Paul Bernard (1929–2015), continuing until the Soviet invasion in 1979 brought them to a close. The site, known as Ai Khanoum, was a city – probably ancient Eucratidia – founded by Greek settlers in the wake of Alexander's conquest [see box on p. 203].

The existence of a Greek city in central Asia so far from the Greek homeland is by itself extraordinary. But the implications go much further. A Hellenistic-derived art had long been known in the region, that of Gandhāra, usually expressed in the architecture of Buddhism. But Gandhāran art flourished in the first few centuries CE, some four centuries or more after Alexander's conquest. Ai Khanoum at last provided concrete

Left — Joseph Hackin, photographed in 1937 by his wife, during excavations at Begram, with one of the thousand 1st- to 2nd-century ivory panels discovered there.

Opposite — Begram under excavation in 1939 by Joseph Hackin.

Below — Mikhail Rostovtzeff (right), leader of the excavation at Dura-Europos, with Franz Cumont (1868–1947) at the Mithraeum after its discovery in 1932.

evidence that Hellenistic culture had not only been planted in the region, but had taken root.

The distance – roughly 5,000 km (3,000 miles) – between Ai Khanoum and Greece might seem a long way, but the complex network of connections extended much further. It has already been observed that the Hellenistic art of the region was expressed through the medium of the Buddhist religion, which originated in plains of northeastern India. Pataliputra (modern Patna) on the Ganges, where excavations begun in 1913 are still ongoing, became the capital of the Maurya empire (321–185 BCE) and its greatest king, Aśoka (r. *c.* 268–*c.* 232 BCE), initiated the spread of Buddhism throughout India. The city was described by the Greek envoy Megasthenes, who visited it in 303 BCE; another Greek, King Menander (r. 165/155–120 BCE), incorporated it briefly into his Indo-Greek kingdom and became a Buddhist.

From the 2nd century BCE, the expansion of a steppe confederacy to its north, the Xiongnu [*see* pp. 70–75], resulted in the displacement of the Yuezhi peoples in the Hexi corridor. The Yuezhi settled eventually in central Asia and, united under the Kushan clan, they invaded the former Greek kingdom of Bactria in the last century BCE. From their former capital, modern Balkh, the Kushans carved out a great empire straddling central Asia and northern India. Balkh, on the plains of northern Afghanistan, is one of the greatest archaeological sites in central Asia, dubbed 'the mother of cities' by the early Arab geographers, and surrounded by immense ramparts. Until recently, the Greek and Kushan levels defied successful excavation, leading the founder of the French Archaeological Mission in Afghanistan, Alfred Foucher (1865–1952), to dub Balkh 'the Bactrian Mirage'. Following the collapse of the Taliban regime in the early 2000s, however, the French returned to the city and uncovered Greek and Kushan remains.

Far more impressive remains – and even more startling international connections – have been uncovered at two other Kushan cities, Begram on the Koh-i Daman plain near the upper reaches of the Kabul river in Afghanistan, and Taxila [*see* box on p. 163] on the great Punjab plains, watered by the Indus and its tributaries (the Kabul river being one). Begram was first brought to scholarly attention in the mid-19th century by the extraordinary British pioneer antiquary, explorer and adventurer Charles Masson (1800–1853). Masson amassed a huge collection of coins and other objects from Begram and the surrounding area, now mainly held by the British Museum, which led to the first scholarly study of the Kushans and the identification of Begram as ancient Kapisa. The site was subsequently excavated between 1937 and 1939 by a French Mission led by Joseph Hackin (1886–1941), a former member of the famous 1931–32 Citroen Expedition from Beirut to Beijing, and then by a White Russian émigré, Roman Ghirshman (1895–1979), between 1941 and 1942. It was in two walled-off rooms in the palace that Hackin uncovered one of the most eclectic and spectacular hoards ever discovered: it comprised elaborately carved ivories from India (including part of an ivory throne), Hellenistic bronzes, Chinese lacquers and intricately moulded glassware from the Roman world.

Buddhism in its Greco-Roman artistic guise flourished under the Kushans in an explosion of creativity. The city where this is perhaps seen at its best is Taxila in present-day Pakistan, largely due to extensive excavations by Sir John Marshall (1876–1958) between 1912 and 1934. Marshall's excavations revealed an extensive city laid out on a grid system, as well as many Buddhist stupa-monastery complexes, both within the city and in the surrounding hills [*see* box on p. 163].

Further reading: Ball 2008; Francfort et al. 2014; Hopkins 1979; Marshall 1960.

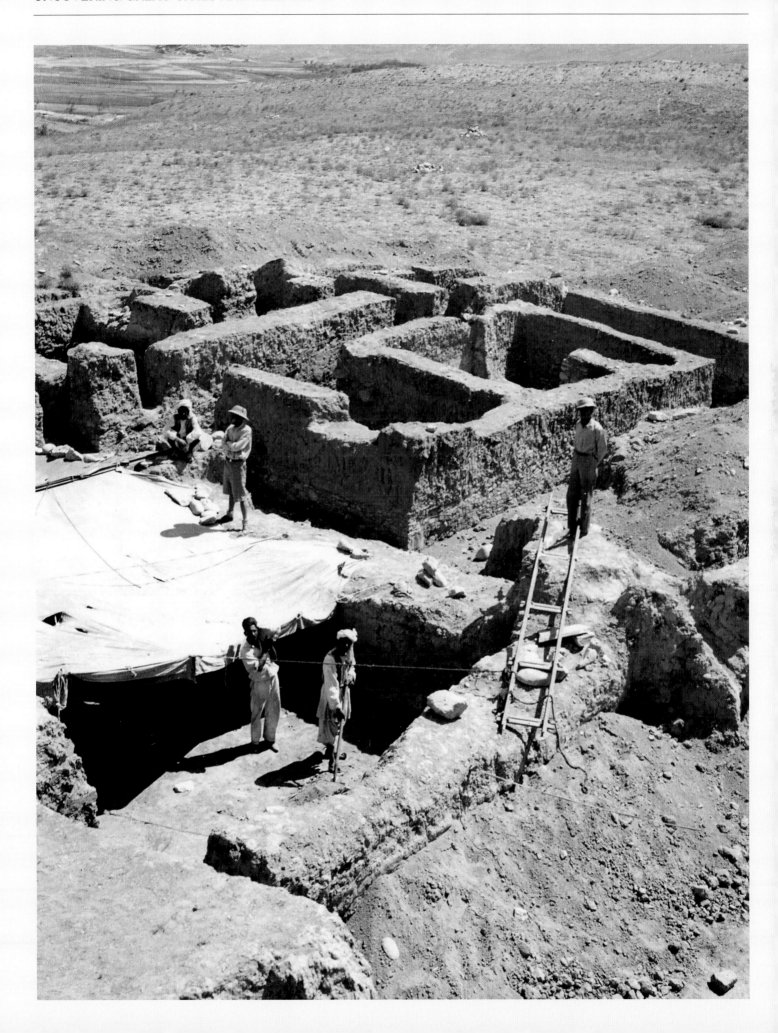

Great empires of the Silk Roads

Touraj Daryaee

"Al-Hasan b. Amr told me that at Mansura he had seen people from Lower Kashmir. They also come down the river Mihran... at flood time. They do this on bags of grain, each weighing seven to eight hundred pounds. They are wrapped in skins which have been treated with resin, which makes them waterproof. Tying them together forms a raft...they reach Mansura in forty days, without the grain being damaged by water."

Buzurg ibn Shahriyar (10th century), *Book of the Wonders of India*.
Translated from the Arabic by G. S. P. Freeman-Grenville.

Opposite — The Battle of the Indus (1221), showing Chorasmian cavalry fording the river, fleeing Genghis Khan and his army. Folio from the epic of Genghis Khan painted by Banwarí Khúrd, Dharm Dás (1597–1600).

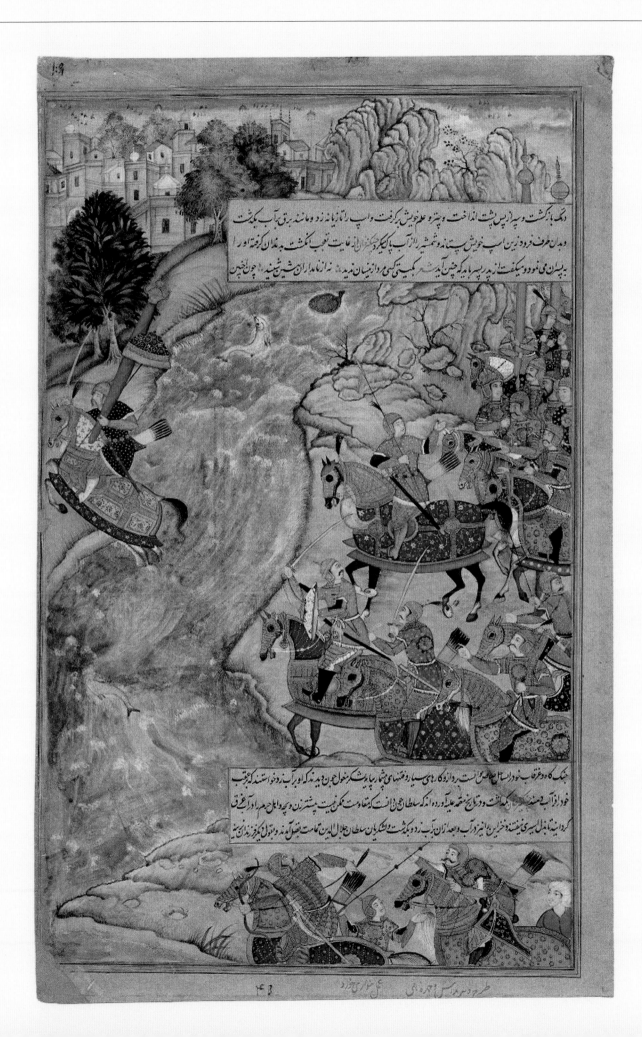

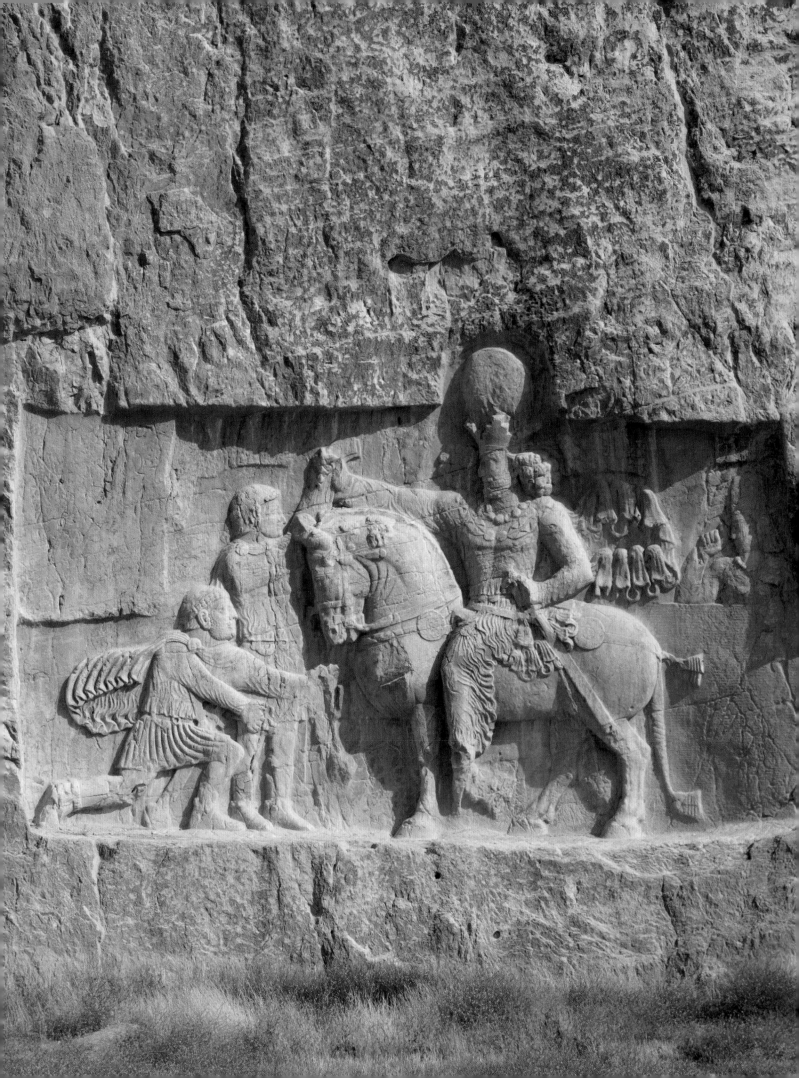

The irrigated plains of the great rivers across Afro-Eurasia enabled the growth of wealth, trade and large empires. The latter included the Han dynasty (206 BCE–220 CE) on the plains of China, fed by the Yellow and Yangzi rivers; the Kushan empire (1st to 3rd centuries CE), which controlled the Indus valley and its routes from central Asia to the sea; the Parthians (247 BCE–224 CE) on the Iranian plain; and the Roman empire (27 BCE–395 CE) around the Mediterranean, including north Africa.

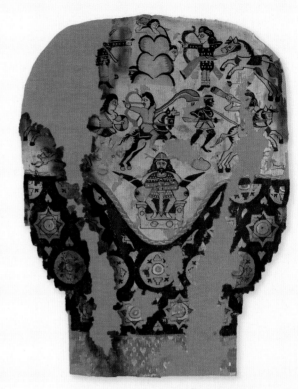

Opposite — Rock relief at the Achaemanid and Sasanian necropolis of Naqsh-e Rostam near Persepolis, showing the victory of Shapur I (r. 240–270) over the Roman emperors Valerian and Philip the Arab.

Above — Fragment of Coptic wool and linen gaiters showing a battle, tentatively identified as between the Sasanian emperor Khusrau II (r. 591–628), pictured centre, and the Axumite army in Ḥimyar, southern Arabia.

Sasanian coins from the Caucasus

From the late 5th century onwards, Sasanian (224–651) coins, almost exclusively silver drachms, entered the Caucasus region in increasing numbers. Interestingly enough, they originated from mints throughout the entire Sasanian realm. As of today, almost 2,000 specimens from Armenia and Georgia have been published, coming mainly from coin hoards. During the early 7th century, considerable numbers of Byzantine silver coins also circulated in the Caucasus area together with the Sasanian drachms, as is revealed by the large hoard of 1,385 Sasanian drachms and ten Byzantine silver coins from Tsitelitskaro in present-day Georgia.

The Sasanians also operated local mints in Armenia and Georgia, bearing in the Pahlavi alphabet the mint signatures ALM (Armin, Armenia) and WLC (Wiruzan, Georgia), as shown here with coins of Khusrau I (r. 531–578) and Ardashir III

(630s). Sasanian drachms served as models for local issues that mostly bear the still not properly understood word ZWZWN or GWGWN. A rare group of issues bear Georgian legends, but its dating is currently under debate: the coins are traditionally dated to the late 6th century, but may possibly be 8th century. Another group, probably separate, replaces religious symbols of Zoroastrianism with Christian devices such as the cross, attesting to the cultural and religious identity of the local Christian elites. NS

Further reading: Akbarzadeh & Schindel 2017; Moushegian et al. 2003; Tsotselia 2003.

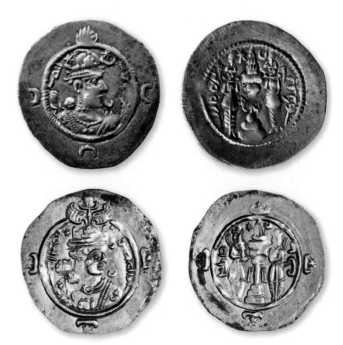

The Parthians had moved from the steppe borders to settle in the river plains of the Iranian plateau and Mesopotamia to become part of the larger network of the Silk Road. They were replaced by the Sasanians (241–651), while the Roman empire to their west split and the Byzantines (395–1453) ruled to the Sasanian border. China, meanwhile, was ruled by a succession of kingdoms, several of them Turkic peoples from the steppe, until reunified under the Sui (581–618) and then the Tang (618–907).

The Bactrians to the south of the Amu Darya were among the first trading populations that took advantage of the connections made through the Silk Road, while the Sogdians, to the north of the river, famously came to dominate much of its eastern and northern parts. Chorasmians were the masters of the routes that passed northwards to the steppes of northern Caspian and the plains around the Volga and Don rivers. Rus from Scandinavia took advantage of the great south-flowing rivers of Europe to trade here. In turn, Parthian, Persian, Jewish and Armenian merchant diasporas also came to control various land and sea routes, and their involvement expanded with the spread of Islam [see pp. 256–67].

From the 7th century, Arab caliphates expanded around the Mediterranean and across Mesopotamia and the Iranian plateau, reaching the border of the Tang empire. The two powers clashed in central Asia at the battle of Talas in 751. While the caliphate was victorious, central Asia was to test the logistical limits of both empires.

Turkic peoples moved from the steppe to rule some of these lands, but it was not until the expansion of the Mongols, moving southeast from the steppe, that the imperial borders in central Asia were broached. The Mongols took the river plains of northern China and then moved across the steppe and central Asia into the Iranian plateau, Mesopotamia and as far as the borders of Europe, their rule stretching across traditional geographical boundaries.

Opposite —The Byzantine emperor Theophilus (r. 829–842) flanked by two bodyguards, members of the elite Varangian Guard, largely made up of northern European recruits. From the 11th century *Synopsis of Histories* by the Greek historian John Skylitzes (1040–1101).

Byzantine coins in south Asia

Fewer than 500 Byzantine (395–1453) gold coins are securely documented in south Asia, clustering in the late 4th and early 5th centuries and almost all found in southern peninsular India. Examples are very rare after the reign of Justinian I (r. 527–565). They were frequently pierced, as seen below left, suggesting that they were used for ornament, and they were also imitated locally. In addition, several thousand badly worn Byzantine copper coins minted in the 4th to 5th centuries have been discovered, mainly in Tamil Nadu (below right). Their purpose remains unclear, but large numbers also seem to have been moved from India to Sri Lanka. When these ran out on the island in the late 5th century they were briefly imitated locally and hoarded like the originals. Precious metal finds are rare and such coins provide scant evidence for the engagement of Sri Lanka with the western Indian Ocean trade routes. RD

Further reading: Darley 2017; Turner 1989; Walburg 2008.

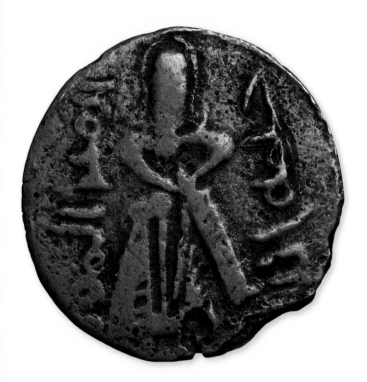

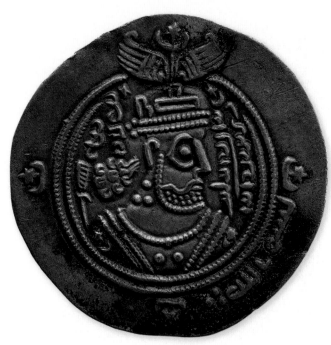

Early Islamic coinage

The Hijaz, homeland of Muhammad (c. 570–632), lacked an indigenous tradition of coin production; what little money did circulate there came from the Byzantine (330–1453) and Sasanian (224–651) empires. In the second quarter of the 7th century, the Muslim invaders of former Byzantine and Sasanian territories were confronted with traditional coinages that emphasized both the current ruler and the state religions (Christianity and Zoroastrianism, respectively). In the Byzantine area, the Muslims issued imitations of imperial copper coins, which retained their Christian symbols; only rarely can early examples of Islamization be observed. Under Umayyad caliph 'Abd al-Malik (r. 685–705), shown above left, there were attempts to create a separate Arab iconography, with an image of the caliph on the obverse. However, the coins that have been found represent a short experimental phase of just four years (74–77 AH or 693–696 CE). In the Sasanian east, the silver drachms essentially retained their Zoroastrian iconography, with the addition of short religious phrases in Arabic and the name of the Sasanian king being replaced with that of the Arab governor, such as that for 'Ubaydallah bin Ziyad (d. 686 CE), above right. The great monetary reform of 77/78 AH (696–698 CE) removed all pictorial devices, and created a coin typology based entirely on Qur'anic inscriptions in Kufic script, marking the beginning of Islamic coinage proper. NS

Further reading: Album & Goodwin 2002; Schindel 2009.

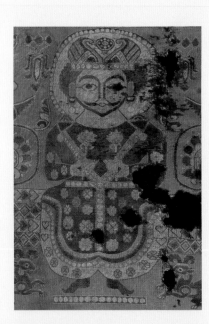

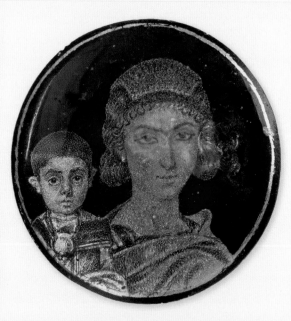

Far left — Silk samite showing a Sasanian emperor, possibly Khusrau II (r. 591–628); woven in Sasania or central Asia, 7th–8th century.

Left — Early 4th-century medallion made of glass and gold leaf showing a woman and child; Roman, probably made in Alexandria.

The religions of all these empires spread with them – Zoroastrianism with the Sasanians [*see* pp. 346–55], Islam with the Arabs [*see* pp. 256–67], and Christianity with Rome and Byzantium [*see* pp. 169–75] – but there were also many other religions and cults that continued to thrive or survive. The local religious art of the Bactrians, with gods such as the river deity Wakhš, incorporated Greek, Indian and Iranian religious iconographies. Artistic traditions often merged in order to create unique pieces, such as the Nigār mural paintings in Dokhtar-ī Nušīrwān cave, just north of Bamiyan in Afghanistan, where obvious Sasanian Iranian depictions of kings and deities are augmented by Gandhāran Buddhist and Hindu devotional items and markers.

Further reading: Daryaee et al. 2010; Hansen 2000; Rezakhani 2017.

Above — Glazed and lustre-painted vessel of around 1200, in the form of a figurine of a mother and baby, from Iran.

Right — Figurine of an elite Chinese woman from Chang'an, dating to the 7th to 8th century. The blue glaze from cobalt oxide was only imported into China from Iran from the second half of the 7th century.

Money and mints

Robert Bracey

Money is very old, probably as old as urban civilization, but in one of its physical representations, coinage, it is surprisingly young. In the 1st millennium BCE, the representation of money as standardized metal units was invented at least three times, quite independently, in Lydia (eastern Turkey), central Asia and China. And from just a handful of mints 2,700 years ago, the technology spread across the world.

By the 1st century CE there were mints throughout the Mediterranean, west Asia, parts of Iran, northern central Asia, in the oasis cities of eastern central Asia, and in most of the kingdoms of north India and some south Indian ones, and coin production was widespread in China and bordering regions. However, coinage was not made in northern Europe, among the many otherwise sophisticated pastoralist societies of the steppe, or in many of the kingdoms in southeast Asia. And even where it was made, rural populations often had little use for it.

The methods of manufacturing coins – die striking in the west, casting in the east and initially punch-marking in central and south Asia – are relatively simple and none offers any absolute advantage over the others. The bulk of effort involved in coin production is in mining, smelting, and refining metals, the administration of the mint, and dealing with the substantial problem of distributing coins after they are made. As a result all mints are dependent upon social, economic and political infrastructure, which is largely invisible to historians. Not only did these structures need to exist to sustain the mint, but also the mint (or the coins it made) had to offer some advantage to be established in the first place.

Until very recently in human history, most transactions did not involve money, and even fewer

involved coins. We know, for example, that although the Chinese state supplied coins to its garrisons along the Silk Road, many important payments were made in silk. The use of such 'commodity money' was very common and could even operate without the authority of a state, as in the case of the cowrie shells used in northeast India. Exchanges could also be made in kind, managed on account, or within personal relationships made without any reference to money at all. Indeed, long-distance trade in the past was dependent more on goods of intrinsic value than on money. Where money was more widely used, as for example on the interconnected maritime routes from China to east Africa, commodity money, such as cowrie shells, tended to be more important than coins.

Many of these older forms of transaction are still used today and have never been entirely displaced by money in the form of coins. However, over time coins have certainly become more common. By the early centuries CE, most large states issued coins, and some, such as Han China (206 BCE–220 CE), Parthian Iran (247 BCE–224 CE) and the Roman empire (27 BCE–395 CE), had circulating currencies that were the principal means for making monetary transactions in urban centres. These coins were sufficiently common that they were carried along trade routes, sometimes as loose change, sometimes

Previous pages — The 12th–15th century Katsuren Castle, Japan, where excavations from 2013 uncovered 2nd- to 4th-century Roman copper coins, probably acquired through China.

Sino-Kharoṣṭhī coins of Khotan

During the 1st to 2nd centuries CE, copper coins were issued in the names of the kings of the central Asian oasis kingdom of Khotan [*see* box on p. 221]: Gurga, Gurgadama, Gurgamoya (shown below), Inaba, [...]toga and Pañatosana. Their fronts show an animal (a horse or camel) and a Prakrit inscription in Kharoṣṭhī script giving the king's name and title: *yitiraja* ('king of Khotan') or *maharaja rajatiraja yitiraja* ('Great king, king of kings, king of Khotan'). The backs have a Chinese inscription giving the weight: *liu zhu qian* ('6-grain coin') or *zhong nian si zhu tong qian* ('24-grain copper coin'). Some issues also have a *tamga* emblem on the back, as seen here.

The coins can be dated through the close association of their denominations and inscriptions with the issues of the 1st-century Indo-Parthian kings in Gandhāra and 1st- to 2nd-century Kushan kings in Bactria, Gandhāra and Kashmir.

King Gurgamoya's coins are occasionally found overstruck on coins from Begram issued in the reign of the first Kushan king, Kujula Kadphises (r. *c.* 50–90 CE). JC

Further reading: Cribb 1984, 1985; Wang 2004.

 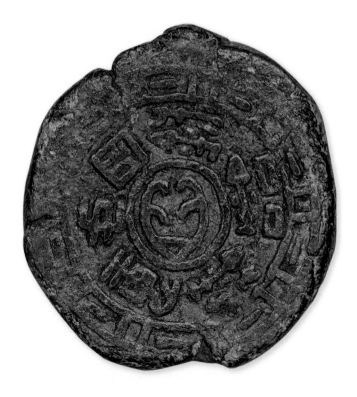

Coins in the Taklamakan kingdoms

The archaeological evidence, in the form of coins found at sites in the Tarim basin and Mongolian steppe, indicates that there were influxes of Chinese coins into these regions at times when there was a strong Chinese presence. Most are Han dynasty (206 BCE–220 CE) *wuzhu* types (or derivatives) and Tang dynasty (618–907) *Kaiyuan tongbao* coins (first issued in 621 and shown here).

Officials and military personnel needed to be paid, and there is evidence that coins and military equipment were transported together. However, the expense and logistics of transporting low-value coins over long distances no doubt contributed to the rise of local coin production, particularly in the northern Tarim. Large quantities of 'Chinese-style' coins (i.e. cast in a copper alloy, with

a square hole in the middle) were made in the Kucha area. Initially modelled on the *wuzhu* type (issued between 118 BCE and 621 CE), the locally produced coins sometimes have inscriptions or added marks asserting their local identity. Tang dynasty *Kaiyuan tongbao* coins have been found over a vast area, at sites from central Asia to the Korean peninsula and Japan, and there are plenty of local

imitation issues from this time too. HW

Further reading: Wang 2004, 2004a.

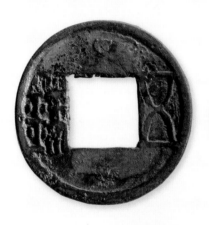
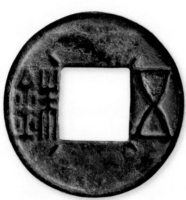
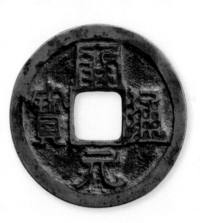

Far left — A Chinese bronze coin of emperor Wang Mang (r. 9–23), often called 'spade money' because of its shape.

Left — A gold stater of the Kingdom of Lydia showing a lion attacking a bull, struck under Croesus (r. *c.* 560–546 BCE), excavated at Sardis.

as gifts and sometimes for the metal they contained. They were often hoarded by the recipients. Occasionally, as in 5th-century Sri Lanka, when old Roman coinage was imported from India, foreign coins would be used in local circulation. Stray finds of silver coins from central Asia are sometimes made in Europe, and gold Byzantine coins have been found in China, reused as, for example, decorative objects.

Initially coinage seems to have served primarily as an instrument of state power. Coins were used to pay the administration, and importantly the army, and then to gather taxes from those same groups. This cycle could serve both to bind an important section of society to the state and also as a

revenue-generating activity. Little evidence survives of how mints were supplied with raw materials or how coins were distributed, but if coined money had been perceived as a public good then it would have made sense for mints to be numerous and positioned either to supply need or close to raw materials, but that was rarely the case. Most minting, in most states, was centralized, often in an important political location. Control mattered more than practicality.

The Chinese state made early attempts to distribute coin production, experimenting with private minting under the emperor Wen (r. 179–157 BCE), though this was exceptional. The best evidence that the supply of coinage did not meet

the needs of the general population is provided by forgery. Although some forgers were seeking profit, coating base metal with gold or silver, many forgeries were of low-value coins that would have offered only modest profits. Unsurprisingly, the mints of forgers were less sophisticated than those run by states: they lacked the ability to mine, refine and widely distribute their coins. Many, even in areas where die striking was normal, depended on casting, because this allowed them to copy coins without having the tools necessary to produce their own designs. Forgers' mints are also better attested than official ones because they took less care to destroy tools once they had been used.

Copper-alloy coin of the Axumite King Joel (r. 6th century), with his name inscribed in Ge'ez. Axumite coins had a cross on the back since the conversion of King Ezana in the 4th century.

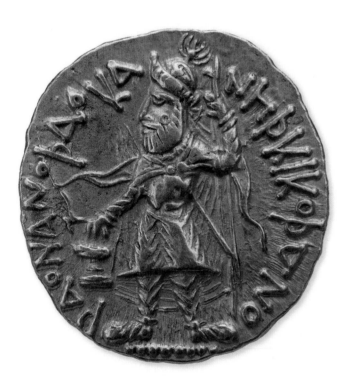

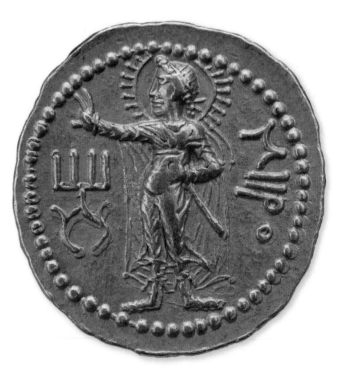

A Kushan coin hoard in Africa

In 1940, 105 gold Kushan coins minted in central Asia in the 2nd to early 3rd centuries were found below the walls of the Christian monastery of Debre Damo in what was the Axumite kingdom (100–940), in present-day Ethiopia. The location of the coins is not known today, but the Italian archaeologist who discovered them, Antonio Mordini, published a preliminary report describing them in some detail. The Kushan (1st to 3rd centuries) ruled from north India to central Asia and most of the

Debre Damo coins were made in Bactria. Tantalizing clues in the report suggest they may not have changed hands many times before their deposit.

Kushan copper coins travelled widely, and some have been found in west Asia, probably brought in the purses of a merchant and then simply mislaid. However, gold coins were a relatively recent innovation for the Kushans. The earliest coins in the Debre Damo hoard – five gold double-staters of Wima Kadphises (r. early 2nd century)

– are among the first they minted, and were probably originally used to express royal largesse. The hoard also included coins of successive kings, such as Kaniska I (r. c. 127–150), as shown here. Axum at this time was an important east African kingdom, its merchants trading across the Indian Ocean to south Asia. But it did not become Christian until the 4th century and Debre Damo was only built in the 6th century. So these coins, possibly originally stored in an Indian decorated box, may have been a diplomatic

gift, or the store of wealth for an important traveller, later deposited in the monastery as a gift or for safekeeping – or it is possible that they were not associated with the monastery at all. RB

Further reading: Mordini 1967; Whitfield 2018.

Silk as money

Textiles were an important form of money in ancient China. This roll of plain silk and these fragments of plain silk with a handwritten inscription, both surviving in the deserts of central Asia, hold the key to the use of such silk as currency during the Han dynasty (206 BCE–220 CE).

The roll was found at Kroraina in the Taklamakan desert (British Museum, MAS 677a&b, L.A.I.002), and the fragments were retrieved from a refuse heap below one of the Chinese watchtowers in the Hexi corridor to the east (British Library, Or.8211/539(A&B)). Their selvedge matches that of the roll. The inscription translates as '1 roll of *gu-fu* silk, from the kingdom of Rencheng [in northeast China], width 2 *chi* [feet] 2 *zhang* [inches], length 40 *chi*, weight 25 *liang* [ounces], value 618 *qian* [coins]'. It is

helpful to consider the value of the roll of silk as being 600 coins (with the 18 coins as a 3 per cent adjustment), because 600 is easily divisible. Thus, if a roll of silk was 40 *chi* long and worth 600 coins, then 1 *chi* of silk was worth 15 coins. And, if that same roll of silk weighed 25 *liang*, then 1 *liang* was worth 24 coins.

The use of silk as money is also mentioned in many contemporary documents. The contract illustrated here, for example, dated to 20 December 991, exchanges a slave girl in lieu of a debt of silk (British Library, Or.8210/S.1946). HW

Further reading: Hansen & Wang 2013; Wang 2004

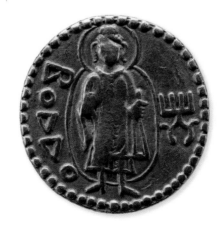

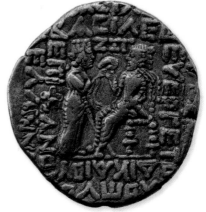

Right — The reverse of a gold coin of the Kushan king Kaniska I (r. *c*. 127–150), showing the Buddha.

Far right — The reverse of a silver coin of the Parthian king Vologases I (r. *c*. 51–78), showing the enthroned king receiving his diadem from the goddess of cities, Tyche. The Greek inscription gives the place (Selucia ad Tigrim) and date (55–56) of minting.

The Spillings Hoard: Islamic dirhams for slaves

The discovery across northern Europe of numerous and substantial hoards of silver dirhams, many minted by the Samanids (819–1005) in central Asia, highlights an important element of long-distance trade. The peoples of northern Europe utilized the rivers that flowed south to the Black and Caspian seas – the Danube, Dnieper and Volga – to travel great distances to trade furs, slaves and other goods. Accounts are given of this by contemporary Islamic writers, who refer to the merchants as the Rus and report on their trade in the Bulgar and Khazar steppe kingdoms. Possibly Vikings, the Rus travelled as far as Constantinople, where some became members of a special imperial guard, the Varangians.

By some estimates, 125 million silver dirhams were imported into northern Europe in the 10th century. The largest cache found to date in Scandinavia is the Spillings Hoard, now in Gotland Museum (52803). It was discovered in 1999 in northern Sweden, originally hidden under the floor of a Viking outhouse. A small part of the hoard is shown here. It contained over 14,000 silver coins along with other silver and bronze objects, the silver alone weighing 67 kg (148 lb). Like many other northern hoards, it contained both genuine and imitation coins. SW

Further reading: Noonan 1998; Pettersson 2009.

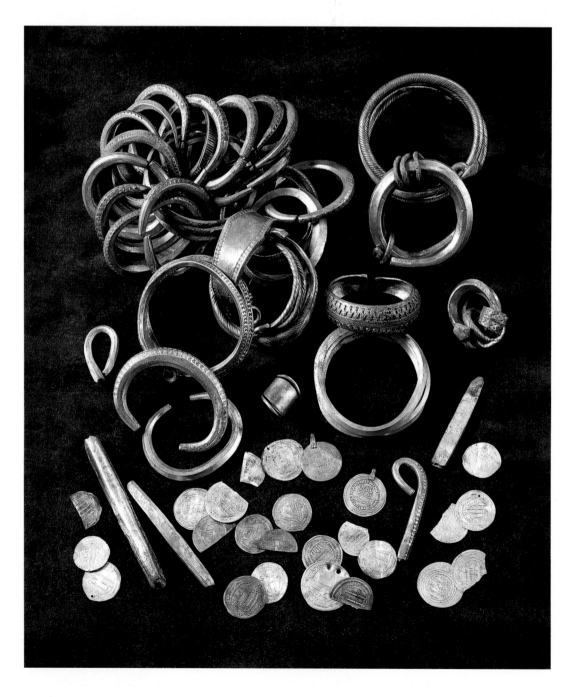

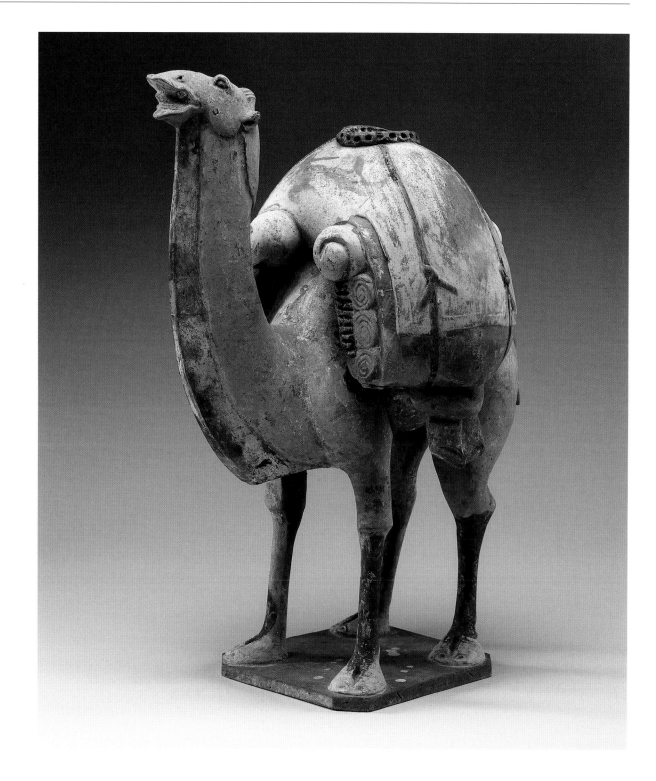

Coins initially had limited value beyond where they were made and were thus only of limited use in long-distance trade, although in facilitating more local trade coins undoubtedly played a role in the movement of goods. Over time, as the use of coinage became more widespread, this role gradually grew; coins minted throughout the Islamic world at the end of the 1st millennium were accepted from Bukhara to Spain. As the economic and social utility of coins increased so the mints proliferated and production increased.

——

Further reading: Cribb 1983; Kakinuma 2014; Schaps 2004; Walburg 2008; Yang 2011.

The Bactrian camel is commonly found in Chinese tombs, this one dated between 550 and 577. His load includes bolts of silk, used for trade and money.

Silkworms and mulberry trees: Silk Road settlers

Susan Whitfield

The oasis kingdom of Khotan [*see* box on p. 221] became a place of silk production in the early centuries CE, and this 7th- or 8th-century painted wooden plaque, found at Dandan-Uiliq, is interpreted as showing the story of the silk princess who hid cocoons in her headdress when sent to marry a foreign king.

With the opening of routes from China to central Asia at the start of the 1st millennium CE, moriculture and sericulture – the domestication of mulberry trees (*Morus* sp.) for their leaves and of the silkworm (*Bombyx mori*) for the silk thread of their cocoons – inevitably started to spread out of China.

Silk production had not in fact been confined to China before this time: India had wild silk production from as early as the mid-3rd millennium BCE; fibres of wild silk may have been found in Cyprus dating from 2000 BCE; and there is evidence for silk in the Bronze Age Aegean. China also produced wild silk. But the only strong evidence for the specialist breeding and cultivation of domestic silkworms and the unreeling of the unbroken cocoons in the early period is from China, and current evidence suggests that this may have started as early as 2700 BCE.

By the time of the Silk Road, China had had long practice in refining the time-consuming and skilled technology of sericulture and was producing strong, sophisticated silks from the thread of the domestic silkworm, fed by the leaves of the white mulberry (*Morus alba*). The silkworm larvae munched their way through prodigious quantities of leaves, increasing their weight up to ten thousand times in less than a month. The leaves had to be finely shredded for the newly hatched worms, themselves little more than the size of a pinprick, and they were sometimes fed twice an hour for the first day and

二眠
吳蠶一再眠竹屋下簾
幕拍手羨嬰兒一笑姑
不惡風來麥秀寒雨過
桑沃若日高蠶未起谷
鳥鳴百箔

Print from a woodblock of a depiction
by Jiao Bingzhen showing silkworms
being reared in the domestic setting.
From the Chinese imperially
commissioned *Gengzhi tu*, Beijing, 1696.

night. As they grew the leaves were presented in
larger pieces and the number of feeds decreased.
But this was still very labour intensive. The silkworm
beds had to be cleared constantly of faecal remains
and old leaves. The worms also had to be checked for
infection and kept warm and dry during this process
– which lasted four or five weeks depending on the
worms. Early Chinese records show that the rearing
was the work of women and that both special rearing
buildings and domestic farmhouses were used, with
the worms placed on trays.

Apart from the skills involved, silkworm-rearing
required a ready supply of fresh leaves and therefore
plantations of healthy mulberries: any fungal or

other infection would harm the delicate worms.
Trees took three to six years to reach maturity.
Mulberry trees are not particularly vulnerable,
requiring a temperate climate and level, moist,
light and fertile soil. Leaves of the white mulberry
are the preferred food of the *Bombyx* moth and
produce the best silk. The tree is indigenous to
northern China, perhaps one reason why China
took the lead in sericulture. Chinese farmers also
developed the skills of grafting white mulberries,
so improving the crop.

The black mulberry (*Morus nigra* L.) is a distinct
species, but can also be used to feed silkworms,
although producing coarser thread. It was probably

indigenous to the mountainous areas of west Asia, but was cultivated from very early times throughout central and west Asia and is reported to have reached Egypt by the middle of the 2nd millennium BCE. Black mulberry fruit was popular in Roman Europe, and the tree might have already spread as far as northern Europe by pre-Roman times. The spread of white mulberry in early times is not so well documented, and there continued to be a confusion about the trees well into modern times.

Once the silkworms had spun their cocoon – after three or four moults – they had to be killed by stifling or their further development had to be impeded by cold conditions, so the moth did not emerge and

break the cocoon. The dead worms could later be fried and eaten – still a delicacy in China today.

The silk then had to be reeled, another skilled and delicate task. The cocoons were heated in a basin of water, and the ends of a small number of threads were picked out and unreeled together: the more threads, the heavier the silk thread and resulting fabric. The threads could be as long as 900 m (3,000 ft). A slight twist was introduced into the thread at this point. However, the warp thread required a much greater twist, as many as two to three thousand twists per metre of thread, and a spindle wheel was needed to achieve this. The thread was twisted in one of two ways: the S-twist is so

Depiction of the rearing of silkworms and gathering of mulberry leaves. Print by Karel van Mallery after Jan van der Straet, published in Antwerp in c. 1595.

called because the direction of the twist follows the
central slant of the letter S, while Z-twisted thread
is twisted to follow the central slant of the letter Z,
that is, in the other direction. S-twisted threads are
more typical of those produced in central China.
The silk thread was then ready, either for dyeing
[*see* pp. 324–29], sale or weaving [*see* pp. 316–23].

——

Further reading: Coles 2019; Muthesius 1997; Vainker 2004;
Whitfield 2018.

Detail of a watercolour copy of the mid-
7th-century Ambassadors' Painting at
Afrasiab showing Turkic escorts (to
right) and Chinese envoys (to the left)
bringing silk – in the form of cocoons,
yarn and woven bolts – for the king.

Details from a Chinese silk handscroll attributed to Liang Kao (mid 1100s to early 1200s) showing the stages of silk production.

Complex looms for complex silks

Zhao Feng

As well as domesticating and rearing silkworms and the mulberry trees to feed them, China was also inventor of the treadle and pattern looms, enabling the production of polychrome compound weaves.

Two types of looms are used for weaving: plain weave and pattern. Plain weave looms are found worldwide. The warp thread is stretched onto the loom, between a fabric beam on one end and a warp beam on the other, and then a shed is formed between these warp threads. The simplest shed is where the weft yarn alternates over and under the warp. The warp threads are thus divided into two groups, whereby the odd numbers are pulled through one heddle and the even numbers through another. Shafts are attached to the heddle. When one heddle shaft is raised, the uneven warp threads will be brought to the top position. When it is not raised, or when the other heddle shaft is raised, the even warp threads will be at the top. By alternating the insertion of the weft threads through the sheds using a shuttle, the warp and weft threads are interwoven to form the textile. The simplest weave is a tabby, where the weft goes over one warp thread and then under the next.

The loom elements are organized on a weaving frame, which can be horizontal, vertical or oblique. Sometimes the frame is completed by the weaver's body – as in the backstrap loom – or suspended. In complete frames, shedding can be done manually, or treadles can be added to manipulate the heddle shafts. Backstrap looms are common in many early cultures across Afro-Eurasia and beyond, and remain in use today.

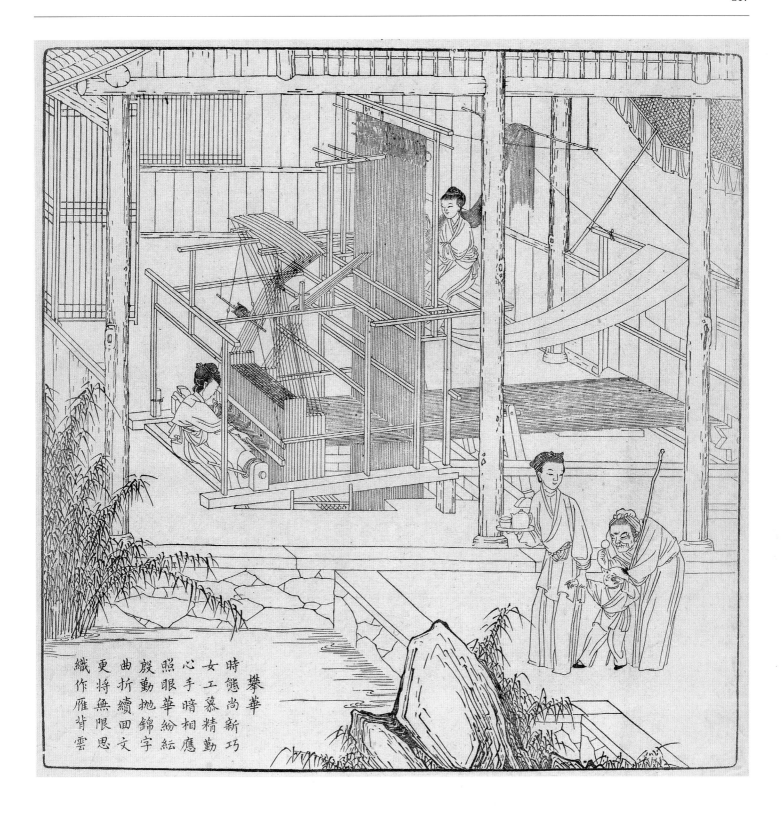

攀華
時態尚新巧
女工慕精勤
心手暗相應
照眼華紛紜
殷勤抛錦字
曲折續回文
更將無限思
織作雁背雲

Print from a woodblock of a depiction by Jiao Bingzhen showing a complex pattern loom, with a drawgirl on top. From the Chinese imperially commissioned *Gengzhi tu*, Beijing, 1696.

In Mediterranean Europe upright looms with warp weights were popular. In ancient Egypt two types were used: horizontal (floor) looms and vertical (upright) rug looms. In the early period in China, backstrap looms were mostly used. Later, treadle backstrap looms were developed and then, during the Han dynasty (206 BCE–220 CE), treadle looms with a complete harness became more common, with an oblique warp and treadles to control the sheds. Such treadle looms were invented in China: early images have been found in present-day Shandong, Henan and Sichuan.

On the pattern loom the different sets of warps required for the pattern are threaded onto separate rods. Treadles operate lifting shafts to raise the rods in the shed combinations required for particular patterns. The overall principle is to increase the numbers of changes in the warp shedding, while also preserving this shedding information. Two main types of pattern loom were developed. That with multiple heddle shafts was used for weaving patterns by increasing the number of heddle shafts on the warp, thus increasing the different combinations of warp shedding. The other, the drawloom, had a pattern sample fitted onto the loom in its upper part, on which information on the pattern lifting was stored. By linking the warp with the pattern sample, the information of the latter

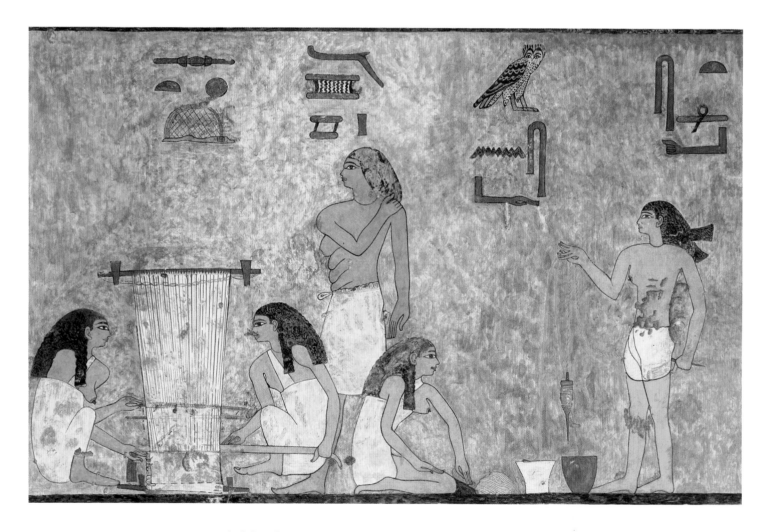

Copy painting by Norman de Garis Davies of a depiction of plying linen thread and weaving from the Egyptian tomb of Khnumhotep (1897–1878 BCE) at Beni Hasan.

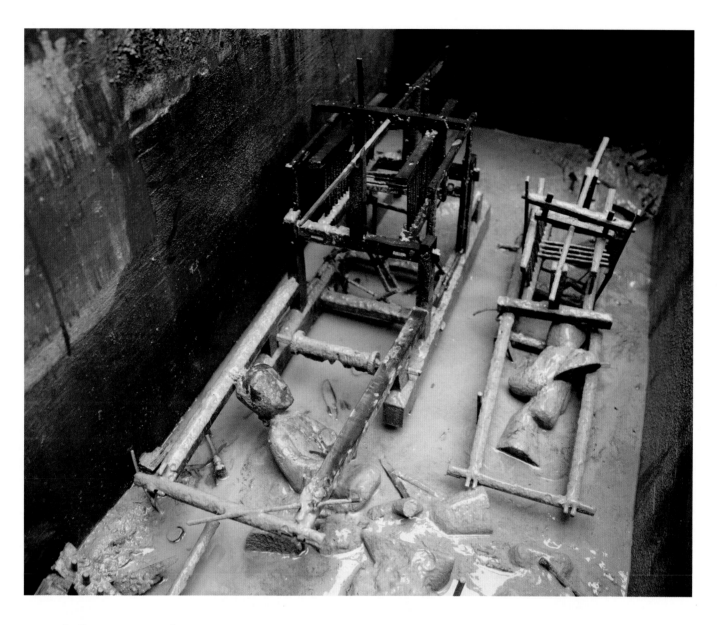

Model pattern looms

Laoguanshan, located in Chengdu in the southwest of China in the Shu region, was a production centre for polychrome woven silk with a warp-faced compound weave structure from the Qin (221–206 BCE) to the Tang (607–918 CE) dynasties. The region had good connections with the Hexi corridor in the northwest of China, so that *jin* silk could easily be exported along the trade routes westwards.

Four pattern loom models were discovered in the lower chamber of Laoguanshan Tomb 2, along with weaving tools and fifteen painted wooden figures, each with their name written on their chests and probably representing weavers and other workers. The tomb

contained a female corpse, about fifty years old, named Wan Dinu, assumed to be the owner of the silk workshop. It is dated to the second half of the 2nd century BCE.

The models are made mainly of wood with some bamboo and include cinnabar-dyed silk threads. They can be divided into two groups according to their structure and size: L.186 is the largest, with a sliding frame and hook, while the others, L.189, L.190 and L.191, with hook rods, are smaller. ZF

Further reading: Zhao et al. 2017.

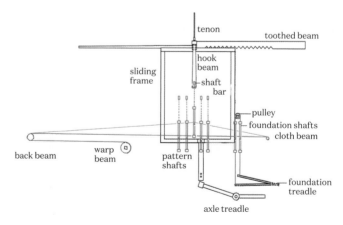

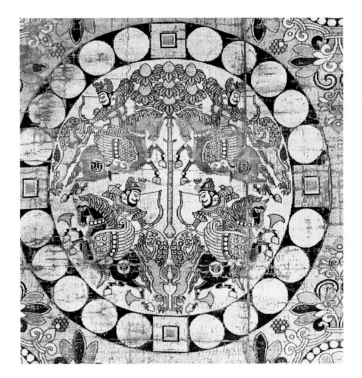

Persian patterns on a Chinese samite

'Persian' silk is mentioned in many Chinese manuscripts, especially those found in 6th-century tombs at the Astana cemetery in the Turfan basin. The *Suishu* ('History of the Sui dynasty', 589–618) records the gift of silks woven with gold threads from Sasanian envoys to the Chinese emperor Wen in around 585. He Chou, the officer in charge of the imperial silk workshop, successfully made copies. This probably influenced the development in China of a samite (weft-faced compound twill) with a design showing animal or bird motifs within a pearl roundel. The pattern is repeated in both the warp and weft directions, distinguishing it from central Asian samites. Such a Tang-style samite can only be produced using a drawloom.

The piece illustrated here, dating from the second half of the 7th century and held at the Hōryūji in Nara, Japan [*see* box on p. 180], is the most complex extant example of a Tang-style samite. The whole piece has three repeats of a roundel, each approximately 45 cm (18 in.) in diameter, in the weft, and five repeats in the warp direction; in total it is 134 cm (53 in.) in width and 250 cm (98 in.) in length. The design follows the traditional depictions of royal hunters, as seen on Sasanian rock reliefs and metalwares. But it also represents a step in the Chinese modification of the typical Sasanian pearl roundel into the Tang floral medallion. ZF

Further reading: Nosch, Zhao & Varadarajan 2014; Yokohari 2006.

Right — Fragment of an 8th-century Chinese silk samite from a Buddhist banner found at Dunhuang, with a typical Sasanian roundel design with confronting ibex.

could be transferred to the warp threads in order to alter the shedding combination.

The pattern loom was very popular in ancient China, as evidenced by historical records and excavated objects, and the earliest known pattern loom model has been excavated recently at Laoguanshan [*see* box on p. 319]. To date, the earliest unambiguous evidence of the drawloom dates to around the 6th to 7th centuries. A drawboy or girl sat at the top to pull up the warp according to the pattern and this became the most common pattern loom. One major difference distinguishing Chinese textiles from those woven elsewhere was the repeat of a pattern in the warp direction.

This was enabled by the use of domesticated silk. As a long continuous thread, it was extremely strong compared to short spun threads such as wool, cotton and linen, enabling a very strong warp and longer textiles. Pattern looms are also seen in Iran, India, Turkey and, later on, Italy and France, but they create a pattern on the weft rather than the warp.

A whole array of different textiles was woven on such looms, including patterned and compound patterned weaves. Single-layer patterned fabrics were usually monochrome, including damask, gauze and satin. The structure of polychrome weaves (*jin* in Chinese, but often translated as brocade) was very complicated. Warp threads with a minimum of two but usually five colours were first stretched between the warp and fabric beams. All the threads that would be visible in the pattern were placed at the front of the fabric during the weaving process, while all others were placed at the back. This type of weave – a warp-faced compound tabby – was invented in China [*see* box on p. 72].

Warp-faced patterned weaves first appeared in China in about 1000 BCE and remained fashionable until 700 CE. But during the 2nd to 4th centuries, the principles of this type of pattern lifting structure

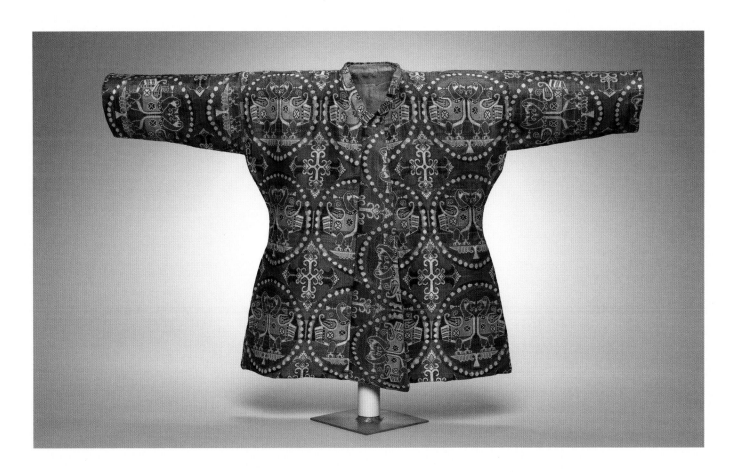

A child's silk coat

The two materials of the outer part and lining used in this child's coat, which was found with a pair of trousers, reflect the exchange and blending of silk cultures along the Silk Road.

The outer fabric has a design of pearl roundels enclosing confronted birds against a red background. Its basic structure is the then popular samite (weft-faced compound twill), with strongly Z-twisted warps, using a tripled main warp and single binding warps, and untwisted weft yarn. The number of beads in the different medallions varies, some with forty and others forty-one. From this it can be seen that these medallions do not repeat precisely in the warp direction, but only show exact repeats in the weft direction; this indicates that the material was woven by central Asians, possibly by Sogdians. The lining, however, is a twill weave with a floral pattern, a typical Chinese textile. That the two were joined to form this coat and trousers reflects the interregional transmission of silk, designs and technology at this time. ZF

Further reading: Heller 2018; Watt & Wardell 1997.

were emulated by wool weavers, resulting in the production of taqueté, a weft-faced compound tabby, that is with the pattern turned ninety degrees. The earliest examples are seen in woollen fragments excavated from Masada in west Asia (1st century BCE to 1st century CE) and north Africa, with larger quantities found at later sites in central Asia and on the Tibetan plateau. This structure further evolved into the samite, a weft-faced compound twill [*see* box on p. 320]. It is very likely that it was first used in Sogdiana and then transmitted into China.

———

Further reading: Becker 2009; Kuhn 1995; Zhao 2014.

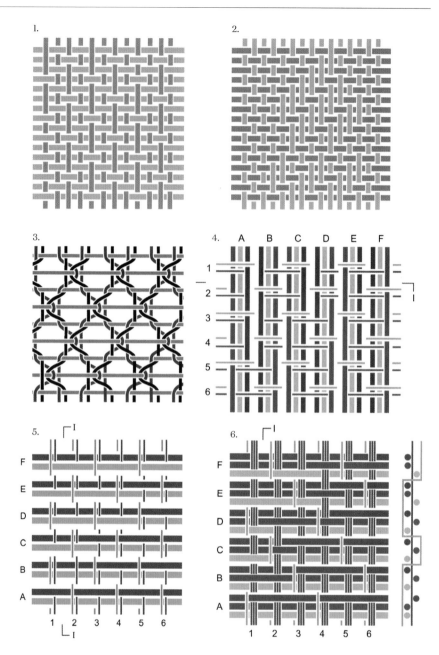

Diagrams showing weaves: (1) varied tabby; (2) twill on tabby; (3) complex gauze; (4) warp-faced compound tabby; (5) weft-faced compound tabby; (6) weft-faced compound twill.

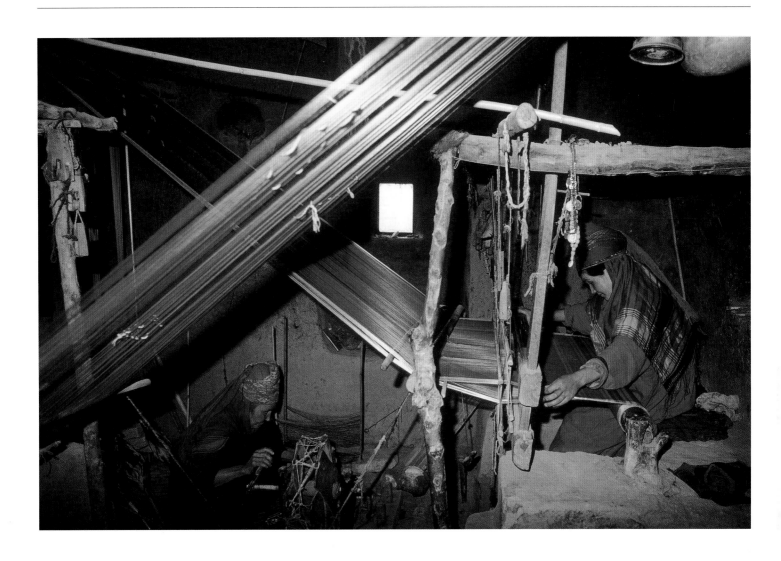

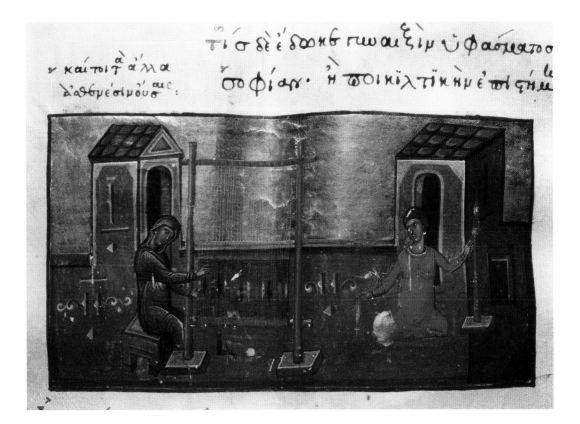

Above — Traditional silk-weaving
in central Asia, 1973.

Right — Spinning and weaving, from
a 13th-century Greek manuscript
of the 'Book of Job'.

Yarns, textiles and dyes

Sophie Desrosiers

The natural environment influences many aspects of human life, including the production and use of textiles. It affects, for example, the cultivation of plants and the breeding of animals from which fibres or colourants can be extracted, and also demands adaptation of clothing and other artifacts. Variations in the landscape therefore result in regional differences.

Individuals and societies have sought to compensate for these through the circulation of raw materials and expertise, the diffusion of biological species and the techniques necessary for their transformation, as well as the movement of finished textiles and the local production of imitations that, in turn, have often led to innovations.

Parallel to this, the natural environment has favoured a very unequal preservation of organic materials, yielding textiles in greater numbers and in better condition in arid environments, such as the Taklamakan, Syrian and Egyptian deserts. This has resulted in a bias of material sources. In addition, research often favours prestigious textiles and struggles to give a balanced presentation of what may have once existed. Attempting to reconstruct the circulation of artifacts, people and ideas across Afro-Eurasia on the basis of textiles is a complex undertaking, but also one that can lead to surprises.

The forty-nine textile fragments discovered at Karadong [see box on p. 215], an ancient site in the Keriya river valley in the Tarim basin, illustrate this well. They include several imports: lac dye and mohair wool in raw and woven form acquired from regions west or south of the Tarim; taffetas made from silk supposedly woven in China; and cotton textiles with indigo resist-dyed patterns from India and Gandhāra.

The presence of Buddhism at Karadong is demonstrated by two small sanctuaries excavated there. The Buddhas' mantles depicted in the wall paintings are the same colours as those on the cotton textiles, with similar resist-dyed patterns. This, as well as the wool and silk discovered at the site, suggests that the resist-dyed decoration was introduced along with Buddhism from India. Cotton textiles with the same patterns dating to the late 4th to 5th centuries have also been discovered at Berenike, a Red Sea port, showing that India also exported its textiles westwards by sea.

Study of the Karadong textiles has confirmed the practice of sericulture outside China by the 3rd century CE, a hypothesis already suggested by the discovery of a cocoon and mulberries in Caḍota, east of Keriya, and further supported by the legend of a princess who concealed silkworm eggs in her headdress when she travelled from further east to marry the king of Khotan [see box on p. 221]. The local silk was not drawn continuously from the cocoons, as in Chinese silk, but was largely acquired in discontinuous form and thus had to be spun into yarn, in the same way as cotton or wool. The existence of such silk – considered by some as inferior to continuous silk – may be explained by adherence to the Buddhist respect for all life: the moths were allowed to complete

Previous spread and below — Wall paintings of Buddha from a 3rd- to 4th-century temple at Karadong in the Tarim basin along with fragments of a resist-dyed silk, also from Karadong, bearing the same design as the Buddha's mantle.

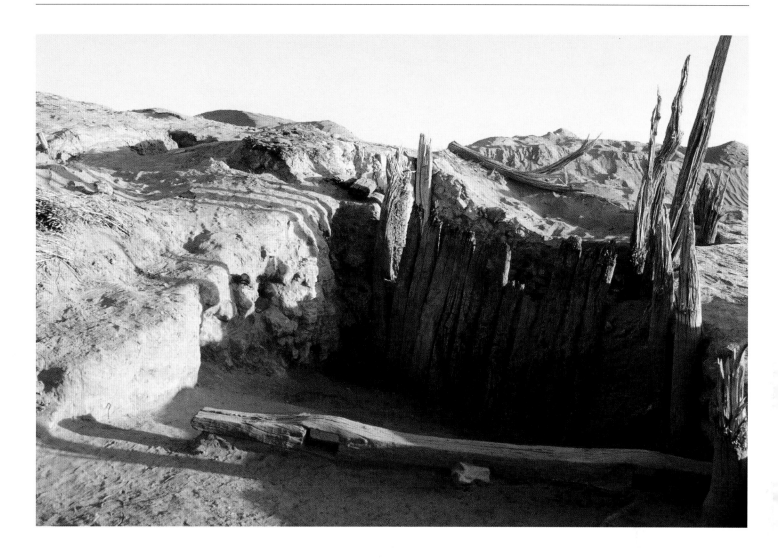

Top — The gate to the mid-1st millennium BCE fortified city of Djoumboulak Koum, north of Karadong on the ancient course of the Keriya river.

Above — Indian wild silk and cotton shawl from the 5th to 7th century found at Antinoopolis in Egypt.

their life cycle and hatch, thus breaking the threads of their cocoons.

Three fragments from Karadong in very poor condition but remaining sewn together reveal the impact of the circulation of textiles on daily life. One piece is tufted, one of felt and the other woven with a braided pattern. These must have constituted a thick, fluffy bedding and cover, similar to those discovered underneath corpses in the At-Tar burial caves in west Asia. Some particular features suggest that these textiles found at distant sites might have a common provenance and that the Karadong fragments were not local, perhaps brought to the city as part of a traveller's personal belongings.

Some centuries later, at the other end of the Silk Road, Queen Arégonde (*c.* 515–580) and other members of the Merovingian royal family were buried in the Basilica of Saint Denis near Paris. They were dressed in sumptuous clothes made of refined woollen fabrics in shades of purple, imported silks from the eastern Mediterranean, central Asia and perhaps China, and belts and braids, woven or embroidered locally with gold and silk imported as yarn, perhaps from Byzantium [*see* box on p. 117]. This attests to the luxurious lifestyle at the Merovingian court and the presence of very light silks, which were a driving force behind the development of the silk industry in Lucca in the 13th century, and then in Bologna until the 18th century.

Domesticated silk was not the only yarn to have been transported great distances. So-called wild silk from non-domesticated moths, used for weaving since the 3rd millennium BCE in the Indus valley, crossed the Indian Ocean between the 5th and the 7th centuries CE and arrived in Egypt, as demonstrated by an Indian shawl woven of wild silk and cotton recently rediscovered in Antinoopolis.

Asbestos, another important textile, was used in the Roman empire (27 BCE–395 CE), appreciated for its brilliance and fire-resistant qualities, and is mentioned in written sources as arriving in China

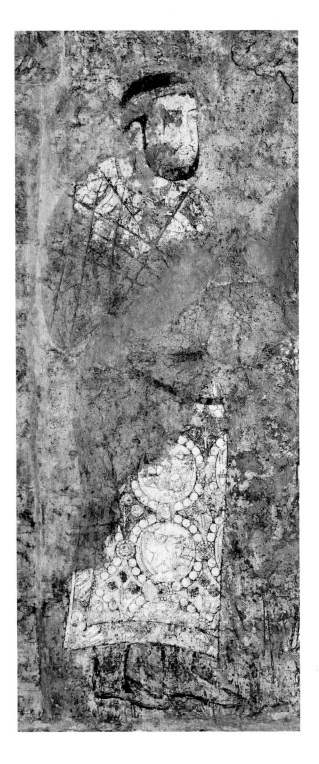

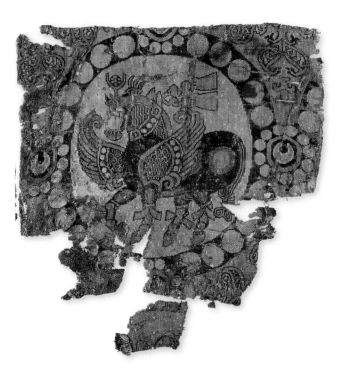

Sasanian samite in Africa

This samite with a winged horse design and another showing ibex were excavated by Albert Gayet (1856–1916) in Antinoopolis in 1898. They are preserved in the Textile Museum in Lyon (MT 26812.11 , MT 26812.10) and in the Louvre (E 29210, E 29376). The winged horses and ibexes wear pearl necklaces and floating ribbons, emblems of Sasanian kings. They move in procession to the right or the left, depending on the row, the winged horses inserted in pearl roundels.

The technical and stylistic similarities, as well as the presence of the same motifs in Sasanian art, suggest that both silks, of high quality, were woven in a workshop close to royal power. Both used triple yarn for the main warp and a special effect called *berclé*, whereby two weft colours are alternately used to obtain an intermediary tone, making them similar to samites found at the Vatican and in a Swiss church (Beromünster) used to wrap relics [*see* box on p. 142]. A samite of hybrid design – pearl roundels framing four mounted hunters with Chinese inscriptions – preserved at the Hōryūji in Nara [*see* box on p. 320] unexpectedly shares both these features. SD

Further reading: Bivar 2006; Desrosiers 2004; Durand & Calament 2013; Schmedding 1978; Wilckens 1991.

Opposite left — The Sasanian pearl roundel motif is commonly seen on textiles used in clothing, as in this copy of a detail of the Ambassadors' Painting at Afrasiab [*see* box on p. 284].

Below — Slippers of Archbishop Hubert Walter from Canterbury; Byzantine or Islamic silk with garnets from south Asia.

during the Han dynasty (206 BCE–220 CE) from the Roman east, and somewhat later from India. But contradictions in the written sources leave this issue unsettled until such time as there is corroborating evidence, such as actual traces of the fibre in China. Asbestos dating to the first centuries CE has also been found in Java, serving as shrouds, just as it did in Italy in the graves of wealthy Romans.

The availability of dyes is another factor influenced by local flora and fauna. But the choice of colour is also determined by the fibres to be dyed. For example, fibres of animal origin, such as wool and silk, are easier to dye with brighter and more colours than those of vegetable origin such as linen and cotton. These latter are more sensitive to vat dyes, or colourants that fix themselves onto the fibres through a process of chemical fermentation.

Some colourants are widely available, such as indigo or woad, whereas others, such as the purple from the murex shellfish so prized in Byzantium (395–1453), were more localized – and also expensive to produce. These may have been factors in the use of other purple sources from lichen sometimes mixed together with murex purple.

———

Further reading: Cameron et al. 2015; Cardon 2007; Desrosiers 2000; Desrosiers & Debaine-Francfort 2016; Durand & Calament 2013; Fuji et al. 1991; Wild & Wild 1996.

Paper and printing

Jonathan Bloom

Paper, perhaps the most ubiquitous manufactured material in the modern world, was invented in China in the early centuries BCE. It is technically a mat of plant-derived cellulose fibres that have been beaten in the presence of water, collected on a screen and dried into sheets. Fibres from a variety of plants were used, including the bark of both the paper and silk mulberry trees, hemp, ramie and many others.

The Chinese initially used paper as a textile, for wrapping and covering, but certainly by the 1st century CE they had learned that it could be a light, flexible and relatively cheap medium for writing, compared with the wooden and bamboo slips and silk textiles previously used.

Chinese interest in Buddhism, and particularly in collecting Buddhist texts in India and disseminating them throughout Asia, led to the introduction of paper and papermaking to the Korean peninsula, Japan, Vietnam and central Asia. Most of the documents in the Dunhuang Library Cave [see box on p. 138 and pp. 264, 333, 334–35, 350 and 404], dating from the 4th to 10th centuries, are on paper.

But in addition to Buddhists, adherents of other religions in central Asia, such as Manichaeans, Zoroastrians and Christians, also used paper [see boxes on pp. 151, 350 and 361]. Paper was also used for official and commercial documents, for example 4th-century letters from Sogdian merchants [see boxes on pp. 250 and 416].

After Arab armies conquered western central Asia in the early 8th century, Muslim bureaucrats readily adopted paper for the empire's record-keeping needs. It was cheaper than parchment made from animal skins, and more widely available than papyrus, which was made from a plant that grew mainly along the Nile river in Egypt. By the second

half of the 8th century, paper was being made in Baghdad and it was available by about 800 CE [*see* box on p. 336 and p. 337] in Syria, where even Christian writers were using it. By the 10th century, paper was known across north Africa from Egypt to the Atlantic and the Iberian peninsula, where it slowly began to replace papyrus and parchment. The Cairo *geniza* [*see* box on p. 285] shows the range of writing media in use.

By the beginning of the 2nd millennium, European Christians, particularly in Sicily, southern Italy and Spain, became aware of paper and papermaking through contact with Muslim users. Europeans, however, used only rags for paper production and did not realize that it could be made from plants

Previous spread — Store of the 81,258 woodblocks at Haein Temple used to print the Buddhist Tripitaka in 13th-century Goryeo in the Korean peninsula.

This page — Images showing paper production from the Chinese encyclopedia *Tiangong kaiwu*, 1637.

The world's earliest dated printed book

This paper scroll of an important Buddhist sacred text, *Vajracchedikā Prajñāpāramitā Sūtra*, more commonly known as the *Diamond Sutra*, is the earliest dated printed book in the world (British Library, Or.8210/P.2). Found at Dunhuang [*see* box on p. 138] in the Hexi corridor, but probably printed in southwest China, it is dated by a colophon stating that it was commissioned by a man called Wang Jie for his parents on a date corresponding to 11 May 868 CE. The sophisticated woodblock printing shows it is the product of a mature technology, and earlier printed paper fragments found in the Korean peninsula and Japan suggest that this technology had been developed in east Asia by the early 8th century if not before.

The frontispiece shows Buddha, surrounded by disciples, with the monk Subhūti kneeling on a mat before him; the text records their discussion on the nature of non-duality, a central tenet of Buddhism. Buddhism also teaches that duplicating and distributing the image and words of the Buddha is an act of piety. Printing therefore became widely used in the Buddhist world as it enabled the rapid reproduction of multiple copies. SW

Further reading: Morgan & Walters 2011; Wood & Barnard 2010.

Left — A 19th-century depiction from Kashmir of papermaking in the Islamic world.

Overleaf — Detail of a Chinese printed almanac dated to 877, with a *fengshui* diagram and the animal zodiac, possibly printed in southwest China and found in the Library Cave at Dunhuang.

until they came in contact with Chinese papermaking centuries later. Nevertheless, by the 13th century major papermaking centres had been established in Europe, preparing the way for the European printing revolution of the 15th century.

The introduction of paper to the Muslim world had a profound impact on virtually all aspects of society. Although Muslims were initially reluctant to use paper for copying the Qur'an, preferring the traditional medium of parchment [*see* box on p. 264], by the 10th century they increasingly accepted paper for this purpose. The ready availability of this medium encouraged an extraordinary florescence of writing on all subjects, ranging from the religious sciences, history and geography to popular genres, including the collected tales now known as *One Thousand and One Nights*. The availability of paper also encouraged the development of new scripts and systems of notation, whether in mathematics, music or the arts, although paper was never so cheap that it could be used as profligately as it is today. An effective system of publishing was developed whereby an author dictated to a group of auditors, who could then disseminate copies themselves. This led to the growth of libraries housing thousands or tens of thousands of titles, a figure in sharp contrast to the mere dozens or hundreds of manuscripts in even the richest medieval European collections.

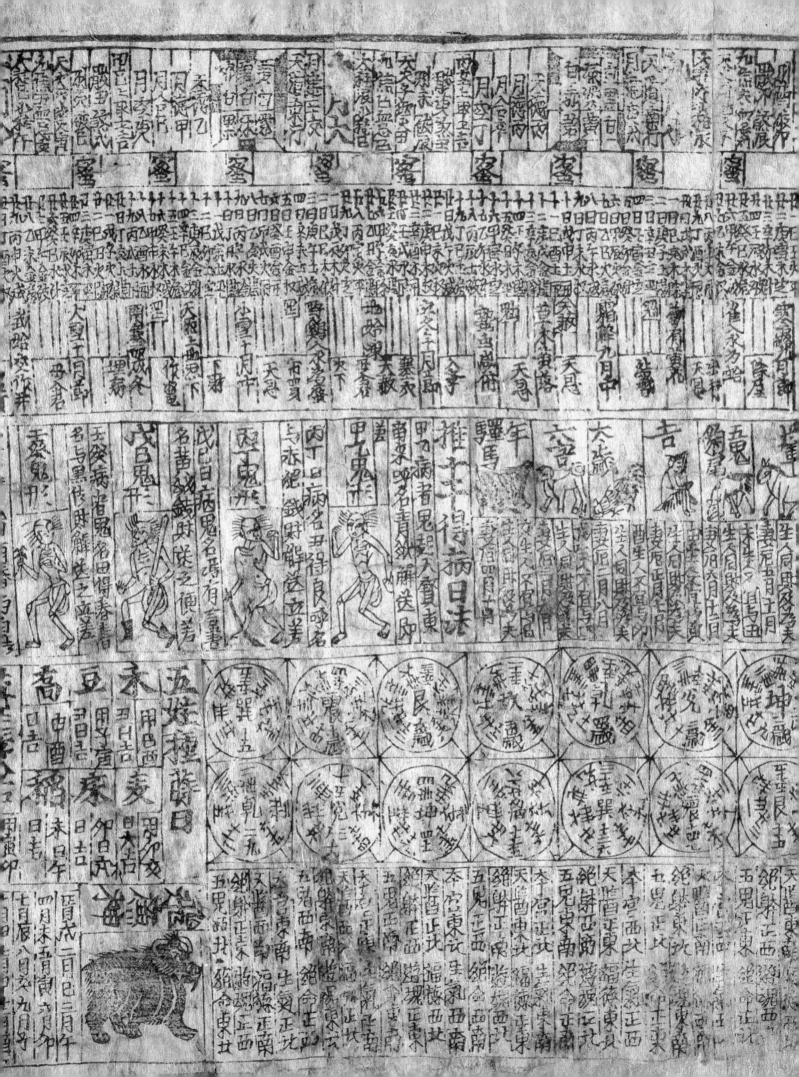

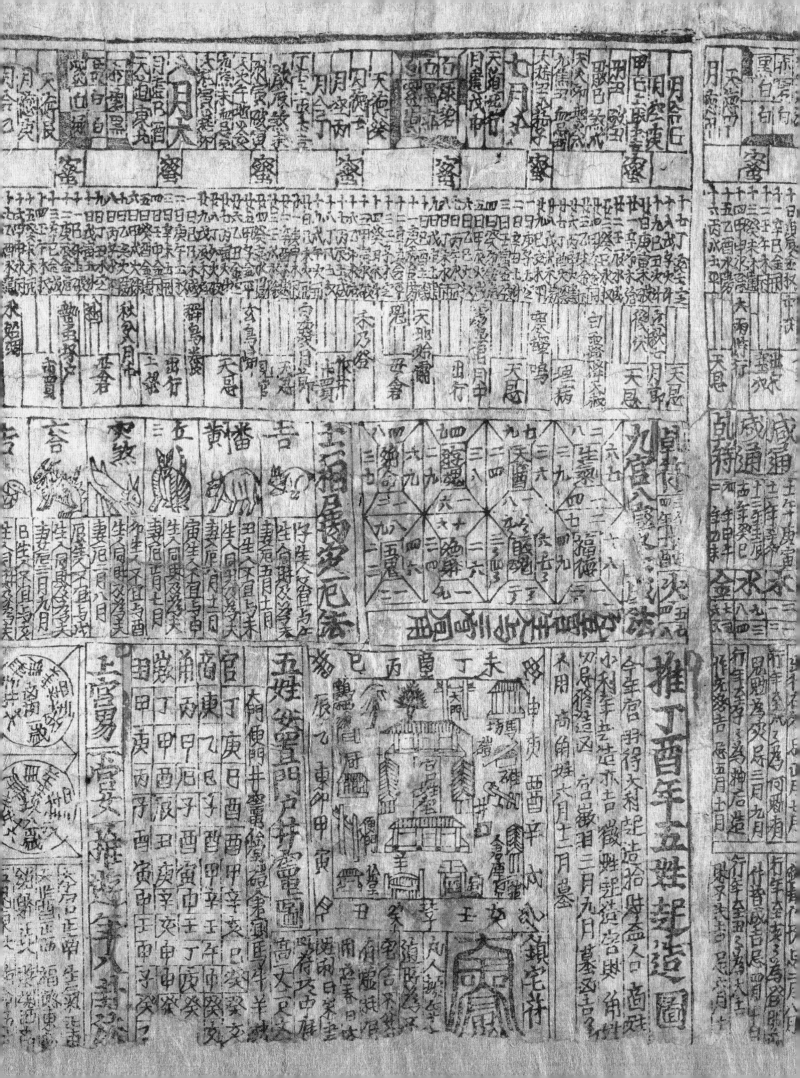

Muslim societies generally held the written word in very high esteem, and, combined with the availability of paper, a relatively high level of literacy was achieved, particularly in comparison with other contemporary societies.

The Chinese had developed woodblock printing by around the 7th century, using it to print pages of both text and illustration, notably the voluminous Buddhist canon. Private printers also flourished, producing multiple copies of almanacs for sale. The method was adopted by neighbouring cultures, such as the Tanguts and those on the Korean peninsula and Japan. Although the Chinese also experimented with moveable type, using wood or

clay, this technique was not as efficient as woodblock printing for their non-alphabetic script; but moveable type was used by the Uygurs in central Asia, with some 10th-century pieces surviving in Dunhuang [*see* box on p. 138].

Muslims were also familiar with various techniques of making multiples from a single mould, whether in seals, ceramics, textiles or embossing leather, but they were generally reluctant to apply this technology to the written word, as the Arabic script has certain peculiarities that make it particularly difficult to create a printed text as attractive and legible as a handwritten one. Foremost among them is that many Arabic letters

Baghdad: a centre of scholarship

Located along the strategically important Tigris river, in modern-day Iraq, Baghdad was founded in the mid-8th century CE as the capital of the Abbasid caliphate by al-Mansur (r. 754–775). It grew rapidly to become a great city: a major political, cultural and commercial centre, which, by the 10th century, was one of the largest cities in the world. Unusually, it was designed with a circular plan, but as it was sacked on a number of occasions, and subsequently redeveloped, we know few details

about the early medieval city. It had a circular outer city wall, perhaps about 2.5 to 3 km (1.5 to 2 miles) in diameter, with a circular inner central precinct. The margins of the latter were reserved for the palaces of the caliph's children, as well as staff and servants, kitchens, barracks and state offices, while at the centre lay the Great Mosque and the caliph's palace, an expression of the union between temporal and spiritual authority.

The city became famous as a centre of scholarship and the

arts within the medieval world. Paper was made here and a great library, the House of Wisdom, was founded around 800 CE, shown here in an illustration dated to 1247 by al-Wasiti, from al-Hariri's *Maqamat*. It contained works from the classical European and Islamic world and by the end of the 9th century was probably the world's largest library. The 13th-century Madrasa al-Mustansiriyya commissioned by al-Mustansir (r. 1226–1242), also shown here, survives today as part of the university.

The city was largely destroyed by the Mongols in 1258 CE. It was rebuilt, although on a new plan, and flourished during the 13th and 14th centuries, before being sacked again by Timur in 1401 CE. Again rebuilt, it prospered due to its pivotal location, and became the capital of the independent Kingdom of Iraq in 1932. TW

Further reading: Duri 2007; Le Strange 1900; Weber et al. 2014.

١٣٣

Left — Block-printed amulet for a soldier with the text 'God's support and a speedy victory' and quotations from the Qur'an. Probably made in Egypt in the 10th to 11th century.

Above — A copy on paper of the *Kitab al-Hiyal* (The Book of Ingenious Devices), first published in 850 by three brothers working at the House of Wisdom in Baghdad.

change their shape depending both on their position in a word and whether they connect to the previous or following letter. So even though there are only 28 phonemes in the Arabic alphabet, a basic typeface would need some 500 unique characters to print a fully vowelled text.

In Egypt, woodblock printing was occasionally used for producing inexpensive amulets on paper. Europeans, however, were the first to develop typefaces for Arabic, although they remained fairly uncommon until the 19th century, when new techniques, particularly lithography, allowed the acceptable reproduction of writing. The development of digital technology in the

20th century has finally allowed typesetters to approach the inherent beauty of a finely calligraphed Arabic text.

——

Further reading: Barrett 2008; Bloom 2001, 2017; Hanebutt-Benz et al. 2002; Needham & Tsien 1985; Osborn 2017; Schaefer 2006.

Ceramics from Mesopotamia to China

Rosalind Wade Haddon

The clay needed for pottery production is available almost everywhere across Afro-Eurasia, but especially in the floodplains of great rivers such as the Tigris and Euphrates in Mesopotamia and the Yellow and Yangzi in China. Early wares reflect the local clay in their colour and fineness but, as glazing technology developed, imported ideas started to be imitated, such as Chinese whitewares with or without green splashes.

Pottery was always part of trade, partly in the form of fine pottery for the elite, but mostly as containers to transport other goods, such as oil, wine and date syrup [see box on p. 398].

While the early pottery of southern Mesopotamia reflects the landscape, the urban settlements were also linked to the maritime trade routes by the third quarter of the 4th century BCE, when Alexander the Great (r. 336–323 BCE) founded his port city of Alexandria on the Tigris about 50 km (30 miles) inland from Basra. Later it was known as Charax Spasinou (today's Naisān). Under the Parthian (247 BCE–224 CE) and Sasanian (224–651) empires it was a major emporium receiving goods traded

from the oasis cities of Palmyra, Hatra and those of Greater Iran. The administrative centre and winter capital of these empires was Ctesiphon, south of present-day Baghdad, which spanned both banks of the Tigris. The population was polyglot, with Iranians, Aramaeans, Jews and later Arabs present. Ctesiphon continued as an administrative centre after the Arab conquest in 637 and until Baghdad's foundation in 762 [see box on p. 336]. It controlled and taxed the cultivated area between the Tigris and Euphrates and their tributaries from approximately Tikrit in the north to Basra and the Shatt al-Arab in the south through an intricate network of canals and land routes; the Khuzistan plain in present-day Iran,

A 9th-century storage jar with
cobalt glaze and green painting made
in Mesopotamia.

Islamic pottery

Calligraphy was used in many contexts in Islamic cultures, including on pottery. This 9th-century bowl, 28 cm (11 in.) in diameter, has a cobalt blue inscription reading 'Blessing and Good Fortune' (Metropolitan Museum of Art, 30.112.46). It is in the Kufic script, used for both early manuscripts [*see* box on p. 264] and in architectural decoration, as at the Dome of the Rock in Jerusalem [*see* box on p. 262].

The bowl is earthenware but the glaze and decoration shows the influence of imported Chinese stonewares. With the opaque white glaze Islamic potters were probably attempting to replicate Chinese whitewares that, fired at higher temperatures, had a harder body and more luminous quality. The green decoration, made from copper oxide or ferrous oxide, was painted onto the white glaze, probably to replicate Chinese *sancai* wares. RWH

Further reading: Watson 2006.

Two 9th-century bowls made in Mesopotamia, with cobalt-blue Kufic inscriptions. Their shape and opaque white glaze are in emulation of Chinese stonewares.

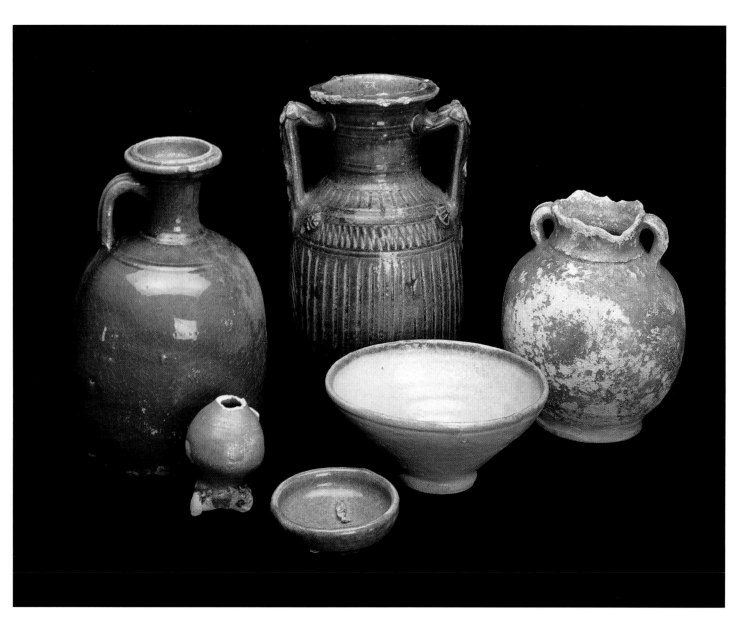

A collection of 2nd- and 3rd-century Parthian glazed wares.

to the southeast, and the area west of the Zagros mountains was also part of this network. Urban settlements sprang up along the major canals and over the centuries these rivers created a flat, featureless alluvial plain, blocked in to the west by the desert plateau; it flooded regularly, despite specially engineered weirs and barrages, and the river courses shifted through avulsions, accounting for some ancient settlements lying well away from today's river courses.

Throughout the region building materials were limited to mud, baked bricks, gypsum and limestone plaster, date-palm fronds and reeds for matting and fuel for brick kilns, date-palm trunks for roofing,

or imported teak for grander structures. One noteworthy feature is that the bricks turned a distinctive yellow when fired, the same colour as that identified as the typical 'Basra body' seen in early Islamic pottery. Limited raw materials established a uniformity in decorative style – for example, in grand residences, moulded and carved stucco was employed to cover the lower halves of interior walls, some with wall paintings above these. With a known stylistic corpus it is possible to date and provenance excavated fragments. For example, Ctesiphon's 6th-century moulded stucco tiles are distinct from the slant-cut, bevelled style of Samarra's 9th-century Abbasid dado panels.

In all periods pottery was an important product, employed widely for storage vessels, coffins and tablewares and recycled for drainage, inhumations and building materials. Bitumen was used to line large vessels to render them non-porous, while smaller vessels were glazed. A variety of clays is recorded, but the one that predominates is the same yellow calcareous type used for Parthian slipper coffins, both glazed and non-glazed storage vessels, Sasanian glazed wares and in the early Islamic period opaque white so-called 'Basra wares' – although these could have been crafted anywhere in this area with its uniform clay. When the caliph al-Mu'taṣim (r. 833–842) founded Samarra in 836,

An Abbasid-period kiln recently excavated at Raqqa by Veronique Francoise, N. Mohammed and I. Shaddoud.

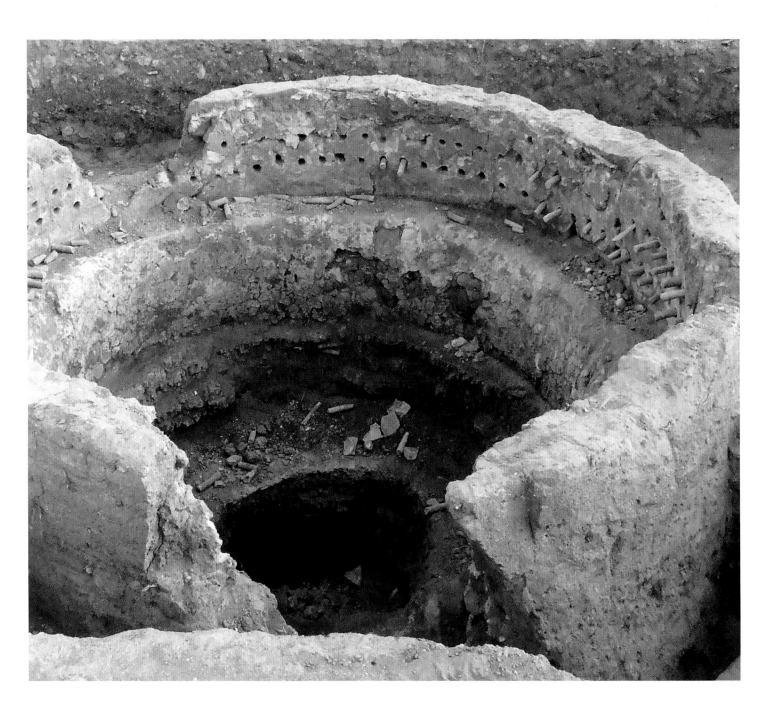

Top — Decorative stucco from the 9th-century residence of the caliphs in Abbasid Samarra, excavated in 1911–13 by Friedrich Sarre and Ernst Herzfeld.

Bottom — Decorative stucco from a 6th-century elite residence at Sasanian Ctesiphon on the Tigris.

the historical sources record that he brought potters from Basra, Kufa and Baghdad [*see* box on p. 336]. The updraft kiln was ubiquitous, with excavations where kilns are reported in both Parthian and Sasanian levels at Ctesiphon, Babylon and several other sites. At Ashur, just north of Tikrit, both horseshoe and circular kilns have been excavated. Indeed, judging from the kiln furniture found, technologically there was little difference between Parthian, Sasanian and Islamic techniques, except in the glazes. Close examination of the magnificent green-glazed slipper coffin from Uruk in the British Museum showed that it was too fragile and large to have been transported far from its

Ceramics by sea

This dish, 23 cm (9 in.) in diameter, is a rare example of a complete vessel from the Tang dynasty (618–907) produced in the Gongxian kilns in northern China using cobalt-blue glaze. This glaze was new to Chinese potters, only recently imported from Iran, possibly on the same ships that travelled back with ceramics such as this. It was used for pieces produced for local use, specifically for grave figurines, but this dish was produced for export. It was one of three such pieces discovered on the Belitung wreck [see box on p. 400]; this one is now in the National Museum of Singapore (2005.1.00474).

The lozenge and vegetal decorative motif is reminiscent of similarly decorated Abbasid opaque whitewares and certainly not to Chinese taste. Similar decoration is seen on many fragments found in the caliphal palace at Samarra; but none of the Chinese imports found there was decorated with cobalt blue, only green splashwares. Taken alongside fragmentary examples

discovered at the Chinese port of Yangzhou and the Baihe kiln site at Gongxian, the suggestion is that the Belitung dishes were trade samples, perhaps specially commissioned.

A tiny fragment of the same Chinese blue and white type with a rivet hole was found at Siraf [see box on p. 379], an important transshipment port on the Iranian side of the Gulf with deeper port facilities than Basra. This proves that some of these wares were transported westwards. Given that the Belitung shipwreck occurred in the Java Sea, it is not possible to confirm that all the cargo was bound for the west – some of it was undoubtedly for trading en route, as indicated by the finds at Mantai, Sri Lanka. RWH

Further reading: Krahl et al. 2010; Spataro et al. 2018.

A Parthian green-glazed clay 'slipper' coffin, 1.96 m (6 ft 5 in.) long, excavated in Uruk on the ancient course of the Euphrates by William Loftus (1820–1858).

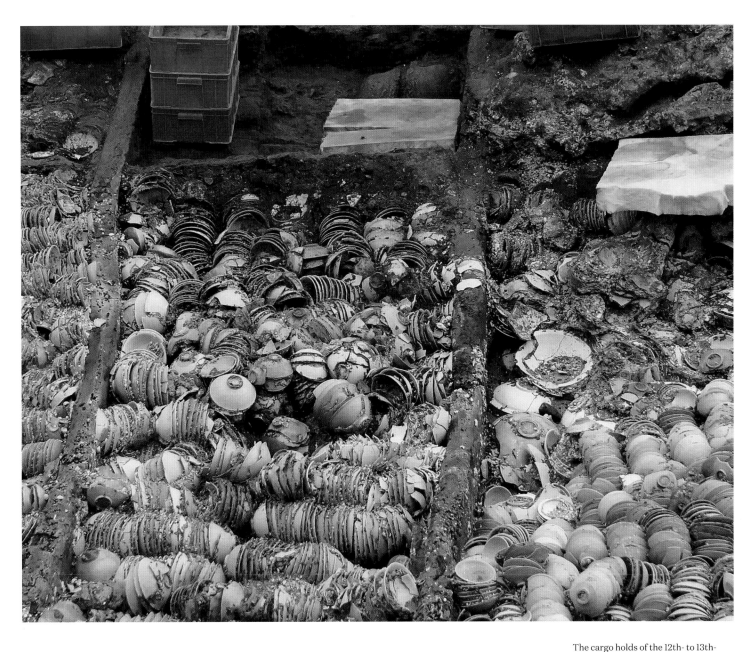

The cargo holds of the 12th- to 13th-century Nanhai No. 1 ship, wrecked off south China, showing part of its cargo of an estimated 160,000 items, including many Chinese porcelain bowls.

manufacturing source, supporting the hypothesis that pottery workshops existed at multiple urban sites. Preliminary research notes that there are negligible pottery imports, confirming that local production met needs.

China was also a major producer of fine ceramics and, during the 1st millennium, contacts between the two cultures grew with wares and glazes being traded by land and sea. The first examples probably arrived as diplomatic gifts – Harun al-Rashid (r. 786–809) is known to have received one consignment. The Belitung shipwreck [*see* box on p. 400], dating to between 824 and 850, gives us a glimpse of Chinese wares in circulation, designed for the

Islamic market, and a few examples have been found in southern Mesopotamia and at Gulf sites, with many more imitated. Given the long tradition of producing glazed vessels in southern Mesopotamia, it should come as no surprise that the potters had the skills required to copy Chinese imports in the 9th century; but the question is why this sudden change after centuries of tradition?

Further reading: Hauser 1996; Middleton et al. 2008; Northedge 2001; Sarre 1925; Verkinderen 2015; Weber et al. 2014.

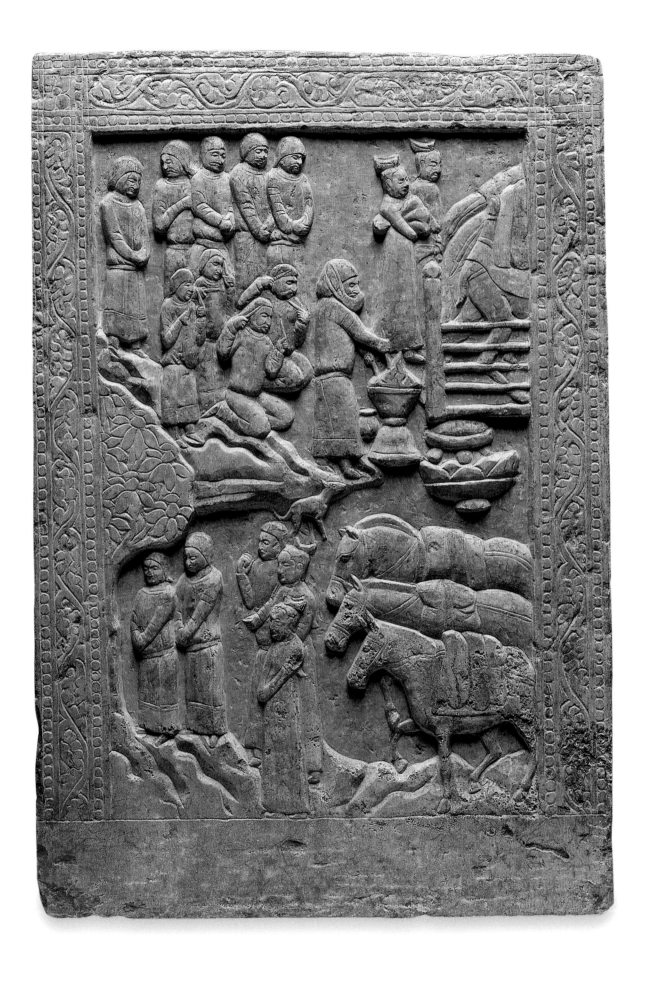

Zoroastrianism: the spread of an ancient religion

Sarah Stewart

Linguistic evidence suggests that Zoroastrianism was established in central Asia in the 2nd millennium BCE, spreading southwest across the Iranian plateau to western Iran where it later became the religion of three empires: Achaemenid (550–330 BCE), Parthian (247 BCE–224 CE) and Sasanian (224–651 CE). Under the last it spread as far as southern Arabia and eastwards into northern China.

The Zoroastrian holy book, the *Avesta*, takes its name from an eastern Iranian language, Avestan, which was the language of Zarathushtra (or Zoroaster), the eponymous founder of the religion who is thought to have lived some time between 1200 and 1000 BCE. Zarathushtra proclaimed Ahura Mazda as the deity responsible for creation. The *Avesta* achieved its final form in western Iran, but there is no evidence of its transcription until the 5th or 6th centuries CE and the earliest extant manuscripts date from the 9th century.

Zoroastrian ritual and religious practice in western Iran enters recorded history during the Achaemenid period. Rock reliefs and inscriptional evidence from sites near the capital of Persepolis as well as accounts from Greek authors such as Herodotus attest to the worship of Ahura Mazda, a reverence towards fire, and a calendar in which the twelve months of the year are dedicated to the seven major divine beings of Zoroastrianism, as well as other lesser divinities. Early Achaemenid kings brought much of central Asia under their rule, including Sogdiana, which was conquered by Cyrus II (r. 559–530 BCE) in 540 BCE, and Chorasmia soon thereafter. Both areas are the source of material that shows a fusion of what might be considered indigenous and mainstream Zoroastrian ideas and religious practice. By the end of the Achaemenid

Taq-e Bustan: Zoroastrianism

The rock reliefs at Taq-e Bustan near the city of Kermanshah show, in fine detail, investiture scenes of several Sasanian kings including Shapur II (r. 309–379 CE), Ardashir II (r. 379–383 CE) and Khusrau II (r. 591–628 CE). The site overlooks two large pools fed by natural springs. The upper register in the larger of the two recesses (shown below) depicts Khusrau II standing between the Zoroastrian god Ahura Mazda and Anahita, goddess of the waters, who each hand him diadems with long flowing ribbons – clearly a token of his divine right to rule as a member of the royal house of Sasan. In the lower register, the king is shown mounted on horseback wearing full armour. Two hunting scenes decorate the side walls: in one the king is stalking deer and in the other boar. The detail of these

scenes represents the importance attached by the royal household to the sport, considered an excellent preparation for warfare [*see* box on p. 142].

In the smaller recess, Ardashir II stands beside Ahura Mazda and Mithra (shown right). The latter guards the king with his raised sword, reminiscent of the ancient *Yasht*, or hymn to Mithra, in which the deity wields a mighty club. Beneath the king's feet lies the body of a fallen enemy [*see* box on p. 67]. SS

Further reading: Choksy 2002; Compareti 2016a; Curtis 2000; Nariman 2002.

Previous spread — A panel from a 6th-century marble funerary couch of a Sogdian buried in China, with scenes from his life, including the Zoroastrian tending of the eternal flame.

Above — The Achaemenid royal tomb of Artaxerxes I (r. c. 465–424 BCE) at Naqsh-e Rostam, with the king, fire altar, and the winged symbol of Zoroastrianism.

period, for example, Zoroastrian calendars used in Bactria, Sogdiana and Chorasmia named each day and month after a Zoroastrian deity; Ahura Mazda, on the other hand, was not a deity that is prominent in the art and iconography in this region.

Zoroastrian prescriptions for dealing with the dead are set out in the Avestan text of the *Vendidād*, or law book, and include the rite of exposure. In Iran, the custom of encircling a mountain top with a wall in order to lay out the dead appears to have led to the building of *dakhmehs* ('Towers of Silence') for this purpose. One of the oldest was established on a hilltop of what is now known as Shahr-e Rei in the south of modern Tehrān. Mary Boyce has suggested

that traders from Bactria had settled here from as early as the 8th century BCE. The bones, once stripped and bleached, were placed in clay ossuaries or in a charnal house (*naus*) where the remains of members of the same family could be interred. Ossuaries provide a wealth of information about Zoroastrian religious beliefs. One such from Yumalaktepa near Shahr-i Sabz in modern Uzbekistan is stamped in the lower register with a scene showing the ritual performed for the soul on the fourth morning after death. Another example comes from Mulla Kurghan, near Samarkand in Sogdiana: the lower register depicts two priests performing a ritual before a fire altar, and the upper

A Zarathushtra text

Although Zoroastrianism was the traditional religion of the Sogdians, most surviving Sogdian manuscripts contain Buddhist, Manichaean or Christian rather than Zoroastrian texts. This paper fragment, measuring 24 by 27 cm (9.5 by 10.5 in.), discovered in the Library Cave at Dunhuang [*see* box on p. 138] and now in the British Library (Or.8212/84) is a rare exception.

The main part of the text, from line three onwards, is written in the normal Sogdian language of about the 9th century CE and describes an encounter between the prophet Zarathushtra or Zoroaster and an unnamed 'Supreme God'. The preceding two lines contain a version of the *Ashem Vohu*, one of the most holy prayers in the *Avesta*, the Zoroastrian scripture. Remarkably, this prayer is given neither in standard Sogdian nor in standard Avestan, but in a fossilized Old Iranian language, preserving a form of the text significantly more archaic than that of the *Avesta* as it is known today and well over a millennium older than the manuscript in which it is preserved. For example, the word for 'truth' is written -*rtm*, a spelling that represents Old Iranian **ərtam*, the form that underlies Avestan *ašəm* and which would have given Sogdian **ərtu* (if such a word had survived). NSW

Further reading: Sims-Williams 1976, 2000.

shows two dancing girls and astral symbols including flowers – imagery resonating with a Pahlavi text (*Selections of Zadspram*, 30.61) that refers to *houris* as one of the pleasures awaiting the soul in Paradise [*see* p. 355].

An important site for understanding Zoroastrianism in central Asia is the 3rd- to 2nd-century BCE Akchakhan-kala in the Amu Darya delta. Painted fragments belonging to a colossal figure, discovered in the ceremonial area of the site, have been identified with the Zoroastrian divinity of prayer, Sraosha. A major divinity in the *Avesta*, Sraosha is sometimes represented visually in the form of a cockerel, which symbolizes the arrival of dawn and reminds people of the first watch of the day and the obligation to pray. In the *Vendidād* (18.14), the cock is referred to as Sraosha's assistant priest. There are various Zoroastrian themes that can be identified in the painting of the figure, in particular the 'bird priests' facing each other in a vertical line down the central panel of the tunic. These roosters with human heads are wearing the priestly *padam* or mouth covering, used to protect the sacred fire from pollution. In their hands, they hold *barsom* rods, implements used in priestly rituals.

Funerary traditions were probably adapted as Zoroastrianism spread into new regions, such as

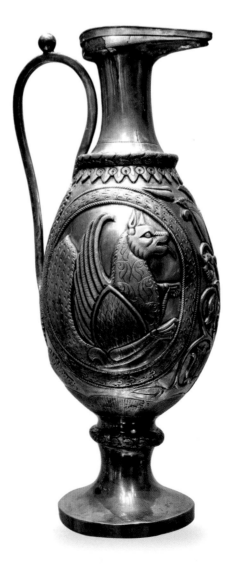

Gilt-silver ewer from 6th- to 7th-century Sasania, showing the *simurgh*, a mythical bird from the Zoroastrian *Avesta*.

Pir-e Sabz:
a Zoroastrian cave shrine

Pir-e Sabz ('green shrine') has long been an important place of pilgrimage for Zoroastrians in Iran. According to the *Yashts*, hymns addressed to Zoroastrian divinities, worship took place traditionally in the open air, on mountain tops and by sources of water. Pir-e Sabz, referred to locally as Chak Chak, is in such a location. Situated on a rocky escarpment some 50 km (30 miles) north of the city of Yazd, the shrine is beside a pool of water fed by a mountain spring. It is shaded by trees including an ancient willow, the twisted trunk of which frames the upper part of the entrance to the shrine, which is inside the rock.

The shrine legend tells of a princess, Hayat Banu ('Lady of Life'), daughter of the last Sasanian ruler, Yazdegerd III (r. 632–651 CE), who, pursued

by Arab invaders, was offered refuge in the rock, which opened and took her in. An earlier tradition may have associated the shrine with the water goddess Anahita.

Individual and collective worship takes place at the shrine and includes candles being lit, incense burned, prayers recited and votive ribbons tied to the branches of nearby trees. Pavilions built along nearby terraces provide accommodation for pilgrims to Pir-e Sabz, who gather for several days according to the religious calendar. SS

Further reading: Boyce 1989; Langer 2004; Rose 2011; Stausberg 2015.

Towers of Silence

Exposure of the dead, in order to avoid the pollution of fire, water or earth, is detailed in the *Vendidād*, or Zoroastrian law book, and there is evidence from central Asia that this was an ancient custom. Dead matter is believed to be the most potent source of ritual impurity and death itself represents the triumph of evil, personified in the form of the Evil Spirit, Ahriman, over the righteous person. Funerary rituals are designed to hasten the passage of the soul towards judgment at Chinvat Bridge.

Traditionally, the dead were laid out on a rocky hillside for carrion birds and wild animals to devour and from where the sun-bleached bones could be gathered and placed in an ossuary or clay casket. The custom of walling in a hilltop in order to dispose of bodies collectively is first attested in the 4th century CE at Chil'pyk, a site overlooking the valley of the Amu Darya in Chorasmia. The spur of rock, surrounded by a mud wall, encloses an area that once contained both a *sagri*, or place for fire, and *pavis*,

demarcated areas for bodies to be laid out.

Circular towers known as *dakhmehs* ('Towers of Silence'), built for the same purpose, became widespread in Iran from the Islamic period until the mid-20th century and continue to be used by the Parsi community in Mumbai today (shown below). The small *dakhmeh* in Cham, north of Yazd (pictured right), shows the remains of the stone slabs on which bodies were laid as well as the central pit into which the bare bones were swept. A fire lit in a small tower shone through 'two eyes' and faced a small aperture in the wall of the *dakhmeh*. SS

Further reading: Grenet 2013; Rose 2011.

China. Graves of Sogdian merchants in China, for example, contain funerary couches made of carved stone or painted wood with scenes showing the merchant during his lifetime. However, when Zoroastrians migrated to south Asia following the spread of Islam, they retained their exposure rituals, the Towers of Silence in Mumbai (shown opposite, below) used by the surviving Zoroastrian (Parsi) community being among the last in use today.

——

Further reading: Boyce 1992; Rose 2011; Stewart 2013.

Previous spread — Sasanian complex outside Isfahan, including fire temples and a beacon tower.

Below — This 6th- to 7th-century ossuary found near Samarkand is stamped in the lower register with a scene showing the Zoroastrian ritual performed for the soul on the fourth morning after death.

Manichaeism: its flourishing and demise

Zsuzsanna Gulácsi

Manichaeism was a missionary world religion that originated in Mesopotamia during the middle of the 3rd century CE and rapidly spread along the trade routes of Afro-Eurasia. It survived until the early 11th century in east central Asia and until the early 17th century in the coastal provinces of southern China.

Its Parthian founder, Mani (216–274/277 CE), grew up in an Elkasite baptist community near the Parthian and later Sasanian capital city of Ctesiphon. This city was a vibrant centre of culture and learning, as reflected in Mani's knowledge of science and the arts, as well as his familiarity with Greek philosophy and multiple religious traditions. Mani's doctrine – about the duality of light and darkness, the salvation of the light, the human and divine messengers of God, the structure and origin of the universe, and the end of the world – reflects his Zoroastrian [see pp. 346–55] and Judeo-Christian background, as well as his inquiries into Jain and Buddhist teachings of contemporaneous

northwest India. Exposure to such multiple bodies of knowledge allowed Mani to create an original synthesis. He provided a comprehensive explanation of how the divine and the demonic powers operate in the universe and how humans can contribute to what he called the 'work of religion' by following the uncorrupted teachings of the true prophets of the past and his teachings in the present.

From the elite and learned environment of the province of Babylon, Mani acquired various intellectual tools for achieving this goal, including a sophisticated literary and pictorial culture. In order to prevent the adulteration of his doctrine, he composed numerous books, wrote letters to

Illustrated manuscript fragment from a Zoroastrian text found at Kocho in the Tarim basin.

guide his followers and employed images in a solely
pictorial role to illustrate his instructions. These
written and pictorial works authored by Mani
became the canon of his religion, fragments of which
survive in later translations and editions. Quite
remarkably, the only known relic from this first era
of Manichaean history is the actual sealstone Mani
used for authenticating his letters, preserved today
in Paris.

Spreading further east along the Silk Roads,
Mani's religion reached the oasis cities of east
central Asia and the realm of the Turkic-speaking
Uygurs, where Manichaeism experienced a golden
age of peace, prosperity and imperial protection.

Illustrated manuscript fragments from
Zoroastrian texts found at Kocho in the
Tarim basin.

Mani's pendant seal

This seal, 2.9 cm (1.15 in.) in diameter and 0.9 cm (0.35 in.) high, was delicately carved in Ctesiphon around 240–76 CE from transparent rock crystal, valued for its magical properties across the ancient world. It was designed as a double-sided object, and was originally framed in gold, to fulfil a dual purpose: its round side was a sealstone with a negative intaglio used for authenticating clay bullas attached to letters and its flat side functioned as a gem pendant, on which the incised content showed through from below as a positive image with a legible inscription. The lettering exhibits a precise calligraphy. Written in the Manichaean script, the Syriac-language text attributes this object to the founder of the Manichaean religion, identifying him as 'Mani, the apostle of Jesus Christ' – a phrase routinely attested in the opening sentences of Mani's letters. The image conveys the bust of three figures in the abstract visual language of late Parthian coinage. In the centre and on a larger scale, the owner of the seal, Mani himself), is shown long-bearded and long-haired, wearing a wide headband (Old Persian *tiyārā*). The figures at either side of him seem to reference his elects, who are also noted in the starting formula of Mani's epistles. The seal is now in the Bibliothèque nationale de France in Paris (INT.1384 BIS). ZG

Further reading: Gulácsi 2014.

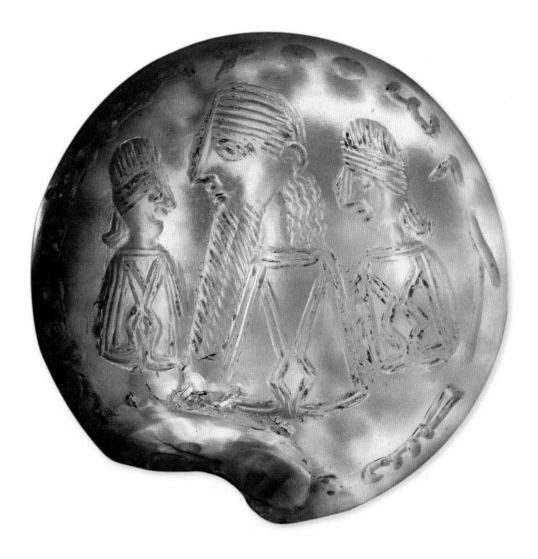

This roughly 270-year period commenced when Mani's teachings were introduced to the ruling elite of the Uygurs, resulting in the conversion of their great khan, Bögü, in 762 CE. The Uygurs were based in Kocho – the main mercantile and agricultural centre of the region, and the seat of a Manichaean bishop – from where the largest concentration of Manichaean remains have been discovered. Located in what is today northwest China, the mud-brick ruins of Kocho were identified as an archaeological site when German expeditions explored them between 1902 and 1914. Although their work led to the discovery of a significant number of Buddhist and a few Syriac Christian artifacts, Kocho turned out to be most famous for its Manichaean finds, all of which are housed in Berlin collections today. The ruins include two buildings that are securely identified as Manichaean by their murals, about 5,000 manuscript fragments written in Parthian, Middle Persian, Sogdian and Uygur languages, and 110 high-quality artistic remains. Among them are four fragments of wall paintings and seventeen hanging scrolls, most of which were painted in a Chinese style. The majority of the artistic remains, however, are fragments of exquisitely painted and heavily gilded books that follow Syro-Mesopotamian book designs, but, unlike these models, the Manichaean books were made of paper as early

The only extant Manichaean wall painting with a didactic subject, dating to around the 10th century, is found in the rock-cut temples of Bezeklik, near Turfan in the Tarim basin.

Manichaean liturgy

This manuscript fragment, measuring 13.4 by 7.8 cm (5.3 by 3.1 in.), was discovered in the Uygur city of Kocho and dates from the 9th to 10th centuries (Asian Art Museum, Berlin, MIK III 4947). It was part of a luxurious liturgical book. The illustrations were oriented at right angles to the writing. The one shown portrays a core Manichaean ritual, but the image has no direct ties to the adjacent text. Instead, it visually summarizes a soteriological teaching of Mani, *The Salvation of the Light*: laypeople donate vegetarian food to the elect; once consuming their sacred meal, the elect sing hymns to release the light particles their bodies liberated; the freed light fills up the moon and then the sun, which ferry it back to God, to the Realm of Light.

Arranged neatly in two columns and lettered in a superb hand using the Manichaean script, the text is a Middle Persian benediction on the Uygur community that continues on the verso, where now-faded floral motifs surround the header. ZG

Further reading: Gulácsi 2001, 2005, 2015.

as 755 CE. The largest group is formed by fragments of service books in the codex format illuminated in a west Asian painting style. Without exception, all examples feature their images oriented sideways.

Reaching the eastern hub of the Silk Roads by the 7th century, Manichaeism was present in the major cities of the Tang dynasty (618–907), surfacing in the historical records as *monijiao* ('religion of Mani'). For a brief period corresponding to the zenith of Uygur military might and political influence on the Tang, Manichaeism enjoyed imperial tolerance and was propagated among the Chinese inhabitants of the capitals, including Chang'an [*see* box on p. 286]. Soon after the fall of the Uygur steppe empire

(840/1 CE), during the persecutions of all foreign religions in 843–45 CE, Manichaeism disappeared from northern China. Its Chinese converts fled westwards, to the territories of the Ganzhou Uygur kingdom in the region of Dunhuang [*see* box on p. 138] and the Tarim basin, and to the coastal provinces of southern China. Here a fully sinicized version of the religion, referred to in Chinese sources as *mingjiao* ('religion of light'), started merging with local Daoist practices after the 15th century.

The material remains of this last phase of Manichaean history include a temple-shrine with a statue of Mani from 1339 CE *in situ* in the Cao'an

The Manichaean universe

Cosmological texts discuss the Manichaean universe as a highly structured space that has centres and peripheries, and cardinal directions. Such principles of organization are evident in the visual language of this 13th- or 14th-century Chinese hanging scroll painted with gold and colours on silk. They include the repeated motif of Mani as a visionary witness, an overall *macranthropos* (giant human form) as an organism of salvation, and numerous layers. The lower part of the image features the eight earths, stacked one upon the other, of which our own earth is the topmost. The atmosphere separates the surface of our earth from the ten firmaments of the sky. Through and above these firmaments, the process of liberating light from the cosmos occurs, along the 'Column of Glory', nurtured by the actions of sun and moon, gradually forming the 'Perfect Man' as a kind of reconstructed

double of the 'Primal Man' whose primordial sacrifice initiated the mixture of light and darkness, which the cosmos operates to resolve. The New Aeon rests atop this operational cosmos and is in turn surmounted by the Realm of Light. The image as reproduced here is a digital matching of the three parts of the scroll now housed in the Nara National Museum and Yamato Art Museum in Nara, Japan. ZG

Further reading: Gulácsi & BeDuhn 2011/2015; Kósa 2012; Yoshida & Furokawa 2015.

REALM OF LIGHT

NEW AEON

LIBERATION OF LIGHT

TEN FIRMAMENTS OF THE SKY

ATMOSPHERE
Judgment, Transmigration
and Rebirth

EIGHT LAYERS OF THE EARTH
Two vistas (surface of eighth earth
and surface of fifth earth) and eight
cross-sections of the earth

A 14th-century statue of Mani at a local shrine near the Chinese sea-port of Quanzhou [*see* box on p. 380].

Temple near Quanzhou [*see* box on p. 380] as well as a corpus of recently identified silk paintings. These exquisite Chinese Manichaean works of art date from between the 12th and 15th centuries and are housed in various art collections in the United States (San Francisco) and Japan (Dazaifu, Kofu and Nara). They depict various soteriological and prophetological subjects, as well as a monumental cosmological diagram.

Further reading: BeDuhn 2000; Lieu 1992; Lieu et al. 2012; Moriyasu 2004; Tardieu 2008.

Fruits and nuts across Eurasia

Robert Spengler

Every market bazaar in central Asia displays an impressive variety of fruits and nuts, and many of these were highly praised articles of trade in the past: the golden peaches of Samarkand, mare's teat grapes, Bukharan apples and melons from Hami among others. Medieval texts mention the cultivation of and commerce in arboreal crops, and archaeobotanical remains of these fruits and nuts illustrate how prominent their cultivation was during the 1st millennium CE.

Settlements across central Asia in this period were surrounded by irrigated orchards and vineyards, whether in the mountains, desert oases or river valleys. However, the cultivation of fruits stretches much further back in time. Archaeologists have recovered carbonized grape pips from central Asia at the 1st millennium BCE village of Tuzusai, as well as from contemporaneous desiccated burials in the Taklamakan. These seeds demonstrate a long tradition of fruit cultivation in the ecologically rich foothills of northern central Asia. This region is also well known as the homeland of the apple, and these early village farmers brought the tree under cultivation for the first time.

The connection between people and fruits on the trans-Eurasian corridors of exchange is deeply intertwined; archaeobotanical and genetic data suggest that dispersal along these trade routes caused the domestication of several now common fruits. A study of the ancient plant remains recovered from the site of Sarazm demonstrated that the first farming communities in the central Asian mountains, dating to the 4th millennium BCE, were collecting wild fruits and nuts. In addition, the close connection between people and trees in the central Asian foothills ultimately led to the cultivation of those trees. Apples, pistachios, walnuts and almonds are among the trees that were,

Previous spread — Wild apples growing in northern central Asia, homeland of this fruit.

Above — Fruit market in Samarkand taken around 1905 by the Russian photographer, Prokudin-Gorskii, by colour separation negative.

Right — Apricots are still grown and dried for year-round eating in the Pamir.

at least in part, domesticated in the river valleys that would eventually support the trade routes.

The dispersal of these fruits across Eurasia has left a lasting impact on their genetics. Geneticists have shown that the spread of apple trees from the Tianshan, along ancient trade routes, led to hybridization between disparate populations of wild crab apples. The descendants of these hybrid apples are the domesticated varieties eaten today. Similarly, the genetics of modern populations of walnuts show that they are hybrids of long-separated populations that were genetically isolated from each other before humans started transporting the nuts. The trade routes enabled the movement of east Asian fruits, such as the peach, to west Asia and Europe and west Asian fruits, such as the grape, to both Europe and east Asia.

———

Further reading: Cornille et al. 2014; Pollegioni et al. 2017; Spengler 2019; Spengler & Willcox 2013.

Right — Fresco painted in *c.* 62–69 CE from a house, possibly that of a merchant, in Herculaneum north of Pompeii. It shows peaches, said to have been introduced to Rome by Lucullus (118–57 BCE) after he saw them during a military campaign in Pontus on the Black Sea.

Below — Desiccated orchard in 2011, surviving from the 2nd- to 4th-century oasis kingdom of Caḍota in the Tarim basin [*see* box on p. 239].

Seas and skies

Seas and skies

Previous spread — The coast of Socotra, an island off south Arabia and long a stopping point for merchant ships whose sailors left graffiti in island caves [*see* box on p. 388].

Opposite — Stars were vital for navigation across the Indian ocean in the era of the Silk Road.

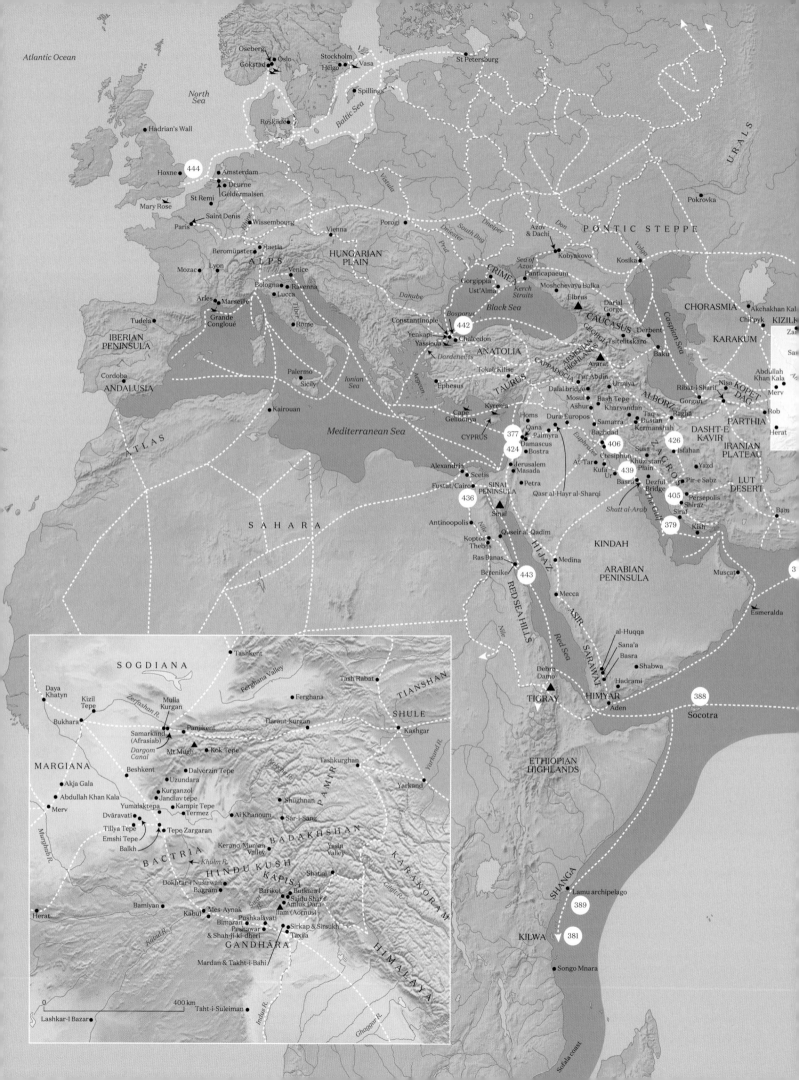

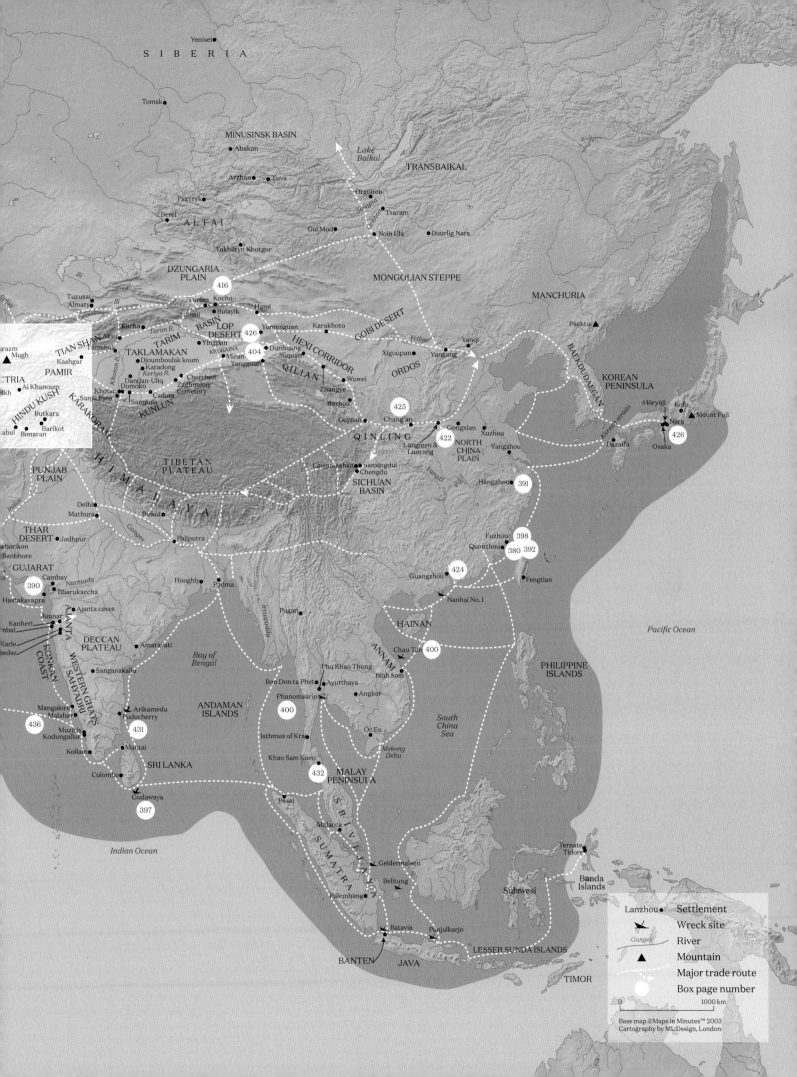

Interconnected seas

Tim Williams

"Here on the coast stands a city called Hormuz, which has an excellent harbour. Merchants come by ship from India, bringing all sorts of spices, precious stones, pearls, silks, gold, elephants' tusks and many other wares. In this city they sell them to others, who distribute them through the length and breadth of the world."

Marco Polo (13th century), *The Travels*.
After translation from the French by Ronald Latham.

Opposite — The sea enabled transport of both delicate and heavy cargoes, such as ceramics and slaves, but many ships were lost in storms on the Indian Ocean.

Serçe Limanı, a natural harbour in the
northeastern Mediterranean and site
of an 11th-century Byzantine shipwreck
excavated in the 1970s.

The seas and oceans of Afro-Eurasia provide a complex interconnected network of navigable water, which for millennia has had a profound impact on the movement of peoples, goods and ideas. Ships have enabled the transport of large quantities of fragile items and heavy cargoes, much more profitable to move by sea than by land. The great maritime routes have also carried people, and their beliefs, over great distances, and have often led to communities of traders – and slaves – growing up in far-flung settlements. Trade led to the growth of many ports, large and small, along the coasts and rivers of the region, and the struggle to control these ports, and the shipping they served, has been a major factor in the shifting powers of empires through time.

Winds and tides have always played a crucial role in the development and nature of maritime shipping. Long-distance voyages became possible once mariners understood the principles of seasonal winds, and especially those of the monsoons. During northern hemisphere summers, the Asian continent warms up and hot air from the land, through convection, draws in moist air from the oceans to the south to create the southwest monsoon. In winter, the opposite process occurs, with cold dry air expelled from Asia out over the oceans, creating the northeast monsoon. Other wind systems, such as the southern hemisphere trade winds, and the equatorial currents, were used by mariners to link in to the monsoon system, extending trade networks, for example down the African coast.

In the west, the Mediterranean, covering some 2.5 million sq. km (970,000 sq. miles), provided a vital resource for many societies from prehistory to the present. A space for trade, travel and cultural exchange, it played a critical part in the development of many modern societies. It is divided into two deep basins, with an average depth of 1,500 m (5,000 ft). Nearly landlocked, with only a narrow connection to the Atlantic Ocean, tides are very limited and the Mediterranean is subject to intensive evaporation. Nevertheless, it can still be a challenging sea to cross, especially in a small boat, and wrecks from antiquity pepper the coastlines.

Tyre and the Mediterranean

The port-city of Tyre (Sour in Arabic), founded in the Bronze Age at the centre of the eastern Mediterranean shoreline, became an important trading node from the Iron Age. It connected the eastern continental trade networks of the Syro-Mesopotamian steppes with the shipping routes of the Mediterranean. Originally an island, it was joined by Alexander the Great (r. 336–323 BCE) to the mainland in 332 BCE during his campaigns against the Persians, who had hosted part of their fleet there. Following Alexander's death, the trade routes shifted to Alexandria. Under the Romans, Tyre became a major city with monumental architecture, such as the arch shown here, built in the 2nd century CE. It witnessed a new era of trade and prosperity until the end of the Byzantine period (395–1453).

Conquered by the Arabs during the 7th century CE, the city remained prosperous under the Fatimids (909–1171). Later, trade continued with the Crusaders for almost two centuries. The Mamluks (1250–1517) took the city in 1291, after which it fell into disrepair, until it was revitalized in the 18th century. Following the fall of the Ottoman empire, the city was included in the state of Greater Lebanon in 1920 and in the Lebanese Republic in 1943. Tyre was inscribed on the UNESCO World Heritage list in 1984. ASe

Further reading: Jidejian 1969; Maïla-Afeiche et al. 2012.

Barbarikon and the Indus river

The site of the port of Barbarikon in the Indus delta has not been conclusively identified. The delta, as shown here, covers a large area and its channels have shifted over the centuries. From textual references, however, we know that it was near the ancient city of Banbhore. It is described in the 1st-century CE *Periplus of the Erythraean Sea* as a major destination for ships sailing northwest from the Red Sea.

The list of materials passing through Barbarikon illustrates its importance as a meeting point of northern, overland and Indian Ocean maritime commercial networks. It imported goods such as linen, frankincense, coral, wine and gold and silver plate and exported goods including silk, indigo, turquoise and lapis lazuli, the last from modern Afghanistan [*see* pp. 182–87]. The *Periplus* reports that goods and revenues from the port were carried upriver to a royal capital further inland, and indicates that in the 1st century CE control over Barbarikon and the Indus system was contested between Indo-Scythian kings. Gaining and retaining access to western Indian Ocean trade via Barbarikon was also probably a strategic priority for the Kushan empire (1st to 3rd centuries) in central Asia. RD

Further reading: Casson 1989; Neelis 2011.

Moving southeast, the Mediterranean was connected, via overland routes through Egypt and Sinai, as well as caravan routes from the east, with the Red Sea and the Gulf, and thence to the Indian Ocean. The Red Sea is 2,350 km (1,450 miles) in length and about 350 km (220 miles) at its widest, with jagged coral reefs along much of the coastline, and depths of up to 2,300 m (7,500 ft). The Gulf, in contrast, is some 1,000 km (620 miles) in length, with depths averaging only 35 m (with a maximum of around 100 m or 330 ft). Both have high evaporation rates and thus high salinity. Important ports lined these seas in antiquity. The 1st-century CE *Periplus of the Erythraean Sea* describes navigation and trading from Roman Egyptian ports along the coast of the Red Sea, and within the Indian Ocean, including the Arabian peninsula, the east African coast and India. It mentions many trade goods, such as iron, gold, silver, drinking cups, myrrh, frankincense, cinnamon, fragrant gums, cloves, ivory, animal skins and slaves, reflecting the diversity of trade across the region.

The Indian Ocean extends over 70 million sq. km (27 million sq. miles), comprises almost 20 per cent of the water on the Earth's surface, and is the warmest ocean in the world. Its currents are largely controlled by the monsoon winds: the northeasterly winds, blowing from October until April, and southerly and westerly winds, from May until October, which bring the violent monsoon rains to south Asia. The Indian Ocean has been a crucial area for maritime trade, dating back to the 1st millennium BCE. The processes of cultural exchange in the region have been fundamental to the development of many communities, societies and imperial systems over time, and the peoples of south and southeast Asia have played a central role in these processes, establishing networks of interaction long before the impact of European and east Asian empires.

The northeastern part of the Indian Ocean, the Bay of Bengal, bounded today to the west and northwest by India, to the north by Bangladesh, and to the east by Myanmar and the Malay peninsula, was a concentrated zone of trade and cultural interaction. Covering over 2 million sq. km (770,000 sq. miles), it connects with numerous important river systems, such as the Ganges-Hooghly, the Padma and the Irrawaddy, and many important ports developed around its shores. From January to October, the East Indian Current flows with a clockwise circulation, while for the remainder of the year, the region experiences the counterclockwise East Indian Winter Jet. The Bay of Bengal monsoon moves in a northwest direction, striking the Andaman and Nicobar Islands first around the end of May, and then the northeastern coast of India by the end of June.

To the east, the Strait of Malacca, a relatively narrow channel, some 890 km (550 miles) long, between the Malay

peninsula and Sumatra, forms the main shipping route between the Indian and Pacific oceans. It was a vital connection to southeast and east Asia for early traders from Arabia, Africa and south Asia, and vice versa. Palembang in today's Indonesia was capital of the Srivijaya kingdom, and became an important trading centre by controlling the trade through the channel from the 7th to 13th centuries. As with many ports in southeast Asia, Palembang was situated on a major river, rather than on the coast, to protect the harbours from the violent monsoon weather and tsunamis that beset the area.

Further east the waters open out into the Pacific Ocean, with the area of around 3.5 million sq. km (1.35 million sq. miles) between the Strait of Malacca and the southern shores of China often now called the South China Sea. It is of huge strategic importance: today, one-third of the world's shipping passes through it, and it was no less significant in antiquity. Numerous major river systems flow into the sea and again many of the major ports of the region, such as Guangzhou, were situated on these river systems. Smaller ports developed in a complex network of interactions. Óc Eo in Vietnam, for example, became an important trading settlement and recent excavations have produced Roman, Persian, Indian, Greek and Chinese material.

The waters between China, the Korean peninsula and Japan were an integral part of the development of the maritime Silk Roads. All were vital spaces that shaped communication in the region, initially enabling coastal trading, and then developing longer-distance contacts that spread beliefs, ideas and technologies and led to significant political and social interactions. As elsewhere, major port-cities developed to harness the potential of maritime trade.

A number of inland seas were also significant: principally the Caspian, Black and Baltic seas. The Caspian Sea is the largest inland body of water on Earth, covering some 371,000 sq. km (143,000 sq. miles), with a maximum depth of around 1,000 m (3,300 ft). Merchants and travellers connected the Caspian via overland portages to the Volga, the Don and various rivers that flow into the Baltic Sea, providing an important link between central Asia and the Baltic region. However, the Caspian's

Siraf: a Sasanian port

Siraf, located on a natural harbour in the Gulf, was excavated extensively in the 1960s and 1970s. The site revealed a substantial Sasanian period (224–651 CE) fort and associated buildings. Ceramic evidence suggests that Sasanian Siraf served mainly local maritime commerce, with some long-distance connections. Its primary value likely lay in defence of the Gulf coast.

In the 7th to 8th centuries the fort fell into disrepair, but Siraf revived and expanded from around 800 onwards. A large congregational mosque, extensive rock-cut cemeteries (shown here), smaller mosques, a bazaar and domestic and industrial quarters indicate a bustling coastal city. Islamic Siraf also became deeply involved in Indian Ocean trade. Numerous Chinese ceramics have been found [see box on p. 344], while gold and timber were probably imported from east Africa and spices and textiles from western India.

Siraf declined from the late 10th century, due to reduced Gulf trade, the rise of the nearby port of Kish and, perhaps, damage from an earthquake in 977. Nevertheless, from the 11th to 15th centuries Siraf remained an important local Gulf port. From the 16th century it shrank to become a small coastal village known as Taheri. RD

Further reading: Whitehouse et al. 2009.

landlocked nature meant that few of its major cities, such as Baku, relied on the development of port facilities. The Black Sea, in contrast, is connected both to major river systems – the Danube, Dnieper, Southern Bug, Dniester, Don and the Rioni – and to the Mediterranean, via the Dardanelles and the Bosporus. Covering an area of around 435,000 sq. km (168,000 sq. miles), with a maximum depth of over 2,000 m (6,550 ft), it linked the steppes to the north, the Caucasus and central Asia to the east, as well as west Asia and eastern Europe, making it a nexus of the Silk Roads.

The impact of mastering the seas for transportation is obvious because of the relative efficacy of moving goods by ship rather than by land: it has been estimated, for example, that a dhow, a type of sailing ship, could carry the equivalent of 1,000 camel loads. As shipbuilding technologies developed, mariners began to master open seas and more difficult conditions, and carry greater loads. Moving from flat-bottomed boats to ones with keels provided deep-water stability; the development of approaches to rigging, sails and masts changed the mariners' abilities to adapt to weather conditions, and work with different scales of crew [*see* pp. 394–401]. But the waters of the Silk Roads held many dangers, and the numerous wrecks now being uncovered on the seabed provide crucial information on the development of ships and the nature and organization of their cargoes [*see* pp. 382–85 and boxes on pp. 397 and 400].

However, without the ability to navigate, improvements in ship technology were insufficient to allow long-distance voyages on the open sea. So, while archaeological evidence suggests that sailors developed a sophisticated knowledge of the South China Sea and neighbouring areas as early as 2,500 years ago, and that by 250 BCE southeast Asian mariners were crossing the Bay of Bengal to south Asia, it is likely that ships' captains rarely lost sight of land. Indeed, Islamic merchants in the medieval era preferred to sail from harbour to harbour along the coast of north Africa, around the eastern Mediterranean coast, and along the Byzantine coast of Anatolia, to reach the Aegean and Ionian seas, rather than cross the Mediterranean.

Understanding winds, the observation of birds and using landmarks were soon supplemented by celestial navigation: the beauty and practicality of traveling by night across open water became possible [*see* pp. 402–7]. Perhaps the earliest account of navigating by the stars is in Homer's *Odyssey*, when Calypso

Quanzhou: a Chinese international port

During the 10th century, when Quanzhou, a port on the southeast coast of China, was first an independent city and then part of the local Min kingdom (909–945), it experienced a steep commercial uprise. In 1087, a Maritime Trade Office was established in order to manage overseas trade and around the same time Quanzhou overtook Guangzhou's traditional role as the major destination for foreign merchants from the Indian Ocean. The mosque shown above dates from this period. The local ceramics industry flourished, and the city was linked with its hinterlands through a network of rivers and roads. During the Song (960–1279) and Yuan (1271–1368) periods, commodities from all over the country were exported through the port.

A report on foreign countries whose ships frequently called at Quanzhou, or Zayton as it was known in Arabic, lists more than thirty locations overseas, among them places in the Arab world, the Srivijayan archipelago and both peninsular and insular southeast Asia. During Marco Polo's (1254–1324) time, Quanzhou had developed as one of the most cosmopolitan cities of the world, with Islamic tombstones, such as the one above, revealing the merchants who both lived and died here [*see also* box on p. 392]. The city's commercial importance declined after the 14th century not only because of Ming China's (1368–1644) private maritime trade proscription but also due to the silting of the river.
ASc

Further reading: Clark 1991; Schottenhammer 1999, 2000; So 2000.

Kilwa: an African trading port

Kilwa emerged in the 13th century as the largest and most important of the east African trading ports, feeding natural materials (ivory, skins and ambergris), minerals (gold, copper and iron) and luxury items (precious stones, rock crystal) into the Indian Ocean trading networks. The port, on a small island of the same name, which forms part of the Kilwa archipelago off the coast of southeastern Tanzania, was extensively excavated between 1958 and 1967 and is now a World Heritage Site. Remains of a monumental mosque

(12th century with a vaulted extension of around 1300, shown here) as well as an unfinished royal palace (Husuni Kubwa, *c.* 1300) are indicative of the scale of Kilwa at its apogee. Stone houses from the 15th century are also found. Kilwa's history was recorded in two versions of a chronicle compiled in the 16th century. But after occupation by the Portuguese in 1502, Kilwa itself declined to little more than a village.

Kilwa prospered at the interface of two trading networks: it was at the southern limit of reliable monsoon winds

from the northern hemisphere, while accessible to the Sufala coast (now Mozambique) where routes led into the African interior to supply ivory, gold and copper. Kilwa merchants may have connected both to Mapungubwe (on the Limpopo) and Great Zimbabwe, where a copper coin of a Kilwa sultan has been found as well as sherds of Chinese ceramics. Southern African ivory may have been an important commodity and may have reached China on Arab and Indian vessels. The bulk of Chinese ceramics found at Kilwa, some shown above, date to the

13th to 15th centuries and are often of high quality, including a fine *qingbai* glazed bottle of the Yuan dynasty from Husuni Kubwa. A mosque cistern at Songo Mnara – another stone town in the archipelago – was found to contain a large Longquan bowl, an heirloom possibly brought from Kilwa. By the 15th century the quantity of Chinese pottery present exceeded that of Islamic pottery. MH

Further reading: Chittick 1972; Horton et al. 2017; Wood 2018.

tells Odysseus to keep the Bear (Ursa Major) on his left, and to observe the position of the Pleiades and Orion as he sailed eastwards from her island. Major advances came with the invention of magnetic compasses, quadrants and the astrolabe [*see* box on p. 406]. A mastery of the night sky became vital to navigation along the maritime Silk Roads.

Determining latitude was relatively easy: from the difference between the altitude of the sun at noon against the sun's declination for the day, or from the position of many stars at night. But the calculation of longitude was more problematic. Although al-Biruni (973–1050) argued that the Earth rotated on an axis, which provided the platform for our modern understanding of how time and longitude are related, it was not until the early modern era that accurate methods of

establishing longitude were achieved. Before then, the mariner had to rely on dead reckoning, which was often inaccurate out of sight of land. It was not uncommon for long ocean voyages to end in tragedy.

Further reading: Buschmann & Nolde 2018; Paine 2014.

Treasures from the deep

Jun Kimura

"I am absolutely enraptured by the atmosphere of a wreck. A dead ship is the house of a tremendous number of live fish and plants. The mixture of life and death is mysterious, even religious. There is the same sense of peace and mood that you feel on entering a cathedral."

Jacques-Yves Costeau, 'Poet of the Depths', *Time*, 28 March 1960.

The salvaging of the *Vasa* in the Bay of Stockholm on 24 April 1961.

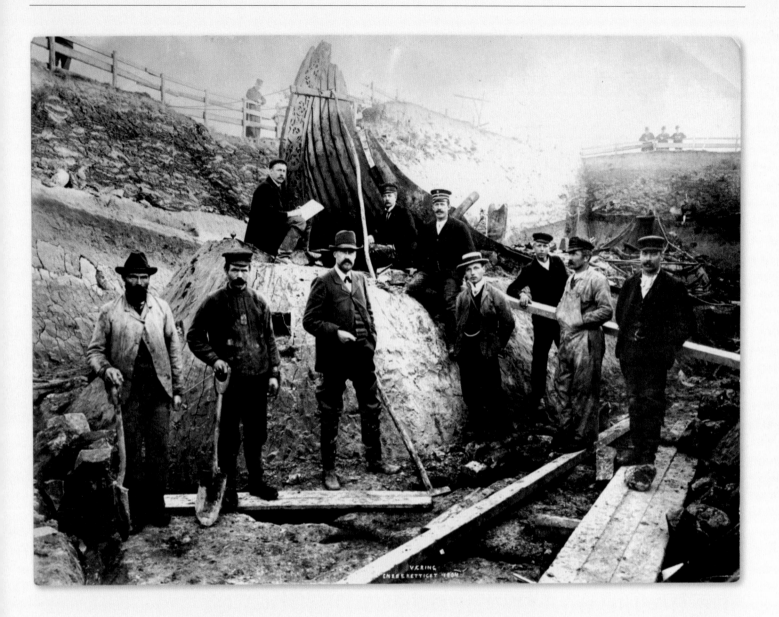

Maritime archaeology is the study of submerged landscapes and sunken watercraft with the aim of understanding past human activities on the sea, around lakes and in riverine environments. The discipline developed with the recognition of the existence of material remains underwater in the 1900s; sponge divers in the Mediterranean, for example, found artifacts from the Roman period on the seabed near the Greek island of Antikythera, including a corroded bronze object with many gears, known today as the Antikythera Mechanism. It was an ancient astronomical device from around the end of the 2nd century BCE, designed to portray and predict the

cycles of the solar system [*see* pp. 402–7]. The unique metal device would probably not have survived if the ancient Roman ship it was on had reached its destination and the instrument had been used. Today Greek underwater archaeologists are conducting continuing surveys in deeper water at the Antikythera wreck site in search of further remnants of the mechanism.

The Viking burial mound at Oseberg, dating from 834, containing an older ship and two female corpses. Excavated in 1904–5 by Häkan Shetelig and Gabriel Gustafson.

The beginning of underwater archaeological surveys came with the invention of scuba-diving. In the 1950s Jacques-Yves Cousteau (1910–1997), an innovator of the system, excavated an underwater wreck in Grande Congloué near Marseille and recovered artifacts including wine amphorae dating to about 100 BCE. Many Mediterranean divers began to raise intact terracotta amphorae from the seabed, leading George F. Bass (b. 1932) to pioneer more systematic underwater archaeological excavation. His 1960 excavation of the Cape Gelidonya wreck off the southern coast of Anatolia, dated to the Late Bronze Age (1600–1000 BCE), identified many copper ingots that were raw material for bronze production. Analysis clarified that seafarers from west Asia transported these items and confirmed their active engagement in early shipping, counter to the existing perspective that Mycenaean sailors had figured prominently in Roman maritime trade.

The hulls of two sunken early modern warships broke surface in the late 20th century, which raised public interest in well-preserved historic vessels on the seabed. The Swedish ship *Vasa* is best known for her successful archaeological salvage and exceptional state of preservation. Constructed in 1628 with the intention of making Sweden a strong nation state with naval power, *Vasa* sank immediately in the Bay of Stockholm on her maiden voyage. The royal warship was lifted in the 1960s, with more than 95 per cent of its original hull structure intact. The raising of the Tudor *Mary Rose* in 1982 was another landmark in maritime archaeology. The *Mary Rose*, the flagship of Henry VIII (r. 1509–1547), was in naval service for more than thirty years and sank in the Solent in 1545 during a war with the French. Following an acoustic sonar search, underwater archaeologists confirmed that a substantial portion of the sunken ship was preserved on the seabed. Through more than thirty years of conservation work, the two warships have been intensively examined and have provided insights into hull construction methods of the time and life aboard naval vessels. Ongoing study and conservation are crucial activities at the museums that display the large hull sections of the *Vasa* and *Mary Rose* inside specially constructed buildings.

In the case of the Dutch East India Company (VOC) shipwreck *Batavia*, excavated in western Australian waters in the 1970s to 1980s, the safeguarding of a historic shipwreck was addressed, and the first legal protection was developed against the disturbance and pillaging of wreck sites. Acting through UNESCO, in 2001 the international community adopted the Convention on the Protection of the Underwater Cultural Heritage, and submerged sites including sunken watercraft older than 100 years are legally protected as archaeological heritage.

In Asia, a sunken shipwreck found near the village of Godawaya in southern Sri Lanka is the oldest known shipwreck in the region, dating back to around the 1st century CE [see box on p. 397]. Glass ingots from the wreck are an interesting commodity, revealing the role of early water transportation for raw materials [see pp. 420–27]. Asian maritime archaeology

faced some challenges in its early phase. The salvage of the VOC ship *Geldermalsen* in Indonesia in the 1980s was an example of pursuit of the commercial value of sunken cargo, and resulted in increased auctioning of Asian ceramics from wreck sites. The salvage of the cargo from the Belitung wreck, an ancestral type of Arabian dhow, occasioned a dispute over the issue of loss of archaeological value if cargo items were sold off, considering this wreck's historical significance in illustrating 9th-century trading networks between the Indian Ocean and east Asia. By the 1980s, China had established a governmental body for underwater archaeology, and one of their greatest achievements is the nationally significant project of salvaging the Nanhai No. 1 wreck [see p. 345]. This 12th-century merchant ship with intact trading ceramics stored *in situ* in its holds has been under continuing excavation in the specially designed Maritime Silk Route Museum on the coast near Guangzhou. Shipwrecks are regarded as part of the nation's archaeological heritage, giving new insights into maritime trade, naval hegemony and seafaring.

———

Further reading: Delgado 1997; Hocker 2011; Rule 1982; Staniforth & Nash 2006.

Officials, crew and sponge divers (who originally found the ship) during the excavation of the Roman Antikythera wreck in the eastern Mediterranean between 1900 and 1901, holding remains of the Antikythera Mechanism.

Travelling the treacherous seas: pirates, storms and sirens

Eivind Heldaas Seland

"Adulis...lies at the inner end of a bay that runs in toward the south. Before the harbour lies the so-called Mountain Island, about two hundred stadia sea-ward from the very head of the bay, with the shores of the mainland close to it on both sides. Ships bound for this port now anchor here because of attacks from the land. Opposite Mountain Island, on the mainland twenty stadia from shore, lies Adulis, a fair-sized village, from which there is a three-days' journey to Coloe, an inland town and the first market for ivory."

The Periplus of the Erythraean Sea (1st century).
Translated from the Ancient Greek by Wilfred H. Schoff.

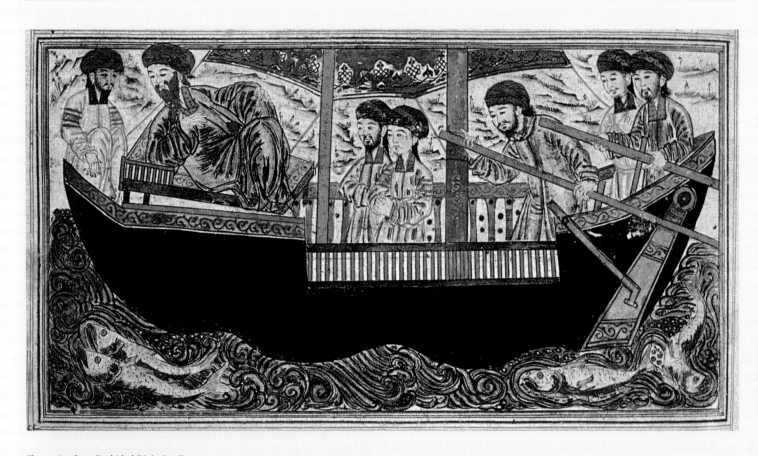

Illustration from Rashid-al-Din's *Jāmiʿ al-Tawārīkh* of 1314 depicting Noah and his sons in the Ark, represented as a dhow with a double steering oar.

Along the southern axis of the Silk Road system, from east Asia to Africa and the Mediterranean, the sea was the obvious and, in many cases, the only available option for trade and travel. Trade between Mesopotamia and the Indus valley was well established by the mid-3rd millennium BCE, and genetics bear witness to the spread of crops and domesticated animals between Africa, Arabia and south Asia from the 2nd millennium BCE onwards. Navigation across the Indian Ocean depended on the monsoon system. Strong winds provided stable sailing conditions from west to east in the northern hemisphere summer and from east to west in the winter months.

The Red Sea, Gulf, Arabian Sea, Bay of Bengal and South China Sea formed regional circuits of exchange within the larger system. Communities situated at the edges and intersections of these circuits were in a good position to develop the skills and expertise necessary to handle both the commercial, navigational and cross-cultural aspects of long-distance connectivity.

By the late 1st millennium BCE, Greek-Egyptian, Arabian, Persian, and south and southeast Asian mariners had all mastered the art of transoceanic crossing. East African and Chinese navigators would follow suit. Archaeological, historical and ethnographic sources reveal a range of vessels active in the trade [*see* pp. 394–401].

Ports developed at sites that could offer the combination of safe anchorage and access to hinterland networks or transit to other maritime exchange circuits. In the eastern part of the system such sites were typically on river estuaries, such as at Barbarikon on the Indus delta [*see* box on p. 378]. In the arid regions of Arabia and the Red Sea, rulers invested in infrastructure to provide water for ports and overland communication to more densely populated areas inland.

The demand for raw materials and products from distant lands was insatiable. Imported goods were excellent status

markers for local elites. While Chinese silk and Indian cotton dyed with imported pigments provided rich Romans with a way to show off their wealth in a world clad in greyish wool and white linen, Tamil princes could demonstrate their affluence and generosity by sharing imported Mediterranean wine and paying their retainers in Roman gold. Other products were extremely expensive in bulk, but affordable to many in limited quantities. Pepper could spice up the meals of Roman soldiers at Hadrian's Wall [*see* box on p. 444], and children in the Korean peninsula wore coloured beads made in Egyptian glass kilns [*see* pp. 420–27]. A single grain of frankincense offered to the gods could provide a poor person with a direct link to the divine world, even if a camel load of the substance cost several years' average wages in the markets of west Asia. People depended on spices

and aromatics to mask smell, as ingredients in cosmetic products and for drugs [*see* pp. 440–45]. Gemstones and pearls were not only popular ornaments, but also widely believed to hold medicinal and magical powers [*see* pp. 428–33].

Chinese silk reached the Indian Ocean by way of central Asia and the great Indian rivers such as the Indus. Spices including cinnamon and nutmeg were traded from southeast Asia to India, Sri Lanka and the Gulf of Aden. Gemstones, pearls, cotton textiles and a wide range of spices and pigments were exported from south Asia [*see* pp. 440–45]. African ports offered aromatics, ivory and tortoiseshell. Frankincense and myrrh from southern Arabia were sought after for religious as well as medicinal and cosmetic uses. Ports in the Red Sea and Gulf such as Berenike [*see* box on p. 443] and Siraf [*see* box on p. 379]

A cave with sailors' graffiti

From literary sources such as the *Periplus of the Erythraean Sea* it has long been known that the island of Socotra – situated off the tip of the Horn of Africa and also close to the South Arabian coast – was frequented by Indian vessels from early times. Later texts such as Arabic histories or 19th-century Gujarati navigational maps and pilot books show that it remained an important navigation point for Indian merchants.

In 2000, Belgian cavers from the Socotra Karst Project discovered in one of the large karst underground caves on the northern shore of the island a huge number of graffiti on the walls, on the stalagmites and stalactites and on the floor of the cave. It soon became clear that they had found evidence of the activities of sailors in the Indian Ocean trade networks at the beginning of the common era.

Almost 200 of the inscriptions were in Indian scripts and languages. They contained mostly the names, titles and provenances of the cave's visitors. According to the content and the palaeographical features of the scripts, the cave

was frequented between the 1st and 5th centuries CE by sailors from western India. Places like Bharukaccha (modern Broach) and Hastakavapra (modern Hathab) are mentioned. The names of the visitors also reveal that they came from different religious backgrounds, and among them were Buddhists, Śaivas and Vaiṣṇavas.

As well as the Indian inscriptions, there are contemporary graffiti in other scripts and languages, among them Greek, Bactrian, South Arabian, Axum and Palmyrene, indicating the international character of the western Indian Ocean trade networks. IS

Further reading: Strauch 2012.

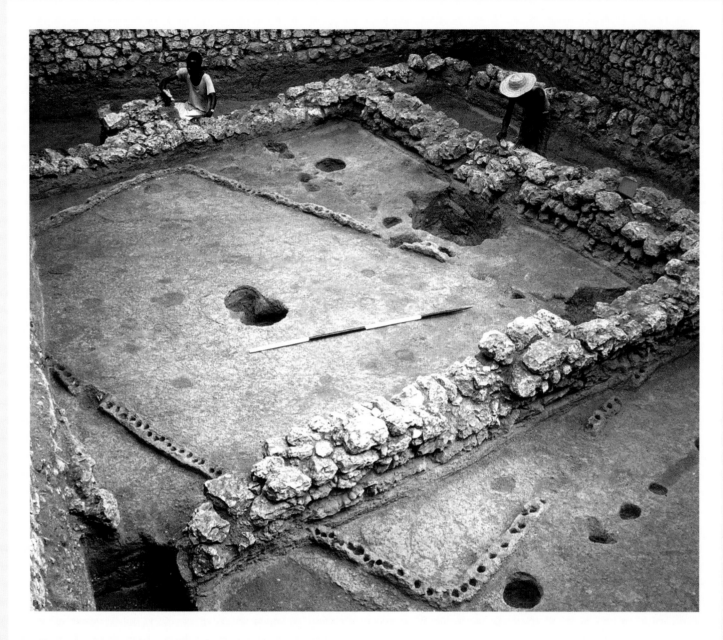

Shanga and Indian Ocean trade

Shanga was a coastal port in the Lamu archipelago (modern Kenya), extensively excavated between 1980 and 1988. It was first occupied around 750 as a small fishing community, and had expanded threefold by the time of its sudden abandonment in about 1420. The site has produced the first evidence for Islam in east Africa, with burials and timber mosque remains dating from about 780. The foundations of the 9th-century mosque are shown here. Shanga was one of several ports along the Swahili coast that supplied largely natural materials (ivory, timber, ambergris, skins, gums and tortoiseshell) into the

western Indian Ocean networks. While the majority of ceramic finds are of local manufacture, small quantities of glass as well as Islamic, Indian and Chinese pottery were found.

The Chinese ceramics occurred through the whole sequence and included Changsha wares, Yue celadons and olive-green stoneware jars from the Tang (618–907). Later pottery included Ding ware sherds, *qingbai* glazed wares, moulded whitewares, a range of Longquan greenwares and 'Martabani' jars. Three sherds of early Ming blue and white porcelain were found in the uppermost levels and helped in the estimation of the

abandonment date for the site. In earlier periods, Chinese pottery generally comprised under 5 per cent of the total imported wares, but by the 14th century, with the arrival of Longquan greenwares, this proportion increased to 27 per cent. Most of the Chinese material probably arrived via a Gulf port rather than directly across the Indian Ocean. The Swahili certainly valued Chinese ceramics, often using them to decorate their tombs.

Chinese knowledge of this part of east Africa was generally accurate. Almost certainly the fleet of Zheng He passed by Shanga during his fifth

(1417–18), sixth (1421–22) and seventh (1431–32) voyages. There are surviving descriptions of Somali and northern Swahili settlements from the sixth voyage and it is noteworthy that Shanga was abandoned at exactly this time – possibly because of the introduction of plague carried by the ships. MH

Further reading: Filesi 1972; Hirth & Rockhill 1911; Horton 1996.

The tomb of an Islamic merchant in India

Tombstones currently offer us some of the best evidence for the spread of Islam through the mercantile networks of the Indian Ocean world. Of course, not everyone wanted, or could afford, a permanent grave marker, but important examples have survived at the eastern Chinese ports [*see* box on p. 380] and throughout southeast Asia, in east Africa and in south Asia. Some of the most artistically accomplished productions originated at the port of Cambay (now Khambhat) in modern-day Gujarat, beginning with modest incised stones in the early 13th century and culminating in the 14th and 15th centuries in large, relief-carved headstones and cenotaphs. Their luxury nature is confirmed by the fact that Cambay tombstones were ordered all around the Indian Ocean rim by the Muslim elites of the period, from east Africa to Java.

This relief-carved headstone, in marble from west India, comes from the cenotaph of one of the foremost merchants of Cambay

in the 14th century, 'Umar ibn Ahmad al-Kazaruni (d. 1333 or 734 AH), and was installed in his mausoleum at the port. Originally from Iran but with homes and agents all across the Indian Ocean, even as far as China, al-Kazaruni is typical of medieval cosmopolitan merchant elites. The decoration and inscriptions of his grave merge Islamic and west Indian motifs and techniques, producing a fittingly hybrid memorial. EL

Further reading: Flood 2009; Lambourn 2004; Wink 1991–2004.

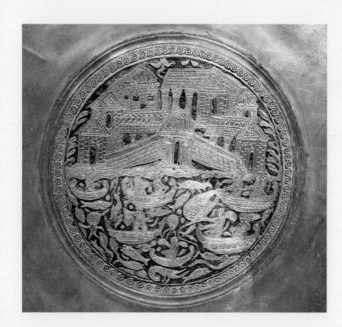

The central medallion of a 4th-century gilt silver plate showing a villa by the sea. Part of the Kaiseraugst Treasure.

channelled commodities from the Mediterranean and west Asia into the system, including glass [*see* pp. 420–27], wine, metalwork and foodstuffs such as date syrup [*see* box on p. 398]. At different times fine ceramics from the Mediterranean, south Asia, Persia and China found a wide distribution [*see* boxes on pp. 398 and 439]. Artisans, artists, sex-workers and mercenaries found work overseas or travelled as victims of the slavery that was also part of Silk Road exchange [*see* pp. 408–13].

Seafaring and long-distance trade were risky activities in the premodern world. Shipwreck and piracy were real hazards, and authorities were often unpredictable and predatory by modern standards. The seasonality of the monsoons caused traders to spend weeks and months in their ports of call before returning home. Foreign communities formed in many harbour cities, with merchants settling permanently and marrying local women, while also maintaining their sense of identity and their ties to their home community.

Religion was important for creating trust among strangers as well as cohesion within communities. Merchant ships were the only available means of sea communication for missionaries spreading their faith as well as for religious experts catering for the needs of already established communities. Buddhism spread from its Indian wellspring to Sri Lanka, southeast and east Asia [*see* pp. 152–59]; Judaism travelled to India from Mesopotamia [*see* pp. 434–39]; and Christianity reached east Africa and eastern south Asia from the Red Sea and the Gulf [*see* box on p. 392]. In a cave on the island of Socotra, off the tip

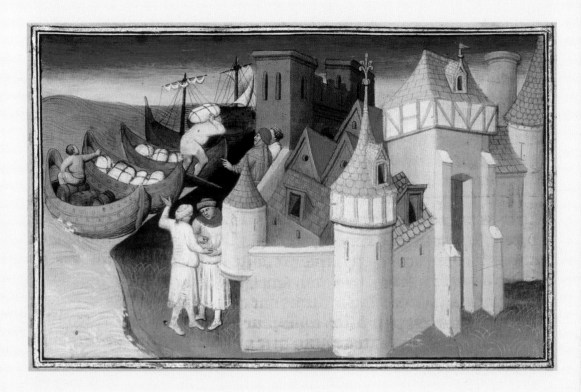

Traders at the India port of Cambay, from the *c.* 1412 edition of Marco Polo's *Livre des Merveilles du Monde*, produced in Paris by the Studio of the Boucicaut master.

The mosque at Hangzhou

Islamic communities had settled in China during the Tang dynasty (618–907) and mosques were built in major sea-ports such as Guangzhou, Quanzhou [*see* box on p. 380] and Hangzhou. That shown here, in Hangzhou, was rebuilt and expanded under the Mongol Yuan dynasty (1271–1368), when many Islamic merchants and others settled here from Iran and elsewhere, under the patronage of one of their community, Aladin. The mosque dominated the city's skyline from its position at the heart of the commercial district a few minutes' walk from the commanding Drum Tower and the gateway to the palace precinct of the former emperors. Contemporary Persian historians speak of worshippers thronging at the complex for Friday prayers and then dispersing without trace into the bustling streets. The mosque was again rebuilt in the 15th century.

The mosque's current architecture reflects both its Chinese environment and Islamic heritage, with three brick domes concealed by Chinese-style roofs. The *mihrab* is the oldest part of the building. The community's graveyard commanded the southeastern corner of Hangzhou's West Lake on land that was formerly part of the royal gardens. Unfortunately, of the 100 or so elaborately inscribed tombstones unearthed in 1920 only twenty-one have survived, and these are now on display within the mosque's complex. They record the stories of the merchants who once knelt in the prayer hall and traded in the markets outside. GL

Further reading: Gernet 1962; Lane 2018; Steinhart 2008.

Christian tombstones in Quanzhou

Over the course of the last three centuries, more than seventy Christian tombstones from the Yuan dynasty (1271–1368) have been unearthed in Quanzhou, with most now housed in the Quanzhou Maritime Museum. Many carry funeral inscriptions in various languages and scripts: Old Turkic written with the Syriac script, Chinese and 'Phags-pa. A few of them bear a Sino-Turkic bilingual epitaph. The motifs engraved on these stones – a cross standing upon a lotus and/or a cloud pattern, or accompanied by figures of angels on either side – point towards a Christian origin, whereas the Trinitarian formula in Syriac at the beginning of the epitaphs and the use of the Seleucid (312–63 BCE) calendar and the Turkic twelve-animal cycle for dating indicate an affiliation of the deceased with the Church of the East, commonly known as the 'Nestorian' Church, that was present in medieval China [see pp. 169–75].

These inscriptions not only testify to a sizeable Christian diaspora in Quanzhou during the Yuan period, but also suggest that the majority of medieval Quanzhou Christians were Turkic-speaking people originating mainly from northwest China and central Asia. LT

Further reading: Lieu et al. 2012; Niu 2008; Tang 2011; Wu & Wu 2005.

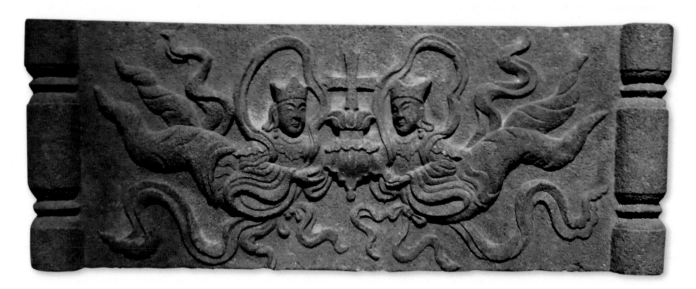

of the Horn of Africa, graffiti reveal Indian merchants of Buddhist as well as Brahminic leanings worshipping together with people from Ethiopia, Arabia, Syria and the Mediterranean [see box on p. 388]. The Christian and Jewish communities in the Indian Ocean region trace their origin back to these contacts. Later, trade brought Islam from the Arabian Peninsula to east Africa and south, southeast and east Asia [see pp. 256–67].

People and places changed over time. The Indian and Roman merchants who were very active in the early centuries CE gave way to Persian and Arabian networks in the second half of the 1st millennium. And while contacts between south and east Asia can again be traced to the early centuries CE, it was probably during the Tang dynasty (618–907) that China started engaging with maritime networks on a large scale. Roman-period ports like Egyptian Berenike [see box on p. 443] and Indian Muziris were long forgotten in the heydays of Aden and Guangzhou. The basic workings of the maritime Silk Road, however, were determined by the natural environment and remained the same until the combined weight of the circumnavigation of Africa, the introduction of steam technology and the opening of the Suez Canal changed the rules of the game.

———

Further reading: Beaujard 2012; Daryaee 2003; Margariti 2012; Power 2012; Seland 2016; Sidebotham 2011; Tomber 2008.

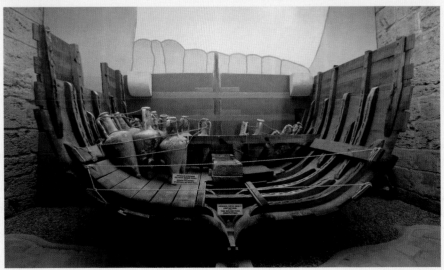

Above — Nanhai No. 1, a 12th- to 13th-century Chinese ship recovered off the southern coast of China, with some of its 160,000 items of cargo still in the holds.

Right — A reconstruction of the 4th-century BCE Greek ship, with planks fixed by mortise-and-tenon joints, discovered near Kyrenia in the Mediterranean [*see* box on p. 394].

Ships and shipbuilding

Jun Kimura

Wreckage and other nautical remains have helped us to understand ship structure and the construction methods of the past. The shipbuilding tradition of the Mediterranean world, for example, used edge-joined planks with wooden tenons inserted into mortises, as seen in Egyptian Dahshur boats, originally intended for riverine use and built from around 1850 BCE.

The Uluburun ship, with a date from the 14th century BCE making it the oldest wreck ever found in Turkish waters, illustrates the mortise-and-tenon joinery of a seagoing ship of west Asian origin. The 4th-century BCE Kyrenia ship, belonging to Greek merchants and found off the coast of northern Cyprus, has a hull shell that was built of planks, with 4,000 mortise-and-tenon joints, and frames were then fastened inside the hull with copper spikes.

Shipwrights of the Byzantine period (395–1453) made innovations in shipbuilding, moving from shell-first to frame-first construction. The 7th-century Yassiada ship was principally built with a shell of planks, but its upper planks were nailed to the erected frames. An excavation at Yenikapı, a Byzantine port, uncovered thirty-seven ships, including a 9th-century vessel demonstrating this technological transition. These early medieval cargo ships were 10 to 15 m (30 to 50 ft) long, typically with triangular lateen sails and quarter rudders. The excavated war galleys, over 25 to 30 m (80 to 100 ft) long, confirmed that ships for troops were built in a manner similar to cargo ships.

Scandinavian ships were characterized by clinker-built design, with the edges of the planks overlapping. They were seaworthy enough for Vikings to voyage to Greenland and North America. Also highly manoeuvrable, they enabled Norse

القرآن ثم قرّب عدّة أساطير بلّاها وزخارف جلّاها وقال اركبوا فيها بسم الله مجراها

ومرساها ثمّ نفّس نفس المغرمين أو عباد الله المكرمين وقال إما انّا

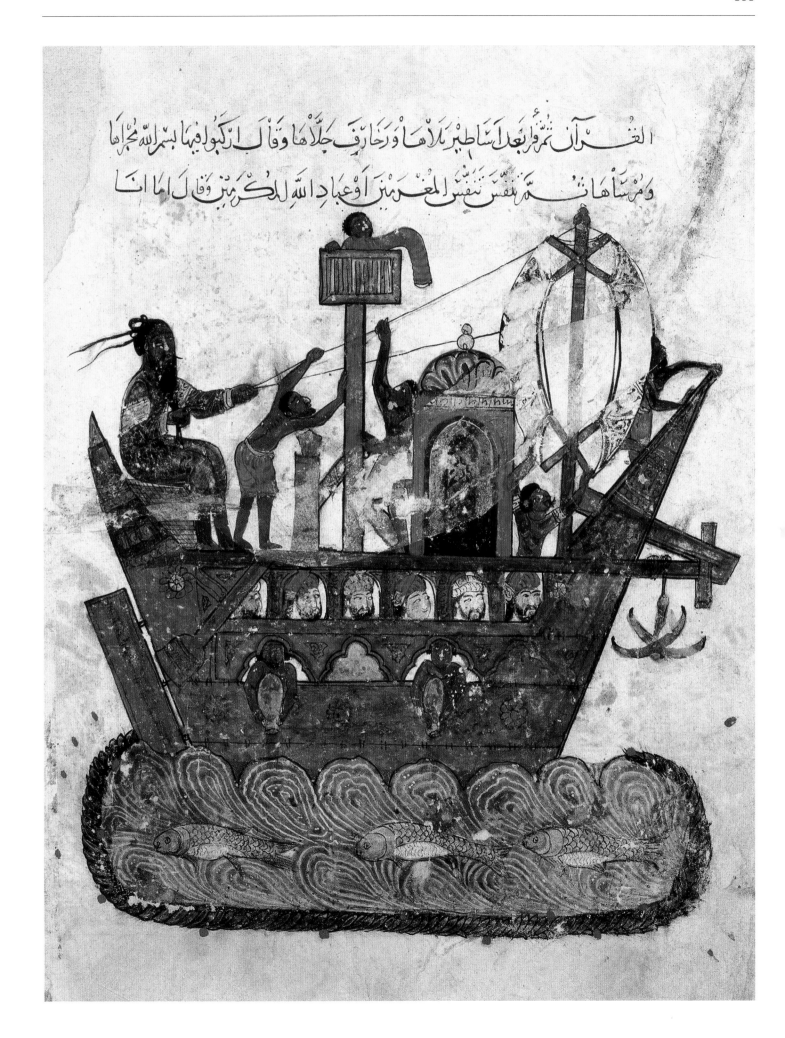

Die vorneme ſtat venedig ·

The Godawaya shipwreck

Godawaya is a coastal site in southern Sri Lanka. It is mentioned as a port in both the Sinhala 'Great Chronicle' (Mahāvaṃsa) and a local inscription of the early 2nd century CE, granting revenues from trade to a local Buddhist monastery [see pp. 152–59]. Excavation and an archaeological survey has identified a monastic complex, a large residential area and the port itself. While trenches in the first two have been dated to the 3rd century CE, coastal explorations have not uncovered demonstrably ancient material to date. However, in 2008 a shipwreck was identified nearby, as shown here, with a probable date in the 1st century CE based on radiocarbon analysis of wooden samples from the wreck. This is the oldest shipwreck known in the Indian Ocean and testifies to trade between peninsular India and Sri Lanka. Its cargo included large glass ingots, quern stones and ceramics, such as the large storage jars seen here buried on the sea floor. RD

Further reading: Kessler 1998; Muthucumarana et al. 2014.

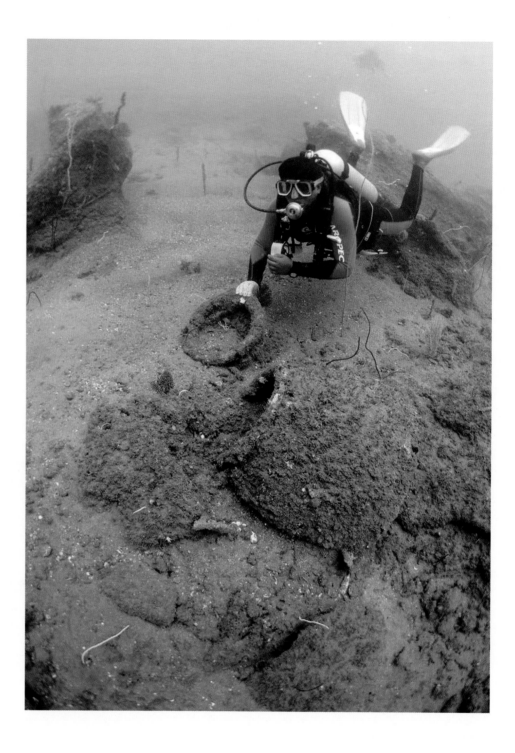

Previous spread — A depiction in the 1237 edition of al-Hariri's *Maqamat* of a two-masted double-ended ship with sewn planks, a common type in the west Indian Ocean.

Opposite — Image from a 15th-century German manuscript giving an account of a journey from Venice to the eastern Mediterranean and Egypt showing a typical Mediterranean ship, a *nau* or carrack.

penetration of estuaries and rivers during raids and settlement, as evidenced by the establishment of Viking Rus in medieval western Europe and their trading missions down the Volga and Dneiper rivers to central Asia [see box on p. 308]. The early Viking ships had greater breadth, as represented by the 9th-century Oseberg and Gokstad ships in Norway. It can be seen how the Viking ships of the 11th century varied through the ships excavated near Roskilde in Denmark: a slim longship for troop transportation and a cargo ship with wide beam. The later longship had an increased cargo-carrying capacity, which enabled expansion of trading networks across northern Europe. The longship,

however, disappeared by the 14th century, replaced by a single-mast cog with castles and still with a clinker-built hull, an example being the 14th-century Bremen cog in Germany. The introduction of bow sprits and further masts in the 14th to 15th centuries heralded the end of the cogs, and the advent of a full-rigged carrack demonstrates the carvel-built hull, with edge-to-edge planks attached to a robust frame, representing a new phase in European shipbuilding. The 16th-century *Mary Rose*, the flagship of Henry VIII (r. 1509–1547), is a purpose-built carrack designed for warfare with cannons.

The discovery of seasonal monsoon patterns on the Red Sea by 200 BCE propelled a vibrant exchange of goods between the Red Sea and Indian coasts and led to the flourishing of ports in India, such as Arikamedu [*see* box on p. 431]. A 5th-century mural painting in the Ajanta Caves in India depicts a trading vessel with three monopod masts. The construction of the sewn-plank boat, as shown in the ship illustrated on the al-Hariri manuscript [*see* p. 395], became the standard in the western Indian Ocean and presumably disseminated along the east African coasts.

The primitive watercraft inscribed on bronze artifacts from the southeast Asian region reveal the existence of ancient seafarers in the South China Sea. Networks formed between coastal ports, and

Shipping jars for date syrup

Large glazed pottery storage jars with applied decoration, such as the one shown here, 77 cm (about 30 in.) tall, from the Ashmolean Museum (EA2005.85), were used to transport date syrup in the early Islamic period (7th to 8th centuries). Fragments of these vessels have been found at most southern Iraqi sites and at many Indian Ocean ones. The jars were once thought to have been produced late in the Sasanian period (224–651 CE), but are now recognized as dating to the early Islamic period. Whole dates were exported in baskets and used for ballast; indeed, stowage space on ships was calculated using these baskets, which were produced at a standard size.

Jars such as these were made in two halves and then joined together; this was a standard practice for large closed forms, continuing through to the 14th century. Typically, both the green- and turquoise-glazed jars were crafted using southern Mesopotamian yellow clay [*see* pp. 338–45]. Three such jars, each around 75 cm (30 in.) high, were found reused in the tomb of a Southern Han (917–71) princess, Liu Hua (d. 930), in Fuzhou, China, giving valuable dating evidence. According to Jessica Hallett, 'they were filled with oil and placed on stone pedestals in front of the burial chamber to serve as Buddhist "everlasting" lamps' (2000: 297, pl. 93). RWH

Further reading: Hallett 2000.

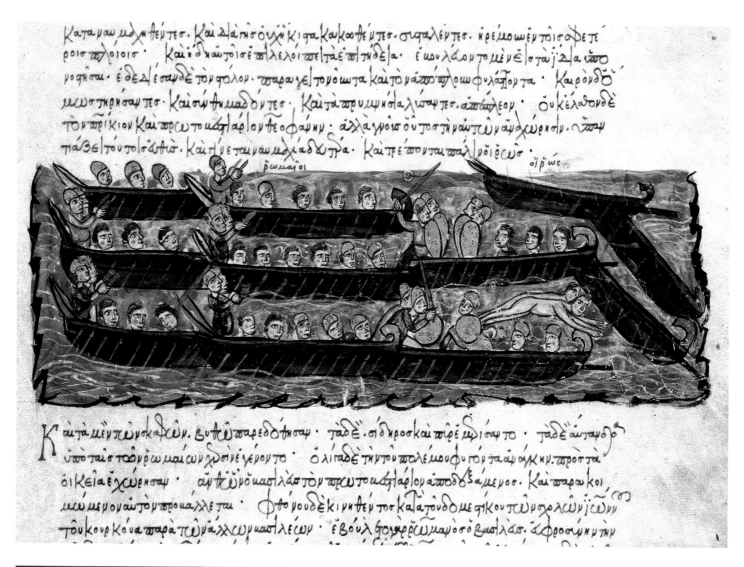

Top — A depiction from the *Madrid Skylitzes* of the Rus attack on Constantinople in 941 in their fleet of clinker-built ships.

Above — Relief from Palmyra dating to 200–300, showing a Roman *corbis*.

long-distance maritime routes stretched to southeast Asia, where port-cities such as Óc Eo in the Mekong Delta and Palembang in present-day Vietnam and Indonesia respectively became powerful. Excavation of an ancient shipyard at Zhongshansilu has revealed the growth of Guangzhou as a maritime centre dating back to the 3rd century BCE, when Qin Shi Huangdi, the first emperor, conquered part of southern China. Ships arrived here from Gulf and Indian ports. The 9th-century Belitung ship was an Indian Ocean trader and had loaded merchandise in Guangzhou from the interior of China before voyaging to Indonesia. It was a sewn ship, with fibres used to stitch planks together without other fastenings, and was built of African woods. Merchants and Buddhist pilgrims also embarked on seagoing ships built in the southeast Asian tradition. Ships of this type have been found at underwater and land sites across the region, dating from the 7th to 8th centuries. The Punjulharjo ship from Java has edge-joined planks

The Chau Tan and Phanomsurin shipwrecks

The 9th-century Belitung shipwreck is probably the best-known Silk Road wreck, but it is not the only example. The Chau Tan shipwreck was salvaged from the waters of modern Binh Son in central Vietnam, and Tang-period (618–907) Changsha ceramics from this wreck are identical to the Belitung ceramic cargo. The construction of the Chau Tan ship has been dated to the 7th to 8th centuries. It was built using southeast Asian techniques, the shell of the hull constructed first, with wooden dowels as fastenings for the edge-joined system of planks, and palm fibre cordage for reinforcement.

Finds from the Chau Tan wreck included pottery storage pots with writing on the base, such as the two shown here. The one shown above has an inscription in Arabic giving the name 'Muhammad'. The one pictured right is in Brahmi script and Early Kawi language and gives the name 'Ambārak', a place near the east coast of the Gulf.

The Belitung hull is no longer extant, but the 9th-century Phanomsurin ship found in Thailand makes up for the loss. Its hull is about 30 m (100 ft) long with edge-sewn planks, similar to the techniques used in the Belitung vessel. However, the Phanomsurin ship was built of wood from the eastern part of the Indian Ocean and southeast Asia. Its remains attest to the involvement of at least two distinct types of ships in the transportation of seaborne commodities on the maritime Silk Roads. JK

Further reading: Guy 2017; Nishino et al. 2017.

with wooden dowels used for the construction of the shell. The Chau Tan ship timbers, salvaged with Tang dynasty cargo from the waters of central Vietnam, were similar.

In the 11th to 12th centuries, Chinese traders started to be actively involved in trading within the South China Sea. The Song dynasty (960–1279) ruled in a period of socio-economic maturity with the rise of governmental and administrative elites, which led to the establishment of new commercial ports, such as Quanzhou. A medieval trader about 30 m (100 ft) long was discovered in China at the Guangzhou waterfront: the cargo capacity of its holds, divided by bulkheads, was over 150 tons.

The hull has a wide beam for stability and has a combination of clinker-built and carvel-built design for long-distance voyaging. Examining its hull in comparison to that of the Nanhai No. 1 ship provides an understanding of the evolution of medieval Chinese traders.

———

Further reading: Bass 2005; Crumlin-Pedersen 2010; Kimura 2014.

A 5th-century mural in Ajanta Cave 2 in India of a ship with three monopod masts carrying amphora.

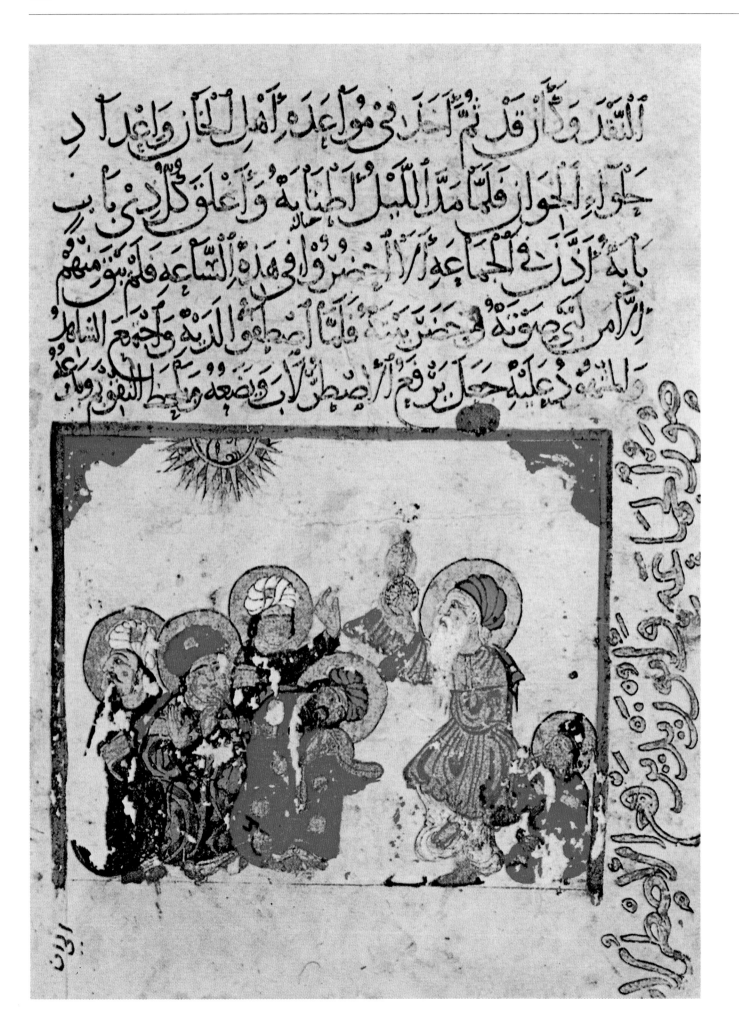

النقر وكان قد تم أخذ في مواعده أهل الكار وأعدّا

جلوا الخوان فلمّا مدّ الليل أطنابه وأعلق كلّ ذي باب

بابه وأذن للجماعة الحضور وفي هذه الساعة فلم يبقَ منهم

الّا من وصل لحضرته فلمّا اصطفوا الدية وأحجم الساهر

الساهر وعليه دخل يرفع الأصطار الأب وصفّه وسط النفور وما

Astronomy and navigation

Jean-Marc Bonnet-Bidaud

For human beings on earth, one of the best views one can have of the celestial vault with its myriad stars is from truly dark places, far from artificial lights and free from any obstacles, such as on the huge surface of the oceans or in vast deserts.

In such locations, the absence of any significant natural landmarks offers an unobstructed view but also makes it necessary to find a specific means of determining one's position and direction. Probably from the dawn of humanity, the stars have been used for this purpose. Astronomy and navigation are therefore linked together, deep in human history.

In European culture, a famous early account of navigation by the stars is provided by the *Odyssey*, the evocative 8th-century BCE poem attributed to Homer, describing the voyage of Odysseus (Ulysses), guided by the goddess Calypso: 'He [Odysseus] sat and guided his raft skilfully with the steering-oar, nor did sleep fall upon his eyelids, as he watched the

Pleiades, and late-setting Boötes, and the Bear, which men also call the Wain....For this star, Calypso, the beautiful goddess, had bidden him to keep on the left hand as he sailed over the sea.'

Relatively precise navigation is possible by the observation of the stars without the need for any instruments. Modern expeditions have completed the 4,000-km (2,500-mile) journey from Tahiti to Hawaii in about a month in this manner using a 19-m (60-ft) double-hulled Polynesian canoe equipped with sails, thus illustrating the way the different Pacific islands were colonized from about 3,000 years ago. The technique is called 'sailing down the latitude': that is, in this case, sailing approximately

The Dunhuang star chart

This manuscript is the world's oldest complete preserved star chart (British Library, Or.8210/S.3326). It was discovered in 1900 in a hidden sealed cave among the Buddhist rock-cut temples at Mogao, near the Silk Road town of Dunhuang on the northwest border of China [*see* box on p. 138], but it was almost certainly produced in the Chinese capital, Chang'an [*see* box on p. 286]. Astronomy was strictly controlled by the imperial court as the movements of the stars and planets were believed to be linked to events on earth; so, for example, an eclipse might be interpreted as a result of immoral acts of an emperor and used to justify rebellion.

The well-preserved star chart is on a scroll made of extremely thin paper, with a total length of 210 cm (83 in.) and a width of 25 cm (10 in.). It shows more than 1,300 stars grouped into 257 named Chinese constellations. It displays the full sky visible from China, rigorously organized into twelve equatorial panels, one shown here, complemented by a circular map of the North Polar region. A detailed scientific study has shown that the positions of the brightest stars are surprisingly accurate to within a few degrees, in accordance with a rigorous projection similar to modern ones, such as that of the Flemish cartographer Gerardus Mercator (1512–1594).

The chart has been dated to around 700 CE and, from a mention in the text, its most probable author was Li Chunfeng (602–670), an astronomer of the early Tang dynasty (618–907). It is unknown how it ended up on the borders of China. JMBB

Further reading: Bonnet-Bidaud et al. 2009; Whitfield 1995.

Previous spread — Illustrated edition of al-Hariri's *Maqamat* showing the teaching of the use of the astrolabe.

Right — Illustration from a 15th-century manuscript of Marco Polo's *Travels*, showing a mariner on a *nau* using a magnetic compass. The stars are also depicted.

north until a precise latitude is reached and then steering west keeping the same latitude. The latitude can be estimated quite accurately by the elevation above the horizon of a given star or constellation, such as the distinctive Southern Cross. As any given star always rises or sets on the horizon at the same fixed azimuth, the stars form a natural compass. Arab and Chinese navigators used this 'star compass' to cross the Indian Ocean. Around the equator, the star rising-setting directions only slowly change with latitude and therefore can be used for long-term navigation. This 'astronavigation' has of course to be complemented by solar observations during the day and also by the ability to keep course

with respect to waves and currents and to locate land by cloud observations and birdwatching.

As sky configuration and star identifications would otherwise have to be memorized, this probably led to the first star charts. The earliest extant manuscript star map, incorporating the traditional Chinese constellations, was found in Dunhuang [*see* box opposite]. During the Islamic expansion, Persian-Arabic astronomers such as al-Sufi (903–986 CE) designed detailed inventories of constellations such as the *Book of Fixed Stars* [*see* box below].

Navigation by eye is, however, limited in accuracy and, with increased maritime exchanges, navigational instruments were soon introduced. In any location, precise latitude can be estimated by the altitude above the horizon of the celestial North Pole, which lies close to the Polaris star. For this measure, Arab seafarers first used different types of quadrant, basically a graduated quarter-circle with a plumb line attached to the centre. With one edge aligned towards Polaris, the vertical plumb line marked the elevation angle on the graduated scale.

Contrary to what is often stated, the complex astrolabe was not directly used for navigation but was adapted into a simplified version, the sea or mariner's astrolabe. One of the most precious specimens, a finely graduated 17.5-cm (6.9-in.)

The *Book of Fixed Stars*

The *Book of Fixed Stars* (Kitāb al-Kawākib al-Thābita) is the earliest known document providing a complete description of the Arabic stellar constellations. It was composed around 964 CE by the Persian astronomer 'Abd al-Rahman al-Sufi (903–986 CE).

The Arabic text gives a deeply revised version of the star catalogue included in the *Almagest* (*Mathematika Syntaxis*), an astronomical treatise composed by the Greek-Roman Ptolemy (*c*. 100–170 CE) [*see* pp. 24–25]. It includes fifty-five astronomical tables listing the ecliptic coordinates of 1,022 stars, taking into account precession. Charts corresponding to forty-eight different constellations are also presented in two different forms, one as seen in the sky, the other as a mirror version seen from above as depicted on a celestial

globe. The figure of each constellation is drawn bearing Arabic star names.

The original copy of al-Sufi's manuscript is no longer extant. The oldest version is thought to be the manuscript MS. Marsh 144 (Bodleian Library, Oxford). It is dated 1009 CE by its colophon, which states that it was composed by al-Sufi's son, but some parts may have been added up to more than a century later. The manuscript shown here is a late 15th-century copy (Metropolitan Museum of Art, 13.160.10) showing Cepheus (right, and then below from left to right), Cassiopeia, Andromeda B, Sagittarius, Argo Navis and Draco. JMBB

Further reading: Hafez 2010; Schjellerup 1874.

Nasṭūlus astrolabe

The earliest known astrolabe is an Islamic planispheric instrument precisely dated 927/928 CE (315 AH) and preserved in the Kuwait National Museum (LNS 36 M). The 20-cm (8-in.) diameter disc is made of cast brass and the maker's name and date of manufacture are indicated below the suspension ring: 'Made by Nasṭūlus in the year 315', with the date given in the year of the Hijra. Little is known of Nasṭūlus, who can possibly be identified as the astronomer Muḥammad ibn 'Abd Allāh, working in Baghdad [see box on p. 336].

The astrolabe is a complex instrument designed primarily to compute date and time from the stars or sun altitudes and vice versa. The front face realized a stereographic projection of the celestial sphere. It is made of a background plate (the mater) graduated in altitude and azimuth on which is superposed a rotating hollowed disk (the rete) bearing pointers

representing a number of fixed stars. On the back, a rotating bar with two aligned sights (the alidade) allows star altitudes to be measured when the astrolabe is held vertically, suspended by its ring on the top (the throne).

The astrolabe was intensively used in the Islamic caliphate to schedule Muslim prayers, find the direction of Mecca and for navigation. For this last purpose, however, a simplified version was developed by the 15th century, if not before; this was the mariner's astrolabe, which had parts of the disc cut away to reduce wind resistance on ships. JMBB

Further reading: King 1987; Morrison n.d.; Stimson 1988; Whitfield 1995.

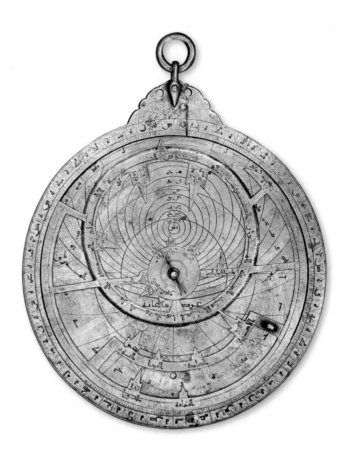

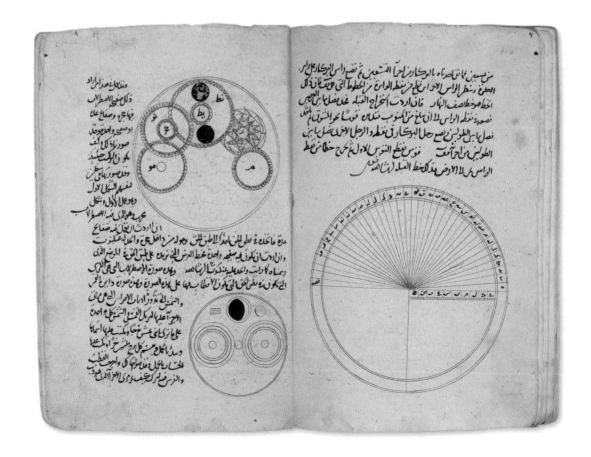

Al-Bīrūnī' (973–1050), an astronomer and mathematician working in the Ghaznavid court, wrote a treatise on the astrolabe, including descriptions of those invented by Nasṭūlus [see box above]. This is a 13th-century copy of this work, produced in Persia or Anatolia.

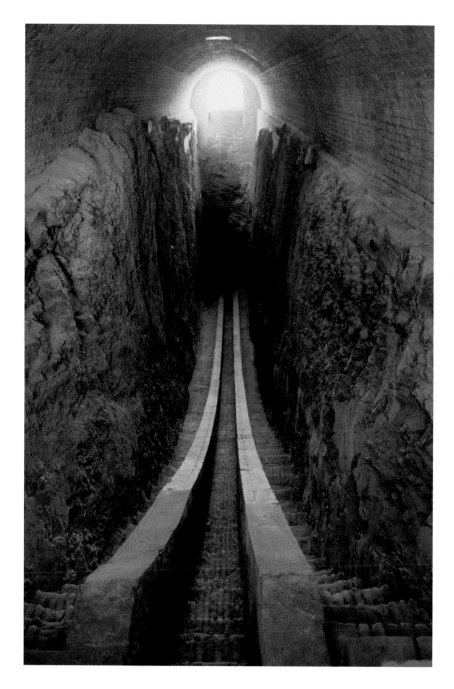

diameter bronze disc, was excavated in 2014 in the wreckage of *Esmeralda*, a Portuguese ship from Vasco da Gama's fleet, which sank in 1503 off the Oman coast. The magnetic compass invented in China was used concurrently to provide steering directions when no star was visible, as attested in China from around 1100 CE.

With a one-degree error in latitude translating into a distance of 111 km (69 miles), early astronomical instruments were of limited accuracy. The Europeans improved the technique of astronavigation with the use of the more elaborate sextants, able to measure angular distances down to one hundredth of a degree. Finally, the inception of stable marine chronometers, starting in 1773, solved the long-standing problem of the longitude measure, allowing a precise location also in the east–west direction.

———

Further reading: de Saussure 1928; Ferrand 1928; King 1987; Kyselka 1987; Mörzer Bruyns & Dunn 2009; Thompson 1980.

Above left — Part of the observatory in Samarkand built in the 1420s by the astronomer Ulugh Beg (1394–1449).

Left — A mariner's astrolabe recovered from the *Esmeralda*, part of Vasco da Gama's fleet that sunk off the coast of Oman in 1503.

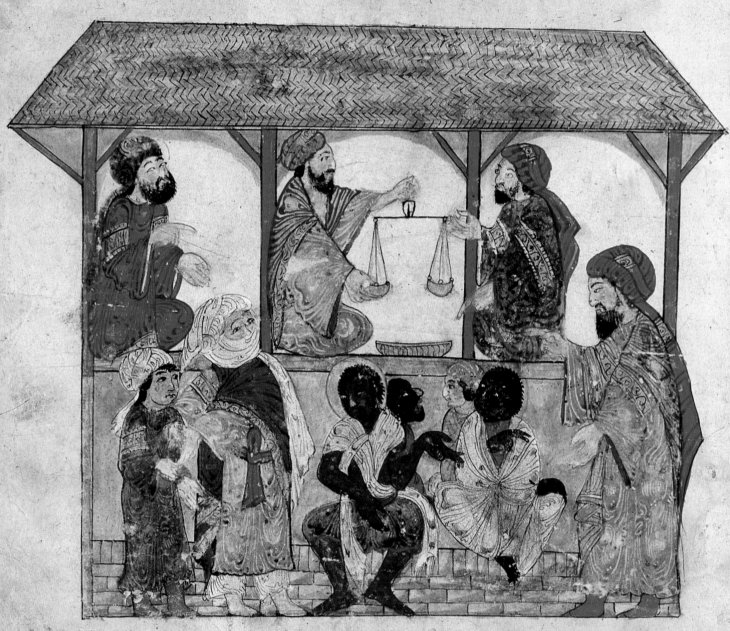

١٠٩

وكن اخسب انه سينظر شزرا ويغلى السمة على واحلق الحيت حلفت بما اغلقت بل قال ان العبد اذا نزرت ثمنه وخفت مونته ترك مولاه والتحف عليه هواه فانت

لا تزنجبنى هذا الغلام النك بان اخفت ثمنه عليك من مائى درهمان سينن

واشكرنى ما جبت فنقلته المبلغ فى الكال كما انقدنى الرخص الغال ولم

Slavery and servitude in the Indian Ocean

Elizabeth Lambourne

The much-reproduced scene of a slave market from a popular Arabic text, al-Hariri's *Maqamat*, typifies common assumptions about Indian Ocean slavery as a trade in male, black Africans controlled by Arabs. Certainly human chattel – slaves in the sense of owned and sellable property – existed, and west Asian merchants and polities were key intermediaries in this trade.

The system the *Maqamat* depicts was already well established by the time this manuscript was illustrated in early 13th-century southern Iraq, and the area had in fact been the locus of a major rebellion of agricultural slaves in the 9th century. However, this was but one of a huge variety of forms of servitude that have been identified around the Indian Ocean rim, and which in turn fed trans-oceanic circulations of servile labour.

If we take 'slavery' to designate any form of un-free, coerced labour, then it has been widespread across Afro-Eurasia since before earliest records; it is little surprise, then, that the maritime trade routes of the Indian Ocean served also in the circulation of slaves. However, Gwyn Campbell, one of the foremost scholars of Indian Ocean slavery, has helpfully cautioned about the use of this term. In the Indian Ocean world, he suggests, slavery needs to be understood within the local context, away from the 'division of society into free and slave, and [the idea of] slaves as property' that effectively underpin, and rightly so, the Atlantic trade. Campbell argues that slavery across the Indian Ocean world is more accurately understood as a form of dependency within societies that were all, at their core, 'hierarch[ies] of dependency' (Campbell, 2014: 137), and he prefers the terms 'servitude' and 'servile labour'. Ideas of personal freedom are, in effect,

highly anachronistic in the Indian Ocean arena until
the early modern period and even then coexisted
alongside region-specific systems.

Chattel slavery was itself complex and Habtamu
Tegegne's 2016 study of the Ethiopian monarch
Gälawdéwos's (r. 1540–1559) attempts to regulate
slavery in his domains gives a welcome indigenous
insight into the nuances of this system in the Horn
of Africa and on the cusp of the early modern period.
A portrait of the military commander Malik Ambar
(1548–1626) is also a reminder of the high status
male African slaves might achieve in their adopted
homes. Born in Ethiopia in the year of Gälawdéwos's
edict, and sold as a child by his parents, he was

Previous spread — Slave market
in Zabid in southern Arabia, from
al-Hariri's *Maqamat*, illustrated
by al-Wasiti, 1237.

Below — Illustration in a Spanish
manuscript from around 1284 of the
'Hermit captured by the Moors',
showing an Islamic ship with galley
slaves.

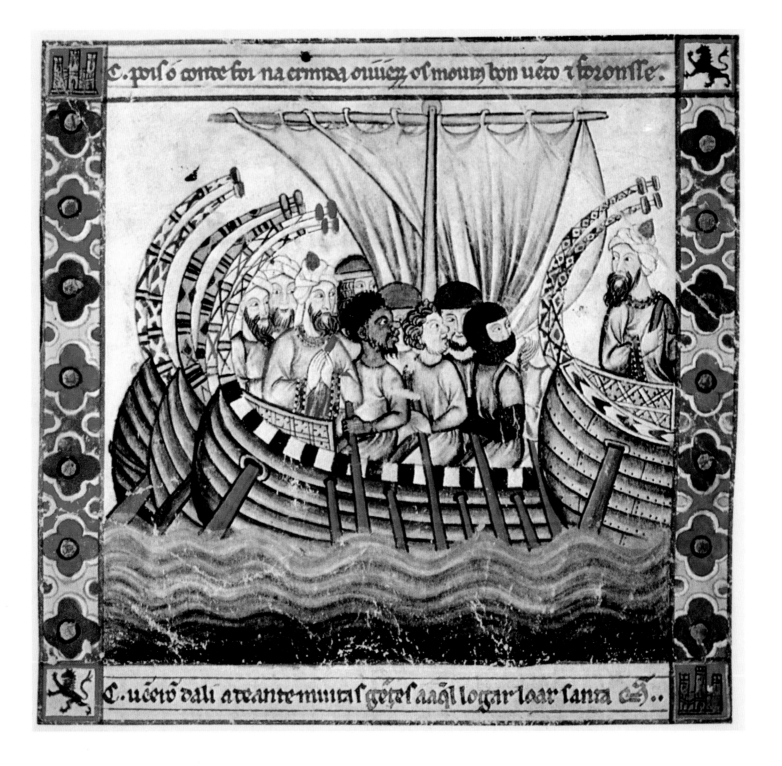

The capture of Tripoli from the Crusaders by the Mamluks in 1289, shown in a Latin treatise on the Seven Vices commissioned by the Cocharelli family of Genoa around 1330–40.

traded to India where – newly converted to Islam and renamed Ambar – he eventually rose to command the army of the Nizam Shahi dynasty (1490–1636).

The scholarly consensus is that this form of slavery was far from being the prevalent form of servile labour. More widely practised across this area were forms of servitude that can be broadly described under categories such as debt-bondage or pawnship, client slavery and agrestic servitude (systems of hereditary servitude attached to land, seen particularly in India). And unlike the Atlantic focus on male slaves destined for agricultural (plantation) labour, in the Indian Ocean world female servile labour was an equally important element.

In the chattel system in particular, it was young female slaves who, along with eunuchs, were seemingly the most widely sought out, for their domestic labour certainly but also for sexual services and entertainment.

The study of slavery in the Indian Ocean area faces particular challenges in terms of the sources available. Servile labour generally left few material traces, and certainly the physical infrastructure characteristic of the Atlantic – its forts, shackles and dedicated slaving ships – is largely absent. Textual records therefore play a particularly important role, although they span a huge variety of languages and time frames. Some of the most groundbreaking work

on medieval Indian Ocean servitude thus comes from scholars exploiting new or overlooked documents or corpora. Craig Perry's patient trawling of the Cairo *geniza* [*see* box on p. 285], documentary materials belonging to a repository of medieval Jewish texts and documents, has brought new insights into the wide geographical origins of female slaves in Egypt during the 10th to 13th centuries CE, and their complex interactions with the households in which they lived. However, the convergences of sources required to write biographies such as Ambar's, let alone more connected histories of premodern Indian Ocean slavery, are still all too rare.

Only towards the end of its history, in the late 18th and 19th centuries, does Indian Ocean slavery begin to offer the same hard quantitative data – on numbers of slaves transported, mortality rates, and so on – that makes histories of Atlantic slavery so powerful and shocking. Yet, in their very difference from the Atlantic, Indian Ocean practices and institutions of servitude offer a challenging place to develop new questions and new approaches to this subject.

——

Further reading: Campbell 2014; Eaton 2005; Perry 2014; Sheriff and Teelock 2010; Tegegne 2016.

Below left — Al-Harith buying a slave, from al-Hariri's *Maqamat*, illustrated by al-Wasiti, 1237.

Below right — Malik Ambar, depicted here, was born in Ethiopia in 1548 and sold as a slave. Bought by the Nizam Shahi court in India, he became a soldier, then a commander of the army and, eventually, regent, effectively ruling between 1600 and 1626. Painted by Hashim in around 1620.

The founder of the Sasanian empire,
Ardashir (r. 224–242 CE), in bed with
the slave, Gulnar, of the last Parthian
king, Ardavan. Gulnar was entrusted
with the treasury of the king and the
couple take money and flee the court,
later defeating Ardavan in battle. From
the *Shanamah*, 1335–40.

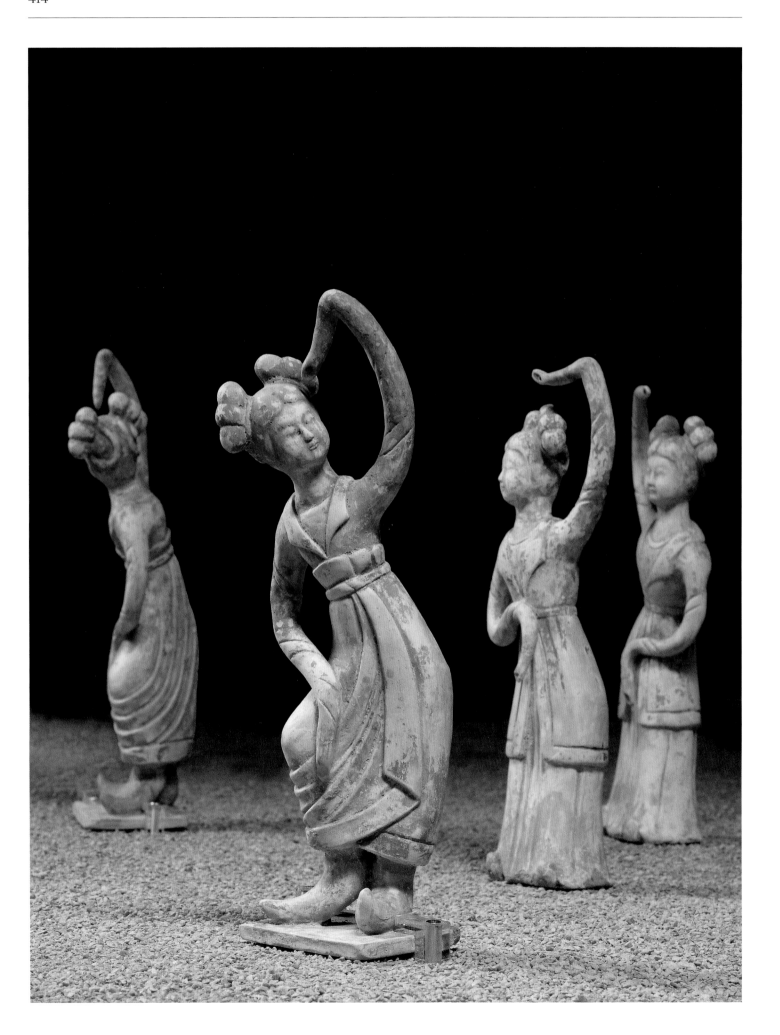

Pirates and slaves on the South China Sea

Angela Schottenhammer

Slaves were among the major trade commodities in the ancient and medieval maritime world. Because slavery never played a major role in China's historical economy and production, it is, however, rarely mentioned in relation with the China trade, but it is undisputed that slaves, both male and female, were a frequent and profitable human cargo by both land and sea. Merchants from various countries of origin, including China, engaged in the trading of slaves.

While we still know little about the shipment of slaves during the first centuries CE, there is more information from Tang times (618–907). The typical Tang slave was 'a foreigner whose sale put money in the pocket of a dealer', wrote Edward Schafer (1966: 45). The greatest sources of non-Chinese slaves were peoples from neighbouring kingdoms in southern China and southeast Asia. But slaves also came from the north. Young women from the kingdoms of the Korean peninsula, for example, were in great demand as personal maids, concubines or entertainers in wealthy Chinese households. Traded in Shandong, they were a 'luxury commerce [that] supported a horde of pirates...and occasioned

the protests of the governments of the Korean peninsula' (Schafer 1966: 45). Foreign slaves were also imported from the Malay archipelago, India and even from east Africa and the west Asian world. The Tang histories (*Tangshu*) both refer to deliveries of slaves – collectively called Zāngī – as tribute to the imperial court. We also learn about what are called Persian (Bosi) slaves. In the 8th century on Hainan Island off the coast of southern China, a local warlord named Feng Ruofang engaged in piracy and is said to have captured two or three Persian merchant ships every year, taking the goods for himself and the crew as his slaves. They subsequently settled in the villages on the island.

Until later in the 8th century, young slaves were also sent to the Tang court as annual tribute from the Annamese border. Zhao Rugua (1170–1231) notes that in Annam (Zhancheng) a boy slave was priced at three *liang* of gold or its equivalent in scented wood. According to *Lingwai daida* ('Answers from Beyond the Mountain Passes') by Zhou Qufei (d. after 1178), in the country of Champa, which had a large territory but only a small population, people frequently purchased male and female slaves and overseas vessels were full of human cargo. Zhou Qufei also speaks of a place in the South Seas (Nanhai) called Shahuagong (possibly Sulawesi), where people were addicted to piracy and sold their captives in Java.

The official history of the Song dynasty (960–1279) mentions *kunlun* slaves as servants with deep-set eyes and black bodies in an embassy from Persia that reached the Jin court in 977. Perhaps the most vivid contemporary description of trade in foreign slaves stems from Zhu Yu (b. *c.* 1075). In the port-city of Guangzhou he noted individuals of great strength, whom he calls 'devil slaves' (*guinu*), who were commonly owned by resident foreign merchants: 'The wealthy in Guang[zhou] maintain numerous foreign slaves. These slaves are unequalled in strength and are capable of carrying – on their backs – several hundred *catties* [pounds]. Neither their language nor their passions bear any connection

A Sogdian slave contract

Slaves were found throughout the Silk Road, traded by land and sea. This perfectly preserved paper document, measuring 46.5 by 28.5 cm (18.3 by 11.2 in.), is a bill of sale for a slave girl, neatly written by a professional scribe at Kocho in the Turfan oasis in 639 CE. While the seller and the witnesses all bear Sogdian names, the purchaser is a Chinese Buddhist monk,

Yansyan of the Chan family, very possibly the same person who is named as Zhang Yanxiang in two contemporary Chinese documents from Turfan. The ethnicity of the slave girl herself, Upach of the Chuyakk family, who is described as 'born in Turkestan', is unclear.

The opening lines of the contract record the date, the place, the persons involved and

the price (120 Persian drachms), while the final paragraphs name the witnesses and the scribe. Most interesting are the intervening clauses, which define in detail the rights of Yansyan and his family and heirs over their new slave, as well as the fact that the seller no longer has any rights over her. The formulation of these clauses has much in common both with the few

surviving legal contracts from Sogdiana and with the more numerous Bactrian contracts, which include a deed of sale of a slave. NSW

Further reading: Hansen & Yoshida 2003.

Previous spread — Painted earthenware figures of dancers, 7th–8th century, from China. There was a slave market at a port in Shandong for girls from the Korean peninsula.

Below — Young girls, such as this one shown resting on a camel, were traded as slaves. China, 8th–9th century.

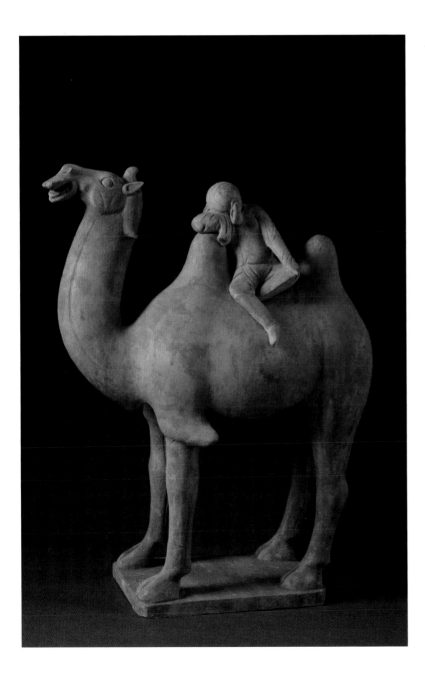

to ours. Their natures are simple; they do not attempt to flee. For their part, the people of Guangzhou call them "wildmen". As for the colour of these slaves, it is as black as ink. Their lips are red and their teeth are white. Their hair is curly as well as ochre-coloured. They are both male and female, and they inhabit the various mountains across the sea.... These slaves are able to immerse themselves in water without batting or blinking their eyes. They are called *kunlun* slaves' (Zhu 1921: 2.4). Although these were not necessarily black Africans, and could have been Malay or other southeast Asian peoples, we know that thousands of black people were traded as slaves by Arab merchants on Arab ships, and that they realized high prices.

The prosperity of Chinese coastal cities and the rich cargoes of seaborne commerce led to the increase of piracy. An early example of a pirate is Sun En (d. 402), who was active in south China and Vietnam and finally established a base in northern Zhejiang, gathering an army of followers and justifying his activities with religious Daoist arguments. His raids covered the entire length of the coast, disrupting commerce and terrorizing the people, and carrying away as many as 200,000 people to his stronghold, before he was defeated by a government fleet. Piracy was omnipresent along the Chinese coast during the middle and early modern period, and it strongly influenced international relations and trade policies.

Natural disasters in the 1230s prompted many Japanese to raid the coasts of the Korean peninsula and China. These *wakō* were not only interested in trade goods but also engaged in slavery. One story reports, for example, that 200 to 300 Chinese slaves were being kept by Japanese families on Satsuma. To enslave prisoners of war was also a common phenomenon throughout Eurasia, China being no exception. In the early modern period European merchants, such as the Portuguese and the Dutch, became involved in the slave trade in the South China Sea.

Further reading: Antony 2010; Eichforn 1954; Jákl 2017; Schafer 1966; Wilensky 2000; Zhu 1921.

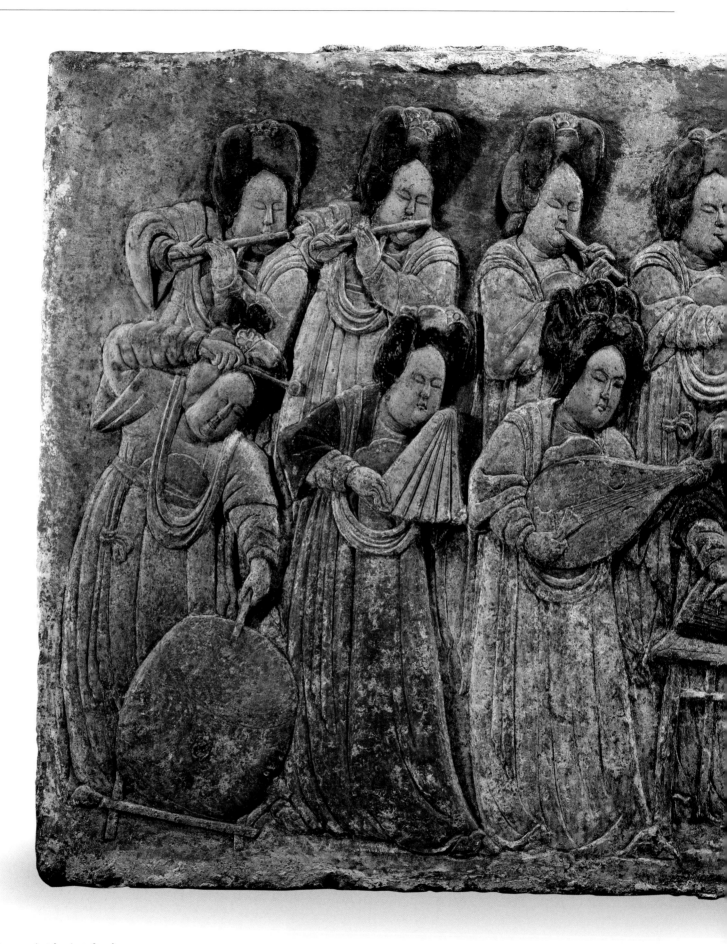

Painted stone carving showing a female
orchestra, from the 10th-century tomb
of Wang Zhizhi in central China. Many
slave women were trained as musicians
and dancers.

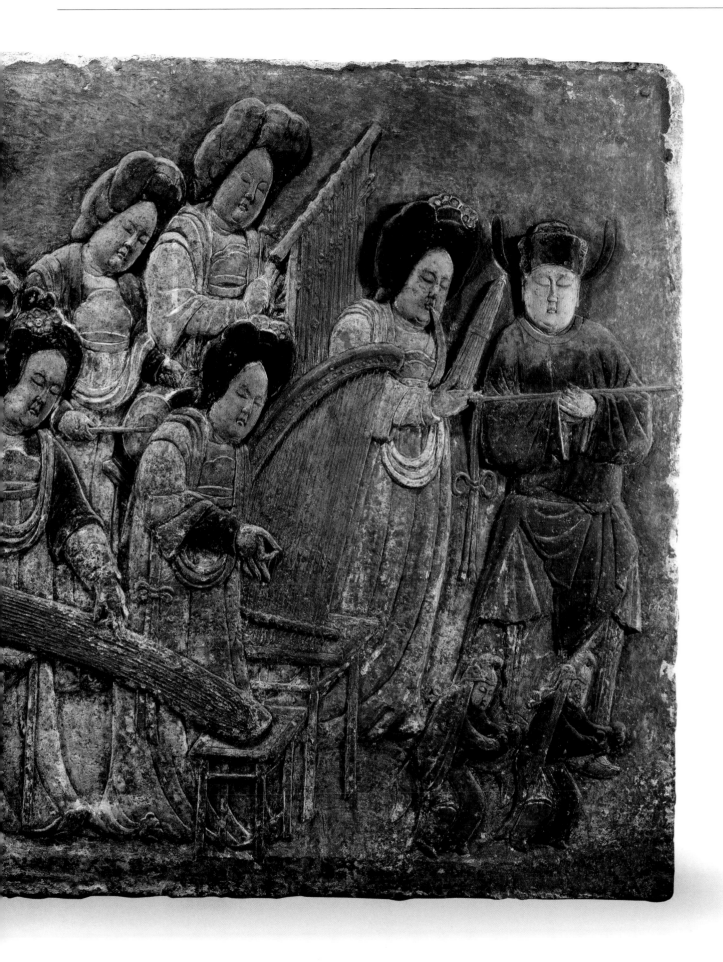

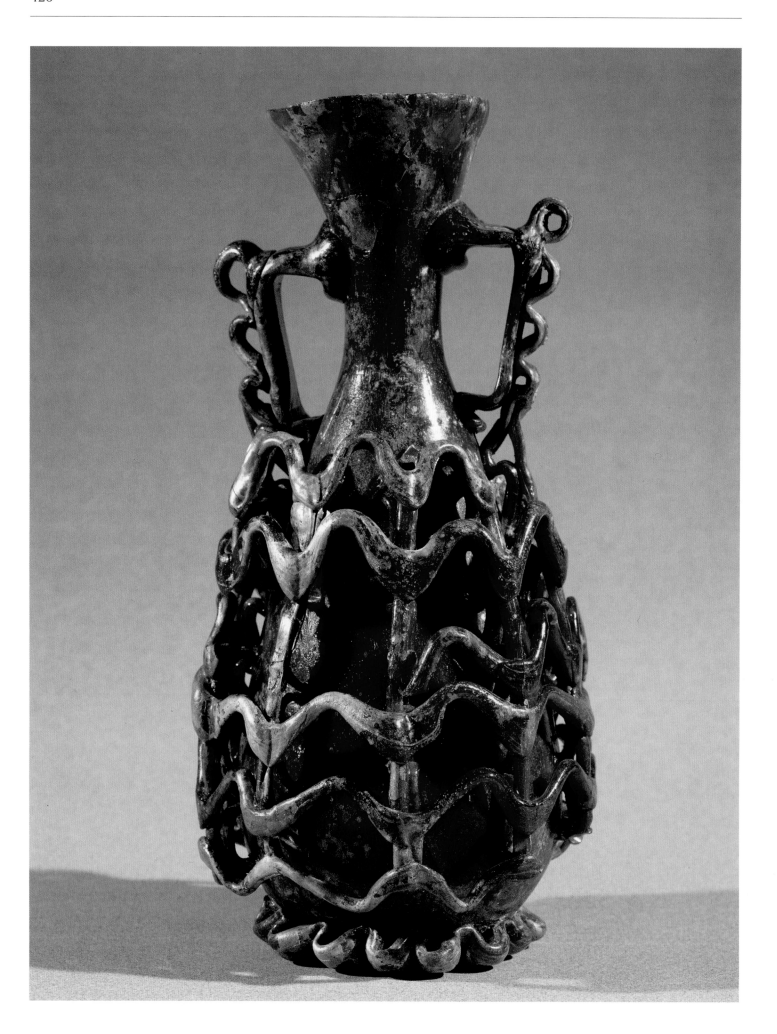

From beads to bowls: glass production and trade

Julian Henderson

The earliest glass was made in west Asia using silica and a plant ash flux in around 2500 BCE. Glass later appeared in south Asia, but probably did not reach the central China plains until the Spring and Autumn period (770–476 BCE).

One reason for this might have been the availability of another translucent material, jade, used in this region since the Neolithic period and which continued in use, especially in ritual contexts, after glass first appeared.

Although archaeological evidence for the manufacture of glass, such as furnaces and crucibles, is sparse across Asia and north Africa, by using scientific analysis it becomes possible to identify the raw materials used and, in some cases, their provenance. Evidence is found for primary glassmaking in west Asia in later periods, especially during the second half of the 1st millennium BCE and through the 1st millennium CE. Plant-ash glass is

seen in the late Bronze Age, Sasanian (224–651) and Islamic periods (661 onwards), while glass in the Hellenistic (323–31 BCE) and Roman periods (27 BCE onwards) was made using a mineral flux, natron, sourced mainly in Egypt.

Central Asian glasses were also made using plant-ash glass technology from as early as the 1st millennium BCE, but in China glassmakers innovated with new recipes. The first lead-barium glass appeared from around the 4th century BCE and was manufactured on quite a large scale, including for the production of chimes, such as the large examples, weighing up to 131 kg (189 lb), found in the mausoleum of Liu Fei, king of Jiangdu

(r. 153–128 BCE) in Jiangsu. Clearly, furnaces for their manufacture must have existed but they have not yet been found. Lead-silica glass appears from the 1st century CE. From the Han dynasty (206 BCE–220 CE), saltpetre was used as a flux instead of plant ash to make glass in south China and Vietnam. Other areas on the Silk Road (such as south and southeast Asia) probably also manufactured high-potassium and high-alumina glass, judging from the distribution of such glasses, especially in countries with access to sea ports: it was considerably safer and cheaper to transport large numbers of glass vessels and beads by ship than by land, although raw glass was also transported [*see* box on p. 397].

Chemical analyses of high-potassium and high-alumina glasses with associated impurities show that there were several different production centres but again there is very limited archaeological evidence for the primary production from raw materials of the glass itself, so we are unclear precisely where the various glass types were made.

In central Asia glass has been found in Kizil in the northern Taklamakan dating to the start of the 1st millennium BCE. Its chemical characteristics suggest that it derived from west Asia. Some pieces are undecorated globular and annular types; one is a simple blue eye bead, a type found in central and southern Europe. Stratified eye beads of a type used

Previous spread — Greco-Roman glass bottle with decoration of glass rolls, from the 1st- century CE central Asian site of Begram.

Opposite — A Roman blown-glass bottle found in a 1st- to 2nd-century CE tomb in Luoyang, China. Similar bottles have been found in Tillya Tepe in central Asia, suggesting some were transported by land.

Necklaces of Indo-Pacific beads

Small Indo-Pacific glass beads such as these, highly coloured and strung on necklaces, were easy to transport across land and sea and were manufactured in their hundreds of thousands. They have been found in large numbers in India and southeast Asia but also, in smaller quantities, in China, Turkey and east Africa, suggesting that they were transported along both the maritime and land Silk Roads.

The wide range of colours would have involved the use of a range of colourants. One basic chemical characteristic of Indo-Pacific beads is high levels of alumina; this sets them apart from, for example, glass made in western Asia. When other compositional characteristics are taken into account, such as elevated levels of uranium and thorium, the most likely interpretation is that granitic sands were used to make these particular examples.

Scientific studies strongly suggest that the beads were made in south Asia and also possibly in southeast Asia. Interesting compositional variations seem to reflect a variety of origins but no direct evidence of primary production has been found. Although such beads are quite rare in China, the discovery of this necklace of 150,000 beads at the early 6th-century Yongning Buddhist Temple in Luoyang, once the capital of China, is an interesting exception. Glass is commonly found in Buddhist contexts, being substituted for crystal, one of the Seven Treasures of Buddhism [*see* pp. 176–81 and box on p. 425]. JH

Further reading: Francis 2002; Wood et al. 2012.

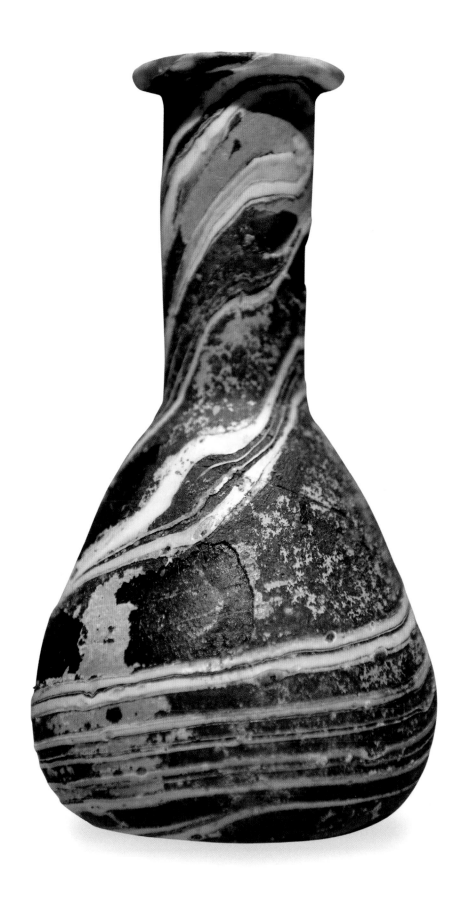

by the Phoenicians are also found in high-status Chinese burials dating to as early as 600 BCE. These would have been made in the eastern Mediterranean. Two typical late Hellenistic glass bowls found in an elite tomb in southern China suggest that glass was being transported across the Indian Ocean and into the South China Sea at that time. Roman glass vessels have also been found in Chinese burials, but Sasanian glass is more common, probably transported by both land and sea. Fine pieces are found also in elite tombs on the Korean peninsula and in the Shōsōin, the Japanese imperial repository. The Sasanian examples are somewhat thicker than the Roman vessels but both were facet

cut with a rotary wheel. Plant ash was used in place of the natron flux that was used for the Hellenistic and Roman glass vessels. This same recipe was used by Islamic glassmakers after the Islamic expansion from the late 8th century, with a peak in production reached from the early 9th century.

Islamic glassmakers experimented with various glassworking techniques, such as lustre painting and scratch decoration. Vessels with scratched decoration were probably made in several centres in western Asia using both a natron and plant ash flux. The best collection of complete scratch-decorated vessels has been found in a Buddhist reliquary in the Famen temple stupa near Chang'an. The scratch

Mediterranean glass in China

In the last Hellenistic period (323–31 BCE) west Asia experienced an increase both in terms of general population and the proportion that were middle class, accompanied by the rise of important urban centres. The dining rituals of the middle classes created a high demand for fine bowls as food containers. Although it is often claimed that the introduction of glass-blowing led to the first phase of mass

production of glass vessels, in fact the occurrence of hundreds of late Hellenistic bowls still extant today suggests that mass production began in the 2nd century BCE, before glass-blowing was invented. The bowls were shaped – slumped – over moulds and often had linear decoration on the outside just below the rim.

These translucent glass bowls were made in a variety of bright

colours, mainly using a mineral (natron) alkali source. Relatively recent excavations in Beirut have revealed remains of massive tank furnaces in which such glass was fused, producing up to 12 tons of fresh glass with each firing. The two bowls found in Hengzhigang tomb in Guangzhou – one of which, now in the National Museum of China, is shown here – are rather rare examples in China of such objects, but they

presumably were shipped here in large quantities. These mass-produced vessels then became treasured items in China, as shown by their inclusion in an elite tomb. JH

Further reading: Oikonomou et al. 2018; Triantafyllidis 2000; Whitfield 2018.

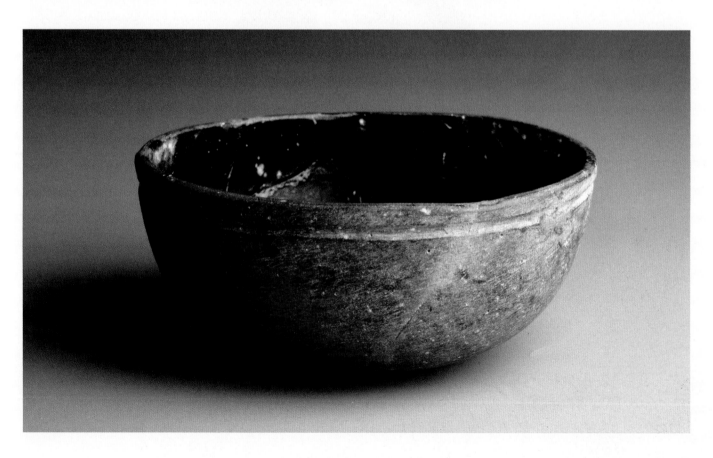

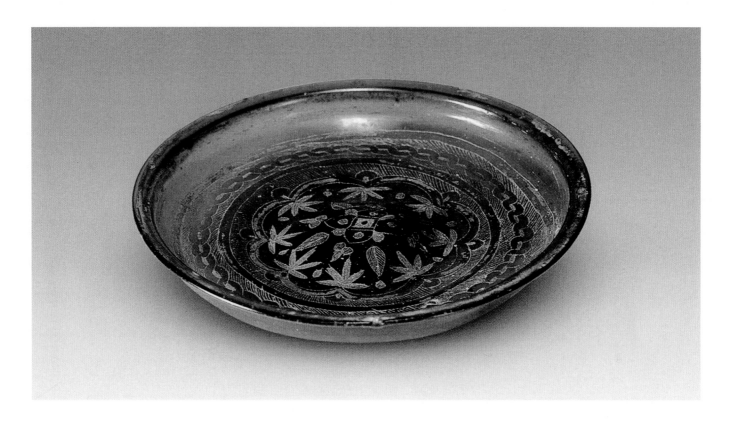

An Islamic scratch-decorated bowl

Scratch-decorated glass vessels have been found at a range of archaeological sites across west Asia. Although the decoration can be of a very high quality, the vessels occur quite commonly at early Islamic sites. Designs were made by scratching onto highly coloured translucent glass, with purple glass, for example, coloured using manganese oxide.

Manganese is a raw material that was deliberately added to early Islamic (8th- to 9th-century) glass, according to the alchemist Jābir ibn Hayyān (c. 721–c. 815).

The vessels were made with either a mineral or a plant ash flux and fused in the Levantine/ Egyptian area or in inland locations across western Asia. The best and most complete

collection was found in a Buddhist reliquary in the Famen temple stupa near the former capital of China, Chang'an. Glass is often found in reliquaries, used as one of the Seven Treasures of Buddhism [see pp. 176–81]. Scientific analysis shows that some of the glass vessels found at Chang'an were probably made in the Islamic world. This dish,

14 cm (5.5 in.) in diameter, is decorated with maple leaves and an outer ring of interlace; it is also gilded. JH

Further reading: Carboni 2001; Li et al. 2016.

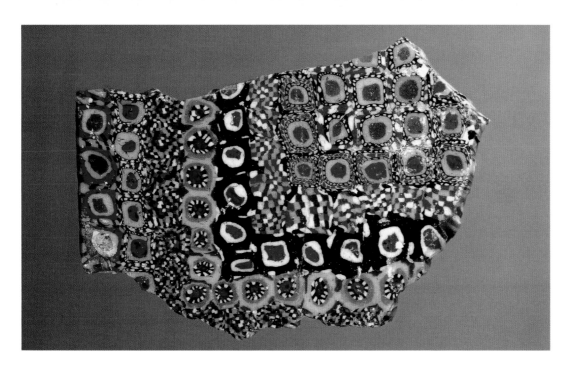

A tile fragment of millefiori glass from 9th-century Samarra, used to decorate a wall. Made from multicoloured glass rods that were bundled together, cut into a cross section, and then fused together.

A Sasanian glass bowl

While a relatively large number of Roman and a smaller number of Hellenistic glass vessels have been found in east Asia, Sasanian vessels are the most common. Sasanian facet-cut vessels have their origins in the technology of the Roman period. Unlike Roman glass, which was mainly made in east Mediterranean coastal locations, some of the glass used was made in inland locations in areas that coincide with modern Iraq and Iran, using a salt-loving plant-ash flux; other Sasanian glasses were made using natron.

The vessels are made of thick (cast) glass and are often quite weathered. This 8th-century piece, 8.5 cm (3.3 in.) high, from the Japanese imperial repository in Nara, the Shōsōin, is slightly weathered, probably due to the use of an alkaline plant-ash source: such glass is less durable than natron glass. The decoration of the bowl would have been produced using a rotary wheel, perhaps using abrasive material like carborundum stone. The design

required careful planning, since each facet is of a similar size.

The inclusion of such bowls in elite tombs in China and Japan, especially from the 3rd to 6th centuries, shows that they were probably highly valued. A similar bowl was discovered, for example, in the 6th-century tumulus of Emperor Ankan (r. 531–536) in Osaka, Japan. They were also valued in a Buddhist context, as exemplified by this 9th-century silk banner from Dunhuang (now in the British Museum, 1919,0101,0.139) showing a bodhisattva holding a similar vessel. JH

Further reading: Mirti et al. 2009; Whitehouse & Brill 2005; Whitfield & Sims-Williams 2004.

decoration on the vessels is very complex and finely executed, with two of the examples having gold leaf decoration.

Somewhat earlier, brightly coloured strings of beads dating from around the 2nd century CE and later were distributed across the Indo-Pacific area along the maritime and land routes, their small size making them easy to transport. Scientific analysis shows that they were probably made in India and southeast Asia, and examples have been found as far afield as Turkey, east Africa and China.

———

Further reading: An 1984; Carboni 2001; Dussubieaux et al. 2010; Henderson 2013; Henderson et al. 2018; Wood 2012.

A glass ewer and beaker found in a 6th-century Silla tomb at Gyeongju on the Korean peninsula, probably imports from west Asia.

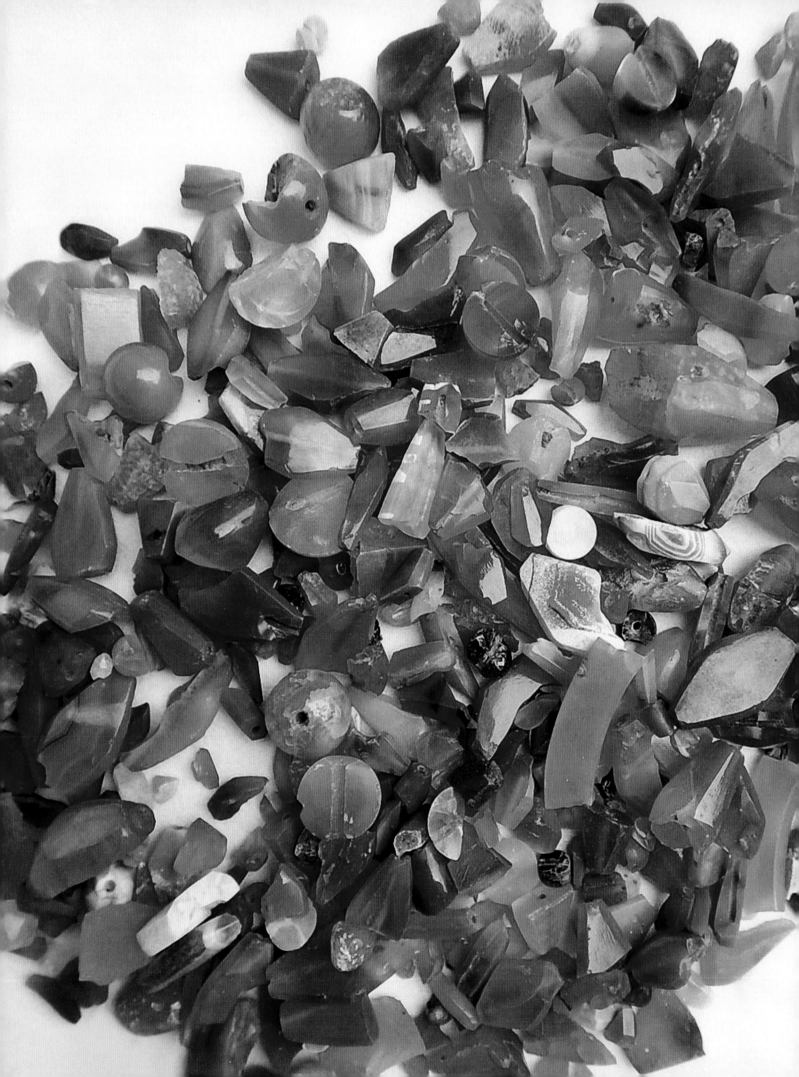

Importing and working coloured stones in southeast Asia

Bérénice Bellina

Stones were worked in southeast Asia in the form of adzes and ornaments long before the maritime Silk Roads began to spread new raw materials, techniques and ideas. Obsidian and nephrite/jade were the first stones to be exchanged over long distances in southeast Asia.

Nephrite/jade ornaments have a long history in China, Taiwan and Vietnam, but during the last centuries BCE, several specific forms of nephrite ornaments in the shape of double-headed animal and of the 'lingling-o', a sort of ring with a slit in one side possibly to fit a pierced earlobe, spread across the present-day area of the Philippines, east Malaysia, central and southern Vietnam, eastern Cambodia, and peninsular Thailand. The location of production was thought to be in the Philippines or Vietnam, with their subsequent distribution viewed as evidence of earlier prehistoric southeast Asian networks.

The appearance of ornaments made of carnelian, agate, jasper, garnet and amethyst in southeast Asia was initially interpreted as signalling the beginning of contacts with south Asia and the process of 'Indianization', a broad cultural exchange process leading to the adoption of Buddhism, Hinduism and political concepts in southeast Asia. Until quite recently, south Asian stone ornaments were viewed as prestigious items evidencing the adoption of elaborate external cultural influences by southeast Asian populations that were lacking complex concepts internally. The transfer was assumed to have taken place thanks to the arrival of Indian princes and priests travelling on merchant ships. The earliest Indianized states were all located in coastal zones, suggesting that the maritime Silk

Roads were an enabling factor. The earliest ornaments have been found in ports associated with these early states, such as Óc Eo or Funan in southern Vietnam. Ornaments have also been found along major terrestrial routes of exchange, such as at Ban Don ta Phet in west central Thailand, at the exit of the Three Pagoda Pass.

Carnelian and agate ornaments were similarly thought to have been imported from the best-known early historical workshops located at the early port of Arikamedu, southeastern India. The site yielded amphorae, Arretine ware and evidence of stone and glass production and for a long time was conceived

as a major port of the Indo-Roman trade. Besides the prestige drawn from these ties another reason for this interpretation was that the Indian subcontinent, and in particular the Deccan region, is a major source for these stones in the ancient world and a place that had already elaborated a sophisticated ornament-manufacturing tradition going back to the 3rd millennium BCE.

However, the discovery of workshops in the earliest southeast Asian port-settlements, such as Khao Sam Kaeo [*see* box on p. 432], has revised this picture of the production networks and cultural exchanges. From the start of their appearance in

Previous spread — Imported carnelian, probably from India, found in southeast Asian workshops ready to be worked into beads and other ornaments.

Below — Jewelry reconstructed from glass and imported stones such as agate, carnelian and jade found at Óc Eo.

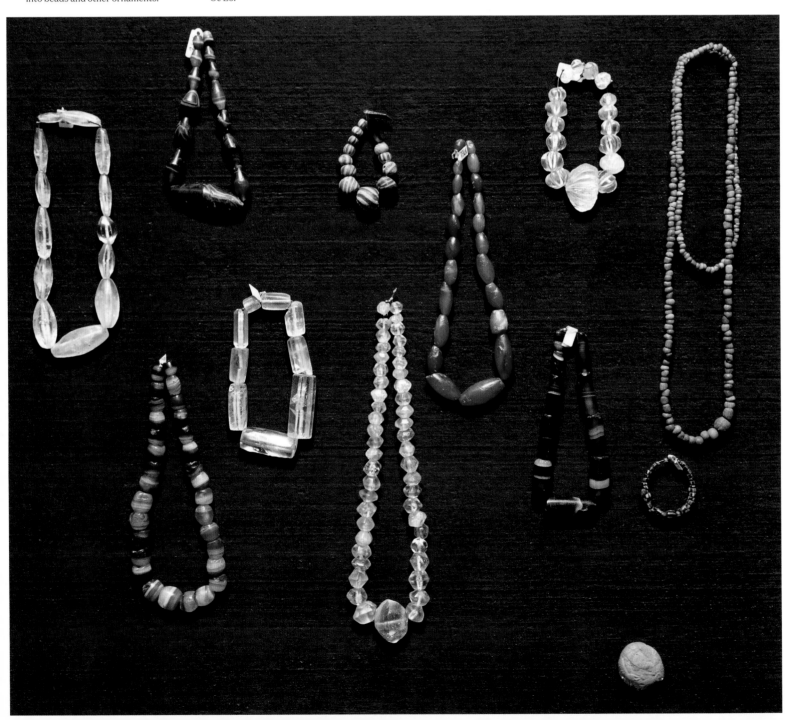

Arikamedu: an Indian trading port

Arikamedu was identified in 1945 by the British archaeologist Mortimer Wheeler (1890–1976) as a key site of Roman trade with India, and was substantially excavated from 1945 to 1950. Located immediately south of Puducherry in Tamil Nadu, India, the coastal site has been associated with the emporium of Poduke, mentioned in the 1st-century CE *Periplus of the Erythraean Sea*.

The first excavators concluded that the site was a Roman trading outpost that thrived in the 1st and 2nd

centuries before declining. However, subsequent excavations, led by Vimala Begley in the early 1990s, demonstrated that the rouletted ware at Arikamedu, previously identified as western, was produced locally in south Asia. These excavations also re-dated activity at the site. While a major intensification in the 1st and 2nd centuries CE was still evident, Begley's team highlighted the emergence of rouletted ware at the site in the 2nd to 1st centuries BCE and showed continued use of the site into the 4th to 7th centuries CE.

The most significant Roman import to the site was probably Mediterranean wine. Evidence has also been found for local fishing, bangle and cameo production, and the making of glass beads, such as the ones shown here. RD

Further reading: Begley et al. 1996.

southeast Asia, hard stone ornaments were in fact locally produced in ports that hosted foreign artisans. These workshops used imported raw material, siliceous stones from south Asia and nephrite from east Asia, and implemented foreign production techniques. Nephrite blocks of several shapes (cylindrical and square plaques), both unworked and partially worked, have been found in these ports. Many came from the Fengtian source in Taiwan, along with mica possibly extracted from Filipino sources. The distribution of Taiwanese nephrite on both sides of the South China Sea emphasizes how extensive links were during the late prehistoric period in this maritime basin. Nephrite

was more likely exchanged through the Philippines and Vietnam and handled by middlemen, who could very well have been from the Philippines themselves.

Objects of nephrite, carnelian and agate were made to conform to a regional style shared by trading communities. Given the level of expertise required, it is assumed that foreign artisans circulated at the initial stage, before apprentices were trained locally. The workshops established themselves in ports where merchants and specialists from different horizons hybridized their source cultures, combining stones, techniques and styles to make ornaments reflecting their shared values. The ornaments helped to connect the social and

Khao Sam Kaeo: a southeast Asian port

Southeast Asia in the 4th century BCE witnessed the emergence of urban walled settlements and state-like polities. Khao Sam Kaeo in the Isthmus of Kra on the Malay peninsula represents the earliest of this type of settlement known so far in maritime southeast Asia. This urban cosmopolitan complex extended over 35 ha (85 acres) and was limited on its western side by a river connecting it with the South China Sea to the east, with tin ores sources and resource-rich forests to the west, as shown here.

Commanding trans-peninsular routes and most probably acting as an international market place for a set of smaller city-states, Khao Sam Kaeo hosted foreign communities of merchants and artisans, living in quarters demarcated by embankments. Within these, there was a dense network of living spaces, workshops and terraces, all resting on piles. Workshops for gold and silver, carnelian and glass jewelry were supported by an agricultural regime based on rice and millet.

The configuration of the settlement heralds those found in later maritime city-states such as Pasai, Banten, Malacca and Ayutthaya, where highly specialized industries were attached to compounds, implementing advanced technologies to produce prized products such as stone and glass ornaments, such as the cameo shown here, several of which were part of the symbolic assemblages shared by the maritime elites. BB

Further reading: Bellina 2014, 2017, 2018.

Stone statue from the Funan empire, in mainland southeast Asia, 6th–7th century.

economic networks of the port-cities, both with their hinterland, which provided goods for trade, and with its political peers.

At a later stage, the regional styles evolved to integrate more Hindic-inspired symbols, bearing witness to an increase of ideational cross-fertilization along the maritime Silk Roads. Workshops of varying scale implementing mass-production techniques developed within cities and small communities across southeast Asia. The evolution of production and distribution networks for historical periods during the 1st millennium CE remains to be studied, but there is little doubt that more unsuspected aspects of cross-cultural exchanges along the early maritime Silk Roads will be revealed.

———

Further reading: Bellina 2014, 2018, 2019; Carter 2015; Hung et al. 2005.

Judaism in the Indian Ocean world

Elizabeth Lambourn

Jewish communities have a long history of interaction with, and in, the Indian Ocean world, one that was in some ways inevitable given southwest Asia's privileged position on that ocean's western edge. We now know through archaeological analysis that Indian Ocean spices such as cinnamon reached early Iron Age Phoenicia in the 11th to late 10th centuries BCE, earlier therefore than the first biblical references to this spice and others such as pepper.

Some 2,000 years later, documents from the Cairo *geniza* [*see* box on p. 285] record Jews in west Asia not only consuming a wide range of Indian Ocean products but also actively involved in their trade via ports around the Arabian peninsula, and at their sources in south and southeast Asia. As the *geniza* material vividly illustrates, Jewish individuals joined the streams of merchants who, at different times across the centuries, left west Asia for the east, and often ended up settling somewhere along the route.

Typically of Indian Ocean history, sources on Jews and Jewish communities in this area are very varied, materially and linguistically, and they are spread highly unevenly. Currently there exists no single synthetic account of Jewish presence in the Indian Ocean over the longue durée. Part of the problem is that it is generally difficult to identify the faith of an individual from archaeological remains. Texts also cannot be relied upon to explicitly record the faith of an individual or community and in fact ethnicity or linguistic belonging were far more frequently noted than faith. Notable exceptions are the brief Arab Jewish kingdom of Ḥimyar in what is now Yemen, which converted to Judaism in the late 4th century and flourished for a little over a century. A century earlier in the same region, traces of a 3rd-century synagogue at the Hadrami port of Qana, the centre

The luggage list of a Jewish merchant

This small slip of paper, measuring 9 cm by 27 cm (3.5 by 10.5 in.), which we know from its text originated in the Malabar region of southwestern India, vividly embodies the connectivities of the Indian Ocean world. Both its materials – the ink and paper – and the contents of its two texts bear witness to the dense commercial and cultural exchanges then ongoing between south and west Asia. Southern India incised its texts on palm leaves, therefore we know that this paper, like the main ingredients of its ink, must have been imports to Malabar. This assumption is confirmed by the wider corpus of documents to which this slip belongs – the so-called 'India Book' of the Cairo *geniza* [*see* box on p. 285] – which record the concerted efforts of Jewish traders to have paper and ingredients for ink couriered out to India. Nevertheless, in India paper remained a scarce commodity and was frequently reused, as this slip of paper also testifies. It was first written on at the port of Mangalore, where the trader Joseph b. Abraham used it for an update on business matters and to request essential food provisions from Aden. Its recipient, Abraham Ben Yiju, apparently kept this note and carried it back to Malabar where he eventually used its blank reverse to note down over 170 items he had just packed as luggage for his final return west in 1149. It is now in Cambridge University Library (T-S NS 324.114). EL

Further reading: Goitein & Friedman 2008; Hoffman & Cole 2011; Lambourn 2018.

Previous spread — Thule, a city dating from the Ḥimyarite kingdom (110 BCE–525 CE) in southern Arabia. The Ḥimyar kings converted to Judaism around 380 CE.

Above — One of the wall paintings decorating the synagogue at Dura-Europos, completed in 244 CE, showing Moses being taken from his basket on the Nile.

of the region's trade in aromatics, evidence the earlier importance of Jewish mercantile activity in this area.

South Asia presents different sources again to the Arabian peninsula and Red Sea. Although Indian Jewish narratives of arrival often place that moment in the early 1st millennium CE, after the destruction of the Temple in Jerusalem in 70 CE, hard physical or textual evidence of Jewish presence is often much later or largely circumstantial. That is not to say that the Jewish diaspora did not reach India or other locations, or that Jews were not active in Indo-Roman trade, but simply that the evidence is fragile and complex. Secure points in time for India are the four Jewish names written in Judeo-Persian (Middle

Persian written in Hebrew script) found on an Indian grant document of 849 CE from the southern Malabari port of Kollam, evidence that four Persian Jewish traders were at that port in that year. More significant perhaps is a grant document of around 1000 CE from the region of Kodungallur that records the trade privileges assigned to a certain Isuppu Irappan, probably a Malayalam rendering of the personal name Yusuf Rabban. While Isuppu is not specifically designated as a Jew, the fact that this document remained in the possession of the Jewish community of Malabar suggests that he was an early and influential merchant of that faith. During the period when west Asia was in the process of

Islamization, but certainly far from majority Muslim, it is clear that Jews were just another west Asian faith community active in the Indian Ocean, alongside Zoroastrians, Christians and, of course, Muslims. But it is only in the 12th century, thanks to the 'India Book' documents (that part of the *geniza* related to Indian Ocean trade) and to travel accounts such as that of Benjamin of Tudela (1130–1173), that we begin to get a picture, however distorted, of the size and distribution of Jewish communities in the western Indian Ocean and beyond.

The 'India Book' documents and Tudela's account suggest that by the 12th century southeast and east

Right — Unfinished letter from the India trader Abraham Ben Yiju to Khalaf b. Bundar or a family member in Aden, discussing family business and the sale of iron from his warehouse to repay a debt. Written at Aydhab on the Red Sea coast in *c.* 1152. The letter's unfinished state suggests that it was never sent.

Below — Remains of the 4th- to 5th-century synagogue at Capernaum on the Sea of Galilee, built on the remains of an earlier synagogue.

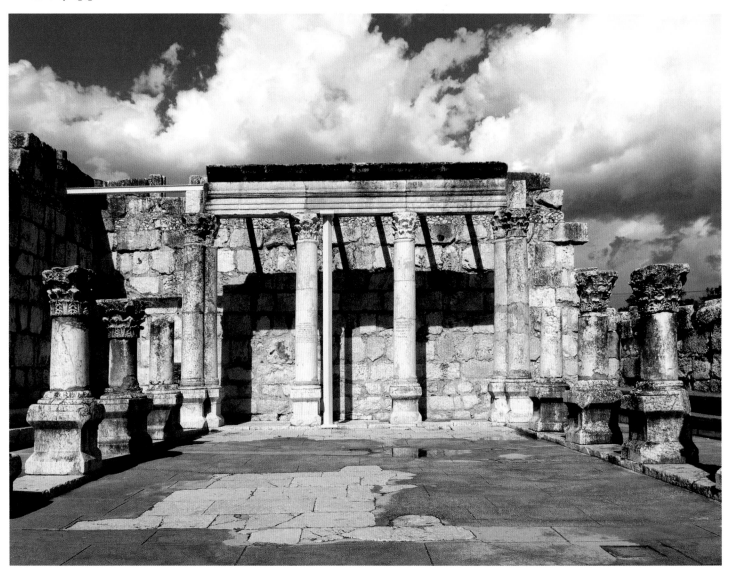

Incantation bowl

Incantation bowls used in folk medicine are common finds at southern Mesopotamian sites. This example, now in the British Museum (1957,0925.1), was long thought to be a modern copy but is now believed to be original, dating from the late Sasanian period (224–651 CE). Some 21.2 cm (8.3 in.) in diameter and 6.5 cm (2.6 in.) high, it is unglazed and is formed from the distinctive yellow clay of the region [see pp. 338–45]. The spiral Aramaic inscription written in black ink lists a number of pagan deities and states where they were thought to live in Mesopotamia. Most of these places are identifiable, and the content indicates that the scribe was Jewish.

Owners of these incantation bowls believed that if they drank from one part of the text it would dissolve in the liquid and thus be swallowed, simultaneously invoking the gods' protection.

In the 1988–89 archaeological season at Nippur, six almost complete bowls were found under a courtyard floor in an early Islamic context, evidence that the incantation bowl tradition persisted into the Islamic period. RWH

Further reading: Levene & Bohak 2012.

One of two unique fragments from the *geniza* written in the northern Indian script Devanāgarī. Numerals suggest that they are business accounts, but we do not know who wrote them or where they were written. Late 11th–early 13th centuries.

Asia lay substantially beyond the main axes of Jewish trade, in sharp contrast to multiple 9th-century references to their presence in these regions. A 10th-century source, the *Akhbār al-Ṣīn wa 'l-Hind* (Notices of China and India), mentions Jews alongside Muslims, Christians and Zoroastrians among the 120,000 people reportedly killed in the eastern Chinese port of Guangzhou in 877–78 during the Huang Chao rebellion. Whatever the doubts about the precise numbers involved, the message is that west Asians, Jews among them, had been present in coastal China in large numbers. It was not until the early modern period and the new connectivities of the European Age of Exploration that Jewish traders again travelled and settled across the Indian Ocean world in substantial numbers.

Further reading: Bowerstock 2013; Gilboa & Namdar 2015; Goitein & Friedman 2008; Katz 2000; Lambourn 2018.

Spice production and distribution

Cristina Castillo

Spices are aromatic substances used mainly as food flavouring, but also to provide smell and colour. Between 400 and 500 plant species have been identified as being used as spices worldwide, more than half of which are from tropical Asia, including cardamom, cinnamon, clove, ginger, nutmeg, turmeric and black pepper. Spices have long been articles of trade and luxury and, like today, were valued not only as comestibles but also as key ingredients for medicine, preservatives and aromatics from prehistoric times.

Spices played an important role as speciality and luxury products in early trading ports in the Red Sea dating to the Roman period, such as Berenike [*see* box on p. 443], and in the later international trade routes, such as those to northwestern Europe and China between 1250 and 1350 CE.

The history of the spice trade in southeast Asia is mostly known from the 15th century onwards, when European long-distance explorations and voyages took place in search of exotic goods from the islands they called the East Indies. However, spices were traded commodities long before a European presence in southeast Asia. Written sources, such as the 1st-century CE *Periplus of the Erythraean Sea*,

document some of the traded items, many of them coming from the Indian Ocean to Red Sea ports (such as black and long pepper) but also from southeast Asia via India (such as sandalwood and possibly cinnamon and cassia). Archaeological evidence prior to 1200 is minimal and the spice trade is mainly known from rare discoveries and historical accounts. Spices in prehistory encompass a wide range of products, including exotics, citrus fruits and the betel nut.

Trading centres would have been established along the coasts of Afro-Eurasia in order to manage the distribution networks. Two such entrepôts dating to the late 1st millennium BCE on the

Malay peninsula were Khao Sam Kaeo [*see* box on p. 432] and Phu Khao Thong, strategically located as points of entry and exit of goods flowing from the Bay of Bengal and the South China Sea. At these sites we have evidence of luxury plant items, such as cotton and sesame, originating from south Asia, but also of southeast Asian domesticates such as the fruit rind of pomelo (*Citrus maxima*). This is the earliest archaeological evidence of pomelo, although the Chinese character *yòu* [柚] suggests it was known from at least the Han dynasty (206 BCE–220 CE), indicating it formed part of the South China Sea trade network. Western Han (206 BCE–9 CE) artifacts found at Khao Sam Kaeo further

Previous spread — An 8th-century gilt silver incense burner from the Buddhist reliquary at Famen Temple near Chang'an.

Right — Tapping a myrrh tree. Illustration from an Arabic translation of the Greek text *Peri hyle iatrikes* (*De Materia medica*) by Pedanius Dioscorides (*c.* 40–90), made in Mosul in 1228 by Yusuf al-Mawsili.

Constantinople: Byzantine port and capital

During the transformation of the Roman empire into a Christian, Greek-speaking empire, the small town of Byzantion on the Bosporus was renamed Constantinople in 330 after its founder, Constantine I (r. 306–337 CE). By the 6th century, the city, with a population of about half a million, stood at the nexus of trade routes connecting east and south Asia to the Mediterranean world, its markets filled with 'Indian drugs' and 'Arabian perfume'. It received envoys from the Göktürks in central Asia and allied with the Axumites in east Africa to bypass the Sasanid monopoly, while as the seat of the Orthodox patriarch it welcomed pilgrims from Christian west Asia, the Mediterranean and, in later centuries, eastern Europe and Russia.

From the 7th to 11th centuries, the Islamic caliphates were both enemies and trade partners of the Byzantine empire. Even though an alliance was struck with the steppe Khazars north of the Caspian Sea to stop the Islamic advance in the Caucasus and circumvent Islamic control of the trade routes through west Asia, Islamic markets were the main venues for the exchange of goods between the Byzantines and the rest of Asia. By the 9th and 10th centuries, a Jewish merchant network connected China to Europe via Egypt and Constantinople, while Muslim merchants were lodged in their own quarter in the city [*see* pp. 434–39]. The infrastructure that made this connectivity possible can be seen in the size and number of medieval ships discovered in the Yenikapı district during excavations in the early 2000s.

The fall of Constantinople in 1453 became the subject of church wall paintings, such as the 16th century fresco shown above from Moldoviţa monastery. The city plan was made not long before, in 1422, by the Florentine cartographer Cristoforo Buondelmonti (1386–1430). KD

Further reading: Hughes 2017; Kocabas 2014; Norwich 2013.

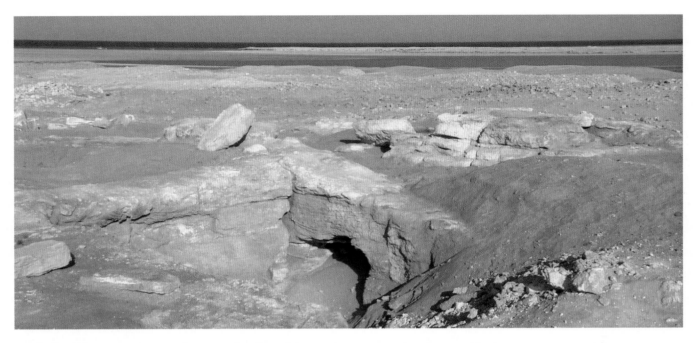

Berenike: minerals and elephants

Ancient Berenike is situated on the Red Sea coast of Egypt, close to the border with present-day Sudan. The settlement was founded by Ptolemy II (r. 283–246 BCE) of Egypt and named after his mother. The promontory of Ras Banas gave some shelter from the prevailing northerly winds, and a track with fortified wells and cisterns connected the city with the Nile port of Koptos, twelve days' travel to the northeast. Water had to be brought in from sources some 8 km (5 miles) away.

Berenike was probably founded as part of a programme to ease access to mineral resources and war-elephants from the Red Sea, but it became an important entrepôt for trade between the Roman empire and the Indian Ocean. Dependent on the changing patterns of trade as well as government willingness to maintain and protect infrastructure, it flourished in the first two centuries CE and again in the 4th century. The city was probably abandoned in the 6th century.

Berenike has been excavated by Dutch, Polish and American archaeologists since 1994. Their work has revealed the remains of a vibrant and multicultural city, with evidence of twelve different languages and a number of religious cults. EHS

Further reading: Sidebotham 2011.

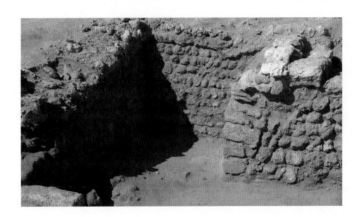

demonstrate the links between Han China and the Thai peninsula.

The most well-known spices of southeast Asia are nutmeg from the Banda Islands and cloves from Ternate and Tidore. Nutmeg (*Myristica fragrans*) has not, to date, been found in any archaeological context. However, it is mentioned as early as 540 CE in Constantinople. A clove (*Syzygium aromaticum*) has been found in Mantai, Sri Lanka, dated to *c.* 500 CE and there is another unconfirmed find from Syria dating to the 2nd millennium BCE.

Pliny the Elder (23–79 CE) mentions that cloves were traded between India and Rome, and the 6th-century traveller Cosmas Indicopleustes [*see* pp. 30–31] provides an account of traded commodities in Sri Lanka, some of which were sourced from southeast Asia, including cloves and sandalwood.

Another popular spice, ginger (*Zingiber officinale*), originates from south China, southeast Asia or northeast India, but the centre of diversity for *Zingiber* lies in southeast Asia. Ginger has been found in Chinese tombs dating to 160 BCE and is

also mentioned in Dioscorides' *Peri hyle iatrikes* (*De Materia medica*), dating to 77 CE. Dried rhizomes have been identified in Quseir al-Qadim on the Red Sea dating to the 12th century CE.

Very early networks are exemplified by the translocation of the aromatic sandalwood (*Santalum album*), a less well-known spice that originated from Indonesia, possibly Timor or the Lesser Sunda Islands. It has been identified at the site of Sanganakallu in south India, dating to *c*. 1300 BCE. Another possible translocation to south Asia is the

betel palm (*Areca catechu*), which yields betel nut, commonly chewed as a stimulant narcotic throughout south Asia, southeast Asia and the Pacific Islands. The earliest archaeological find outside southeast Asia is at Quseir al-Qadim, dating to the 12th to 13th centuries CE, and although the betel nut here was most probably imported from India, it provides clear evidence of the early circulation of products from southeast Asia.

Archaeobotanical research in southeast Asia has started to gain momentum in the past decade and

A treatise on nutmeg, from a 15th-century manuscript copy of the Latin text *Tractatus de herbis* by Pedanius Dioscorides (*c*. 40–90).

A Roman pepper pot

Pepper, imported from Asia, was widely used in the Roman empire (27 BCE–395 CE), and was shipped across the Indian Ocean to the Red Sea and then across the Mediterranean. It was used as a spice for food, but also in medicine and religion. It was widely accessible: pepper has been found in the rubbish heaps of Roman soldiers on the borders of the empire in Britain, along with coriander, another imported spice. But pepper pots such as this one were luxury items for the elite in Roman Britain.

This gilt-silver 4th-century piece, 10 cm (4 in.) high, was discovered in a hoard of gold and silver in Hoxne, in eastern England, and is now in the British Museum (1994,0408.33). The woman, with a 4th-century hairstyle, holds a scroll, the

predominant form of the book in both the Roman and east Asian worlds at this time. The pot has a disc in the base that can be turned to three positions: closed; one with a large hole to enable the pot to be filled with ground pepper; and a third that has groups of small holes for sprinkling. SW

Further reading: Cobb 2018; Hobbs & Jackson 2010; Johns 2010.

will undoubtedly provide more hard evidence for the trade in exotic plants. In the meantime, the few scattered pieces of evidence attest that a network of trade existed from early times, although many of the luxury products, including spices, have not been preserved or have yet to be unearthed and identified.

———

Further reading: Asouti & Fuller 2008; Bellina 2017; Dalby 2002; De Guzman & Siemonsma 1999; Kingwell-Banham 2015; van der Veen 2011.

13th- to 14th-century brass incense burner inlaid with silver and gold, probably made in Damascus.

Bibliography

A

Abduressul, Idriss 伊弟利斯·阿不都热苏勒 et al. 2013. "新疆克里雅河流域考古调查概述。" In 新疆文物考古研究所, edited by Idriss Abduressul et al. 938–50. Urümqi: Xinjiang renmin chubanshe.

Abe, Stanley. 2002. *Ordinary Images*. Chicago: University of Chicago Press.

Adams, N. 2003. "Garnet Inlays in the Light of the Armaziskhevi Dagger Hilt." *Medieval Archaeology* 47: 167–75.

Adler, Marcus Nathan, trans. 2017. *The Itinerary of Benjamin of Tudela*. CreateSpace Independent Publishing Platform.

Aillagon, Jean-Jacques, ed. 2008. *Rome and the Barbarians: The Birth of a New World*. Milan: Skira.

Akbarzadeh, Daryoosh and Nikolaus Schindel. 2017. *Sylloge Nummorum Sasanidarum Iran: A late Sasanian Hoard from Orumiye*. Vienna: Austrian Academy of Sciences Press.

Album, Stephen and Tony Goodwin. 2002. *Sylloge of the Islamic Coins in the Ashmolean – Volume 1: The Pre-Reform Coinage of the Early Islamic Period*. Oxford: Ashmolean.

Allsen, Thomas T. 2006. *The Royal Hunt*. Philadelphia: University of Pennsylvania Press.

Allsen, Thomas T. 2008. *Culture and Conquest in Mongol Eurasia*. Cambridge: Cambridge University Press.

Ammianus Marcellinus. Trans. by J. C. Rolfe. 1939. *History, Volume III: Books 27–31. Excerpta Valesiana*. Loeb Classical Library 331. Cambridge, MA: Harvard University Press. http://penelope.uchicago.edu/Thayer/E/Roman/Texts/Ammian/home.html [last accessed 7 June 2019]

An, Jiayao. 1984. "Early Glass Vessels of China." *Acta Archaeologica Sinica* 4: 413–48.

Andaloro, Maria, ed. 2006. *Nobiles Officinae: Perle, Filigrane e Trame di Seta dal Palazzo Reale di Palermo*, 2 vols. Catania: Giuseppe Maimone Editore.

Andrianov, Boris V. Trans. by Simone Mantellini. 2016. *Ancient Irrigation Systems of the Aral Sea Area*. Oxford: Oxbow Books.

Antony, Robert, ed. 2010. *Elusive Pirates, Pervasive Smugglers: Violence and Clandestine Trade in the Greater China Seas*. Hong Kong: Hong Kong University Press.

Asouti, Eleni and Dorian Q. Fuller. 2008. *Trees and Woodlands of South India: Archaeological Perspectives*. California: Left Coast Press.

B

Ball, Warwick. 1998. "Following the Mythical Road." *Geographical* 70.3: 18–23.

Ball, Warwick. 2008. *The Monuments of Afghanistan. History, Archaeology and Architecture*. London: I. B. Tauris.

Barfield, Thomas. 1992. *The Perilous Frontier: Nomadic Empires and China, 221 BC to AD 1757*. London: John Wiley & Sons.

Barrett, T. H. 2008. *The Woman Who Discovered Printing*. New Haven: Yale University Press.

Bass, George F. 2005. *Beneath the Seven Seas: Adventures with the Institute of Nautical Archaeology*. London: Thames & Hudson.

Baums, Stefan. 2012. "Catalog and Revised Texts and Translations of Gandharan Reliquary Inscriptions." In *Gandharan Buddhist Reliquaries*, edited by D. Jongeward, E. Errington, R. Salomon and S. Baums, 201–51. Seattle: University of Washington Press.

Beaujard, Philippe. 2012. *Les Mondes De L'océan Indien. 1, De La Formation De L'état Au Premier Système-Monde Afro-Eurasien (4e Millénaire Av. J.-C. - 6e Siècle Apr. J.-C.)*. Paris: Colin.

Becker, John. 2009. *Pattern and Loom: A Practical Study of the Development of Weaving Techniques in China, Western Asia, and Europe*. Copenhagen: Nias Press.

Bedrosian, Robert, trans. 1985. *Ghazar P'arpec'i's History of the Armenians*. New York: Sources of the Armenian Tradition.

BeDuhn, Jason D. 2000. *The Manichaean Body in Discipline and Ritual*. Baltimore: Johns Hopkins University Press.

Begley, Vimala et al. 1996. *The Ancient Port of Arikamedu: New Excavations and Researches, 1989–1992*, 2 vols. Pondichéry: École française d'Extrême-Orient.

Behrendt, Kurt A. 2007. *The Art of Gandhara in the Metropolitan Museum of Art*. New York: Metropolitan Museum of Art.

Behrens-Abouseif, Doris. 1989. *Islamic Architecture in Cairo: An Introduction*. Leiden: E. J. Brill.

Behrens-Abouseif, Doris, Bernard O'Kane and Nicholas Warner. 2012. *The Minarets of Cairo: Islamic Architecture from the Arab Conquest to the End of the Ottoman Empire*. London: I. B. Tauris.

Bellina, Bérénice. 2014. "Maritime Silk Roads Ornament Industries: Socio-political Practices and Cultural Transfers in the South China Sea." *Cambridge Journal of Archaeology* 24.3: 345–77.

Bellina, Bérénice, ed. 2017. *Khao Sam Kaeo: An Early Port-City between the Indian Ocean and the South China Sea (Mémoires Archéologiques 28)*. Paris: École française d'Extrême-Orient.

Bellina, Bérénice. 2018. "Khao Sek Hard-stone Industry: an Insight into Early Port-Polities Structure and Regional Material Culture." *Archaeological Research in Asia* 13: 13–24.

Bellina, Bérénice. 2019. "Southeast Asian Evidence for Early Maritime Exchange and Trade-related Polities." In *The Oxford Handbook of Southeast Asian Archaeology*, edited by C. Higham and N. Kim. Oxford: Oxford University Press.

Bemmann, Jan and Michael Schmauder, eds. 2015. *Complexity of Interaction Along the Eurasian Steppe Zone in the First Millennium CE*. Bonn: Vor- und Frühgeschichtliche Archäologie.

Benard, Elisabeth. 1988. "The Living Among the Dead: a Comparison of Buddhist and Christian Relics." *The Tibet Journal* 13.3: 33–48.

Bendezu-Sarmiento, Julio, ed. 2013. "L'archéologie française en Asie centrale. Nouvelles recherches et enjeux socioculturels." *Cahiers d'Asie centrale* 21/22.

Benjamin of Tudela *see* Adler 2017.

Berggren, J. L. and Alexander Jones. 2000. *Ptolemy's Geography: An Annotated Translation of the Theoretical Chapters*. Princeton, NJ: Princeton University Press.

Bernard, Paul. 2008. "The Greek Colony at Aï Khanum and Hellenism in Central Asia." In *Afghanistan: Hidden Treasures from the National Museum, Kabul*, edited by Fredrik T. Hiebert and Pierre Cambon, 81–129. Washington, DC: National Geographic Society.

Bernbaum, Edwin. 1997. *The Sacred Mountains of the World*. Berkeley: University of California Press.

Bertrand, Arnaud. 2012. "Water Management in Jingjue (精絕) Kingdom: The Transfer of a Water Tank System from Gandhara to Southern Xinjiang in the Third and Fourth Centuries C.E." *Sino-Platonic Papers* 223: 184.

Bertrand, Arnaud. 2015. "La formation de la commanderie impériale de Dunhuang (Gansu) des Han antérieurs: l'apport des sources archéologiques." *Arts Asiatiques* 70: 63–76.

Bibikov, M. 1996. "Byzantinoscandica." In *Byzantium, Identity, Influence*, XIX International Congress of Byzantine Studies, edited by Karsten Fledelius and Peter Schreiner, 201–11. Copenhagen: Eventus.

Bivar, A. D. H. 1972. "Cavalry Equipment and Tactics on the Euphrates Frontier." *Dumbarton Oaks Papers* 26: 271–91.

Bivar, A. D. H. 2006. "Sasanian Iconography on Textiles and Seals." In *Central Asian Textiles and their Contexts in the Early Middle Ages*, edited by R. Schorta, 9–21. Riggisberg: Abegg-Stiftung.

Black, Jeremy. 2000. *Maps and History: Constructing Images of the Past*. New Haven: Yale University Press.

Bloom, Jonathan M. 2001. *Paper Before Print: The History and Impact of Paper in the Islamic World*. New Haven: Yale University Press.

Bloom, Jonathan M. 2015. "The Blue Koran Revisited." *Journal of Islamic Manuscripts* 6: 196–218.

Bloom, Jonathan M. 2017. "Papermaking: The Historical Diffusion of an Ancient Technique." In *Mobilities of Knowledge*, edited by Heike Jöns, Peter Meusburger and Michael Heffernan, 51–66. Cham: Springer Open.

Bonnet-Bidaud, J. M., Françoise Praderie and Susan Whitfield. 2009. "The Dunhuang Chinese Sky: A Comprehensive Study of the Oldest Known Star Atlas." *Journal for the Astronomical History and Heritage* 12.1: 39–59.

Bowersock, Glen W. 2013. *The Throne of Adulis: Red Sea Wars on the Eve of Islam*. Oxford: Oxford University Press.

Boyce, Mary. 1989. *A Persian Stronghold of Zoroastrianism*. New York: University Press of America.

Boyce, Mary. 1992. *A History of Zoroastrianism: Volume Two – Under the Achaemenians*. Leiden: Brill.

Brancaccio, Pia. 2011. *The Buddhist Caves at Aurangabad: Transformations in Art and Religion*. Leiden: Brill.

Braund, David. 2018. *Greek Religion and Cults in the Black Sea Region: Goddesses in the Bosporan Kingdom from the Archaic Period to the Byzantine Era*. Cambridge: Cambridge University Press.

Breeze, David. 2011. *The Frontiers of Imperial Rome*. Barnsley: Pen & Sword Military.

Briant, Pierre, ed. 2001. *Irrigation et drainage dans l'Antiquité: qanāts et canalisation souterraines en Iran, en Égypte et en Grèce*. Paris: Thotm Éditions.

Brosseder, U. 2015. "A Study on the Complexity of Interaction and Exchange in Late Iron Age Eurasia." In *Complexity of Interaction along the Eurasian Steppe Zone in the First Millennium CE*, edited by J. Bemmann and M. Schmauder, 199–332. Bonn: Vor- und Frühgeschichtliche Archäologie.

Brosseder, U. and B. K. Miller. 2011. "State of Research and Future Direction of Xiongnu Studies." In *Xiongnu Archaeology: Multidisciplinary Perspectives of the First Steppe Empire in Inner Asia*, edited by U. Brosseder and B. K. Miller, 19–33. Bonn: Vor- und Frühgeschichtliche Archäologie.

Brosseder, U. and B. K. Miller. 2018. "Global Networks and Local Agents in the Iron Age Eurasian Steppe." In *Globalization in Prehistory: Contact, Exchange, and the 'People Without History'*, edited by Nicole Boivin and Michael D. Frachetti, 162–83. Cambridge: Cambridge University Press.

Brown, Peter. 1982. *The Cult of Saints: Its Rise and Function in Latin Christianity*. Chicago: University of Chicago Press.

Bulliet, Richard W. 1990. *The Camel and the Wheel*. New York: Columbia University Press.

Bunker, Emma. 1997. *Ancient Bronzes of the Eastern Eurasian Steppes from the Arthur M. Sackler Collections*. New York: Arthur M. Sackler Foundation.

Burjakov, Ju. 2006. "L'extraction minière en Asie centrale aux VIIIe-Xe siècles de notre ère." In *Islamisation de l'Asie central*, edited by É. de la Vaissière, 257–74 . Paris: Paris Association pour l'Avancement des Études Iraniennes.

Burns, Ross. 2005. *Damascus: A History*. London: Routledge.

Buzurg ibn Shahriyar *see* Freeman-Grenville 1981.

Buschmann, Rainer F. and Lance Nolde, eds. *The World's Oceans: Geography, History, and Environment*. Santa Barbara: ABC-CLIO.

Bussagli, Mario. 1979. *Central Asian Painting*. Geneva: Skira/Rizzoli.

C

Cai Yan. 1999. Trans. by Dore J. Levy. "Eighteen Songs of a Nomad Flute." In *Women Writers of Traditional China: An Anthology of Poetry and Criticism*, edited by Kang-I Sun Chang and Haun Saussy, 22–30. Stanford: Stanford University Press.

Cameron, Judith, Agustijanto Indrajaya and Pierre-Yves Manguin. 2015. "Asbestos Textiles from Batujaya (West Java, Indonesia): Further Evidence for Early Long-Distance Interaction between the Roman Orient, Southern Asia and Island Southeast Asia." *Bulletin de L'École française d'Extrême-Orient* 101.1: 159–76.

Campbell, Gwyn. 2014. "The Question of Slavery in Indian Ocean World History." In *The Indian Ocean: Oceanic Connections and the Creation of New Societies*, edited by Abdul Sheriff and Engseng Ho, 123–49. London: Hurst & Co.

Canby, Sheila. 2014. *The Shahnama of Shah Tahmasp: The Persian Book of Kings*. New York: Metropolitan Museum of Art.

Caner, Daniel. 2002. *Wandering, Begging Monks: Spiritual Authority and the Promotion of Monasticism in Late Antiquity*. Berkeley: University of California Press.

Cao Wanru 曹婉如. 1995. *Zhongguo gudai ditu ji: Mingdai* 中国古代地图集: 明代. Beijing: Wenwu chubanshe.

Carboni, Stefano. 2001. *Glass from Islamic Lands: The al-Sabah Collection*. London: Thames & Hudson.

Cardon, Dominique. 2007. *Natural Dyes: Sources, Tradition, Technology and Science*. London: Archetype Publications.

Carter, Alison K. 2015. "Beads, Exchange Networks and Emerging Complexity: A Case Study from Cambodia and Thailand (500 BCE–CE 500)." *Cambridge Archaeological Journal* 25.4: 733–57.

Carter, M. 1978. "Silver Gilt Ewer with Female Figures." In *The Royal Hunter: Art of the Sasanian Empire*, edited by Prudence O. Harper, 60–61. New York: Asia House Gallery.

Casson, Lionel, trans. and ed. 1989. *The Periplus Maris Erythraei: Text with Introduction, Translation and Commentary*. Princeton, NJ: Princeton University Press.

Ceva, Juan. The Cresques Project. http://www.cresquesproject. net/home [last accessed 7 June 2019]

Chang, Chun-shu. 2006. *The Rise of the Chinese Empire*, 2 vols. Ann Arbor: University of Michigan Press.

Chin, Tamara T. 2013. "The Invention of the Silk Road, 1877." *Critical Inquiry* 40.1: 194–219.

Chittick, Neville. 1972. *Kilwa: An Islamic Trading City on the Coast of East Africa*, 2 vols. Nairobi: British Institute in Eastern Africa.

Choksy, Jamshed K. 2002. "The Theme of Truth in Zoroastrian Mythology." In *A Zoroastrian Tapestry: Art, Religion and Culture*, edited by P. J. Godrej and F. Punthakey Mistree, 149–59. Ahmedabad, NJ: Mapin Publishing Pvt, Ltd.

Christian, David. 1994. "Inner Eurasia as a Unit of World History." *Journal of World History* 5.2: 173–211.

Ciolek, Matthew. 2012. *Old World Trade Routes (OWTRAD) Project*. Canberra: ANU. http://www.ciolek.com/owtrad.html [last accessed 7 June 2019]

Clark, Hugh R. 1991. *Community, Trade, and Networks: Southern Fujian Province from the Third to the Thirteenth Century*. Cambridge: Cambridge University Press.

Clement of Alexandria. Trans. by Peter Kirkby. 2001–9. *Stromata*. http://www.earlychristianwritings.com/text/ clement-stromata-book1.html [last accessed 7 June 2019]

Cobb, Matthew. 2018. "Black Pepper Consumption in the Roman Empire." *Journal of the Economic and Social History of the Orient* 61.4: 519–59.

Coles, Peter. 2019. *Mulberry*. London: Reaktion Press.

Compareti, Matteo. 2006. "The So-Called Senmurv in Iranian Art: A Reconsideration of an Old Theory." In *Loquentes linguis: Studi linguistici e orientali in onore di Fabrizio A. Pennacchietti*, edited by Pier Giorgio Borbone et al., 185–200. Wiesbaden: Harrassowitz Verlag.

Compareti, Matteo. 2016. "Flying over Boundaries: Auspicious Birds in Sino-Sogdian Funerary Art." In *Borders: Itineraries on the Edges of Iran*, edited by Stefano Pellò, 119–53. Venice: Ca' Foscari.

Compareti, Matteo. 2016a. "Observations on the Rock Relief at Taq-i Bustan: A Late Sasanian Monument Along the 'Silk Road'." *The Silk Road* 14: 71–83. http://www. silkroadfoundation.org/newsletter/vol14/Compareti_ SR14_2016_71_83.pdf [last accessed 7 June 2019]

Compareti, Matteo. 2016b. *Samarkand, The Center of the World*. Costa Mesa: Mazda Publishers.

Constantine VII. Trans. by A. T. Moffat, 2012. *De ceremoniis* [Books of Ceremonies], *Byzantina Australiensia* 18. Canberra: Australian Association for Byzantine Studies.

Cornille, Amandine et al. 2014. "The Domestication and Evolutionary Ecology of Apples." *Trends in Genetics* 30: 57–65.

Cosmas Indicopleustes *see* McCrindle 1897 and Wolska-Conus 1968.

Creel, H. G. 1965. "The Role of the Horse in Chinese History." *American Historical Review* 70.3: 647–72.

Cribb, Joe. 1983. "Investigating the Introduction of Coinage in India – A Review of Recent Research." *Journal of the Numismatic Society of India* 45: 80–101.

Cribb, Joe. 1984, 1985. "The Sino-Kharoshthi Coins of Khotan: Parts 1 and 2." *Numismatic Chronicle* 144: 128–52 and 145: 136–49.

Cribb, Joe. 2019. "The Bimaran Casket: The Problem of its Date and Significance." In *Relics and Relic Worship in Early Buddhism: India, Afghanistan, Sri Lanka and Burma*, edited by J. Stargardt and M. Willis, 47–65. London: The British Museum Press.

Crill, Rosemary, ed. 2015. *The Fabric Of India*. London: V&A.

Crumlin-Pedersen, Ole. 2010. *Archaeology and the Sea in Scandinavia and Britain*. Oslo: Viking Ship Museum.

Cunliffe, Barry. 2015. *By Steppe, Desert and Ocean: The Birth of Eurasia*. Oxford: Oxford University Press.

Curtis, John. 2000. *Ancient Persia: Introductory Guides*. London: British Museum Press.

D

D'Onofrio, Mario, ed. 1994. *I Normanni: Popolo d'Europa, 1030–1200*. Venice: Marsilio Editori.

Dalby, Andrew. 2002. *Dangerous Tastes: The Story of Spices*. London: British Museum.

Dankoff, Robert and James Kelly, trans. 1982–85. *Maḥmūd al-Kāšgarī: Compendium of the Turkic Dialects (Dīwān luγāt at-Turk)*, 3 vols. Cambridge, MA: Harvard University Printing Office.

Darley, Rebecca. 2017. "'Implicit Cosmopolitanism' and the Commercial Role of Ancient Lanka." In *Sri Lanka at the Crossroads of History*, edited by Z. Biedermann and A. Strathern, 44–65. London: UCL Press.

Daryaee, Touraj. 2003. "The Persian Gulf Trade in Late Antiquity." *Journal of World History* 14.1: 1–16.

Daryaee, Touraj, Khodadad Rezakhani and Matteo Compareti. 2010. *Iranians on the Silk Road*. Santa Monica: Afshar Publishing.

Davidson, H. R. Ellis. 1976. *The Viking Road to Byzantium*. London: George Allen & Unwin Ltd.

De Guzman, C. C. and J. S. Siemonsma, eds. 1999. *Plant Resources of South-East Asia No 13. Spices*. Leiden: Backhuys Publishers.

de Saussure, Léopold. 1928. "L'origine de la rose des vents et l'invention de la boussole." In *Instructions Nautiques Et Routiers Arabes Et Portugais des XVe Et XVIe Siècles reproduits, traduits et annotés; Tome III Introduction à l'Astronomie Nautique Arabe*, edited by Gabriel Ferrand, 31–127. Paris: Librairie Orientaliste Paul Geuthner.

Debaine-Francfort, Corinne and Idriss Abduressul, eds. 2001. *Keriya, mémoires d'un fleuve. Archéologie et civilisation des oasis du Taklamakan*. Paris: Éditions Findakly.

Dehejia, Vidya. 1972. *Early Buddhist Rock Temples: A Chronological Study*. London: Thames & Hudson.

Delgado, James. 1997. *Encyclopedia of Underwater and Maritime Archaeology*. London: British Museum Press.

Desrosiers, Sophie. 2000. "Sur l'origine d'un tissu qui a partecipé à la fortune de Venise: le velours de soie." In *La seta in Italia dal Medioevo al Seicento*, edited by Luca Molà, Reinhold C. Mueller and Claudio Zanier, II: 60–61. Venice: Marsilio Editori.

Desrosiers, Sophie. 2004. *Soieries et Autres Textiles de l'Antiquité au XVIe Siècle*. Paris: RMN.

Desrosiers, Sophie and Corinne Debaine-Francfort. 2016. "On Textile Fragments Found at Karadong, a 3rd to Early 4th Century Oasis in the Taklamakan Desert (Xinjiang, China)." *Textile Society of America Symposium Proceedings* 958: 66–75.

Di Cosmo, Nicola. 2002. *Ancient China and Its Enemies: The Rose of Nomadic Power in East Asian History*. Cambridge: Cambridge University Press.

Di Cosmo, Nicola and Michael Maas, eds. 2018. *Empires and Exchanges in Eurasian Late Antiquity: Rome, China, Iran, and the Steppe, ca. 250–750*. Princeton: Princeton University Press.

Diaz-Andreu, Margarita. 2007. *A World History of Nineteenth-Century Archaeology: Nationalism, Colonialism and the Past*. Oxford: Oxford University Press.

Dikovitskaya, Margaret. 2007. "Central Asia in Early Photographs: Russian Colonial Attitudes and Visual Culture." In *Empire, Islam, and Politics in Central Eurasia*, edited by Tomohiko Uyama, 99–121. Slavic Research Center.

Dolezalek, Isabelle. 2017. *Arabic Script on Christian Kings: Textile Inscriptions on Royal Garments from Norman Sicily*. Berlin: Walter de Gruyter GmbH.

Donner, Fred. 2010. *Muhammad and the Believers: At the Origins of Islam*. Cambridge, MA: Harvard University Press.

Dunn, Marilyn. 2003. *The Emergence of Monasticism: From the Desert Fathers to the Early Middle Ages*. London: John Wiley & Sons.

Durand, Maximilien. 2014. "Suaire de saint Austremoine, dit aussi 'Suaire de Mozac.'" Description for online catalogue, Musée des Tissus/ Musée des Arts Décoratifs de Lyon (MTMAD): www.mtmad.fr [last accessed 7 June 2019]

Durand, Maximilien and Florence Calament. 2013. *Antinoé, à la vie, à la mode: vision d'élégance dans les solitudes*. Paris: Fage Editions.

Duri, A. A. 2007. "Baghdād." In *Historic Cities of the Islamic World*, edited by C. Edmund Bosworth, 30–47. Leiden: Brill.

Dussubieux, Laure, Bernard Gratuze and Maryse Blet-Lemarquand. 2010. "Mineral Soda Alumina Glass: Occurrence and Meaning." *Journal of Archaeological Science* 37: 1646–55.

E

Eaton, Richard M. 2005. "*A Social History of the Deccan, 1300–1761: Eight Indian Lives*. Cambridge: Cambridge University Press.

Edson, Evelyn et al. 2004. *The Medieval Cosmos: Picturing the Universe in the Christian and Islamic Middle Ages*. Oxford: Bodleian Library.

Egeria. Trans. by John Wilkinson. 2006. *Egeria's Travels*. Oxford: Aris & Phillips.

Eichhorn, Werner. 1954. "Description of the Rebellion of Sun En and Earlier Taoist Rebellions." *Mitteilungen des Instituts für Orientforschung* 2: 325–52.

Epstein, Anne Wharton. 1986. *Tokalı Kilise: Tenth-Century Metropolitan Art in Byzantine Cappadocia*. Washington, DC: Dumbarton Oaks.

Eregzen, G., ed. 2011. *Treasures of the Xiongnu*. Ulaanbaatar: Shinzhlèkh Ukhaany Akademi, Arkheologiïn Khùréélèn.

Errington, Elizabeth. 2017. *Charles Masson and the Buddhist Sites of Afghanistan: Explorations, Excavations, Collections 1833–1835*. London: The British Museum Press.

Ettinghausen, Richard, Oleg Grabar and Marilyn Jenkins-Madina. 2001. *Islamic Art and Architecture 650–1250*. New Haven and London: Yale University Press.

Eusebius of Caesarea. Trans. by Paul L. Maier. 1999. *Eusebius: The Church History*. Grand Rapids: Kregel.

Evans, Helen C. and William D. Wixon, eds. 1997. *The Glory of Byzantium: Art and Culture of the Middle Byzantine Era, A.D. 843–1261*. New York: Metropolitan Museum of Art.

F

Faccenna, Domenico. 2001. *Il fregio figurato dello Stūpa Principale nell'area sacra buddhista di Saidu Sharif I (Swat, Pakistan)*. Rome: IsIAO Reports and Memoirs XXVIII.

Faccenna, Domenico and Piero Spagnesi. 2014. *Buddhist Architecture in the Swat Valley, Pakistan: Stupas, Viharas, a Dwelling Unit*. Lahore: Sang-e-Meel Publications.

Faller, Stefan. 2011. "The World According to Cosmas Indicopleustes – Concepts and Illustrations of an Alexandrian Merchant and Monk." *Transcultural Studies* 1: 193–232.

Fan Jinshi. Trans. by Susan Whitfield. 2013. *The Caves of Dunhuang*. London: Scala Arts Publishers.

Faxian *see* Legge 1886.

Ferdowsi, Abu'l Qasim. Trans. by Dick Davies. 2016. *Shahnameh: The Persian Book of Kings*. New York: Penguin Books.

Ferrand, Gabriel. 1928. *Instructions nautiques et routiers Arabes et Portugais des XVe et XVIe siècles: reproduits, traduits et annotés; Tome III Introduction à l'Astronomie Nautique Arabe*. Paris: Librairie Orientaliste Paul Geuthner.

Filesi, Teobaldo. 1972. *China and Africa in the Middle Ages*. London: Frank Cass.

Filigenzi, Anna. 2003. "The Three Hares from Bīr-Koṭ-Ghwaṇḍai: Another Stage in the Journey of a Widespread Motif." In *Studi in onore di Umberto Scerrato in occasione del suo settantacinquesimo compleanno*, edited by M. V. Fontana and B. Genito, 327–46. Naples: Universita' Studi Napoli.

Filigenzi, Anna. 2006. "From Saidu Sharif to Miran." *Indologica Taurinensia* 32: 67–89.

Filigenzi, Anna. 2012. "Orientalised Hellenism versus Hellenised Orient: Reversing the Perspective on Gandharan Art." *Ancient Civilizations from Scythia to Siberia* 18: 111–41.

Finlay, Victoria. 2007. *Color: A Natural History of the Palette*. New York: Random House Publishing Group.

Finn, Richard. 2009. *Asceticism in the Graeco-Roman World*. Cambridge: Cambridge University Press.

Fisher, Greg, ed. 2015. *Arabs and Empires before Islam*. Oxford: Oxford University Press.

Fitzhugh, William et al. 2013. *Genghis Khan and the Mongol Empire*. Hong Kong: Odyssey Books and Maps.

Flood, Finbarr Barry. 2001. *The Great Mosque of Damascus: Studies on the Makings of an Umayyad Visual Culture*. Boston: Brill.

Flood, Finbarr Barry. 2009. *Objects of Translation: Material Culture and Medieval "Hindu-Muslim" Encounter*. Princeton, NJ: Princeton University Press.

Forêt, Philippe and Andreas Kaplony, eds. 2008. *The Journey of Maps and Images on the Silk Road*. Leiden: Brill.

Forsyth, Thomas Douglas. 1875. *Report of a Mission to Yarkund in 1873*. Calcutta: Foreign Department Press.

Foucher, Alfred in collaboration with Mme Bazin-Foucher. 1942, 1947. "La vieille route de l'Inde, de Bactres à Taxila." In *Mémoires de la Délégation archéologique française en Afghanistan*, 2 vols. Paris: Édition d'Art et d'Histoire.

Fragner, Bert G. et al. 2009. *Pferde in Asien: Geschichte, Handel und Kultur*. Vienna: Austrian Academy of Sciences Press.

Francfort, Henri-Paul. 2011. "Tillya Tépa (Afghanistan). La sépulture d'un roi anonyme de la Bactriane du 1er siècle p.C." *Topoi* 17.1: 277–347.

Francfort, Henri-Paul, F. Grenet, G. Lecuyot, B. Lyonnet, L. Martinez-Sève and C. Rapin. 2014. *Il y a 50 ans... la découverte d'Aï Khanoum*. Paris: Diffusion de Boccard.

Francis, Peter. 2002. *Asia's Maritime Bead Trade: 300 B.C. to the Present*. Honolulu: University of Hawaii Press.

Fray, Geraldine, F. Grenet, M. Khasanov, M. Reutova and M. Riep. 2015. "A Pastoral Festival on a Wall Painting from Afrasiab (Samarkand)." *Journal of Inner Asian Art and Archaeology* 6: 53–73.

Freeman-Grenville, G. S. P., trans. 1981. *Book of the Wonders of India: Mainland, Sea and Islands*. Bishop's Stortford: East-West Publications.

Frumkin, Grégoire. 1970. *Archaeology in Soviet Central Asia*. Leiden: Brill.

Fuji, Hideo, K. Sakamoto, M. Ichihashi, M. Sadahira and Fibers & Textiles Laboratories, Toray Industries. 1991. "Textiles from At-Tar Caves: Part II–(2): Cave 16, Hill C." *Al Râfidan* 12: 157–65.

G

Gadjiev, Murtazali. 2008. "On the Construction Date of the Derbend Fortification Complex." *Iran and the Caucasus* 12.1: 1–15.

Gavrilov, M. 1928. "O remeslennykh tsekhakh Sredney Azii i ikh statutakh-risola." *Invizes-tiya Sredne-Aziatskogo komiteta po delam muzeyev i okhrana pamyatnikov stariny, iskusstva i prirody* 3: 223–41.

Geary, Patrick J. 1991. *Furta Sacra: Thefts of Relics in the Central Middle Ages*. Princeton, NJ: Princeton University Press.

Gentelle, Pierre. 2003. *Un Géographe Chez les Archéologues*. Paris: Bélin.

George, Alain. 2009. "Calligraphy, Colour and Light in the Blue Qur'an." *Journal of Qur'anic Studies* 11: 75–125.

Gernet, Jacques. 1962. *Daily Life in China on the Eve of the Mongol Invasion, 1250–1276*. Stanford: Stanford University Press.

Gernet, Jacques. Trans. by Franciscus Verellen. 1998. *Buddhism in Chinese Society: An Economic History from the Fifth to the Tenth Centuries*. New York: Columbia University Press.

al-Ghabban and Ali Ibrahim, eds. 2010. *Roads of Arabia: Archaeology and History of the Kingdom of Saudi Arabia*. Paris: Somogy Art Publishers.

Ghose, Rajeshwari. 2000. *In the Footsteps of the Buddha: An Iconic Journey from India to China.* Hong Kong: Odyssey Publications.

Gilboa, Ayelet and Dvory Namdar. 2015. "On the Beginnings of South Asian Spice Trade with the Mediterranean Region: A Review." *Radiocarbon* 57.2: 265–83.

Goitein, Shelomo Dov and Mordechai Friedman. 2008. *India Traders of the Middle Ages: Documents from the Cairo Geniza 'India Book'.* Leiden: Brill.

Golden, Peter B. 2010. *Turks and Khazars: Origins, Institutions, and Interactions in Pre-Mongol Eurasia.* Aldershot: Ashgate Publishing.

Goldman, Bernard M. and Norma W. Goldman. 2011. *My Dura-Europos: The Letters of Susan M. Hopkins, 1927–1935.* Detroit: Wayne State University Press.

Gordon, Stewart T., Matthew Ciolek, Lizabeth H. Piel and Gita Gunatilleke. 2009. *The Electronic Atlas of Buddhist Monasteries.* Ann Arbor: Center for South Asian Studies. http://www.ciolek.com/GEO-MONASTIC/geo-monasteries-home.html [last accessed 7 June 2019]

Grabar, Oleg. 1966. "The Earliest Islamic Commemorative Structures." *Ars Orientalis* 4: 7–46.

Grabar, Oleg. 2006. *The Dome of the Rock.* Cambridge, MA: Belknap Press.

Grabar, Oleg, R. Holod, J. Knutstad and W. Trousdale. 1978. *City in the Desert: Qasr al-Hayr East.* USA: Harvard Middle Eastern Monographs.

Granscay, S. V. 1963. "A Sasanian Chieftain's Helmet." *Bulletin of the Metropolitan Museum of Art* n.s. 21: 253–62.

Green, Caitlin R. 2017. "Sasanian Finds in Early Medieval Britain and Beyond: Another Global Distribution from Late Antiquity." http://www.caitlingreen.org/2017/07/sasanian-finds-in-early-medieval-britain.html#fn20 [last accessed 7 June 2019]

Greeves, Tom, Sue Andrew and Chris Chapman. 2017. *The Three Hares: A Curiosity Worth Regarding.* South Moulton: Skerryvore Productions.

Grenet, Frantz. 2002. "Regional interaction in Central Asia and North-west India in the Kidarite and Hephthalite periods." In *Indo-Iranian languages and peoples*, edited by Nicholas Sims-Williams, *Proceedings of the British Academy* 116: 222–23.

Grenet, Frantz. 2004. "Maracanda/Samarkand, une métropole pré-mongole: sources écrites et archéologie." *Annales. Histoire, Sciences Sociales* 5/6: 1043–67.

Grenet, Frantz. 2013. "Zoroastrian Funerary Practices in Sogdiana and Chorasmia and among Expatriate Sodgian Communities in China." In *The Everlasting Flame: Zoroastrianism in History and Imagination*, edited by Sarah Stewart, 18–33. London: I. B. Tauris.

Grosjean, Georges, ed. and trans. 1978. *Mapamundi: The Catalan Atlas of the Year 1375.* Dietikon-Zurich: Abaris Books.

Gryaznov [Grjasnoff], M. P. 1929. "Ein bronzener Dolch mit Widderkopf aus Ostsibirien." *Artibus Asiae* 4: 192–99.

Gulácsi, Zsuzsanna. 2001. *Manichaean Art in Berlin Collections: A Comprehensive Catalogue. Corpus Fontium Manichaeorum: Series Archaeologica et Iconographica 1.* Turnhout: Brepols.

Gulácsi, Zsuzsanna. 2005. *Mediaeval Manichaean Book Art: A Codicological Study of Iranian and Turkic Illuminated Book Fragments from 8th – 11th Century East Central Asia. (Nag Hammadi and Manichaean Studiesi 57).* Leiden: Brill.

Gulácsi, Zsuzsanna. 2014. "The Prophet's Seal: A Contextualized Look at the Crystal Sealstone of Mani (216–276 CE) in the Bibliothèque nationale de France." *Bulletin of the Asia Institute* 24: 161–85.

Gulácsi, Zsuzsanna. 2015. *Mani's Pictures: The Didactic Images of the Manichaeans from Sasanian Mesopotamia to Uygur Central Asia and Tang-Ming China (Nag Hammadi and Manichaean Studies 90).* Leiden: Brill.

Gulácsi, Zsuzsanna and Jason BeDuhn. 2011/15. "Picturing Mani's Cosmology: An Analysis of Doctrinal Iconography on a Manichaean Hanging Scroll from 13th/14th-century Southern China." *Bulletin of the Asia Institute* 25: 55–105.

Guy, John. 2017. "The Phanom Surin Shipwreck, a Pahlavi Inscription, and their Significance for the Early History of Lower Central Thailand." *Journal of the Siam Society* 105: 179–96.

H

Hafez, Ihsan. 2010. *Abd al-Rahman al-Sufi and his* Book of the Fixed Stars: *A Journey of Re-discovery.* PhD thesis, James Cook University.

Hahn, Cynthia. 2012. *Strange Beauty: Issues in the Making and Meaning of Reliquaries, 400–circa. 1204.* Pennsylvania: Penn State University Press.

Hallett, Jessica. 2000. *Trade and Innovation: The Rise of a Pottery Industry in Abbasid Basra, Vol. 1.* Oxford: Oxford University Press.

Hanebutt-Benz, Eva, Dagmar Glass and Geoffrey Roper, eds. 2002. *Middle Eastern Languages and the Print Revolution, a Cross-Cultural Encounter, a Catalogue and Companion to the Exhibition.* Westhofen: WVA-Verlag Skulima.

Hansen, Valerie. 2000. *The Open Empire: A History of China to 1600.* New York and London: W. W. Norton & Co.

Hansen, Valerie. 2004. "Religious Life in a Silk Road Community: Niya During the Third and Fourth Centuries." In *Religion and Chinese Society: Ancient and Medieval China*, edited by John Lagerwey, 279–315. Hong Kong: Chinese University Press.

Hansen, Valerie. 2012. *The Silk Road: A New History.* New York: Oxford University Press.

Hansen, Valerie. 2017. *The Silk Road: A New History with Documents.* Oxford: Oxford University Press.

Hansen, Valerie and Helen Wang, eds. 2013. *Textiles as Money on the Silk Road? (Journal of the Royal Asiatic Society 23.2).* Cambridge: Cambridge University Press.

Hansen, Valerie and Yoshida Yutaka. 2003. "New Work on the Sogdians, the Most Important Traders on the Silk Road, AD 500-1000, with an Appendix by Y. Yoshida, 'Translation of the contract for the purchase of a slave girl found at Turfan and dated 639.'" *T'oung Pao* 89.1-3: 149–61.

Hanshu *see* Hulsewé and Loewe 1979.

Harley, J. B. and David Woodward, eds. 1992. *Cartography in the Traditional Islamic and South Asian Societies, The History of Cartography, Vol. 2, Bk. 1.* Chicago: University of Chicago Press.

Harper, Kyle. 2017. *The Fate of Rome: Climate, Disease, and the End of an Empire.* Princeton, NJ: Princeton University Press.

Harper, Prudence O. 1971. "Sources of Certain Female Representations in Sasanian Art." In *Atti del convegno internazionale sul tema: La Persia nel Medioevo (Roma, 31 marzo–5 aprile 1970),* 503–15. Rome: Accademia nazionale dei Lincei.

Harper, Prudence O. 2001. "Iranian Luxury Vessels in China from the Late First Millennium BCE to the Second Half of the First Millennium CE." In *Nomads, Traders and Holy Men along China's Silk Road,* edited by Annette Juliano and Judith Lerner, 95–114. Turnhout: Brepols.

Harper, Prudence O. 2006. *In Search of a Cultural Identity: Monuments and Artifacts of the Sasanian Near East, 3rd to 7th Century A.D.* New York: Bibliotheca Persica.

Härtel, Herbert and Marianne Yaldiz. 1982. *Along the Ancient Silk Routes: Central Asian Art from the West Berlin State Museum.* New York: Metropolitan Museum of Art.

Hauser, Stefan R. 1996. "The Production of Pottery in Arsacid Ashur." In *Continuity and Change in Northern Mesopotamia from the Hellenistic to the Early Islamic Period,* edited by Karin Bartl and Stefan R. Hauser, 55–85. Berlin: Reimer.

Hawkes, Jason and Akira Shimada, eds. 2009. *Buddhist Stupas in South Asia, Recent Archaeological, Art-Historical and Historical Perspectives.* Delhi: Oxford University Press.

Hazrat Inayat Khan. 1963. *The Sufi Message of Hazrat Inayat Khan: The Mysticism of Sound, Music, The Power of the Word, and Cosmic Language.* The Library of Alexandria.

Hedeager Krag, Anne. 2004. "New Light on a Viking Garment from Ladby. Denmark." In *Priceless Invention of Humanity—Textiles, 8th North European Symposium for Archaeological Textiles,* edited by J. Maik, 81–86. Lodz: Łódzie Towarzystwo Naukowe.

Hedeager Krag, Anne. 2010. "Oriental Influences in the Danish Viking Age: Kaftan and Belt with Pouch." In *North European Symposium for Archaeological Textiles X,* edited by Eva Andersson Strand, 113–16. Oxford: Oxbow.

Helle, Knut, ed. 2003. *The Cambridge History of Scandinavia, Vol. 1. Prehistory to 1520.* Cambridge: Cambridge University Press.

Heller, Amy. 2018. "An Eighth Century Child's Garment of Sogdian and Chinese Silks." In *Chinese and Central Asian Textiles: Selected Articles from* Orientations *1983–1997.* Hong Kong: Orientations.

Henderson, Julian. 2013. *Ancient Glass: An Interdisciplinary Exploration.* Cambridge: Cambridge University Press.

Henderson, Julian, J. An and H. Ma. 2018. "The Archaeology and Archaeometry of Chinese Glass: a Review." *Archaeometry* 60: 88–104.

Heng Chye-kiang. 1999. *Cities of Aristocrats and Bureaucrats: The Development of Medieval Chinese Cityscapes.* Honolulu: University of Hawaii Press.

Herodotus. Trans. by George Rawlinson. 1909. *The History of Herodotus.* New York: The Tandy-Thomas Co. https://oll.libertyfund.org/titles/herodotus-the-history--6 [last accessed 7 June 2019]

Herrmann, G. 1968. "Lapis Lazuli: the Early Phases of its Trade." *Iraq* 30: 21–57.

Herrmann, G. 1999. *Monuments of Merv: Traditional Buildings of the Karakum.* London: Society of Antiquaries.

Hillenbrand, Robert. 1994. *Islamic Architecture: Form, Function and Meaning.* Edinburgh: Edinburgh University Press.

Hirth, Friedrich and W. W. Rockhill, trans. 1911. *Chau Ju-Kua: his work on the Chinese and Arab Trade in the Twelfth and Thirteenth Centuries, entitled Chuo fan-chi.* St Petersburg: Imperial Academy of Sciences.

Hobbs, Richard and Ralph Jackson. 2010. *Roman Britain: Life at the Edge of Empire.* London: British Museum Press.

Hocker, Frederick. 2011. *Vasa: A Swedish Warship.* Stockholm: Medströms Bokförlag.

Hoffman, Adina and Peter Cole. 2011. *Sacred Trash: The Lost and Found World of the Cairo Geniza.* New York: Schocken Books.

Homer. Trans. by E. V. Rieu. 2003. *The Odyssey.* London: Penguin Classics.

Hopkins, Clark. 1979. *The Discovery of Dura-Europos.* New Haven: Yale University Press.

Hopkins, Susan *see* Goldman and Goldman 2011.

Hopkirk, Peter. 2011. *Foreign Devils on the Silk Road.* London: John Murray.

Horton, Mark. 1996. *Shanga. The Archaeology of a Muslim Trading Community on the Coast of East Africa*. London: British Institute in Eastern Africa.

Horton, Mark, Jeffrey Fleisher and Stephanie Wynne-Jones. 2017. "The Mosques of Songo Mnara in their Urban Landscape." *Journal of Islamic Archaeology* 4.2: 63–188.

Howard, Angela Falco et al. 2003. *Chinese Sculpture*. New Haven: Yale University Press.

Huang Xinya. Trans. by Yu Guoyang and Yan Hongfu. 2014. *The Urban Life of the Tang Dynasty*. Reading: Paths International Ltd.

Hughes, Bettany. 2017. *Istanbul: A Tale of Three Cities*. London: Weidenfeld & Nicolson.

Hulsewé, Anthony F. P. and Michael Loewe. 1979. *China in Central Asia: the Early Stage: 125 B.C.–A.D. 23, an Annotated Translation of Chapters 61 and 96 of the History of the Former Han Dynasty*. Leiden: Brill.

Hung, Hsiao-Chun, Y. Iizuka, P. Bellwood, Kim Dung Nguyen, B. Bellina, P. Silapanth, E. Dizon, R. Santiago, Ipoi Datan and J. Manton. 2005. "Ancient Jades Map 3000 Years of Prehistoric Exchange in Southeast Asia." *Proceedings of the National Academy of Sciences*, 104.50: www.pnas.org/cgi/doi/10.1073/pnas.0707304104 [last accessed 7 June 2019]

Huntington, Susan. 2015. "Shifting the Paradigm: The Aniconic Theory and Its Terminology." *South Asian Studies* 31.2: 163–86.

Hyecho *see* Wegehaupt 2012.

I

Ierusalimskaja, Anna. 1978. "Le cafetan aux simourghs du tombeau de Motchtchevaja Balka (Caucase Septentrional)." *Studia Iranica* 7.2: 182–211.

Ierusalimskaja, Anna. 1996. *Die Gräber der Moscevaja Balka: Frühmittelalterliche Funde an der nordkaukasischen Seidenstrasse*. München: Editio Maris.

al-Iṣṭakhrī. Trans. and ed. by M. J. de Goeje. 2014. *Kitāb al-Masālik wa l-mamālik* by Abū Isḥāq al-Iṣṭakhrī. Leiden: Brill.

J

Jäger, Ulf. 2007. "Schriften und Schriftlichkeit im Tarim-Becken bis zum vierten nachchristlichen Jahrhundert." In *Ursprünge der Seidenstrasse. Sensationelle Neufunde aus Xinjiang, China*, edited by Alfried Wieczorek and Christoph Lind, 260. Stuttgart: Theiss; Mannheim: Reiss-Engelhorn-Museen.

Jákl, Jiří. 2017. "Black Africans on the Maritime Silk Route, Indonesia and the Malay World. Jəŋgi in Old Javanese epigraphical and literary evidence." *Indonesia and the Malay World* 45.133: 334–51.

Japan Center for International Cooperation in Conservation, ed. 2005. *Preserving Bamiyan. Proceedings of the International Symposium "Protecting the World Heritage Site of Bamiyan" Tokyo, 21 December 2004*.

Jerome. Trans. by W. H. Fremantle. 1893. "Against Jovinian." *Nicene and Post-Nicene Fathers* 6: 346–416.

Jerusalimskaja *see* Ierusalimskaja.

Jettmar, Karl. 1970. "Metallurgy in the Early Steppes." *American Journal of Archaeology* 74: 229–30.

Jidejian, Nina. 1969. *Tyre Through the Ages*. Beirut: Dar el-Mashreq Publishers.

Jing Ai 景爱. 2001. *Shamo kaogu tonglun* 沙漠考古通论. Beijing: Zijincheng chubanshe.

Johns, Catherine. 2010. *The Hoxne Late Roman Treasure: Gold Jewellery and Silver Plate*. London: British Museum Press.

Juliano, Annette L. and Judith A. Lerner. 2001. *Monks and Merchants: Silk Road Treasures from Northern China*. New York: Asia Society.

K

Kaizer, Ted. 2002. *The Religious Life of Palmyra: A Study of the Social Patterns of Worship in the Roman Period*. Stuttgart: Franz Steiner Verlag.

Kakinuma, Yohei. 2014. "The Emergence and Spread of Coins in China from the Spring and Autumn Period to the Warring States Period." In *Explaining Monetary and Financial Innovation: A Historical Analysis*, edited by P. Bernholz and R. Vaubel, 79–126. Switzerland: Springer.

Kalopissi-Verti, Sophia and Maria Panayotidi. 2010. "Excavations on the Holy Summit (Jebel Mūsā) at Mount Sinai: Preliminary Remarks on the Justinianic Basilica." In *Approaching the Holy Mountain. Art and Liturgy at St Catherine's Monastery in the Sinai*, edited by Sharon E. J. Gerstel and Robert S. Nelson, 73–106. Turnhout: Brepols.

Kaplony, Andreas. 2008. "Comparing al-Kāshgharī's Map to his Text: On the Visual Language, Purpose, and Transmission of Arabic-Islamic Maps." In *The Journey of Maps and Images on the Silk Road*, edited by Philippe Forêt and Andreas Kaplony, 137–54. Leiden: Brill.

Karev, Yury. 2005. "Qarakhanid Wall Paintings in the Citadel of Samarqand: First Report and Preliminary Observations." *Muqarnas* 22: 45–84.

al-Kashgari, Mahmûd. Trans. by Mustafa S. Kaçalin. 2017. *Dîvânu lugâti't-turk*. Istanbul: Kabalcı Publishing.

al-Kashgari, Mahmûd *see also* Dankoff and Kelly 1982–85.

Katz, Nathan. 2000. *Who Are the Jews of India?* Berkeley: University of California Press.

Kennedy, Hugh. 1986. *The Prophet and the Age of the Caliphates.* London: Longman.

Kessler, Oliver. 1998. "The Discovery of an Ancient Sea Port at the Silk Road of the Sea: Archaeological Relics of the Godavaya Harbour." In *Sri Lanka: Past and Present, Archaeology, Geography, Economics,* edited by M. Domrös and H. Roth, 12–37. Weikersheim: Margraf Verlag.

Kiani, Muhammad Y. 1981. *Discoveries from Robat-e Sharaf.* Tehran: Sekkeh Press.

Kimura, Jun. 2014. *Archaeology of East Asian Shipbuilding.* Gainesville: University Press of Florida.

King, David A. 1987. *Islamic Astronomical Instruments.* London: Variorum Reprints.

Kingwell-Banham, Eleanor J. 2015. *Early Rice Agriculture in South Asia. Identifying Cultivation Systems using Archaeobotany.* PhD thesis, University College London.

Kiselev, S. V. 1965. "Bronzovyy vek SSSR." *Novoe v sovetskoy arkheologii. Pamyati Sergeya Vladimirovicha Kiselova. K 60-letiyu so dnya rozhdeniya* 130: 17–61.

Klanten, Robert. 2012. *Nostalgia: The Russian empire of Czar Nicholas II. Captured in colour photographs by Sergei Mikhailovich Prokudin-Gorskii.* Berlin: Gestalten.

Klee, Margot. 2006. *Grenzen des Imperiums. Leben am römischen Limes.* Stuttgart: Theiss Verlag.

Kleiss, Wolfram. 1996–2001. *Karawanenbauten in Iran,* 6 vols. Berlin: Reimer Verlag.

Klimburg-Salter, Deborah. 1989. *The Kingdom of Bāmiyān: Buddhist Art and Culture of the Hindu-kush.* Naples-Rome: IsMEO.

Kocabas, Ufuk. 2014. "The Yenikapı Byzantine-Era Shipwrecks, Istanbul, Turkey: a preliminary report and inventory of the 27 wrecks studied by Istanbul University." *The International Journal of Nautical Archaeology* 44.1: 5–38.

Kominko, Maja. 2013. *The World of Kosmas: Illustrated Byzantine Codices of the Christian Topography.* Cambridge and New York: Cambridge University Press.

Kósa, Gábor. 2012. "Atlas and Splenditenens in the Cosmology Painting." In *Gnostica et Manichaica: Festschrift für Aloïs van Tongerloo,* edited by M. Knüppel and L. Cirillo, 39–64. Wiesbaden: Harrassowitz Verlag.

Kozlovskaya, Valeriya, ed. 2017. *The Northern Black Sea Region in Antiquity.* Cambridge: Cambridge University Press.

Krahl, Regina, John Guy, J. Keith Wilson and Julian Raby, eds. 2010. *Shipwrecked: Tang Treasures and Monsoon Winds.* Washington, DC: Smithsonian Institution.

Kroll, Paul W. 1981. "The Dancing Horses of T'ang." *T'oung Pao,* 2nd series, 67.3.5: 240–68.

Kubarev, Gleb V. 2005. *Kul'tura drevnikh tyurok Altaya (po materialam pogrebal'nykh pamyatnikov).* Novosibirsk: Institute of Archaeology and Ethnography, SB RAS.

Kuhn, Dieter. 1995. "Silk Weaving in Ancient China: From Geometric Figures to Patterns of Pictorial Likeness." *Chinese Science* 12: 77–114.

Kulikov, V. E., E. Yu. Mednikova, Yu. I. Elikhina, S. S. Miniaev. 2009. "An Experiment in Studying the Felt Carpet from Noyon uul by the Method of Polypolarization." *The Silk Road* 8: 73–78.

Kunst und Ausstellungshalle der Bundesrepublik Deutschland GmbH, ed. 1985. *Gandhara – das buddhistische Erbe Pakistans.* Mainz: Philipp von Zabern.

Kurbanov, Aydogdy. 2010. *The Hephthalites: Archaeological and Historical Analysis.* PhD thesis, Free University Berlin. http://www.diss.fu-berlin.de/diss/receive/FUDISS_thesis_000000016150 [last accessed 7 June 2019]

Kyselka, Will. 1987. *An Ocean in Mind.* Honolulu: University of Hawaii Press.

L

la Vaissière, Étienne de. Trans. by James Ward. 2005. *Sogdian Traders: A History.* Leiden: Brill.

la Vaissière, Étienne de. 2017. "Early Medieval Central Asian Population Estimates." *Journal of the Social and Economic History of the Orient* 60.6: 788–817.

Laboa, Juan María. 2003. *The Historical Atlas of Eastern and Western Christian Monasticism.* Collegeville: Liturgical Press.

Laing, Ellen Johnston. 1991. "A Report on Western Asian Glassware in the Far East." *Bulletin of the Asia Institute* n.s. 5: 109–21.

Lambourn, Elizabeth. 2004 "Carving and Communities: Marble Carving for Muslim Communities at Khambhat and around the Indian Ocean Rim (late 13th–mid-15th centuries CE)." *Ars Orientalis* 34: 101–35.

Lambourn, Elizabeth. 2018 *Abraham's Luggage. A Social Life of Things in the Medieval Indian Ocean World.* Cambridge: Cambridge University Press.

Lambton, Ann Katharine Swynford and Janine Sourdel-Thomine. 2007. "Isfahan." In *Historic Cities of the Islamic World,* edited by Clifford Edmund Bosworth, 167–79. Leiden: Brill.

Landau-Tasseron, Ella. 2010. "Arabia." In *The New Cambridge History of Islam. Volume 1,* edited by Chase Robinson, 395–447. Cambridge: Cambridge University Press.

Lane, George. 2018. *The Phoenix Mosque and the Persians of Medieval Hangzhou*. London: Gingko Library Publications.

Langer, Robert. 2004. "From Private Shrine to Pilgrimage Centre." In *Zoroastrian Rituals in Context*, edited by M. Stausberg, 563–92. Leiden: Brill.

Lawergren, Bo. 1995/6. "The Spread of Harps Between the Near and Far East During the First Millennium A.D.: Evidence of Buddhist Musical Cultures on the Silk Road." *Silk Road Art and Archaeology* 4: 244.

Lawergren, Bo. 2003. "Western Influences on the Early Chinese Qin-Zither." *Bulletin of The Museum of Far Eastern Antiquities (Östasiatiska Museet)* 75: 79–109.

Łazar P'arpec'i *see* Bedrosian 1985.

Le Strange, Guy. 1900. *Baghdad under the Abbasid Caliphate from Contemporary Arabic and Persian Sources*. Oxford: Clarendon Press.

Leader-Newby, Ruth. 2004. *Silver and Society in Late Antiquity*. Farnham: Ashgate.

Legge, James, trans. 1886. *A Record of the Buddhistic Kingdoms: Being an account by the Chinese monk Fâ-Hien of his travels: India and Ceylon (A.D. 399–414) in search of the Buddhist books of discipline*. Oxford: The Clarendon Press.

Levene, Dan and Gideon Bohak. 2012. "A Babylonian Jewish Aramaic Incantation Bowl with a List of Deities and Toponyms." *Jewish Studies Quarterly* 19.1: 56–72.

Lewis, Bernard, ed. and trans. 2011. *Music of a Distant Drum: Classical Arabic, Persian, Turkish, and Hebrew Poems*. Princeton, NJ: Princeton University Press.

Li Qinghui, Jie Jiang, Xinling Li, Song Liu, Donghong Gu and Julian Henderson. 2016. "Chemical Analysis of the Glass Vessels Unearthed from the Underground Palace of Famen Temple Using a Portable XRF Spectrometer." In *Recent Advances in the Scientific Research on Ancient Glass and Glaze*, edited by Gan Fuxi, Li Qinghui and Julian Henderson, 157–78. Singapore: World Scientific Publishing Co.

Lieu, Samuel N. C. 1992. *Manichaeism in the Later Roman Empire and Medieval China*. Tübingen: Mohr.

Lieu, Samuel N. C. et al., eds. 2012. *Medieval Christian and Manichaean Remains from Quanzhou (Zayton)*. Turnhout: Brepols.

Lin Meicun 林梅村. 2003. "Handai xiyu yishu zhong de xila wenhua yinsu" 汉代西域艺术中的希腊文化因素. *Jiuzhou xuelin*. 九州学林 2: 2–35.

Lindström, Gunvor and Rachel Mairs, eds. 2017. *Ritual Matters. Archaeology and Religion in Hellenistic Central Asia (Proceedings of the 2nd Meeting of the Hellenistic Central Asia Research Network [HCARN], 2017). (Archäologie in Iran und Turan)*. Darmstadt: Verlag Philipp von Zabern.

Lindström, Gunvor, Svend Hansen, Alfried Wieczorek, Michael Tellenbach. eds. 2013. *Zwischen Ost und West. Neue Forschungen zum antiken Zentralasien (Wissenschaftliches Kolloquium 30.9.-2.10.2009 in Mannheim). (Archäologie in Iran und Turan 14)*. Darmstadt: Verlag Philipp von Zabern.

Linduff, Katheryn M. and Jianjun Mei. 2008. "Metallurgy in Ancient Eastern Asia." SAA Vancouver. https://www. britishmuseum.org/pdf/Linduff%20Mei%20China.pdf [last accessed 7 June 2019]

Linduff, Katheryn M. and Karen S. Rubinson, eds. 2008. *Are All Warriors Male? Gender Roles on the Ancient Eurasian Steppe*. Lanham: AltaMira Press.

Liu, Xinru. 1988. *Ancient India and Ancient China, Trade and Religious Exchanges AD 1–600*. Delhi: Oxford University Press.

Liu, Xinru. 1996. *Silk and Religion: An Exploration of Material Life and the Thought of People, AD 600–1200*. Delhi: Oxford University Press.

Liu, Yan. 2017. "Exotica as Prestige Technology: The Production of Luxury Gold in Western Han Society." *Antiquity* 91.360: 1588–1602.

Liu, Yang. 2013. "Nomadic Influences in Qin Gold." *Orientations* 44.4: 119–25.

Lo Muzio, Ciro. 2017. *Archeologia dell'Asia centrale preislamica. Dall'età del Bronzo al IX secolo d.C.* Milan: Mondadori Università.

Lubo-Lesnichenko, E. I. 1961. *Drevniye kitayskiye sholkovyye tkani i vyshivki. V v. do n.e. — III v.n.e. v sobranii Gosudarstvennogo Ermitazha*. St Petersburg: State Publishing House, Hermitage.

Lubo-Lesnichenko, E. I. 1994. *Kitay na Shelkovom puti, shelk i vneshniye svyazi drevnego i rannesrednevekovogo Kitaya*. Moscow: Izdatel'skaia firma "Vostochnaia literatura".

Lukonin, Vladimir G. and Anatoli Ivanov. 2003. *Persian Art: Lost Treasures*. London: Mage Publishers.

M

Macfarlane, Robert. 2008. *The Wild Places*. London: Penguin Books.

Maïla-Afeiche, Anne-Marie et al. 2012. *L'Histoire de Tyr au témoignage de l'archéologie, Actes du séminaire International Tyr 2011, Liban, Direction Générale des Antiquitées (BAAL, Hors-Série VIII)*. Beirut: Institut français du Proche-Orient.

Mairs, Rachel. 2011. *The Archaeology of the Hellenistic Far East: A Survey. Bactria, Central Asia and the Indo-Iranian Borderlands, c. 300 BC – AD 100. (British Archaeological Reports International Series* 2196). Oxford: BAR.

Mairs, Rachel. 2013–18. "The Archaeology of the Hellenistic Far East: A Survey. Supplements." *Hellenistic Far East Bibliography*. https://hellenisticfareast.wordpress.com/about/supplement-5-2017/ [last accessed 7 June 2019]

Manginis, George. 2016. *Mount Sinai. A History of Travellers and Pilgrims*. London: Haus Publishing Ltd.

Mango, Marlia Mundell and Anna Bennett. 1994. *The Sevso Treasure, vol. 1*. Ann Arbor: Journal of Roman Archaeology.

Marco Polo. Trans. by Ronald Latham. 1958. *The Travels of Marco Polo: The Venetian*. London: Penguin Classics.

Marco Polo. Trans. by Henry Yule. 1993. *The Travels of Marco Polo: The Complete Yule-Cordier Edition: Including the Unabridged Third Edition (1903) of Henry Yule's Annotated Translation, as Revised by Henri Cordier*. New York: Dover Publications.

Margariti, Roxani Eleni. 2012. *Aden & the Indian Ocean Trade: 150 Years in the Life of a Medieval Arabian Port*. Chapel Hill, NC: University of North Carolina Press.

Margoliouth, David Samuel. 1907. "An Early Judaeo-Persian Document." In *Ancient Khotan*, M. Aurel Stein, 570–74. Oxford: Clarendon Press.

Marshak, Boris. 1971. *Sogdiĭskoe serebro*. Moscow: Akademiya Nauk SSSR.

Marshak, Boris. 2004. "Central Asian Metalwork in China." In *China: Dawn of a Golden Age 200-750 AD*, edited by James Watt et al., 256–57. New York: Metropolitan Museum of Art.

Marshall, John Hubert. 1960. *A Guide to Taxila*. Cambridge: Cambridge University Press.

Martinez-Sève, Laurianne. 2015. "Ai Khanoum and Greek Domination in Central Asia." *Electrum* 22: 17–46.

Masia-Radford, Kate. 2013. "Luxury Silver Vessels of the Sasanian Period." In *The Oxford Handbook of Ancient Iran*, edited by Daniel Potts, 920–42. New York: Oxford University Press.

Masson, Mihail E. 1953. *K istorii gornogo dela na territorii Uzbekistana*. Tashkent: University of Sciences Publishing.

Matthee, Rudi. 2012. *Persia in Crisis: Safavid Decline and the Fall of Isfahan*. London: I. B. Tauris.

McCrindle, John Watson. 1897. *The Christian Topography of Cosmas, an Egyptian Monk*. London: Hakluyt Society.

Menshikov, L. N. 1999. "Samuil Martynovich Dudin (1863–1929)." *IDP News* 14.

Merrony, Mark. 2004. *The Vikings: Conquerors, Traders and Pirates*. London: Periplus Publishing London Ltd.

Merzlyakova, I. 2002. "The Mountains of Central Asia and Kazakhstan." In *The Physical Geography of Northern Eurasia*, edited by M. Shahgedanova, 380–402. Oxford: Oxford University Press.

Mez, Adam. 1973. *Musul'manskij Renessans*. Moscow: Izdat Nauka.

Michell, G. and G. Rees. 2017. *Buddhist Rock-cut Monasteries of the Western Ghats*. Mumbai: Jaico.

Middleton, Andrew, St John Simpson and Anthony P. Simpson. 2008. "The Manufacture and Decoration of Parthian Glazed 'Slipper Coffins' from Warka." *The British Museum Technical Research Bulletin* 2: 29–37.

Middleton, Nick. 2009. *Deserts: A Very Short Introduction*. Oxford: Oxford University Press.

Miller, Bryan K. 2015. "The Southern Xiongnu in Northern China: Navigating and Negotiating the Middle Ground." In *Complexity of Interaction along the Eurasian Steppe Zone in the First Millennium CE*, edited by J. Bemmann and M. Schmauder, 127–98. *Bonn Contributions to Asian Archaeology* 7.

Miller, Bryan K. and Ursula Brosseder. 2013. "Beasts of the North: Global and Local Dynamics as Seen in Horse Ornaments of the Steppe Elite." *Asian Archaeology* 1: 94–112.

Miller, Konrad. 1926–31. *Mappae Arabicae: Arabische Welt- und Länderkarten des 9.-13. Jahrhunderts*, 6 vols. Stuttgart: Konrad Miller.

Miller, Konrad. 1981. *Weltkarte des Arabers Idrisi vom Jahre 1154*. Stuttgart: Brockhaus/Antiquarium.

Millward, James A. 2012. "Chordophone Culture in Two Early Modern Societies: 'A Pipa-Vihuela' Duet." *Journal of World History* 23.2: 237–78.

Milwright, Marcus. 2016. *The Dome of the Rock and Its Umayyad Mosaic Inscriptions. Edinburgh Studies in Islamic Art*. Edinburgh: Edinburgh University Press.

Miniaev, Sergei S. and L. M. Sakharovskaia. 2007. "Investigation of a Xiongnu Royal Complex in the Tsaraam Valley. Part 2: The Inventory of Barrow No. 7 and the Chronology of the Site." *The Silk Road* 5.1: 44–56.

Mirsky, Jeannette. 1998. *Sir Aurel Stein, Archaeological Explorer*. Chicago: University of Chicago Press.

Mirti, Piero, Marco Pace, Maria Maddalena Negro Ponzi and Maurizio Aceto. 2008. "ICP-MS Analysis of Glass Fragments of Parthian and Sasanian Epoch from Seleucia and Veh Ardašīr (central Iraq)." *Archaeometry* 50: 429–50.

Miya, Noriko 宮紀子. 2007. モンゴル帝国が生んだ世界図: 地図は語る。Tokyo: Nikkei Publishing Inc.

Mizuno, Seiichi. 1965. *Asuka Buddhist Art: Horyu-ji*. New York: Weatherhill Inc.; Tokyo: Heibonsha.

Mordini, Antonio. 1967. "Gold Kushana Coins in the Convent of Dabra Dammo." *Journal of the Numismatic Society of India* 29.2: 19–25.

Mordvintseva, Valentina. 2013. "The Sarmatians: The Creation of Archaeological Evidence." *Oxford Journal of Archaeology* 32.2: 203–19.

Mordvintseva, Valentina and Mikhail Treister. 2007. *Toreutik und Schmuck im nördlichen Schwarzmeergebiet. 2. Jh. v. Chr. – 2. Jh. n. Chr*, 3 vols. Simferopol, Bonn: Tarpan.

Morgan, Joyce and Conrad Walters. 2011. *Journeys on the Silk Road: A Desert Explorer, Buddha's Secret Library, and the Unearthing of the World's Oldest Printed Book*. Sydney: Picador.

Morgan, Llewelyn. 2012. *The Buddhas of Bamiyan*. Cambridge, MA: Harvard University Press.

Moriyasu, Takao. Trans. by Christian Steineck. 2004. *Die Geschichte des uigurischen Manichäismus an der Seidenstrasse*. Wiesbaden: Harrassowitz.

Morris, Henry M. and James M. Wiggert. 1972. *Applied Hydraulics in Engineering*. New York: The Ronald Press.

Mörzer Bruyns, Willem F. J. and Richard Dunn. 2009. *Sextants at Greenwich: A Catalogue of the Mariner's Quadrants, Mariner's Astrolabes Cross-staffs, Backstaffs, Octants, Sextants, Quintants, Reflecting Circles and Artificial Horizons in the National Maritime Museum, Greenwich*. Oxford: Oxford University Press.

Moushegian, Khatchatur, Anahit Moushegian, Cécile Bresc, Georges Depeyrot and François Gurnet. 2003. *History and Coin Finds in Armenia. Inventory of Coins and Hoards (7-19th c.), Volume II*. Wetteren: Moneta.

Munro-Hay, Stuart. 2002. *Ethiopia, the Unknown Land: A Cultural and Historical Guide*. London: I. B. Tauris.

Muthesius, Anne. 1997. *Byzantine Silk Weaving, AD 400 to AD 1200*. Vienna: Verlag Fassbaender.

Muthucumarana, Rasika et al. 2014. "An Early Historic Assemblage Offshore of Godawaya, Sri Lanka: Evidence for Early Regional Seafaring in South Asia."*Journal of Maritime Archaeology* 9: 41–58.

N

Nagaraju, S. 1981. *Buddhist Architecture of Western India*. Delhi: Agam Kala Prakashan.

Narasimhan, Vagheesh M. et al. 2018. *The Genomic Formation of South and Central Asia, Science*. BIORIX preprint: https://www.biorxiv.org/content/biorxiv/early/2018/03/31/292581.full.pdf [last accessed 7 June 2019]

Nariman, F. 2002. "The Contribution of the Sasanians to Zoroastrian Iran." In *A Zoroastrian Tapestry: Art, Religion & Culture*, edited by Pheroza J. Godrej and Firoza Punthakey Mistree, 117–33. Ahmedabad and New Jersey: Mapin Publishing Pvt Ltd.

Needham, Jospeh and Tsien Tsuen-Hsuin. 1985. *Science and Civilisation in China: Volume 5, Chemical Technology, Part 1, Paper and Printing*. Cambridge: Cambridge University Press.

Neelis, Jason. 2011. *Early Buddhist Transmission and Trade Networks*. Leiden: Brill.

Nickel, Lukas. 2013. "The First Emperor and Sculpture in China." *Bulletin of the School of Oriental and African Studies* 76: 413–47.

Nishino, Noriko, Toru Aoyama, Jun Kimura, Takenori Nogami and Thi Lien Le. 2017. "Nishimura Masanari's Study of the Earliest Known Shipwreck Found in Vietnam." *Asian Review of World Histories* 5.2: 106–22.

Niu Ruji 牛汝極. 2008. *Shizilianhua: Zhongguo Yuandai Xuliyawen Jingjiao beiming wenxianyanjiu* 十字蓮花:中國元代敘利亞文景教碑銘文獻研究. Shanghai: Shanghai guiji chubanshe.

Noonan, Thomas S. 1998. *The Islamic World: Russia and the Vikings*. Aldershot: Variorum/Ashgate.

Northedge, Alastair E. 2001. "Thoughts on the Introduction of Polychrome Glazed Pottery in the Middle East." In *La céramique Byzantine et proto-islamique en Syrie-Jordanie (IVe-VIIIe siècles apr. J.-C.)*, edited by E. Villeneuve and P. M. Watson, 207–14. Beirut: Institut français d'archéologie du Proche-Orient.

Norwich, John Julius. 2013. *A Short History of Byzantium*. London: Penguin Books.

Nosch, M-L., Zhao Feng and L. Varadarajan, eds. *Global Textile Encounters (Ancient Textile Series 20)*. Oxford: Oxbow.

O

Oikonomou, Artemios, J. Henderson, M. Gnade, S. Chenery and N. Zacharia. 2018. "An Archaeometric Study of Hellenistic Glass Vessels: Evidence for Multiple Sources." *Journal of Archaeological and Anthropological Sciences* 10: 97–10.

Olivieri, Luca M. 2018. "Amluk-dara (AKD 1). A Revised Excavation Report." *Journal of Asian Civilizations* 42: 1–106.

Olivieri, Luca M. 2018a. "Vajīrasthāna/Bazira and beyond. Foundation and Current Status of the Archaeological Work in Swat.' In *The Creation of Gandhara: An Archaeology of Museum Collections*, edited by Himanshu Prabha Ray, 173–212. New York: Routledge.

Olivieri, Luca M. and A. Filigenzi. 2018. "On Gandhāran Sculptural Production from Swat: Recent Archaeological and Chronological Data." In *Problems of Chronology in Gandhāran Art*, edited by W. Rienjang and P. Stewart, 71–92. Oxford: Archaeopress Publishing Ltd.

Olivieri, Luca M. and E. Iori. 2019. "Data from the 2016 Excavation Campaigns at Barikot, Swat (Pakistan): A Shifting Perspective." In *Proceedings of the 29th South Asian Art and Archaeology Conference (Cardiff, July 2016)*, edited by A. Hardy and L. Greaves, 19–43. Delhi: Dev Publishers & Distributors.

Ortloff, Charles R. 2003. "The Water Supply and Distribution System of the Nabataean City of Petra (Jordan), 300 BC–AD 300." *Cambridge Archaeological Journal* 15.1: 93–109.

Ortloff, Charles R. 2009. *Water Engineering in the Ancient World: Archaeological and Climate Perspectives on Ancient Societies of South America, the Middle East and South East Asia*. Oxford: Oxford University Press.

Ortloff, Charles R. 2014. "Three Hydraulic Engineering Masterpieces at 100 BC-AD 300 Nabataean Petra (Jordan)." In *Conference: De Aquaductu Atque Aqua Urbium Lyciae Phamphyliae Pisidiae: The Legacy of Sextus Julius Frontinus, Vol. 1*, edited by G. Wiplinger, 155–67. Leuven: Peeters Publishing.

Ortloff, Charles R. 2014a. "Water Engineering at Petra (Jordan): Recreating the Decision Process underlying Hydraulic Engineering at the Wadi Mataha Pipeline." *Journal of Archaeological Science* 44: 91–97.

Osborn, J. R. 2017. *Letters of Light: Arabic Script in Calligraphy, Print, and Digital Design*. Cambridge, MA: Harvard University Press.

Ousterhout, Robert G. 2017. *Visualizing Community: Art, Material Culture, and Settlement in Byzantine Cappadocia*. Washington, DC: Dumbarton Oaks.

P

Paine, Lincoln. 2014. *The Sea and Civilization: A Maritime History of the World*. London: Vintage Books.

Pan, Ling. 2011. "A Summary of Xiongnu Sites Within the Northern Periphery of China." In *Xiongnu Archaeology. Multidisciplinary Perspectives of the First Steppe Empire in Inner Asia*, edited by Ursula Brosseder and Bryan Miller, 463–74. *Bonn Contributions to Asian Archaeology* 5, Bonn.

Papahrist, O. A. 1985. *Ferrous Metallurgy of Northern Fergana*. PhD thesis, Moscow.

Parzinger, Hermann. 2017. "Burial Mounds of Scythian Elites in the Eurasian Steppe: New Discoveries." *Journal of the British Academy* 5: 331–55.

Peck, Elsie H. 1969. "The Representations of Costumes in the Reliefs of Taq-i Bustan." *Artibus Asiae* 31: 101–46.

Penn, James R. and Larry Allen. 2001. *Rivers of the World: A Social, Geographical, and Environmental Handbook*. Santa Barbara: ABC-CLIO.

Periplus of the Erythraean Sea *see* Casson 1989; Schoff 2012.
Perry, Craig. 2014. *The Daily Life of Slaves and the Global Reach of Slavery in Medieval Egypt, 969-1250 CE*. PhD thesis, Atlanta GA, Emory University.

Peterson, Sara. 2011–12. "Parthian Aspects of Objects from Grave IV, Tillya Tepe, With Particular reference to the Medallion Belt." https://www.academia.edu/1485067/Parthian_Aspects_of_Objects_from_Grave_IV_Tillya_Tepe [last accessed 7 June 2019]

Petrie, Cameron A. and Peter Magee. 2014. "The Achaemenid Expansion to the Indus and Alexander's Invasion of North-West South Asia." In *History of Ancient India, III: The Texts, and Political History and Administration till c.200 BC*, edited by D. K. Chakrabarti and M. Lal, 205–30. New Delhi: Vivekananda International Foundation and Aryan Books.

Pettersson, Ann-Marie, ed. 2009. *The Spillings Hoard: Gotland's Role in Viking Age World Trade*. Visby: Fornsalens Förlag.

Phillipson, David W. 1998. *Ancient Ethiopia: Aksum: Its Antecedents and Successors*. London: British Museum Press.

Philo of Alexandria. Trans. by F. H. Colson. 1941. *De Vita Contemplation. (Loeb Classical Library 9: 104–70)*. Cambridge, MA: Harvard University Press.

Picken, Laurence. 1955. "The Origin of the Short Lute." *The Galpin Society Journal* 8: 32–42.

Pietz, David A. 2015. *The Yellow River*. Cambridge, MA: Harvard University Press.

Pollegioni, Paola et al. 2017. "Ancient Humans Influenced the Current Spatial Genetic Structure of Common Walnut Populations in Asia." *PLoS ONE* 10.9: e0135980.

Pope, Hugh. 2005. "The Silk Road: A Romantic Deception?" *The Globalist* https://www.theglobalist.com/the-silk-road-a-romantic-deception/ [last accessed 7 June 2019]

Power, Tim. 2012. *The Red Sea from Byzantium to the Caliphate: AD 500–1000*. Cairo: American University of Cairo Press.

Pribytkova, A. M. 1955. "Karavan-saraĭ Daia-Khatyn." In *Pamiatniki Arkhitektury XI veka v Turkmenii*, edited by A. M. Pribytkova, 39–64. Moscow: Gosudarstvennoe Izd-vo.

Price, Martin F. et al. 2013. *Mountain Geography: Physical and Human Dimensions*. Berkeley: University of California Press.

Procopius. Trans. by H. B. Dewing. 1914. *Procopius: History of the Wars: Books 1–2*. Cambridge, MA: Loeb Classical Library.

R

Rapin, Claude. 2013. "On the way to Roxane. The Route of Alexander the Great in Bactria and Sogdiana (328–327 BC)." In *Zwischen Ost und West. Neue Forschungen zum antiken Zentralasien*, edited by G. Lindström, S. Hansen, A. Wieczorek and M. Tellenbach, 43–82. Darmstadt: Verlag Philipp von Zabern.

al-Rashid, Saad. 1980. *Darb Zubaydah: The Pilgrim Road from Kufa to Mecca*. Riyadh: University of Riyadh.

Raymond, André. 2002. *Cairo*. Cambridge, MA: Harvard University Press.

Reddé, Michel. 2014. *Les frontières de l'Empire romain (1er siècle avant J-C – 5e siècle après J-C)*. Lacapelle-Marival: Éditions Archéologie Nouvelle.

Revire, Nicolas. 2012. "New Perspectives on the Origin and Spread of Bhadrāsana Buddhas through Southeast Asia (7th-8th centuries)." In *Connecting Empires and States. Selected Papers from the 13th Conference of the European Association of Southeast Asian Archaeologists*, vol. 2, edited by Mai Lin Tjoa-Bonatz, Andreas Reinecke and Dominik Bonatz, 127–43. Singapore: NUS Press.

Rezakhani, Khodadad. 2017. *ReOrienting the Sasanians: East Iran in Late Antiquity*. Edinburgh: Edinburgh University Press.

Rhie, Marylin. 1988. *Interrelationships Between the Buddhist Art of China and the Art of India and Central Asia from 618–755 AD*. Monograph supplementum to *Annali*. Naples: Istituto Universitario Orientale.

Robinson, Chase, ed. 2010. *The New Cambridge History of Islam I: The Formation of the Islamic World: Sixth to Eleventh Centuries*. Cambridge: Cambridge University Press.

Rodley, Lyn. 2010. *Cave Monasteries of Byzantine Cappadocia*. Cambridge: Cambridge University Press.

Rose, Jenny. 2011. *Zoroastrianism: An Introduction*. London: I. B. Tauris.

Rousseau, Philip. 1999. *Pachomius: The Making of a Community in Fourth-Century Egypt*. Berkeley: University of California Press.

Rowland, Benjamin. 1960. *Gandhara Sculpture from Pakistan Museums*. New York: The Asia Society.

Rudenko, S. I. 1953. *Kul'tura naseleniya Gornogo Altaya v skifskoye vremya*. Moscow: Izdatelstvo Akademii nauk SSSR.

Rudenko, S. I. 1962. *Kul'tura chunnov i noinulinskiye kurganyyu*. Moscow: Izdatelstvo Akademii nauk SSSR.

Rudenko, S. I. 1970. *Frozen Tombs of Siberia: The Pazyryk Burials of Iron Age Horsemen*. Berkeley: University of California Press.

Rule, Margaret. 1982. *The Mary Rose: The Excavation and Raising of Henry VIII's Flagship*. Annapolis: Naval Institute Press.

Rumi *see* Lewis 2011.

S

Sarianidi, Viktor I. 1985. *The Golden Hoard of Bactria: from the Tillya-tepe Excavations in Northern Afghanistan*. St Petersburg: Aurora Art Publishers.

Sarre, Friedrich Paul Theodor. 1925. *Die Keramik von Samarra im Kaiser-Friedrich-Museum, Forschungen zur islamischen Kunst, Herausgegeben von Friedrich Sarre II, Die Ausgrabungen von Samarra*, vol. II. Berlin: Reimer.

Sauer, Eberhard et al. 2013. *Persia's Imperial Power in Late Antiquity: the Great Wall of Gorgān and Frontier Landscapes of Sasanian Iran*. Oxford: Oxbow Books.

Sauer, Eberhard, ed. 2017. *Sasanian Persia between Rome and the Steppes of Eurasia*. Edinburgh: Edinburgh University Press.

Sauer, Eberhard, L. Chologauri and D. Naskidashvili. 2016. "The Caspian Gates: Exploring the Most Famous Mountain Valley of the Ancient World." *Current World Archaeology* 80: 18–24.

Schaefer, Karl R. 2006. *Enigmatic Charms: Medieval Arabic Block Printed Amulets in American and European Libraries and Museums*. Leiden: Brill.

Schafer, Edward H. 1966. *Golden Peaches of Samarkand*. Berkeley: University of California Press.

Schaps, David M. 2004. *The Invention of Coinage and the Monetization of Ancient Greece*. Ann Arbor: University of Michigan Press.

Schiettecatte, Jérémie and Abbès Zouache. 2017. "The Horse in Arabia and the Arabian Horse: Origins, Myths and Realities." *Arabian Humanities* 8 (online). http://journals.openedition.org/cy/3280 [last accessed 7 June 2019]; DOI: 10.4000/cy.3280

Schiltz, Véronique, ed. 2001. *L'Or des Amazones, peuples nomades entre Asie et Europe, VIIe siècle av. J.-C.–IVème siècle apr. J.-C.* Paris: Éditions Findakly.

Schiltz, Véronique. 2002. "Les Sarmates entre Rome et Chine: nouvelles perspectives." *Comptes rendus des séances de l'Académie des Inscriptions et Belles-Lettres* 146.3: 845–87.

Schindel, N. 2009. *Sylloge Nummorum Sasanidarum Israel. The Sasanian and Sasanian-type coins in the collections of the Hebrew University (Jerusalem), the Israel Antiquity (Jerusalem), the Israel Museum (Jerusalem) and the Kadman Numismatic Pavilion at the Eretz Israel Museum (Tel Aviv)*. Vienna: Verlag der Österreichischen Akademie der Wissenschaften.

Schjellerup, H. C. F. C. 1874. *Description des Etoiles Fixes Composèe au Milieu du Dixième Sièccle de Notre ere par l'Astronome Persan Abd-al-Rahman al-Sûfi*. St Petersburg: Commissionaires de l'Academie Imperial des Sciences.

Schlingloff, Dieter. 1971. "Das Sasa-Jataka." *Wiener Zeitschrift für die Kunde Süd- und Ostasiens* 15: 57–67.

Schlumberger, Daniel. 1952. "Le palais ghaznévide de Lashkari Bazar." *Syria. Archéologie, Art et histoire* 29-3-4: 251–70.

Schmedding, Brigitta. 1978. *Mittelalterliche Textilien in Kirchen und Klöstern der Schweiz: Katalog (Schriften der Abegg-Stiftung Bern)*. Bern: Verlag Stämpfli.

Schmidt-Colinet, Andreas. 1995. *Palmyra: Kulturbegegnung im Grenzbereich*. Mainz am Rhein: Verlag Philipp von Zabern.

Schoff, W. H., trans. 1912. *The Periplus of the Erythraean Sea: Trade and Travel in the Indian Ocean*. New York: Longmans.

Schopen, Gregory. 1997. *Bones, Stones, and Buddhist Monks: Collected Papers on the Archaeology, Epigraphy, and Texts of Monastic Buddhism in India*. Honolulu: University of Hawaii Press.

Schottenhammer, Angela. 1999. "Quanzhou's Early Overseas Trade: Local Politico-Economic Particulars During its Period of Independence." *Journal of Sung-Yuan Studies* 29: 1–41.

Schottenhammer, Angela, ed. 2000. *The Emporium of the World: Maritime Quanzhou, 1000–1400.* Leiden: Brill.

Schwartz, Daniel. 2009. *Travelling Through the Lens of Time.* London: Thames & Hudson.

Segalen, Victor. 1923–24. *Mission archéologique en Chine, 1914 et 1917,* 2 vols. Paris: Paul Geuthner.

Seland, E. H. 2016. *Ships of the Desert, Ships of the Sea: Palmyra in the world trade of the first three centuries CE.* Wiesbaden: Harrassowitz.

Sen, Sudipta. 2019. *Ganges: The Many Pasts of an Indian River.* New Haven: Yale University Press.

Shahgedanova, Maria, ed. 2003. *The Physical Geography of Northern Eurasia.* Oxford: Oxford University Press.

Al-Shanfarā *see* Stetkevych 1986.

Sheriff, Abdul and Vijayalakshmi Teelock. 2010. *Dhow Cultures of the Indian Ocean. Cosmopolitanism, Commerce and Islam.* London: Hurst & Co.

Shōsōin, ed. 1967. *Shōsōin no Gakki* 正倉院の楽器. Tokyo: Nihon Keiza Shimbun Sha.

Sidebotham, Steven E. 2011. *Berenike and the Ancient Maritime Spice Route.* Berkeley: University of California Press.

Simonsohn, Uriel, Nimrod Hurvitz, Christian Sahner and Luke Yarbrough, eds. Forthcoming. *Turning to Mecca: A Sourcebook on Conversion to Islam in the Classical Period.* Oakland: University of California Press.

Sims-Williams, Nicholas. 1976. "The Sogdian Fragments of the British Library." *Indo-Iranian Journal* 18/1-2: 43–82.

Sims-Williams, Nicholas. 1989, 1992. *Sogdian and other Iranian inscriptions of the Upper Indus,* 2 vols. London: SOAS.

Sims-Williams, Nicholas. 1996. "The Sogdian Merchants in China and India." In *Cina e Iran: Da Alessandro Magno alla dinastia Tang,* edited by A. Cadonna and L. Lanciotti, 45–67. Florence: Leo S. Olschki Editore.

Sims-Williams, Nicholas. 1997–98. "The Iranian inscriptions of Shatial." *Indologica Taurinensia* 23–24.

Sims-Williams, Nicholas. 2000. "Some Reflections on Zoroastrianism in Sogdiana and Bactria." In *Realms of the Silk Roads: Ancient and Modern,* edited by D. Christian and C. Benjamin, 1–12. Turnhout: Brepols.

Sims-Williams, Nicholas. 2005. "Towards a new edition of the Sogdian Ancient Letters: Ancient Letter 1." In *Les sogdiens en chine,* edited by É. de la Vaissière and É. Trombert, 181–93. Paris: École française d'Extrême-Orient.

Sims-Williams, Nicholas. 2007, 2012. *Bactrian Documents from Northern Afghanistan,* 3 vols. London: The Nour Foundation.

Sims-Williams, Nicholas. 2009. "Christian literature in Middle Iranian languages." In *The Literature of Pre-Islamic Iran. A History of Persian Literature, XVII,* edited by R. E. Emmerick and M. Macuch, 266–87. London: I. B. Tauris.

Sims-Williams, Nicholas. 2017. *An Ascetic Miscellany: The Christian Sogdian Manuscript E28 (Berliner Turfantexte, 42).* Turnhout: Brepols.

Sims-Williams, Nicholas and François de Blois. 2018. *Studies in the Chronology of the Bactrian documents from Northern Afghanistan (Denkschriften der Österreichischen Akademie der Wissenschaften).* Vienna: Verlag der Österreichischen Akademie der Wissenschaften.

Sinai, Nicolai. 2017. *The Qur'an: A Historical-Critical Introduction.* Edinburgh: Edinburgh University Press.

Sinor, Denis. 1972. "Horse and Pasture in Inner Asian History." *Oriens extremus* 19: 171–84.

Skaff, Jonathan K. 2012. *Sui-Tang China and its Turko-Mongol Neighbors. Culture, Power, and Connections, 580-800.* Oxford: Oxford University Press.

Skjaervo, Oktor. 2002. *Khotanese Manuscripts from Chinese Turkestan in the British Library.* London: The British Library.

Smith, Douglas Alton. 2002. *A History of the Lute from Antiquity to the Renaissance.* Manhattan, CA: Lute Society of America.

So, Billy K. L. 2000. *Prosperity, Region, and Institutions in Maritime China: The South Fukien Pattern, 946-1368.* Cambridge, MA: Harvard University Press.

Sommer, Michael. 2017. *Palmyra: A History.* London: Routledge.

Sotomura, Ataru 外村中. 2013. "Shōsōin biwa genryū kō" 正倉院琵琶源流攷.人文学報 *Jinbun gakuhō* 103.3.

Soyinka, Wole. 2002. *Samarkand and Other Markets I Have Known.* London: Methuen Publishing Ltd.

Spataro, Michela, Nigel Wood, Nigel Meeks, Andrew Meek and Seth Priestman. 2018. "Pottery Technology in the Tang Dynasty (9th century AD): Archaeometric Analyses of a Gongyi Sherd found at Siraf, Iran." *Archaeometry* 61.3: 574–87.

Spengler, R. N. 2019. *Fruits from the Sands: Artifacts of the Silk Road on your Dinner Table.* Oakland: University of California Press.

Spengler, R. N. and George Wilcox. 2013. "Archaeobotanical results from Sarazm, Tajikistan, an Early Bronze Age village on the edge: Agriculture and exchange." *Journal of Environmental Archaeology* 18.3: 211–21.

Spengler, R. N. et al. 2014. "Early Agriculture and Crop Transmission among Bronze Age Mobile Pastoralists of Central Eurasia." *Proceedings of the Royal Society B* 281: 2013.3382.

Staniforth, Mark and Michael Nash, eds. 2006. *Maritime Archaeology: Australian Approaches*. Boston: Springer.

Stargardt, Janice and Michael Willis, eds. 2018. *Relics and Relic Worship in Early Buddhism: India, Afghanistan, Sri Lanka and Burma*. London: British Museum Press.

Stark, Sören. 2009. *Die Alttürkenzeit in Mittel- und Zentralasien. Archäologische und historische Studien. Nomaden und Sesshafte 8*. Wiesbaden: Reichert Verlag.

Stausberg, Michael. "Zoroastrians in Modern Iran." In *The Wiley Blackwell Companion to Zoroastrianism*, edited by M. Stausberg and Y. S. D. Vevaina, 173–90. Chichester: John Wiley & Sons.

Stein, M. Aurel. 1907. *Ancient Khotan*. Oxford: Clarendon Press.

Stein, M. Aurel. 1912. *Ruins of Desert Cathay*, 2 vols. London: Macmillan & Co.

Stein, M. Aurel. 1921. *Serindia*. Oxford: Clarendon Press.

Stein, M. Aurel. 1930. *An Archaeological Tour in Upper Swat and Adjacent Hill Tracts. Memoirs of the Archaeological Survey of India, 42*. Calcutta: Archaeological Survey of India.

Steinhardt, Nancy Shatzman. 2008. "China's Earliest Mosques." *Journal of the Society of Architectural History* 67.3: 330–61.

Stetkevych, Suzanne Pinckney. 1986. "Archteype and Attribution in Early Arabic Poetry: Al-Shanfarā and the Lāmiyyat 'al-Arab." *International Journal of Middle East Studies* 18: 361–90.

Stewart, Sarah et al., eds. 2013. *The Everlasting Flame: Zoroastrianism in History and Imagination*. London: I. B. Tauris.

Stimson, Alan. 1988. *The Mariner's Astrolabe: A Survey of Known, Surviving Sea Astrolabes*. Leiden: Hes Publishers.

Stoneman, Richard et al. 2012. *The Alexander Romance in Persia and the East*. Groningen: Barkhuis.

Strauch, Ingo, ed. 2012. *Foreign Sailors on Socotra: The Inscriptions and Drawings from the Cave Hoq (Vergleichende Studien zu Antike und Orient 3)*. Bremen: Ute Hempen Verlag.

T

Taaffe, Robert N. 1990. "The Geographical Setting." In *The Cambridge History of Early Inner Asia*, edited by Denis Sinor, 19–40. Cambridge: Cambridge University Press.

Talbert, Richard J. A. 2010. *Rome's World: The Peutinger Map Reconsidered*. Cambridge: Cambridge University Press. Maps and database at www.cambridge.org/9780521764803 [last accessed 7 June 2019]

Tang, Li. 2011. *East Syriac Christianity in Mongol-Yuan China. Orientalia Biblica et Christiana: 18*. Wiesbaden: Harrassowitz Verlag.

Tardieu, Michel. 2008. *Manichaeism*. Urbana: University of Illinois Press.

Tegegne, Habtamu M. 2016. "The Edict of King Gälawdéwos Against the Illegal Slave Trade in Christians: Ethiopia, 1548." *The Medieval Globe* 2.2: 73–114.

Teploukhov, S. A. 1929. "Opyt klassifikatsii drevnikh metallicheskikh kul'tur Minusinskogo kraya." *Materialy po etnografii* 4.2: 41–62.

Thompson, Nainoa. 1980. "Recollections of the 1980 Voyage to Tahiti." http://archive.hokulea.com/holokai/1980/nainoa_to_tahiti.html [last accessed 7 June 2019]

Thurman, Robert A. F., trans. 1976. *The Holy Teaching of Vimalakīrti: A Mahāyāna Sutra*. University Park: Pennsylvania State University Press.

Timperman, Ilse. 2016. *Early Niche Graves in the Turfan Basin and Inner Eurasia*. PhD thesis, SOAS University of London.

Tolmacheva, Marina. 1996. "Bertius and al-Idrisi: an Experiment in Orientalist Cartography." *Terrae Incognitae* 28: 36–45.

Tolmacheva, Marina. 2005. "'al-Idrisi." In *Medieval Islamic Civilization: An Encyclopedia*, vol. 1, edited by Josef W. Meri and Jere L. Bacharach, 379–38. New York and London: Routledge.

Tomber, Roberta. 2008. *Indo-Roman Trade, from Pots to Pepper*. London: Duckworth.

Trever, Camilla. 1932. *Excavations in Northern Mongolia (1924-1925)*. Leningrad: J. Fedorov.

Triantafyllidis, Pavlos. 2000. *Rhodian Glassware I. The Luxury Hot-formed Transparent Vessels of the Classical and Early Hellenistic Periods*. Athens: Ministry of the Aegean Sea.

Trombert, Éric. 2011. "Note pour une évaluation nouvelle de la colonisation des contrées d'occident au temps des Han." *Journal Asiatique* 299.1: 67–123.

Trümpler, Charlotte, ed. 2008. *Das Grosse Spiel: Archäologie und Politik (1860–1940)*. Koln: DuMont Buchverlag GmbH & Co. KG.

Tsotselia, Medea. 2003. *History and Coin Finds in Georgia: Sasanian Coin Finds and Hoards*. Wetteren: Moneta.

Turkestanii Album. http://www.loc.gov/rr/print/coll/287_turkestan.html [last accessed 7 June 2019]

Turnbull, Harvey. 1972. "Origin of the Long-Necked Lute." *The Galpin Society Journal* 25: 58–66.

Turner, Paula. 1989. *Roman Coins from India*. London: Routledge.

V

Vainker, Shelagh. 2004. *Chinese Silk: A Cultural History*. London: British Museum Press.

Van der Veen, M. 2011. *Consumption, Trade and Innovation: Exploring the Botanical Remains from the Roman and Islamic Ports at Quseir al-Qadim, Egypt.* Frankfurt: Africa Magna Verlag.

Van Donzel, E. J. and Andrea Schmidt. 2010. *Gog and Magog in Early Syriac and Islamic Sources: Sallam's Quest for Alexander's Wall.* Leiden: Brill.

Van Driel-Murray, C. 2000. "A Late Roman Assemblage from Deurne (Netherlands)." *Bonner Jahrbücher des Rheinischen Landesmuseums in Bonn* 200: 293–308.

Verkinderen, Peter. 2015. *Waterways of Iraq and Iran in the Early Islamic Period: Changing Rivers and Landscapes of the Mesopotamian Plain.* London: I. B. Tauris.

W

Wagner, Mayke et al. 2009. "The Ornamental Trousers from Sampula (Xinjiang, China): Their Origins and Biography." *Antiquity* 83 (322): 1065–75.

Walburg, Reinhold. 2008. *Coins and Tokens from Ancient Ceylon, Ancient Ruhuna: Sri Lanka-German Archaeological Project in the Southern Province. Vol. 2.* Wiesbaden: Reichert Verlag.

Wang Bo, Wang Mingfeng, Minawar Happar and Lu Lipeng. 2016. *Textile Treasures of Zaghunluq.* Riggisberg: Abegg-Stiftung; Beijing: Cultural Relics Press.

Wang, Helen. 2004. *Money on the Silk Road, the Evidence from Eastern Central Asia to c. AD 800.* London: British Museum Press.

Wang, Helen. 2004a. "How Much for a Camel? A New Understanding of Money on the Silk Road Before AD 800." In *The Silk Road: Trade, Travel, War and Faith,* edited by Susan Whitfield and Ursula Sims-Williams, 24–33. London: The British Library.

Watson, Oliver. 2006. *Ceramics from Islamic Lands.* London: Thames & Hudson.

Watt, James and Anne Wardwell. 1997. *When Silk Was Gold: Central Asian and Chinese Textiles.* New York: The Metropolitan Museum of Art.

Waugh, Daniel C. 2010. "Richthofen's 'Silk Roads': Towards the Archaeology of a Concept." faculty.washington.edu/dwaugh/publications/waughrichthofen2010.pdf [last accessed 7 June 2019]

Webb, Peter. 2016. *Imagining the Arabs: Arab Identity and the Rise of Islam.* Edinburgh: Edinburgh University Press.

Weber, Stefan, Ulrike al-Khamis and Susan Kamel, eds. 2014. *Early Capitals of Islamic Culture: the Artistic Legacy of Umayyad Damascus and Abbasid Baghdad (650-950).* Munich/Sharjah: Hirmer.

Wegehaupt, Matthew, trans. 2012. "Open Road to the World: Memoirs of a Pilgrimage to the Five India Kingdoms." In *Collected Works of Korean Buddhism vol. 10. Korea Buddhist Culture: Accounts of a Pilgrimage Monuments and Eminent Monks,* edited by R. Whitfield, 73–74. Seoul: Jogye Order of Korean Buddhism.

Whitehouse, David and R. H. Brill. 2005. *Sasanian and Post-Sasanian Glass in the Corning Museum of Glass.* Corning, NY: The Corning Museum of Glass.

Whitehouse, David et al. 2009. *Siraf: History, Topography and Environment.* Oxford: Oxbow.

Whitfield, Peter. 1995. *The Mapping of the Heavens.* London: British Library.

Whitfield, Roderick, Susan Whitfield and Neville Agnew. 2015. *Cave Temples of Mogao at Dunhuang: Art and History on the Silk Road.* Los Angeles: Getty Publications.

Whitfield, Susan. 2007. "Was There a Silk Road?" *Asian Medicine* 3: 203–13.

Whitfield, Susan. 2009. *La Route de la Soie: Un voyage à travers la vie et la mort.* Brussels: Fonds Mercator.

Whitfield, Susan. 2015. *Life Along the Silk Road.* Oakland: University of California Press.

Whitfield, Susan. 2018. *Silk, Slaves, and Stupas: Material Culture of the Silk Road.* Oakland: University of California Press.

Whitfield, Susan and Ursula Sims-Williams, eds. 2004. *The Silk Road: Trade, Travel, War and Faith.* London: The British Library.

Wilckens, Leonie von. 1991. *Die textilen Künste. Von der Spätantike bis um 1500.* Munich: Beck.

Wild, John Peter, and Felicity Wild. 1996. "The Textiles." In *Berenike 1995: Preliminary Report of the 1995 Excavations at Berenike (Egyptian Red Sea Coast) and the Survey of the Eastern Desert,* edited by Steven E. Sidebotham and Willeke Z. Wendrich, 245–56. Leiden: Research School CNWS.

Wilensky, Julie. 2000. "The Magical Kunlun and 'Devil Slaves': Chinese Perceptions of Dark-skinned People and Africa before 1500." *Sino-Platonic Papers* 122: 1–51.

Williams, Tim. 2014. *Silk Roads: An ICOMOS Thematic Study.* Charenton-le-Pont: ICOMOS.

Williams, Tim. 2015. "Mapping the Silk Roads." In *The Silk Road: Interwoven History. Vol. 1, Long-distance Trade, Culture, and Society,* edited by M. N. Walter and J. P. Ito-Adler, 1–42. Cambridge, MA: Cambridge Institutes Press.

Williams, Tim and Sjoerd van der Linde. 2008. "The Urban Landscapes of Ancient Merv, Turkmenistan." Archaeology Data Service. http:archaeologydataservice.ac.uk/archives/view/merv_ahrc_2008/ [last accessed 7 June 2019]

Wink, André. 1991–2004. *Al-Hind. The Making of the Indo-Islamic World*, 3 vols. Leiden and New York: Brill.

Witsen, Nicolaas. 1696. *Noord en Oost Tartarye*. Amsterdam. http://resources.huygens.knaw.nl/retroboeken/witsen/#page=0&accessor=toc&view=homePane [last accessed 7 June 2019]

Wolska-Conus, Wanda. 1968. *Topographie chrétienne / Cosmas Indicopleustès*. Paris: Les Éditions du Cerf.

Wong, Dorothy, ed. 2008. *Hōryūji Reconsidered*. Newcastle: Cambridge Scholars Publishing.

Wood, Frances. 2004. *The Silk Road: Two Thousand Years in the Heart of Asia*. London: The British Library.

Wood, Frances and Mark Barnard. 2010. *The Diamond Sutra: The Story of the World's Earliest Dated Printed Book*. London: The British Library.

Wood, Marilee. 2012. *Interconnections: Glass Beads and Trade in Southern and Eastern Africa and the Indian Ocean - 7th to 16th centuries AD*. PhD thesis, Uppsala, Department of Archaeology and Ancient History.

Wood, Marilee. 2018. "Glass Beads and Indian Ocean Trade." In *The Swahili World*, edited by S. Wynne-Jones and A. LaViolette, 458–71. London and New York: Routledge.

Wood, Marilee, L. Dussubieux and P. Robertshaw. 2012. "The Glass of Chibuene, Mozambique: New Insights into Early Indian Ocean Trade." *South African Archaeological Bulletin* 67: 59–74.

Woodward, Hiram. 1988. "Interrelationships in a Group of Southeast Asian Sculptures." *Apollo* 118: 379–83.

Wordsworth, Paul. 2019. *Moving in the Margins: Desert Trade in Medieval Central Asia*. Leiden: Brill.

Wu, Wenliang 吳文良 and Wu Youxiong 吳幼雄. 2005. *Quanzhou zongjiao shike* 泉州宗教石刻. Beijing: Science Publishing.

X

Xu, Jay. 2001. "Bronze at Sanxingdui." In *Ancient Sichuan: Treasures from a Lost Civilization*, edited by Robert Bagley, 59–152. Seattle Art Museum and Princeton University Press.

Y

Yang, Bin. 2011. "The Rise and Fall of Cowrie Shells: The Asian Story." *Journal of World History*, 22.1: 1–25.

Yokohari, Kazuko. 2006. "The Horyu-ji Lion-hunting Silk and Related Silks." In *Central Asian Textiles and their Contexts in the Early Middle Ages*, edited by Regula Schorta, 155–73. Riggisberg: Abegg-Stiftung.

Yoshida, Yutaka. 2016. "Sogdians in Khotan: some new interpretations of the two Judeo-Persian letters from Khotan." In *Sogdians in China: New Evidence in Archaeological Finds and Unearthed Texts*, vol. 2, edited by Rong Xinjiang and Luo Feng, 621–29. Beijing: Science Press.

Yoshida, Yutaka 吉田 豊 and Shoichi Furukawa 古川 攝一, eds. 2015. *Chūgoku Kōnan Mani kyō kaiga kenkyū*. 中国江南マニ教絵画研究. Kyoto: Rinsen Book Co.

Yūsuf Balasağuni. Trans. by Dolkun Kamberi and Jeffrey Yang. 2010. "On Knowledge." *Some Kind of Beautiful Signal* 17: 244–91.

Z

Zeeuw, Hans de. 2019. *Tanbûr Long-Necked Lutes Along the Silk Road and Beyond*. Oxford: Archaeopress.

Zhang Guangda. 1996. "The City-states of the Tarim Basin." In *History of Civilizations of Central Asia, vol. III – The Crossroads of Civilizations: A.D. 250–750*, edited by B. A. Litvinsky, 281–301. Paris: UNESCO Publishing.

Zhang Guangda and Rong Xinjiang. 1998. "A Concise History of the Turfan Oasis and Its Exploration." *Asia Major*, third series, 11.2: 13–36.

Zhang Xu-shan. 2004. "The Name of China and its Geography in Cosmas Indicopleustes." *Byzantion* 74: 452–62.

Zhang Yue 張說. Trans. by Kroll. 1981. "Lyrics for Dancing Horse." *T'oung Pao* 67: 240–68.

Zhang Zhan 張湛. 2018. "Secular Khotanese Documents and the Administrative System in Khotan." *Bulletin of the Asia Institute* 28: 57–98.

Zhang Zhan 張湛 and Shi Guang 時光. 2008. "Yijian xinfaxian Youtai-Bosiyu xinzha de duandai yu shidu." 一件新發現猶太波斯語信劄的斷代與釋讀 *Dunhuang Tulufan Yanjiu* 敦煌吐魯番研究 11: 71–99.

Zhao Feng et al. 2017. "The Earliest Evidence of Pattern Looms: Han Dynasty Models from Chengdu, China." *Antiquity* 91.356: 360–74.

Zhao Feng 赵丰. 2005. "Xinjiang dichan mianxian zhijin yanjiu." 新疆地产绵线织锦研究. *Xiyu Yanjiu* 西域研究 1: 51–59.

Zhao Feng. 2014. "The Development of Pattern Weaving Technology Through Textile Exchange along the Silk Road." In *Global Textile Encounters (Ancient Textile Series 20)*, edited by M.-L. Nosch, M-L., Zhao Feng and L. Varadarajan, 49–64. Oxford: Oxbow.

Zhu Yi 朱翌. 2014. "Lun Huo Qubing mu shijiao jiaosu de caizhi." 论霍去病墓石雕雕塑的材质. *Dazhong Wenyi* 大众文艺 8: 91.

Zhu Yu 朱彧. 1921. 萍洲可談 *Pingzhou ketan*. Shanghai: Boguzhai.

Zhuang Yongping 庄永平. 2001. *Pipa shouce* 琵琶手册. Shanghai: Shanghai yinyue chubanshe.

Contributors' biographies

General editor

Dr Susan Whitfield is a scholar, traveller, lecturer and curator of the Silk Roads and her many books, articles and exhibitions have looked at its histories, arts and archaeology. During her time at the British Library, UK, curating the Central Asian manuscript collection from the explorations of M. Aurel Stein and others in the early twentieth century, she developed and directed a project to make Silk Roads artifacts freely available. She has documented archaeological sites and museum collections worldwide.

Foreword

Peter Sellars has gained international renown as a stage and festival director for his transformative interpretations of artistic masterpieces and for collaborative projects with an extraordinary range of creative artists. The Silk Roads and particularly the Buddhist paintings of Dunhuang have long been central to his creative practice, most recently to his ongoing Vimalakīrti Sutra project.

Advisory board members and contributors

Dr Alison Aplin Ohta is director of the Royal Asiatic Society of Great Britain and Ireland, UK.

Dr Bérénice Bellina is a senior researcher at the CNRS (National Centre for Scientific Research), France.

John Falconer is a photographic historian, formerly Head of Visual Arts at the British Library, UK.

Dr Sergey Miniaev is Senior Scientific Researcher at the Institute for the History of Material Culture, Russia, and head of the trans-Baikal archaeological expedition.

Dr Luca M. Olivieri is the director of the Italian Archaeological Mission in Pakistan (ISMEO).

Ursula Sims-Williams is curator for Iranian Languages at the British Library, UK.

Professor Daniel C. Waugh is Emeritus Professor in the Department of History at the University of Washington, USA.

Tim Williams is a reader in Silk Roads archaeology at University College London, UK.

Zhao Feng is director of the China National Silk Museum in Hangzhou, China.

Other contributors

Idriss Abduressul is Honorary Director of the Xinjiang Institute of Archaeology, China.

Warwick Ball is a Near Eastern archaeologist and author.

Dr Arnaud Bertrand is a research associate for Archaeology of Central Asia (ArScAn) at the CNRS and teaching assistant in the Faculty of Letters at the Catholic University of Paris (ICP), France.

Jonathan M. Bloom is an author and the former Norma Jean Calderwood University Professor of Islamic and Asian Art at Boston College, along with the Hamad bin Khalifa Endowed Chair in Islamic Art at Virginia Commonwealth University, USA.

Dr Jean-Marc Bonnet-Bidaud is an astrophysicist at the Commissariat a l'Energie Atomique (CEA), and in the Département d'Astrophysique, IRFU, France.

Dr Robert Bracey works in the Department of Coins and Medals, British Museum, UK.

Dr Sonja Brentjes is a historian of science affiliated with the Max Planck Institute for the History of Science in Berlin, Germany.

Dr Ursula Brosseder is a visiting research scholar at the Institute for the Study of the Ancient World (ISAW), New York University, USA.

Dr Cristina Castillo is affiliated with the Institute of Archaeology, University College London, UK.

Dr Tamara T. Chin is affiliated with the departments of Comparative Literature and East Asian Studies at Brown University, USA.

Dr Joe Cribb was Keeper of Department of Coins and Medals at the British Museum, UK, for forty years, from 1970 to 2010.

Dr Rebecca Darley is a lecturer in medieval history at Birkbeck, University of London, UK.

Professor T. Daryaee is Professor of Iranian history and Director of the Dr. Samuel M. Jordan Center for Persian Studies at the University of California, Irvine, USA.

Dr Sophie Desrosiers teaches the history and anthropology of textiles at the School for Advanced Studies in the Social Sciences (EHESS), France.

Claire Dillon is a doctoral student in the Department of Art History and Archaeology at Columbia University, USA.

Dr K. Durak is an associate professor in the Department of History, Boğaziçi University, Turkey.

Dr Anna Filigenzi is a temporary lecturer at the University of Naples 'L'Orientale', Italy, and Director of the Italian Archaeological Mission in Afghanistan (ISMEO).

Professor Frantz Grenet is Deputy-Director of DAFA (Délégation Archéologique Française en Afghanistan), research fellow at and Professor at the Collège de France.

Professor Zsuzsanna Gulácsi is a professor of art history, Asian studies and comparative religious studies at Northern Arizona University, USA.

Anne Hedeager Krag is an archaeologist and senior researcher at the Danish National Committee for Byzantine Studies, University of Copenhagen, Denmark.

Professor Julian Henderson is professor of archaeological science at the University of Nottingham, UK, and Li Dak Sum Chair Professor of Silk Road Studies at the University of Nottingham, China.

Dr Georgina Herrmann is Honorary Professor, University College London, UK.

Dr B. Hildebrandt is a lecturer (*Privatdozentin*) in Ancient History at the University of Hannover, Germany, and also works on different projects regarding socially relevant museums.

Professor P. P. Ho is professor of architecture and head of the Department of Architecture at the National University of Singapore.

Professor Mark Horton is Professorial Research Fellow at the Royal Agricultural University, Cirencester, UK.

Professor Susan L. Huntington is Distinguished University Professor, Emerita, at the Ohio State University, Columbus, USA.

Dr Karel C. Innemée is a former assistant professor at the Universities of Leiden and Amsterdam in the Netherlands and currently a research fellow at the University of Amsterdam and the University of Divinity in Melbourne, Australia.

Dr Jun Kimura is a maritime archaeologist and lecturer at Tokai University, Japan.

Dr Elizabeth A. Lambourn is associate professor in South Asian and Indian Ocean Studies, De Montfort University, Leicester, UK.

Professor Lewis Lancaster is Professor Emeritus in the Department of East Asian Languages and Cultures at the University of California, Berkeley, USA.

Dr George Lane is a traveller, author and lecturer on medieval Islamic and Mongol history at SOAS, University of London, UK.

Dr Li Tang was a postdoctoral research fellow at the National University of Singapore and is now senior research fellow and university lecturer at the Department of Biblical Studies and Ecclesiastical History, Salzburg University, Austria.

Professor Li Wenying is Director of the Xinjiang Institute of Cultural Relics and Archaeology, China.

Professor Dr Xinru Liu is a professor emeritus of the College of New Jersey in Ewing, USA, and is associated with the Institute of World History, Chinese Academy of Sciences, China.

Dr George Manginis is the Academic Director of the Benaki Museum, Athens, and has taught art history at SOAS, the Courtauld Institute and the University of Edinburgh.

Dr Kate Masia-Radford is an independent scholar on the Sasanian period based in Sydney, Australia.

Professor James A. Millward is Professor of Inter-societal History in the Department of History and School of Foreign Service, Georgetown University, USA, and an affiliated professor in the Masters programme in East Asian Studies at the University of Granada, Spain.

Dr Noriko Miya is an assistant professor at the Institute for Research in Humanities at Kyoto University, Japan.

Dr Valentina Mordvintseva is an associate professor at the National Research University Higher School of Economics, Centre of Classical and Oriental Archaeology, Russia.

Davit Naskidashvili is a lecturer and doctoral student at the Institute of Archaeology, Ivane Javakhishvili Tbilisi State University, Georgia.

Professor Dr Lukas Nickel is Chair of Art History of Asia and head of the Department of Art History at Vienna University, Austria.

Dr Jebrael Nokandeh is director of the National Museum of Iran in Tehran and research fellow at the Research Institute of Cultural Heritage and Tourism, Iran.

Professor Dr Mehmet Ölmez teaches Old Turkic and Modern Turkic languages at Istanbul and Boğaziçi Universities, Turkey.

Hamid Omrani Rekavandi is the director of the Great Gorgan Wall Cultural Heritage Base, Iranian Cultural Heritage, Handicraft and Tourism Organization, Gorgan, Iran.

Dr Charles R. Ortloff is director of CFD Consultants International, active in fluid dynamics research and development activities for major US and international corporations.

Dr Sara Peterson is a postdoctoral research associate at SOAS, University of London, UK, and a lecturer for the Postgraduate Diploma in Asian art.

Dr Marinus Polak is assistant professor of Roman archaeology at Radboud University Nijmegen the Netherlands.

Dr Gethin Rees is lead curator, digital mapping at the British Library, UK.

Dr Nicolas Revire is a lecturer at Thammasat University, Bangkok, Thailand.

Dr W. K. Rienjang is a project assistant for the Gandhara Connections Project at the Classical Art Research Centre, University of Oxford, UK.

Professor Rong Xinjiang is a professor in the Department of History, Peking University, China.

Professor Eberhard W. Sauer is Professor of Roman archaeology at the School of History, Classics and Archaeology, University of Edinburgh, UK.

Dr Nikolaus Schindel is a scientific employee at the Austrian Academy of Sciences, Vienna, Austria.

Professor Dr Angela Schottenhammer is Professor of Non-European History at Salzburg University, Austria, and research associate and adjunct professor of the Indian Ocean World Centre, McGill University, Canada.

Dr Assaad Seif is an associate professor at the Lebanese University, Lebanon, and honorary senior research associate at University College London, UK.

Professor Eivind Heldaas Seland teaches ancient history and global history at the University of Bergen, Norway.

Dr Angela Sheng is the 2017 recipient of a five-year Insight grant from the Social Sciences and Humanities Council of Canada to research the nomadic contribution to knowledge transmission in the first millennium.

Professor Nicholas Sims-Williams is Emeritus Professor of Iranian and Central Asian Studies at SOAS, University of London, UK.

Dr Robert N. Spengler is the director of the Paleoethnobotany Laboratories at the Max Planck Institute, Jena, Germany.

Dr Sarah Stewart is the Shapoorji Pallonji Senior Lecturer in Zoroastrianism in the Department of Religions and Philosophies at SOAS, University of London, UK.

Professor Dr Ingo Strauch is Professor for Buddhist Studies and Sanskrit at the University of Lausanne, Switzerland.

Professor Richard J. A. Talbert is Kenan Professor of History at the University of North Carolina, Chapel Hill, USA.

Dr Ilse Timperman was formerly a museum and exhibition curator in Brussels and a lecturer in Silk Roads archaeology at SOAS, University of London, UK, and the University of Münster, Germany.

Professor Dr Marina Tolmacheva is President Emerita of the American University of Kuwait and Professor Emerita at Washington State University, USA.

Dr Dmitriy Voyakin is director of the International Institute for Central Asian Studies, Uzbekistan.

Dr Rosalind Wade Haddon is a research associate at SOAS, University of London, UK, and currently completing the digitization of the Ernst Herzfeld Samarra finds collection in the British Museum, UK.

Dr Helen Wang is curator of East Asian money, Department of Coins and Medals, British Museum, UK.

Dr Wang Xudong was formerly Director of the Dunhuang Academy and is now Director of the Palace Museum in Beijing, China.

Dr Peter Webb is a lecturer in Arabic literature and culture at Leiden University, the Netherlands.

Dr Peter Whitfield is the author of a number of standard works on the history of cartography, exploration and travel.

Dr Paul D. Wordsworth is a research fellow at the Faculty of Oriental Studies, University of Oxford, UK.

Picture credits

a=above, c=centre, b=below, l=left, r=right

Index

University of California Press, one of the most distinguished university presses in the
United States, enriches lives around the world by advancing scholarship in the humanities,
social sciences, and natural sciences. Its activities are supported by the UC Press Foundation
and by philanthropic contributions from individuals and institutions. For more information,
visit www.ucpress.edu.

University of California Press
Oakland, California

Published in the United Kingdom in 2019 by Thames & Hudson Ltd.

Silk Roads: Peoples, Cultures, Landscapes © 2019 Thames & Hudson Ltd., London

Text © 2019 the contributors
Foreword © 2019 Peter Sellars
All illustrations © 2019 the copyright holders, for details please see the picture
credits list on pp. 468–69
Maps on pages 8–9, 52–53, 122–23, 210–11, 280–81 and 372–73:
base map © Maps in Minutes™ 2003, cartography by ML Design, London

Extract from "Only Breath" by Rumi (p. 10) republished with permission of Princeton
University Press, from *Music of a Distant Drum: Classical Arabic, Persian, Turkish,
and Hebrew Poems*, translated by Bernard Lewis, 2011; permission conveyed through
Copyright Clearance Center, Inc.
"The Amalgamated Map of the Great Ming Empire" (p. 35) translated from the Japanese
by Helena Simmonds
"Keriya: River routes across the Taklamakan" (p. 215), "Oasis kingdoms of the Taklamakan"
(pp. 266–31), "Dunhuang" (p. 138), "Complex looms for complex silks" (pp. 316–23), "Chinese
silk on the steppe" (p. 72), "A child's silk coat" (p. 321), "A woollen caftan" (p. 229) and
"Yarns, textiles and dyes" (pp. 324–29) translated from the Chinese by Ilse Timperman
"Sasanian samite in Africa" (p. 328) translated from the French by Ilse Timperman

Every effort had been made to contact copyright owners for material reproduced in this book.
Please contact Thames & Hudson with any queries.

Designed by Kummer & Herrman
Picture research by Sally Nicholls with additional help by Ilse Timperman

ISBN 978-0-520-30418-5

Printed and bound in Italy by Printer Trento SrL

28 27 26 25 24 23 22 21 20 19
10 9 8 7 6 5 4 3 2 1

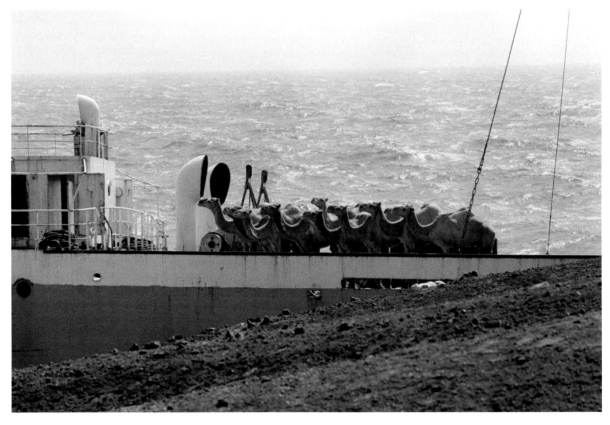

Below — A reminder of the Silk Roads
in modern times: dromedaries stranded
on a Saudi cargo ship off the coast of
Yemen in the Red Sea in 1974.